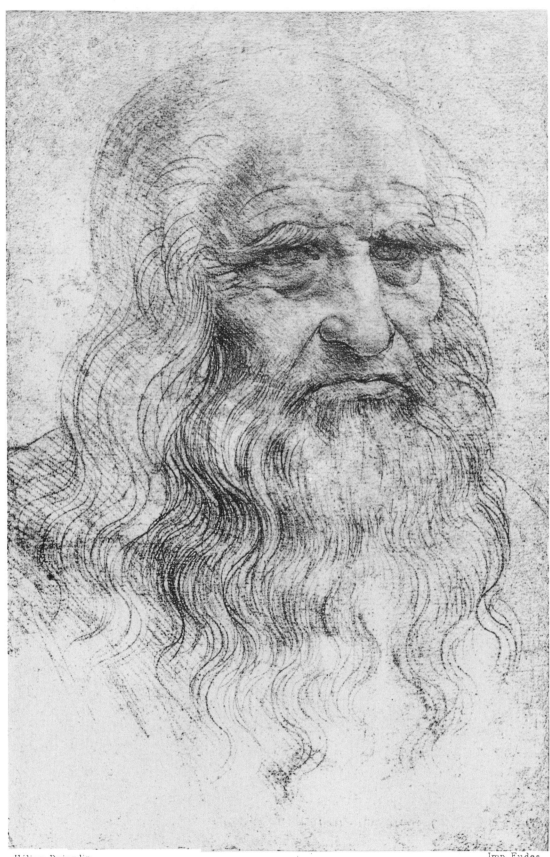

THE NOTEBOOKS OF LEONARDO DA VINCI

Compiled and edited

from the original manuscripts

by Jean Paul Richter

In two Volumes

VOLUME I

Dover Publications, Inc., New York

Standard Book Number: 486-22572-0
Library of Congress Catalog Card Number: 72-104981

Manufactured in the United States of America
Dover Publications, Inc., 31 East 2nd Street, Mineola, N.Y. 11501

DEDICATED

BY PERMISSION

TO

HER MOST GRACIOUS MAJESTY

THE QUEEN

LIST OF SUBSCRIBERS.

H. R. H. THE PRINCE OF WALES.

H. I. H. THE CROWN PRINCE OF GERMANY.

H. R. H. THE DUKE OF ALBANY.

H. R. H. THE LANDGRÄFIN ANNA OF HESSE, PRINCESS OF PRUSSIA.

———————•••———————

BERLIN, INDUSTRIAL MUSEUM (1 copy).

 „ MINISTRY OF PUBLIC INSTRUCTION (2 copies).

 „ ROYAL MUSEUM (1 copy).

BONN, ROYAL UNIVERSITY (1 copy).

BOSTON, U. S., BOSTON ATHENÆUM (1 copy).

BRESLAU, PROVINCIAL MUSEUM (1 copy).

 „ ROYAL UNIVERSITY (1 copy).

BUDAPEST, HUNGARIAN NATIONAL GALLERY (1 copy).

CAMBRIDGE, FITZWILLIAM MUSEUM (1 copy).

CASSEL, ROYAL PICTURE GALLERY (1 copy).

COPENHAGEN, ROYAL LIBRARY (1 copy).

 „ ROYAL PICTURE GALLERY (1 copy).

DELFT, POLYTECHNIC (1 copy).

DRESDEN, GENERAL DIRECTIÓN DER KOENIGL. SAMMLUNGEN &c. (1 copy).

DUBLIN, KING'S INN LIBRARY (1 copy).

 „ NATIONAL LIBRARY OF IRELAND (1 copy).

HAGUE, THE, ROYAL LIBRARY (1 copy).

HALLE, ROYAL UNIVERSITY (1 copy).
HARROW, VAUGHAN LIBRARY (1 copy).
LONDON, ATHENÆUM CLUB (1 copy).
 „ BURLINGTON FINE ARTS CLUB (1 copy).
 „ FINE ART SOCIETY (2 copies.)
 „ GUILDHALL LIBRARY (1 copy).
 „ NATIONAL GALLERY (1 copy).
 „ NEW UNIVERSITY CLUB (1 copy).
 „ REFORM CLUB (1 copy).
 „ ROYAL ACADEMY OF ARTS (SUBSCRIPTION OF ONE HUNDRED POUNDS).
 „ SOUTH KENSINGTON MUSEUM (1 copy).
MUNICH, ROYAL PINACOTECA (1 copy).
NEW YORK, BROOKLYN LIBRARY (1 copy).
OXFORD, CHRIST CHURCH (1 copy).
PARIS, BIBLIOTHÈQUE NATIONALE DES BEAUX-ARTS (1 copy).
 „ MUSÉE DU LOUVRE (1 copy).
PRAGUE, IMPERIAL AND ROYAL UNIVERSITY (1 copy).
TURIN, ROYAL LIBRARY (1 copy).
VIENNA, THE ALBERTINA (1 copy).
 „ IMPERIAL AND ROYAL UNIVERSITY (1 copy).
 „ MUSEUM OF ART AND INDUSTRY (1 copy).
WEIMAR, GRAND DUCAL MUSEUM (1 copy).
WINDSOR, ROYAL LIBRARY (1 copy).

———————•◦•———————

ALMA-TADEMA, L. ESQ., R. A., LONDON (1 copy).
AMSLER & RUTHARDT, BERLIN (2 copies).
ANTINORI, THE MARQUESE, SENATORE DEL REGNO, FLORENCE (1 copy).
ARTOM, SENATORE DEL REGNO, ASTI (1 copy).
ASHER & CO., LONDON (4 copies).
AZEGLIO, THE MARCHESE D', SENATORE DEL REGNO, TURIN (1 copy).
BAIN, JAMES, LONDON (4 copies).
BARING, EDW. CHAS. ESQ., M. P., LONDON (1 copy).
BARTLETT, W. H. AND CO., LONDON (1 copy).
BELL, HUGH ESQ., LONDON (1 copy).
BICKERS AND SONS, LONDON (2 copies).
BIRKETT, THE REVᴰ. A. H., BROMHAM (1 copy).
BLACKER, LOUIS, ESQ. (1 copy).
BODE, DR. W. DIRECTOR OF THE ROYAL MUSEUM, BERLIN (1 copy).
BOWER, R. M. ESQ., LONDON (1 copy).
BRAMBILLA, SIGNOR P., MILAN (1 copy).
BREDINS, HERR A., THE HAGUE (1 copy).
BRIOSCHI, PROF. FRANC., DIRECTOR OF THE POLYTECHNIC, MILAN (1 copy).

BRUN, HERR CARL, ZÜRICH (1 copy).
BUMPUS, JOHN, LONDON (6 copies).
BUMPUS, EDW., LONDON (2 copies).
BUMPUS, T. B., LONDON (1 copy).
BURNS AND OATES, LONDON (2 copies).
BUTE, THE MARQUIS OF (1 copy).
CAGNOLA, SENATORE DEL REGNO, MILAN (1 copy).
CAMPORI, THE MARCHESE G., MODENA (1 copy).
CARTER, DR. F. A., LEAMINGTON (1 copy).
CLEMENT, C. G. ESQ., LONDON (1 copy).
CHRISTIE, A. H. ESQ., LONDON (1 copy).
CIVIL SERVICE SUPPLY ASSOCIATION, LONDON (3 copies).
COLVIN, PROF. SIDNEY, CAMBRIDGE (1 copy).
COOMES'S REGENT LIBRARY, LONDON (2 copies).
COOTE, WALTER, ESQ., LONDON (1 copy).
CORNISH, JOS. AND SONS, LONDON (1 copy).
CORNISH, J. E., MANCHESTER (7 copies).
CORNISH, BROS., BIRMINGHAM (1 copy).
CORSINI, H. H. PRINCE TOMMASO, FLORENCE (1 copy).
DENNY, A., LONDON (1 copy).
DAWSON, BROS., MONTREAL, CANADA (2 copies).
DEVONSHIRE, THE DUKE OF (1 copy).
DOETSCH, HENRY ESQ., LONDON (1 copy).
DOUGLAS AND FOULIS, EDINBURGH (5 copies).
DOWNING AND CO., BIRMINGHAM (1 copy).
DUGUID, JOHN ESQ., DOVER (1 copy).
DUMOLARD, FRATELLI, MILAN (3 copies).
DUNN, JOHN, LONDON (1 copy).
ELLIS AND WHITE, LONDON (1 copy).
EASTLAKE, LADY, LONDON (1 copy).
FRIZZONI, DR. GUSTAVO, MILAN (1 copy).
FÜRSTENBERG, H. S. H., PRINCE KARL EGON ZU (1 copy).
GEROLD, L. C., VIENNA (1 copy).
GILBERT AND FIELD, LONDON (1 copy).
GILL, M. H. AND SON, DUBLIN (1 copy).
GIOVANNELLI, H. H. PRINCE, VENICE (1 copy).
GOODE, MRS., BADEN (1 copy).
GRAHAM, W. ESQ., LONDON (1 copy),
GRIMM, PROF. HERMAN, BERLIN (1 copy).
GOWER, LORD RONALD (1 copy).
HABICH, HERR EDW., CASSEL (1 copy).
HAAR AND STEINERT, PARIS (1 copy).
HAMILTON, ADAMS AND CO., LONDON (6 copies).
HATCHARD, MESSRS., LONDON (2 copies).
HARRISON AND SONS, LONDON (1 copy).

HEIMBÜRGER, FRL. N., ACHERN (1 copy).
HENDERSON AND CO., J. T., LEGHORN (1 copy).
HERTZ, FRL. H., NORTHWICH (1 copy).
HESELTINE, J. P. ESQ., LONDON (1 copy).
HICHENS, ANDREW K., LONDON (1 copy).
HICHENS, J. K., LONDON (1 copy).
HODJES, FIGGIS, AND CO., DUBLIN (1 copy).
HODSON, J. STEWART, ESQ., HASLEMERE (1 copy).
HOEPLI, ULRICO, MILAN (8 copies).
HOLLOND, MRS. ROBT., LONDON (1 copy).
JAMES, F. H. ESQ. M. D., LANCASTER, U. S. (1 copy).
JARROLD AND SONS, NORWICH (1 copy).
JERSEY, THE EARL OF (1 copy).
JOEL, H. F. ESQ., DALSTON (1 copy).
JORDAN, GEH. RATH, DR. M., BERLIN (1 copy).
KLINCKSICK, C., PARIS (2 copies).
LANDRIANI, SIGNOR C., MILAN (1 copy).
LAYARD, SIR HENRY A. (1 copy).
LEHMANN, RUDOLPH ESQ., LONDON (1 copy).
LEIGHTON, SIR F., P. R. A., LONDON (1 copy).
LEUCHNER AND LUBENSKY, GRAZ (1 copy).
LEVIS, DR. GIUSEPPE, MILAN (1 copy).
LIPPMANN, DR., DIRECTOR OF THE ROYAL MUSEUM, BERLIN (1 copy).
LITTLE, BROWN AND CO., BOSTON, U. S. (3 copies).
LOCKWOOD (CROSBY) AND CO., LONDON (2 copies).
LÖSCHER AND CO., ROME (1 copy).
MC KELVIE AND SONS, GREENOCK (1 copy).
MACLEHOSE AND SONS, GLASGOW (1 copy).
MARKS, A. ESQ., LONG DITTON (1 copy).
MARTIN, SIR THEODORE, K. C. B. (1 copy).
MAXWELL, ANDREW, ESQ., GLASGOW (1 copy).
MENEFEE, R. J., ESQ., LOUISVILLE, U. S. A. (1 copy).
MEYER, DR., DIRECTOR OF THE ROYAL MUSEUM, BERLIN (1 copy).
MILDMAY, H. B. ESQ., LONDON (1 copy).
MINGHETTI, H. E. CAV. MARCO, BOLOGNA (1 copy).
MOLINEUX, R. J., ESQ. GUILDFORD (1 copy).
MONGERI, PROF. GIUS., MILAN (1 copy).
MORELLI, COMM. GIOV. SENATORE DEL REGNO, MILAN (1 copy).
MORISON, TH. ESQ., LONDON (1 copy).
MORRISON, ALFRED ESQ., LONDON (1 copy).
NAST-KOLB, A. VON, GERMAN CONSUL, ROME (1 copy).
NORTHBROOK, THE EARL OF (1 copy).
NUNN, H. AND CO., LONDON (1 copy).
PAPADOPOL, THE CONTE, SENATORE DEL REGNO, VENICE (1 copy).
PARSON, EDW. ESQ., LONDON (1 copy).

PETRIE, GEO., DUNDEE (2 copies).

PHILIP, SON AND NEPHEW, LIVERPOOL (1 copy).

PONTI, SIGNOR ANDREA, MILAN (1 COPY).

POYNTER, EDW. J. ESQ., R. A., LONDON (1 copy).

POWELL, FRANCIS ESQ., DUNOON (1 copy).

POWERSCOURT, THE VISCOUNT (1 copy).

PRENDERGAST, J. ESQ., SAN FRANCISCO (1 copy).

PRINETTI, C., SENATORE DEL REGNO, MILAN (1 copy).

QUARITCH, BERNARD, LONDON (8 copies).

RADFORD, W. T. ESQ., SIDMOUTH (1 copy).

RAMSDEN, MRS. JOHN, GODALMING (1 copy).

RICHMOND, W. B. ESQ, LONDON (1 copy).

ROBINSON, J. C. ESQ., LONDON (1 copy).

ROSE, J. ANDERSON ESQ., LONDON (1 copy).

ROTH, MATTHIAS, ESQ. M. D., LONDON (1 copy).

ROTHERHAM, L. AND S. SOCIETY (1 copy).

SARTORIS, E. J. ESQ., LONDON (1 copy).

SAUNDERS, W., LONDON (1 copy).

SCHRÖDER, BARON H., LONDON (1 copy).

SCRIBNER AND WELFORD, NEW YORK (6 copies).

SERENA, ARTHUR, ESQ., LONDON (1 copy).

SLOPHER, TH. ESQ., WINCHESTER (1 copy).

SIEMENS, C. W. ESQ., LONDON (1 copy).

SMITH, A. WATSON ESQ., STOUBRIDGE (1 copy).

SMITH, W. H. AND SONS, LONDON (2 copies).

SPALETTI, THE CONTE V., REGGIO (1 copy).

SOTHERAN, H. AND CO., LONDON (11 copies).

SOUTHAMPTON BOOK SOCIETY (1 copy).

SPENCER, THE EARL OF (1 copy).

SPITHOEVER AND CO., ROME (1 copy).

STANFORD, E., LONDON (1 copy).

STEVENS, B. F., LONDON (2 copies).

STUBLEY, R., BOSTON (1 copy).

STUTFIELD, MARION, BRIGHTON (1 copy).

TEANO, H. H. THE PRINCE, ROME (1 copy).

THIBAUDEAU, A. W. ESQ., LONDON (1 copy).

THOMSON, J. A. ESQ., LIVERPOOL (1 copy).

TRIVULZIO, THE MARCHESE G. G., MILAN (1 copy).

TRÜBNER AND CO., LONDON (4 copies).

TUBBS, BROOKS AND CHRYSTAL, MANCHESTER (2 copies).

UZIELLI, PROF. GUSTAVO, TURIN (1 copy).

VENOSTA, H. E. THE MARCHESE VISCONTI, MILAN (1 copy).

WALLACE, SIR RICHARD, BART., LONDON (1 copy).

WALLIS, HENRY ESQ., LONDON (1 copy).

WALMSLEY, G. G., LIVERPOOL (1 copy).

WARDLE, GEORGE ESQ., LONDON (1 copy).
WATERS, G. W., LONDON (1 copy).
WHARNCLIFFE, THE EARL OF (1 copy).
WESTHORP, STERLING ESQ., IPSWICH (1 copy).
WIGAN, FRED. ESQ., LONDON (1 copy).
WILLETT, HENRY ESQ., BRIGHTON (1 copy).
WILLIAMS AND NORGATE, LONDON (1 copy).
WOODGATE, JOHN, ESQ., COLCHESTER (1 copy).
WYLLIE AND SON, ABERDEEN (1 copy).
WYNDHAM, HON. PERCY, LONDON (1 copy).

PREFACE.

A singular fatality has ruled the destiny of nearly all the most famous of Leonardo da Vinci's works. Two of the three most important were never completed, obstacles having arisen during his life-time, which obliged him to leave them unfinished; namely the Sforza Monument and the Wall-painting of the Battle of Anghiari, while the third—the picture of the Last Supper at Milan—has suffered irremediable injury from decay and the repeated restorations to which it was recklessly subjected during the XVII^{th} and XVIII^{th} centuries. Nevertheless, no other picture of the Renaissance has become so wellknown and popular through copies of every description.

Vasari says, and rightly, in his Life of Leonardo, "that he laboured much more by his word than in fact or by deed", and the biographer evidently had in his mind the numerous works in Manuscript which have been preserved to this day. To us, now, it seems almost inexplicable that these valuable and interesting original texts should have remained so long unpublished, and indeed forgotten. It is certain that during the XVI^{th} and XVII^{th} centuries their exceptional value was highly appreciated. This is proved not merely by the prices which they commanded, but also by the exceptional interest which has been attached to the change of ownership of merely a few pages of Manuscript.

That, notwithstanding this eagerness to possess the Manuscripts, their contents remained a mystery, can only be accounted for by the many and great difficulties attending the task of deciphering them. The handwriting is

so peculiar that it requires considerable practice to read even a few detached phrases, much more to solve with any certainty the numerous difficulties of alternative readings, and to master the sense as a connected whole. Vasari observes with reference to Leonardo's writing: "he wrote backwards, in rude characters, and with the left hand, so that any one who is not practised in reading them, cannot understand them". The aid of a mirror in reading reversed handwriting appears to me available only for a first experimental reading. Speaking from my own experience, the persistent use of it is too fatiguing and inconvenient to be practically advisable, considering the enormous mass of Manuscripts to be deciphered. And as, after all, Leonardo's handwriting runs backwards just as all Oriental character runs backwards—that is to say from right to left—the difficulty of reading direct from the writing is not insuperable. This obvious peculiarity in the writing is not, however, by any means the only obstacle in the way of mastering the text. Leonardo made use of an orthography peculiar to himself; he had a fashion of amalgamating several short words into one long one, or, again, he would quite arbitrarily divide a long word into two separate halves; added to this there is no punctuation whatever to regulate the division and construction of the sentences, nor are there any accents— and the reader may imagine that such difficulties were almost sufficient to make the task seem a desperate one to a beginner. It is therefore not surprising that the good intentions of some of Leonardo's most reverent admirers should have failed.

Leonardo's literary labours in various departments both of Art and of Science were those essentially of an enquirer, hence the analytical method is that which he employs in arguing out his investigations and dissertations. The vast structure of his scientific theories is consequently built up of numerous separate researches, and it is much to be lamented that he should never have collated and arranged them. His love for detailed research—as it seems to me—was the reason that in almost all the Manuscripts, the different paragraphs appear to us to be in utter confusion; on one and the same page, observations on the most dissimilar subjects follow each other without any connection. A page, for instance, will begin with some principles of astronomy, or the motion of the earth; then come the laws of sound, and finally some precepts as to colour. Another page will begin with his investigations on the structure of the intestines, and end with philosophical remarks as to the relations of poetry to painting; and so forth.

Leonardo himself lamented this confusion, and for that reason I do not think that the publication of the texts in the order in which they occur in the originals would at all fulfil his intentions. No reader could find his way through such a labyrinth; Leonardo himself could not have done it.

Added to this, more than half of the five thousand manuscript pages which now remain to us, are written on loose leaves, and at present arranged in a manner which has no justification beyond the fancy of the collector who first brought them together to make volumes of more or less extent. Nay, even in the volumes, the pages of which were numbered by Leonardo himself, their order, so far as the connection of the texts was concerned, was obviously a matter of indifference to him. The only point he seems to have kept in view, when first writing down his notes, was that each observation should be complete to the end on the page on which it was begun. The exceptions to this rule are extremely few, and it is certainly noteworthy that we find in such cases, in bound volumes with his numbered pages, the written observations: "turn over", "This is the continuation of the previous page", and the like. Is not this sufficient to prove that it was only in quite exceptional cases that the writer intended the consecutive pages to remain connected, when he should, at last, carry out the often planned arrangement of his writings?

What this final arrangement was to be, Leonardo has in most cases indicated with considerable completeness. In other cases this authoritative clue is wanting, but the difficulties arising from this are not insuperable; for, as the subject of the separate paragraphs is always distinct and well defined in itself, it is quite possible to construct a well-planned whole, out of the scattered materials of his scientific system, and I may venture to state that I have devoted especial care and thought to the due execution of this responsible task.

The beginning of Leonardo's literary labours dates from about his thirty-seventh year, and he seems to have carried them on without any serious interruption till his death. Thus the Manuscripts that remain represent a period of about thirty years. Within this space of time his handwriting altered so little that it is impossible to judge from it of the date of any particular text. The exact dates, indeed, can only be assigned to certain note-books in which the year is incidentally indicated, and in which the order

of the leaves has not been altered since Leonardo used them. The assistance these afford for a chronological arrangement of the Manuscripts is generally self evident. By this clue I have assigned to the original Manuscripts now scattered through England, Italy and France, the order of their production, as in many matters of detail it is highly important to be able to verify the time and place at which certain observations were made and registered. For this purpose the Bibliography of the Manuscripts given at the end of Vol. II, may be regarded as an Index, not far short of complete, of all Leonardo's literary works now extant. The consecutive numbers (from 1 to 1566) at the head of each passage in this work, indicate their logical sequence with reference to the subjects; while the letters and figures to the left of each paragraph refer to the original Manuscript and number of the page, on which that particular passage is to be found. Thus the reader, by referring to the List of Manuscripts at the beginning of Volume I, and to the Bibliography at the end of Volume II, can, in every instance, easily ascertain, not merely the period to which the passage belongs, but also exactly where it stood in the original document. Thus, too, by following the sequence of the numbers in the Bibliographical index, the reader may reconstruct the original order of the Manuscripts and recompose the various texts to be found on the original sheets—so much of it, that is to say, as by its subject-matter came within the scope of this work. It may, however, be here observed that Leonardo's Manuscripts contain, besides the passages here printed, a great number of notes and dissertations on Mechanics, Physics, and some other subjects, many of which could only be satisfactorily dealt with by specialists. I have given as complete a review of these writings as seemed necessary in the Bibliographical notes.

In 1651, Raphael Trichet Dufresne, of Paris, published a selection from Leonardo's writings on painting, and this treatise became so popular that it has since been reprinted about two-and-twenty times, and in six different languages. But none of these editions were derived from the original texts, which were supposed to have been lost, but from early copies, in which Leonardo's text had been more or less mutilated, and which were all fragmentary. The oldest and on the whole the best copy of Leonardo's essays and precepts on Painting is in the Vatican Library; this has been twice printed, first by Manzi, in 1817, and secondly by Ludwig, in 1882. Still, this ancient copy, and the published editions of it, contain much for which it would be rash to hold Leonardo responsible, and some portions—such as the very

important rules for the proportions of the human figure—are wholly wanting; on the other hand they contain passages which, if they are genuine, cannot now be verified from any original Manuscript extant. These copies, at any rate neither give us the original order of the texts, as written by Leonardo, nor do they afford any substitute, by connecting them on a rational scheme; indeed, in their chaotic confusion they are anything rather than satisfactory reading. The fault, no doubt, rests with the compiler of the Vatican copy, which would seem to be the source whence all the published and extensively known texts were derived; for, instead of arranging the passages himself, he was satisfied with recording a suggestion for a final arrangement of them into eight distinct parts, without attempting to carry out his scheme. Under the mistaken idea that this plan of distribution might be that, not of the compiler, but of Leonardo himself, the various editors, down to the present day, have very injudiciously continued to adopt this order—or rather disorder.

I, like other enquirers, had given up the original Manuscript of the Trattato della Pittura for lost, till, in the beginning of 1880, I was enabled, by the liberality of Lord Ashburnham, to inspect his Manuscripts, and was so happy as to discover among them the original text of the best-known portion of the Trattato in his magnificent library at Ashburnham Place. Though this discovery was of a fragment only—but a considerable fragment— inciting me to further search, it gave the key to the mystery which had so long enveloped the first origin of all the known copies of the Trattato. The extensive researches I was subsequently enabled to prosecute, and the results of which are combined in this work, were only rendered possible by the unrestricted permission granted me to investigate all the Manuscripts by Leonardo dispersed throughout Europe, and to reproduce the highly important original sketches they contain, by the process of "photogravure". Her Majesty the Queen graciously accorded me special permission to copy for publication the Manuscripts at the Royal Library at Windsor. The Commission Centrale Administrative de l'Institut de France, Paris, gave me, in the most liberal manner, in answer to an application from Sir Frederic Leighton, P. R. A., Corresponding member of the Institut, free permission to work for several months in their private collection at deciphering the Manuscripts preserved there. The same favour which Lord Ashburnham had already granted me was extended to me by the Earl of Leicester, the Marchese Trivulzi, and the Curators of the Ambrosian Library at Milan, by the Conte Manzoni at Rome and by

other private owners of Manuscripts of Leonardo's; as also by the Directors of the Louvre at Paris; the Accademia at Venice; the Uffizi at Florence; the Royal Library at Turin; and the British Museum, and the South Kensington Museum. I am also greatly indebted to the Librarians of these various collections for much assistance in my labours; and more particularly to Monsieur Louis Lalanne, of the Institut de France, the Abbate Ceriani, of the Ambrosian Library, Mr. Maude Thompson, Keeper of Manuscripts at the British Museum, Mr. Holmes, the Queen's Librarian at Windsor, the Rev^d Vere Bayne, Librarian of Christ Church College at Oxford, and the Rev^d A. Napier, Librarian to the Earl of Leicester at Holkham Hall.

In correcting the Italian text for the press, I have had the advantage of valuable advice from the Commendatore Giov. Morelli, Senatore del Regno, and from Signor Gustavo Frizzoni, of Milan. The translation, under many difficulties, of the Italian text into English, is mainly due to Mrs. R. C. Bell; while the rendering of several of the most puzzling and important passages, particularly in the second half of Vol. I, I owe to the indefatigable interest taken in this work by Mr. E. J. Poynter R. A. Finally I must express my thanks to Mr. Alfred Marks, of Long Ditton, who has most kindly assisted me throughout in the revision of the proof sheets.

The notes and dissertations on the texts on Architecture in Vol. II I owe to my friend Baron Henri de Geymüller, of Paris.

I may further mention with regard to the illustrations, that the negatives for the production of the "photo-gravures" by Monsieur Dujardin of Paris were all taken direct from the originals.

It is scarcely necessary to add that most of the drawings here reproduced in facsimile have never been published before. As I am now, on the termination of a work of several years' duration, in a position to review the general tenour of Leonardo's writings, I may perhaps be permitted to add a word as to my own estimate of the value of their contents. I have already shown that it is due to nothing but a fortuitous succession of unfortunate circumstances, that we should not, long since, have known Leonardo, not merely as a Painter, but as an Author, a Philosopher, and a Naturalist. There can be no doubt that in more than one department his principles and discoveries were infinitely more in accord with the teachings of modern science, than with the views of his contemporaries. For this reason his extraordinary gifts and merits are far more likely to be appreciated in our own time

than they could have been during the preceding centuries. He has been unjustly accused of having squandered his powers, by beginning a variety of studies and then, having hardly begun, throwing them aside. The truth is that the labours of three centuries have hardly sufficed for the elucidation of some of the problems which occupied his mighty mind.

Alexander von Humboldt has borne witness that "he was the first to start on the road towards the point where all the impressions of our senses converge in the idea of the Unity of Nature." Nay, yet more may be said. The very words which are inscribed on the monument of Alexander von Humboldt himself, at Berlin, are perhaps the most appropriate in which we can sum up our estimate of Leonardo's genius:

"Majestati naturae par ingenium."

LONDON, April 1883.

J. P. R.

CONTENTS OF VOLUME I.

All drawings here reproduced are in pen and ink, unless otherwise stated. The reproductions are of the exact size of the originals, except that Plates I, XVIII and XLVI are slightly reduced. Plate I is the frontispiece; Plate II is on p. 124; Plates III–XXXV follow p. 124; Plate XXXVI is on p. 202; Plates XXXVII–LXIV follow p. 202.

LIST OF ILLUSTRATIONS IN VOLUME I.

I.

Prolegomena and General Introduction to the Book on Painting.

--- ----

Clavis sigillorum.

1. *In the few instances in which Leonardo has written from left to right in the ordinary way this is stated in a note. In all other cases the writing is backwards.*

2. *The numbers printed above the line in the revised text:* ², ³, ⁴ *&c. indicate the heads of the lines in the original MS. In many instances the breaking off of the lines in the original MS. accounts for peculiarities in the construction of Leonardo's sentences. In the translation the numbers refer only to the footnotes and they have been introduced in such passages, which require an explanation.*

3. *Clerical errors and obvious mistakes in spelling have been corrected in the text, but are given in the notes, so that all the peculiarities of the original text which are omitted in the revised text may be seen at a glance.*

4. *Leonardo frequently employs the following abbreviations:*—

ᕁ *for* per *or* pr; *e. g.* ᕁ che = perche; so ᕁ a = sopra.

ᕀ *for* di.

ᕂ *for* br; *e. g.* ᕂ eve = breve.

ᕃ *for* ver; *e. g.* in ᕃ so = inverso.

ᕄ *for* ser; *e. g.* ᕄ vo = servo.

These occur so constantly and are so unimportant that it has not been thought necessary to point them out. He also uses:

i *for* uno.

î *for* una.

5. *Such abbreviations as are common in familiar speech are retained in the text;* *e. g.* un sol punto.

6. *Leonardo's usual way of spelling*, ochio spechio *for* occhio specchio, *has also been left unaltered.*

7. *The combinations of two or three words into one, which Leonardo so frequently used, and which are so puzzling to the eye as to render reading difficult, though plain to the ear, have been separated in the revised text; e. g.* leforme ditutti=le forme di tutti. *These combinations were, however, intentional no doubt; in almost every case they indicate the author's desire of substituting a sort of phonetic writing for the rules in general use. This doubling of the letters—as, for instance in* chessia *for* che sia *and* essella *for* e se la—*is, I believe, clear evidence of what may be called the orthography of Leonardo da Vinci. The separation of the words has involved the loss of these doubled letters, but the original spelling has been given, for reference, in the foot notes.*

8. *Leonardo commonly wrote* ā ē ī ō ū *or* v̄ *for* an, en, in, on, un. *This sign occasionally, but not often, represents* m. *It has been retained, as it was usual in printed type in the XV^{th} and XVI^{th} centuries.*

9. *Leonardo sometimes writes* j *for* i, *particularly where it is joined to* m, n *or* u; *e. g.* linje, tienj, mjnor. *As he never sets a dot over the ordinary* i *(at any rate when he writes from right to left), it is plain that he uses* j *for* i *(he does not dot the* j*) simply to avoid confounding* ni *or* ui *with* m, *or* mi *with* nu. *As this difficulty cannot occur in print I have restored the usual spelling* i *for* j *without referring to it in the notes.*

10. *Accents and apostrophes are entirely lacking in the original manuscript, but it seemed necessary to introduce them into the printed text. The accent has also been added in those parts of the verb* avere *in which Leonardo had dropped the* h: *as* ò, ài, à, ànno.

11. | || ||| () *In the MSS. there are no marks of punctuation but these, and they have been retained wherever they occur.* · *is always placed by Leonardo just above the line of writing and is never used as a full stop, but only to divide the words according to the sense; it very often occurs between every word, particularly in MSS. of about* 1490. *When a letter or number is placed between two points, as* . a ., *or* . 3 ., *it usually refers to a corresponding sign on a diagram or sketch.*

| || ||| *commonly serve to separate sentences which are entirely distinct.*

| . *This mark commonly indicates that words written above or below the line are to be inserted. In the revised text they have been simply inserted.*

In the notes these passages are distinguished by the following signs:—

« » *indicates that the words were written above the line.*

" " *that the words were written below the line.*

() *This mark is used by Leonardo to mark off a digression, or parenthesis, or a quotation from some other work of his own; but it often takes the place of the colon:*

(*A simple bracket placed at the beginning of one or more lines serves to lay stress on particular sentences; it is also used to mark distinct sentences which have no connection with the rest of the text on the same page. In the printed text such sentences have been denoted by the mark* ¶.

— *The last line of a section commonly ends with a horizontal line of variable length, making it of equal length with the preceding lines of writing.*

12. *3, 4, 5. These figures, if written large, or some similar mark, are occasionally placed at the end of a page or at the beginning of a passage that has been crossed out; and this indicates that the continuation is to be sought for elsewhere, where the same sign is repeated.*

The signs ⊝ o, which occur in the passages on painting, have been added by some early copyist and have therefore not been reproduced in the notes.

13. *, . : ; ! ? These stops are never used in the original MSS. It seemed necessary however to insert such marks in order to render the text intelligible. A full stop is only used at the end of a section to avoid confusion with Leonardo's own use of points (see No. 11), for he never places one at the end of a section or paragraph. Wherever a full stop seemed wanting in the course of the text I have put a semi colon (;) The colon (:) is used instead of a full stop where, in the original, a point (.) occurs.*

14. *[] Passages between brackets are crossed out in the original.*

15. *When a word or passage of the revised text is printed in small type it indicates that the reading is doubtful in consequence of partial obliteration.*

16. *⫼⫼⫼ indicates passages in which the original writing is entirely destroyed.*

17. *R indicates that the passage is written in red chalk.*

18. *(R) indicates that the original writing in red chalk has been written over in pen and ink.*

19. *P indicates that the original writing is in silverpoint.*

20. *1^a 2^a 3^a &c. the front page—recto—of sheet 1, 2, 3, &c.*
1^b 2^b 3^b &c. the back page—verso—of sheet 1, 2, 3, &c.

The MSS. Tr. and S. K. M. I² are the only ones in which the pages are numbered. In all other MSS. the leaf only is numbered. In referring to the Codex Atlanticus a double series of numbers has been used. The first apply only to the larger leaves of the Codex, on which two or more of the original leaves of the MS. have been mounted; the second series does not exist in the Codex itself; it refers to the original pages in the order in which they have been placed in it. By this second series of numbers the correspondence of the front and back pages has been verified. Wherever, in addition to the consecutive numbering, a different number occurs in Leonardo's writing it is quoted in a parenthesis, thus:—C 27^b (3^a), and this indicates that the back page of leaf 27 in the MS. C was originally numbered 3.

21. *A Roman II, as 26 IIa 26 IIb, indicates that the same number (26) occurs twice. In the Codex Atlanticus $\frac{1}{1}$ is used for II.*

22. *O', O'' indicates that the passages so marked are originally notes written on the inside of the cover of the MS.; O' within the front or upper cover, O'' within the under cover.*

23. *The wood-cuts introduced into the text are facsimile-reproductions of Leonardo's own sketches and drawings which accompany the MSS. But the letters and numbers affixed to them have been inserted in ordinary writing.*

24.　*The following is a list of Leonardo's letters and numbers, as they are found on those original drawings which are here reproduced by facsimile engravings. The reader will have to refer to this list, by which he will be enabled to identify the letters and numbers on the originals with the corresponding figures in the printed text.*

ʌ ʌ A	= a		N	= n
ᘓ δ ꭾ	= b		o	= o
ꓵ	= c		ꮋ	= p
φ φ	= d		ꭾ	= q
ꙿ ᓫ ꓱ D	= e		ɣ Я	= r
Ϯ	= f		s ⌐	= s
8	= g		⊣ +	= t
ꝺ	= h		ꙇ	= u
ı ı	= i		√	= v
K	= k		x	= x
ꝑ	= l		Υ	= y
ꟺ ꟺ ꟺ	= m		ξ ʒ	= z

ı ı	= 1
⊂2	= 2
ʒ ʒ ʒ ʒ	= 3
⊁ 4	= 4
⸝ 5	= 5
ꝺ 6	= 6
⟨ ⟩	= 7
8	= 8
ℓ ꝯ	= 9
0	= 0

INDEX OF MANUSCRIPTS.

	MARK OF MA-NUSCRIPT	DESCRIPTION OF MANUSCRIPT	PLACE	TOTAL NUM-BER OF PAGES	SIZE IN CENTIMÈ-TRES	DATE
I.	W. An. I.	Fragment of first treatise on Anatomy.	Royal Library, Windsor.	10	18,7×13,2	1489
2.	C.	Treatise on Light and Shade, bound, marked C.	Institut de France, Paris.	56	31×22	1490, 1491
3.	B.	Bound Volume, marked B.	Institut de France, Paris.	168	23,5×17	about 1490
4.	Ash. II.	Volume stitched in wrapper, marked $\frac{1875}{1}$, in the Library of Lord Ashburnham.	Ashburnham Place, Sussex.	26	24×17	about 1490
5.	Ash. I.	Fragment of the *Libro di Pittura*, marked $\frac{1875}{2}$, in the Library of Lord Ashburnham.	Ashburnham Place, Sussex.	68	21×11,5	1492
6.	A.	Fragment of MS., treating on various matters.	Institut de France, Paris.	126	21×14	1492
7.	S. K. M. III.	Notebook, marked III.	ForsterLibrary,South Kensington Museum, London.	176	9×6,7	1493
8.	H.3	Notebook, forming the third portion of the bound Volume, marked H.	Institut de France, Paris.	94	10,3×7,2	1493, 1494
9.	H.2	Notebook, forming the second portion of the bound Volume, marked H.	Institut de France, Paris.	92	10,3×7,2	1494, January
10.	H.1	Notebook, forming the first portion of the bound Volume, marked H.	Institut de France, Paris.	96	10,3×7,2	1494, March
11.	S. K. M. II.2	Notebook, forming the second part of the bound Volume, marked II.	ForsterLibrary,South Kensington Museum, London.	126	9,9×7,2	1493—1495
12.	S. K. M. II.1	Notebook, forming the first part of the bound Volume, marked II.	ForsterLibrary,South Kensington Museum, London.	190	9,9×7,2	1495
13.	I.2	Notebook, forming the second part of the bound Volume, marked I.	Institut de France, Paris.	182	10×7,2	1497
14.	I.1	Notebook, forming the first portion of the bound Volume, marked I.	Institut de France, Paris.	96	10×7,2	1497 ?
15.	W. P.	Studies on the Proportions of the Human Figure, loose sheets.	Royal Library, Windsor.	19	various large sizes	1490—1495
16.	W. H.	Treatise on the Anatomy of the Horse, loose sheets.	Royal Library, Windsor.	80	various sizes	1490—1495
17.	W. An. II.	Second treatise on Anatomy, loose sheets.	Royal Library, Windsor.	72	19×13,5	1490—1500

	MARK OF MA-NUSCRIPT	DESCRIPTION OF MANUSCRIPT	PLACE	TOTAL NUM-BER OF PAGES	SIZE IN CENTIMÈ-TRES.	DATE
18.	L.	Notebook, in original binding, marked L.	Institut de France, Paris.	188	10×7	1502
19.	W. M.	Collection of Maps.	Royal Library, Windsor.	12	various large sizes	about 1502
20.	S. K. M. I.¹	Treatise on Stereometry, first portion of a bound Volume, marked I.	Forster Library, South Kensington Museum, London.	76	14×10,5	1505
21.	S. K. M. I.²	Notebook, second portion of a bound Volume, marked I.	Forster Library, South Kensington Museum, London.	28	14×10,5	about 1505
22.	F.	Notebook, in original binding, marked F.	Institut de France, Paris.	192	15×10,2	1508
23.	Br. M.	Collection of treatises and notes, bound Volume, marked: Arundel 263.	British Museum, London.	566	19×12,5	about 1509
24.	W. An. III.	Third treatise on Anatomy, loose sheets of greyish-blue colour.	Royal Library, Windsor.	46	29×21	1513
25.	E.	Notebook, in original binding, marked E.	Institut de France, Paris.	160	15,4×9,3	1513 and 1514
26.	G.	Notebook, in original binding, marked G.	Institut de France, Paris.	186	14×10	about 1515
27.	M.	Notebook, in original binding, marked M.	Institut de France, Paris.	188	10×7	about 1515
28.	Tr.	Volume treating on various matters, bound, in possession of Marchese G. G. Trivulzio.	Trivulzi Palace, Milan.	102	21×14	between 1497 and 1516
29.	Leic.	Bound Volume, containing chiefly scientific observations.	Leicester Library, Holkham Hall, Norfolk.	72	30×22	between 1500 and 1516, 1510?
30.	Mz.	Volume treating on various subjects, in original binding.	In possession of Count Manzoni, Rome.	26	21,3×15,5	between 1490 and 1516
31.	D.	Treatise on the Eye, in original binding, marked D.	Institut de France, Paris.	20	25×16	between 1490 and 1516
32.	K.¹	Notebook, forming the first part of a bound Volume, marked K.	Institut de France, Paris.	96	10×6,6	after 1504
33.	K.²	Notebook, forming the second part of a bound Volume, marked K.	Institut de France, Paris.	62	10×6,6	after 1504
34.	K.³	Notebook, forming the third part of a bound Volume, marked K.	Institut de France, Paris.	96	10×6,6	after 1504
35.	W. An. IV.	Fourth treatise on Anatomy, loose sheets.	Royal Library, Windsor.	138	29×22	about 1515
36.	W. L.	Collection of loose sheets in bound Volume (Fragment of Leoni's collection).	Royal Library, Windsor.	30	various large sizes	1490—1516
37.	W.	Loose sheets, partly mounted.	Royal Library, Windsor.		various sizes	about 1490—1516

	MARK OF MANUSCRIPT	DESCRIPTION OF MANUSCRIPT	PLACE	TOTAL NUMBER OF PAGES	SIZE IN CENTIMÈTRES	DATE
38.	C. A.	Bound Volume, commonly called Codex Atlanticus, 395 folios, each containing one or more MS-sheets.	Ambrosian Library, Milan.	1222	various sizes	about 1483—1518
39.	Trn.	five loose sheets.	Royal Library, Turin.	10	various sizes	uncertain
40.	F. U.	two loose sheets.	Uffizi Gallery, Florence.	4	various sizes	1473 and 1478
41.	V.	five loose sheets.	Academy, Venice.	10	various sizes	uncertain
42.	Mi. A.	one sheet.	Gallery in the Ambrosian Library, Milan.	2	20×14	uncertain
43.	Mi. A. R.	one sheet.	Ambrosian Library, Cod. Resta.	2	8o	uncertain
44.	Mch.	one sheet.	Pinakothek, Munich.	2	4o	uncertain
45.	P. V.	one sheet, marked N. 2260.	Cod. Vallardi, Louvre, Paris.	2	4o	uncertain
46.	P. L.	one sheet (previously in the Collection of the King of Holland).	Collection of drawings, Louvre, Paris.	2	27,7×21	about 1480—1500
47.	P. A.	one sheet.	Collection of drawings, M. Armand, Paris.	2	26×18,5	uncertain
48.	Br. M. P.	two sheets.	British Museum, Printroom.	4	8o and 4o	uncertain
49.	Th.	one sheet.	Collection of A. W. Thibaudeau, Esq. London.	2	19,5×7,5	uncertain
50.	Mo.	one sheet.	Collection of A. Morrison, Esq.	2	8o	uncertain
51.	P. H. N.	one sheet (previously in the Collection of Henry, Prince of Netherlands).	2	8o	uncertain
52.	B. H.	five sheets.	Langton, Berkshire, seat of the Hon. Mr. Baillie Hamilton.	10	various sizes	uncertain
53.	Ox.	two sheets.	Library of Christ Church College, Oxford.	4	4o and 8o	uncertain
54.	Md.	one sheet.	Archivio Palatino, Modena.	2	. . .	1507
55.	Ash. III.	Treatise on Mechanics, Architecture &c. by Francesco di Giorgio, with notes by Leonardo (on different pages).	Ashburnham Place, Sussex.	7	14,8×10	uncertain.

Contrary to the universal custom of western nations, Leonardo committed almost all his notes to paper in a handwriting that goes from right to left. This singular habit has sometimes been accounted for by supposing that Leonardo felt it necessary to put every difficulty in the way of the publication of his works. This assumption, however, seems to me to rest on no solid grounds, and is but an hypothesis at best. Perfectly explicit statements prove, on the contrary, that Leonardo wished to publish his writings, and that he cared greatly that they should be known and read; and any one who has taken the trouble to make himself familiar with the Master's writing will, I think, hardly resist the conviction that even the character of the writing was expressly adapted to that view.

We know from the evidence of his friend Luca Paciolo that Leonardo drew with his left hand, and used it with perfect ease.[1] In point of fact, in almost every drawing authentically known to be genuine—as those included in the texts of MSS. must be— wherever shading is introduced the strokes lie from left to right (downwards) as they would be drawn with the left hand.[2]

The question as to why Leonardo drew and wrote with his left hand is now probably a vain one. There is nothing to justify us in deciding whether accidental circumstance or mere caprice was the cause. It is worthy of remark, that the earliest notes, written in his twenty-first year, when he could hardly have had such reasons for caution as are attributed to him[3], are written backwards.

The contents of Leonardo's MSS. sufficiently prove that he certainly intended them for publication, though the form is probably not always what he finally meant it to be.

The appeal or address 'tu', which frequently occurs and more particularly in theoretical passages, is often no doubt meant for the reader; but in other cases it indicates rather the specially meditative character of the passage. Abstract speculations acquire a particular charm from this soliloquizing form—it is as if we overheard the mental process of the author.

In the passages indicated below Leonardo expresses himself clearly as to the end and purpose of his literary labours.

In one passage in the MS. at Holkham (No. 1) he speaks of keeping a certain invention to himself, and not making it public. As he uses this reserve in no other instance, this exception sufficiently proves the rule.

[1] "Scrivesi ancora alla rovescia e mancina che non si posson legere se non con lo specchio, ovvero guardando la carta dal suo rovescio contro alla luce, come so m'intendi senz' altro dica, e come fa il nostro Leonardo da Vinci, lume della pittura, quale è mancino, come più volte è detto." (L. PACIOLO, *Divina Proportione*, Venezia, 1509.)

[2] This was first pointed out in the '*Critical review of the drawings by the old Masters in the Dresden Gallery*' by Senatore GIOV. MORELLI.

[3] "Pour s'exprimer à peu près comme lui, des esprits étroits et routiniers d'une part, et de l'autre des aventuriers partant à cheval contre tout ce qui avait permis jusque-là d'établir ces règles qui, déterminant la limite du possible et de l'impossible, empêchent le chercheur de tomber dans le désespoir et la mélancolie, exagéraient à plaisir ce qu'il avait dit (?) pour réagir contre les abus et les paradoxes, et se servaient de ses propres expressions (?) pour le représenter comme un charlatan ou un fou. Lorsqu'il parlait du moins, son éloquence persuasive donnait à ses idées toute leur valeur; mais *laisser voir* dans ses papiers des pensées incomplètement exprimées, des rédactions inachevées, des projets d'inventions de toutes sortes, *c'eût été s'exposer à la calomnie et au vol*." (CH. RAVAISSON-MOLLIEN, *Les Manuscrits de L. de Vinci*, Paris 1881, *p.* 2). *But we might suppose that Leonardo would have considered his papers and his instruments quite safe, by keeping them locked away in his own room.*

In the passage from the MS. F (No. 2) the expression "mettere insieme" *is equally characteristic of his method of working and of the condition of the MSS. By it he means the classification of the separate details of his researches so as to make a connected whole, which could be done the more easily since it was his practice to write separate chapters on separate sheets.*

The MS. in the British Museum begins with an apology (No. 4) which is very interesting, for the self-evident disorder of the MS. This apology applies equally well to the notes on mathematics—where it is placed—and to all the branches of science on which Leonardo wrote.

The passages (Nos. 5—7) are soliloquies, *and refer to the arrangement of different MSS. as preparatory to publication in the form intended by Leonardo himself. From all this it was clearly not his intention that the notes should be printed as they lay, in confusion, under his hand.*

The schemes, which Leonardo himself proposed for the arrangement of the Book on Painting. as well as of his other writings, give us a clue—as we shall presently see—which enables us perfectly to construct the whole work on the basis of his own rules and with some pretention to logical sequence.

We may conclude that the sections 9, 10 and 11 headed 'Proemio' refer to the Book on Painting, and more particularly to the lessons on Perspective, because section 21 with its special title "Proemio di prospettiva" *is, in the original (Cod. At. 117b; 561b), written on the same sheet.*

Sections 12 to 20 give us the guiding idea of the general plan and of the object and purpose of the Libro di Pittura.

No. 21 'Proemio di prospettiva, cioè dell' ufitio dell' ochio' follows naturally after the other general introductions. Our acceptance of this introduction, it is true, wholly invalidates the arrangement of the materials which has been adopted by every editor of the old copies of the Trattato *since* DUFRESNE; *but those, it must be remembered, contain only disconnected fragments of Leonardo's treatise on Perspective. His investigations in all the branches of optics do not, of course, come under consideration here. With regard to the physiology of the eye the reader will find, in Nos. 24, 28—39, passages which show that Leonardo understood the effect of the variation in the size of the pupil on the perception of objects. The insertion of these passages seemed indispensable because they form the basis of certain general principles of Perspective. The same may be said about his explanation of the difference between seeing with one eye and seeing with two (No. 25—29) as well as of his acute remarks as to the apparent variation in the size of objects according to the amount of light in which they are seen (No. 30—39).*

1.

Come molti stie²no con istruméto al-
quáto sotto l'acque; Come e perchè io non
scrivo il mio modo di ³star sotto l'acqua;
quáto io posso star sanza mágiare, e questo
nō publico o diuolgo per le ma⁴le nature
delli omini, li quali vserebono li assasina-
méti ne' fondi de' mari col rompere ⁵i na-
vili in fondo e sommergierli insieme colli
omini che ui son dentro, e benchè io insegni
⁶delli altri, quelli nō son di pericolo, perchè
di sopra all'acqua apparisce la bocca della
canna, ⁷onde alitano, posta sopra otri o
sughero.

How by a certain machine many may
stay some time under water. And how and
wherefore I do not describe my method of
remaining under water and how long I can
remain without eating. And I do not publish
nor divulge these, by reason of the evil
nature of men, who would use them for
assassinations at the bottom of the sea by
destroying ships, and sinking them, together
with the men in them. Nevertheless I will
impart others, which are not dangerous be-
cause the mouth of the tube through which
you breathe is above the water, supported
on air sacks or cork.

The author's
intention to
publish his
MSS.

2.

Quādo tu metti insieme la scien²za de
moti dell' acqua, ricordati di met³tere di
sotto a ciascuna propositione ⁴li sua gioua-
méti, acciochè tale scien⁵tia non sia inutile.

When you put together the science of the
motions of water, remember to include under
each proposition its application and use, in
order that this science may not be useless. —

The prepa
ration of the
MSS. for pu-
blication.

3.

Nō mi legga, chi non è matematico, ²nelli
mia prīcipi.

Let no man who is not a Mathematician
read the elements of my work.

Admonition
to readers.

1. 2. isscrivo. 3. quáto iposso . . . mágare ecquesto. 5. sonmergierli . . chi . . bēce. 6. apariscie la bocha. 7. otri ossugero.
2. 1. scien. 3. acciasscuna. 4. gouaméti acco chettale.
3. 1. leggha . . . matematicho.

1. The leaf on which this passage is written, is
headed with the words *Casi* 39, and most of these
cases begin with the word '*Come*', like the two here
given, which are the 26th and 27th. 7. *Sughero.*
In the Codex Antlanticus 377ª; 1170ª there is a sketch,
drawn with the pen, representing a man with a tube
in his mouth, and at the farther end of the tube a
disk. By the tube the word '*Channa*' is written,
and by the disk the word '*sughero*'.

2. A comparatively small portion of Leonardo's
notes on water-power was published at Bologna
in 1828, under the title: "*Del moto e misura del-
l'Acqua, di L. da Vinci*".

Br. M. 1 *a*] **4.**

The disorder in the MSS.

Comīciato in Firenze in casa Piero di Braccio Martelli addi 22 di ²marzo 1508: e questo fia vn racolto sanza ordine, tratto di mol³te carte le quali io ho qui copiate sperando poi metterle per ordine alli lo-⁴chi loro, secondo le materie di che esse tratteranno, e credo che auānti ch'io ⁵sia al fine di questo, io ci avrò a riplicare vna medesima cosa più volte, si chè ⁶lettore nō mi biasimare, perchè le cose son molte e la memoria nō le ⁷può riseruare e dire, questa non voglio scriuere perchè dinanzi la scrissi; ⁸e se io nō uolessi cadere in tale errore, sarebbe necessario che per ogni caso ⁹ch'io uolessi copiare, sicchè per nō repli-carlo, io auessi senpre a rilegere tutto ¹⁰il passato, e massime stante co' lunghi inter-ualli di tenpo allo scriuere ¹¹da una volta a un altra.

Begun at Florence, in the house of Piero di Braccio Martelli, on the 22ⁿᵈ day of March 1508. And this is to be a collection without order, taken from many papers which I have copied here, hoping to arrange them later each in its place, according to the subjects of which they may treat. But I believe that before I am at the end of this [task] I shall have to repeat the same things several times; for which, O reader! do not blame me, for the subjects are many and memory cannot retain them [all] and say: 'I will not write this because I wrote it be-fore.' And if I wished to avoid falling into this fault, it would be necessary in every case when I wanted to copy [a passage] that, not to repeat myself, I should read over all that had gone before; and all the more since the intervals are long between one time of writing and the next.

F. 23 *a*] **5.**

Suggestions for the ar-rangement of MSS treat-ing of par-ticular sub-jects. (5—8).

Da profondare vn canale; ²fa questo nel libro de giovamē³ti, e nel provarli allega le ⁴propositioni prouate; e que⁵sto è il uero ordine, perchè se ⁶tu volessi mostrare il giova⁷mēto a ogni propositione, ⁸ti bisognerebbe anco⁹ra fare novi strumēti ¹⁰per prouar tale utilità, e co¹¹si cōfon-deresti l'ordine de' ¹²quarāta libri e cosi l'ordi¹³ne delle figurationi, cioè ¹⁴avresti a mischiare pratica ¹⁵con teorica, che sarebbe ¹⁶cosa cōfusa e interrotta.

Of digging a canal. Put this in the Book of useful inventions and in proving them bring forward the propositions already proved. And this is the proper order; since if you wished to show the usefulness of any plan you would be obliged again to devise new machines to prove its utility and thus would confuse the order of the forty Books and also the order of the diagrams; that is to say you would have to mix up practice with theory, which would produce a confused and in-coherent work.

Br. M. 32 *b*] **6.**

Non è da biasimare lo mostrare infra l'ordine del processo della scientia ²alcuna regola generale nata dall' antidetta con-clusione.

I am not to blame for putting forward, in the course of my work on science, any general rule derived from a previous con-clusion.

4. 1. Chomīciato in firenze . . . piero di bracco martelli. 2. ecquessto. 3. cqui. 5. ciaro. 6. ella. 7. po . . scriuere [al] . . . sscrissi. 8. essio nō. 9. repricarlo. 10. collunghi.

5. 2. cquesto . . . govamē. 3. allegha. 13. coe. 14. aresti a misciare. 15. teoricha.

6. 1. llordine.

4. 1. In the history of Florence in the early part of the XVIᵗʰ century *Piero di Braccio Martelli* is frequently mentioned as *Commissario della Signoria*. He was famous for his learning and at his death left four books on Mathematics ready for the press; comp. LITTA, *Famiglie celebri Italiane, Famiglia Martelli di Firenze*.—In the Official Catalogue of MSS. in the Brit. Mus., New Series Vol. I., where this passage is printed, *Barto* has been wrongly given for *Braccio*.

2. *addi 22 di marzo* 1508. The Christian era was computed in Florence at that time from the Incar-nation (Lady day, March 25ᵗʰ). Hence this should be 1509 by our reckoning.

2. 3. *racolto tratto di molte carte le quali io ho qui copiate*. We must suppose that Leonardo means that he has copied out his own MSS. and not those of others. The first thirteen leaves of the MS. in the Brit. Mus. are a fair copy of some notes on physics.

W. An. IV. 167 a] **7.**

Il libro della sciētia ²delle machine va inā³zi al libro de giovamēti; ⁴fa legare li tua libri di notomia!

The Book of the science of Mechanics must precede the Book of useful inventions. — Have your books on anatomy bound![4]

C. A. 146 IIa; 436a] **8.**

La regola del tuo libro prociederà in questa ²forma: prima l'aste senplice · poi le sosten³ute di sotto · poi le sospese · in parte, poi tutte, ⁴poi esse aste fieno sostenitori d'altri pesi.

The order of your book must proceed on this plan: first simple beams, then (those) supported from below, then suspended in part, then wholly [suspended]. Then beams as supporting other weights[4].

C. A. 117 b; 361 b] **9.**

PROEMIO.

²Vedendo io non potere pigliare materia di grāde vtilità o diletto, ³perchè li omini ināti a me nati ànno preso per loro tutte l'utili e ne⁴ciessari temi, farò come colui il quale per povertà ⁵giv̄gnie l'ultimo alla fiera; e nō potēdo d' altro fornirsi piglia ⁶tutte cose già da altri viste e non accettate ma rifiutate per la ⁷loro poca valitudine; io questa disprezata e rifiutata ⁸mercātia rimānēte de' molti cōpratori metterò sopra ⁹la mia debole soma, e con quella nō per le grosse città, ma pouere ¹⁰ville andrò distribuendo, pigliādo tal premio qual merita ¹¹la cosa da me data.

INTRODUCTION.

Seeing that I can find no subject specially useful or pleasing—since the men who have come before me have taken for their own every useful or necessary theme— I must do like one who, being poor, comes last to the fair, and can find no other way of providing himself than by taking all the things already seen by other buyers, and not taken but refused by reason of their lesser value. I, then, will load my humble pack with this despised and rejected merchandise, the refuse of so many buyers; and will go about to distribute it, not indeed in great cities, but in the poorer towns, taking such a price as the wares I offer may be worth.

General introductions to the book on Painting (9—13).

C. A. 117 b; 361 b] **10.**

PROEMIO.

³So che molti diranno · questa · essere opera invtile; ⁴e questi · fieno · quelli de quali Demetrio disse, nō facie⁵va conto ·

INTRODUCTION.

I know that many will call this useless work [3]; and they will be those of whom Demetrius [4] declared that he took no more

7. 3. govamēti. 4. libri di no "a".
8. 1. quessta. 2. laste . . poi lossen. 3. poi . sosspese. 4. asste . . sosstenitori.
9. 3. ano . . tutte luti [ebe] enc. 4. sciessari temi . . . chome cholui. 6. chose . . aciettate. 7. pocha. 8. merchātia . . . chopratori. 9. chon quela. 10. disstribuendo. 11. chosa.
10. 2. naturalmente li omini boni disiderano sapere. 3. dirano. 4. ecquesti . . deometr \\\\\\ disse. 5. chonto . . . bocha.

7. 4. The numerous notes on anatomy written on loose leaves and now in the Royal collection at Windsor can best be classified in four Books, corresponding to the different character and size of the paper. When Leonardo speaks of '*li tua libri di notomia*', he probably means the MSS. which still exist; if this hypothesis is correct the present condition of these leaves might seem to prove that he only carried out his purpose with one of the Books on anatomy. A borrowed book on Anatomy is mentioned in F,O¹.

8. 4. Leonardo's notes on Mechanics are extraordinarily numerous; but, for the reasons assigned in my introduction, they have not been included in the present work.

9. It need hardly be pointed out that there is in this '*Proemio*' a covert irony. In the second and third prefaces, Leonardo characterises his rivals and opponents more closely. His protest is directed against Neo-latinism as professed by most of the humanists of his time; its futility is now no longer questioned.

10. In the original, the *Proemio di prospettiva cioè dell' uffitio dell' occhio* (see No. 21) stands between this and the preceding one, No. 9.

3. *questa essere opera inutile*. By *opera* we must here understand *libro di pittura* and particularly the treatise on Perspective.

4. *Demetrio*. "With regard to the passage attributed to Demetrius", Dr. H. MÜLLER STRÜBING writes, "I know

piv · del uento · il quale nella lor bocca
⁶causaua le parole, che del uēto ch' usciua
delle parti ⁷di sotto · vomini i quali · ànno ·
solamēte desiderio di ⁸corporal richezze, e
īteramēte priui di quello della ⁹sapiētia ·
cibo · e veramēte sicura richezza del' ¹⁰anima;
perchè quāt' è piv degnia · l'anima · che 'l
corpo, ¹¹tanto · piv · degni fiē le richezze
dell' anima · che del ¹²corpo · e spesso ·
quādo vedo · alcū di questi pigliare ¹³essa
opera ī mano, dubito · nō sia come fa la
scimi¹⁴a, se 'l mettino al naso, o che mi
domādino, se è cosa ¹⁵māgiatiua.

account of the wind that came out their mouth
in words, than of that they expelled from
their lower parts: men who desire nothing
but material riches and are absolutely devoid
of that of wisdom, which is the food and the
only true riches of the mind. For so much
more worthy as the soul is than the body,
so much more noble are the possessions of
the soul than those of the body. And
often, when I see one of these men take this
work in his hand, I wonder that he does
not put it to his nose, like a monkey, or
ask me if it is something good to eat.

PROEMIO.

¹⁷So bene che per non essere · io literato,
che alcuno ¹⁸prosuntuoso gli parà ragione-
volmente potermi ¹⁹biasimare coll' allegare ·
jo · essere homo sanza lettere; ²⁰giēte stolta!
nō sano questi · tali ch' io potrei si²¹come
Mario · rispose contro a' patriti romani, io
si ²²rispondere, diciendo · quelli che del-
l'altrui fatiche ²³se medesimi fanno · ornati ·
le mie a me mede²⁴simo nō uogliono · cō-
ciedere: diranno che per non a²⁵vere · io ·
lettere · non potere ben dire quello, di che
²⁶voglio trattare · or nō sano · questi che le
mie chose ²⁷son piv da esser tratte dalla
speriētia, che d'altra pa²⁸rola, la quale fu
maestra di chi bene scrisse ²⁹e cosi per
maestra la ³⁰in tutti casi allegherò.

INTRODUCTION.

I am fully concious that, not being a
literary man, certain presumptuous persons
will think that they may reasonably blame
me; alleging that I am not a man of letters.
Foolish folks! do they not know that I might
retort as Marius did to the Roman Patricians [21]
by saying: That they, who deck themselves
out in the labours of others will not allow
me my own. They will say that I, having
no literary skill, cannot properly express
that which I desire to treat of [26]; but they
do not know that my subjects are to be
dealt with by experience rather than by
words [28]; and [experience] has been the
mistress of those who wrote well. And so,
as mistress, I will cite her in all cases.

6. chausaua. 7. vomini equali. 8. corporal "richeze" diletta e priua. 9. sichura richeza de. 10. lanima chelchorpo. 11. fie . .
richeze. 12. chorpo . alchū. 13. imano . . . sichomellassimi. 14. domādi . . chosa. 17. alchuno. 18. prosuntooso. 19. siasi-
mare choll alegare . . . esere. 21. chome mario . . . chontro. 22. quello. 23. amememede. 24. chōciedere. 25. lettero.
26. chelle. 28. scrise. 29. [mia equel] e chosi per maestra la *peris* \\\\\\\\ *nu*lla. 30. chasi allegero.

not what to make of it. It is certainly not Demetrius
Phalereus that is meant and it can hardly be Deme-
trius Poliorcetes. Who then can it be—for the name
is a very common one? It may be a clerical error for
Demades and the maxim is quite in the spirit of his
writings; I have not however been able to find any
corresponding passage either in the 'Fragments' (C.
MÜLLER, *Orat. Att.*, II. 441) nor in the Supplements
collected by DIETZ (*Rhein. Mus.*, vol. 29, p. 108)."

The same passage occurs as a simple Memorandum
in the MS. Tr. 57, apparently as a note for this
'*Proemio*' thus affording some data as to the time
where these introductions were written.

21. *Come Mario disse ai patriti Romani.* "I am unable
to find the words here attributed by Leonardo to
Marius, either in Plutarch's Life of Marius or in the
Apophthegmata (*Moralia*, p. 202). Nor do they occur
in the writings of Valerius Maximus (who frequently
mentions Marius) nor in Velleius Paterculus (II, 11

to 43), Dio Cassius, Aulus Gellius, or Macrobius.
Professor E. MENDELSON of Dorpat, the editor of
Herodian, assures me that no such passage is the
found in that author" (communication from Dr.
MÜLLER STRÜBING). Leonardo evidently meant to
allude to some well known incident in Roman history
and the mention of Marius is the result probably of
some confusion. We may perhaps read, for Marius,
Menenius Agrippa, though in that case it is true
we must alter Patriti to *Plebei*. The change is a
serious one, but it would render the passage per-
fectly clear.

26—28. *le mie cose che d'altra parola.* This
can hardly be reconciled with Mons. RAVAISSON's
estimate of L. da Vinci's learning. "*Léonard de Vinci
était un admirateur et un disciple des anciens, aussi bien
dans l'art que dans la science et il tenait à passer pour
tel même aux yeux de la postérité.*" *Gaz. des Beaux arts.*
Oct. 1877.

C. A. 115*a*; 357*a*]

II.

Se bene come loro nō sapessi allegare
gli autori · molto magiore e piv degnia · cosa ·
allegherò · allegando ²la speriētia · maestra ·
ai loro · maestri; Costoro · vanno · sgonfiati
e pōposi, vestiti e ornati ³nō delle loro ·
ma delle altrui fatiche, · e le mie · a me
medesimo nō conciedono · e se ⁴me · inven-
tore · disprezzeranno · quāto magiormente ·
loro non inventori, ma trōbetti e recita⁵tori
dell'altrui opere potranno essere biasimati.

Though I may not, like them, be able
to quote other authors, I shall rely on that
which is much greater and more worthy:—
on experience, the mistress of their Masters.
They go about puffed up and pompous, dressed
and decorated with [the fruits], not of their
own labours, but of those of others. And
they will not allow me my own. They will
scorn me as an inventor; but how much
more might they—who are not inventors
but vaunters and declaimers of the works of
others—be blamed.

PROEMIO.

⁷E' ànno da essere · givdicati · e non
altrementi · stimati · li omini ⁸inventori inter-
petri tralla natura · e gli omini a comparatione
de recitatori e trōbetti · dell' altrui opere;
⁹quāt' è dall' obietto · fori dello spechio · alla
similitudine d'esso obietto · apparente nello
spechio · che l'u¹⁰no per se · è qualche cosa,
e l'altro è niēte · giente poco obbligate alla
natura, perchè sono sol' d'acidētal ¹¹vestiti ·
sanza il quale · potrei · aconpagnarli infra
li armēti delle bestie.

INTRODUCTION.

And those men who are inventors and
interpreters between Nature and Man, as com-
pared with boasters and declaimers of the
works of others, must be regarded and not
otherwise esteemed than as the object in front
of a mirror, when compared with its image
seen in the mirror. For the first is some-
thing in itself, and the other nothingness.—
Folks little indebted to Nature, since it is
only by chance that they wear the human
form and without it I might class them with
the herds of beasts.

C. A. 117*b*; 361*b*]

12.

Molti mi crederanno ragionevolmēte
potere riprēdere, ²allegando · le mie · prove ·
esser cōtro · all' autorità ³d'alquanti · omini
di grā reuerēza · apresso de loro · inesperti
ivditi, ⁴nō cōsiderādo le mie cose essere
nate sotto la senplice e mera ⁵sperientia ·
la quale · è maestra vera. ⁶Queste regole
son cagione · di farti conosciere · jl uero · dal
falso · la ⁷qual cosa fa che li omini · si pro-
mettano · le cose possibili e con piv mode-
ranza, ⁸e che tu non ti veli di ignoranza ·
cosa tale · che non avendo · effetto, tu abbi
⁹con disperatione · a darti malinconia.

Many will think they may reasonably
blame me by alleging that my proofs are
opposed to the authority of certain men held
in the highest reverence by their inexperienced
judgments; not considering that my works
are the issue of pure and simple experience,
who is the one true mistress. These rules
are sufficient to enable you to know the true
from the false—and this aids men to look
only for things that are possible and with due
moderation—and not to wrap yourself in
ignorance, a thing which can have no good
result, so that in despair you would give
yourself up to melancholy.

C. A. 200*a*; 594*a*]

13.

Intra li studi delle naturali cause e ra-
gioni la luce · diletta · più i contēplanti; jtra
le · cose grandi ²delle matematiche · la cer-

Among all the studies of natural causes
and reasons Light chiefly delights the beholder;
and among the great features of Mathematics

11. 1. 𝒜 sebene chome . . . sapesi . . . altori . . . chosa allegere. 2. schonfiati e pōpo. si. 3. elle mie . . . conciedano . [chos-
toro] esse. 4. disprezerano . . [da me] loro non inventore. 5. tori [potrano] delli . . . opere otrano esere. 7. E da . . . giv-
8. chonperatione. 9. quāte dall obietto . fori de dello dessobietto . aparente . . chellu. 10. chosa ellaltro he . . . pocho
obrigate. 11. achonpgnarli.

12. 1. poter "e". 2. chōtro . . alturita . [di qualche loro]. 4. chōsiderādo . . . chose. 6. cagione . . . chonossciere. 7. chelli
. . . chose "possibili e" chon. 8. chettu nonti [per] "veli di" ignoranza . chosa . . . t abi. 9. chon . . malinchonia.

13. 1. lisstudi . . . chause . rationi . chōntēplanti . . . lle chose. 2. matematice . certeza . . plecharamente invesstighāti.

tezza · della dimostratione · īalza · piv · pre-
claramente l'ingiegni dell' investigāti; ³la
prospectiva · adunque à da essere preposta ·
a tutte · le trattazioni · e discipline · vmane,
nel campo · della · quale · ⁴la linia · radiosa · è
complicata · dai modi · delle · dimostrationi,
nella · quale · si truova la gloria nō tāto
⁵della matematica · quanto della fisica ·,
ornata cō fiori · dell' una · e dell' altra: le
sentētie della quale ⁶distese con gran · cir-
cuitioni · io le ristrignierò jn conclusiua
breuità · jntessendo · secondo jl modo ⁷della
materia naturale e matematiche dimostra-
tioni; alcuna · volta · conchiudendo · gli effetti
⁸per le · cagioni e alcuna volta · le cagioni ·
per li effetti: agivgniēdo · ancora alle mie ·
cōclusioni alcuna ⁹che nō sono · j quelle ·
nō di meno · di quelle · si tragano · come si
degnierà · jl signiore · luce d'ogni ¹⁰cosa,
illustrare · me per trattare · della luce · per
cui partirò la presente opera j 3 parti.

the certainty of its demonstrations is what
preeminently (tends to) elevate the mind of
the investigator. Perspective, therefore, must
be preferred to all the discourses and systems
of human learning. In this branch [of science]
the beam of light is explained on those
methods of demonstration which form the
glory not so much of Mathematics as of Phy-
sics and are graced with the flowers of both[5].
But its axioms being laid down at great length,
I shall abridge them to a conclusive brevity,
arranging them on the method both of their
natural order and of mathematical demon-
stration; sometimes by deduction of the
effects from the causes, and sometimes
arguing the causes from the effects; adding
also to my own conclusions some which, though
not included in them, may nevertheless be in-
ferred from them. Thus, if the Lord—who is
the light of all things—vouchsafe to enlighten
me, I will treat of Light; wherefore I will di-
vide the present work into 3 Parts [10].

Ash. I. 17*b*] **14.**

DI TRE NATURE PROSPETTIVE.

The plan of
the book on
Painting
(14—17).

²Come sono · di 3. nature prospectiue:
la prima s'astēde · jtorno alla ³ragione del
diminvire (e diciesi prospettiva diminvitiva)
le cose che si allōtanano · dall' ochio; la
secōda ⁴cōtiene · ī se · il modo · del uariare ·
i colori che si allōtanano dall' ochio; ⁵la
terza e vltima s'astēde · alla dichiaratione
come le cose deuono ⁶essere meno finite
quanto piv s' alontanano | e nomi fieno
questi.

⁷prospetiva liniale ·
⁸prospetiva di colore ·
⁹prospetiva di speditione .

ON THE THREE BRANCHES OF PERSPECTIVE.

There are three branches of perspective;
the first deals with the reasons of the (apparent)
diminution of objects as they recede from the
eye, and is known as Diminishing Perspec-
tive.—The second contains the way in which
colours vary as they recede from the eye.
The third and last is concerned with the ex-
planation of how the objects [in a picture]
ought to be less finished in proportion as they
are remote (and the names are as follows):
Linear Perspective.
The Perspective of Colour.
The Perspective of Disappearance.

3. "e" da . . . prepossta . attutte . le traduzioni . . . champo. 4. chomplichata . . inella . . . groria. 5. matematicha . . .
fisicha . . . chō . . . eddell. 6. chom . . . circhuitioni . . . risstrigniero . . . chonclusiua . . . sechondo. 7. dela . . . mate-
matice . . . alchuna . . . chonchiudendo. 8. chagioni . . . alchuna . . . chagioni . . . ancora chōclusi"o"ni alchuna.
9. traghano chome. 10. chosa [illuminare] ilustrare me trattare . . . luce . el quale . partiro.
14. 1. prosspettire. 2. alle. 3. "(e diciesi prospettiva diminuetiva)" le chose chessi. 4. cholori chessi. 5. diciaratione chome.
6. mē finite qūto . . feno.

13. From the character of the handwriting I infer
that this passage was written before the year 1490.

5. Such of Leonardo's notes on Optics or on
Perspective as bear exclusively on Mathematics or
Physics could not be included in the arrangement
of the *libro di pittura* which is here presented to
the reader. They are however but few.

10. In the middle ages—for instance, by ROGER
BACON, by VITELLONE, with whose works Leonardo
was certainly familiar, and by all the writers of
the Renaissance—Perspective and Optics were not
regarded as distinct sciences. Perspective, indeed,

is in its widest application the science of seeing.
Although to Leonardo the two sciences were clearly
separate, it is not so as to their names; thus we
find axioms in Optics under the heading Perspective.
According to this arrangement of the materials for the
theoretical portion of the *libro di pittura* propositions
in Perspective and in Optics stand side by side or
occur alternately. Although this particular chapter
deals only with Optics, it is not improbable that
the words *partirò la presente opera in 3 parti* may
refer to the same division into three sections which
is spoken of in chapters 14 to 17.

E. 80b] **15.**

DE PICTURA E PROSPETTIVA.

²3. sono le parti della prospettiua di che si ³serue la pictura, delle quali la prima s'astē⁴de alla diminutione delle quantità de' corpi oppachi; la ⁵secōda è delle diminuitioni e perdimēti delli ter⁶mini d'essi corpi oppachi; La terza è della ⁷diminuitione e perdimēti de' colori in lūga ⁸distātia.

ON PAINTING AND PERSPECTIVE.

The divisions of Perspective are 3, as used in drawing; of these, the first includes the diminution in size of opaque objects; the second treats of the diminution and loss of outline in such opaque objects; the third, of the diminution and loss of colour at long distances.

G. 53b] **16.**

DISCORSO DE PICTURA.

²La perspectiva, la qual s'astende nella ³pictura, si diuide in tre parti prīcipali, del-⁴le quali la prima è della diminuitione che fan ⁵le quātita de' corpi in diverse distantie; ⁶La seconda parte è quella che tratta ⁷della diminuitiō de colori di tali corpi, — ⁸Terza è quella che diminuisce la notitia ⁹delle figure e termini, che ànno essi corpi in varie distā¹⁰tie.

THE DISCOURSE ON PAINTING.

Perspective, as bearing on drawing, is divided into three principal sections; of which the first treats of the diminution in the size of bodies at different distances. The second part is that which treats of the diminution in colour in these objects. The third [deals with] the diminished distinctness of the forms and outlines displayed by the objects at various distances.

E. 79b] **17.**

DELLE PARTI DELLA PICTURA.

²La prima parte della pittura è che li ³corpi cō quella figurati si dimostrino ⁴rilevati, e che li cāpi d'esse circūdatori, col-⁵le lor distantie, si dimostrino ētrare ⁶dentro alla pariete, doue tal pittura è giene⁷rata mediante le 3 prospective, cioè dimi⁸nuition delle figure de' corpi | · diminui⁹tion delle magnitudini loro e dimi¹⁰nuitiō de' loro colori: e di queste 3 prospec¹¹tive la prima à origine dall' ochio, le altre due ¹²ànno deriuatione dall' aria interposta infra l'occhio

ON THE SECTIONS OF [THE BOOK ON] PAINTING.

The first thing in painting is that the objects it represents should appear in relief, and that the grounds surrounding them at different distances shall appear within the vertical plane of the foreground of the picture by means of the 3 branches of Perspective, which are: the diminution in the distinctness of the forms of the objects, the diminution in their magnitude; and the diminution in their colour. And of these 3 classes of Perspective the first results from [the structure of] the eye, while the other two are caused by the atmosphere which intervenes between the eye and the objects seen

15. 1. presspectiva. 2. parte . . prospectiua [che] di chessi. 3. quale . . sasstē. 4. "delle quantita" de chorpi. 5. sechonda "he" delle. 7. decholori in lūgha. 8. disstātia.

16. 2. sasstende. 3. parte. 4. la p"a"he . . . cheffan. 5. chorpi in diuersi disstantie. 6. sechonda . . . hecquellachettracta. 7. cholori . . chorpi. 8. Terza ecquella cheddiminuisscie. 9. "ettermini" . . . chorpi.

17. 1. parte. 2. he chelli. 3. chorpi . . . fighurati si dimosstrino. 4. chelli chāpi . . . circhūdatori chol. 5. disstantie si dimosstrino. 6. alla . . he. 8. chorpi. 9. delle [quātita] magnitudine. 10. cholori . . . presspec. 12. interpossta infralloc-

15. The division is here the same as in the previous chapter No. 14, and this is worthy of note when we connect it with the fact that a space of about 20 years must have intervened between the writing of the two passages.

17. This and the two foregoing chapters must have been written in 1513 to 1516. They undoubtedly indicate the scheme which Leonardo wished to carry out in arranging his researches on Perspective

as applied to Painting. This is important because it is an evidence against the supposition of H. LUDWIG and others, that Leonardo had collected his principles of Perspective in one book so early as before 1500; a Book which, according to the hypothesis, must have been lost at a very early period, or destroyed possibly, by the French (!) in 1500 (see H. LUDWIG. *L. da Vinci: Das Buch von der Malerei.* Vienna 1882 III, 7 and 8).

¹³e li obbietti da esso ochio veduti, La 2ª parte del¹⁴la pictura è li atti appropriati e variati nelle statu¹⁵re, si che li omini nō pajano fratelli ecc.

by it. The second essential in painting is appropriate action and a due variety in the figures, so that the men may not all look like brothers, &c.

C. A. 218b; 648a]

18.

The use of the book on Painting.

Queste · regole · sono da vsare solamēte per ripruova delle figure · jnperochè ogni omo nella prima cōpositione · fa qualche errore; ²e chi nō li conoscie · nō li · raconcia · onde tu · per conosciere li errori · riprouerai l'opera tua, e dove trovi detti errori racō-ciali; ³e tieni a mēte di mai piv ricaderci; Ma se tu volessi adoperare le regole nel cōporre non verresti mai acapo e fare⁴sti · confusione nelle · tue opere.

⁵Queste regole fanno · che tu possiedi · uno libero · e bono · giuditio . jnperochè 'l bono · givditio · nascie · dal bene · intēdere ·, e 'l bene intēdere ⁶diriua da ragione · tratta da bone · regole · e le bone regole · sono figliole della · bona · speriētia: comvne madre · di tutte ⁷le sciētie · e arti; Onde · avēdo · tu · bene · a mēte i precietti · delle mie regole · potrai · solamēte col racōcio givditio giv⁸di-care · e conosciere · ogni · sproportionata · opera: cosi · in prospettiua · come in figure o altre cose.

These rules are of use only in correcting the figures; since every man makes some mistakes in his first compositions and he who knows them not, cannot amend them. But you, knowing your errors, will correct your works and where you find mistakes amend them, and remember never to fall into them again. But if you try to apply these rules in composition you will never make an end, and will produce confusion in your works.

These rules will enable you to have a free and sound judgment; since good judgment is born of clear understanding, and a clear understanding comes of reasons derived from sound rules, and sound rules are the issue of sound experience—the common mother of all the sciences and arts. Hence, bearing in mind the precepts of my rules, you will be able, merely by your amended judgment, to criticise and recognise every thing that is out of proportion in a work, whether in the per-spective or in the figures or any thing else.

G. 8a]

19.

DELL' ERRORE DI QUELLI CHE VSANO LA PRATICA SANZA SCIĒTIA.

OF THE MISTAKES MADE BY THOSE WHO PRACTISE WITHOUT KNOWLEDGE.

Necessity of theoretical knowledge (19. 20).

³Quelli che s'inamorā di pratica ⁴sāza sciētia, sō come 'l nochiere che ē⁵tra navilio sanza timone o bussola · ⁶che mai à certezza dove si uada; ⁷sēpre la pratica debbe esser edi⁸ficata sopra la bona teorica della ⁹quale la prospettiva è guida e ¹⁰porta, e sanza questa nulla si ¹¹fa bene ne' casi di pittura.

Those who are in love with practice without knowledge are like the sailor who gets into a ship without rudder or compass and who never can be certain whether he is going. Practice must always be founded on sound theory, and to this Perspective is the guide and the gateway; and without this no-thing can be done well in the matter of drawing.

C. A. 75a; 219a]

20.

Il pittore che ritrae per pratica e giv-ditio d'ochio, sanza ²ragione è come lo spechio, che in se imita tutte ³le a se cō-traposte cose sanza cognitione d'esse.

The painter who draws merely by practice and by eye, without any reason, is like a mirror which copies every thing placed in front of it without being conscious of their existence.

chio. 13. elli. 14. elli . apropiati . . nelli. 15. recelli . . . nō paj.
18. 1. "solamēte" . . . chōpositione. 2. chonosscie . nolli . rachoncia . . chonossciere . erori . . erori . rachōciali. 3. richaderci. Massettu . . . chōpore nōne veresti achapo effare. 4. chonfusione. 5. rego fanno . chettu possiedi . i̊ . lbero . . . nasscie. 6. elle bone . . chomvne. 7. chol rachōcio. 8. dichare . echonossciere . . . chosi . in prosspettiua chome . . chose.
19. 1—11 R. 1. eror. 2. praticha. 3. chessinamora di praticha. 4. nochieri. 5. obbussola. 6. cierteza. 8. teoricha. 9. qua la presspettiva. 10. essanza.
20. 1. praticha. 2. chome. 3. assechōtra poste chose . . chognitione dese.

C. A. 117*b*; 361*b*]　　　　　　**21.**

PROEMIO DI PROSPETTIVA, CIOÈ DEL' UFITIO DELL' OCHIO.

[3] Or', guarda · lettore · quello che non potremo [4] credere ai nostri antichi, i quali [5] ànno voluto difinire che cosa sia a[6]nima e uita: cose inprovabili; quando [7] quelle (cose) che con isperiētia · ogni ora si possono [8] chiaramēte conosciere e provare, sono [9] per tāti seculi ignorate · o falsamēte cre[10]dute · ! l'ochio, che cosi chiaramēte fa sperie[11]tia del suo · ofitio, è insino ai mia tē[12]pi per infiniti autori stato difinito in v̄ mo[13]do: trovo per isperiētia essere vn altro.

INTRODUCTION TO PERSPECTIVE:—THAT IS OF THE FUNCTION OF THE EYE.

Behold here O reader! a thing concerning which we cannot trust our forefathers, the ancients, who tried to define what the Soul and Life are—which are beyond proof, whereas those things, which can at any time be clearly known and proved by experience, remained for many ages unknown or falsely understood. The eye, whose function we so certainly know by experience, has, down to my own time, been defined by an infinite number of authors as one thing; but I find, by experience, that it is quite another[13].

The function of the eye (21—23).

C. A. 337*b*; 1026*b*]　　　　　　**22.**

Qui le figure, qui li colori, qui [2] tutte le spetie delle parti dell' u[3]niverso sō ridotte in v̄ punto; [4] e quel punto è di tāta mara[5]viglia! [6] O mirabile, o stupēda neciessità tu costri[7]gni colla tua leggie tutti li effet[8]ti per breuissima [9] via a participare delle lor cau[10]se! questi sono li miracoli. . .

[17] in tanto minimo spatio pos[18]sa rinasciere e ricōpor[19]si nella sua dilatatione; [20] scriui nella tua notomia che proportione [21] ànno infra loro li diamitri di tutte [22] le spetie dell' ochio e che distantia [23] à da loro la spera cristallina.

Here [in the eye] forms, here colours, here the character of every part of the universe are concentrated to a point; and that point is so marvellous a thing . . . Oh! marvellous, O stupendous Necessity—by thy laws thou dost compel every effect to be the direct result of its cause, by the shortest path. These [indeed] are miracles; . . .

In so small a space it can be reproduced and rearranged in its whole expanse. Describe in your anatomy what proportion there is between the diameters of all the images in the eye and the distance from them of the crystalline lens.

Ash. I. 13*a*]　　　　　　**23.**

DE' · 10 · OFITI DELL' OCHIO TUTTI APARTENENTI · ALLA · PICTURA.

[3] La pictura s'astēde · in tutti i · 10 · ofiti dell' ochio · cioè · tenebre · luce [4] corpo e colore · figura e sito · remotione · propīquita · moto · e quiete; [5] de quali ofiti · sarà intessuta · questa mia piccola opera · ricordādo [6] al pictore con che regola e modo debe imitare colla · sua arte tutte [7] queste · cose, opera di natura e ornamēto del mōdo.

OF THE 10 ATTRIBUTES OF THE EYE, ALL CONCERNED IN PAINTING.

Painting is concerned with all the 10 attributes of sight; which are:—Darkness, Light, Solidity and Colour, Form and Position, Distance and Propinquity, Motion and Rest. This little work of mine will be a tissue [of the studies] of these attributes, reminding the painter of the rules and methods by which he should use his art to imitate all the works of Nature which adorn the world.

21. 3. no. 5. chosa s |\|\|\|\|. 6. chose inprovabili q |\|\|\|\|. 7. quelle che chon . . . agniora sipossano. 9. sechuli. 10. locio . chosi . . chosi. 12. altori . . 13. nvn̄altra.

22. 2. parte. 6. "o stupēda" . . . chosstri. 8. ti [a participare] per [v]. 9. della lor chau. 10. miracholi. 11—16. *The leaf is here injured; only the following words at the beginning of the lines are preserved:*—11. que stupēdo |\|\|\|. 12. col quale |\|\|\|\|. 13. quasi |\|\|\|. 14. re |\|\|\|. 15. finita |\|\|\|: 16. gia per tute f |\|\|\|. 17. po. 18. rinasciere. 20. che ¦pro"ne". 21. infralloroli. 22. lesspetie. 23. dalloro. crisstallina.

23. 1. hofiti. 2. apartenti. 3. e . 10 . li ofiti. 4. cholore . . . essito. 5. pichola . richordādo. 6. chon . . cholla. ᷾7. chose.

21. In section 13 we already find it indicated that the study of Perspective and of Optics is to be based on that of the functions of the eye. Leonardo also refers to the science of the eye, in his astronomical researches, for instance in MS. F 25[b] '*Ordine del provare la terra essere una stella: Imprima difinisce l'occhio*', &c. Compare also MS. E 15[b] and F 60[b]. The principles of astronomical perspective.

13. Compare the note to No. 70.

E. 17*b*] **24.**

PICTURA.

Variability of the eye.
²1ᵃ La popilla dell' ochio diminuiscie tanto la ³sua quātita quāto crescie il luminoso che ⁴in lei s'inprime. ⁵2ᵃ Tanto crescie la popilla dell' ochio quāto di⁶minuiscie la chiarezza del giorno o d'altra lu⁷cie, che in lui s'inprime. ⁸3ᵃ Tanto più intensiuamēte vede e cono⁹scie l'ochio le cose che li stanno per obbietto, ¹⁰quāto la sua popilla più si dilata, e que¹¹sto proviamo mediante li animali nocturni, ¹²come nelle gatte e altri volatili, come il ¹³gufo e simili, nei quali la popilla fa grā¹⁴dissima variatione da grāde a piccola ecc. ¹⁵nelle tenebre o nell' alluminato. ¹⁶4ᵃ L'ochio posto nell' aria alluminata ve¹⁷de tenebre dētro alle finestre delle abi¹⁸tationi alluminate; ¹⁹5ᵃ tutti li colori posti in lochi onbrosi paiāo ²⁰essere d'equale oscurità infra loro. ²¹6ᵃ Ma tutti li colori posti in lochi luminosi nō ²²si uariā mai della loro essentia.

ON PAINTING.

1ˢᵗ. The pupil of the eye contracts, in proportion to the increase of light which is reflected in it. 2ⁿᵈ. The pupil of the eye expands in proportion to the diminution in the day light, or any other light, that is reflected in it. 3ʳᵈ. [8] The eye perceives and recognises the objects of its vision with greater intensity in proportion as the pupil is more widely dilated; and this can be proved by the case of nocturnal animals, such as cats, and certain birds—as the owl and others—in which the pupil varies in a high degree from large to small, &c., when in the dark or in the light. 4ᵗʰ. The eye [out of doors] in an illuminated atmosphere sees darkness behind the windows of houses which [nevertheless] are light. 5ᵗʰ. All colours when placed in the shade appear of an equal degree of darkness, among themselves. 6ᵗʰ. But all colours when placed in a full light, never vary from their true and essential hue.

C. A. 136*b*; 412*b*] **25.**

DELL' OCHIO.

Focus of sight.
²Se l'ochio à a vedere · cosa · che sia tropo presso nō la può bē giudicare, come īteruiene ³a quello · che si vol · vedere la pūta del naso; Onde per regola gienerale la natura ⁴īsegnia che la cosa nō si vedrà mai perfettamēte se lo ītervallo che si trova tra l'ochio ⁵e la cosa vista nō sarà almeno simile alla grādezza del uiso.

OF THE EYE.

If the eye is required to look at an object placed too near to it, it cannot judge of it well—as happens to a man who tries to see the tip of his nose. Hence, as a general rule, Nature teaches us that an object can never be seen perfectly unless the space between it and the eye is equal, at least, to the length of the face.

C. A. 339*a*; 1033*a*] **26.**

DELL' OCHIO.

Differences of perception by one eye and by both eyes(26—29).
²Quādo · i · 2 ochi · conduranno · la piramide · visuale · sopra l'obietto, ³esso · obietto · fia dalli ochi · veduto · e bene · conpreso.

OF THE EYE.

When both eyes direct the pyramid of sight to an object, that object becomes clearly seen and comprehended by the eyes.

H. 3. 85*a*] **27.**

Le cose vedute da uno medesimo ochio ²paranno alcuna volta · grāde alcuna ³volta· picole.

Objects seen by one and the same eye appear sometimes large, and sometimes small.

24. 2. p ᵃ La . . . diminuiscie. 3. cresscie. 4. sinpreme. 5. cresscie. 6. minuisscie. chiareza. 7. sinprema. 8. chonos. 9. chose chelli. 10. ecques. 11. sto proviano. 12. chome . . . ghatte . . . chome. 13. ghùfo essimili li quali. 14. disima . . appichola. 15. ōnellaluminato. 16. possto . . . alluminato. 17. finesstre. 19. cholori . . . inllochi. 20. [simi] essere . . . osschurità infralloro. 21. ttutti licholori possti.
25. 2. sellochioavedere . chososa . . . preso nolla po . . giudichare chome. 3. acquello . chessi. 4. chella chosa . . . sello . . . chessi . . . trallochio. 5. ella . . . sara il meno . . grādeza.
26. 1. de ochio. 2. chondurano. 3. chonpreso.
27. 1—3 R. 1. chose ` . . . da 1̊. 3. pichole.

24. 8. The subject of this third proposition we find fully discussed in MS. G. 44ᵃ.

28.

Tr. 74]

Il movimēto · della · cosa · visiua · alla cosa stabile · fa spesse ²volte · essa · cosa · stabile · parere · trasmvtarsi in nel moto della ³cosa · movēte · e la cosa movēte, parere · stabile e ferma.

PITTURA.

⁵Le cose di rilievo da presso · viste con ū sol' ochio parā simili ⁶a vna · perfetta pittura; Se vederai · coll'ochio · ||| · a · b · il pūto c, ⁷parratti · esso · pūto · c · in · d · f ⁸e se lo guardi col solo · ochio · g · parrà ti ⁹h · in · m ○ · e la pittura non avrà mai ¹⁰in se queste · 2 · varietà.

The motion of a spectator who sees an object at rest often makes it seem as though the object at rest had acquired the motion of the moving body, while the moving person appears to be at rest.

ON PAINTING.

Objects in relief, when seen from a short distance with one eye, look like a perfect picture. If you look with the eye a, b at the spot c, this point c will appear to be at d, f, and if you look at it with the eye g, h will appear to be at m. A picture can never contain in itself both aspects.

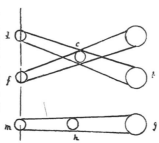

29.

W. An. IV. 153 b]

Sia il rilieuo t ²veduto da due ochi; ³volēdo ⁴te cōsiderare l'obbie-⁵tto coll' ochio m destro, ⁶tenēdo chiuso il sinistro · n · ⁷l'obbietto parrà overo occuperà lo spatio a; e se chiuderai il destro e aprirai il sinistro, l'obietto occuperà ⁸lo spatio b; e se aprirai tutti e due li ochi esso obietto nō occuperà più a b, ma lo spatio e r f; ⁹perchè la pittura veduta cō due ochi nō fia ¹⁰dimostratrice di tal relievo, come il rilieuo ¹¹veduto cō due ochi, e perchè la pittu¹²ra veduta con ū ochio parrà di rilievo, ¹³come il propio rilievo, auēte le medesime ¹⁴qualità di lumi e d'ōbre?

Let the object in relief t be seen by both eyes; if you will look at the object with the right eye m, keeping the left eye n shut, the object will appear, or fill up the space, at a; and if you shut the right eye and open the left, the object (will occupy the) space b; and if you open both eyes, the object will no longer appear at a or b, but at e, r, f. Why will not a picture seen by both eyes produce the effect of relief, as [real] relief does when seen by both eyes; and why should a picture seen with one eye give the same effect of relief as real relief would under the same conditions of light and shade?

30.

C. 7 b (9)]

L'ochio · piv terrà · e più riserberà · in se le similitudini delle cose luminose · che l'ōbrose; la ragiō si è · che l'ochio ²in se è somma oscurita · e perchè il simile infra 'l simile nō diuide, adūque la notte o altre cose oscure non possono essere riser³uate · o conosciute dall' ochio : il lume è interamēte contrario · e piv divide ed è più detrimēto e varietà alla cōsueta scurità ⁴dell' ochio · onde di se lascia inpressa la sua similitudine.

The eye will hold and retain in itself the image of a luminous body better than that of a shaded object. The reason is that the eye is in itself perfectly dark and since two things that are alike cannot be distinguished, therefore the night, and other dark objects cannot be seen or recognised by the eye. Light is totally contrary and gives more distinctness, and counteracts and differs from the usual darkness of the eye, hence it leaves the impression of its image.

The comparative size of the image depends on the amount of light (30—39).

28. 1. chosa .. chosa. 2. inel. 3. ella ... efferma. 5. chose .. chonūsolocio. 8. essella .. chol ... paratti. 9. ella ... ara.
29. 3. alli quali ochi vole. 4. te cōsiderare. 5. "m"desstro. 7. ochupera losspatio a esse ... desstro ... sinisstro l'obietto ||||||||||. 8. |||| spatio besse apirai ... due ochi lobietto esso obietto nō ochupera ... ma malo. 11. pittu[ra]. 12. porra.
30. 1. temera .. similitudine ... chellochio. 2. essomā osschurita ... "adūque" ... chose osschure po[ste]sono "es-sere" riser. 3. ochonosciuti "dallochio" ilume e intera . mēte chontrario ... divide epi detrimēto .. allala. 4. lasscia.

29. In the sketch, m is the left eye and n the right, while the text reverses this lettering. We must therefore suppose that the face in which the eyes m and n are placed is opposite to the spectator.

H². 38 a] **31.**

Tutte · le cose vedute parrāno ²magiori · di mezza notte, che · di ³mezzo · dì · e maggiori di mattina che ⁴di mezzo dì.

⁵Questo · accade · perchè · la pupilla ⁶dell' ochio · è minore · assai di mezzo ⁷dì · che di nessuno · altro tenpo.

Every object we see will appear larger at midnight than at midday, and larger in the morning than at midday.

This happens because the pupil of the eye is much smaller at midday than at any other time.

H.² 40 a] **32.**

¶Quella popilla che sarà maggiore, vederà ²le cose di maggiore · figura.¶

³questo si dimostra nel uedere de' corpi lu⁴minosi e massime · de' celesti; quādo ⁵l'ochio escie delle tenebre e subito risgu⁶arda · essi corpi · li parirrāno ⁷maggiori e poi diminuiscono; e se ⁸riguarderai essi corpi per un picciolo ⁹buso, li uederai minori · perchè mi¹⁰nore · parte d'essa (pupilla) s'adopera a tale ofitio.

The pupil which is largest will see objects the largest. This is evident when we look at luminous bodies, and particularly at those in the sky. When the eye comes out of darkness and suddenly looks up at these bodies, they at first appear larger and then diminish; and if you were to look at those bodies through a small opening, you would see them smaller still, because a smaller part of the pupil would exercise its function.

H.² 43 b] **33.**

Quell' ochio che uscendo dalle tenebre ²vederà subito vn corpo luminoso, ³li parrà assai maggiore nel primo is⁴guardo · che nel perseuerare il uederlo. ⁵Il luminoso · corpo parrà · maggiore ⁶e piv · luminoso · con due occhi · che ⁷con ū solo. ⁸Quel luminoso · si dimostrerà · di minor ⁹corpo · che per minore spiraculo ¹⁰dall' ochio fia veduto. ¹¹Quel corpo · luminoso · di lunga figura ¹²si dimostrerà · di piv · rotōdo · corpo ¹³che piv · distante· dall' ochio· situato ¹⁴fia.

When the eye, coming out of darkness suddenly sees a luminous body, it will appear much larger at first sight than after long looking at it. The illuminated object will look larger and more brilliant, when seen with two eyes than with only one. A luminous object will appear smaller in size, when the eye sees it through a smaller opening. A luminous body of an oval form will appear rounder in proportion as it is farther from the eye.

Ash. I. 12 a] **34.**

Perchè l'ochio, visto la luce, il loco di mezzano ²lume li pare tenebroso, e similmēte ³vscito dalle tenebre, il loco di mezzana luce, ⁴gli pare chiarissimo?

Why when the eye has just seen the light, does the half light look dark to it, and in the same way if it turns from the darkness the half light look very bright?

L. 41 b] **35.**

DE PICTURA.

²L'ochio che sta · all' aria luminosa e vede il loco ōbro³so, esso sito si dimostrerà di molta ma⁴ggiore oscurità che non è. ⁵Questo · accade sol perchè l'ochio che sta ⁶all' aria, diminuisce tanto piv la sua pu-

ON PAINTING.

If the eye, when [out of doors] in the luminous atmosphere, sees a place in shadow, this will look very much darker than it really is. This happens only because the eye when out in the air contracts the pupil in propor-

31. 1. tucte . le chose. 2. meza. 3. mezo . . magiori. 4. mezo. 5. acchade . mezo.

32. 1—10 R. 1. "popilla" [chio] chessara magiore. 2. chose "di" magiore. 3. quessto . . dimosstra. 4. ēmassime . cellessti quādo lo. 5. escie . . . essubitorissgu. 6. chorpi . li parirano [mino]. 7. magiori . diminuisschano esse. 8. chorpi. 10. dessa sadopera attale.

33. 1. vssciēdo delle tenebr. 2. chorpo . para . . magiore. 5. chorpog. 6. chon. 7. chon. 8. dimossterra. 9. "corpo" [forma] . . . spirachulo. 11. chorpo. 12. dimossterra . . . retōdo chorpo.

34. 1. ilocho . mezano. 3. ilocho . . mezana.

35. 2. chessta . . . "luminosa" . . . locho. 3. dimossterra. 4. gore osscurita. 5. Quessto achade . . . chessta. 6. diminuisscie.

32. 9. *buso* in the Lomb. dialect is the same as *buco*.
35. 14. *La luce entrerà. Luce* occurs here in the
sense of pupil of the eye as in no 51: C. A. 84 b; 245 a; 1—5; and in many other places.

⁷pilla, quanto l'aria, che in se si spechia, è pi⁸ù luminosa · E quanto essa popilla pi⁹ù diminuisce, manco la cosa da lei ve¹⁰duta si dimostra luminosa. ¶Ma quando ¹¹l'ochio entrerà in alcuno loco onbroso, ¹²subito la oscurità di tale onbroso parrà ¹³diminuire.¶ Questo accade, perchè quā¹⁴to la luce entrerà in aria più tenebrosa, ¹⁵più cresce sua figura, il quale accrescimē¹⁶to fa che la grande oscurità pare dimi¹⁷nuirsi.

tion as the atmosphere reflected in it is more luminous. And the more the pupil contracts, the less luminous do the objects appear that it sees. But as soon as the eye enters into a shady place the darkness of the shadow suddenly seems to diminish. This occurs because the greater the darkness into which the pupil goes the more its size increases, and this increase makes the darkness seem less.

S. K. M. II.¹ 1a]　　　**36.**

DE PROSPETTIVA.

²L'ochio, che si parte dal bianco alluminato dal ³sole e va in loco di minor luce, ogni cosa li pa⁴rrà tenebrosa; E questo accade, perchè l'ochio ⁵che sta a esso biāco alluminato o si viene a ristri⁶gniere le sue popille ī modo che se erano prima ⁷vna quātità visiua esse mācano piv che 'l 3/4 ⁸di sua quātità e mācado ·di ⁹quātità esse mācano di potētia, benchè tu mi ¹⁰potresti dire · uno piccolo vccello vederebbe all'a¹¹venate molto poco e per le piccole sue popille ¹²il biāco li parebbe nero; a questa parte ti rispō¹³derei, che qui s'attende alla proportione della sō¹⁴ma di quella parte del ciervello, dedicata alla vir¹⁵tù visiua, e nō ad altra cosa; o per tornare · questa ¹⁶nostra popilla cresce e diminvisce secōdo la ¹⁷chiarità o scurità del suo obietto· e perchè cō qual¹⁸che tēpo fa esso cresciere e discresciere esso ¹⁹nō vede cosi presto vsciēdo dal lume e andādo all' oscu²⁰ro, e similmēte dallo scuro al luminoso e questa ²¹cosa già m'īgannò nel dipignere vn ochio e di li l'imparai.

ON PERSPECTIVE.

The eye which turns from a white object in the light of the sun and goes into a less fully lighted place will see everything as dark. And this happens either because the pupils of the eyes which have rested on this brilliantly lighted white object have contracted so much that, given at first a certain extent of surface, they will have lost more than 3/4 of their size; and, lacking in size, they are also deficient in [seeing] power. Though you might say to me: A little bird (then) coming down would see comparatively little, and from the smallness of his pupils the white might seem black! To this I should reply that here we must have regard to the proportion of the mass of that portion of the brain which is given up to the sense of sight and to nothing else. Or—to return—this pupil in Man dilates and contracts according to the brightness or darkness of (surrounding) objects; and since it takes some time to dilate and contract, it cannot see immediately on going out of the light and into the shade, nor, in the same way, out of the shade into the light, and this very thing has already deceived me in painting an eye, and from that I learnt it.

I 1. 19b]　　　**37.**

Speriēza dell' a²crescimēto e di³minvitione della ⁴popilla pel moto ⁵del sole o d'altro ⁶luminoso. ⁷Quāto il cielo sarà più oscuro, tanto le stelle ⁸si dimostrerā di maggiore figura, e se tu ⁹allumini il mezzo,

Experiment [showing] the dilatation and contraction of the pupil, from the motion of the sun and other luminaries. In proportion as the sky is darker the stars appear of larger size, and if you were to light up

7. in sisspechia he pi. 8. Ecquanto. 9. diminuisscie mancho . . . dallei. 10. dimosstra . . . cquando. 11. enterra in alchuno locho. 12. osscurita. 13. Quessto acade. 14. enterra. 15. cressce . . . accrescimē. 16. chella . . . osscurita.

36. 2. chessi . . biano. 2. iloco. 4. re tenebroso Ecquesto acade. 5. allumina o si. 6. poille imodo lelerano. 7. māchano. 8. [tava parte] di sua . . . māchādo. 9. beche. 10. dire . ī picholo vciello vederebe. 11. pichole. 12. parebe . . acquesta. 16. crescie e diminvisscie. 17. osscurita . . cōquel. 18. chettēpo . . cresciere e discresciere. 19. vsciēdo alume andādo elloscu. 20. ecquesta. 21. mīgano . . dililāparai.

37. 2. crescimēto. 4. popila. 7. Quā il . . . ossuro. 8. dimosterā . magiore . . essettu. 9. mezo dimosterā. 10. ecquesta.

esse stelle si dimostrerā [10]minori, e questa tale mutatione sol' [11]nasciē dalla popilla, la quale crescie e discre[12]scie mediante la chiarezza del mezzo che si [13]truova infra l'ochio· e'l corpo luminoso; [14]sia fatta la sperienza con vna cādela po[15]sta sopra la testa in nel medesimo tenpo che tu [16]risguardi tale stella, di poi vieni abbassando [17]detta cādela a poco a poco, insino che ella [18]sia uicina alla linia che uiene dalla stella [19]all' ochio, e allora uederai diminuire tāto [20]la stella che quasi la perderai di uista.

the medium these stars would look smaller; and this difference arises solely from the pupil which dilates and contracts with the amount of light in the medium which is interposed between the eye and the luminous body. Let the experiment be made, by placing a candle above your head at the same time that you look at a star; then gradually lower the candle till it is on a level with the ray that comes from the star to the eye, and then you will see the star diminish so much that you will almost lose sight of it.

I.1 20 a]

38.

¶La popilla del[2] l'ochio· stante all' aria in ogni [3]grado di moto fatto dal sole muta [4]gradi· di magnitudine.¶ [5]e in ogni grado· di magnitudine [6]una medesima cosa veduta si dimostre[7]rà di diuerse grandezze, benchè spesse vol[8]te il paragone delle cose circunstanti [9]nō lascino disciernere tali mvtationi d'u[10]na sola cosa che si risguarda.

The pupil of the eye, in the open air, changes in size with every degree of motion from the sun; and at every degree of its changes one and the same object seen by it will appear of a different size; although most frequently the relative scale of surrounding objects does not allow us to detect these variations in any single object we may look at.

C. A. 200 a; 594 a]

39.

La luce operādo nel vedere le cose cōuerse· alquāto le spetie di quelle ritiene. Questa· conclusiō [2]si pruova per li effetti, perchè la vista ɪn vedere luce· alquāto (ne) tiene. Ancora dopo lo sguardo [3]rimāgono nel' ochio· similitudini della cosa intēsa· e fanno parere tenebroso il logo di minor [4]luce· per insino che dall' ochio sia sparito il uestigio della īpresiō della maggior luce.

The eye—which sees all objects reversed —retains the images for some time. This conclusion is proved by the results; because, the eye having gazed at light retains some impression of it. After looking (at it) there remain in the eye images of intense brightness, that make any less brilliant spot seem dark until the eye has lost the last trace of the impression of the stronger light.

11. nasscie . . . cresscie. 12. ciareza mezo chessi. 13. infrallochio . fatto. 15. sta . . . inel . . chettu. 17. apocho apoco . . . chella. 20. uissta.

38. 3. fatta. 5. enōgni . . . magnitudine [laco]. 6. dimoster. 8. circhunstanti. 9. lasscino . . . mvtationi. 10. chessirissguarda.

39. 1. chose chōuerse . . quele . . . chunclusiō. 2. Anchora . lossguardo. 3. rimāgano . . similitudine . . chosa . . effano . . ilogo. 4. insinode . . . spartito . . dela . . . dela magior.

37. No reference is made in the text to the letters on the accompanying diagram.

II.

Linear Perspective.

We see clearly from the concluding sentence of section 49, where the author directly addresses the painter, that he must certainly have intended to include the elements of mathematics in his Book on the art of Painting. They are therefore here placed at the beginning. In section 50 the theory of the "Pyramid of Sight" is distinctly and expressly put forward as the fundamental principle of linear perspective, and sections 52 to 57 treat of it fully. This theory of sight can scarcely be traced to any author of antiquity. Such passages as occur in Euclid[1] for instance, may, it is true, have proved suggestive to the painters of the Renaissance, but it would be rash to say any thing decisive on this point.

Leon Battista Alberti treats of the "Pyramid of Sight" at some length in his first Book of Painting[2]; but his explanation differs widely from Leonardo's in the details. Leonardo, like Alberti, may have borrowed the broad lines of his theory from some views commonly accepted among painters at the time; but he certainly worked out its application in a perfectly original manner.

The axioms as to the perception of the pyramid of rays are followed by explanations of its origin, and proofs of its universal application (58—69). The author recurs to the subject with endless variations; it is evidently of fundamental importance in his artistic theory and practice. It is unnecessary to discuss how far this theory has any scientific value at the present day; so much as this, at any rate, seems certain: that from the artist's point of view it may still claim to be of immense practical utility.

According to Leonardo, on one hand, the laws of perspective are an inalienable condition of the existence of objects in space; on the other hand, by a natural law, the

[1] Si imaginibus procedentibus passio visiva gignitur et si ab omni corpore continuae imagines profluunt quae nostros sensus commovent, qua de causa fit ut quaerens acum, itidemque librum accurate legens omnes literas non perspicit. Ed. L. PACIOLI, Venetiis, 1509.

[2] Questi razzi extrinsici, cosi circuendo la superfitie che l'uno tocchi l'altro, chiudono tutta la superficie quasi come vetrici ad una gabbia, e fanno, quanto si dice, quella piramide visiva, &c. Ed. JANITSCHEK, Vienna 1877, p. 61 seq.

eye, whatever it sees and wherever it turns, is subjected to the perception of the pyramid of rays in the form of a minute target. Thus it sees objects in perspective independently of the will of the spectator, since the eye receives the images by means of the pyramid of rays "just as a magnet attracts iron".

In connection with this we have the function of the eye explained by the Camera obscura, and this is all the more interesting and important because no writer previous to Leonardo had treated of this subject (70—73). Subsequent passages, of no less special interest, betray his knowledge of refraction and of the inversion of the image in the camera and in the eye (74—82).

From the principle of the transmission of the image to the eye and to the camera obscura he deduces the means of producing an artificial construction of the pyramid of rays or—which is the same thing—of the image. The fundamental axioms as to the angle of sight and the vanishing point are thus presented in a manner which is as complete as it is simple and intelligible (86—89).

Leonardo distinguishes between simple and complex perspective (90, 91). The last sections treat of the apparent size of objects at various distances and of the way to estimate it (92—109).

40.

PICTURA.

²La prospettiva · è briglia · ottima della ³pittura.

ON PAINTING.

Perspective is the best guide to the art of Painting.

General remarks on perspective (40—41).

41.

¶La prospettiva · è di tale · natura · ch'ella fa · parere · il piano · rilievo e 'l rilievo piano.

The art of perspective is of such a nature as to make what is flat appear in relief and what is in relief flat.

42.

Tutti i casi della prospectiua sono intesi ²mediante i cinque termini de' matematici cioè · punto ³linia · angolo · superfitie e corpo, de quali il punto è solo ⁴in sua gieneratione · e questo pūto non à altezza nè larghezza o lū⁵ghezza o profondità, onde si conclude essere indiuisibile e non auere ⁶loco: linia · è di 3 nature, cioè retta curva e flessuosa e quella · non à larghezza nè altezza o profōdi⁷tà, onde è indiuisibile, saluo che per la sua lūghezza i sua termi⁸ni sō 2 pūti; Angolo è il termine di 2 linie nel pūto.

All the problems of perspective are made clear by the five terms of mathematicians, which are:—the point, the line, the angle, the superficies and the solid. The point is unique of its kind. And the point has neither height, breadth, length, nor depth, whence it is to be regarded as indivisible and as having no dimensions in space. The line is of three kinds, straight, curved and sinuous and it has neither breadth, height, nor depth. Hence it is indivisible, excepting in its length, and its ends are two points. The angle is the junction of two lines in a point.

The elements of perspective:— Of the Point (42—46).

43.

Pūto non è parte di linia.

A point is not part of a line.

40. 2. ottimo [ne]della. — **41.** 1. prosspettiva . . chela.
42. 1. tucti. 3. ancolo . . he chorpo . . . essolo. 4. altezza nellargeza ollū. 5. geza. 6. locho . . 1 "edi 3 nature cioe retta gurva e flessuosa" e quella che nona largeza ne alteza. 7. onde hessi indiuisibile . . . lūgeza.

40. Compare 53, 2.

Ash. III. 27 *b*]

44.

DEL PŪTO NATURALE.

²Il minore pūto naturale è maggiore di tutti ³i punti matematici, e que⁴sto si pruova perchè il punto naturale è quan⁵tità continua, e ogni cōtinuo è diuisibile in in⁶finito, e il punto matematico è indivisibile, ⁷perchè non è quātità.

OF THE NATURAL POINT.

The smallest natural point is larger than all mathematical points, and this is proved because the natural point has continuity, and any thing that is continuous is infinitely divisible; but the mathematical point is indivisible because it has no size.

Br. M. 131 *b*]

45.

¹1. La superfitie è termine del corpo. ²2. e 'l termine d'un corpo · non è · parte d'esso corpo, ³4. e 'l termine · d'un corpo · è principio d'un altro ⁴3. quello è niēte · che non è parte d'alcuna cosa. ⁵Quello è niēte che niēte occupa.

1, The superficies is a limitation of the body. 2, and the limitation of a body is no part of that body. 4, and the limitation of one body is that which begins another. 3, that which is not part of any body is nothing. Nothing is that which fills no space.

⁶Se un solo · punto posto nel circulo può essere principio d'infinite linie, ⁷e'l termine d'infinite linie · da tal punto separate sono · infiniti punti, ⁸i quali · ridotti insieme ritornano · in uno · qui seguita che la parte sia ⁹equale · al tutto.

If one single point placed in a circle may be the starting point of an infinite number of lines, and the termination of an infinite number of lines, there must be an infinite number of points separable from this point, and these when reunited become one again; whence it follows that the part may be equal to the whole.

Br. M. 132 *a*]

46.

E'l punto · per essere · indiuisibile · niente occupa. ²Tutte le cose che niēte · occupano · niente · sono. ³E 'l termine d'una · cosa · è principio d'un altra. ⁴2. e Quel si dice · esser niente · che non è parte d'alcuna cosa ⁵1. quel che non à termine non à figura · alcuna; ⁶i termini di 2 corpi insieme congiunti sono scanbie⁷volmente · superfitie · l'uno · dell' altro. ⁸Tutti i termini delle cose nō sono parte alcuna d'esse · cose.

The point, being indivisible, occupies no space. That which occupies no space is nothing. The limiting surface of one thing is the beginning of another. 2. That which is no part of any body is called nothing. 1. That which has no limitations, has no form. The limitations of two conterminous bodies are interchangeably the surface of each. All the surfaces of a body are not parts of that body.

W. L. 145. C *b*]

47.

DIFINITIŌ DELL' ESSER DELLA LINIA.

Of the line (47—48).

²La linia non à in se materia o sustātia alcuna ma si può nomi³nare più presto cosa spirituale che sustātia, e per essere lei ⁴cosi cōditionata, essa non occupa loco,

DEFINITION OF THE NATURE OF THE LINE.

The line has in itself neither matter nor substance and may rather be called an imaginary idea than a real object; and this being its nature it occupies no space. There-

44. 2. magiore. 3. punti naturali matematematici ecques. 5. chontinua . . divisibile ini. 6. matematicho he.
45. 1. he termine. 5. ochupa. 6. se î solo. po. 8. equali . . . innuno . . . chella.
46. 1. puncto . . ochupa. 2. tucte le chose . . ochupano. 3. chosa. 5. cquel . . . alchuna. 6. [il]i ter. 7. altro "come lacqua collaria". 8. tutti e.
47. 2. nana . . . ossustātia alchuna massi. 3. chosa . . . susstātia. 4. chosi chōditionata . . ochupa locho . . interseghātioni.

44. This definition was inserted by Leonardo on a MS. copy on parchment of the well-known "*Trattato d'Architettura civile e militare*" &c. by FRANCESCO DI

GIORGIO; opposite a passage where the author says: '*In prima he da sapere che pvnto è quella parte della quale he nulla—Linia he luncheza senza āpieza;* &c.

adūque le intersegationi ⁵d'infinite linie si può immaginare esser fatte in pūto, il quale ⁶è sanza mezzo e per grossezza (se grossezza si può nominare) equa⁷le alla grossezza d'una sola linia.

fore an infinite number of lines may be conceived of as intersecting each other at a point, which has no dimensions and is only of the thickness (if thickness it may be called) of one single line.

COME CŌCLUDIAMO NOI LA SU²PERFITIE RIDURSI IN PUNTO?

HOW WE MAY CONCLUDE THAT A SUPERFICIES TERMINATES IN A POINT?

¹⁰La superfitie angulare si riducie in punto quando ella ¹¹si termina nel suo angolo, o se saranno i lati di tale angolo ¹²prodotti in continuo diretto, allora dopo tale angolo si ¹³gienererà vn'altra superfitie minore o equale o maggiore ¹⁴della prima.

An angular surface is reduced to a point where it terminates in an angle. Or, if the sides of that angle are produced in a straight line, then—beyond that angle—another surface is generated, smaller, or equal to, or larger than the first.

Ash. I. 21 a]

48.

DE PICTURA · LINIALE.

OF DRAWING OUTLINE.

²Siano con somma · diligiēza · cōsiderati · i termini · di qualunque · corpo: il modo · del lor serpeg³giare, le quali · serpeggiature · siano · givdicate · separate, se le sue volte · participano di ⁴curvità · arculare o di cōcavità · angulare.

Consider with the greatest care the form of the outlines of every object, and the character of their undulations. And these undulations must be separately studied, as to whether the curves are composed of arched convexities or angular concavities.

G. 37 a]

49.

Li termini delli corpi sono la minima ²cosa di tutte le cose ‖ provasi essere ³vero quel che si propone, perchè il termi⁴ne della chosa è vna superfitie, la qual non ⁵è parte del corpo uestito di tal superfitie, nè è ⁶parte dell'aria circūdatricie d'esso cor⁷po ma 'l mezzo interposto infra l'a⁸ria e 'l corpo come a suo loco è pro⁹vato; Ma li termini laterali d'essi cor¹⁰pi è la linia termine della superfitie, ¹¹la qual linia è di grossezza invisibile; adūque tu ¹²pittore nō circūdare li tua corpi di ¹³linie, e massime nelle cose minori ¹⁴che 'l naturale, le quali nō che possino mo¹⁵strare li termini laterali, ma li lor menbri ¹⁶per distantia sono invisibili.

The boundaries of bodies are the least of all things. The proposition is proved to be true, because the boundary of a thing is a surface, which is not part of the body contained within that surface; nor is it part of the air surrounding that body, but is the medium interposted between the air and the body, as is proved in its place. But the lateral boundaries of these bodies is the line forming the boundary of the surface, which line is of invisible thickness. Wherefore O painter! do not surround your bodies with lines, and above all when representing objects smaller than nature; for not only will their external outlines become indistinct, but their parts will be invisible from distance.

The nature of the outline.

A. 3 a]

50.

[la pittura · è fondata · sulla · prospettiva: non è · altro che ²sapere bene figurare · lo vfitio · dell' ochio, ⁴il quale · ofitio · s'estēde ·

[Drawing is based upon perspective, which is nothing else than a thorough knowledge of the function of the eye. And this function simply

Definition of Perspective.

5. fatta. mezo . . grosseza . . grosseza. 7. grosseza 9. cōcludiano. 10. anghulare. 11. angholo osse sarā . . . angholo. 12. chontinuo . . angholo. 13. iminore . . magiore.
48. 2. sia chon . . cōsiderato . . chorpo . . serpe. 3. serpegiature sia givdicato [seperati] selle. 4. churvita . archulareodi chōchavita·
49. 1. chorpi sō la minima. 2. chosa . . chose. 4. chosa . . no. 5. ne parte. 6. circhūdatricie . . chor. 7. mezo interpossto infralla. 8. chorpo chome assuo locho. 9. Malli. 10. piella. 11. "di grossezza" . . addūque. 12. circhūdare . . chorpi. 13. chose. 14. possī mos. 15. "laterali" ma lelor. 16. disstantia sono "invisibili" [inchognito].
50. 1. effondata sula che[lle]. 2. ochio 4 cioe [jn che modo le similitudine]. 3. [delle chose vengano a esso ochio]. 4. 4 il quale

50. 1—5. Compare with this the Proem. No. 21. The paragraphs placed in brackets: lines 1—9, 10—14,

solo in pigliare per piramide · le forme e colori ⁵di tutti li obietti · contra · se · posti: per piramide dico, perchè non è cosa ⁶si minima · che · nō sia · maggiore · che 'l loco, dove si cōducono · nell'ochio · esse ⁷piramidi: adunque se torrai le linie ali stremi di ciascuno corpo ⁸e il loro concorso cōducierai a vn solo · pūto, è necie⁹ssario che dette linie · sieno piramidali.]

¹⁰[prospettiva · non è altro che ragione dimostrativa · la quale s' estēde ¹¹a considerare come · li obietti contraposti · al'ochio mādano di loro a ¹²quello per linie piramidali la loro propria · similitudine; Piramide ¹³sono dette quelle linie che si partono da superfitiali · stremi di ciascuno ¹⁴corpo e per distante cōcorso si cōducono · a un solo pūto.]

¹⁷[prospettiva · è ragiō dimostrativa per la · quale effettualmēte ¹⁸si cōprende come li obietti· mādano ¹⁹di loro la propia similitudine ²⁰per linie piramidali all' occhio.]

¶ ²²prospettiva è ragione dimostratiua · per la quale · la sperentia cōferma ²³tutte · le cose mādare · all'ochio · per linie piramidali la lor similitudine ²⁴e quelli corpi d'equale grādezza farāno maggiore o minore āgolo a la lor piramide secōdo la ²⁵varietà della distātia che fia da l'una a l'altra; ²⁶linie · piramidali · intēdo essere quelle · le quali · si partono da superfitiali ²⁷stremi de corpi · e per distāte · concorso · si cōducono a un solo pūto; ¶ ²⁸pūto dicono · essere · quello · il quale in nessuna parte si può diuidere ²⁹e questo pūto è quello il quale stādo nell'ochio ricieue ī se tutte le pūte delle piramidi.

consists in receiving in a pyramid the forms and colours of all the objects placed before it. I say in a pyramid, because there is no object so small that it will not be larger than the spot where these pyramids are received into the eye. Therefore, if you extend the lines from the edges of each body as they converge you will bring them to a single point, and necessarily the said lines must form a pyramid.]

[Perspective is nothing more than a rational demonstration applied to the consideration of how objects in front of the eye transmit their image to it, by means of a pyramid of lines. The *Pyramid* is the name I apply to the lines which, starting from the surface and edges of each object, converge from a distance and meet in a single point.]

[Perspective is a rational demonstration, by which we may practically and clearly understand how objects transmit their own image, by lines forming a Pyramid (centred) in the eye.]

Perspective is a rational demonstration by which experience confirms that every object sends its image to the eye by a pyramid of lines; and bodies of equal size will result in a pyramid of larger or smaller size, according to the difference in their distance, one from the other. By a pyramid of lines I mean those which start from the surface and edges of bodies, and, converging from a distance meet in a single point. A point is said to be that which [having no dimensions] cannot be divided, and this point placed in the eye receives all the points of the cone.

C. A. 84*b*; 245*a*] **51.**

Ī CHE MODO L'OCCHIO VEDE LE COSE POSTELI DINĀZI.

IN WHAT WAY THE EYE SEES OBJECTS PLACED IN FRONT OF IT.

The perception of the object depends on the direction of the eye.

²Pogniamo che quella palla figurata di sopra sia la palla dell'ochio, e quella parte minore ³della palla ch'è diuisa dalla linia

Supposing that the ball figured above is the ball of the eye and let the small portion of the ball which is cut off by the line *s t*

. . sastēde . . . pigliare periramide . . cholori. 5. cosa si [pi]. 6. maggiore chelocho . . chonduchano. 7. piramide . . tora . . chorpo[e tire]. 8. [ralealcho] e iloro chonchorso chōducierai sario. 10. quasastēde. 11. chonsiderare chome . . chontraposti. 12. quelo per "linie" . . . Piramide [e della]. 13. [da 2 linie] sonoquelinie . . . partano . . . ciaschuno. 14. chorpo . . chōchorsosi cōduchano . . a ī solo. 15. [prospettiva evna ragione dimostrativa per la quale [chon isperi] con uera is pe]. 16. [rientia]. 17. e[vna] ragiō. 18. [chiaro] si chōplende chome . . . obietti [chōtra posti allochio]. 19. di loro "per linie piramidali . acuuelle" acquello 4̇ la propia similitudine. 20. similitudine per. 21. [prospettiva e ragione dimostrativa . per la quale . effettualmete . c]. 23. chose . . lor [propia]. 24. ecqueli chorpi dequali grādeza . . maggiore . . . ōminore . . . piramida. 25. dela . . . cheffia. 26. esere . . . partano . . . superfitiali stre. 27. chorpi . . . chonchorso . si chōduchano a ī solo. 28. dichano . . inessuna parte parte . . po. 29. ecquesto . . . quelo . . . nelochio . . . piramide. *Lines 24 and 25 are in the original numbered as* 1; 26 *and* 27 *as* 2; 28 *and* 29 *as* 3.

51. 1—14 *written from left to right. The diagram stands above the text.* 1. chose possteli. 2. fighurato . . occhi equelle. 3. sie

and 17—20, are evidently mere sketches and, as such, were cancelled by the writer; but they serve as a commentary on the final paragraph, lines 22—29.

51. In this problem the eye is conceived of as fixed and immovable; this is plain from line 11.

$s\,|\,t\,|$ sia la luce, e tutte le cose specchiate sul mezzo della [4]superficie di detta luce subito discorrono e vanno nelle popille, passando per vn cierto umore cri[5]stallino che non occupa nella popilla cosa che si dimostri alla luce; E essa popilla, rice[6]vute le cose dalla luce, immediatamente · le riferiscie e porge allo ītelletto · per la linia $7\,a\cdot b\,|$ E sappi che la popilla nō porgie nessuna cosa perfettamēte allo intelletto over sēso comune · se non quā[8]do · le cose a lei date · dalla luce si dirizzano per la linia · $a\cdot b$ · sicome vedi che fa la linia · $c\cdot a$; [9]e bēchè le linie $m\cdot n\cdot f\cdot g$ · sieno vedute dalla popilla, nō sono cōsiderate · perchè nō si dirizzano [10]colla linia, $a\cdot b$ · E la pruova si è questa, se questo occhio qui di sopra vorrà nvmerare le let[11]tere poste li dināzi cōverrà che l'occhio giri da lettera a lettera: perchè nō la discierne[12]rebbe, se nō le dirizasse per la linia · $a\cdot b$ · siccome fa la linia · $c\cdot a$: e tutte le cose vedute [13]uēgono all' occhio per linie piramidate, e la pūta di detta piramide · fa termine [14]e fine nel mezzo della popilla, come di sopra è figurato.

be the pupil and all the objects mirrored on the centre of the face of the eye, by means of the pupil, pass on at once and enter the pupil, passing through the crystalline humour, which does not interfere in the pupil with the things seen by means of the light. And the pupil having received the objects, by means of the light, immediately refers them and transmits them to the intellect by the line *a b*. And you must know that the pupil transmits nothing perfectly to the intellect or common sense excepting when the objects presented to it by means of light, reach it by the line *a b;* as, for instance, by the line *b c*. For although the lines *m n* and *f g* may be seen by the pupil they are not perfectly taken in, because they do not coincide with the line *a b*. And the proof is this: If the eye, shown above, wants to count the letters placed in front, the eye will be obliged to turn from letter to letter, because it cannot discern them unless they lie in the line *a b*; as, for instance, in the line *a c*. All visible objects reach the eye by the lines of a pyramid, and the point of the pyramid is the apex and centre of it, in the centre of the pupil, as figured above.

la luce ettutte le chose . . mezo delle. 4. superfice . . disschorrono . . . omore. 5. none occhupa nelle popille chose chessi dimosstri. 6. chose dalle . . immediante le riferisscie epporge. 7. Essappi chella . . . chosa . . . "over sēsochomune" sennō. 8. chose allei . . dirizano . sicchome . . cheffa. 9. chōsiderate . . dirizano. 10. cholla . . Ella . . questto . . vorrannvmerarelele. 11. posste . . chōverra chellocchio . . disscierne. 12. nolle . . . sicchome . . chose. 13. uēghono . . ella pūta . . piramida. 14. effine . . chome . . fighurato.

A. 10 a] **52.**

Experimental proof of the existence of the pyramid of sight (52—55).

Prospettiva · è ragione · dimostratiua · per la quale · la sperientia conferma [2]tutte · le cose · mādare · all'occhio · per linie piramidali · la loro · similitudine;

[3]linie · piramidali · intēdo · esser quelle · le quali · si partono dai superfitiali · stremi [4]de' corpi · e per distante · cōcorso · si conducono · a vno · solo · pūto, il quale pūto [5]in questo caso · mostrerò essere collocato · nell' ochio, vniuersale giudice di tutti i corpi; [6]punto · dico · esser · quello · il quale non si può diuidere · in alcuna parte; adūque [7]sendo · questo punto indiuisibile · che collocato nella uista · nessuno [8]corpo · fia veduto · dal' ochio: che nō sia maggiore d'esso pūto: essēdo cosi [9]è neciessario · che le linie · che vengono · dal corpo al pūto · sieno piramidate, [10]e se alcuno volesse provare · la uirtù visiua · nō cōsistere in esso punto [11]anzi essere quello pūto nero che si uede in mezzo alla popilla, [12]a questo si potrebbe rispōdere · che vna piccola cosa mai potrebbe diminvire per alcuna [13]distantia · come sarebbe un grano di miglio o di panico o altra simile cosa e qu'el[14]la cosa · · che fusse maggiore che detto punto, mai potrebbe essere veduta interamēte [15]come appare nella prova di sotto; [16]sia · a · la uirtù · visiua, b · e sia il concorso

Perspective is a rational demonstration, confirmed by experience, that all objects transmit their image to the eye by a pyramid of lines.

By a pyramid of lines I understand those lines which start from the edges of the surface of bodies, and converging from a distance, meet in a single point; and this point, in the present instance, I will show to be situated in the eye which is the universal judge of all objects. By a point I mean that which cannot be divided into parts; therefore this point, which is situated in the eye, being indivisible, no body is seen by the eye, that is not larger than this point. This being the case it is inevitable that the lines which come from the object to the point must form a pyramid. And if any man seeks to prove that the sense of sight does not reside in this point, but rather in the black spot which is visible in the middle of the pupil, I might reply to him that a small object could never diminish at any distance, as it might be a grain of millet or of oats or of some similar thing, and that object, if it were larger than the said [black] spot would never be seen as a whole; as may be seen in the diagram below. Let a.

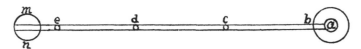

delle linie che uēgono al'occhio [17]e. d. siano i grani del miglio dentro a detto · concorso: vedi per ragione questi [18]mai per distātia diminvire · e il corpo · m · n · non potersi da quelle interamēte [19]cōprēdere: adūque è neciessario · cōfessare l'occhio · avere ī se un solo pūto [20]indiuisibile, a il quale conferiscono tutte le punte della piramide partite [21]dai corpi, come appare qui di sotto [22]a b · sia · l'occhio; il ciētro suo tēga il punto prenominato: se la linia · e · f · à

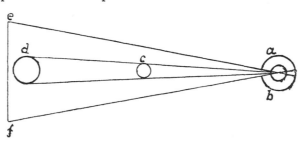

be the seat of sight, b e the lines which reach the eye. Let e d be the grains of millet within these lines. You plainly see that these will never diminish by distance, and that the body m n could not be entirely covered by it. Therefore you must confess that the eye contains within itself one single indivisible point a, to which all the points converge of the pyramid of lines starting from an object, as is shown below. Let a. b. be the eye; in the centre of it is the point

52. 1. Prospectiva . . lassperientia chonferma. 2. chose. 3. partano. 4. chorpi . . chonchorso . si chonduchano. 5. chaso . . mostero . . cholochato. 6. dicho . . quelo . po . alchuna. 7. cholochato . nela . nessuna [chosa]. 8. [eviden] corpo magiore. 9. [bisogn] e . . chelle . . vegano . . . sieno [mag] piramidate. 10. esse . . volessi . . . esso puno [a questi]. 11. [si potrebbe] anzizi . . quelo . . imezo. 12. acquesti . . chosι . . potrebe . . potrebe . alchuna. 13. come sare î grano di miglio o di panicho . . chosa ecque. 14. cheffussi magiore . . . potrebe . . essere deduto apare nela. 16. conchorso . . vēgano. 17. chonchorso. 18. chorpo . . dacquelle. 19. cōplēdere . chōfessare . î solo. 20. chomferiscano . . . delle. 21. apare . . s octo

a ētrare [23]per similitudine per si piccolo · foro dell' occhio · bisogna · cōfessare che la cosa mi[24]nore nō può entrare nella minore. se quella nō diminviscie e diminvendosi [25]cōuiene che cangi la piramide.

above mentioned. If the line *e f* is to enter as an image into so small an opening in the eye, you must confess that the smaller object cannot enter into what is smaller than itself unless it is diminished, and by diminishing it must take the form of a pyramid.

C. 27 b (3 a)] **53.**

PROSPETTIVA.

¶ [2]prospettiva · agivgnie doue · māca il givditio . nelle cose che diminviscono; ¶[3]l'o-chio · nō potrà · mai essere · vero judice a determinare cō verità quanto · vna quātità [4](sia) vicina · a vn altra simile, la quale altra sia · colla · sua · sommità · al pari dell'ochio [5]riguardatore · d'esse parti, se nō per mezzo · della pariete maestra e guida · della prospettiva.¶

[6]sia *n* · l'ochio, *e · f* · sia · la sopra · detta pariete · *a · b · c · d* · sieno le 3 parti l'una sotto [7]l'altra: se la linia · *a · n* e *c · n* · sono lūghe a vno modo · e l'ochio · *n* · si troua in mezzo, tāto parà [8]*a · b* · quanto · *b · c · c · d* è piv bassa e piv lontana da · *n*: adūque parà · minore, [9]e questo medesimo appare nelle · 3 · partitioni del uolto · quādo l'ochio del ritraēte pittore [10]è di pari · altezza · all'ochio · del ritratto.

PERSPECTIVE.

Perspective comes in where judgment fails [as to the distance] in objects which diminish. The eye can never be a true judge for determining with exactitude how near one object is to another which is equal to it [in size], if the top of that other is on the level of the eye which sees them on that side, excepting by means of the vertical plane which is the standard and guide of perspective.

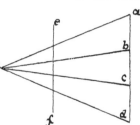

Let *n* be the eye, *e f* the vertical plane above mentioned. Let *a b c d* be the three divisions, one below the other; if the lines *a n* and *c n* are of a given length and the eye *n* is in the centre, then *a b* will look as large as *b c*. *c d* is lower and farther off from *n*, therefore it will look smaller. And the same effect will appear in the three divisions of a face when the eye of the painter who is drawing it is on a level with the eye of the person he is painting.

C. A. 201 a; 597 a] **54.**

PRUOVA · COME LE COSE VĒGONO ALL' OCHIO.

[2]Guardādo · il sole o altra · cosa lumi-nosa · e serrādo poi l'ochio · la rivedrai similemēte dētro all'ochio [3]per lūgo spatio di tēpo; questo · è segnio · che le spetie ētrano dētro.

TO PROVE HOW OBJECTS REACH THE EYE.

If you look at the sun or some other luminous body and then shut your eyes you will see it again inside your eye for a long time. This is evidence that images enter into the eye.

22. lochia . . sella. 23. picholo . . delochio biso[che]gia chōfessare chella chosa. 24. nopo . . nella mino . . no. 25. chō-viene . . achagiala.
53. 1. mācha . . chose che diminviscano. 2. "a terminare cō verita [a chonossciere] quanto. 3. sotto vicina . . . "simile" . . chola. rigiardatore . . mezo . . dela. 7. he c . n . lūge . . imezo. 9. apare . . partitione. 10. alteza.
54. 1. vēgano. 2. esserādo . . lochi. 3. essegnio.

A. 36b]　　　　　　　　　　　55.

PRĪCIPIO DELLA · PROSPETTIVA.　　　　ELEMENTS OF PERSPECTIVE.

[2] Tutte · le cose · mādano · all'ochio · la lor similitudine · per piramidi · le quali · quāto · sarano · ta[3]gliate più vicine all'ochio · tāto ·

All objects transmit their image to the eye in pyramids, and the nearer to the eye these pyramids are intersected the smaller

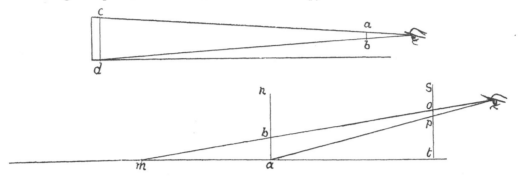

minore · si dimostrerà · la similitudine · della · sua cagione; [4] adūque taglierai · la piramide colla pariete che tochi la base · d'essa pira-mide come [5] si dimostra nella pariete *a · n.*

will the image appear of the objects which cause them. Therefore, you may intersect the pyramid with a vertical plane [4] which reaches the base of the pyramid as is shown in the plane *a n.*

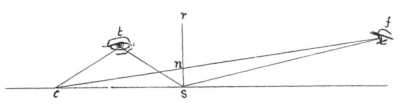

[6] L'ochio · *f* · e l'ochio · *t* · sono · vna · mede-sima · cosa: ma l'ochio · *f* · denota · la distātia, [7] cioè · quanto · tu stai · lontano · a vedere · la cosa · e l'ochio · *t* · ti dimostra · la dirittura · cioè [8] se tu sei nel mezzo o da lato: o da cāto · della · cosa che tu · riguardi; e ricordoti che sē[9]pre l'ochio · *f* · e l'ochio · *t* · sieno · situati · a vna · medesima · altezza · l'uno che l'altro, [10] verbi gratia · se abasserai · o alzerai · l'ochio · della distātia · *f* · che tu facci quel medesimo [11] dell' ochio · della · dirittura · *t* · e se il pūto *f* · mostra quāto · l'ochio è dis-costo al qua[12]dro e nō mostra a qual parte ·

The eye *f* and the eye *t* are one and the same thing; but the eye *f* marks the distance, that is to say how far you are standing from the object; and the eye *t* shows you the direction of it; that is whether you are opposite, or on one side, or at an angle to the object you are look-ing at. And remember that the eye *f* and the eye *t* must always be kept on the same level. For example if you raise or lower the eye from the distance point *f* you must do the same with the direction point *t*. And if the point *f* shows how far the eye is distant from the square plane but does not show on which

55. 1. prospettiva. 2. chose · . piramide. 3. gliate visine all . . . dimoste . . dela l . . chagione. 4. chola . . labassa . . chome. 5. nela. 6. ellochio . . chosa · . lochio . t. 7. chos⁻. 8. settu senel mezo odalalato . . chāto . . chosa chettu . . richordoti. 9. ellochio . . ⸗lteza. 10. dela . . chettuffacci. 11. t . [Effassi] esse . . dischosto. 12. eli . . chosi. 13. chol. 14. î . quadro

55. The two diagrams above the chapter are explained by the first five lines. They have, how-ever, more letters than are referred to in the text, a circumstance we frequently find occasion to remark.

4. *Pariete.* Compare the definitions in 85, 2—5, 6—27. These lines refer exclusively to the third diagram. For the better understanding of this it should be observed that *c s* must be regarded as

representing the section or profile of a square plane, placed horizontally (comp. lines 11, 14, 17) for which the word *pianura* is subsequently employed (20, 22). Lines 6—13 contain certain preliminary observations to guide the reader in understanding the diagram; the last three seem to have been added as a supplement. Leonardo's mistake in writing *t denota* (line 6) for *f denota* has been rectified.

egli è per riscōtro: E cosi se 'l pūto · *t* · mostra il riscōtro, e nō mostra ¹³la distātia; adūque per sapere l'uno e l'altro farai · l'uno · coll'altro e fieno vna medesima cosa · ¹⁴se l'ochio · *f* · vederà un quadro · perfetto · il quale · in ciascuna · delle · sue faccie · sia · simile ¹⁵allo spatio · che è · tra · *s · c*, e al prīcipio · di quella · faccia · ch'è diuerso · esso · ochio, si sta¹⁶bilisca · una aste · o altra cosa · diritta come appare in · *r · s* · la quale · sia · ferma · per li¹⁷nia · perpēdiculare · dico · che se riguarderai · la facia · del quadro ch'è uerso · di te ella batte¹⁸rà · al nascimēto · della pariete · *r · s*: e se riguarderai la seconda faccia opposita ¹⁹paratti · che s'alzi · all' altezza · della pariete · · in nel pūto · *n*: adūque per questa · dimostratio²⁰ne · tu puoi cōprēdere · che se l'ochio · fia piv alto · che infinite cose poste sopra · una pianvra ²¹l'una · dopo · l'altra · quāto · piv · s'alontana · piv · s'alzano · insino a riscontro · dell' altezza ²²dell' ochio · e nō piv: inperochè le cose · poste sopra · la pianvra dove · posi i piedi, ²³se sarà piana, se detta · pianvra · fusse · infinita: mai · passano · piv su, che l'ochio · perchè l'o²⁴chio à · in sè · quello · pūto · al quale · si dirizano e cōgivngono · tutte · le piramidi che por²⁵tano le spetie deli obietti all' ochio; E questo · pūto · senpre · si diriza · col pūto · della dimi²⁶nvtione · il quale · appare nel fine delle · cose vedute: e dalla basa della prima piramide ²⁷insino al pūto della · diminvtione.

side it is placed—and, if in the same way, the point *t* shows the direction and not the distance, in order to ascertain both you must use both points and they will be one and the same thing. If the eye *f* could see a perfect square of which all the sides were equal to the distance between *s* and *c*, and if at the nearest end of the side towards the eye a pole were placed, or some other straight object, set up by a perpendicular line as shown at *r s*—then, I say, that if you were to look at the side of the square that is nearest to you it will appear at the bottom of the vertical plane *r s*, and then look at the farther side and it would appear to you at the height of the point *n* on the vertical plane. Thus, by this example, you can understand that if the eye is above a number of objects all placed on the same level, one beyond another, the more remote they are the higher they will seem, up to the level of the eye, but no higher; because objects placed upon the level on which your feet stand, so long as it is flat—even if it be extended into infinity—would never be seen above the eye; since the eye has in itself the point towards which all the cones tend and converge which convey the images of the objects to the eye. And this point always coincides with the point of diminution which is the extreme of all we can see. And from the base line of the first pyramid as far as the diminishing point

The relations of the distance points to the vanishing point (55—56).

A. 37*a*]

56.

nō · si · trova · se nō base sanza piramidi le quali sēpre diminviscono insino a esso pūto; E dalla prima · basa · dou'è situata · la pariete ²inverso il pūto · dell' ochio · nō sarà · se nō piramide sanza base · come appare ·

there are only bases without pyramids which constantly diminish up to this point. And from the first base where the vertical plane is placed towards the point in the eye there will be only pyramids without bases;

. . . il quale ciascuna. 15. alo . . che . tra . . q¹ela. 16. bilischa . \hat{i} . asste . . chosa dirita apare. 17. perpēdichulare dicho . . del qroche diuerso te ella. 18. nasscimēto . . esse . . sechonda. 19. chessalzi . alalalteza . inel. 20. poi chōprēdere . chessellochio . . chose . . sopra . \hat{i} . pianvra. 21. laltra[se] . arisschōtro delalteza. 22. dellochio [e lechose] e nō piv . . chose. 23. sessara piana[su] detta . . chellochio. 24. quelo . . chōgivngano . . . piramide. 25. Ecque₃to . chol. 26. nvitione . . . apare . . dele chose . . e dala basa dela . . pirami"de". 7 diminvitione 4

56. 1. 4 nō si . . . base [dele]"sanza" piramide "le quali sepre diminvischano insino a eso pūto" E dalla. 2. delochio [nō si]

56. For the easier understanding of the diagram and of its connection with the preceding I may here remark that the square plane shown above in profile by the line *c s* is here indicated by *c d o p*. According to lines 1, 3 *a b* must be imagined as a plane of glass placed perpendicularly at *o p*.

nello ³esenplo · della · figura · di sopra cioè · sia · *a* · *b* · la prenominata · pariete · *r* · sia il pūto ⁴delle piramidi termināti nell'ochio: *n* · sia il pūto della · diminvtione · il quale ⁵riguarda · senpre · il punto visivo per linia retta · e senpre · si mvta · cō quello come mv⁶tando la uerga · si mvta la sua ōbra e camina · non altremēti con seco che camina ⁷l'onbra · col corpo · e ciascuno pūto è capo di piramidi le quali ⁸si fanno · comvne basa della inframessa · pariete · e bēch'essi sieno · equali di basa ⁹sono difformi d'angolo inperochè'l punto · della · diminvtione · è capo di minore angolo ¹⁰che quello · dell'ochio · Se tu mi dicessi · cō che speriēza · mi dimostrerai · tu questi pūti, ¹¹io ti dirò che in quāto · al pūto della diminvtione che camina · cō teco · che riguardi quā¹²do camini lūgo le possessioni · arate · cō diritti solchi i quali capitino ¹³coi loro stremi alla strada dōde camini · vederai che sēpre ciascuno paro di solchi ¹⁴ti parrà che si voglino a appressare e cōgivgnere ai lor fini.

as shown in the example given above. Now, let *a b* be the said vertical plane and *r* the point of the pyramid terminating in the eye, and *n* the point of diminution which is always in a straight line opposite the eye and always moves as the eye moves—just as when a rod is moved its shadow moves, and moves with it, precisely as the shadow moves with a body. And each point is the apex of a pyramid, all having a common base with the intervening vertical plane. But although their bases are equal their angles are not equal, because the diminishing point is the termination of a smaller angle than that of the eye. If you ask me: "By what practical experience can you show me these points?" I reply—so far as concerns the diminishing point which moves with you —when you walk by a ploughed field look at the straight furrows which come down with their ends to the path where you are walking, and you will see that each pair of furrows will look as though they tried to get nearer and meet at the [farther] end.

A. 37 *b*]　　　　　　　　57.

How to measure the pyramid of vision. Inquāto al pūto · che viene all'ochio · Si comprende con piv · facilità inpero²chè se riguarderai nell'ochio · a uno, vi vederai · la tua similitudine · onde se imaginerai ³2 linie partirsi dai tua orechi · concorrere · alli orechi della similitudine che vedi di te ⁴nell'altrui ochio · chiaro · conoscerai quelle linie ristrignersi in modo tale che poco ⁵dopo la tua imagine spcchiata in detto ochio seguitando si tocherebono in v̄ pūto. ⁶E se volessi misurare il diminuire della piramide per l'aria · che si truova · infra la · cosa veduta · e l'ochio ⁷farai · in questa · forma · di sotto figurata · diciamo · che *m · n* · sia una torre, E che ⁸*e · f* · sia una uerga, la quale tu tiri tanto innāzi · e indirieto che i sua · stremi ⁹si scontrino · colli · stremi · della torre · di poi l'appressa all'ochio · in

As regards the point in the eye; it is made more intelligible by this: If you look into the eye of another person you will see your own image. Now imagine 2 lines starting from your ears and going to the ears of that image which you see in the other man's eye; you will understand that these lines converge in such a way that they would meet in a point a little way beyond your own image mirrored in the eye. And if you want to measure the diminution of the pyramid in the air which occupies the space between the object seen and the eye, you must do it according to the diagram figured below. Let *m n* be a tower, and *e f* a rod, which you must move backwards and forwards till its ends correspond with those of the tower [9]; then bring it nearer to the eye, at *c d* and you

nō . . no [ba] piramide . . chome apare. 3. dela. 4. dele piramide . . . terminate nelochio . . della diminvitione . . quale[sia]. 5. retta essenpre . . chō quelo chome. 6. chamina . . chonsecho che chamina chonsecho che chamina. 7. chol chorpo e chiasscuno pūto[e ma] e chapo . . [el] lequali [ano]. 8. [cho] si . . chomvne bēchele. 9. difforme . . dela diminvitione . e chapo. 10. checquello . . Settumi diciesi . chō . . dimosterai. 11. dela diminvitione . . chamina chōtecho. 12. chamini . possessione . chō . . quali [sieno diritta] 13. ala . . chamini . . 14. para apressare . chōgivgniere . . fini | *5*.

57. 1. *5* Inquāto . . al . . choplende chon. 2. chesse . . nelochio. 3. chochorere . ali . dela. 4. nelaltrui . . chonosscierai . . risstrigniersi īmodo . . pocho. 5. seguitāto. 6. Esse . . misurare | "il diminuire dela piramide" per laria . chessi . . chosa. *In the original Manuscript the words above the line are clearly marked as forming part of the text. In Mons. Ravaisson's Transcript however they are mistaken for a heading of the paragraph.* 7. imquesta . . sia î torre Ecche. 8. sia î verga . .

57. 9. *I sua stremi . . della torre* (its ends . . . of the tower) this is the case at *e f.*

c · d · e vede[10]rai la similitudine della torre apparire minore come vedi in · *r · o ·* poi l'appressa [11]all' ochio, e vederai la uerga avāzare fori della similitudine · della torre

will see that the image of the tower seems smaller, as at *r o.* Then [again] bring it closer to the eye and you will see the rod project far beyond the image of the tower

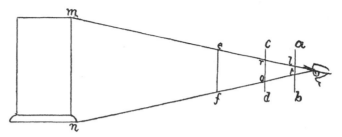

[12]da · *a · b ·* et da *t · b ·* e poi conoscerai che poco piv oltre [13]le linie cōcorrono al pūto.

from *a* to *b* and from *t* to *b,* and so you will discern that, a little farther within, the lines must converge in a point.

A. 27 *a*]

58.

PROSPETTIVA.

[2]Subito · che l'aria · fia · alluminata · s'empierà · d'infinite spetie, le qua[3]li son cavsate da vari · corpi e colori, che infra essa sono collocati, [4]delle · quali · spetie · l'ochio · si fa · bersaglio · e calamita.

PERSPECTIVE.

The instant the atmosphere is illuminated it will be filled with an infinite number of images which are produced by the various bodies and colours assembled in it. And the eye is the target, a loadstone, of these images.

The Production of pyramid of Vision (58—60).

W. 232 *b*]

59.

¶ tutta la superfitie de' corpi oppachi à tutto il simvlacro in tutta l'aria [2]alluminata che lo circunda per qualunche aspetto. ¶

The whole surface of opaque bodies displays its whole image in all the illuminated atmosphere which surrounds them on all sides.

C. A. 136 *b*; 412 *b*]

60.

Che l'aria · attragga · a se · come calamita tutte · le similitudini [2]delle · cose · che la · circūdano nō che le forme de' corpi, ma āncora le nature chiaramēte · si vede · nel sole · il quale · è corpo · caldo e luminoso; [3]tutta · l'aria · che li è per obietto · tutta · per tutto · s'incorpóra · di lume · e di calore e tutta [4]ricieve ī se la forma · della cagione del calore e splēdore e in ogni minima parte · fa il simile; [5]la tramōtana dimostra per la calamita · fare · questo · medesimo: e la luna · e altri pianeti [6]sāza diminvtione di se fā il simile; īfra le cose terrestri è fatto il simile dal moscato [7]e altri odori.

That the atmosphere attracts to itself, like a loadstone, all the images of the objects that exist in it, and not their forms merely but their nature may be clearly seen by the sun, which is a hot and luminous body. All the atmosphere, which is the all-pervading matter, absorbs light and heat, and reflects in itself the image of the source of that heat and splendour and, in each minutest portion, does the same. The Northpole does the same as the loadstone shows; and the moon and the other planets, without suffering any diminution, do the same. Among terrestrial things musk does the same and other perfumes.

tuttiri . schontrino cholli . . lapressa alochio. 10. dela tore aparire [piv] . . pola. 11. alochio . . dela. 12. chonossciere poche. 13. chōcorano.

58. 2. chellaria . . senpiera. 3. chavsati . . chorpi e chonori . . esa . . chollocati. 4. berzaglio e chalamita.

59. 1. chorpi oppachi "actutto il simvlacro" in tucta. 2. chello circhunda . . asspecto.

60. 1. Che [ciasschuno chorpo · m] laria . siatraga . asse . chome chalamita . . similitudine. 2. chose chella . circhūdano ¦ "ne che le forme de corpi ma āncora le nature" chiaramēte . . . chorp . caldo. 3. tuttutta . . sinchorpora . . chalore . . ettutta. 4. chagione . . chalore einōni. 5. chalamita . . elluna. 6. diminvitione . . tereste effatto . . moscado.

Ash. I. 22 b] **61.**

Tutti · i corpi · insieme · e ciascuno · per se empie la circūstāte · aria · d' īfinite ²sua · similitudini · le quali son tutte per tutto e tutte nella parte · portādo cō lo³ro la qualità · del corpo · colore · e figura · della · loro · cagione.

All bodies together, and each by itself, give off to the surrounding air an infinite number of images which are all-pervading and each complete, each conveying the nature, colour and form of the body which produces it.

⁴Che i corpi · siano per similitudine · tutti per tutta la circūstāte aria · e tutti nella parte per corpo figura ⁵e colore chiaramēte si dimostra per le spetie di molti vari corpi, che si producono ⁶a un solo · pūto per-forato, doue con ītersegate linie portano per piramidi cōtrarie ⁷le cose sotto sopra alla prima oscura pariete; ⁸la ragione di questo si è—

It can clearly be shown that all bodies are, by their images, all-pervading in the sur-rounding atmosphere, and each complete in it-self as to substance form and colour; this is seen by the images of the various bodies which are reproduced in one single perforation through which they transmit the objects by lines which intersect and cause reversed pyramids, from the objects, so that they are upside down on the dark plane where they are first reflected. The reason of this is —

W. L. 146 a] **62.**

Ogni pūto è capo d'īfinite linie le quali, givgniēdo a fare basa ²subito detta basa per le medesime linie tornano alla piramide ³si per colore come per fazione. ⁴imme-diate che la forma è creata o cōposta, su-bito ⁵di se gienera īfiniti āgoli e linie, le quali linie ⁶ispargiēdosi con ītersegazione per l'aria, ne resultano īfiniti ⁷āgoli, oppo-siti l'uno all' altro, cō ciascuno degli opposti angoli, ⁸dato li basa, ritrarà triāgolo, e porterà ī se forma e proporzione ⁹simile all'angolo magiore, e se la basa ētra 2 volte ī ciascheduna ¹⁰delle 2 linie piramidali, quel medesimo farà piccolo triāgolo.

Every point is the termination of an in-finite number of lines, which diverge to form a base, and immediately, from the base the same lines converge to a pyramid [imaging] both the colour and form. No sooner is a form created or compounded than suddenly infinite lines and angles are produced from it; and these lines, distributing themselves and intersecting each other in the air, give rise to an infinite number of angles opposite to each other. Given a base, each opposite angle, will form a triangle having a form and proportion equal to the larger angle; and if the base goes twice into each of the 2 lines of the pyramid the smaller triangle will do the same.

61. 1. ciaschuno . . . enpie . . circhūstāte. 2. similitudine . . pertutta ettutte nela . . colo. 3. la ["essentia"] qualita . . effigura chagione. *Between lines* 3 *and* 4 *stands the diagram given on Plate II, No.* 1. 4. "per similitudine" . . ettutti nela. 5. ciara-mēte . . chorpi chessi producano. 6. a ī solo . . con . . piramide. 7. prime oscure pariete.

62. chapo . . affare . piramida. 3. cholore chome. *Here follow, in the original MS., ten lines bearing on geometry.* 4. ["subito"] imēdiate . . chōpossto. 5. āgholi ellinie . . quallinie. 6. isspargiēdosi chon īterseghazione . . risulta. 7. āgholi . . cocias-schuno . . oposti angli. 8. rinara triāgholo. 9. alangholo . . basētra . . ciasscheduna. 10. lini . . piccholo triāgholo.

61. The diagram intended to illustrate the state-ment (Pl. II No. 1) occurs in the original between lines 3 and 4. The three circles must be understood to represent three luminous bodies which transmit their images through perforations in a wall into a dark chamber, according to a law which is more fully explained in 75—81. So far as concerns the present passage the diagram is only intended to explain that the images of the three bodies may be made to coalesce at any given spot. In the circles are written. *giallo*—yellow, *biācho*—white, *rosso*—red.

The text breaks off at line 8. The paragraph No. 40 follows here in the original MS.

Ash. I. 27 II a] **63.**

Ogni corpo · ōbroso · empie · la circūstāte · aria ²d'infinite sue · similitudini · le quali da infinite pira³midi infuse per essa rappresentano esso corpo ⁴tutto per tutto · e tutto · in ogni parte. ⁶Ogni piramide cōposta da lū⁷go concorso · di razzi cōtiene ⁸dētro a se · infinite · piramidi ⁹e ciascuna · à potētia per tutte e tutte ¹⁰per ciascuna; ¹¹l'equidistāte · circuito di pirami¹²dal cōcorso darà al suo obietto equa¹³le qualità · d'āgoli; e d'equale grādeza ¹⁴fia ricievuto la cosa dall'obbietto. ¹⁵Il corpo · dell' aria · è pieno · d'infinite · piramidi · conposte da radiose e rette linie · le quali ¹⁶si cavsano dai superfitiali · stremi · de' corpi · ombrosi · posti · in essa (aria) · e quāto piv s'alōta-¹⁷nano dalla · loro · cagione · piv si fano acute: e benchè il loro cōcorso sia intersegato e in¹⁸tessuto, nō dimeno nō si cōfondono l'una con l'altra e cō disgregāte concorso si vāno āplifi¹⁹cādo e infondēdo per tutta la circūstante aria · e sono infra loro · d'equale potētia e tutte ¹⁰quāto ciascuna · e ciascuna · quāto tutte · e per esse · la similitudine del corpo è portata ²¹tutta · per tutto · e tutta nella · parte e ciascuna piramide · per se riciene in ogni ²²minima · sua parte tutta la forma della sua cagione.

Every body in light and shade fills the surrounding air with infinite images of itself; and these, by infinite pyramids diffused in the air, represent this body throughout space and on every side. Each pyramid that is composed of a long assemblage of rays includes within itself an infinite number of pyramids and each has the same power as all, and all as each. A circle of equidistant pyramids of vision will give to their object angles of equal size; and an eye at each point will see the object of the same size. The body of the atmosphere is full of infinite pyramids composed of radiating straight lines, which are produced from the surface of the bodies in light and shade, existing in the air; and the farther they are from the object which produces them the more acute they become and although in their distribution they intersect and cross they never mingle together, but pass through all the surrounding air, independently converging, spreading, and diffused. And they are all of equal power [and value]; all equal to each, and each equal to all. By these the images of objects are transmitted through all space and in every direction, and each pyramid, in itself, includes, in each minutest part, the whole form of the body causing it.

C A. 100 b; 313 a] **64.**

Il corpo dell'aria è pieno d'īfinite piramidi radiose ²cavsate dalla cosa posta · in essa, le quali intersegate ³e intessute sanza occupatione · l'una dell'altra cō disgre⁴gante concorso s'infondono per tutta la circū⁵state aria, e sono d'equale potētia e tutte pos-

The body of the atmosphere is full of infinite radiating pyramids produced by the objects existing in it. These intersect and cross each other with independent convergence without interfering with each other and pass through all the surrounding atmosphere; and

63. 1. chorpo .. circhūstāte. 2. dinfine .. similitudine. 3. midi .. essa [aria] raprētano .. chorpo. 4. ettutto. 5. [Ogni radiosa piramide di lūgo]. 6. chōposta. 7. chonchorso .. chontiene. 8. asse .. pyramide. 9. ettutte. 11. lecquidistāte . circhuito. 12. chōchorso. *Lines* 1—5 *are written on the left side and lines* 6—14 *on the right side of the diagram. Below it is the rest of the text:* 15. chorpo .. piramide chonposte. 16. chavsano .. chorpi onbrosi poste .. [aria]. ecquāto. 17. chagione .. achute .. chōchorsia. 18. tesuto .. luna per laltra e chō .. chonchorso. 19. circhūstante .. essono .. ettutte. 20. ecciascuna. 21. e portata tutto .. ettutta. 22. chagione.

64. 1. piramide. 2. chavsate dala .. esa. 3. ochupatione .. chō. 4. chonchorso sinfondano [portādo] pertutta [lari]. 5. ettutte

sono quãto ciascuna, [6]e ciascuna · quãto tutte: e per esse la similitudine del corpo è porta[7]ta · tutta · per tutto e tutta ĩ nella parte, e ciascuna per se ricieve [8]in ogni minima parte tutta la sua cagione.

are of equal force and value—all being equal to each, each to all. And by means of these, images of the body are transmitted everywhere and on all sides, and each receives in itself every minutest portion of the object that produces it.

C. A. 136a; 412a] **65.**

PROSPETTIVA.

Proof by experiment (65—66).

[2]L'aria · è piena d'ĩfinite · similitudini · delle · cose · le quali ĩfra · quella · sono distribuite [3]e tutte · si rapresētano · in tutte e tutte in vna · e tutte · jn ciascuna õde accade · che se sarãno [4]2 · spechi · volti · ĩ modo · che per linia · retta · si guardino · l'uno · l'altro · jl primo si spechierà [5]nel secondo e 'l secondo nel primo: il primo · che si spechia nel secondo · porta cõ seco · la similitudine di se cõ tutte le [6]similitudini · che dentro · vi si rapresētano: ĩfra le quali · è la spetie del secondo spechio · e da simi[7]litudine · ĩ similitudine se ne vanno · in ĩfinito · ĩ modo · che ciascuno · spechio à dētro in se li [8]spechi · l'uno · minore · che l'altro · e dentro · l'uno all'altro. [9]Onde · per questo · esemplo · chiaramēte · si pruova · ciascuna · cosa · mãdare · la similitudine [10]ĩ tutti quelli lochi · li quali · possono · vedere · detta · cosa · e cosi de cõuerso · detta · cosa · essere capace [11]di pigliare · in se · tutte · le similitudini · delle cose che dinanzi se le rappresentano. [12]Adũque · l'ochio · mãda · ĩfra l'aria · la sua · similitudine · a tutti · li obietti che li · sono · opposti e ĩ se [13]li ricieve · cioè ĩ sulla · sua · superfi'ie · dõde il sēso · comvne · le piglia c le cõsidera e quelli [14]che piaciono le mãda · alla memoria. [15]Onde io givdico · che la · virtù · spirituale delle · spetie · delli ochi · si faccino · ĩcõtro · all'obietto come [16]le spetie dell'obietto · all'ochio. [17]Che le spetie di tutte · le cose · sieno · seminate · ĩfra l'aria · lo esemplo si veda ĩ molti specchi [18]ĩn circolo e ĩfinite volte spechierãno l'uno l'altro · e gĩvto l'uno nell'altro · risalta dirieto [19]alla sua cagione e indi diminvēdo · risalta vn'altra volta all'obietto e poi ritorna e cosi fa ĩfinite [20]volte. [21]Se metti un lume di notte ĩfra 2 specchi · piani i quali · abbino · d'intervallo un braccio vedrai ĩ cias-

PERSPECTIVE.

The air is filled with endless images of the objects distributed in it; and all are represented in all, and all in one, and all in each, whence it happens that if two mirrors are placed in such a manner as to face each other exactly, the first will be reflected in the second and the second in the first. The first being reflected in the second takes to it the image of itself with all the images represented in it, among which is the image of the second mirror, and so, image within image, they go on to infinity in such a manner as that each mirror has within it a mirror, each smaller than the last and one inside the other. Thus, by this example, it is clearly proved that every object sends its image to every spot whence the object itself can be seen; and the converse: That the same object may receive in itself all the images of the objects that are in front of it. Hence the eye transmits through the atmosphere its own image to all the objects that are in front of it and receives them into itself, that is to say on its surface, whence they are taken in by the common sense, which considers them and if they are pleasing commits them to the memory. Whence I am of opinion: That the invisible images in the eyes are produced towards the object, as the image of the object to the eye. That the images of the objects must be disseminated through the air. An instance may be seen in several mirrors placed in a circle, which will reflect each other endlessly. When one has reached the other it is returned to the object that produced it, and thence—being diminished—it is returned again to the object and then comes back once more, and this happens endlessly. If you put a light between two flat mirrors with a distance of 1 braccio between them you will see in each

pọssano quãte. 7. to. tutto per tutta ettutti inella.

65. 2. similitudine .. chose .. sono strebuite. 3. ettutte si .. in tutte "ettutte in vna" ettutte jn ciasschuna .. acchade 4. recta. sisghuardino .. spechier ǁǀ. 5. nel. 2° el 2° ne prˆ. .. nel 2° porta. chõsecho chõ tutte ǁǀ. 6. quale .. del 2° spechio. e chõ si ǁǀ. 7. vano .. ciaschuno .. dētro ĩs ǁǀǀ. 9. esenplo. 10. possano .. chosa e chosi de chõuerso. detta chosa .. chapa ǁǀǀ. 11. similitudine .. chose .. sili. 12. attutti .. : opositi e ĩ s ǁǀ. 13. chomvne .. chõsidera e c ǁǀǀǀ piaciano. 15. chella .. ĩchõtro all obietto ch ǁǀ. 17. Chelle .. chose .. llaria .. molti spe ǁǀǀǀ. 18. circholo .. gĩvta lũnel .. risalta e dirieto. 19. chagione e dili diminvēdo .. alobietto e po ritorna e chosi fa ĩf ǁǀǀǀǀǀǀǀ. 21. Si metti ĩ lume .. dintervallo ĩ br. ..

cuno di quelli spec²²chi īfiniti lumi · l'uno · minore che l'altro; ²³se di notte metterai vn lume · īfra le parieti d'una camera · tutte le parti d'essa · pariete rimarāno tīte di ²⁴simi- litudini · d'esso lume · e tutte · quelle che sa- raño viste · dal lume, e 'l lume vederà si- milemēte, ²⁵cioè quando īfra loro nō fia · alcuna oppositione · che · rōpa · il cōcorso · delle spetie. ²⁶Questo medesimo · esēplo · magiormēte · appare in nel cōcorso de razzi solari, ²⁷i quali tutti per tutti, e ciascuno per se porta al suo obietto · la similitudine ²⁸della · cagione; ²⁹Che ciascū · corpo · per se · solo empie tutta la cōtraposta · aria · delle · sue similitudini: e che · questa · mede- sima · aria fia capace. ³⁰j quel medesimo · tēpo di ricievere · ī se · le spetie d'īnfiniti · altri · corpi · che īfra quella fussino, chiara- mente ³¹si dimostra · per questi · esēpli; E ciascuno · corpo · appare · tutto · per tutta la detta aria · e tutto in ogni minima ³²parte di quella; tutti · per tutta · e tutti in ōnj minima parte, ³³ciascuno per tutta · e tutti nella parte.

of them an infinite number of lights, one smaller than another, to the last. If at night you put a light between the walls of a room, all the parts of that wall will be tinted with the image of that light. And they will receive the light and the light will fall on them, mutually, that is to say, when there is no ob- stacle to interrupt the transmission of the images. This same example is seen in a greater degree in the distribution of the solar rays which all together, and each by itself, convey to the object the image of the body which causes it. That each body by itself alone fills with its images the atmosphere around it, and that the same air is able, at the same time, to receive the images of the endless other ob- jects which are in it, this is clearly proved by these examples. And every object is every- where visible in the whole of the atmosphere, and the whole in every smallest part of it; and all the objects in the whole, and all in each smallest part; each in all and all in every part.

W. L. 145 B. a]

66.

Sono le spetie de corpi tutte infuse per l'aria ²che le vede e tutte in ogni parte di quella; provasi ³siē a c e obbietti, le spetie de quali penetrano in loco oscuro ⁴per li spiraculi n p e s'inpremono nella pariete f i cōtraposta a es⁵si spiracoli; le quali inpressioni sarà fatte in tāti lochi d'essa parie⁶te quāto sarà il numero delli predetti spiracoli.

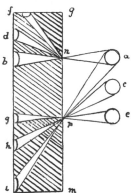

The images of objects are all diffused through the atmosphere which receives them; and all on every side in it. To prove this, let a c e be objects of which the images are admitted to a dark chamber by the small holes n p and thrown upon the plane f i opposite to these holes. As many images will be produced in the chamber on the plane as the number of the said holes.

C. A. 176 b; 531 b]

67.

Tutti j corpi · ànno · infuse e miste tutte · loro · spetie · e similitudini ²in tutta la quantità · dell' aria · a · se · contraposta; ³La spetie di ciascun · punto · delle · cor- poree · superfitie · è in ciascū punto ⁴dell'aria; ⁵Tutte · le spetie de' corpi · sono · in ciascū

All objects project their whole image and likeness, diffused and mingled in the whole of the atmosphere, opposite to themselves. The image of every point of the bodily surface, exists in every part of the at- mosphere. All the images of the objects are

General con- clusions.

ciaschuno di \\\\\\\\. 22. chelaltro elluno minore chellaltro. 23. se "di notte" . . īfralle pariete duna tutte le parti d'esse. 24. ettucte . . . chessarano . . da lume. 25. quā infrallo . . opositione . . chōchorso. 26. inel chōchorso . . "solari" [del sole]. 27. per tutti [ettu] o ciasciuno . . "li obietti ettala caione in oni minima parte dellobietto". 28. chagione. 29. ciassū. chorpo . . ēpia "tutta" la chōtraposta . . . [spetie] "similitudine" . . fia c \\\\\\\\\\\. 30. tēpo [di] . . chorpi . . . fussino chiar \\\\\\\\. 31. esēpli E ciascuno . . apare . . aria ettutto īonīm \\\\\\\\\. 33. ettutti.

66. 1. lesspetie . . . chorpi [infuse per laria] tutte [infus] fure per laria. 2. chelle vede ettutte. 3. siē [a b c] a c e obbietti les- spetie . . illocho osscuro. 4. spirachuli . . essinprememano . . contrapossta. 5. spiracholi. 6. quāto sarānno il . . spiracholi.

67. 1. chorpi . . infuso ēmisto | "tutte" . . essimilitudine. 2. asse chontrapossta. 3. la spetie di *is written on the margin*. La

pūto d'essa aria; ⁶Tutta e la parte della similitudine · dell'aria · è in ciascuno pūto delle ⁷superfitie · delli · antiposti · corpi; ⁸Adunque la parte · e 'l tutto delle · spetie · de' corpi · appare · in tutta ⁹e nella parte · della · superfitie · d'essi corpi. ¹⁰Onde chiaramente possiamo · dire la similitudine di ciascū · corpo · essere ¹¹tutto e in parte in ciascuna · parte · e nel tutto · scanbievolmēte ¹²delli opposti · corpi; Come si uede nelli spechi l'uno all altro opposti.

in every part of the atmosphere. The whole, and each part of the image of the atmosphere is [reflected] in each point of the surface of the bodies presented to it. Therefore both the part and the whole of the images of the objects exist, both in the whole and in the parts of the surface of these visible bodies. Whence we may evidently say that the image of each object exists, as a whole and in every part, in each part and in the whole interchangeably in every existing body. As is seen in two mirrors placed opposite to each other.

Ash. I. 32*b*] 68.

That the contrary is impossible.

Ipossibile è che l'ochio mādi fori di se per li razzi visuali · la uirtù · visiua, ²perchè nello suo aprire quella prima parte che desse prīncipio all'uscita, ³e auessi d'andare all'obietto · nō lo potrebbe fare sāza tēpo, essēdo cosi nō ⁴potrebbe caminare in v̄ mese all'altezza del sole, quādo l'ochio lo uolesse ⁵vedere · e se la · vi agivgniesse sarebbe neciessario ch'ella ⁶fusse cōtinuata per tutta la uia ch'è dall' ochio al sole, e ch'e⁷lla sēpre alargasse · in modo che tra 'l sole e l'ochio cōponessino la basa ⁸e la pūta d'una piramide: essēdo questo e'nō basterebbe se l'ochio fusse ⁹per un milione di mōdi che tutto nō si cōsumasse ī detta virtù · e se pure que¹⁰sta virtù · avesse a caminare īfra l'aria come fa l'odore, i venti no ¹¹la torciereb-

It is impossible that the eye should project from itself, by visual rays, the visual virtue, since, as soon as it opens, that front portion [of the eye] which would give rise to this emanation would have to go forth to the object and this it could not do without time. And this being so, it could not travel so high as the sun in a month's time when the eye wanted to see it. And if it could reach the sun it would necessarily follow that it should perpetually remain in a continuous line from the eye to the sun and should always diverge in such a way as to form between the sun and the eye the base and the apex of a pyramid. This being the case, if the eye consisted of a million worlds, it would not prevent its being consumed in the projection of its virtue; and if this virtue would have to travel through the air as perfumes do, the winds

Ciascun . . he in. 5. lesspetie dechorpi. 6. ella . . . he in. 7. chorpi. 8. chorpi apare. 9. chorpi appare. 10. dire | "la similitudine di" ciaschū chorpo. 11. ciasscuna. 12. opositi chorpi opposssto.

68. 1. chellochio . . razi. 2. dessi prīcipo all usita. 3. auessiandare . . nollo potrebe. 4. potrebe chaminare . . alteza . . uolessi. 5. essella [vi chaminasse] viagivgniessi sarebe . . chela. 6. [sēpre fa] fussi chotinuata . . tuta. 7. lo alargassi imodo . . ellochio chōponessino. 8. ella . . basterebe sellochio fussi. 9. per ī̆ milione . . chettutto . . cōnsumassi . . esse pure. 10. avessi . . chome ivēnto (?). 11. porterebbero no . . chō. 12. presteza . . vederemo ī̆ distantia. 13. dunobr. . alchuno . . accidente.

68. The view here refuted by Leonardo was maintained among others by Bramantino, Leonardo's Milanese contemporary. Lomazzo writes as follows in his *Trattato dell' Arte della pittura* &c. *(Milano* 1584. *Libr. V cp. XXI): Sovviemmi di aver già letto in certi scritti alcune cose di Bramantino milanese, celebratissimo pittore, attenente alla prospettiva, le quali ho voluto riferire, e quasi intessere in questo luogo, affinchè sappiamo qual fosse l'opinione di così chiaro e famoso pittore intorno alla prospettiva . . Scrive Bramantino che la prospettiva è una cosa che contrafà il naturale, e che ciò si fa in tre modi Circa il primo modo che si fa con ragione, per essere la cosa in poche parole conclusa da Bramantino in maniera che giudico non potersi dir meglio, contenendovi si tutta l'arte del principio al fine, io riferirò per appunto le proprie parole sue (cp. XXII, Prima prospettiva di*

Bramantino). La prima prospettiva fa le cose di punto, e l'altra non mai, e la terza più appresso. Adunque la prima si dimanda prospettiva, cioè ragione, la quale fa l'effetto dell' occhio, facendo crescere e calare secondo gli effetti degli occhi. Questo crescere e calare non procede della cosa propria, che in se per esser lontana, ovvero vicina, per quello effetto non può crescere e sminuire, ma procede dagli effetti degli occhi, i quali sono piccioli, e perciò volendo vedere tanto gran cosa, bisogna che mandino fuora la virtù visiva, *la quale si dilata in tanta larghezza, che piglia tutto quello che vuol vedere, ed* arrivando a quella cosa la vede dove è: *e da lei agli occhi per quello circuito fino all' occhio, e tutto quello termine è pieno di quella cosa.*

It is worthy of note that Leonardo had made his memorandum refuting this view, at Milan in 1492

bono e porterebbero in altro loco; e noi vediamo cō quel¹²la medesima prestezza il corpo del sole · che noi vediamo una distantia ¹³d'uno braccio e nō si mvta per sofiare de' uēti, nè per alcuno altro accidēte.

would bent it and carry it into another place. But we do [in fact] see the mass of the sun with the same rapidity as [an object] at the distance of a braccio, and the power of sight is not disturbed by the blowing of the winds nor by any other accident.

A. 9 b]

69.

Si come · la pietra · gittata · nell'acqua · si fa · ciētro · e cavsa · di uari circuli, ²e 'l suono · fatto in nell' aria circularmente si spargie, ³cosi ogni corpo posto · infra l'aria luminosa circularmēte ⁴spargie · e ēpie le circūstanti · parti · d'infinite sue similitudini · e appare tutto ⁵per tutto · e tutto in ogni [minima] parte; ⁶Questo si prova · per · isperiētia imperochè se serrerai una finestra volta a ponēte e farai uno buso . .

Just as a stone flung into the water becomes the centre and cause of many circles, and as sound diffuses itself in circles in the air: so any object, placed in the luminous atmosphere, diffuses itself in circles, and fills the surrounding air with infinite images of itself. And is repeated, the whole every-where, and the whole in every smallest part. This can be proved by experiment, since if you shut a window that faces west and make a hole [6] · ·

A parallel case.

C. A. 133 b; 404 b]

70.

Se la cosa cōtra · posta all' ochio · māda a quello di se la similitudine: ācora · l'ochio · māda la sua similitudıne ²alla cosa. E della cosa · per le partite · similitudini · nō si strema · parte alcuna d'alcuna ragione nè all' occhio nè alla cosa. ³Adūque · possiamo · piv tosto credere · essere · natura e potētia di questa · aria · luminosa ⁴che attrae e piglia · ī se · le spetie delle · cose che dētro vi sono che natura delle cose · in mādare · le spetie · īfra essa aria; ⁵Se la cosa · cōtra · posta · all' ochio mādasse a quello di se · la similitudine: quel medesimo · avrebbe · a fare ⁶l'ochio · alla cosa, onde · cōuerebbe che queste · spetie · fussino · virtù · spirituali: essēdo · cosi · sarebbe ⁷neciessario · che ciascuna cosa · presto · venisse meno, īperochè ciascuno · corpo · appare per similitudine ⁸nella cōtraposta · aria; cioè tutto il corpo ī tutta · l'aria; e tutto nella parte, tutti i corpi ī tutta l'aria, ⁹e tutti nella parte, parlādo di quell'aria ch'è capace · di ricievere ī se le rette e radiose linie ¹⁰delle spetie · mādate dalli

If the object in front of the eye sends its image to the eye, the eye, on the other hand, sends its image to the object, and no portion whatever of the object is lost in the images it throws off, for any reason either in the eye or the object. Therefore we may rather believe it to be the nature and potency of our luminous atmosphere which absorbs the images of the objects existing in it, than the nature of the objects, to send their images through the air. If the object opposite to the eye were to send its image to the eye, the eye would have to do the same to the object, whence it might seem that these images were an emanation. But, if so, it would be necessary [to admit] that every object became rapidly smaller; because each object appears by its images in the surrounding atmosphere. That is: the whole object in the whole atmosphere, and in each part; and all the objects in the whole atmosphere and all of them in each part; speaking of that atmosphere which is able

The function of the eye as explained by the camera obscura (70. 71).

69. 1. Si chome . . nellacqua . . chavsa . . circhuli. 2. el sono. fatto inellaria . . spargie [la sua voce Cosi]. 3. Cosi i [chorpi spargano] ogni 4. circhūstanti . . similitudine . eapare 5. ettutto in ogni [minima] parte. 6. per · risperiētia in perochesse sererai ī finestra . effarai ī buso.

70. 1. māda | "aquello" di. 2. se . . cossa "e" per . . alchuna dalchuna rasione nea locho ne. 3. [quel medesimo fa locchio] Adūque posiamo . . natura "e potētia" di. 4. che | "altraee" piglia . . dele cose | "che dētro vi sono" che natura . . chose imādere . . īfra [l] "essa" aria. 5. Sella chosa chōtra . . . mādassi acquello . . . arebe. affare. 6. choso | ōnde chonuerebbe . . chosi sarebe. 7. ciasschuna chosa . . venisi . . chorpo, 8. [inōni . parte della] "nella" chōtraposta . . tutto "il corpo" ī

69. Compare LIBRI, *Histoire des sciences mathématiques en Italie.* Tome III, p. 43.
6. Here the text breaks off.

obietti; Onde · per questo pare · neciessario · cōfessare · essere · natura di questa ¹¹aria che · si trova · infra · li obbietti · la quale · tiri come · calamita in se le similitudini delle cose ¹²īfra quella · poste.

to contain in itself the straight and radiating lines of the images projected by the objects. From this it seems necessary to admit that it is in the nature of the atmosphere, which subsists between the objects, and which attracts the images of things to itself like a loadstone, being placed between them.

¶ Pruova · come tutte le cose poste in un sito · sono tutte per tutto ¹⁴e tutte nella parte. ¶

PROVE HOW ALL OBJECTS, PLACED IN ONE POSITION, ARE ALL EVERYWHERE AND ALL IN EACH PART.

¹⁵Dico che, se vna faccia d'uno edifitio · o altra piazza · o cāpagnia che sia · illuminata dal sole ¹⁶avrà al suo opposito vn'abitatione, e ī quella faccia che nō uede il sole sia fatto un piccolo spiracolo ¹⁷rotōdo: che tutte le alluminate cose māderāno la loro · similitudine · per detto spiraculo e apparirāno ¹⁸dentro all' abitatione · nella cōtraria faccia, la quale vuol essere biāca · e saranno li appunto e sotto sopra; ¹⁹e se per molti lochi di detta · faccia faciessi · simili · buchi, simile effetto sarebbe · ī ciascuno; Adūque le spetie ²⁰delle alluminate · cose · sono · tutte per tutta detta · faccia · e tutte in ogni minima parte di quella ²¹la ragiō si è: noi sappiamo · chiaro · che quello buco debe rēdere alquāto di lume ī detta abitatione, e lume che ²²lui mezzano · rēde · è cavsato da vno · o da molti corpi luminosi; se detti corpi fieno di vari colori e varie stāpe · di uari ²³colori e stāpe saranno i razzi delle spetie e di uari colori e stāpe fieno · le rappresētationi in nel mvro.

I say that if the front of a building—or any open piazza or field—which is illuminated by the sun has a dwelling opposite to it, and if, in the front which does not face the sun, you make a small round hole, all the illuminated objects will project their images through that hole and be visible inside the dwelling on the opposite wall which may be made white; and there, in fact, they will be upside down, and if you make similar openings in several places in the same wall you will have the same result from each. Hence the images of the illuminated objects are all everywhere on this wall and all in each minutest part of it. The reason, as we clearly know, is that this hole must admit some light to the said dwelling, and the light admitted by it is derived from one or many luminous bodies. If these bodies are of various colours and shapes the rays forming the images are of various colours and shapes, and so will the representations be on the wall.

D. 8 a] 71.

Come s'intersegano le spetie delli obbietti ²ricevuti dall ochio dentro al omore albugino.

HOW THE IMAGES OF OBJECTS RECEIVED BY THE EYE INTERSECT WITHIN THE CRYSTALLINE HUMOUR OF THE EYE.

³La speriētia che mostra come li obbietti mandino ⁴le loro spetie over si-

An experiment, showing how objects transmit their images or pictures, inter-

tutta . . ettutto . . tuttutti. 9. ettutti nella pare . . chapace . . "ī se" le rette [linie de radira] e radiose. 10. pare [essere] . . . chōfessare. 11. aria [la quale] "che". si chome chalamita . . similitudine. 12. ī fracquella. 13. chome tutti le chose poste nvn sito. 14. ettutte. 15. dicho chesse . . facia . . piazao chāpagnia chessia. 16. ara al suo oposito . . fatto ī picholo spiracholo. 17. retōdo . . chose . . siraculo. 18. chōtraria . . viol esere biācha e sarano lapunto essotto. 19. esse per . . busi simile . . sarebe ī ciaschuno. 20. chose . . facia ettutte inoniniminima. 21. sapiano . . quello buso. 22. mezano . . chavsata . . da [molti] corpi . . chorpi . . cholori "e varie stāpe" di uari. 23. cholori | "e stāpe" sarano irazi . . cholori | "e stāpe" fieno . le rapresentatione inel mvro [osscuro].

70. 15—23. This section has already been published in the "*Saggio delle Opere di Leonardo da Vinci.*" Milan 1872, pp. 13, 14. G. Govi observes upon it, that Leonardo is not to be regarded as the inventor of the Camera obscura, but that he was the first to explain by it the structure of the eye. An account of the Camera obscura first occurs in Cesare Cesarini's Italian version of Vitruvius, pub. 1523, four years after Leonardo's death. Cesarini expressly names Benedettino Don Papnutio as the inventor of the Camera obscura. In his explanation of the function of the eye by a comparison with the Camera obscura Leonardo was the precursor of G. Cardano, Professor of Medicine at Bologna (died 1576) and it appears highly probable that this is, in fact, the very discovery which Leonardo ascribes to himself in section 21 without giving any further details.

militudini intersegate dentro all'o⁵chio nello umore albugino si dimostra quando ⁶per alcuno piccolo spiraculo rotōdo penetrāno le ⁷spetie delli obbietti alluminati in abitatione for-⁸temente oscura; allora tu rice-verai tale spetie in v⁹na carta bianca posta dentro a tale a-¹⁰bitatione alquāto vicina a esso spiraculo e ve¹¹drai tutti li pre-detti obbietti in essa carta colle lor ¹²propie figure e colori, ma sarā minori e fieno sot¹³to sopra per causa della detta interse-gatione li qua¹⁴li simulacri se nascierāno di loco alluminato dal ¹⁵sole parā propio dipīti in essa carta, la qual uole ¹⁶essere sottilissima e veduta da riverscio, e lo spira¹⁷colo detto sia fatto in piastra sotti-lissima di ferro; ¹⁸*a b c d e* sieno li detti obietti alluminati dal sole, *o r* ¹⁹sia la fac-cia della abitatione oscura, nella quale è lo spi²⁰racolo detto in *n m, s t* sia la detta carta dove si ta²¹gliano li razzi delle spetie d'essi obietti sotto sopra perchè essē²²do li lor razzi diritti, *a* destro si fa sinistro in *k* e lo *e* si²³nistro si fa destro in ·*f*·, e cosi fa dentro alla popilla.

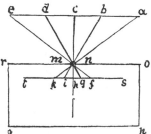

secting within the eye in the crystalline humour, is seen when by some small round hole penetrate the images of illu-minated objects into a very dark chamber. Then, receive these images on a white paper pla-ced within this dark room and rather near to the hole and you will see all the objects on the paper in their proper forms and colours, but much smaller; and they will be upside down by reason of that very inter-section. These images being transmitted from a place illuminated by the sun will seem actually painted on this paper which must be extremely thin and looked at from behind. And let the little perforation be made in a very thin plate of iron. Let *a b c d e* be the ob-ject illuminated by the sun and *o r* the front of the dark chamber in which is the said hole at *n m*. Let *s t* be the sheet of paper intercepting the rays of the images of these objects upside down, because the rays being straight, *a* on the right hand becomes *k* on the left, and *e* on the left becomes *f* on the right; and the same takes place in-side the pupil.

C. A. 201 *b*; 598 *b*]

72.

Il lume nel ufitio della prospettiva ²non à alcuna differēza coll'ochio.

In the practice of perspective the same rules apply to light and to the eye.

The practice of perspec-tive (72. 73).

W. L. 145; D.*b*]

73.

Ciò che vede la lucie dell'ochio ²è ve-duto da essa lucie, ³e ciò che vede la lucie è ⁴veduto dalla sua popilla.

The object which is opposite to the pupil of the eye is seen by that pupil and that which is opposite to the eye is seen by the pupil.

Br. M. 221*b*]

74.

Il concorso · delle linie create dalle spetie delli obbietti antiposti all' ochio nō con-corro²no in punte dentro a esso ochio per linie rette.

The lines sent forth by the image of an object to the eye do not reach the point within the eye in straight lines.

Refraction of the rays falling upon the eye (74. 75).

71. 3. Lassperientia . . mosstra. 5. omore. 6. picholo . . retōdo peneterāno. 8. te osscura alora . . spetie nv. 9. biancha [de-pola] posta . . attale. 10. spirachulo. 12. . effieno so. 13. chausa . . interseghatione li qᵘ"aᵘ". 14. nasscierāno dillocho. 16. ello spira. 17. cholo . . inpiasstra. 19. fachia . . osscura . . nel . . ello spi. 20. racol. 21. razi. 22. razi . . desstro . . sinisstro ., hello *e*. 23. desstro.
72. 1. ufio della. 2. differēza chol.
73. 3. eccio . . lucie he.
74. linie crete . . antipossti . . concorra.

71. This chapter is already known through a translation into French by VENTURI. Compare his '*Essai sur les ouvrages physico-mathématiques de L. da*

Vinci avec des fragments tirés de ses Manuscrits, apportés de l'Italie. Lu à la première classe de l'Institut national des Sciences et Arts.' Paris, An V (1797).

75.

Br. M. 220*b*]

Se 'l giudi̅tio dell' ochio è dentro di lui, le linie rette delle spetie ²si rompono · insulla superfitie sua perchè uanno dal raro al denso; ³se tu sia sotto l' aqua e riguardi la cosa infrall' aria · tu vedrai essa cosa ⁴fori del suo sito, e cosi fa la cosa infrall' acqua veduta dall' aria.

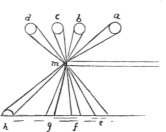

If the judgment of the eye is situated within it, the straight lines of the images are refracted on its surface because they pass through the rarer to the denser medium. If, when you are under water, you look at objects in the air you will see them out of their true place; and the same with objects under water seen from the air.

76.

Br. M. 171*b*]

The inversion of the images.

Tutte le similitudini delle cose che passano per finestra ²dall' aria libera all' aria co̅stretta da pariete, sono viste ³i̅ co̅trario sito, e quella cosa che nella libera aria ⁴si moverà da orie̅te a occide̅te apparirà, per o̅bra nelle parie⁵te · alluminate dalla co̅stretta aria di co̅trario movime̅to.

All the images of objects which pass through a window [glass pane] from the free outer air to the air confined within walls, are seen on the opposite side; and an object which moves in the outer air from east to west will seem in its shadow, on the wall which is lighted by this confined air, to have an opposite motion.

77.

W. L. 145; B.*b*]

The intersection of the rays (76—82).

PRINCIPIO COME LE SPETIE DE' CORPI S'INTER-²SEGANO NELLI LABRI DELLI SPIRACULI DA LOR PENETRATI.

³Che difere̅tia è dalla penetra⁴tione delle spetie che passano ⁵in spiraculi stretti a quelle ⁶che passā per larghi spiracoli ⁷o da quelle che passan' ne' la⁸ti de corpi onbrosi? ⁹Movansi le spetie delli obbietti inmobili, movendosi li labri di quello ¹⁰spiracolo donde li razzi delle spetie penetrano ¹¹e questo accade per la 9ª che dicie ¶le spetie di qualunche cor¹²po son tutte per tutto e tutte in ogni parte del sito a lor circu̅stāte¶ ¹³seguita che move̅do vn delli labri dello spiracolo, donde tali spetie pe-¹⁴netrano in loco oscuro, esso lascia li razzi delle spetie che li era¹⁵no in co̅tatto e si congiu̅gono con altri razzi d' esse spetie che li erā ¹⁶remoti ecc.

THE PRINCIPLE ON WHICH THE IMAGES OF BODIES PASS IN BETWEEN THE MARGINS OF THE OPENINGS BY WHICH THEY ENTER.

What difference is there in the way in which images pass through narrow openings and through large openings, or in those which pass by the sides of shaded bodies? By moving the edges of the opening through which the images are admitted, the images of immovable objects are made to move. And this happens, as is shown in the 9th which demonstrates[11]: the images of any object are all everywhere, and all in each part of the surrounding air. It follows that if one of the edges of the hole by which the images are admitted to a dark chamber is moved it cuts off those rays of the image that were in contact with it and gets nearer to other rays which previously were remote from it &c.

75. 1. adi. 2. ronpano. 3. settu . . lac q. . esa cosa. 4. infrallacq . . dellaria.

76. 1. similitudine. 2. dalaria. 3. chososa . . nellalbra. 4. ocide̅te aparira | "per o̅bra" nelle.

77. 1. chome . . chorpi. 2. seghano . . spirachuli dallor. 3. he dalla. 5. isspirachuli . . acquelle. 6. cheppassā . . spriracholi. 8. chorpi. 9. lesspetie . . movenli labri. 10. spircholo donte . razi. 11. ecquesto achade . . cheddicie lesspetie. 12. son tucte . . ettutte in . . allor circu̅sstāte. 13. spiracholo donte. 14. locho ossechuro e lasscia . razi . chelli. 15. cho̅tacto essi

77. 2. In the first of the three diagrams Leonardo had drawn only one of the two margins, at *m*.

11. *per la 9ª che dicie.* When Leonardo refers thus to a number it serves to indicate marginal diagrams; this can in some instances be distinctly proved. The ninth sketch on the page W. L. 145 *b* corresponds to the middle sketch of the three reproduced.

DEL MOTO DEL LABRO DESTRO O SINISTRO, O
SUPERIORE, [18]O INFERIORE.

OF THE MOVEMENT OF THE EDGE AT THE RIGHT
OR LEFT, OR THE UPPER, OR LOWER EDGE.

[19]Se moverai il lato destro dello spiracolo, allora si moverà la inpres[20]sione sinistra dell' obbietto destro, che penetrava per esso spiracolo, [21]e 'l simile farā tutti li altri lati di tale spiracolo e questo si pro[22]va coll'aiuto

If you move the right side of the opening the image on the left will move [being that] of the object which entered on the right side of the opening; and the same result will happen with all the other

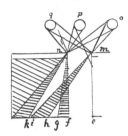
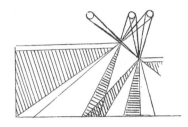
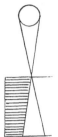

della seconda di questo che dicie ¶tutti li razzi che portā le spe[23]tie de corpi per l' aria son retti lini ¶; adunque, avendo a passare le spe[24]tie delli corpi massimi per li minimi spiraculi e dopo tale spiraco[25]lo ricōporsi alla massima dilatatione, egli è neciessario gienerar[26]si la intersegatione.

sides of the opening. This can be proved by the 2nd of this which shows: all the rays which convey the images of objects through the air are straight lines. Hence, if the images of very large bodies have to pass through very small holes, and beyond these holes recover their large size, the lines must necessarily intersect.

W. L. 145; B. a] **78.**

Neciessità à proveduto che tutte le spetie de corpi antiposti all'och[2]io s'interseghino in due lochi, delle quali l' una intersegatio[3]ne si gienera dentro alla popilla l'altra dentro alla spera cris[4]tallina, il che se così nō si faciesse, l'ochio nō potrebbe vedere [5]si grā numero di cose quāto esso vede; [6]pruovasi perchè tutte le linie che s'intersegano gienerā tale in[7]tersegatione in punto, cōciosiachè de corpi nō ci si dimostra se[8]nō le loro superfitie, li termini delle quali sō linie per la cō[9]versa della difinitiō delle superfitie, e ogni minima parte della linia [10]è equale al pūto, perchè minima è detta quella cosa della quale nessu[11]na altra può essere minore, e questa tal difinitione è simile al[12]la difinitione del pūto; adunque è pos[13]sibile che tutta la circūferentia d'un cierchio mandi la sua similitu[14]dine alla sua intersegatione come mostra la quarta di que[15]sto che

Necessity has provided that all the images of objects in front of the eye shall intersect in two places. One of these intersections is in the pupil, the other in the crystalline lens; and if this were not the case the eye could not see so great a number of objects as it does. This can be proved, since all the lines which intersect do so in a point. Because nothing is seen of objects excepting their surface; and their edges are lines, in contradistinction to the definition of a surface. And each minute part of a line is equal to a point; for *smallest* is said of that than which nothing can be smaller, and this definition is equivalent to the definition of the point. Hence it is possible for the whole circumference of a circle to transmit its image to the point of intersection, as is shown in the 4th of this which shows: all the smallest parts of the images cross each

chongiugnie chon . . chelli. 17. desstro ossini o. 19. desstro . . siracholo. 20. sinisstra . . desstro . . spiracholo. 21. spiracholo ecquesto . . 22, choll . . 2ᵃdi. 23. chorpi . . recti . . appassare. 24. chorpi . . spirachuli eddopo . . spiracho. 26. interseghatione. 78. 1. chettutte . . chorpi antipossti. 2. interseghatio. 4. stallina . . chosi . . faciessi . . vedere se. 5. [il nvmero delle chose che] si . . chose. 6. tutte [le ch] le . . chessinterseghano. 7. terseghatione . . ciossiache dimosstrasē. 8. li termini delle qua li termini. 10. chosa . . nesu. 11. ecquesta . . essimile al. 12. lla difiniō . . adunque eppos. 13. chettutta la circhū-

dicie ¶tutte le parti minime delle spetie penetrā una l'altra sanza [16]occupatione l'una dell'altra.¶ [17]Queste dimostrationi [18]son per esēplo dell'ochio; [19]nessuna spetie di

other without interfering with each other. These demonstrations are to illustrate the eye. No image, even of the smallest object, enters the eye without being turned

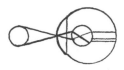 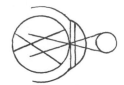 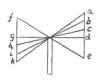

si minimo [20]corpo penetra nell'ochio [21]che non si volti sotto sopra, [22]e nel penetrare la spe[23]ra cristallina an:ora [24]si rivolta sotto sopra, e co[25]si ritorna diritta la spe[26]tie dentro all'ochio co[27]me era l'obbietto di fori [28]dell'ochio.

upside down; but as it penetrates into the crystalline lens it is once more reversed and thus the image is restored to the same position within the eye as that of the object outside the eye.

W. L. 145; D.*b*]

79.

DELLA LINIA CIĒTRALE DELL'OCHIO.

[2]Solamēte vna linia è quella infra le spetie [3]che penetrano alla virtù visiva che nō si intersega, e questa [4]non à virtù sensibile perchè è linia matematica la [5]quale à origine dal pūto matematico il quale non à mezzo.

[6]Neciessità vole secōdo l'avversa[7]rio che la linia ciētrale di tut[8]te le spetie che ētrā per li sottili [9]e stretti spiraculi in loco oscu[10]ro sia volta sotto sopra insieme [11]cō tutte le spetie de corpi che la [12]vestano.

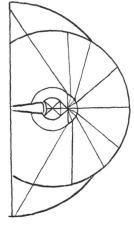

OF THE CENTRAL LINE OF THE EYE.

Only one line of the image, of all those that reach the visual virtue, has no intersection; and this has no sensible dimensions because it is a mathematical line which originates from a mathematical point, which has no dimensions.

According to my adversary, necessity requires that the central line of every image that enters by small and narrow openings into a dark chamber shall be turned upside down, together with the images of the bodies that surround it.

Wind. L. 145; C.*b*]

80.

SE LA LINIA CIĒTRALE DELLE SPETIE SI PUÒ IN SE [2]INTERSEGARE DĒTRO ALLO SPIRACOLO O NO?

[3]Inposibile è che la linia in se si possa intersegare cioè che 'l [4]lato destro d'una delle sua fronti passi al lato sinistro del lato [5]della frōte opposita, e cosi il suo lato si-

AS TO WHETHER THE CENTRAL LINE OF THE IMAGE CAN BE INTERSECTED, OR NOT, WITHIN THE OPENING.

It is impossible that the line should intersect itself; that is, that its right should cross over to its left side, and so, its left side become its right side. Because such

ferentia. 14. interseghatione [perche] . . la 4ª di . . parte. 16. ochupatione. 17. Quesste dimosstrationi. 20. chorpo. 21. socto. 22. penetrare [piu]. 23. crisstallina anchora. 24. socto . . cho. 26. cho.

79. 2. ecquella infralle. 3. visiva nō si intersegha ecquesta. 4. perche [nasscie dal] ellinia matematicha. 5. matematicho. 6. sechōdo laversa. 7. chella . . di tuc. 8. lesspetie. 9. esstretti spirachuli illocho osscu. 10. so voliti. 11. lesspetie . . chorpi chella. 12. ve stano.

80. 1. sella . . po. 2. interseghare . . spiracholo ōno. 3. he chella . . interseghare. 4. desstro . . sinisstro. 5. chosi . . sinisstro,

nistro passi al lato de⁶stro, perchè tale inter-segatione richiede due linie per li due det⁷ti lati, delli quali nō si può dar moto da de-stra e sinistra e da sini⁸stra a destra in se medesimo, se nō v'è spa-tio di grossezza, il quale sia ca⁹pacie di tal moto: e se v'è spatio, essa non è linia, āzi è superfitie, e ¹⁰noi cierchiamo la natura della linia e nō d'essa superfitie, e perchè la ¹¹linia non avendo mezzo nella sua grossezza essa nō si pvò diuidere; ¹²adunque cōcludiamo la linia nō potere aver lati inter¹³segabili infra loro; pruovasi nel moto della linia *a f* ¹⁴in *a b*, e della linia *e b* in *e f*, le quali sō lati della super¹⁵fitie *a f e b*; Ma se tu moverai la linia *a b* e la linia ¹⁶*e f* colle fronti *a e* al sito *c*, tu avrai mosso li oppositi ¹⁷stremi *f b* l'uno inverso l'altro al punto *d*, e avrai di due li-¹⁸nie fatto la linia retta *c d*, la quale ri-siede in mezzo al¹⁹la intersegatione d'esse due linie nel pūto *n,* sanza alcuna ²⁰inter-segatione, perchè se tu immaginerai tali due linie ²¹essere corporee, egli è necessario mediāte il detto mo²²to che l'una copra integralmēte l'altra, essendo equali sanza ²³alcuna intersegatione nel sito *c d*, e questo basta a pro²³vare il nostro proposito.

an intersection demands two lines, one from each side; for there can be no motion from right to left or from left to right in itself without such extension and thickness as admit of such motion. And if there is extension it is no longer a line but a surface, and we are in-vestigating the properties of a line, and not of a surface. And as the line, having no centre of thickness cannot be divided, we must conclude that the line can have no sides to intersect each other. This is proved by the movement of the line *a f* to *a b* and of the line *e b* to *e f*, which are the sides of the surface *a f e b*. But if you move the line *a b* and the line *e f*, with the frontends *a e*, to the spot *c*, you will have moved the opposite ends *f b* towards each other at the point *d*. And from the two lines you will have drawn the straight line *c d* which cuts the middle of the intersection of these two lines at the point *n* without any intersection. For, you imagine these two lines as having breadth, it is evident that by this motion the first will entirely cover the other—being equal with it—without any intersection, in the position *c d*. And this is sufficient to prove our proposition.

W. L. 145; D. *b*]

81.

COME INNVMERABILI RAZZI DELLE INNVME²RABILI SPETIE SI POSSĀ RIDURRE IN UN SOL PŪTO.

³Siccome ï un punto passā tutte le linie sanza occupatione ⁴l'una dell'altra per essere incorporee, cosi possono pas-sarvi ⁵tutte le spetie delle superfitie, e siccome o⁶gni dato punto vede ogni anti-posto obbiecto, e ogni obiet⁷to vede l'antiposto punto natu-rale, ancora per esso punto possono ⁸transire i diminviti razzi di tali spetie, dopo il transito del⁹le quali si rifor-meranno, e ricresceràno le qūatità di tali

HOW THE INNUMERABLE RAYS FROM INNUMER-ABLE IMAGES CAN CONVERGE TO A POINT.

Just as all lines can meet at a point without interfering with each other—being without breadth or thickness—in the same way all the images of sur-faces can meet there; and as each given point faces the object op-posite to it and each object faces an opposite point, the conver-ging rays of the image can pass through the point and diverge again beyond it to reproduce and re-magnify the real size of that image. But their impressions will

. des. 6. interseghatione . . due . . dec. 7. desstro essinistro . . ssinis. 8. stro a desstro . . grosseza . . qual . . . cha. 9. esse cie mezo . . grosseza. 12. cōcludiano. 13. seghabili infralloro li. 15. Massettu . . ella lini. 16. arai. 17. arai. 19. lla interseghatione . . alchuna. 20. interseghatione . . settu inmaginerai tale. 21. chorporee . . neciessario che mediāte. 22. chellala copra. 23. alchuna interseghatione . . ecquesto bassta. 24. nosstro.
81. 1. Chome . . invme. 2. nū sol. 3. sichome . . ochupatione. 4. chosi possā. 5. essichome [in ogni] ho. 6. obiec. 7. an-

81. On the original diagram at the beginning of this chapter Leonardo has written *"azurro"* (blue) where in the facsimile I have marked *A*, and *"giallo'* (yellow) where *B* stands.

Fig. I. Fig. II. Fig. III.

spe[10]tie; Ma le loro inpressioni sarā river-
scie, come è provato [11]nella prima di so-
pra, dove dicie che ogni spetie s'intersega
[12]nello introito delli stretti spiraculi fatti
in materia di mini[13]ma grossezza.

[14]Leggi a riscōtro in margine

W. L. 145; D. a]

[15]Quanto lo
spiracolo è
minore del cor-
po ōbroso, tan-
to meno le spe-
[20]tie penetrate
in esso spiraco-
lo penetrano
l'una nell' altra.
Li simulacri che passano
[25]per spiracoli in loco oscuro
intersegano li lor lati tanto
più vicino allo spiraculo quā-
to esso spiracolo fia di minore
larghezza; pruovasi, e sia a b il
[30]corpo ōbroso il quale, nō l'onbra, ma
il simulacro della sua oscurità e
figura manda per lo spiracolo-
lo · d e · il quale è della larghezza
d'esso corpo ōbroso, e li sua la-
[35]ti a b essendo rettilini (com' è pro-
vato) è neciessario che s'interseghi-
no infra 'l corpo ōbroso e lo spi-
racolo, ma tāto piv vicino allo
spiracolo, qvanto esso spiraco-
[40]lo è di minor larghezza che il cor-
po ōbroso, come si dimostra dal
lato tuo destro e dal lato sini-
stro nelle due figure a b c
n m o, dove essendo lo spiracolo
[45]destro · d e eguale in larghezza
al corpo ōbroso a b, la intersega-
tione de lati di tale ōbroso si fer-
ma in mezzo infra lo spiracolo
e 'l corpo onbroso nel punto c,
[50]il che far nō può la figura sinis-
tra per essere lo spiracolo o as-
sai minore del corpo ōbroso
n m.
jpossibile è
[55]che le spetie
de' corpi si pos-
sino vedere in-
fra li corpi e

appear reversed—as is shown in the first,
above; where it is said that every image
intersects as it enters the narrow openings
made in a very thin substance.

Read the marginal text on the other side.

In proportion as the
opening is
smaller than the
shaded body, so much
less will the images
transmitted through
this opening
intersect
each other.
The sides of images which pass
through openings into a dark room
intersect at a point which is
nearer to the opening in proportion
as the opening is narrower.
To prove this let a b be
an object in light and shade which sends
not its shadow but the image
of its darkened form through the opening
d e which is as wide as
this shaded body; and its sides
a b, being straight lines (as has been
proved) must intersect
between the shaded object and the
opening; but nearer to the
opening in proportion as it
is smaller than the
object in shade. As is shown,
on your right hand and your
left hand, in the two diagrams a b c
n m o where, the right opening
d e, being equal in width
to the shaded object a b, the intersection
of the sides of the said shaded object
occurs half way between the opening
and the shaded object at the point c.
But this cannot happen in the
left hand figure, the opening o
being much smaller than the shaded object
n m.
It is impossible
that the images
of objects should
be seen between
the objects and the

chora . . . puo. 8. le . . tale. 9. ricresscierāno. 10. Malle . . chome. 11. sintersegha. 12. spirachuli. 14. Legge. 15. los.
16. piracholo. 19. lesspe. 21. spiracho. 25. per isspiracholi illocho osschuro. 26. interseghano. 27. spirachulo. 28. spira-
cholo. 29. larghe . . essia. 30. chorpo. 31. osscurita. 32. fighura . . spiracho. 34. chorpò . . elli. 35. pr"o". 37. ello.
38. racholo mattanto . . allos. 39. spiracholo . . spiracho. 41. chome . . da. 42. tuo [sin] desstro. 43. fighure. 44. spira-
cholo. 45. desstro . . equale illarghezza. 46. intersegha. 48. mezo infrallo spiracholo. 49. chorpo. 51. stra . . losspiracholo.

15—23. These lines stand between the diagrams
I and III.

24—53. These lines stand between the diagrams
I and II.

li spiracoli,
60 per li quali pene-
trano li simula-
cri d'essi corpi;
e questo si ma-
nifesta perchè
65 doue l'aria è al-
luminata, tali si-
mulacri nō si gie-
nerano evidēti.

Li simulacri ra-
70 doppiati per la pene-
tratiō che scanbi-
evolmēte è fat-
ta dall'uno nel-
l'altro, senpre rad-
75 doppiā la loro
oscurità; pro-
vasi e sia tal
radoppiamēto
d e h, il quale
80 ancora che es-
so nō ueda se
nō dentro allo
spatio de' corpi
in *b i*, e nō re-
85 sta che esso nō
sia veduto da
f g e dal
f m, il qua-
le è conpo-
90 sto delli si-
mulacri
a b i k, li
quali in
d e h s'in-
95 fondano
l'un nel-
l'altro.

openings through
which the images
of these bodies are
admitted; and this
is plain, because
where the atmo-
sphere is il-
luminated these
images are not
formed visibly.

When the images
are made double by
mutually crossing
each other they
are invariably
doubly as dark
in tone.
To prove this
let *d e h*
be such a
doubling which
although it is only
seen within
the space between
the bodies in *b* and *i*
this will not
hinder its being
seen from
f g or
from *f m;*
being com-
posed of the
images
a b i k
which
run to-
gether in
d e h.

C. A. 123 *b*; 380 *b*] **82.**

Speriēzia come nō movēdo ²la pupilla del suo sito le cose ³viste da quella paiono moversi ⁴fori del suo loco.

⁵Se riguarderai · vna cosa alquāto distāte da te ⁶la quale sia piv bassa · che l'ochio, e fermerai ī quella ⁷le tue due popille, e coll'una · delle mani apri e tieni ⁸fermo · il coperchio di sopra e coll'altra · alzerai ⁹in

An experiment showing that though the pupil may not be moved from its position the objects seen by it may appear to move from their places.

If you look at an object at some dis-tance from you and which is below the eye, and fix both your eyes upon it and with one hand firmly hold the upper lid open while

52. chorpo. 54. he. 55. chelle. 56. chorpi. 58. fralli corpi el. 59. spiracholi. 62. cre . . chorpi. 63. ecquesto. 66. laria al. 72. effac. 76. osschurita. 77. essia. 80. anchora. 81. sen. 82. ō dentro allos. 87. eddal. 94. sī. 95. fondan"o". 82. 1. chome. 2. la poilla . . chose. 3. dacquella pare. 4. locho. 5. chosa . . datte. 6. effermerai. 7. cholluna . . tini.

54—97 are written along the left side of diagram I.

alto il coperchio di sotto, senpre tenēdo ferme le luci [10]nella cosa riguardata, vederai essa cosa [11]diuidersi in due e l'una sta ferma, l'altra si mo[12]ve in cō-trario moto, a quello che fai fare col dito [13]al coperchio di sotto; — [14]Com'è falsa l'openione di quegli [15]che dicono · questo accadere perchè [16]la lucie escie fori · di suo · sito.

[17]Come per le sopra dette cose [18]si dimostra la popilla operare [19]sotto, sopra il suo vedere.

with the other you push up the under lid—still keeping your eyes fixed on the object gazed at—you will see that object double; one [image] remaining steady, and the other moving in a contrary direction to the pressure of your finger on the lower eyelid. How false the opinion is of those who say that this happens because the pupil of the eye is displaced from its position.

How the above mentioned facts prove that the pupil acts upside down in seeing.

A. 1 *b*] 83.

PARIETE DI VETRO.

[2]Prospettiva · non è altro · che vedere [3]uno sito dirieto uno vetro piano [4]e ben' transparēte, sulla superfitie del [5]quale · siano · segniate · tutte le cose · che [6]sono da esso · vetro · īdirieto: le qua[7]li si possono cōdurre per piramidi [8]al pūto dell'ochio e esse piramidi si [9]tagliano su detto vetro.

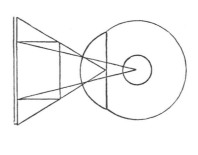

OF THE PLANE OF GLASS.

Perspective is nothing else than seeing a place [or objects] behind a plane of glass, quite transparent, on the surface of which the objects behind that glass are to be drawn. These can be traced in pyramids to the point in the eye, and these pyramids are intersected on the glass plane.

Demonstration of perspective by means of a vertical glass plane (83—85).

Br. M. 220 *a*] 84

Mai la prospettiva de'pittori in pa[2]ri distantia mostrerà [3]la cosa di quella gran-

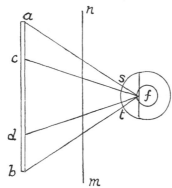

Pictorial perspective can never make an object at the same distance, look of the same

dezza [4]che si mostra all'ochio—[5]vedi la piramide *f c d* essere colla [6]sua punta tanto

size as it appears to the eye. You see that the apex of the pyramid *f c d* is as far

8. choperchio . . choll. 9. choperchio . . luce. 10. chosa . . chosa. 11. elluna. 12. chōtrario . . cheffai . . chol. 13. coperchio. 14. chome falso. 15. dichano . . achadere. 16. escie. 17. chome . . chose. 18. popila.

83. 3. īno . . īno vetro. 4. pen transsparēte sula. 5. sia . segnato . . chose. 7. posano chondure . . piramide. 8. piramide.

84. 1. prosspettiva. 2. disstantia mōsterra [in pari distā]. 3. [tia la cos] la grandeza. 4. chessi mostra alochio 6. disstante .

82. 14—17. The subject indicated by these two headings is fully discussed in the two chapters that follow them in the original; but it did not seem to me appropriate to include them here.

distante all' obbietto ⁷ c d, quanto il medesimo punto f all' obbi⁸etto · a b, e non dimeno · c d basa ⁹fatta dal punto de' pictori è minore ¹⁰che a b · basa fatta dalle linie delle spetie concorrēti all' occhio e ronpendo¹¹si in · s t · superfitie dell' ochio; ¹²di questo farà esperienza · colle linie ¹²uisuali e poi colle linie del filo de pictori ¹⁴tagliando esse linie visuali e essentiali so¹⁵pra una medesima pariete, sopra la quale ¹⁶si misuri · vn medesimo obbietto.

from the object c d as the same point f is from the object a b; and yet c d, which is the base made by the painter's point, is smaller than a b which is the base of the lines from the objects converging in the eye and refracted at s t, the surface of the eye. This may be proved by experiment, by the lines of vision and then by the lines of the painter's plumbline by cutting the real lines of vision on one and the same plane and measuring on it one and the same object.

A. 10 b]
85.

PROSPETTIVA.

²Pariete è · vna linia · perpēdiculare · la quale · si figura · dināzi · al pūto comvne, doue ³ si cōgivgnie · il concorso · delle · piramidi; E fa questa · pariete col detto pūto, ⁴quello · medesimo · ofitio, che farebbe · un vetro · piano per lo quale in riguardādo ⁵varie cose sù ve le disegniasse; E sarebbero le cose disegniate tanto mi⁶nori che l' origine: quāto · lo spatio · che sta tra 'l uetro e l'ochio fusse minore ⁷che quello · che dal vetro alla cosa.

PERSPECTIVE.

The vertical plane is a perpendicular line, imagined as in front of the central point where the apex of the pyramids converge. And this plane bears the same relation to this point as a plane of glass would, through which you might see the various objects and draw them on it. And the objects thus drawn would be smaller than the originals, in proportion as the distance between the glass and the eye was smaller than that between the glass and the objects.

PROSPETTIVA.

⁹Il cōcorso · delle piramidi cavsate · da corpi · mostreranno sulla pariete ¹⁰la uarietà delle grādezze · e distāzie della loro · cagione.

PERSPECTIVE.

The different converging pyramids produced by the objects, will show, on the plane, the various sizes and remoteness of the objects causing them.

PROSPETTIVA.

¹³Tutti · quelli · piani che i loro stremi · si cōgivgneranno con linie · perpēdiculari ¹⁴cavsando angoli · retti, E neciessario che, essendo di pari larghezza, che quāto piv ¹⁵s'alzano all' ochio meno si uegga e quāto piv lo passa piv si vegga la uera grādezza.

PERSPECTIVE.

All those horizontal planes of which the extremes are met by perpendicular lines forming right angles, if they are of equal width the more they rise to the level of eye the less this is seen, and the more the eye is above them the more will their real width be seen.

PROSPETTIVA.

¹⁷Quāto piv s'allontana dall'ochio il corpo sperico piv ne vedi.

PERSPECTIVE.

The farther a spherical body is from the eye the more you will see of it.

A. 38 a]
86.

Modo · senplice · e naturale · cioè come le cose sanza altro ²mezzo appariscono · all' ochio.

A simple and natural method; showing how objects appear to the eye without any other medium.

The angle of sight varies with the distance (86—88)

obbiecto. 8. basa]emi]. 9. fatto . . ēminore. 10. concorēti. 12. quessto . . essperienza. 15. prī medesima.

85. 1. pro *is used here—as in lines 8, 11, 16 as a title, and is an abbreviation for* Prospettiva. *The word is written at full length at the head of the first chapter on this page (see no. 94).* 2. perpēdichulare. 3. chōgivgnie . . conchorso . . piramideEffa. 4. cheffarebbe i vetro . . per | "lo" quale. 5. chose . . disegniassi Essarebono le chose. 6. fussi. 7. quelo . . chosa. 9. chōchorso . . piramide chavsate . . chorpi . mosterano sula. 10. grādeze . . chagione. 12. [tutti . quelli . piani situati in varie alteze e di par.] 13. chōgivgneranno chollinie . perpendichulare. 14. chavsando . . largeza. 15. salza alochio mēsi uega . . vega . . grādeza. 16. salontana dalochio . . chorpo sericho.

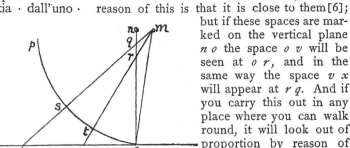

[3]Quella · cosa · ch'è · piv · presso · all'ochio · senpre · appariscie maggiore che vn altra [4]di pari qualità · che sia · piv · distante.

[5]l'ochio · m che vede · li spati · o · v · x · nō conoscie · quasi · differentia · dall'uno · all'altro [6]e questo · nascie · per esser · visino · a loro, e se li leverai detti spati · sulla pariete [7]n · o: lo spatio · o · v · apparirà nella · parte della · pariete · o · r · e cosi lo spatio [8]v · x · apparirà · in · r · q: e se tu' · mettessi · questo · in opera · in qualche loco che vi si [9]potesse andare · attorno · ti parebbe una · cosa · discordante · per la grā varietà ch'è da [10]lo spatio · o · r · e da · r · q: e questo diriva · che l'ochio è tanto · sotto · alla · pariete [11]che la pariete · li scorta: Onde se pure volessi · metterlo in opera, ti bisogniere[12]bbe · che essa prospettiva · si uedesse da uno · solo buso il quale fusse [13]nel loco · m · o veramēte stessi lontano · al meno · 3 volte · la grādezza della cosa che vedi; [14]la pariete: o · p · per l'essere sempre equidistante all'ochio a vno modo renderà [15]le cose bene · e atte a essere vedute da loco a loco.

The object that is nearest to the eye always seems larger than another of the same size at greater distance.

The eye m, seeing the spaces o v x, hardly detects the difference between them, and the reason of this is that it is close to them[6]; but if these spaces are marked on the vertical plane n o the space o v will be seen at o r, and in the same way the space v x will appear at r q. And if you carry this out in any place where you can walk round, it will look out of proportion by reason of the great difference in the spaces o r and r q. And this proceeds from the eye being so much below [near] the plane that the plane is foreshortened. Hence, if you wanted to carry it out, you would have [to arrange] to see the perspective through a single hole which must be at the point m, or else you must go to a distance of at least 3 times the height of the object you see. The plane o p being always equally remote from the eye will reproduce the objects in a satisfactory way, so that they may be seen from place to place.

W. L. 145. C. δ]

87.

Come ogni grā quātità manda [2]fuor di se le sua spetie, le quali sono [3]in potentia di diminuire in infinito.

[4]Le spetie d'ogni grā quātità essendo diuisibili in īfinito son di[5]minuitive in īfinito.

How every large mass sends forth its images, which may diminish through infinity.

The images of any large mass being infinitely divisible may be infinitely diminished.

A. 9 δ]

88.

quelli · corpi d'equale · grādezza · situati ī uarj [2]lochi fieno veduti · per diuerse · piramidi : le qua[3]li saranno tanto · piv. strette [5]quāto piv · lontana · fia · la sua · cagione.

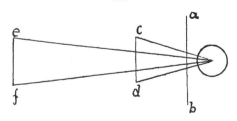

Objects of equal size, situated in various places, will be seen by different pyramids which will each be smaller in proportion as the object is farther off.

86. 1. chome le chose. 2. mezo apparischano. 3. chosa . . appariscie magiore. 4. chessia. 5. lochio. "m" che . . lisspati . . chonosscie . quassi . . diferentia. 6. ecquesto . nascie . . alloro esseli leuera . idetti. 7. losspatio . . aparira nela . . chosi. 8. aparira . . essettu . . locho. 9. potessi . . parebbe . ī. chosa . dischordante. 10. losspatio . . ecquesto . . ettanto. 11. schorta. 12. be . . essa [dipintura si] prosspettiva si vedessi da ī solo . . 13. nelocho . . il mē . . grādeza dela. 14. . . equi"di"stante alochio. 15. chose . . assere . . dallocho allocho.
87. 4. Lesspetie . . diuisibile. 5. ifinite.
88. 1. chorpi . . grādeza . . uarie. 2. [distantie] "lochi" . . piramide. 3. li [sienota] sarano . . strette luna [chella]. 4. tra quanto fia piv lontano luno chorpo che laltro]. 5. chagione.

86. 6. It is quite inconceivable to me why M. RAVAISSON, in a note to his French translation of this simple passage should have remarked: *Il est clair que c'est par erreur que Léonard a écrit per esser visino au lieu de per non esser visino.* (See his printed ed. of MS. A. p. 38.)

G. 53*b*] **89.**

Opposite pyramids in juxtaposition.

La prospectiva adopera nelle distātie ²due contrarie piramidi, delle quali l'u³na à l'angolo nell'ochio e la basa re⁴mota insino all'orizzōte, La secōda ⁵à la basa diuerso l'ochio e l'angolo ⁶all'orizzōte; Ma la prima attēde allo ⁷vniuersale, abracciādosi tutte le quā⁸tità delli corpi antiposti all'ochio, co⁹me sarebbe vn grā paese veduto per ¹⁰istretto spiracolo, che tāto maggiore ¹¹numero di cose per tale spiracolo si uede, ¹²quāto esse cose sō più remote da tal' ¹³ochio, e cosi si gienera la basa all'orizzō-¹⁴te e l'āgolo nell'ochio, come di sopra dissi; ¹⁵La 2ª piramide s'astende in un particu-¹⁶lare, il qual si dimostra tanto minore ¹⁷quāto più si remove dall'ochio, e questa ¹⁸2ª prospectiva nascie dalla prima.

Perspective, in dealing with distances, makes use of two opposite pyramids, one of which has its apex in the eye and the base as distant as the horizon. The other has the base towards the eye and the apex on the horizon. Now, the first includes the [visible] universe, embracing all the mass of the objects that lie in front of the eye; as it might be a vast landscape seen through a very small opening; for the more remote the objects are from the eye, the greater number can be seen through the opening, and thus the pyramid is constructed with the base on the horizon and the apex in the eye, as has been said. The second pyramid is extended to a spot which is smaller in proportion as it is farther from the eye; and this second perspective [= pyramid] results from the first.

G. 13*b*] **90.**

PERSPECTIVA SENPLICE.

SIMPLE PERSPECTIVE.

On simple and complex perspective.

²La sēplicie prospettiua è quella che è fat³ta dall'arte sopra sito equalmente di-stante ⁴dall'ochio con ōgni sua parte,—⁵pro-spettiua conposta è quella che è fatta ⁶sopra sito il quale cō nessuna sua parte è equal-⁷mente distante dall'ochio.

Simple perspective is that which is con-structed by art on a vertical plane which is equally distant from the eye in every part. Complex perspective is that which is con-structed on a ground-plan in which none of the parts are equally distant from the eye.

H.² 33*a*] **91.**

PROSPETTIVA.

PERSPECTIVE.

The proper distance of objects from the eye (91—92).

²Nessuna superfitie si dimostrerà · per-fetta, ³se l'ochio risguardator di quella nō ⁴sarà equalmēte distāte ai sua stre³mi.

No surface can be seen exactly as it is, if the eye that sees it is not equally remote from all its edges.

Ash. I. 12*a*] **92.**

PERCHÈ · LA COSA · POSTA VICINA · ALL'OCHIO LASCIA I SUA TERMINI ĪDISCERNIBILI.

WHY WHEN AN OBJECT IS PLACED CLOSE TO THE EYE ITS EDGES ARE INDISTINCT.

³Tutte quelle · cose opposte all'ochio · che fieno troppo a quello uicine ⁴cōuerrà che · sua termini · sieno cōfusi a disciernere, come aca⁵de delle cose uicine a lume, che fanno ōbra grāde cōfusa, e cosi ⁶fa quest' ochio col givdicare le cose ī fori; ī tutti i casi di prospectiva liniale ⁷l'ochio è simile

When an object opposite the eye is brought too close to it, its edges must be-come too confused to be distinguished; as it happens with objects close to a light, which cast a large and indistinct shadow, so is it with an eye which estimates objects opposite to it; in all cases of linear per-

89. 1. presspectiva . . disstantie. 2. piramide. 3. allangholo . . ella. 4. orizōte . . sechōta. 5. alla . . ellangholo. 6. Malla. 8. antiposste . . cho. 10. isstretto spirachole chettāto. 11. chose . . spirachol. 12. chose . . dattalo. 13. chosi. 14. ellā-gholo . . chome. 15. sasstende nūpartichu. 16. dimosstra. 17. dellochio ecquesta. 18. presspectiva nascie.

90. 2. presspectiua ecquello . . effac. 3. ecqualmente disstante. 4. chon. 5. presspectiua chonpossta ecquella cheffacta. 6. quale chō . . ecqual. 7. disstante dell.

91. 2. perfecta. 3. sellochio.

92. 1. visina alochio. 3. chose oposte . . tropo . . . acquello. 4. chōuera . . acha. 5. cheffano . . chosi. 6. q estoch dal

al lume, e la ragiō si è che l'ochio · fa · una · linia maestra, la qua[8]le per distātia īgrossa e abbraccia cō uera cognitione le cose grādi [9]da lontano come le piccole da presso: ma perchè l'ochio māda moltitudi[10]ne di linie che circūdano questa prī-cipale di mezzo, le quali quan-do le cose si [11]trovano piv lontane dal ciētro in essa cir-culatione sono meno potēti [12]a conosciere · il uero: ac-cade che la cosa posta presso all'ochio, nō [13]sendo in quella distātia, si uicina alla linia maestra capace di cōprēdere i ter[14]mini d'essa cosa; onde cōuiene a essi termini capitare in nelle linie di debole [15]cō · prēsione, le quali sono al'ufitio dell'ochio come i brachi alle caccie, [16]che leuā la preda e nō la · possō pigliare: cosi queste nō possono pi-gliare · ma sono [17]cagione che la linia maestra si uolta alle cose leuate da esse linie, [18]onde le cose, delle quali i termini sono [19]givdi-cati da esse linie, sō cōfuse.

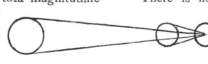

spective, the eye acts in the same way as the light. And the reason is that the eye has one leading line (of vision) which dilates with distance and embraces with true discern-ment large objects at a distance as well as small ones that are close. But since the eye sends out a multi-tude of lines which surround this chief central one and since these which are farthest from the centre in this cone of lines are less able to discern with accuracy, it follows that an object brought close to the eye is not at a due distance, but is too near for the central line to be able to dis-cern the outlines of the object. So the edges fall within the lines of weaker discerning power, and these are to the function of the eye like dogs in the chase which can put up the game but cannot take it. Thus these cannot take in the objects, but induce the central line of sight to turn upon them when they have put them up. Hence the objects which are seen with these lines of sight have confused outlines.

A. 8 b] 93.

PROSPETTIVA.

[2]La cosa · piccola · da presso · e la grāde · da lontano, essendo · viste dentro · a equali [3]angoli ·, apparirāno · d'equale · grandezza.

PERSPECTIVE.

Small objects close at hand and large ones at a distance, being seen within equal angles, will appear of the same size.

The relative size of ob-jects with regard to their distance from the eye (93—98).

A. 10 b] 94.

PROSPETTIVA.

[2]Nessuno · corpo · fia di tāta · magnitudine · che per lunga distantia al-l'ochio non apparisca [3]mi-nore · che 'l minore · obietto piv · vicino.

PERSPECTIVE.

There is no object so large but that at a great distance from the eye ¯it does not appear smaller than a smaller ob-ject near.

C. A. 1 a, 1 b] 95.

Infra le cose d'equal grandezza quella che [2]fia più distante dall'ochio si dimostrerà di minor [3]figura.

Among objects of equal size that which is most remote from the eye will look the smallest.

givdicare . . chasi. 7. l'ochio essimile . . ella . . fa . î . linia. 8. abracia chō . . chose. 9. chome le pichole. 10. circhū-dano . . meza . quā le chessi 11. diētro . . circhulatione. 12. vero . onde achade chella chosa. 13. uisina la . . cōplēdere. 14. cosa cōuiene . . inele. 15. cōplēsione . . chome . . ale chaccie. 16. posono pigliare . . maṡo. 18. 19. *These two lines are written lengthways on the margin.* 18. delle. 19. cōfusi.

93. 2. chosa pichola . . ella . . dallontano . . aeqali. 3. angholi aparirano . . grandeza.

94. 1. prosspettiva. 2. distantia | ' alochio" nōn aparisca.

95. 1. Infralle chose . . grandeza . . chef. 2. disstante . . dimossterra.

95. This axiom, sufficiently clear in itself, is in the original illustrated by a very large diagram, constructed like that here reproduced under No. 108.

The same idea is repeated in C. A. 1 a; 1 a, stated as follows: *Infra le cose d'equal grandeza quella si dimostra di minor figura che sarà più distante dall' ochio.—*

C. A. 142 *b*; 425 *b*] **96.**

Perchè la cosa quanto · piv s'auisina · all'ochio · meno si conosce ·, e perchè gli ochiali e perchè l'ochio nō ben vede da presso [2]o da lontano.

Why an object is less distinct when brought near to the eye, and why with spectacles, or without the naked eye sees badly either close or far off [as the case may be].

S. K. M. II.[2] 63 a] **97.**

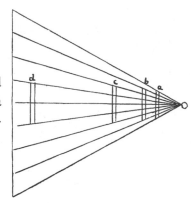

PROSPETTIVA.

[2]Infra le cose d'equal grandezza [3]quella che sarà piv distante dall'o[4]chio si dimostrerà di minore [5]figura.

PERSPECTIVE.

Among objects of equal size, that which is most remote from the eye will look the smallest.

A. 11 *a*] **98.**

PROSPETTIVA.

[2]Nessuna · secōda · cosa fia tanto · piv bassa · che la · prima | che, stādo [3]l'ochio · di sopra · la secōda nō li paia piv alta.

PERSPECTIVE.

No second object can be so much lower than the first as that the eye will not see it higher than the first, if the eye is above the second.

PROSPETTIVA.

[5]E · quella · cosa · secōda · nō fia mai · tāto · piv · alta · che la prima | che, stādo [6]l'ochio · di sotto, nō paia · la secōda sotto · la prima.

PERSPECTIVE.

And this second object will never be so much higher than the first as that the eye, being below them, will not see the second as lower than the first.

PROSPETTIVA.

[8]Se l'ochio riguarderà il secōdo quadrato · per lo ciētro del minore piv uisino [9]apparirà li il secōdo · maggiore esser circūdato · dal minore ·

PERSPECTIVE.

If the eye sees a second square through the centre of a smaller one, that is nearer, the second, larger square will appear to be surrounded by the smaller one.

PROSPECTIVA—PROPOSITIONE.

[11]Le cose · seconde · nō fieno · mai di tāta · grādezza che le prime minori [12]nō le · occupino · o circūdino.

PERSPECTIVE—PROPOSITION.

Objects that are farther off can never be so large but that those in front, though smaller, will conceal or surround them.

96. 1. chosa . . mesi chonosscie.
97. 2. Infralle . . grandeza. 3. chessara. 4. dimossterra.
98. 1. pro. 2. sechōda chosa . . chella. 3. sechōda . . paia "di" [sopra la prima] "piv alta". 4. pro. 5. cqella . . chella. 6. sechōda. 7. pro. 8. sechōdo . . lo [mezo] "ciētro". 9. aparira . . sechōdo magiore . . circhūdato. 10. pro. 11. chose

Definitione.

[14]Questa · propositione si proua · per isperiē-
tia · inperochè, se riguarderai [15]per uno ·
piccolo · spiraculo non sarà · si grā cosa [16]che
per quello nō si vegga [17]e la cosa veduta
parrà circūdata e terminata [18]dalli stremi lati
· d'esso spiraculo ·, e se tu lo stopperai, quello
piccolo [19]stoppamēto fia quello che occuperà
la ueduta della cosa grāde.

Definition.

This proposition can be proved by ex-
periment. For if you look through a small
hole there is nothing so large that it cannot
be seen through it and the object so seen
appears surrounded and enclosed by the
outline of the sides of the hole. And if
you stop it up, this small stopping will
conceal the view of the largest object.

Della prospettiva liniale.

[2]La prospectiva liniale s'astēde · nello
ofitio delle linie visuali a provare [3]per mi-
sura quanto la cosa secōda è minore che
la prima; e quāto la terza [4]è minore che
la seconda, e cosi di grado ī grado insino
al fine delle cose [5]vedute: truovo per
isperiēza che la cosa seconda se sarà tāto
distāte dalla · [6]prima · quāto la prima · è
distāte da · l'ochio tuo, che bēchè īfra loro
[7]sieno di pari grādezza ·, che la 2ª fia altret-
tāto minore che la prima, e se [8]la terza
cosa di pari grādezza alla · 2ª e 3ª inanzi
a essa fia lontana dalla 2ª [9]quāto la 2ª dalla
terza ·, fia di metà grādezza della 2ª e cosi
di grado in gra[10]do per pari distāzia farāno
sempre diminutione per metà la secōda
dalla prima [11]pure che lo ītervallo nō passi
dentro al numero di 20 braccia e īfra 20
dette braccia la [12]figvra simile a te perderà i
$^2/_4$ di sua grādezza e īfra 40 · perderà i $^9/_{10}$ [13]e
poi i $^{19}/_{20}$ ī · 60 braccia, e così di mano ī
mano farà sua diminutione, facendo [14]la pa-
riete lōtana da te · 2 · volte · tua grādezza;
che'l fare una sola fa grā diffe[15]rēzia dalle
prime braccia alle 2ᵉ.

Of linear perspective.

Linear Perspective deals with the action
of the lines of sight, in proving by mea-
surement how much smaller is a second
object than the first, and how much the
third is smaller than the second; and so on
by degrees to the end of things visible.
I find by experience that if a second object
is as far beyond the first as the first is from
the eye, although they are of the same size,
the second will seem half the size of the
first and if the third object is of the same
size as the 2nd, and the 3rd is as far beyond
the second as the 2nd from the first, it will
appear of half the size of the second; and
so on by degrees, at equal distances, the next
farthest will be half the size of the former
object. So long as the space does not exceed
the length of 20 braccia. But, beyond 20 brac-
cia figures of equal size will lose $^2/_4$ and at 40
braccia they will lose $^9/_{10}$, and $^{19}/_{20}$ at 60 brac-
cia, and so on diminishing by degrees. This
is if the picture plane is distant from you
twice your own height. If it is only as far off
as your own height, there will be a great differ-
ence between the first braccia and the second.

The appa-
rent size of
objects de-
fined by cal-
culation
(99—106).

sechōde . . grādeza. 12. ochupino . o circhūdino. 13. difinitione. 15. picholo spirachulo . . chosa [chosa di la da esso].
16. si "vegha" [possa vedere esse stoperai detto spircolo quello]. 17. [stopamēto ti ochu] ella . . para. 18. spirachulo .
essettu . . stoperai . . picholo. 19. ochupera [tutte] la.

99. 2. nelo. 3. quā la cosa . . ecquāto. 4. sechōda ecchosi. 5. chosa sechonda sessara. 7. grādeza chella . esse. 8. grādeza
ala. 9. dala . . grādeza . . ecossi. 10. diminvitione . . sechōda. 11. 20 br . . dette br . la. 12. atte . i $4/_2$ di . . grādeza.
13. 60 br ecossi . . diminvitione. 14. parieta . . datte . . grādeza . . fare ī̃ sola . . dife. 15. 2.

99. This chapter is included in Dufresne's and
Manzi's editions of the Treatise on Painting. H.
Ludwig, in his commentary, calls this chapter *"eines
der wichtigsten im ganzen Tractat"*, but at the same
time he asserts that its substance has been so
completely disfigured in the best MS. copies that we

ought not to regard Leonardo as responsible for it.
However, in the case of this chapter, the old MS.
copies agree with the original as it is reproduced
above. From the chapters given later in this edition,
which were written at a subsequent date, it would ap-
pear that Leonardo corrected himself on these points.

A. 8 b]

100.

DELLA DIMINUTIONE DELLE · COSE PER VARIE DISTÃTIE.

[2] La cosa · 2ª che sia · lontana · dalla prima · quãto · la prima · dall'ochio · apparirà la me[3]tà minore che la · prima · benchè infra loro · sieno di pari grandezza.

OF THE DIMINUTION OF OBJECTS AT VARIOUS DISTANCES.

A second object as far distant from the first as the first is from the eye will appear half the size of the first, though they be of the same size really.

DE' GRADI DEL DIMINVIRE.

[5] Se ti · porrai · la pariete · vicina · all'ochio · uno braccio la prima · cosa · che fia · lontana dal tuo [6] ochio · 4 · braccia diminvirà · ꝺ · 3/4 della sua · altezza in detta · pariete; E se fia lõtana [7] dall'ochio · 8 · braccia, diminvirà · ꝺ 7/8 · e se fia lontona · 16 · braccia diminvirà · ꝺ 15/16 di sua [8] altezza ·, e cosi · farà · di mano · in mano · raddoppiãdo il passato spatio, raddoppierà [9] la diminvitione.

OF THE DEGREES OF DIMINUTION.

If you place the vertical plane at one braccio from the eye, the first object, being at a distance of 4 braccia from your eye will diminish to 3/4 of its height at that plane; and if it is 8 braccia from the eye, to 7/8; and if it is 16 braccia off, it will diminish to 15/16 of its height and so on by degrees, as the space doubles the diminution will double.

C. A. 41 a; 132 a]

101.

Comĩcia prima dalla linia | m f | coll'ochio di sotto [2] poi alza e colla linia | n · f · | rifa il medesimo | po' fã coll'ochio di sopra e riscõtra le [3] 2 mire atte attera cicc ꝺ · m · n · | | e quãto · c · m · | entra · ꝺ · m · n · tanto · n · m · ētra ꝺ · · ꝺ n · s. [4] se | a · n · | entra · 3 · volte ꝺ | f · b · | m · p · | farà quel medesimo ꝺ p · g ·, di poi ti tira tãto ꝺ dirieto che [5] | c · d · | entri · 2 · volte ꝺn · | a · n · | e tãto sarà da · | p · g · | quanto · | da · g · h · | e quãto | d · c entra [6] ꝺ | · o · p ·, tanto · m · p · entra ꝺ · h · p · |

Begin from the line m f with the eye below; then go up and do the same with the line n f, then with the eye above and close to the 2 gauges on the ground look at m n; then as c m is to m n so will n m be to n s.

If a n goes 3 times into f b, m p will do the same into p g. Then go backwards so far as that c d goes twice into a n and p g will be equal to g h. And m p will go into h p as often as d c into o p.

Aṣh. I. 12 b]

102.

IO DO I GRADI DELLE COSE OPPOSTE ALL'OCHIO [2] COME IL MVSICO QUELLI DELLE UOCI OPPOSTE ALL'ORECHIO.

[3] Benchè · le cose opposte all'ochio · si tocchino l'una l'altra di mano ĩ mano, nõ [4] di menσ farò · la mia regola di 20 in 20 braccia

I GIVE THE DEGREES OF THE OBJECTS SEEN BY THE EYE AS THE MUSICIAN DOES THE NOTES HEARD BY THE EAR.

Although the objects seen by the eye do, in fact, touch each other as they recede, I will nevertheless found my rule on spaces of 20

100. 1. diminvitione . . chose. 2. chosa 2ª chessia . aparira. 3. chella . . [che] infralloro . grandeza. 5. Setti porai . . ĩ br la . . chosa cheffia. 6. . . 4 . br . . alteza . . Esseffia. 7. . . 8 . br . . esseffia. . . 16 . br. 8. alteza . e chosi . . imano . radopiãdo . . radopiera.

101. 1. chomĩcia . oposte al . chol. 2. chola . . fa chol . . risschõtra.

102. 1. dala. 2. chome il mvsicho delle. 3. oposte . tocino. 4. 20 br . affatto il mvsicho. 5. apichata. 6. quele . . echosi. 7. ale.

101. The first three lines are unfortunately very obscure.

come à fatto il mvsico īfra ⁵le voci che, benchè la sia vnita e appiccata īsieme, nōdimeno à posti gra⁶di di uocie in uocie · domādādo quello prima e 2ᵃ 3ᵃ 4ᵃ e 5ᵃ e cosi di grado ⁷ī grado à posto nomi alle varietà d'alzare e bassare la voce.

braccia each; as a musician does with notes, which, though they can be carried on one into the next, he divides into degrees from note to note calling them 1ˢᵗ, 2ⁿᵈ, 3ʳᵈ, 4ᵗʰ, 5ᵗʰ; and has affixed a name to each degree in raising or lowering the voice.

S. K. M. II². 16 b]　　　　　**103.**

PROSPETTIVA.

²f sia l'altezza e distantia dell'ochio, ³ a sia la pariete dell'altezza d'un omo ⁴ e sia vn omo; dico cotale fia sulla ⁵ pariete la distā- tia che dalla parie⁶te al 2° homo.

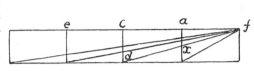

PERSPECTIVE.

Let f be the level and distance of the eye; and a the vertical plane, as high as a man; let e be a man, then I say that on the plane this will be the distance from the plane to the 2ⁿᵈ man.

C. A. 130 b; 398 b]　　　　　**104.**

Li ecciessi della diminutione che fanno le cose equali per essere cō ²uarie distātie dallo occhio remote; àno infra loro le mede- sime propor³tioni ·, quali son quelle delli spazi che infra l'ochio e le cose s'ī⁴terpongono.

The differences in the diminution of ob- jects of equal size in consequence of their various remoteness from the eye will bear among themselves the same proportions as those of the spaces between the eye and the different objects.

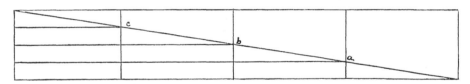

⁵Cierca quādo vn omo diminviscie in tāta distātia quāto ⁶è la sua lūghezza, e poi in 2 lūghezze e poi in 3, e così fa ⁷tua regola gienerale.

Find out how much a man diminishes at a certain distance and what its length is; and then at twice that distance and at 3 times, and so make your general rule.

II.² 28 b]　　　　　**105.**

¶L'ochio nō può giudicare ²doue la cosa alta debe ³di- sciēdere.¶

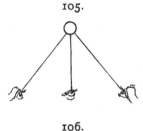

The eye cannot judge where an object high up ought to descend.

G. 29 b]　　　　　**106.**

PROSPETTIVA.

²Infra le due cose simili e equali ³poste l'una dopo l'altra con una data ⁴distantia si dimostrerà maggiore ⁵differētia in nelle loro grādezze, quādo ⁶esse sarā più vicine

PERSPECTIVE.

If two similar and equal objects are placed one beyond the other at a given distance the difference in their size will appear greater in proportion as they are

103. 2. lalteza he. 3. alteza. 4. chotale.
104. 1. delle diminuitioni cheffanno. 2. infralloro. 3. spati che infrallochio elle. 4. terpongano. 5. ciercha .. diminviscie. 6. he la sua lūgeza .. lūgeze.
105. 1—3 R. 1. po. 3. dissciędere.
106. 1. presspeccttiva. 2. Infralle due chose. 3. posste .. chon. 4. disstantia .. dimossterra magiore. 5. diferētia inelle lor .. quā.

all'ochio che le ⁷vede ‖ E cosi de cōverso ⁸si dimostrerà infra loro meno ⁹varietà di grādezza quāto esse sō ¹⁰più remote dal predetto ochio.

¹¹Prouasi me- diante le propor- tioni che ànno ¹²infra loro le lor distantie, perchè se fra ¹³essi due corpi sarà tanta distantia ¹⁴dal- l'ochio alla prima quāto dalla pri¹⁵ma alla 2ᵃ, questa si dimāda 2ᵃ ¹⁶proportione, perchè se la prima è disco- sta vn braccio dall'oc¹⁷chio e la 2ᵃ è discosta 2 braccia, il 2 è do¹⁸pio all'uno e per questo il primo corpo si di¹⁹mostrerà doppio al 2°E se tu ²⁰rimoverai da te cento braccia la prima è cento uno braccio ²¹la secōda, tu trover- rai la prima essere ²²maggiore della secōda quāto cen²³to è minore di cēto uno e questa per cōversa; ²⁴E ācora il medesimo si proua per la 4ᵃ di questo ²⁵che dicie delle cose equali tal proportione è da grādezza ²⁶a grandezza qua²⁷le è da distātia ²⁸a distan- tia ²⁹dell'ochio che le ³⁰vede.

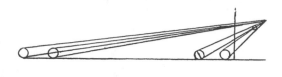

nearer to the eye that sees them. And con- versely there will seem to be less difference in their size in proportion as they are remote from the eye.

This is proved by the proportions of their distances among themsel- ves; for, if the first of these two objects were as far from the eye, as the 2ⁿᵈ from the first this would be called the second propor- tion: since, if the first is at 1 braccia from the eye and the 2ⁿᵈ at two braccia, two being twice as much as one, the first object will look twice as large as the second. But if you place the first at a hundred braccia from you and the second at a hundred and one, you will find that the first is only so much larger than the second as 100 is less than 101; and the converse is equally true. And again, the same thing is proved by the 4ᵗʰ of this book which shows that among ob- jects that are equal, there is the same pro- portion in the diminution of the size as in the increase in the distance from the eye of the spectator.

E. 16 δ]

107.

On natural perspective (107—109).

Pa ¶DELLE COSE EQUALI LA PIÙ REMOTA PAR MINORE. ‖

OF EQUAL OBJECTS THE MOST REMOTE LOOK THE SMALLEST.

³La pratica della prospettiva si diuide ⁴in ··· parti, delle quali la prima figura tut- ⁵te le cose vedute dall'ochio in qualunche ⁶distantia e questa in se mostra tutte esse ⁷cose come l'ochio le uede diminuite, e non ⁸è obbligato l'omo a stare più in un sito ⁹che in un'altro, pure che il muro non ¹⁰la riscorti la secōda volta.

¹¹Ma la 2ᵃ pratica è vna mistione ¹²di pro- spettiua fatta in parte dall'arte e in par¹³te dalla natura, e l'opera fatta ¹⁴colle sua regole non à

The practice of perspective may be divided into ... parts[4], of which the first treats of objects seen by the eye at any distance; and it shows all these objects just as the eye sees them diminished, without obliging a man to stand in one place rather than another so long as the plane does not produce a second foreshortening.

But the second practice is a combination of perspective derived partly from art and partly from nature and the work done by its rules is in

6. chelle. 7. chosi.. cōverso [si dimo]. 8. [sterā] si dimosstera infralloromē. 11. le pro "ne" che. 12. infralloro.. disstantie.. seffra. 13. disstantia. 15. quessta. 16. pro "ne" perche sella p̊ e disscossta vnbr. 17. ella .. disscossta 2 br. do. 18. il p̊. 19. mossterra .. Esse. 20. "datte" certo br .. cento î br. 21. troverrai [lultima] "la prima" essere [mi]. 22. [nore] ma- giore. 23. cēto î e cquessta p "no" cōversa.. 24. 4 di quessto. 25. tal pro "ne". 27. disstātia. 28. addisstantia. 29. chelle. 107. 1. chose. 3. praticha .. presspectiva. 4. in ... parte .. p̊ fighura tuc. 5. dele chose. 6. ecquesta .. mosstra. 7. chose chome . diminute e ne. 8. ne obbrighato .. asstare piu nūn sito. 9. nol. 10. risscorti .. sechōda. 11. Malla 2ᵃ prati- cha .. misstione. 12. presspettiua facta dall .. *As a marginal note* "in parte". 13. natura [e nonam] ellopera. 14. reghole.

107. 4. *in ... parte.* The space for the number is left blank in the original.

parte al[15]cuna che nō sia mista colla prospet-
[16]tiva naturale e colla prospettiva [17]acciden-
tale ‖ colla prospettiva na[18]turale intendo
essere la pariete pia[19]na dove tale prospet-
tiva è figura[20]ta, la qual pariete ancora
ch'e[21]lla sia di lunghezza e altezza paralella,
[22]ella è costretta a diminuire le parti [23]re-
mote più che le sua parti prime, e que[24]sto
si prova per la prima di sopra e la sua
diminu[25]tione è naturale; e la prospettiva
accidē[26]tale cioè quella ch'è fatta dall'arte
fa il cōtra[27]rio in se, perchè crescie nella
pariete scorta[28]ta tanto più li corpi che ī
lor sono equali, [29]quāto l'ochio è più natu-
rale e più vicino al[30]la pariete e quanto la
parte d'essa pariete, [31]dove si figura è più
remota dall'ochio;

[32]e questa tal pari-
[33]ete sia *d e* nel-
[34]la qual si figv-
[35]rā 3 circoli equa-
[36]li che son dopo
[37]esso *d e*, cioè
[38]li circoli *a b c*; ora
[39]tu vedi che l'ochi-
[40]o · *h* · vede sulla
[41]pariete retti
[42]linia li tagli del-
[43]le spetie maggio-
[44]ri nelle maggiori
[45]distantie o mi-
[46]nori nelle vicine.

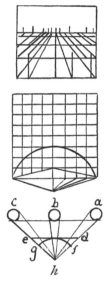

every portion of it, influenced by natural per-
spective and artificial perspective. By natural
perspective I mean that the plane on which
this perspective is represented is a flat surface,
and this plane, although it is parallel both in
length and height, is forced to diminish in its
remoter parts more than in its nearer ones.
And this is proved by the first of what has
been said above, and its diminution is natural.
But artificial perspective, that is that which is
devised by art, does the contrary; for objects
equal in size increase on the plane where it
is foreshortened in proportion as the eye is
more natural and nearer to the plane, and
as the part of the plane on which it is figu-
red is farther from the eye.

And let this plane
be *d e* on
which are seen
3 equal
circles which are
beyond this plane
d e, that is
the circles *a b c*.
Now you see
that the eye
h sees on the
vertical plane
the sections of
the images, largest
of those that are
farthest and
smallest of the
nearest.

E. 16 *a*] 108.

Qui seguita quel che manca in
margine, [2]da piedi dirieto a questa
faccia.

[3]Il che natura nella sua pro-
spectiva [4]adopera in contrario con
ciosiachè nelle [5]maggiori distan-
tie la cosa veduta · si dimo[6]stra
minore e nella distantia minore
[7]la cosa par maggiore; Ma que-
sta ta[8]le inuencione costrignie

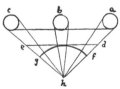

Here follows what is wanting in
the margin at the foot on the other side
of this page.

Natural perspective acts in a
contrary way; for, at greater
distances the object seen appears
smaller, and at a smaller distance
the object appears larger. But
this said invention requires the
spectator to stand with his eye at a

15. chuna... missta cholla prespec. 16. cholle presspettiva. 17. cholla presspettiva. 19. presspettiva effighura. 20. pariete
[in se] anchora. 21. alteza. 22. chostretta .. parterte. 23. chelle .. parte .. ecq. 24. lap'di ... ella sua diminui.
26. cheffatta dallaltre. 27. cresscie. 28. illorsono. 30. ecquanto. 31. fighura eppiu. 32. ecquesta. 34. fighv. 35. ro 3 cl
equa. 36. chesson sop. 38. li cl a. 39. chellochi. 43. magio. 44. magior. 46. nor.
108. 1. mancha. 2. [dir] dappiedi .. acquesta. 3. prosspectiva. 4. inchontrario chon .. chēnel. 5. magior distantie ... vedita,
si dimos. 7. Macquesta. 8. chosstrignie .. ueditore as. 9. chollochio .. pirachlo. 10. dattale spiracholo si dimosstera.

24. *la prima di sopra* i. e. the first of the three diagrams which, in the original MS., are placed in
the margin at the beginning of this chapter.

il ueditore a [9]stare coll'ochio a vno
spiracolo e [10]allora da tale spiracolo si
dimostrerà [11]bene; Ma perchè molti occhi
s'ab[12]battono a vedere a un medesimo tenpo
vna [13]medesima opera fatta con tale arte e
so[14]lo vn di quelli vede bene l'ufitio di tal
pro[15]spectiua e li altri tutti restā confu[16]si;
Egli è dunque da fuggire tal pro[17]spettiva
conposta e a tenersi alla sē[18]plicie, la qual
nō uol uedere pariete in i[19]scorto, ma più
in propia forma che sia [20]possibile; E di
questa prospettiua [21]senplicie, della quale
la pariete taglia le [22]piramidi portatricie
delle spetie all'ochio [23]equalmente distanti
dalla virtù visiua [24]ci ne dà speriētia la
curva lucie del[25]l'ochio sopra la quale tali
piramidi si ta[26]gliano equalmēte distanti
dalla virtù [27]visiua ecc.

small hole and then, at that small hole, it will
be very plain. But since many (men's) eyes
endeavour at the same time to see one and
the same picture produced by this artifice only
one can see clearly the effect of this per-
spective and all the others will see confusion.
It is well therefore to avoid such complex
perspective and hold to simple perspective
which does not regard planes as foreshortened,
but as much as possible in their proper form.
This simple perspective, in which the plane
intersects the pyramids by which the images
are conveyed to the eye at an equal distance
from the eye is our constant experience,
from the curved form of the pupil of the
eye on which the pyramids are intersec-
ted at an equal distance from the visual
virtue.

Br. M. 62*a*] **109.**

Della prospettiva naturale mista colla prospettiva accidētale.

[2]Questa dimostratione divide la pro-
spettiva naturale dalla accidētale, [3]ma
auanti che più oltre proceda difinirai quale
è naturale e quale ac[4]cidētale; prospettiva
naturale dicie così ¶delle cose d'equal

Of a mixture of natural and artificial perspective.

This diagram distinguishes natural from
artificial perspective. But before proceeding
any farther I will define what is natural and
what is artificial perspective. Natural perspec-
tive says that the more remote of a series of

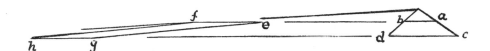

magnitudine [5]la più remota si dimostra
minore; E de converso la più propinqua si
dimo[6]stra maggiore, e tal proportione è da
diminutione a diminutione qua[7]le è da di-
stantia a distantia Ma la prospettiua acci-
dētale pone le co[8]se inequali in varie di-
stantie, riservādo la minore più vicina al-
l'ochio che[9]la maggiore, cō tal distantia che
essa maggiore si dimostra essere minore di
tutte [10]l'altre, e di questo è causa il mvro
doue tal dimostratione è figurata, il quale
[11]à distantia inequale dall'ochio in ogni

objects of equal size will look the smaller, and
conversely, the nearer will look the larger and
the apparent size will diminish in proportion
to the distance. But in artificial perspective
when objects of unequal size are placed at
various distances, the smallest is nearer to
the eye than the largest and the greatest
distance looks as though it were the least
of all; and the cause of this is the plane
on which the objects are represented; and
which is at unequal distances from the eye
throughout its length. And this diminution

11. molti [omi] ochi [p]sa. 12. battano aumedesimo. 13. chon. . . arte esso. 14. lo vn diuuegli vede . . pres. 15. elli . .
resstā. 16. daffuggire . . pre. 17. chonposta e attenersi. 19. chessia. 20. presspectiua. 22. piramide portatricie. 23. distante.
24. cieneda speriētia. 25. tale piramide. 26. distante.

109. 1. presspectiua . . cholla presspectiva. 2. presspectiva. 3. proccieda difinira . . ennaturale ecquale. 4. prespectiua . . chosi.
 5. dimosstra . . chonverso . . dimos. 6. ettal . . diminuitione addiminuitione. 7. disstantia addistantia Malla presspectiua . .
 cho. 8. innequali . . disstantie . . chel. 9. chō disstantia . . magiore . . dimosstra . . di tuc. 10. eddi quessto ecchausa . .

parte della sua lūghezza e questa tal [12]di-
minutione del muro è naturale, ma la pro-
spettiua in esso figurata è accidē[13]tale,
perchè in nessuna parte non si accorda
colla vera diminutione del det[14]to muro;
onde ne resulta che, removendosi alquāto
l'ochio d'essa prospetti[15]va risguardatore,
ogni cosa figurata apparisce mostruosa, il
che nō [16]interviene nella prospettiua natu-
rale, la quale è difinita di sopra ecc. [17]ad-
unque diremo il quadrato *a b c d* figurato
di sopra essere un □ in iscor[18]to, veduto
dall' ochio situato in mezzo della larghezza
che à la sua fronte; Ma [19]la · prospettiva
accidētale mista colla naturale fia trovata
nel quadra[20]to detto el main, cioè *e f g h*,
il quale à a parere all'ochio che lo vede
simile [21]al *a b c d* stāte l'ochio fermo nel
primo sito infra *c d*, e questo si [22]dimostrerà
fare buono effetto: perchè la prospettiua
naturale del muro fa [23]che tal muro occul-
terà il mancamēto di tal mostruosità.

of the plane is natural, but the perspective
shown upon it is artificial since it nowhere
agrees with the true diminution of the said
plane. Whence it follows, that when the
eye is somewhat removed from the [station
point of the] perspective that it has been
gazing at, all the objects represented look
monstrous, and this does not occur in natural
perspective, which has been defined above.
Let us say then, that the square *a b c d*
figured above is foreshortened being seen by
the eye situated in the centre of the side
which is in front. But a mixture of artificial
and natural perspective will be seen in this
tetragon called *el main*, that is to say
e f g h which must appear to the eye of
the spectator to be equal to *a b c d* so
long as the eye remains in its first position
between *c* and *d*. And this will be seen
to have a good effect, because the natural
perspective of the plane will conceal the defects
which would [otherwise] seem monstrous.

dimosstratione e fighurata. 11. disstantia . . ecquesta. 12. diminuitione . . malla presspectiua. 13. acchorda cholla . . dimi-
nuitione del dec. 14. cherremovendosi . . presspecti. 15. rissghuardatore . . chosa fighurata apparisscie mōsstruoso. 16. ne
interviene . . presspectiua . . eddifinita. 17. addunque direno . . fighurato . . innissco "r". 18. largheza . . froncte. 19. lla
. presspectiva . . missta cholla. 20. decto . . apparere . . chello. 21. ecquesto. 22. dimossterra . . presspectiua. 23. chettal
. . ochulture il manchamēto . . musstrvosita.

109. 20. *el main* is quite legibly written in the original; the meaning and derivation of the word
are equally doubtful.

III.

Six books on Light and Shade.

Linear Perspective cannot be immediately followed by either the "prospettiva de' perdimenti" or the "prospettiva de' colori" or the aerial perspective; since these branches of the subject presuppose a knowledge of the principles of Light and Shade. No apology, therefore, is here needed for placing these immediately after Linear Perspective.

We have various plans suggested by Leonardo for the arrangement of the mass of materials treating of this subject. Among these I have given the preference to a scheme propounded in No. 111, because, in all probability, we have here a final and definite purpose expressed. Several authors have expressed it as their opinion that the Paris Manuscript C is a complete and finished treatise on Light and Shade. Certainly, the Principles of Light and Shade form by far the larger portion of this MS. which consists of two separate parts; still, the materials are far from being finally arranged. It is also evident that he here investigates the subject from the point of view of the Physicist rather than from that of the Painter.

The plan of a scheme of arrangement suggested in No. 111 and adopted by me has been strictly adhered to for the first four Books. For the three last, however, few materials have come down to us; and it must be admitted that these three Books would find a far more appropriate place in a work on Physics than in a treatise on Painting. For this reason I have collected in Book V all the chapters on Reflections, and in Book VI I have put together and arranged all the sections of MS. C that belong to the book on Painting, so far as they relate to Light and Shade, while the sections of the same MS. which treat of the "Prospettiva de' perdimenti" have, of course, been excluded from the series on Light and Shade.

GENERAL INTRODUCTION.

Br. M. 171 a]

110.

Bisognia ti descrivere la teorica e poi. ²la pratica; ³discriuerai primo de ōbra e lumi de'corpi ⁴densi e poi de'corpi trasparenti.

You must first explain the theory and then the practice. First you must describe the shadows and lights on opaque objects, and then on transparent bodies.

Prolego-mena.

C. A. 246 a; 733 a]

111.

PROEMIA.

² [Auēdo · io trattato della natura · de' ōbre · e loro · percussione, Ora · tratterò · de lochi, i quali da esse ōbre · tochi · fieno, ³ E di loro curuità, obbliquità · o dirittura o di qualunque qualità trovare per me si potrà.]

⁴Ōbra · è privatione di luce; ⁵Parendo a me le ōbre · essere di somma neciessità · in nella prospettiva, perochè sanza quelle i corpi opachi e cubi · male sieno ⁶intesi; quello che dētro · a' sua termini collocato · fia, e male i sua cōfini ītesi fieno · se essi nō terminano ī cāpo di uario ⁷colore da quello · del corpo; E per questo Jo propōgo nella prima propositione dell'ōbre, dico ī questa forma come ogni corpo ⁸opaco fia circū-

INTRODUCTION.

[Having already treated of the nature of shadows and the way in which they are cast, I will now consider the places on which they fall; and their curvature, obliquity, flatness or, in short, any character I may be able to detect in them.]

Shadow is the obstruction of light. Shadows appear to me to be of supreme importance in perspective, because, without them opaque and solid bodies will be ill defined; that which is contained within their outlines and their boundaries themselves will be ill-understood unless they are shown against a background of a different tone from themselves. And therefore in my first proposition concerning shadow I state that every opaque body is surrounded and its whole surface enveloped in shadow and light. And on

Scheme of the books on Light and Shade.

110. 1. teoricha. 2. praticha. 3. ellume. 4. chorpi trāpareti.
111. 1. tractato delle nature . . elloro . perchussione. 2. choruita . . diritti. 3. Obra . he. 5. āme . . inella prosspettiva . . chorpi |
 "oppachi e" chubi. 6. malle esua chōfini . . chāpo. 7. dacquello . . chorpo . . allōbre | "dicho īquesta forma" chome . .

111. This text has already been published with some slight variations in DOZIO's pamphlet *Degli scritti e disegni di Leonardo da Vinci*, Milan 1871, pp. 30—31. DOZIO did not transcribe it from the original MS. which seems to have remained unknown to him, but from an old copy (MS. H. 227 in the Ambrosian Library).

2. *Avendo io tractato.*—We may suppose that he here refers to some particular MS., possibly Paris C.

dato e superfitialmēte vestito d'ōbre · e di lumi, e sopra questo · edifico · il primo libro; Oltre a di questo ⁹esse ōbre sono in se di uarie qualità d'oscurità · perchè da varie quātità di razzi luminosi abbādonate sono, e queste domādo ōbre originali, ¹⁰perchè sono le prime ōbre, che uestono i corpi doue appiccate sono, e sopra questo · edificherò il 2° libro; ¹¹da queste ōbre originali ne resultano · razzi ōbrosi · i quali si uāno dilatando per l'aria, e sono di tante qualità, quāte ¹²sono le uarietà dell'onbre originali, donde essi derivano · e per questo io chiamo esse ōbre ōbre diriuatiue, perchè da altre ōbre ¹³nascono, e sopra di questo Jo farò il 3° libro; Ancora · queste onbre diriuatiue nelle loro percussioni fanno ¹⁴tanti vari · effetti · quāto · son vari i lochi dove esse percuotono, e qui farò · il quarto libro; E perchè la ¹⁵percussione della diriuatiua ōbra è senpre circūdata da percussione di luminosi razzi · la quale per reflesso cōcorso ¹⁶risaltando indirieto uerso la sua cagione trova l'onbra originale · e si mischia e si cōuerte in quella alquāto variādola di sua ¹⁷natura e sopra questo edificherò · il quīto libro; Oltr'a di questo farò il sesto libro, nel quale si cōterrā le uarie ¹⁸e molte diuersificationi · delli risultanti razzi reflessi, i quali uarierāno la originale di tanti vari colori quā¹⁹to fiē vari i lochi ōde essi reflessi razzi luminosi deriuano ¶ancora farò la settima diuisione delle uarie ²⁰distantie, che fiā infra la percussione del razo reflesso al loco dōde nasce; quāto fiē uarie le similitudini de co-²¹lori che esso nella percussione al corpo opaco appicca.

this proposition I build up the first Book. Besides this, shadows have in themselves various degrees of darkness, because they are caused by the absence of a variable amount of the luminous rays; and these I call Primary shadows because they are the first, and inseparable from the object to which they belong. And on this I will found my second Book. From these primary shadows there result certain shaded rays which are diffused through the atmosphere and these vary in character according to that of the primary shadows whence they are derived. I shall therefore call these shadows Derived shadows because they are produced by other shadows; and the third Book will treat of these. Again these derived shadows, where they are intercepted by various objects, produce effects as various as the places where they are cast and of this I will treat in the fourth Book. And since all round the derived shadows, where the derived shadows are intercepted, there is always a space where the light falls and by reflected dispersion is thrown back towards its cause, it meets the original shadow and mingles with it and modifies it somewhat in its nature; and on this I will compose my fifth Book. Besides this, in the sixth Book I will investigate the many and various diversities of reflections resulting from these rays which will modify the original [shadow] by [imparting] some of the various colours from the different objects whence these reflected rays are derived. Again, the seventh Book will treat of the various distances that may exist between the spot where the reflected rays fall and that where they originate, and the various shades of colour which they will acquire in falling on opaque bodies.

Ash. I. 6b] **112.**

Different principles and plans of treatment (112—116).

¶Tratterai · prima · de' · lumi · fatti dalle . finestre · ai quali porrai nome ²aria cōstretta; poi tratterai de lumi della cāpagnia, ai quali porai nome lume ³libero · di poi tratterai del lume de corpi luminosi.¶

First I will treat of light falling through windows which I will call Restricted [Light] and then I will treat of light in the open country, to which I will give the name of diffused Light. Then I will treat of the light of luminous bodies.

chorpo oppacho . . circhūdato . . vesstito . . edificho. 9. dosschurita . . vari [razi] "quātita dirazzi" luminosi [sono] abbā-donate | "sono" ecqueste. 10. vestano i chorpi . . apichate . . libro [dopo questo]. 11. dacqueste . . resulta razi e quali siuano . . laria [i quali] e. 12. originale essi ōbre "ōbre" diriuatiue. 13. naschano . . Ibro Anchora . . perchussioni. 14. effe effetti . . dove | "esse" perchotano . . perche [dintorno alla]. 15. perchussione . . circhūdata . . perchussione . . chōchorso. 16. essimista essi chōuerte. 17. essopra . . chotera. 18. diuersifichationi . . risaltanti razi refressi . . cholori. 19. refressi . . anchora. 20. cheffia infralla perchussione . . allocho . . nasscie . . similitudine. 21. perchussione . . chorpo oppacho appicha. **112.** 1. porai. 2. aia cōstretta . . tratta. 3. libro dipo trara.

K.3, 25 b] 113.

DE PITTURA.

²Li aspetti dell'onbre e lumi ³coll'ochio sono 3, de quali ⁴l'uno è quãdo l'ochio e 'l lu⁵me son da un medesimo ⁶lato del corpo veduti; ⁷2° è quando l'ochio è dinã⁸ti all'obietto e 'l lume è do⁹po esso obbietto; 3° è ¹⁰quel che l'ochio dinãti al¹¹l'obbietto e 'l lume è da lato ¹²ĩ modo che la linia che s'astē¹³de dall'obbietto all'ochio, e da es¹⁴so obbietto al lume, giugnē¹⁵dosi la cõgiũtiõ sarà rettãgulare.

OF PAINTING.

The conditions of shadow and light [as seen] by the eye are 3. Of these the first is when the eye and the light are on the same side of the object seen; the 2ⁿᵈ is when the eye is in front of the object and the light is behind it. The 3ʳᵈ is when the eye is in front of the object and the light is on one side, in such a way as that a line drawn from the object to the eye and one from the object to the light should form a right angle where they meet.

K.3, 26 a] 114.

DE PITTURA.

²Ecci vn altra partitione, ³cioè della natura dell'ob⁴bietto riflesso posto ĩ⁵fra l'ochio e'l lu⁶me per diuersi aspetti.

OF PAINTING.

This is another section: that is, of the nature of a reflection (from) an object placed between the eye and the light under various aspects.

M. 80 a] 115.

DE PICTURA.

²Di tutte le cose vedute si à a cõsiderare ³·3· cose cioè il sito dell'ochio che ⁴vede, e 'l sito della cosa veduta e'l lume, ⁵el sito del lume che allumina ⁶tal corpo;

OF PAINTING.

As regards all visible objects 3 things must be considered. These are the position of the eye which sees: that of the object seen [with regard] to the light, and the po-

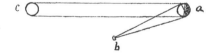 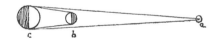

⁷b. è l'ochio · a · è la cosa veduta · c è il lume;
⁸a · è l'ochio · b · è la cosa che allumina, ⁹c è il corpo ch'è alluminato.

sition of the light which illuminates the object. b is the eye, a the object seen, c the light. a is the eye, b the illuminating body, c is the illuminated object.

M. 79 b] 116.

a · sia il lume · b · l'ochio · c è la cosa ²veduta dall'ochio e dal lume; ³Queste dan vna volta l'ochio fra 'l

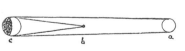

Let a be the light, b the eye, c the object seen by the eye and in the light. These show, first, the eye between

113. 1—15 R. 2. asspetti . . ellumi. 4. equ"a"do . . ellu. 6. veduto. 7. ecqu"a"ndo locho. 10. chellochio. 11. dallato. 12. chella . . chessastē. 13. e da e. 14. gugnē. 15. cõgiũtiõ sare rettãgule.
114. 1—6 R. 2. partione. 3. coe. 4. rēfresso posto. 6. asspetti.
115. 2. chose . . siaha chõsiderare. 3. [la]. 3. cose coe [lochio] il. 5. [che a] el. 7. b. hellochio a ella . . c ellume. 8. ellochio . 6. ella cosa [veduta] che alluma.

lume e'l corpo ⁴la 2ª il lume fra l'ochio e'l corpo, 3ª il corpo fra ⁵l'ochio e'l lume ⁶a · è l'ochio · b · la cosa alluminata · c · è il lume.

the light and the body; the 2nd, the light between the eye and the body; the 3rd the body between the eye and the light. *a* is the eye, *b* the illuminated object, *c* the light.

E. 3 b]

117.

PICTURA.
DELLE 3 SORTE DE' LUMI CHÉ ALLUMINANO ³LI CORPI OPACHI.

Different sorts of Light (117. 118).

⁴Il primo de lumi colli quali s'alluminano li cor⁵pi opachi è detto particulare · e questo è ⁶il sole o altro lume di finestra o fuoco: Il ⁷secondo è vniversale come accade ne' tēpi nu⁸bolosi o di nebbia e simili; Il 3° è cōpo-⁹sto, cioè quando il sole da sera o da mattina ¹⁰è integralmēte sotto l'orizonte.

OF PAINTING.
OF THE THREE KINDS OF LIGHT THAT ILLUMINATE OPAQUE BODIES.

The first kind of Light which may illuminate opaque bodies is called Direct light—as that of the sun or any other light from a window or flame. The second is Diffused [universal] light, such as we see in cloudy weather or in mist and the like. The 3rd is Subdued light, that is when the sun is entirely below the horizon, either in the evening or morning.

G. 3 b]

118.

DE' LUMI.

²I lumi che alluminano li corpi opachi sono ³di 4 sorti, cioè vniversale come quello dell'aria ch'è ⁴dentro al nostro orizzonte ‖e particolare com'è ⁵quello del sole o d'una finestra o porta o altro spa⁶tio; e'l terzo è il lume riflesso ed ecce ne vn ⁷4°, il quale passa per cose trasparēti, come tela ⁸o carta o simili, ma nō trasparēti come vetri, ⁹o cristali o altri corpi diafani, li quali fan il mede¹⁰simo effetto come se nulla fusse interposto ī¹¹fra'l corpo ōbroso e'l lume che l'allumina, e di que¹²sti parleremo distinta-mēte nel nostro discorso.

OF LIGHT.

The lights which may illuminate opaque bodies are of 4 kinds. These are: diffused light as that of the atmosphere, within our horizon. And Direct, as that of the sun, or of a window or door or other opening. The third is Reflected light; and there is a 4th which is that which passes through [semi] transparent bodies, as linen or paper or the like, but not transparent like glass, or crystal, or other diaphanous bodies, which produce the same effect as though nothing intervened between the shaded object and the light that falls upon it; and this we will discuss fully in our discourse.

Ash. I. 13 b]

119.

CHE COSA È ŌBRA E LUME.

Definition of the nature of shadows (119—122).

²Ōbra è priuatiō di luce e sola opposi-tione de' corpi dēsi opposti a razzi luminosi: ōbra è di natu³ra delle tenebre: lume è di natura della luce; l'una ⁴ciela e l'altro di-mostra: sono sēpre ī cōpagnia cōgivti · ai corpi, e l'onbra è di maggiore potētia che

WHAT LIGHT AND SHADOW ARE.

Shadow is the absence of light, merely the obstruction of the luminous rays by an opaque body. Shadow is of the nature of darkness. Light [on an object] is of the nature of a luminous body; one conceals and the other reveals. They are always associated and inseparable from all objects. But shadow

116. 1. c ella. 4. ilume frallochio. 7. ellochio.

117. 2. oppachi. 3. chorpi oppachi. 4. cholli . . li chor. 5. oppachi he detto partichulare ecquesto he. 6. offuocho. 7. sechondo he . . achade. 8. 3° he chōpo. 9. dassera.

118. 3. di [3] "4" sorte coe . . quel. 4. nosstro orizonte. 5. quel. 6. refresso. 7. trassparēti. 8. charta ossimili . . trassparēti. 9. crisstali. 10. chome . . fussi. 12. parlerē . . nosstrodisscorso.

119. ellume. 2. Ōbra "e priuatiō di luce" e sola opositione . . opostia razi. 3. luna [e privatione e laltro]. 4. [di mo] ciela ellaltro . . magiore. 5. proibissce. 6. luce ella luche . . chaciare.

'l lume īpero·chè quella proibisce e priva
[6]īteramēte · i corpi · della · luce, e la luce nō
può mai cacciare ī tutto [7]l'ōbra de' corpi ·
cioè corpi dēsi.

is a more powerful agent than light, for it can
impede and entirely deprive bodies of their
light, while light can never entirely expel sha-
dow from a body, that is from an opaque body.

W. L. 145; D a]

120.

¶Ōbra è lume diminuito [2]mediante l' op-
positiō dell' opaco ¶. [3]¶Ōbra è 'l suppliomē[4]to
del razzo luminoso ta[5]gliato dallo opaco ¶.

[6]Pruovasi, perchè il razzo [7]ōbroso è della
medesima [8]figura e quā-
tità che era [9]il razzo lu-
minoso nel quale [10]essa
ōbra si trāsmuta.

Shadow is the diminution of light by the
intervention of an opaque body. Shadow is
the counterpart of the luminous rays which
are cut off by an opaque body.

This is proved because
the shadow cast is the
same in shape and size
as the luminous rays were
which are transformed
into a shadow.

W. 232 b]

121.

L' ōbra è diminutione di lucie e di tenebre
[2]ed è interposta infra esse tenebre e lucie;

[3]L' onbra è d' infinita oscurità e d' infinita
di[4]minutione d' essa oscurità;

[5]Li principi e fini dell' onbra s' astēdono
infra [6]la lucie e le tenebre ed è d' infinita
dimi[7]nuitione e d' īfinita aumētatione.

L' onbra è pronūtiatione de' corpi delle
lor [9]figure.

[10]Le figure de corpi nō darā notitia
delle lo[11]ro qualità sanza l' onbra.

Shadow is the diminution alike of light and of
darkness, and stands between darkness and light.

A shadow may be infinitely dark, and also
of infinite degrees of absence of darkness.

The beginnings and ends of shadow lie
between the light and darkness and may be
infinitely diminished and infinitely increased.
Shadow is the means by which bodies dis-
play their form.

The forms of bodies could not be under-
stood in detail but for shadow.

Ash. I. 14 a]

122.

DEL' ESSERE DEL' ŌBRA PER SE.

[2]L' ōbra · è della natura · delle cose · vni-
versali · che tutte sono piv [3]potēti · nel prī-
cipio · e īuerso il fine īdeboliscono; dico nel
principio [4]d' ogni forma e qualità · evidēte
ed inevidēte · e nō delle cose cōdotte [5]di
piccol prīcipio ī molto accrescimēto dal tēpo,
come sarebbe una gran [6]quercia che à debole
prīcipio per una piccola ghiāda; āzi dirò la
quer[7]cia essere piv potēte al nascimēto
ch' ella fa della terra, cioè nella [8]maggiore sua
grosseza, adunque le tenebre sono il primo
[9]grado del' onbra · e la · luce · è l' ultimo:
adūque · tu · pittore farai l' ō[10]bra · piv scura
appresso alla · sua · cagione e il fine fa che
si cōverta in luce, cioè che paia sāza
fine.

OF THE NATURE OF SHADOW.

Shadow partakes of the nature of uni-
versal matter. All such matters are more
powerful in their beginning and grow weaker
towards the end, I say at the beginning,
whatever their form or condition may be and
whether visible or invisible. And it is not from
small beginnings that they grow to a great size in
time; as it might be a great oak which has a
feeble beginning from a small acorn. Yet I may
say that the oak is most powerful at its begin-
ning, that is where it springs from the earth,
which is where it is largest—(To return:) Dark-
ness, then, is the strongest degree of shadow
and light is its least. Therefore, O Painter,
make your shadow darkest close to the ob-
ject that casts it, and make the end of it fa-
ding into light, seeming to have no end.

120. 1. ellume. 2. oppacho. 3. Ōbra [ellume]. 4. te del. 5. oppacho. 8. ecquatita.

121. 1. diminuitione .. eddi. 2. ellucie. 3. osschurita. 4. minuitione .. osscurita. 5. effini .. sasstēdano infral. 6. elle tenebr.
. nuitione. 8. chorpi. 10. chorpi .. no dara.

122. 2. dela .. chose .. chettutte. 3. īdeboliscano. 4. ecqualita. 5. pichol .. īmolt .. sarebe ī gra. 6. che he debole .. per
pichola. 7. cie essere .. chela fa dela tera. 8. magiore .. grosseza adunq le tenebre e. 9. ella luce. 10. apresso .
chagione .. cōverti.

Of the var-
ious kinds
of shadows
(123—125).

¶Tenebre è privatiō di luce; [2]ōbra è diminutiō di luce; [3]ōbra primitiva · è quella che è appiccata a corpi ōbrosi; [4]ōbra dirivativa è quella che si spicca da corpi ōbrosi e scorre per l'aria; [5]ōbra ripercossa è quella che è circūdata da luminata pariete; [6]l'ōbra senplice è quella che nō uede alcuna parte del lume che la causa ¶[7]l'ōbra senplice comīcia in nella linia che si parte da' termini de' corpi luminosi · *a* · *b*.

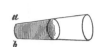

Darkness is absence of light. Shadow is diminution of light. Primitive shadow is that which is inseparable from a body not in the light. Derived shadow is that which is disengaged from a body in shadow and pervades the air. A cast transparent shadow is that which is surrounded by an illuminated surface. A simple shadow is one which receives no light from the luminous body which causes it. A simple shadow begins within the line which starts from the edge of the luminous body *a b*.

¶Onbra senplice è quella che nō vede alcū lumi[2]noso¶

[3]onbra composta è quella che da vno o più lu[4]minosi è alluminata.

A simple shadow is one where no light at all interferes with it.

A compound shadow is one which is somewhat illuminated by one or more lights.

CHE DIFFERĒTIA · È DA ŌBRA CŌGIŪTA COI CORPI A' ŌBRA SEPARATA?

[3]Ōbra · cōgivnta · è quella · che mai · si parte · dai corpi alluminati, [4]come sarebbe una palla · la quale · stāte al lume · sēpre à una parte di se [5]occupata dall' ōbra, la quale mai si diuide per mvtatiō di sito fatto da essa [6]palla; Ombra · separata · può · essere · e non essere creata dal corpo; [7]poniamo che essa palla sia distāte a uno muro uno braccio e dal' opposita parte sia [8]il lume; il detto lume · mādera ī detto mvro · appūto tanta dilatazione di ō[9]bra quāt' è quella che si troua sulla · parte della palla. ch' è volta · a detto [10]muro · Quella parte · dell' ōbra separata · che non appare fia quādo il lume [11]fia di sotto alla palla che la sua ōbra ne va īuerso il cielo e nō trovādo resi[12]stētia pel camino si perde.

WHAT IS THE DIFFERENCE BETWEEN A SHADOW THAT IS INSEPARABLE FROM A BODY AND A CAST SHADOW?

An inseparable shadow is that which is never absent from the illuminated body. As, for instance a ball, which so long as it is in the light always has one side in shadow which never leaves it for any movement or change of position in the ball. A separate shadow may be and may not be produced by the body itself. Suppose the ball to be one braccia distant from a wall with a light on the opposite side of it; this light will throw upon the wall exactly as broad a shadow as is to be seen on the side of the ball that is turned towards the wall. That portion of the cast shadow will not be visible when the light is below the ball and the shadow is thrown up towards the sky and finding no obstruction on its way is lost.

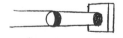

ōbra separata e cōgiūta
(separate and inseparable shadow).

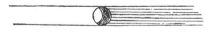

ōbra separata inevidēte
(separate invisible shadow).

123. 1—7 R. 2. ōbra he diminuitiō. 3. he quella . . che he appichata achorpi. 4. he quella . . spicha . . escore. 5. ecquella che he . . dalluminata. 6. lo senplice he . . chella. 7. inella . . chessiparte.

124. 1. ecquela - . . alchū. 3. chonposta ecquella . oppiu.

125. 3. ecquella. 4. chome sarebe ī . . a ī parte. 5. ochopata. 6. po . . corp"o". 7. a ī muro ī br e . . oposita. 8. detta . . apūto dāta. 9. chessi troua. 10. Quela . . seperata . apare . ilume. 11. ala pala. 12. chamino.

Br. M. 171 a] **126.**

COME SON DI 2 RAGIONI LUMI ²L'UNO SEPA-
RATO E L'ALTRO CŌGIV̄TO · ³AI CORPI.

⁴Separato · è quello che illumina ⁵il corpo:
cōgivnto · è quella par⁶te del corpo allumi-
nato da esso lu⁷me; l'uno lume si dimāda
primi⁸tiuo e l'altro dirivatiuo; ⁹e cosi sono
di 2 nature ōbre, ¹⁰l'una primitiva e ōbra
dirivatiua; ¹¹primitiva è quella · ch'è appic-
cata ai ¹²corpi, dirivatiua è quella ¹³che si
separa dai corpi, portādo ¹⁴ī se alle parieti
de'mvri la forma ¹⁵della sua cagione.

HOW THERE ARE 2 KINDS OF LIGHT, ONE
SEPARABLE FROM, AND THE OTHER INSEPARABLE
FROM BODIES.

Separate light is that which falls upon the
body. Inseparable light is the side of the body
that is illuminated by that light. One is called
primary, the other derived. And, in the same
way there are two kinds of shadow:—One
primary and the other derived. The primary
is that which is inseparable from the body,
the derived is that which proceeds from the
body conveying to the surface of the wall
the form of the body causing it.

Of the various kinds of light (126. 127).

Br. M. 170 b] **127.**

Come sono 2 differẽti lumi ²l'uno si chia-
ma libero e l'altro cōstrẽtto, ³il libero è quello
che libero allumina i corpi, ⁴costretto è quello

How there are 2 different kinds of light;
one being called diffused, the other restricted.
The diffused is that which freely illuminates

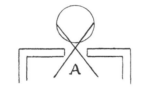

che per qualche ⁵spiracolo o finestra allu-
mina ⁶medesimamẽte i corpi.

objects. The restricted is that which being
admitted through an opening or window
illuminates them on that side only.

C. A. 114 I/I; 355 a] **128.**

Lucie è discacciatore di tenebre, ²onbra
è priuatione di luce, ³lume primitiuo · è
quello ⁴il quale è cagione d'allumina⁵re i
corpi ōbrosi; ⁶e li diriuatiui · lumi sō quelle
⁷parti de'corpi ⁸dal primo lume allumi-
nate; ⁹Onbra primitiua è quella ¹⁰parte de'
corpi che dal lume ¹¹veduta esser nō può;

Light is the chaser away of darkness. Shade
is the obstruction of light. Primary light is that
which falls on objects and causes light and
shade. And derived lights are those portions
of a body which are illuminated by the pri-
mary light. A primary shadow is that side
of a body on which the light cannot fall.

General remarks (128. 129).

126. 2. seperato ealto. 4. [seperato eçquello] seperato ecquello chellumina. 5. ecquella. 8. ellaltro. 11. e que che apicata.
12. ecquella. 13. chessi sepera. 14. ale pariete. 15. chagione.
127. 1. difenti. 2. ciama libro. 3. i libre ecquello . . alumina. 4. costeto ecquelo. 5. alumina. 6. chorpi.
128. 1. discaciatore. 3. ecquello. 4. chagione. 6. el diriuatiui. 7. parte . . corpi [alluminate]. 9. hecquella. 10. chorpi . . da-

127. At the spot marked *A* in the first diagram
Leonardo wrote *lume cōstretto* (restricted light). At

the spot *B* on the second diagram he wrote *lume
libero* (diffused light).

¹²Cōcorso ōbroso e luminoso ¹³è quella soma de' razzi che da ¹⁴corpo ōbroso o luminoso si parto¹⁵no scorrendo per l'arie sanza ¹⁶percussione ōbrosa o luminosa ¹⁷e quel loco che inpediscie e sopra se taglia ¹⁸il concorso de' razzi ōbrosi e lumi¹⁹nosi.

²⁰E quell' ochio meglio conoscierà ²¹le figure de' corpi che infra le parti ²²onbrose e luminose · situato fia.

The general distribution of shadow and light is that sum total of the rays thrown off by a shaded or illuminated body passing through the air without any interference and the spot which intercepts and cuts off the distribution of the dark and light rays.

And the eye can best distinguish the forms of objects when it is placed between the shaded and the illuminated parts.

A. 8*b*] 129.

MĒTIONE DELLE CHOSE · LE QUALI IO DIMANDO · CHE MI SIANO CŌCIEDUTE ²IN NELLE · PROVE DI QUESTA · MIA · PROSPECTIUA.

³Io dimādo che mi sia cōceduto lo · affermare che ciascuno razzo ⁴passando · per aria che sia · d'equale · sottilità scorrino per retta linia · dalla ⁵loro cagione · all' obbiecto o percussione.

MEMORANDUM OF THINGS I REQUIRE TO HAVE GRANTED [AS AXIOMS] IN MY EXPLANATION OF PERSPECTIVE.

I ask to have this much granted me—to assert that every ray passing through air of equal density throughout, travels in a straight line from its cause to the object or place it falls upon.

lume. 11. po. 12. elluminoso. 13. ecquella soma . . razi. 14. olluminoso si parta. 15. scornendo . . sanza percussione. 16. perchussione. 17. ecquellocho . . inpedisscie essopra. 18. chonchorso . . razi. 20. ecquellochio . . chonossciera. 21. decorpi infralle.

129. 1. chose . . sia chōciedute. 2. inelle. 3. chōcieduto lo . affermare [che i razi visuali . e razi luminosi] ' che ciasscuno razo". 4. aria [duna] chessia . . soctilita scorino . . dala. 5. chagione.

FIRST BOOK ON LIGHT AND SHADE.

La ragione perchè il lume à ī se vn solo ciētro si è questa; [2]noi conosciamo chiaramente vn lume grāde avāza[3]re molte volte vna cosa piccola, il quale niēte di meno, [4]benchè lui cō sua razzi la circūdi molto più che mezza, [5]senpre l'onbra apparisce nella prima pariete e senpre si vede;

[6]Poniamo che c | f sia il lume grāde [7]e che | n | sia la cosa opposta gli che genera [8]l'ōbra nella pariete, e che | a · b sia la pariete; [9]chiaro apparisce che il grā lume nō cōducerebbe [10]l'onbra | n · alla parictc; ma perchè il lume à ī se [11]ciētro, provo sperimētādo, l'onbra si cōduce alla [12]pariete, come lo figura | m | o | t | r .

The reason by which we know that a light radiates from a single centre is this: We plainly see that a large light is often much broader than some small object which nevertheless—and although the rays [of the large light] are much more than twice the extent [of the small body]—always has its shadow cast on the nearest surface very visibly.

Let c f be a broad light and n be the object in front of it, casting a shadow on the plane, and let a b be the plane. It is clear that it is not the broad light that will cast the shadow n on the plane, but that the light has within it a centre is shown by this experiment. The shadow falls on the plane as is shown at m o t r.

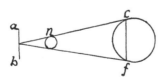

[13]Perchè ī due o dināzi ai dua occhi, [14]rappresentatovi 3 cose si faño 2.

[15]Perchè liuellādo vna dirittura cō 2 mire la prima apparisce [16]falsa: dico

[13]Why, to two [eyes] or in front of two eyes do 3 objects appear as two?

Why, when you estimate the direction of an object with two sights the nearer

130. 1. ilume. 2. noi choi chogniossiamo. 3. chosa .. mene. 4. beneche lui cho .. razi .. circhūdi .. m[eza]. 5. apparissce. 7. e che | a | sia la chosa .. gienerare. 9. aparirebe il .. chonducerebe. 11. ciētro pro sperimētādo lʊnbra schōduce. 12. chomel fighura. 13. dueo odināza ai dua. 14. rapresentatovi .. chose. 15. chō .. apparisscie. 16. dicho chellochio ..

130. 13. In the original MS. no explanatory text is placed after this title-line; but a space is left for it and the text beginning at line 15 comes next.

che l'ochio portãdo con seco jfinite linie le quali [17]sono appicate overo vnite cō le sopravenienti che si partono dalle cose [18]vedute e solo la linia di mezzo d'essa sēsuale è quella che conosce [19]e givdica ȷ corpi e colori, tutte l'altre sono false e bugiarde; [20]e quãdo tu porrai 2 cose distanti vno gomito l'una dall'altra [21]e che la prima sia appresso all'ochio, la superfizie della prima [22]rimarrà in alto piv cōfusa che la secōda, la ragiō si è [23]che la prima è vinta da maggior nvmero di linie false che [24]la secōda, però è piv dubbiosa.

appears confused. I say that the eye projects an infinite number of lines which mingle or join those reaching it which come to it from the object looked at. And it is only the central and sensible line that can discern and discriminate colours and objects; all the others are false and illusory. And if you place 2 objects at half an arm's length apart if the nearer of the two is close to the eye its form will remain far more confused than that of the second; the reason is that the first is overcome by a greater number of false lines than the second and so is rendered vague.

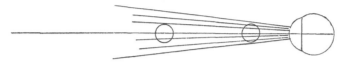

[25]Il lume fa questo medesimo, perchè negli effetti delle [26]sue linie e massime nell'opere di prospettiva è molto simi[27]le all'occhio; e 'l suo ciētro porta il uero nella ripruova [28]dell'onbre · e quãdo la cosa posta gli dinãzi sarà troppo [29]presta vīta da' razzi tristi mostrerà ōbra grãde e spropor[30]zionata e mai terminata; ma quãdo la cosa che à a giene[31]rare l'ōbra taglierà i razzi del lume e sarà apresso alla [32]percussione allora l'ombra s'aviene buona e massime [33]quãdo il lume sarà discosto, perchè il razzo del cētro [34]nella lunga distãzia à meno cōpagnia di razzi falsi · [35]perchè le linie del l'ochio, e solari e altre linie luminose, [36]scorrēdo per l'aria cōuiene a loro osservare retta diri[37]ttura; se già nō fussino ipedite per l'aria piv spessa o piv rara [38]rimarebbero in alcuna parte torte; ma se l'aria è net[39]ta di grossezze o di umidità quelle osseruerãno la loro retta [40]natura, senpre portando ī dirieto alla lor derivazio[41]ne la cagione del lor rōpimento, e se sarà l'occhio li sa[42]rà givdicato 'l ronpimēto per colore come per fazione o grãdezza; [43]Ma se la pariete di detto rōpimēto avrà ī se alcuno piccolo foro [44]il quale ētri in abitazione oscura nō per tītura ma per priva[45]ziō di lume: vedrai le linie entrare per detto forame li [46]portano nella secōda pariete tutta la forma del lor nascimēto, [47]si per colore come per fazione;

Light acts in the same manner, for in the effects of its lines (=rays), and particularly in perspective, it much resembles the eye; and its central rays are what cast the true shadow. When the object in front of it is too quickly overcome with dim rays it will cast a broad and disproportionate shadow, ill defined; but when the object which is to cast the shadow and cuts off the rays near to the place where the shadow falls, then the shadow is distinct; and the more so in proportion as the light is far off, because at a long distance the central ray is less overcome by false rays; because the lines from the eye and the solar and other luminous rays passing through the atmosphere are obliged to travel in straight lines. Unless they are deflected by a denser or rarer air, when they will be bent at some point, but so long as the air is free from grossness or moisture they will preserve their direct course, always carrying the image of the object that intercepts them back to their point of origin. And if this is the eye, the intercepting object will be seen by its colour, as well as by form and size. But if the intercepting plane has in it some small perforation opening into a darker chamber—not darker in colour, but by absence of light—you will see the rays enter through this hole and transmitting to the plane beyond all the details of the

Ma ogni cosa sarà sotto sopra; [48]Ma quãdo e' sarà tãto dal forame al' ultima percussione delle [49]linie, quãto è da lor nascimẽto, sarà la percussione per grandezza a [50]ri-nascimẽto delle linie, [52]ītersegarsi e gie[53]nerare 2 piramidi [54]colle pūte īsieme [55]e le basi opposite; [56]sia | a | b il nascimento delle linie, [57]sia | d | e la prima pariete; sia c | [58]il forame dov'è la intersegazione [59]delle linie; sia · f · g · l'ultima pa-riete: [60]troverai 'l a nell'ultima pa-riete a percussione [61]rimanere di sotto nel luogo del g e 'l · b · di sotto [62]risalire di sopra nel luogo del f; [63]chiaro appa-rirà ali sperimẽtatori che ogni [64]corpo luminoso à per se una virtù recõdita che è ciẽ-tro, dal [65]quale e al quale capitano tutte le linie [66]gie-nerate dalla luminosa super-ficie e di li [67]ritornano o ri-saltano j̄ fuori, e se non ãno īpedimento [68]si spargeranno per l'aria.

object they proceed from both as to colour and form; only every thing will be upside down. But the size [of the image] where the lines are reconstructed will be in proportion to the relative distance of the aper-ture from the plane on which the lines fall [on one hand] and from their origin [on the other]. There they intersect and form 2 pyramids with their point meeting [a common apex] and their bases opposite. Let a b be the point of origin of the lines, d e the first plane, and c the aperture with the intersection of the lines; f g is the inner plane.

You will find that a falls upon the inner plane below at g, and b which is below will go up to the spot f; it will be quite evi-dent to experimenters that every luminous body has in itself a core or centre, from which and to which all the lines radiate which are sent forth by the surface of the luminous body and reflected back to it; or which, having been thrown out and not intercepted, are dispersed in the air.

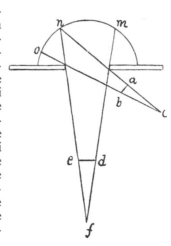

C. 8 a] 131.

I RAZZI ONBROSI E LUMINOSI · SONO · DI MAGGIORE · POTENTIA · E VALITUDINE · NELLE · PUNTE LORO CHE NE' LATI.

THE RAYS WHETHER SHADED OR LUMINOUS HAVE GREATER STRENGTH AND EFFECT AT THEIR POINTS THAN AT THEIR SIDES.

[2]Benchè le punte delle lu-minose piramidi s'astẽdino in õbro sisiti e quelle delle [3]pira-midi õbrose discorrino ī lumi-nosi lochi, e che infra le lumi-nose [4]egli nasca da maggiore basa l'una che l'altra, nõ di meno, se per cagiõ di uarie [5]lunghezze esse luminose pi-ramidi pervengono a equale grossezze d'ãgoli saran[6]no di pari lume infra loro e il simile farãno le piramidi õbrose, come [7]si dimostra nelle tagliate pira-midi a · b · c e cosi d e f che benchè elle nascano [8]da uarie grãdezze di base · pur son si-mili di grãdezza e di lume.

Although the points of lumi-nous pyramids may extend into shaded places and those of pyra-mids of shadow into illuminated places, and though among the luminous pyramids one may start from a broader base than another; nevertheless, if by rea-son of their various length these luminous pyramids acquire an-gles of equal size their light will be equal; and the case will be the same with the pyra-mids of shadow; as may be seen in the intersected pyramids a b c and d e f, which though their bases differ in size are equal as to breadth and light.

sechõda . . nasscimẽto. 47. cholore chome . . chosa. 48. Mquãda . . perchussione. 49. nasscimẽto . . perchusione per ghan-deza. 50. a rianassimẽto. 51. + li +. 52. ītersegharsi. 53. piramida. 54. chole. 55. elle base. 56. nassimẽto. 58. dove lãterseghazione. 60. perchussione. 61. luogho. 62. luogho. 63. aparira alissperimẽtatori. 64. chorpo . . ape serecõdita eccietro. 65. chapitano. 67. esse nonãno īpe. 68. sessparghã per laria.

131. 1. razi . . elluminosi . . maggiore. 2. benchelle . . piramide . . ecquelle. 3. piramide . . dischorrino . . infral[loro]eluminose. 4. enascha . . maggiore . . chellaltra . . chagiõ. 5. lungeze . . piramide peruegino . . grosseze. 6. infralloro ellsimile . . piramide . . chome. 7. piramide . . echosi . . benchelle nasscino. 9. di uarie . . simile . . grãdeza.

51—55. This supplementary paragraph is indicated as being a continuation of line 45, by two small crosses.

Ash. I, 3*a*] **132.**

Che differētia · è da lumi ²a lustri e come i lustri ³nō sono in nel nvmero de co⁴lori ed è saziare di bianco ⁵e nascie ne'stremi de ⁶bagniati corpi; Il lume è ⁷del colore della cosa doue ⁸nascie come oro o ariēto o ⁹simile cosa.

Of the difference between light and lustre; and that lustre is not included among colours, but is saturation of whiteness, and derived from the surface of wet bodies; light partakes of the colour of the object which reflects it (to the eye) as gold or silver or the like.

Ash. I. 3*b*] **133.**

DE'COLMI · DE LUMI CHE SI VOLTANO E TRAS-MUTANO ²SECONDO · CHE SI TRASMUTA · L'OCHIO VEDITORE D'ESSO CORPO.

³Poniamo · che 'l corpo detto sia questo tōdo qui d'acāto · figurato, e che il lume ⁴sia · il pūto *a* · e che la parte del corpo · alluminata sia · *b* · *c*, e che l'ochio ⁵sia nel pūto *d*: dico che 'l lustro perchè è tutto · per tutto e tutto nella parte ⁶che stādo nel pūto *d*, che il lustro · parrà nel pūto · *c* · e tāto quāto l'ochio si tras⁷mvterà da · *d* · all' · *a* tanto il lustro si trasmuterà da *c* · a · *n*.

OF THE HIGHEST LIGHTS WHICH TURN AND MOVE AS THE EYE MOVES WHICH SEES THE OBJECT.

Suppose the body to be the round object figured here and let the light be at the point *a*, and let the illuminated side of the object be *b c* and the eye at the point *d*: I say that, as lustre is every where and complete in each part, if you stand at the point *d* the lustre will appear at *c*, and in proportion as the eye moves from *d* to *a*, the lustre will move from *c* to *n*.

H.² 42*b*] **134.**

DE PICTURA.

²I lumi de' lumi cioè il lustro di qualūque ³cosa non sarà situato · nel mezzo ⁴della · parte · alluminata ·, āzi farà tāste · mutazioni · quāte · farà · l'ochio ri⁶guardatore · di quello.

OF PAINTING.

Heigh light or lustre on any object is not situated [necessarily] in the middle of an illuminated object, but moves as and where the eye moves in looking at it.

E. 31*b*] **135.**

DEL LUME E LUSTRO.

²Che differētia è dal lume al lustro ³che si dimostra nella superfitie ⁴tersa delli corpi opachi?

⁵Li lumi che si gienerāno nelle super-⁶fitie terse delli corpi opachi sa⁷ranno in-mobili ne' corpi inmo⁸bili, ācora che l'ochio d'essi vedito⁹re si · mvova; Ma li lustri sa-¹⁰ran sopra li medesimi corpi in tāti ¹¹lochi della sua superfitie quāti sono ¹²li siti dove l'ochio si move.

OF LIGHT AND LUSTRE.

What is the difference between light and the lustre which is seen on the polished surface of opaque bodies?

The lights which are produced from the polished surface of opaque bodies will be stationary on stationary objects even if the eye on which they strike moves. But reflected lights will, on those same objects, appear in as many different places on the surface as different positions are taken by the eye.

132. 2. lusstri echome ilusstri. 3. inel . . decho. 4. saziaredi *doubtful*. 6. chorpi Elume. 7. cholore dela chosa. 8. chome. 9. chosa.

133. 1. chessi . . trassmutano. 2. sechondo chessi trassmuta. 3. dachāto. 4. chella . . chorpo . . chellochio. 5. dicho. 6. che-lustro para . . ettāto . . sistra. 7. trassmutera.

134. 2. lusstro. 3. chosa . . mezo. 5. quāto.

135. 1. ellustro. 2. differētia . . lustro so. 3. [p] che si dimosstra nella superfitie [del]. 4. [li \\\\ cho] terse . . chorppi oppachi. 5. chessi. 6. chorpi oppachi. 7. chorpi. 8. āchora chellochio. 9. Mallilusstri. 10. chorpi. 12. dove lhio si move. 13. chorpi.

QUALI CORPI SON QUEL¹⁴LI CHE HANNO LUME
SĀZA LUSTRO?

¹⁵Li corpi opachi che avrā superfitie densa ¹⁶e aspra nō gienerāno mai lustro ¹⁷in alcuno loco della sua parte al¹⁸luminata.

QUALI CORPI SŌ QUELGLI ²⁰CHE AVRĀ LUSTRO
E NŌ PAR²¹TE LUMINOSA?

²²Li corpi opachi densi con dēsa ²³superfitie son quelgli che ànno tutto il lustro in ²⁴tanti lochi della · parte alluminata quāti ²⁵sono li siti che possino ricievere l'ango²⁶lo della incidentia del lume e dell'ochio; ma ²⁷perchè tale superfitie spechia tutte le cose cir²⁸custāti, la alluminata nō si cono²⁹scie in tal parte del corpo alluminato.

WHAT BODIES HAVE LIGHT UPON THEM WITHOUT LUSTRE?

Opaque bodies which have a hard and rough surface never display any lustre in any portion of the side on which the light falls.

WHAT BODIES WILL DISPLAY LUSTRE BUT NOT LOOK ILLUMINATED?

Those bodies which are opaque and hard with a hard surface reflect light [lustre] from every spot on the illuminated side which is in a position to receive light at the same angle of incidence as they occupy with regard to the eye; but, as the surface mirrors all the surrounding objects, the illuminated [body] is not recognisable in these portions of the illuminated body.

Br. M. 171 a]　　　**136.**

Ogni ¹/₂ d'ōbra e lume cōgiū²to a' corpi ōbrosi si dirizza al ³mezzo del suo lume primitiuo. ⁴Ogni lume e ōbre si ritrae ⁵a linie pirimidali; ⁶è neciessario che il mezzo ⁷di ciascuna · ōbra risguardi il mezzo ⁸del suo lume per linia retta che passi il ciētro ¹⁰d'esso corpo; ¹¹il mezo del lume sarà a, ¹²dell'ōbra fia · b. ¹³[ancora i corpi ōbrosi circūscritti ¹⁴da ōbre e lume conviē · che 'l mez¹⁵zo di ciascuno si dirizzi al ciētro d'esso corpo ¹⁶e sia linia retta dall'uno all'altro mezzo passā-¹⁷do al ciētro].

The middle of the light and shade on an object in light and shade is opposite to the middle of the primary light. All light and shadow expresses itself in pyramidal lines. The middle of the shadow on any object must necessarily be opposite the middle of its light, with a direct line passing through the centre of the body. The middle of the light will be at a, that of the shadow at b. [Again, in bodies shown in light and shade the middle of each must coincide with the centre of the body, and a straight line will pass through both and through that centre.]

The relations of luminous to illuminated bodies.

W. I.　　　**137.**

PRUOVA COME OGNI ²PARTE DI LUME FA UNO
³PŪTO.

⁴Benchè le palle · a · b · c ⁵abī lume da vna finestra ⁶niēte di meno se seguiterai ⁷le linie delle sue ōbre vedrai ⁸a quelle fare ītersegatione ⁹e pūto · nel angolo · n ·

SHOWS HOW LIGHT FROM ANY SIDE CONVERGES TO ONE POINT.

Although the balls a b c are lighted from one window, nevertheless, if you follow the lines of their shadows you will see they intersect at a point forming the angle n.

Experiments on the relation of light and shadow within a room (137—140).

14. cheà lume saza lusstro. 15. chorpi "oppachi" che arā. 16. easspra no .. lusstro. 17. alchuna [po] locho. 20. arā lusstro.
21. luminoso. 22. chorpi oppachi [chonass] chon. 23. cheantutto. 24. quāto. 25. cheppossino .. langho. 27. chose.
28. chusstāte [la allume] lo .. nō si chon.

136. 1. ellume. 2. accorpi .. diriza. 3. mezo. 4. lumeme. 5. allinie piramidale. 6. mezo. 7. mezo. 13. circhūscritti. 14. ōbrellume convie chōuie chel me. 15. dirizi. 16. essia .. dalluno alaltro mezo.

137. 1. chome. 2. fa î. 3. benchelle balle. 6. seghuiterai. 7. ōbr"e". 8. acquele .. īterseghatione.

136. In the original MS., at the spot marked *a* of the first diagram Leonardo wrote *primitiuo*, and at the spot marked *c—primitiva* (primary); at the spot marked *b* he wrote *dirivatiuo* and at *d deriuatiua* (derived).

137. The diagram belonging to this passage is slightly sketched on Pl. XXXII; a square with three balls below it. The first three lines of the text belonging to it are written above the sketch and the six others below it.

Ash. I. 20*b*] **138.**

Ogni ōbra fatta da' corpi si dirizza colla linia del mezzo ²a vn solo · ³punto · fatto per ītersegatione di linie luminose ⁴in nel mezzo

Every shadow cast by a body has a central line directed to a single point produced by the intersection of luminous lines

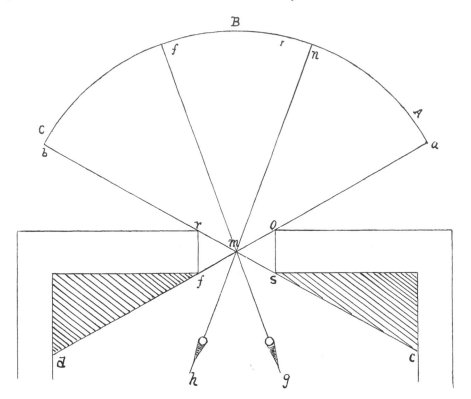

dello spatio e grossezza · della · finestra; ⁵la ragione promessa · di sopra · chiaramēte appare per isperiēza, īperochè ⁶se figurerai vno · sito colla · finestra a tramōtana la quale · sia · *s · f* · ⁷vederai all' orizzōte di levāte produrre vna · linia che toccādo li 2 āgoli del⁸la finestra · *o · f* · capiterà in · *d* · e l' orizzōte di ponēte produrrà la sua ⁹linia toccando li altri 2 āgoli della finestra · *r s* · e finirà in · *c* · e questa ¹⁰intersegatione viene appūto · nel · mezzo dello spatio e della grossezza della ¹¹finestra; ācora ti cōfermerai meglio questa ragione a porre due basto¹²ni · come nel loco di · *g · h* · vi vederai la linia fatta dal mezzo del' ōbra ¹³reale · dirizzarsi al ciētro · *m* ||| e coll' orizzōte · *n · f*.

in the middle of the opening and thickness of the window. The proposition stated above, is plainly seen by experiment. Thus if you draw a place with a window looking northwards, and let this be *s f*, you will see a line starting from the horizon to the east, which, touching the 2 angles of the window *o f*, reaches *d*; and from the horizon on the west another line, touching the other 2 angles *r s*, and ending at *c*; and their intersection falls exactly in the middle of the opening and thickness of the window. Again, you can still better confirm this proof by placing two sticks, as shown at *g h*; and you will see the line drawn from the centre of the shadow directed to the centre *m* and prolonged to the horizon *n f*.

138. 1. diriza . . mezo. 4. inel mezo . . grosseza. 5. apare. 6. figurerai . . cola. 7. alorizōte . . produre . . tochādo . . de. 8. i. d. ellorizōte . . produra. 9. tochando li ātri 2 . . effinira . . ecquesta. 10. mezo . . grossezza. 11. āchora . . meglo . . apore. 12. locho . . linia [del me] fatta . . mezo. 13. dirizarsi . . lorizōte.

138. *B* here stands for *cerchio del' orizonte tramontano* on the original diagram (the circle of the horizon towards the North); *A* for *levante* (East) and *C* for *ponēte* (West).

Ash. I. 20 a] **139.**

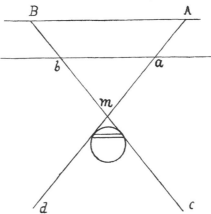

Ogni ōbra cō tutte sue varietà che per distātia cresce [2]per larghezza piv · che la · sua · cagione, le sue linee esteriori [3]si cō-givngono · insieme · īfra il lume · e 'l corpo ōbroso. [4]Questa propositione · chiaramēte appare e si cōferma [5]dalla · esperiē-za, jperochè se · a · b · fia una finestra sāza al-cuna tramezzatura, [6]l'a-ria · luminosa · che sta da destra · in · a · è vista, da sinistra in · d · e l'a[7]ria che sta · da · sinistra allu-mina da destra nel pun-to · c e dette linie s'inter-[8]secano · nel pūto m.

Every shadow with all its variations, which becomes larger as its distance from the object is greater, has its external lines intersecting in the middle, between the light and the object. This proposition is very evident and is confirmed by experience. For, if a b is a window without any object inter-posed, the luminous at-mosphere to the right hand at a is seen to the left at d. And the at-mosphere at the left illu-minates on the right at c, and the lines intersect at the point m.

Ash. I. 20 a] **140.**

Ogni corpo ōbroso si truova īfra · 2 · pi-ramidi [2]vna scura e l'altra luminosa, l'una si uede e l'altra no, [3]e questo solo accade ·

Every body in light and shade is situated between 2 pyramids one dark and the other luminous, one is visible the other is not.

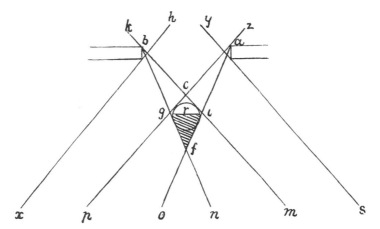

quādo il lume ētra per una finestra; [4]fa cōto · che · a · b · sia la finestra e che · r · sia il corpo ōbroso il lume [5]destro z · passa il corpo da lato sinistro del corpo ōbroso · in · g · e va in · p ·, il lume [6]sinistro · k passa a detto corpo nel lato · destro · in · i · e va ·

But this only happens when the light enters by a window. Supposing a b to be the window and r the body in light and shade, the light to the right hand z will pass the object to the left and go on to p; the light to the left at k will pass to the right of the object at i and

139. 1. chō . . chresscie. 2. largeza . . chella. 3. cōgivngano . . chorpo. 4. Questa [cosa chiaramente] propositione . . apare . . essi. 5. dala . . fia ĩ finestra . . tramézzatura. 6. in . d . ella.

140. 1. piramide. 2. uno scuro e laltro luminoso luno . . ellaltro. 3. ecquesto . . achade . . ilume . . per ĩ finestra. 4. chorpo

139. A here stands for *levante* (East), B for *ponente* (West).

in · *m* · e queste 2 linie s'īter⁷segano ī · *c* · e li faño piramide · dipoi *a* · *b* · tocca il corpo ōbroso in · *i* · *g* · e fa sua ⁸piramide · in · *f* ; *i* · *g* · *f* fia oscuro · perchè mai egli può vedere il lume · *a* · *b* ; ⁹ · *i* · *g* · *c* · sēpre fia luminoso perchè egli uede · il lume.

go on to *m* and the two lines will intersect at *c* and form a pyramid. Then again *a b* falls on the shaded body at *i g* and forms a pyramid *f i g*. *f* will be dark because the light *a b* can never fall there; *i g c* will be illuminated because the light falls upon it.

C. 10 *a*]

141.

Light and
shadow with
regard to the
position of
the eye
(141—145).

Tutti · i corpi ōbrosi di maggior grādezza che la · popilla · i quali s'interporranno · infra l'occhio · e'l corpo · luminoso · si dimo²streranno d'oscura · qualità.

Every shaded body that is larger than the pupil and that interposes between the luminous body and the eye will be seen dark.

³L'ochio · posto · infra 'l · corpo · luminoso · E i corpi · da esso · lume · alluminati · vedrà i detti corpi · sāza alcun ōbra.

When the eye is placed between the luminous body and the objects illuminated by it, these objects will be seen without any shadow.

Ash. I. 12 *a*]

142.

Come i 2 lumi che mettino in mezzo ²vno corpo da 2 lati piramidato di basse ³piramidi lo lasciano sāza ōbra.

Why the 2 lights one on each side of a body having two pyramidal sides of an obtuse apex leave it devoid of shadow.

Br. M. 171 *a*]

143.

Il corpo ōbroso situato ²infra il lume e l'ochio nō mo³strerà mai di se parte lumino⁴sa se l'ochio nō uede tutto il ⁵lume originale.

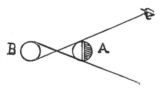

A body in shadow situated between the light and the eye can never display its illuminated portion unless the eye can see the whole of the primary light.

Tr. 20]

144.

L'ochio · che si troverà · in mezzo fra l'onbra e i lumi circūda²tori · delli · ōbrosi ·

The eye which looks (at a spot) half way between the shadow and the light which

[luminoso] ōbroso ilume. 5. pasa . . ecque 2. 7. piramida . . effa. 8. piramida . . oschuro . . mailipo . . ilume. 9. percheli uede.
141. 1. Tucti i chorpi "ōbrosi" di magior grādeza chella . . quali [saranno situatı] "sīnterporanno" infrallocchio el chorpo. 2. steranno dosschura. 3. chorpo . . chorpi . . vedera . . chorpi . . sanzalchun.
142. 1. comeme i 2 . . imezo. 2. chorpo. 3. piramide.
143. 2. infralume. 3. stera. 5. lume [primiti] originale.
144. 1. chessi . . mezo . . ellumi circhūda. 2. chorpi . . vedera . . chorpi . . magiore. 3. sieno . rischōtarsi . chōsecho.

141. The diagram which in the original stands above line 1 is given on Plate II, No 2. Then, after a blank space of about eight lines, the diagram Plate II No 3 is placed in the original. There is no explanation of it beyond the one line written under it.

142. The sketch illustrating this is on Plate XLI No 1.

143. *A* stands for *corpo* (body), *B* for *lume* (light).
144. In both these diagrams *A* stands for *lume* (light) *B* for *ombra* (shadow).

corpi · vedrà · in essi corpi le maggiori ōbre
³ che in esse · sieno · a riscōtrarsi · cō seco ·

surrounds the body in shadow will see that
the deepest shadows on that body will meet

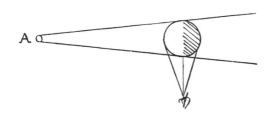

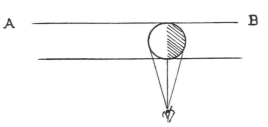

infra equali āgoli ⁴ cioè della incidētia vi-
suale.

the eye at equal angles, that is at the same
angle as that of sight.

Ash. I. 17 a]

145.

DELLA DISCRETIONE DEL' ONBRE DE' SITI ²E DELLE COSE POSTE Ī QUELLI.

OF THE DIFFERENT LIGHT AND SHADE IN VARIOUS ASPECTS AND OF OBJECTS PLACED IN THEM.

³ Se il sole fia · nel' oriēte e guarderai
īuerso · occidēte · vedrai ⁴ tutte le cose lu-
minate essere īteramēte private d' ōbra
perchè vedi ciò che vede 'l sole, e se ri-
guar⁵ di a mezzodì e tramōtana · vedrai
tutt' i corpi essere circūdati da ⁶ ōbra · e
lume perchè vedi quello che nō vede · e vede
il sole e se riguarderai īverso il cāmino del
sole, tutti ⁷ i corpi ti mostreranno la loro
parte aūbrata, perchè quella parte ⁸ nō può
essere veduta dal sole.

If the sun is in the East and you
look towards the West you will see every
thing in full light and totally without shadow
because you see them from the same side
as the sun: and if you look towards the
South or North you will see all objects in
light and shade, because you see both the
side towards the sun and the side away
from it; and if you look towards the coming
of the sun all objects will show you their
shaded side, because on that side the sun
cannot fall upon them.

Tr. 29]

146.

¶ J labri della finestra · che sieno · allumi-
nati · da 2 · vari · lumi ² d' equale · chiarezza ·
nō metteranno · lume
dētro · all' abitatione ³ d'
equale qualità. ¶
⁴ Se · b · fia · vna · cā-
dela · e a · c sia · il nostro
· emisperio; ⁵ l' uno · e
l' altro allumina i labri
della · finestra · m · n ·
ma il lu⁶ me · b · non allu-
mina · se nō · f · g · e lo
emisperio · a · c · allumi-
nerà ⁷ insino in · d · e.

The edges of a window which are illu-
minated by 2 lights of equal degrees of
brightness will not re-
flect light of equal
brightness into the cham-
ber within.

If b is a candle and
a c our hemisphere
both will illuminate the
edges of the window m
n, but light b will only
illuminate f g and the
hemisphere a will light
all of d e.

The law of
the incidence
of light.

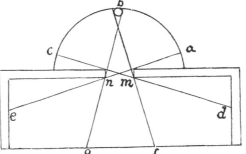

145. 3. vederai. 4. tute lecosse . . dōbra "perce vedi co ce vedel sole" esse. 5. mezodi ettramōtana vederai . . chorpi . . cir-
chūdati. 6. lume "perce vedi quelo ce nō vede . e vede il sole" esse . . chamino. 7. chorpi . . mostrerano . . quela. 8. po.
146. 1. finesstra . . lumi [che]. 2. chiareza. 4. chādela et. 5. alumina . . finesstra. 6. aluma . . ello emissperio.

Ash. I. 28*b*] **147.**

Pittura.

¶[3]Quella · parte · dell' obietto · che ricieve sopra se il razzo lu[4]minoso · infra equali · angoli · Quella · fia · più ch'altra [5]parte d'esso obbietto · luminosa.¶

¶[6]E quella parte che fia ferita da luminoso · razzo [7]infra angoli · piv · disequali · quà apparirà mē lumi[8]nosa.¶

Of painting.

That part of a body which receives the luminous rays at equal angles will be in a higher light than any other part of it.

And the part which the luminous rays strike between less equal angles will be less strongly illuminated.

147. 2. [Illume che ferisscie lobietto infra cqueliangoli]. 3. soprse . . razo. 6. Ecquella . . cheffia . . razo . . aparira.

SECOND BOOK ON LIGHT AND SHADE.

148.

QUELLA PARTE DEL CORPO ŌBROSO FIA · MENO LUMINOSA [2] CHE FIA VEDUTA DA MINORE QUĀTITA DI LUME.

[3] La parte del corpo · *m* è primo grado di lume perchè lì vede tutta la finestra · *a · d ·* [4] per la linia · *a · f ·*, *n* è 'l secōdo grado perchè lì uede il lume · *b · d ·* per la linia · *b · e ·*, *o* è 'l ter[5]zo grado perchè lì vede il lume · *c · d ·* per la linia · *c · h ·* | *p* è 'l penoltimo perchè lì ue [6] de · *c · d ·* per la linea · *d · v ·* | *q* è l'ultimo grado perchè lì non uede nessuna parte [7] della finestra ·

[8] Tanto quāto · *c · d ·* [9] entra in · *a · d ·* tanto [10] è piv scuro · *n · r · s* [11] che · *m ·* e tutto l'altro [12] canpo sanza ōbra.

THAT PORTION OF A BODY IN LIGHT AND SHADE WILL BE LEAST LUMINOUS WHICH IS SEEN UNDER THE LEAST AMOUNT OF LIGHT.

That part of the object which is marked *m* is in the highest light because it faces the window *a d* by the line *a f*; *n* is in the second grade because the light *b d* strikes it by the line *b e*; *o* is in the third grade, as the light falls on it from *c d* by the line *c h*; *p* is the lowest light but one as *c d* falls on it by the line *d v*; *q* is the deepest shadow for no light falls on it from any part of the window.

In proportion as *c d* goes into *a d* so will *n r s* be darker than *m*, and all the rest is space without shadow.

Gradations of strength in the shadows (148. 149).

149.

Ogni · lume · che cade · sopra · ai corpi ōbrosi · īfra equali · āgoli tiene il primo [2] grado · di chiarezza · e quello fia piv scuro che ricieve l'āgoli meno · equali [3] e il lume · o l'onbre faño loro · ofitio per piramide; [4] l'angolo · *c ·* tiene · jl primo · grado · di chiarezza ·

The light which falls on a shaded body at the acutest angle receives the highest light, and the darkest portion is that which receives it at an obtuse angle and both the light and the shadow form pyramids. The angle *c* receives the highest grade of light because it is directly in

148. 1. Quela . . chorpo . . luminoso. 2. cheffia. 4. . *a · f.* el secōdo. 6. novede. 11. ettutto.
149. 1. chade . . chorpi. 2. chiareza ecquelo. 3. ollonbre. 4. chiareza. 5. ettutto lorizōte . . pocha diferētia mettano. 6. socto .

148. The diagram belonging to this chapter is No 1 on Plate III. The letters *a b c d* and *r* are not reproduced in facsimile of the original, but have been replaced by ordinary type in the margin.

5—12. The original text of these lines is reproduced within the diagram.—Compare No 275.

149. The diagram belonging to this chapter is

No 2 on Plate III. In the original it is placed between lines 3 and 4, and in the reproduction these are shown in part. The semi circle above is marked *orizonte* (horizon). The number 6 at the left hand side, outside the facsimile, is in the place of a figure which has become indistinct in the original.

perchè gli uede · tutta · la finestra · a · b · 5e tutto l'orizzōte del cielo·m·x·, l'angolo· d· fa poca · differētia da · c · perchè li āgoli che lo mettono 6ī mezzo · nō sono tāto difformi di proportione · quāto li altri · di sotto · e mācagli solamēte quella 7parte dell'orizzōte · ch'è tra · y · x · bench'eli acquisti altrettāto dall'opposito lato · nōdimeno la sua linia è di po8ca potēza perchè il suo angolo · è minore · che'l suo cōpagno, l'angoli · e · i · fiā di minore lume 9perchè · egli · non vede manco · il lume · m · s · e 'l lume v · x · e i loro āgoli sono assai disformi: l'angolo 10· k · e l'angolo · f · sono messi in mezzo ciascū · per se · da āgoli · molto diformi l'uno dal' altro e però fieno 11di poco lume · perchè in · k · vede solamēte il lume · p · t · e in · f; nō uede se nō t · q · | o · g · fia l'ultimo 12grado di lume perchè lì nō uede nessuna parte del lume del'orizzōte · e sono quelle le linie che vn altra 13volta ricōpōgono una · piramide · simile · alla piramide · c · la quale · piramide · l si troverà 14nel primo grado · d'ōbra, perchè ācora lei cade īfra · equali āgoli e essi āgoli · si dirizzano 15e si sguardano per una · linia retta che passa dal cientro del corpo ōbroso e capita al mezzo del lume; 16le spetie luminose mvltiplicate · ne' termini della · finestra ne' pūti · a · b · fāno 17chiarore · che circūda l'ōbra diriuatiua creata dal corpo ōbroso ne' lochi 4 · e 6 · 18le spetie oscure si mvltiplicano · jn · o · g e finiscono · in · 7 · e 8.

front of the window a b and the whole horizon of the sky m x. The angle a differs but little from c because the angles which divide it are not so unequal as those below, and only that portion of the horizon is intercepted which lies between y and x. Although it gains as much on the other side its line is nevertheless not very strong because one angle is smaller than its fellow. The angles e i will have less light because they do not see much of the light m s and the light v x and their angles are very unequal. The angle k and the angle f are each placed between very unequal angles and therefore have but little light, because at k it has only the light p t, and at f only t q; o g is the lowest grade of light because this part has no light at all from the sky; and thence come the lines which will reconstruct a pyramid that is the counterpart of the pyramid c; and this pyramid l is in the first grade of shadow; for this too is placed between equal angles directly opposite to each other on either side of a straight line which passes through the centre of the body and goes to the centre of the light. The several luminous images cast within the frame of the window at the points a and b make a light which surrounds the derived shadow cast by the solid body at the points 4 and 6. The shaded images increase from o g and end at 7 and 8.

C. A. 46 b; 144 a]

150.

On the intensity of shadows as dependent on the distance from the light (150—152).

Quel corpo si dimostra più ōbroso che sia alluminato da minor luminoso 2e quel luminoso alluminerà minor parte del corpo ōbroso il quale 3li fia più vicino; per la cōuersa tanto maggior quātità n'allu4minerà quāto egli fia più lontano.

5Quel lume che sia minore dell' ōbroso n'alluminerà tanto minor quātità quan6to li fia più vicino e per la cōuersa farà essendo più remoto; Ma 7quando il lume sarà maggiore che l'ōbroso allor tanto più ne veurà 8dell'ōmbroso quāto esso fia più vicino e per il contrario farà essēdo pi9v remoto.

The smaller the light that falls upon an object the more shadow it will display. And the light will illuminate a smaller portion of the object in proportion as it is nearer to it; and conversely, a larger extent of it in proportion as it is farther off.

A light which is smaller than the object on which it falls will light up a smaller extent of it in proportion as it is nearer to it, and the converse, as it is farther from it. But when the light is larger than the object illuminated it will light a larger extent of the object in proportion as it is nearer and the converse when they are farther apart.

e e māchali. 7. orizōte .. daloposito. 8. cha potēza .. chōpagnio langolo. 9. mancha ilume. 10. ellangolo .. imezo. 12. delume .. orlzōte .. quele. 13. volto .. ī piramide .. ala. 14. chade .. ecquali .. dirizano. 15. essi .. per ī . linia .. chapia .. mezo. 18. effiniscano.

150. 1. dimosstra. 2. ecquel. 3. [fia] lifia piu .. magior. 4. quāto eli fia. 5. Quelume chessia .. quātita q̄. 7. cquando .. chellōbroso .. tanta.

C. A. 130b; 398b] **151.**

¶Quella parte della cosa ²alluminata sarà piv lumi³nosa, la qual fia piv vici⁴na alla cavsa del suo lume.¶

That portion of an illuminated object which is nearest to the source of light will be the most strongly illuminated.

H.² 18a] **152.**

Quella parte dell'ōbra primitiva ²sarà meno oscura che fia piv ³lōtana dai sua stremi.

⁴L'ōbra dirivativa che cōfi⁵na colla primitiua fia piv ⁶oscura d'essa primitiva.

That portion of the primary shadow will be least dark which is farthest from the edges.

The derived shadow will be darker than the primary shadow where it is contiguous with it.

E. 17a] **153.**

Quella parte del corpo opaco sa²rà più aōbrato o allumināta che fia ³più vicina all'ōbroso che la oscura ⁴o luminoso che l'alumina.

⁵Le cose vedute infra lume e l'ōbre si di⁶mostrerā di maggiore rilievo che quelle ⁷che sō nel lume o nell'ōbre.

That portion of an opaque body will be more in shade or more in light, which is nearer to the dark body, by which it is shaded, or to the light that illuminates it.

Objects seen in light and shade show in greater relief than those which are wholly in light or in shadow.

On the proportion of light and shade (153—157).

S. K. M. II.² 76b] **154.**

DE PROSPETTIVA.

³Le parti aōbrate e alluminate de'corpi ⁴opachi saraño nella medesima ⁵proportione di chiarezza e oscurità ⁶qual fiē quelle de' loro obbietti.

OF PERSPECTIVE.

The shaded and illuminated sides of opaque objects will display the same proportion of light and darkness as their objects [6].

G. 32a] **155.**

DE PICTURA.

²Li termini e figura di qualunche ³parte de' corpi ōbrosi male si conos⁴cono nelle ōbre e ne' lumi loro, ma ⁵nelle parti interposte infra li lumi ⁶e l'onbre le parti d'essi corpi sono ī⁷primo grado di notitia.

OF PAINTING.

The outlines and form of any part of a body in light and shade are indistinct in the shadows and in the high lights; but in the portions between the light and the shadows they are highly conspicuous.

E. 15a] **156.**

PICTURA.

²J̄fra li corpi di uarie oscurità, pri³vati d'un medesimo lume, tal proportione ⁴fia

OF PAINTING.

Among objects in various degrees of shade, when the light proceeds from a single source,

151. 1—4 R.
152. 2. osschura. 3. dasua. 4. chōfi. 5. cholla. 6. oschura.
153. 1. chorpo oppacho. 2. cheffia. 3. chella osscura. 4. olluminoso chellalumina. 5. chose . . infrallume ellōbre. 6. mossterra. 7. chessō.
154. 2. [le parte obrose elluminose]. 3. parte. 5. ciareza e osscurita.
155. effigura. 3. chorpi. 4. chānelle. 5. interposste infralli. 6. ellonbre le parte . . chorpi.
156. 2. J̄fralli chorpi . . osschurita. 3. proportio. 4. infralle. 5. osscurita.

154. 6. The meaning of *obbietti* (objects) is explained in no 153, lines 1—4. — Between the title-line

and the next there is, in the original, a small diagram representing a circle described round a square.

infra le loro ōbre qual fia la pro⁵portione delle loro naturali oscurità ⁶e il medesimo ài ad intendere delli lor lumi.

there will be the same proportion in their shadows as in the natural diminution of the light and the same must be understood of the degrees of light.

E. 32 δ] 157.

Il lume particulare è causa di dare ²migliore rilievo alli corpi onbrosi che ³lo vniversale come si mostra il para⁴gone d'una parte di campagnia alluminata ⁵dal sole e vna aōbrata dal nuvolo che sol si ⁶allumina del lume vniversale dell'aria.

A single and distinct luminous body causes stronger relief in the object than a diffused light; as may be seen by comparing one side of a landscape illuminated by the sun, and one overshadowed by clouds, and so illuminated only by the diffused light of the atmosphere.

157. 1. Ilume partichulare e chausa. 2. chorpi . . chel. 3. chome si mosstra. 4. ghone . . chanpagnia. 6. delume.

THIRD BOOK ON LIGHT AND SHADE.

W. 232 *b*]

158.

Onbra diriuativa non . è in essere sanza
[2]lume primitivo; pruovasi per la prima
[3]di questo che dicie¶ tenebre essere inte-
grale pri[4]vatiō di lucie, e ōbra è alle-
uiation di te[5]nebre e di lucie, e tanto parti-
cipa più [6]o mē delle tenebre che della
lucie, quāto la [7]tenebra è in se corrotta
da essa lucie.

Derived shadow cannot exist without
primary shadow. This is proved by the first
of this which says: Darkness is the total
absence of light, and shadow is an allevia-
tion of darkness and of light, and it is
more or less dark or light in proportion as
the darkness is modified by the light. _{Definition of derived shadow (158. 159).}

E. 32 *b*]

159.

Onbra è diminuitiō di lume.
[2]Tenebre è privatione di lucie.
[3]L' onbra si diuide in due parti delle
[4]quali la prima è detta onbra pri[5]mitiva, la
secōda è l' onbra diriuativa; [6]senpre l' onbra
primitiva si fa basa [7]dell' onbra diriuativa.
[8]Li termini dell'onbre dirivative [9]son
retti linii.

Shadow is diminution of light.
Darkness is absence of light.
Shadow is divided into two kinds, of which
the first is called primary shadow, the second
is derived shadow. The primary shadow is
always the basis of the derived shadow.
The edges of the derived shadow are
straight lines.

158. 1. non [po] "e in" essere. 2. per la p[a]. 3. essere ingral pri. 5. eddi . . ettanto. 6. ōmē delle. 7. tenebre . . conrocta.
159. 1. honbra. 3. parte. 4. he decta. 5. ellonbra. 8. dirivativi. 10. diminuisscie la osscu. 12. eppiu.

158. The theory of the *ombra dirivativa*—a tech-
nical expression for which there is no precise Eng-
lish equivalent is elaborately treated by Leonardo.
But both text and diagrams (as Pl. IV, 1—3 and
Pl. V) must at once convince the student that the
distinction he makes between *ombra primitiva* and
ombra dirivativa is not merely justifiable but scien-
tific. *Ombra dirivativa* is by no means a mere abstract
idea. This is easily proved by repeating the experi-
ment made by Leonardo, and by filling with smoke the

room in which the existence of the *ombra dirivativa*
is investigated, when the shadow becomes visible.
Nor is it difficult to perceive how much of Leonardo's
teaching depended on this theory. The recognised,
but extremely complicated science of cast shadows—
percussione dell' ombre dirivatve as Leonardo calls them
—is thus rendered more intelligible if not actually
simpler, and we must assume this theory as our
chief guide through the investigations which
follow.

[10]Tanto più diminuisce la oscu[11]rità dell' onbra diriuativa, quãto essa [12]è più remota dall' ōbra primitiva.

The darkness of the derived shadow diminishes in proportion as it is remote from the primary shadow.

C. 7 b]

160.

ONBRA E LUME.

SHADOW AND LIGHT.

Different sorts of derived shadows (160—162). [2]Tre · sono · le figure · dell' ōbre · inper-ochè · se la · materia che fa · l' onbra · è pari · al lume ·, l' ombra è simile a vna co-

The forms of shadows are three: inasmuch as if the solid body which casts the shadow is equal (in size) to the light, the

[3]lonna · nè à · termine alcuno. [4]Se la · materia è maggiore · che 'l lume : l' onbra · sua · è simile · a vna · retrosa e contraria pira-mide e la sua longitudine [5]è sanza alcuno · termine; [6]Ma se la materia · è minore · che la · lucie · l' ombra fia simile a vna · piramide · ed è finita come si dimostra [7]nelle · eclissi della luna.

shadow resembles a column without any termination (in length). If the body is larger than the light the shadow resembles a truncated and inverted pyramid, and its length has also no defined termination. But if the body is smaller than the light, the shadow will resemble a pyramid and come to an end, as is seen in eclipses of the moon.

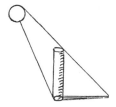

E. 31 a]

161.

DELLE ŌBRE DIRIVATIVE [2]SENPLICI.

OF SIMPLE DERIVED SHADOWS.

[3]La senplicie ōbra dirivativa è [4]di due sorti cioè vna finita in [5]lunghezza e due in-

The simple derived shadow is of two kinds: one kind which has its length defined,

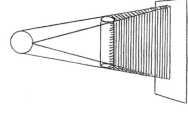

finite [6]e la finita è piramidale [7]e delle infi-[8]nite vna ve n' è colonnale e [9]l' altra dila-tabile, e tutte tre son [10]di lati rettilini; Ma l' onbra cō[11]corrēte cioè piramidale na-sci[12]e dall' onbroso minore del lumino[13]so, e la colōnale nasce da on[14]broso equale al luminoso, e la dila[15]tabile da ōbroso maggiore del lu[16]minoso ecc.

and two kinds which are undefined; and the defined shadow is pyramidal. Of the two undefined, one is a column and the other spreads out; and all three have rectilinear outlines. But the converging, that is the pyramidal, shadow proceeds from a body that is smaller than the light, and the co-lumnar from a body equal in size to the light, and the spreading shadow from a body larger than the light; &c.

160. 2. ōbr . . sella . . cheffa . . lume [lonbra] l' ombra essimile . . cho. 3. alchuna. 4. Sella materia . . magiore . . essimile . . chontraria . . ella. 5. alchuno. 6. Massella . . chella . . chome. 7. nello.

161. 3. he. 4. sorte ciee. 5. lungheza eddue. 6. ella . . he. 8. cholunnale e el. 9. ettutte. 10. rectilini [Mallonbra] cō. 11. chor-rēte . . nassci. 13. ella cholūnale nasscie. 14. ella. 17. chō. 18. posste. 19. onbra . . conposste. 20. sortti . . cholūnali. 21. tabile.

DELLE ŌBRE DIRIUATIVE CŌ[18]POSTE.

[19]Le onbre deriuatiue conposte sono [20]di due sorti cioè colōnali e dila[21]tabili.

OF COMPOUND DERIVED SHADOWS.

Compound derived shadows are of two kinds; that is columnar and spreading.

E. 32 a]　　　　　　　　　　**162.**

DE ONBRA.

[2]L'onbre dirivative sono di tre na[3]ture, delle quali l'una è dilatabile, l'altra co-[4]lunnale, la terza concorrēte al sito della [5]intersegatione delli sua lati, li quali dopo ta[6]le intersegatione sono d'īfinita lunghez[7]za overo rettitudine; E se tu diciessi ta[8]le onbra essere terminata nell'angolo [9]della congiūtione de sua lati e nō passare piv oltre, questo si ni[10]ega · perchè nella prima dell'onbre sopra ò pro[11]vato ¶quella cosa essere interamente termi[12]nata della qual parte alcuna non eccede [13]li sua termini¶ il che qui in tale onbra si ve[14]de il contrario conciosiachè mediante che [15]nascie tale onbra dirivativa nascie manife[16]stamēte la figura di due piramidi ōbrose, le quali nel[17]li sua angoli son congiūte; addunque [18]se per l'aversario la prima piramide ōbrosa è ter-[19]minatrice dell'onbra dirivativa col suo ango[20]lo donde nascie, addunque la seconda pira[21]mide ōbrosa · dicie l'aversario esser cavsa[22]ta dall'angolo e nō dal corpo ōbroso; e questo si [23]niega coll'aiuto della 2ª di questo che [24]dicie ¶l'ōbra essere vn'acci-dēte creato dalli cor[25]pi ōbrosi interposti infra 'l sito d'essa ōbra [26]e 'l corpo luminoso¶, e per questo è chia[27]rito l'onbra nō dal angolo dell'onbra dirivativa [28]esser gienerata, ma sol dal corpo ōbroso ecc. [29]Se lo sperico ōbroso fia alluminato dal lumi-[30]noso di lūga figura, l'onbra che si gienera dalla [31]parte più lunga d'esso luminoso fia di termini [32]men noti che è quella che si gienera dalla larghez[33]za del medesimo lume; E questo si prova per la pas[34]sata che disse quell'ōbra essere di termini mē noti [35]ch'è creata da maggiore luminoso e de cōverso, quel[36]la essere di termini più noti che s'allumina da minor luminoso.

OF SHADOW.

Derived shadows are of three kinds of which one is spreading, the second columnar, the third converging to the point where the two sides meet and intersect, and beyond this intersection the sides are infinitely prolonged or straight lines. And if you say, this shadow must terminate at the angle where the sides meet and extend no farther, I deny this, because above in the first on shadow I have proved: that a thing is completely terminated when no portion of it goes beyond its terminating lines. Now here, in this shadow, we see the converse of this, in as much as where this derived shadow originates we obviously have the figures of two pyramids of shadow which meet at their angles. Hence, if, as [my] opponent says, the first pyramid of shadow terminates the derivative shadow at the angle whence it starts, then the second pyramid of shadow —so says the adversary—must be caused by the angle and not from the body in shadow; and this is disproved with the help of the 2nd of this which says: Shadow is a condition produced by a body casting a shadow, and interposed between this shadow and the luminous body. By this it is made clear that the shadow is not produced by the angle of the derived shadow but only by the body casting the shadow; &c. If a spherical solid body is illuminated by a light of elongated form the shadow produced by the longest portion of this light will have less defined outlines than that which is produced by the breadth of the same light. And this is proved by what was said before, which is: That a shadow will have less defined outlines in proportion as the light which causes it is larger, and conversely, the outlines are clearer in proportion as it is smaller.

162. 2. [si] dirivativ. 3. cho. 4. choncorrēte. 5. interseghatione. 6. interseghatione .. dīfinita "righor" lunghe. 7. Essettu "di" ciessi [chella] ta. 8. angholo. 9. della [interseghatione] "congiūtione" dè sua ati. Questo. *The following occurs in the margin* e nō passare piv oltre. 10. egha · perche [terminata] nella p* dellonbre so pro. 11. chosa. 12. alchuna .. eciede. 13. qui [no] in "t" ale onbra sivi. 14. chontrario chonciossiache. 15. nasscie .. nasscie. 16. piramide "ōbrose". 17. angholi son chongiūte [ella]. 18. etter. 19. chol suo angho. 20. nasscie .. sechonda. 21. ōbrosa [perche] . dicie .. chavsa. 22. angholo .. quesso. 23. niegha [medi] choll .. ched. 24. chor. 26. chorpo luminoso) [addunque] e .. quessto. 27. angholo. 29. Sello spericho. 30. lūgha fighura .. chessi. 31. [parte piu] lungha. 32. [chen] "men" noti che ecquella chessi. 33. Ecquesto. 34. cheddisse. 35. magiore. 36. termini mēnoti chessalumina dāminor.

162. The two diagrams to this chapter are on Plate IV, No. I.

H.² 28 *b*] **163.**

On the rela-
tion of deri-
ved and
primary sha-
dow
(163—165).

¶ L'onbra diriuatiua nō fia mai simile ²al corpo dove nascie · se il lume nō sarà della ³figura e grādezza · del corpo ōbroso¶

¶⁴L'ōbra dirivativa nō può essere simile per figura ⁵alla primitiva, se essa nō percuote fra equali ⁶angoli.¶

The derived shadow can never resemble the body from which it proceeds unless the light is of the same form and size as the body causing the shadow.

The derived shadow cannot be of the same form as the primary shadow unless it is intercepted by a plane parallel to it.

Ash. I. 6 *a*] **164.**

COME L'ŌBRA SEPARATA NŌ FIA
²MAI SIMILE PER GRĀDEZZA ALLA SUA CAGIONE.

³Se li razzi luminosi sono, come speriēza cōferma, cavsati da uno solo ⁴pūto e ī corso circulare al suo pūto si vanno disgregādo e sparg⁵ēdo per l'aria, quāto piv s'alontanano piv s'alargano e sēpre la cosa ⁶posta fra lume e la pariete è portata per ōbra maggiore perchè ⁷i razzi che la toccano ⁸givnto lor cō-cor⁹so alla pariete è fat¹⁰to piv largo.

HOW A CAST SHADOW CAN NEVER BE OF THE SAME SIZE AS THE BODY THAT CASTS IT.

If the rays of light proceed, as experience shows, from a single point and are diffused in a sphere round this point, radiating and dispersed through the air, the farther they spread the wider they must spread; and an object placed between the light and a wall is always imaged larger in its shadow, because the rays that strike it[7] would, by the time they have reached the wall, have become larger.

Br. M. 170 *b*] **165.**

Ogni ōbra · separata dal corpo ōbroso ²è tutta della natura e qualità di quella ³ch'è cōgivnta · a esso corpo; ⁴il mezzo della . lūghezza · di ciascuna ōbra ⁵sēpre si dirizza · al mezzo del corpo luminoso; ⁶neciessario è che o⁷gni ōbra ⁸risguardi col · suo mezzo ⁹il mezzo del suo lume.

Any shadow cast by a body in light and shade is of the same nature and character as that which is inseparable from the body. The centre of the length of a shadow always corresponds to that of the luminous body [6]. It is inevitable that every shadow must have its centre in a line with the centre of the light.

E. 31 *a*] **166.**

On the shape
of derived
shadows
(166—174).

DEL'ŌBRA PIRAMIDALE.

²L'onbra piramidale gienerata dal ³corpo parallelo sarà tanto più stret⁴ta che 'l corpo ōbroso, quāto la sēpli⁵ce onbra deriuativa fia taglia⁶ta più distante al suo corpo ōbroso.

OF THE PYRAMIDAL SHADOW.

The pyramidal shadow produced by a columnar body will be narrower than the body itself in proportion as the simple derived shadow is intersected farther from the body which casts it.

163. 1—6 R. 2. nasscie selume. 3. figure e grādeza. 4. dirivativ . . po. 5. percote.
164. 2. grādeza. 3. razi . . da ī solo. 4. circhulare . . vān. 5. essēpre. 6. magiore perche *4.* 7. *4·* i razi . . tocano.
165. 1. ōbr. 2. ettutta . . quela. 3. chorpo. 4. mezo . . lūgeza. 5. diriza . . mezo. 6. [Egli e] neciessario è cheo. 7. gni ōbra [si dirizi al mezo del suo]. 8. [lume] risguardi . . mezo. 9. mezo.
166. 3. chorpo . . strec. 4. chel chorpo. 6. disstante . . chorpo.

164. 7. The following lines are wanting to complete the logical connection.

165. 6. This second statement of the same idea as in the former sentence, but in different words, does not, in the original, come next to the foregoing; sections 172 and 127 are placed between them.

166. Compare the first diagram to No. 161. If we here conceive of the outlines of the pyramid of shadow on the ground as prolonged beyond its apex this gives rise to a second pyramid; this is what is spoken of at the beginning of No. 166.

B. M. 170*b*] **167.**

Quel'onbra separata [2]fia piv lūga · che avrà il lume [3]piv basso.

The cast shadow will be longest when the light is lowest.

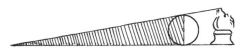

[4]Quell'ōbra separata [5]fia piv brieve, la quale avrà [6]il lume piv alto.

The cast shadow will be shortest when the light is highest.

Tr. 28] **168.**

¶L'onbra primitiva · e dirivativa fia [2]maggiore a essere · cavsata da lume [3]di cādela · che quello dell'aria¶ [4]tāto quāto [5]l'ōbra di-

Both the primary and derived shadow will be larger when caused by the light of a candle than by diffused light. The differ-

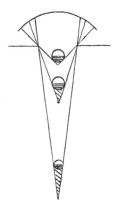
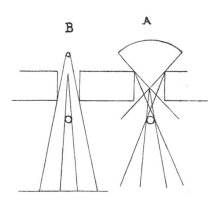

riva[6]tiva · entra [7]la maggiorc nella [8]minor tāto la [9]cavsa della mi[10]nore è piv [11]luminosa che la [12]maggiore.

ence between the larger and smaller shadows will be in inverse proportion to the larger and smaller lights causing them.

Ash. I. 25 *a*] **169.**

QUELLI CORPI · CHE FIENO PIV PROPINQUI | O REMOTI DAL LORO LUME ORIGINALE · FARĀNO PIV [2]O MENO BRIEVE LA LORO · ŌBRA DERIVATIVA.

ALL BODIES, IN PROPORTION AS THEY ARE NEARER TO, OR FARTHER FROM THE SOURCE OF LIGHT, WILL PRODUCE LONGER OR SHORTER DERIVED SHADOWS.

[3]Jfra i corpi d'equal grā[4]dezza quello che da maggior [5]lume alluminato fia avrà [6]la sua ōbra di minore lūghezza; [7]Nello sperimētare · s'afferma · la sopra detta · propositione · per cagione · che 'l corpo [8]*m* · *n* · è

Among bodies of equal size, that one which is illuminated by the largest light will have the shortest shadow. Experiment confirms this proposition. Thus the body *m n* is surrounded by a larger amount of light

167. 1. ombra [sia] separata. 2. ara ilume. 4. Quello ōbra [fia piv] separata. 5. ara. 6. ilume.
168. 2. magiore . . chausata. 3. chādela. 7. magiore nela. 11. chella. 12. magiore.
169. 1. chorpi cheffiano. 3—6 R. 3. chorpi. 4. deza . . magior. 5. ara. 6. lungeza. 7. chagione. 8. abraciato. 9. cheffa . .

168. In the diagrams *A* stands for *celo* (sky), *B* for *cădela* (candle).

169. The diagram, given on Pl. IV, No. 2, stands in the original between lines 2 and 7, while the text

of lines 3 to 6 is written on its left side. In the reproduction of this diagram the letter *v* at the outer right-hand end has been omitted.

abbracciato da piv · parte di lume · che 'l corpo ·
p · q · come di sopra si dimostra; [9]Diciamo ·
che v · c · a · b · d · x · sia il cielo che fa il
lume originale · e che · s · t · sia una [10]finestra
dōde ētri le spetie luminose · e cosi · m · n ·
|| p · q · sieno i corpi ōbrosi [11]cōtraposti · a
detto · lume; m · n · sarà di minore ōbra de-
riuatiua perchè la sua ōbra ori[12]ginale fia ·
poca e il lume diriuatiuo fia · grāde perchè
ancora fia grande [13]il lume originale c · d ·
|| p · q · avrà piv ōbra diriuatiua perchè la
sua · ōbra [14]originale · fia maggiore; il lume
suo derivatiuo · fia minore · che quello del
corpo [15]m · n · perchè quella · parte dell' emis-
perio a · b · che l'allumina è minore [16]che
l'emisperio c · d alluminatore del corpo · m · n.

than the body p q, as is shown above. Let
us say that v c a b d x is the sky, the
source of light, and that s t is a window
by which the luminous rays enter, and so
m n and p q are bodies in light and shade
as exposed to this light; m n will have a
small derived shadow, because its original
shadow will be small; and the derivative
light will be large, again, because the origi-
nal light c d will be large and p q will have
more derived shadow because its original
shadow will be larger, and its derived light
will be smaller than that of the body m n
because that portion of the hemisphere a b
which illuminates it is smaller than the hemi-
sphere c d which illuminates the body m n.

W. II.]

170.

Quella proportione che
à la linia b c [2]colla linia f
c tale avrà la scurità [3]m
colla oscurità n.

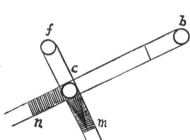

The shadow m bears the
same proportion to the sha-
dow n as the line b c to
the line f c.

Ash. I. 25 I a]

171.

PITTURA.

Infra l'onbre · di pari ·
qualità · quella che sia · piv
· visina · all'ochio [3]appari-
rà · di minore oscurità.

[4]Perchè l'onbra · e · a ·
b è in primo · grado di
scurità [5]b · c · è in secō-
do, c · d è in terzo? La
ragione · si è che [6]e · a ·
b · non vede il cielo in al-
cuna parte · adūque [7]nes-
suna · parte · del cielo ·
uede · lui · e per questo è
priva[8]to del lume origi-
nale · · b · c · vede la parte

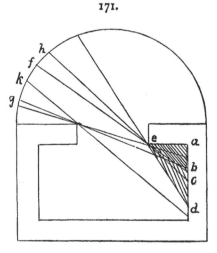

OF PAINTING.

Of different shadows of
equal strength that which is
nearest the eye will seem
the least strong.

Why is the shadow e
a b in the first grade of
strength, b c in the se-
cond; c d in the third?
The reason is that as from
e a b the sky is nowhere
visible, it gets no light
whatever from the sky,
and so has no direct [pri-
mary] light. b c faces
the portion of the sky f

sia ĩ. 10. dōdētri . . echosi. 12. pocha ellume . . anchora. 13. c · d · || [A] p · q · ara. 14. magiore ilume. . . chorpo.
15. perche [lemisper] quella . . chellalumina. 16. chorpo.
170. 2. ara. 3. osscurita.
171. 2. Infrallonbre . . chessia. 3. aparira . . osscurita. 4. schurita. 5. sechōdo. 6. il cieno in alchuna. 9. dacquela. 10. ma-

del cielo $^9 f \cdot g \cdot$ e da quella è alluminata: $c \cdot$ d. vede il cielo $^{10} h \cdot k \cdot$, essendo · visto $c \cdot d \cdot$ da maggiore · soṁa di cielo ^{11}che non è · $b \cdot$ $c \cdot$, e ragione vole che sia · piv luminoso, ^{12}e cosi insino · a cierta · distantia il muro · $a \cdot$ $d \cdot$ senpre ^{13}rischiarerà per le dette ragioni · insino a tāto che la ^{14}scurità · del'abitatione vīcierà · il lume della finestra.

g and is illuminated by it. $c \, d$ faces the sky at $h \, k$. $c \, d$, being exposed to a larger extent of sky than $b \, c$, it is reasonable that it should be more lighted. And thus, up to a certain distance, the wall $a \, d$ will grow lighter for the reasons here given, until the darkness of the room overpowers the light from the window.

Br. M. 170*b*]

172.

^2Quādo il lume dell'aria ^3sarà costretto a luminare i corpi 4ōbrosi, essēdo essi corpi equidistāti ^5dal ciētro d'essa finestra, quello che si ^6troverà piv traverso farà maggiore 7ōbra dopo se.

When the light of the atmosphere is restricted [by an opening] and illuminates bodies which cast shadows, these bodies being equally distant from the centre of the window, that which is most obliquely placed will cast the largest shadow beyond it.

Ash. I. 24*b*]

173.

Quelli · corpi sparsi situati in abitatione alluminata ^2da una · sola · finestra faranno · l'ōbra · diriuativa · piv · o · meno · brieue secōdo ^3che fia piv o meno a riscōtro · d'essa finestra. 4¶Jfra l'onbre fatte ^5da equali corpi ^6e ī disequali distātie ^7dallo spiraculo lo^8ro alluminatore quel^9la fia piv lūga che 10à il suo corpo meno ^{11}luminoso: e tāto fia ^{12}più · luminoso · l'ū ^{13}che l'altro corpo, quā^{14}to l'ombra sua fia ^{15}piv · curta · che l'al^{16}tra.¶ ^{17}Quella · proportione ^{18}che à in se · $n \cdot m \cdot e \cdot v \cdot$ $^{19} k$ cō · $r \cdot t \cdot$ et · $v \cdot x$, ^{20}tale avrà onbra x cō21 $4 \cdot y \cdot$

^{23}La ragione che i corpi ōbrosi, che si trovano situati piv dritti · al mezzo della finestra, ^{24}fanno l'obre piv brieui che quelli situati ī trauerso · sito si è, che vedono mag^{25}giore la finestra ī propia forma, e i corpi traversi la uederanno in iscorto; a quello ^{26}di mezzo la finestra pare grāde, ai traversi pare piccola, quel di mezzo vede

These bodies standing apart in a room lighted by a single window will have derivative shadows more or less short according as they are more or less opposite to the window. Among the shadows cast by bodies of equal mass but at unequal distances from the opening by which they are illuminated, that shadow will be the longest of the body which is least in the light. And in proportion as one body is better illuminated than another its shadow will be shorter than another. The proportion $n \, m$ and $e \, v \, k$ bear to $r \, t$ and $v \, x$ corresponds with that of the shadow x to 4 and y.

The reason why those bodies which are placed most in front of the middle of the window throw shorter shadows than those obliquely situated is:—That the window appears in its proper form and to the obliquely placed ones it appears foreshortened; to those in the middle, the window shows its full size, to the oblique ones it appears smaller; the one in the middle faces the whole hemisphere that is $e \, f$ and those on the side have only a strip; that is $q \, r$ faces $a \, b$;

giore soma. 12. chosi. 13. risciarera . . attāto. 14· surita . . ilume.
172. 1. [lōbra reale sia piv lūga qu̅a̅to piv]. 2. [si trova] Quādo ilume. 3. cosstreto. 5. al . . chessi . . magiore.
173. 1. chorpi [separati chessi trōueranno] sparsi. 2. da ī sola . . ōmeno . . sechōdo. 3. cheffia. 4. īfrallonbre. 5. ecquali. 6. e īdisegli. 7. spirachulo. 8. alumatore que. 9. la effia piv lūga. 10. fia il suo chorpo m̅. 11. ettāto fi"a". 13. chellaltro chorpo qu"a". 15. chorta. 18. n . m . ∞ "e" . v . 19. k chō . r. 20. ara onbra + c"ō". 22. [situati]. 23. chessi . . mezo. 24. lōbra . . queli . . sie [questa] che vede ma. 25. propia . . uechano . . acquelo. 26. mezo . . picola . .

173. Compare the diagram on Pl. IV, No. 3. In the original this drawing is placed between lines 3 and 22; the rest, from line 4 to line 21, is written on the left hand margin.

l'emisperio [27]grāde cioè · e · f · e quelli da lato lo uedono piccolo cioè q · r · vede a · b · e cosi m · n · vede [28]c · d: il corpo di mezzo perchè à maggiore quātità di lume che quelli da cāto, è allumi[29]nato assai piv basso che'l suo cientro, e però · l' ōbra è piv breve, e tāto quāto a · b · entra [30]in · e · f · tanto la piramide g · 4 · entra in · l · y · appunto. [31]Ogni mezzo · d' ōbra dirivativa passa per 6¹/₂ e si dirizza col mezzo dell' ōbra [32]originale e col ciētro del corpo ōbroso e del lume deriuatiuo [3]e col mezzo della finestra · e in vltimo col mezzo di quella [34]parte del lume originale fatto dal' emispe[35]rio cieleste; [36] · y · h · è il mezzo dell' ōbra · diriuatiua · l · h · del' ōbra originale · l · sia il mezzo del corpo ōbroso [37]l · k del lume deriuativo · v sia il mezzo della finestra · e · sia l'ultimo mezzo del lume [37]originale fatto da quella parte dell' emisperio del cielo che lumina il corpo ōbroso.

and m n faces c d; the body in the middle having a larger quantity of light than those at the sides is lighted from a point much below its centre, and thus the shadow is shorter. And the pyramid g 4 goes into l y exactly as often as a b goes into e f. The axis of every derivative shadow passes through 6¹/₂ [31] and is in a straight line with the centre of the primary shadow, with the centre of the body casting it and of the derivative light and with the centre of the window and, finally, with the centre of that portion of the source of light which is the celestial hemisphere. y h is the centre of the derived shade, l h of the primary shadow, l of the body throwing it, l k of the derived light. v is the centre of the window, e is the final centre of the original light afforded by that portion of the hemisphere of the sky which illuminates the solid body.

C. 21 a] **174.**

Quanto più l'onbra · dirivatiua s'allontana · della primitiua · tanto [2]più · participa · di chiarezza.

[3]Tal proportione quale à il diamitro · dell' onbra · diriuatiua [4]con quello della · primitiua, · tale · trouerai · nella oscurità dell' ōbra [5]primitiua · con quello · della · diriuatiua.

[6]a · b · sia il diamitro dell' onbra primitiua · c · d · sia · quello della · di[7]riuatiua ·, dico che ētrando come vedi a · b · 3 · volte in · d · c · [8]che l'onbra · d · c · fia · 3 · volte · piv · chiara che quella di a · b.

[9]se la grandezza del corpo · allumināte · supera · quella · del corpo [10]alluminato · accaderà · onbrosa · intersegatione · dopo la quale

THE FARTHER THE DERIVED SHADOW IS PROLONGED THE LIGHTER IT BECOMES.

You will find that the proportion of the diameter of the derived shadow to that of the primary shadow will be the same as that between the darkness of the primary shadow and that of the derived shadow.

[6] Let a b be the diameter of the primary shadow and c d that of the derived shadow, I say that a b going, as you see, three times into d c, the shadow d c will be three times as light as the shadow a b. [8]

If the size of the illuminating body is larger than that of

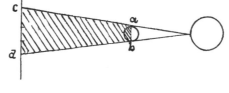
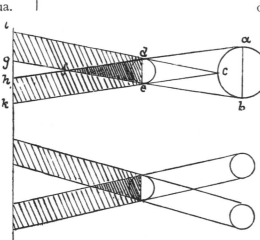

mezo. 27. ecquelli . . vedano picolo. 28. mezo . . magiore . . queli . . chāto e alumi. 29. asai. 30. piramida. 31. mezo . . dirivativa | "passa per 6¹/₂" esi diriza chol mezo. 32. chol . . chorpo . . delume. 33. chol [uacho] mezo . . chol mezo. 34. del lu [emisperio lume] me. 36. mezo . . sie . . mezo. 37. sie . . mezo . . sie . . mezo. 38. dacquela.

174. 2. chiareza. 3. [Quanto quella] tal proportione "quale" che il. 4. chon quello . . talle osscur"i"ta. 5. chonquello. 6. dela. 8. chellaquella. 9. grandeza . . chorpo . . del chorpo. 10. achadera. 11. cho chorreranno . . . chonchorsicho.

31. *passa per* 6¹/₂ (passes through 6¹/₂). The meaning of these words is probably this: Each of the three axes of the derived shadow intersects the centre (*mezzo*) of the primary shadow (*ombra originale*) and, by prolongation upwards crosses six lines.

This is self evident only in the middle diagram; but it is equally true of the side figures if we conceive of the lines 4 *f, x n v m, y l k v,* and 4 *e,* as prolonged beyond the semicircle of the horizon.

174. 6—8. Compare No. 177.

[11]l'onbre correranno · in due diuersi · concorsi ·, co[12]me · se · da · due · diuersi · lumi diriuassino.

the illuminated body an intersection of shadow will occur, beyond which the shadows will run off in two opposite directions as if they were caused by two separate lights.

K.³ 31 b] **175.**

PITTURA.

[2]L'onbra diriuatiua [3]è tāto più potēte quan[4]to ell'è piv vicina [5]alli sua principi.

ON PAINTING.

The derived shadow is stronger in proportion as it is nearer to its place of origin.

On the relative intensity of derived shadows (175—179)

Ash. I. 15 a] **176.**

COME L'ŌBRE PER LŪGA DISTĀTIA SI PERDONO.

[2]L'onbre · si perdono ī lūnga distātia · perchè · la grā quātità · dell'aria luminosa, [3]che si truova īfra l'ochio · e la · cosa · veduta ·, tigne le sue ōbre d'essa cosa nel suo colore.

HOW SHADOWS FADE AWAY AT LONG DISTANCES.

Shadows fade and are lost at long distances because the larger quantity of illuminated air which lies between the eye and the object seen tints the shadow with its own colour.

Tr. 22] **177.**

LUME

Quāte volte · a · b · ētra in [2]c b · tāto fia piv scuro [3]a b · che · c · d.

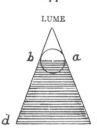

a b will be darker than c d in proportion as c d is broader than a b.

C. A. 36 a; 115 a] **178.**

Pruovasi perchè l'onbra o p c h è tanto piv oscura, [2]quanto ella più s'avicina alla linia p · h, ed è tanto più [3]chiara quāto essa più s'avicina alla linia o c, e sia il [4]lume a b finestra, e la pariete oscura, dove tale finestra [5]è collocata, sia b s cioè vn de lati d'essa pariete.

[6]Addunque diremo la linia p h essere più oscura che [7]altra parte dello spatio · o p c h, perchè essa linia ve[8]de ed è veduta da tutto lo spatio ōbroso

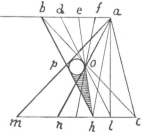

It can be proved why the shadow o p c h is darker in proportion as it is nearer to the line p h and is lighter in proportion as it is nearer to the line o c. Let the light a b, be a window, and let the dark wall in which this window is, be b s, that is, one of the sides of the wall.

Then we may say that the line p h is darker than any other part of the space o p c h, because this line faces the whole surface in shadow of

177. In the original MS. the word *lume* (light) is written at the apex of the pyramid.

178. In the original the diagram is placed between lines 27 and 28.

della pariete *b s·*, ma ⁹la linia *o c* è piv chiara che altra parte d'esso spa¹⁰tio *o p c h* perchè essa linia vede lo spatio lu-¹¹minoso *a b*.

¶¹²Doue l'ōbra è maggiore o minore o equale ¹³al corpo ōbroso sua origine.¶

[¹⁴Di prima della qualità de lumi divisi.

DELL'ONBRA COMPOSTA *F, R, C, H* ¹⁶NATA DAL LUME PARTICULARE.

¹⁷L'onbra composta *f r c h* è in tal modo conditionata ¹⁸che quanto ella si fa più remota dal suo lato intrinsi-¹⁹co, tanto perde della sua oscurità; pruovasi:

²⁰Sia adunque il luminoso *d a* e l'ōbroso *f n*, e sia ²¹*a e* vna delle parieti laterali della finestra cioè ²²*d a*; Dico per la 2ª, la superfitie d'ogni corpo par²³ticipa del color del suo obbietto, adunque il lato *r c*, ch'è ²⁴veduto dalla oscurità *a e*, participa d'essa oscuri²⁵tà e similmēte il lato estrinsico ch'è veduto dal lume ²⁶*d a* participa d'esso lume e cosi abiā definito tale stremo ²⁷del mezzo cōtenuto dalli stremi]

²⁸Questa si diuide in 4 parti ²⁹prima delli stremi cōtenē³⁰ti l'onbra conposita, ³¹seconda, Dell'onbra cōposita ³²dentro alli sua stremi.

the wall *b s*. The line *o c* is lighter than the other part of this space *o p c h*, because this line faces the luminous space *a b*.

Where the shadow is larger, or smaller, or equal the body which casts it.

[First of the character of divided lights [14].

OF THE COMPOUND SHADOW *F, R, C, H* CAUSED BY A SINGLE LIGHT.

The shadow *f r c h* is under such conditions as that where it is farthest from its inner side it loses depth in proportion. To prove this:

Let *d a*, be the light and *f n* the solid body, and let *a e* be one of the side walls of the window that is *d a*. Then I say—according to the 2nd [proposition]: that the surface of any body is affected by the tone of the objects surrounding it,—that the side *r c*, which faces the dark wall *a e* must participate of its darkness and, in the same way that the outer surface which faces the light *d a* participates of the light; thus we get the outlines of the extremes on each side of the centre included between them.]

This is divided into four parts. The first the extremes, which include the compound shadow, secondly the compound shadow between these extremes.

C. A. 201 *a*; 597 *a*]

179.

L'OPERATIONE · DEL LUME · COL SUO · CIĒTRO.

Se tutto · il lume · fusse · quello che cavsasse · l'onbre · dopo i corpi a quello · cōtraposti·, converebbe, ³che quello·corpo·, ch'è molto · minore che'l lume ·, facesse · dopo se vn ōbra · piramidale·, e la spe⁴riēza non lo mostrādo · cōuiene · che'l ciētro d'esso lume· sia · quello che facci · tale ofitio.

THE ACTION OF THE LIGHT AS FROM ITS CENTRE.

If it were the whole of the light that caused the shadows beyond the bodies placed in front of it, it would follow that any body much smaller than the light would cast a pyramidal shadow; but experience not showing this, it must be the centre of the light that produces this effect.

osschura. 8. dactutto losspatio. 9. [losspatio] la linia. 10. tio [perche] o p c h . vede \\\\\ 12. magiore ōminoe. 13. chorpo. 15. chonposste. 16. partichulare. 17. chonposta. 19. cho . . osschurita. 20. ellōbroso . . essia. 21. pariete . . fiṇesstra. 22. Dicho . . dongni chorpo. 23. cholor . . ilato. 24. vedvuta . . osschurita . . osschuri. 25. esstrinsicho che veduta. 26. chosi . . stre "me". 29. 4 p"a" p"a" delli. 31. 2 "a" De Dellonbra chonposita.
179. 1. lume . chosuo. 2. settutto . . fussi . . chavsassi . . acquello . . chonverebe. 3. chorpo . . faciessi . . ella. 4. riēza nol

14. *lumi divisi.* The text here breaks off abruptly.
179. The diagram belonging to this passage is between iines 4 and 5 in the original. Comp. the reproduction Pl. IV, No. 4. The text and drawing of

this chapter have already been published with tolerable accuracy. See M. JORDAN: *"Das Malerbuch des Leonardo da Vinci"*. Leipzig 1873, p. 90.

PRUOVA.

[6] *a · b ·* sia la grādezza · del lume · d'una · finestra ·, la quale dia · il lume · a vno · bastone ritto · ī piè [7] da · *a · c ·* e da · *a · d ·* sia dove la finestra tutta · īteramēte da il suo · lume · · Jn · *c · e ·* nō può vedere · quella · parte [8] della · finestra ·, ch'è īfra · *l · b · ·* E simil · mēte · *d · f ·* nō uede · *a ⸴ m ·* e per questa · cagione ī questi · 2 · lochi co⁹mīcia · a stremare · il lume.

PROOF.

Let *a b* be the width of the light from a window, which falls on a stick set up at one foot from *a c* [6]. And let *a d* be the space where all the light from the window is visible. At *c e* that part of the window which is between *l b* cannot be seen. In the same way *a m* cannot be seen from *d f* and therefore in these two portions the light begins to fail.

C. 8*b*] 180.

[2] Quel corpo · ōbroso · che infra equali lumi collocato fia, farà tāte ōbre quā ti fieno i lumi, le quali ōbre fieno tāto piv scure l'una che l'altra, quāto il lume [4] che fia dall'oppo-

A body in light and shade placed between two equal lights side by side will cast shadows in proportion to the [amount of] light. And the shadows will be one darker

Shadow as produced by two lights of different sizes (180. 181).

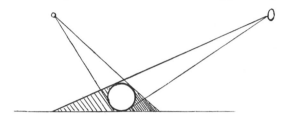 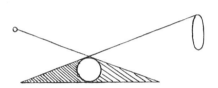

sita parte fia piv visino a esso corpo · che li altri.

[5] Quel corpo onbroso che equalmēte distāte infra 2 lumi situato sia, farà [6] due ōbre tanto piv oscure l'una · che l'altra · quāto · i lumi d'esso cagiō siē maggiori [7] l'una · che l'altra.

than the other in proportion as one light is nearer to the said body than the other on the opposite side.

A body placed at an equal distance between two lights will cast two shadows, one deeper than the other in proportion, as the light which causes it is brighter than the other.

Br. M. 170*b*] 181.

Il lume minore che corpo ōbroso [2] fa l'ombre terminare in esso corpo [3] e fa poca ōbra · mista, e lo vede [4] meno di mezzo; [5] il lume maggiore · che'l corpo ōbroso [6] lo vede piv di mezzo e fa molta ōbra mista.

A light which is smaller than the body it illuminates produces shadows of which the outlines end within [the surface of] the body, and not much compound shadow; and falls on less than half of it. A light which is larger than the body it illuminates, falls on more than half of it, and produces much compound shadow.

mostrādo chōuiene . . cheffacci. 6. grādeza . . pie [c d]. 7. sie . . ītera mēta . . po. 8. Essimil . mēte . . chagione . . iochl cho. 9. ilu:ne.
180. 1—7 R. 1. īnfrae. 2. Quel chorpo . . chollochato . chellaltra. 4. cheffia . . oposita . . chorpo piv chelli. 5. chorpo . . lumi [ch] situato. 6. osschure . . chellaltra . quāto . elumi . . chagiō . magiori 7. chellaltra.
181. 1. ilume . . ōbrso. 3. effa pocha . . mezo. 5. magiore chel chorpo. 6. mezo effa.

6. *bastone* (stick). The diagram has a sphere in place of a stick.

180. In the MS. the larger diagram is placed above the first line; the smaller one between l. 4 & 5.

Ash. I. 5*b*] **182.**

Del' ōbra fatta da uno corpo situato īfra 2 equali lumi.

The effect of light at different distances. Quello corpo che si troverà collocato · īfra 2 equali lumi [4]moverà da se 2 ōbre le quali si dirizzerāno per linia a 2 [5]lumi e se rimoverai detto corpo e farai lo più presso [6]all'uno · de'lumi, l'ombra sua, che si dirizzerà al più propīquo lume, [7]fia di minore oscurità, che quella che si dirizzerà al più lōtano [8]lume.

Of the shadow cast by a body placed between 2 equal lights.

A body placed between 2 equal lights will cast 2 shadows of itself in the direction of the lines of the 2 lights; and if you move this body placing it nearer to one of the lights the shadow cast towards the nearer light will be less deep than that which falls towards the more distant one.

W. L. 145. A*a*] **183.**

Further complications in the derived shadows (183—187). La massima oscurità delle ōbre è la sē[2]plice onbra dirivatiua, perchè essa nō ve[3]de nessun de'due lumi *a b, c d*.
[4]La secōda di minore oscurità è l'ō[5]bra dirivativa *e f n*, e questa è la [6]oscurità minore la metà perchè da vn sol lu[7]me è rischiarata cioè *c d*.
[8]E questa è d'uniforme oscurità natu[9]rale, perchè per tutto vn sol de'due luminosi [10]la vede; Ma si varia colla oscurità [11]accidentale, perchè qùāto più si scosta [12]da tale lume, mē participa della [13]sua chiarezza.

[14]La terza oscurità è l'onbra [15]media, ma questa non è di vniforme [16]oscurità naturale, perchè qùāto più [17]s'avicina alla senplice ōbra diriva[18]tiva, tanto si fa più oscura, e la uni[19]formità vniformemēte difforme acciden[20]tale è quella che la corronpe cioè che quā[21]to più si discosta dalli due luminosi si [22]fa più oscura.

[23]La quarta è l'onbra *k r s*, e questa si fa [24]tanto più oscura di scurità naturale, quanto [25]essa s'avicina al *k s*, perchè mē vede del lu[26]me *a b*, ma per accidentale più perde d'oscu[27]rità, perchè più s'avicina al lume *c d*, e que[28]sta sēpre vede li due lumi.

The greatest depth of shadow is in the simple derived shadow because it is not lighted by either of the two lights *a b, c d*.
The next less deep shadow is the derived shadow *e f n*; and in this the shadow is less by half, because it is illuminated by a single light, that is *c d*.
This is uniform in natural tone because it is lighted throughout by one only of the two luminous bodies [10]. But it varies with the conditions of shadow, inasmuch as the farther it is away from the light the less it is illuminated by it [13].
The third degree of depth is the middle shadow [15]. But this is not uniform in natural tone; because the nearer it gets to the simple derived shadow the deeper it is [18], and it is the uniformly gradual diminution by increase of distance which is what modifies it [20]: that is to say the depth of a shadow increases in proportion to the distance from the two lights.
The fourth is the shadow *k r s* and this is all the darker in natural tone in proportion as it is nearer to *k s*, because it gets less of the light *a b*, but by the accident [of distance] it is rendered less deep, because it is nearer to the light *c d*, and thus is always exposed to both lights.

182. 1. da î corpo. 3. quelo chorpo chessi . . chollochato. 4. muvera ōbre che quali. 5. esse . . detto \|\| corpo effara. 6. de lumi [che allaltro] lombra . . chessi dirizera. 7. oschurita . . chessi dirizera.
183. 1. osschurita ∴ ella. 4. sechōda . . osschurita ello. 5. he *efn* ecquessta ella. 6. osscurita. 7. rissciarata. 8. ecquesta. 9. osschurita. 10. Massi . . cholla osscurita. 11. sisschossta. 12. dattale lume [pi] mē. 14. osschurita ellonbra. 15. macquessta e di. 16. osschurita . . qùāto pi. 18. osscura ella unifor. 20. quela chella . . cioe cheq"ua". 21. disschosta. 22. osschura. 23. hellonbra . . ecquessta. 24. osschura. 26. acidentale . . dosscu. 27. cd ecq. 29. osschurita. 30. ciasscuna.

183. The diagram to this section is given on Pl. V. To the left is the facsimile of the beginning of the text belonging to it.

15. We gather from what follows that *q g r* here means *ombra media* (the middle shadow).
18—20. Compare lines 10—13.

²⁹La quīta è di minore oscurità ³⁰che ciascuna delle altre perchè sen³¹pre vede ū de due lumi interi e tutto ³²o parte dell'altro, e questa tanto ³³più perde d'oscurità quanto ³⁴ella più s'avicina alli due lu³⁵mi, e tanto più quanto più ³⁶s'avicina al lato esteriore *x t*, ³⁷perchè più vede del secōdo lume ³⁸*a b*.

The fifth is less deep in shadow than either of the others because it is always entirely exposed to one of the lights and to the whole or part of the other; and it is less deep in proportion as it is nearer to the two lights, and in proportion as it is turned towards the outer side *x t*; because it is more exposed to the second light *a b*.

C. A. 174*a*; 523*a*]

184.

DELL'ONBRA SENPLICIE.

Perchè nelle intersegationi *a·b* delle due ōbre cōposte ³*e f, m c*, si gienera l'onbra senplicie e cosi in *e h* e *m g*, ⁴e nō si gienera tale ōbra senplicie nelle due altre intersega⁵tioni *c d*, fatte dalle medesime ōbre composte dette di sopra?

RISPOSTA.

⁷Le ōbre conposte son miste di chiaro e di scuro, e ⁸le senplici sō di senplicie oscurità; adūque delli ⁹due lumi *n o* l'uno vede l'ōbre cōposte da vn lato e l'altro ¹⁰vede l'onbre conposte dall'altro, ma nessū lume vede le inter¹¹segatíoni *a b* e però è senplicie ōbra, ma nell'ōbra cōposta ¹²vede l'uno o l'altro lume; e qui nasce vn dubbio ¹³per l'aversario, perchè dicie nelle intersegatiō dell'onbre cōpo¹⁴ste per neciessità vedi li due lumi causa d'esse ōbre, e per ¹⁵questo tali onbre si debbono annullare; concio¹⁶siachè dove nō vede li due lumi, noi diciamo l'ōbra essere ¹⁷senplicie, e dove vede v̄ solo de' due lumi diremo tal'onbra ¹⁸esser cōposta, e dove vede li due lumi, essere ōbra ¹⁹annullata, perchè dove vede li due lumi, nō si gienera ²⁰ōbra di nessuna sorte, ma solo cōpone la chiarezza del cāpo ²¹circūdatore delle ōbre; Qui si rispōde esser vero ²²il detto d'esso aversario, il quale sol fa mentione di quella veri²³tà ch'è ī suo fauore, ma se vi agivgnie il rimanēte, egli cōcluderà ²⁴esser vera la mia proposta, e questo è ²⁵che, se vedendo li due lumi in tale inter²⁶segatione, tali ōbre sarebbono annullate;

OF SIMPLE SHADOWS.

Why, at the intersections *a, b* of the two compound shadows *e f* and *m c*, is a simple shadow produced as at *e h* and *m g*, while no such simple shadow is produced at the other two intersections *c d* made by the very same compound shadows?

ANSWER.

Compound shadow are a mixture of light and shade and simple shadows are simply darkness. Hence, of the two lights *n* and *o*, one falls on the compound shadow from one side, and the other on the compound shadow from the other side, but where they intersect no light falls, as at *a b*; therefore it is a simple shadow. Where there is a compound shadow one light or the other falls; and here a difficulty arises for my adversary since he says that, where the compound shadows intersect, both the lights which produce the shadows must of necessity fall and therefore these shadows ought to be neutralised; inasmuch as the two lights do not fall there, we say that the shadow is a simple one and where only one of the two lights falls, we say the shadow is compound, and where both the lights fall the shadow is neutralised; for where both lights fall, no shadow of any kind is produced, but only a light background limiting the shadow. Here I shall say that what my adversary said was true: but he only mentions such truths as are in his favour; and if we go on to the rest he must conclude that my proposition is true. And that is: That if both lights fell on the

31. ettutto. 32. dellaltro ecqua tanto. 33. dosschurita. 35. ettanto. 36. allato seriore. 37. sechōdo.
184. 2. interseghatione . . cōposste. 3. chosi in a h he m g. 4. intersegha. 5. composste. 6. risspossta. 7. conposste son misste . . edidisscuro. 8. osscurita addūque. 9. ellaltro. 10. conposste. 11. seghatíoni . . essenplicie. 12. ollaltro . . nasscie. 13. interseghatiō . . chōpo. 14. sta . . chausa. 15. annulare [sima] concio. 16. novede . . noi diciā. 17. senplicie eduve vedi vsol de due lumi diriētal. 18. chōpossta . . 20. soli . . ciarezza del chāpo. 21. circhūdatore. 23. se uagivgnie il rimanēte e chōcludera. 24. ecquesto. 25. chesse. 26. ghatione . . tale. 27. Quando. 28. vedessino. 29. vede.

²⁷questo cōfesso esser vero, quando ²⁸le due ōbre nō vedessimo nel medesimo ²⁹sito, perchè se dove vedi vn'ōbra e vn ³⁰lume, si gienera ōbra cōposta, e dove ³¹vedi due ōbre e due lumi simili, nō si pu³²ò variare in parte alcuna essa ōbra, ³³essendo le ōbre equali e equali li lu³⁴mi, e questo si prova nell'ottava de ³⁵proportione dove dicie, tal proportio³⁶ne à senplicie potētia cō senplicie resistē³⁷tia quale à duplicata potētia cō duplicata resistētia.

point of intersection, the shadows would be neutralised. This I confess to be true if [neither of] the two shadows fell in the same spot; because, where a shadow and a light fall, a compound shadow is produced, and wherever two shadows or two equal lights fall, the shadow cannot vary in any part of it, the shadows and the lights both being equal. And this is proved in the eighth [proposition] on proportion where it is said that if a given quantity has a single unit of force and resistance, a double quantity will have double force and double resistance.

Br. M. 243 a] 185.

Definitione.

²La intersegatione n è fatta dall' onbre create dal lume ³b, perchè tale lume b gienera l'onbra x b e l'ōbra s b, ma ⁴la intersegatione m è fatta dal lume a che gienera ⁵l'ōbra s a e l'ōbra x a.

⁶Ma se tu scopri li due lumi a b, allora si gienerà le due ōbre n m ⁷in ū medesimo tēpo, e oltre a di questo se ne gienerà due altre di ⁸senplicie onbre cioè r o, nelle quali nō uede nes⁹sū de due luminosi. ¶ ¹⁰tanto sono li gradi della oscurità che acquistā l'onbre cōpo¹¹ste, quanto saran minori li numeri de'luminosi che la vedono.¶

Definition.

The intersection n is produced by the shadows caused by the light b, because this light b produces the shadow x b, and the shadow s b, but the intersection m is produced by the light a which causes the shadow s a, and the shadow x a.

But if you uncover both the lights a b, then you get the two shadows n m both at once, and besides these, two other, simple shadows are produced at r o where neither of the two lights falls at all. The grades of depth in compound shadows are fewer in proportion as the lights falling on, and crossing them are less numerous.

Br. M. 248 b] 186.

Perchè la intersegatione n essendo cōposta di due cō²poste ōbre diriuatiue giepa

Why the intersections at n being composed of two compound derived shadows,

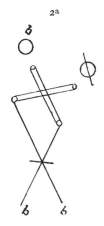

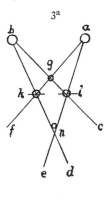

30. cōposita. 31. vede . . "simili". 32. alchuna. 34. ecquesto. 37. cō dup "ta".
185. 2. interseghatione n effatte. 3. ellōbra. 4. interseghatione m effatta. 5. sa he lōbra. 6. Massettu . . gienera. 7. nū medesimo . . addi . . gienera. 10. oscurita. 11. site . . numere . . chella \\\\dano.

nera onbra cōposta ³e nō senplicie come fan l'altre intersegationi dell'ōbre cōpos⁴te. ⁵Questo accade per la 2ª di questo che dicie ¶⁶La intersegatione dell'ōbre dirivative·nata·dalla ⁷intersegatione delli ōbrosi collūnali alluminati da ū sol lu⁸minoso non gienera onbra sēplicie¶; e questo nascie ⁹per la prima che dicie: la intersegatione delle senplici ¹⁰onbre diriuatiue mai acquista oscurità || perchè ¹¹tutte le somme oscurità insieme giunte non ac¹²quistano maggiore oscurità che vna sola, perchè se le mol¹³te somme oscurità crescessino oscurità nelle lor dup¹⁴plicationi, esse non si potrebbino nominare oscurità sō¹⁵me ma parte di oscurità; Ma se tali interse¹⁶gationi sarā alluminate da un secondo lume po¹⁷sto infra l'ochio e li corpi intersegati, allora tali ¹⁸ōbre sarā ōbre conposte e avrā vniforme oscurità ¹⁹cosi nella intersegatione come nel rimanēte; ²⁰per la prima e seconda di sopra le intersegationi *i k* nō ²¹si raddoppiano·di oscurità come elle si raddoppiano di quā²²tità, ma in questa 3ª le intersegationi *g n* si rad-²³doppiā di oscurità e di quantità.

forms a compound shadow and not a simple one, as happens with other intersections of compound shadows. This occurs, according to the 2nd [diagram] of this [prop.] which says:—The intersection of derived shadows when produced by the intersection of columnar shadows caused by a single light does not produce a simple shadow. And this is the corollary of the 1st [prop.] which says:—The intersection of simple derived shadows never results in a deeper shadow, because the deepest shadows all added together cannot be darker than one by itself. Since, if many deepest shadows increased in depth by their duplication, they could not be called the *deepest* shadows, but only part-shadows. But if such intersections are illuminated by a second light placed between the eye and the intersecting bodies, then those shadows would become compound shadows and be uniformly dark just as much at the intersection as throughout the rest. In the 1st and 2nd above, the intersections *i k* will not be doubled in depth as it is doubled in quantity. But in this 3rd, at the intersections *g n* they will be double in depth and in quantity.

C. A. 187 II*a*; 562*a*] **187.**

COME E DOVE L'OBIETTO OSCURO ²SI MISCHIA ³COL LUME DIRIUATIVO DEL CORPO LUMINOSO.

⁴L'onbre diriuative delle parieti oscure ⁵cōlaterali dello splendore della finestra son quel⁶le che colle lor varie oscurità si mischiano col ⁷lume diriuativo d'essa finestra·e cō uarie oscu⁸rità tutto lo tingono eccietto nel lume massi⁹mo·*c*: provasi e sia *d·a* l'onbra primiti¹⁰va la quale tutta vede e fa oscuro colla sua ōbra ¹¹diriuatiua il pūto *e*, come si dimostra per il △ ¹²*a e d* del quale l'angolo *e* vede tutta la basa ¹³oscura *d a e*, il pūto *v* è veduto dalla oscur¹⁴ità *a s*, parte del *a d* e per esser più il tutto che

HOW AND WHEN THE SURROUNDINGS IN SHADOW MINGLE THEIR DERIVED SHADOW WITH THE LIGHT DERIVED FROM THE LUMINOUS BODY.

The derived shadow of the dark walls on each side of the bright light of the window are what mingle their various degrees of shade with the light derived from the window; and these various depths of shade modify every portion of the light, except where it is strongest, at *c*. To prove this let *d a* be the primary shadow which is turned towards the point *e*, and darkens it by its derived shadow; as may be seen by the triangle △ *a e d*, in which the angle *e* faces the darkened base *d a e*; the point *v* faces the dark shadow *a s* which is part of *a d*, and as the whole is greater than a part, *e*

186. 1. interseghatione .. chōposta .. chō. 2. posste .. chōposta. 3. interseghatiō .. chōpo. 4. site. 5. achade. 6. interseghation. 7. interseghation chollūnali. 9. la p*che* .. intersegatione. 10. osschura. 11. some osschurita. 12. magiore osschurita .. selle. 13. some osschurita cresscciessino osschurita. 14. plichationi .. osscurita. 15. disschurita Massettale. 16. ghatione .. sechondo. 17. infrallochio elli chorpi interseghati .. tale. 18. arā .. osscurita. 19. chosi .. interseghation chome. 20. per la p*e* 2*e* disopra .. interseghatio. 21. radoppiano disscurita chomelle se radoppiā. 22. quessta .. interseghationi .. ra. 24. disschurita eddi.

187. come [l] e dovę lobbietto osscuro. 2. si missta colla suōbra diriuatiua. 3. chol .. lumi "noso". 4. lonbra diriuativa .. osscure [chesō la]. 5. finesstra. 6. cholle .. misstaro. 8. tinghano. 9. essia. 10. effa. 12. langholo. 14. eser .. chella. 15. osscu.

187. The diagram on Pl. IV, No. 5 belongs to this passage; but it must be noted that the text explains only the figure on the right-hand side.

¹⁵parte *e*, che vede il tutto della basa, sarà più oscu¹⁶ro che *v* che ne vede parte; mediāte la cōclusio¹⁷ne di sopra alla figura, *t* sarà meno os¹⁸curo che 'l *v*, perchè la basa del *t* △ è parte della ¹⁹basa del △ *v*, e similmēte succede *p* meno o²⁰scuro del *t*, perchè la basa del △ *p* è parte della ba²¹sa del △ *t* · e'l *c* è termine del' ōbra dirivatiua e prī²²cipio massimo della massima parte alluminata.

which faces the whole base [of the triangle], will be in deeper shadow than *v* which only faces part of it. In consequence of the conclusion [shown] in the above diagram, *t* will be less darkened than *v*, because the base of the △ *t* is part of the base of the △ *v*; and in the same way it follows that *p* is less in shadow than *t*, because the base of the △ *p* is part of the base of the △ *t*. And *c* is the terminal point of the derived shadow and the chief beginning of the highest light.

17. fighura . t [e piu] sara. 18. churo. 19. essimilmēte suciede meno os.

FOURTH BOOK ON LIGHT AND SHADE.

I.¹ 37 b]

188.

La stanpa dell' onbra di qualūque cor²po di uniforme grossezza mai sarà simile ³al corpo donde ella nasce.

The form of the shadow cast by any body of uniform density can never be the same as that of the body producing it. On the shape of cast shadows (188—191).

C. A. 184 b; 555 b]

189.

Nessuna ōbra separata potrà stampare sulla pariete la uera forma del corpo ōbroso, ²se il ciētro del lume nō fia equidistāte dalli stremi d'esso corpo.

No cast shadow can produce the true image of the body which casts it on a vertical plane unless the centre of the light is equally distant from all the edges of that body.

A. 1 a]

190.

Se la finestra · a · b · māda · per se · in casa il sole ·, crescierà codesto sole la grā²dezza della · finestra · e diminvirà l' onbra dell' omo · in modo · che quādo detto omo acco³sterà quella ōbra · di se persa · a quella che porta la uera grādezza della finestra, vedrà ⁴in sul contatto dell' onbre · perse e cō-fuse dalla potētia della luce chiu-dere e nō la⁵sciare passare i razzi solari, e farà l' onbra fatta dall' omo sul detto cōtatto ⁶lo effetto che qui di sopra · è figurato appūto.

If a window a b admits the sunlight into a room, the sunlight will magnify the size of the window and diminish the shadow of a man in such a way as that when the man makes that dim shadow of himself, approach to that which defines the real size of the window, he will see the shadows where they come into contact, dim and confused from the strength of the light, shutting off and not allow-ing the solar rays to pass; the effect of the shadow of the man cast by this contact will be exactly that figured above.

188. 2. grosseza. 3. nassciesi.
189. 1 stāpire suli. 2. sel . alli.
190. 1. sella . . chasa . . desto sole. 2. deza . . imodo checquādo . . acho. 3. acquella . grādeza . . vedera. 4. chontatto . . civdere e nō [po] la. 5. razi solari [chome ac]effara. 6. effigurato apūto.

188. Comp. the drawing on Pl. XXVIII, No. 5.
190. It is scarcely possible to render the meaning of this sentence with strict accuracy; mainly because the grammatical construction is defective in the most important part—line 4. In the very slight original sketch the shadow touches the upper arch of the window and the correction, here given is perhaps not justified.

C. A. 237 II; 715 b] 191.

L'onbra nō si dimostrerà mai d'uniforme oscurità nel ²loco dove essa si taglia se tale loco non è equidistante dal ³corpo luminoso; provasi per la 7ª che dice¶ quell'ōbra si ⁴dimostrerà più chiara o più oscura che fia circunda⁵ta da cāpo più oscuro o più chiaro, per la ottava di ⁶questo¶ quel campo avrà le sua parti tanto più ⁷scure o più chiare quāto egli sarà piv remoto o più vicino ⁸al corpo luminoso·e¶ infra li siti d'equal distan-⁹tia dal luminoso quel si dimostrerà più allu-minato ¹⁰che ricieve li razzi luminosi infra angoli più equali, ¹¹senpre¶ l'onbra segnata in qualunche inequalità di sito ¹²si dimo-trerà colli sua vari termini equali al corpo ¹³onbroso, se l'ochio si pone dove fù il ciētro del luminoso.

¹⁴Quell' onbra si dimostra più oscura che è più remota ¹⁵dal suo corpo ōbroso; ¹⁶l'ōbra c d, nata dallo ¹⁷a se equidistāte corpo ō¹⁸broso a b, nō si dimostra ¹⁹equale in oscurità per esse²⁰re in cāpo di uarie chiare²¹zze.

A shadow is never seen as of uniform depth on the surface which intercepts it un-less every portion of that surface is equi-distant from the luminous body. This is proved by the 7th which says:—The shadow will appear lighter or stronger as it is sur-rounded by a darker or a lighter background. And by the 8th of this:—The background will be in parts darker or lighter, in pro-portion as it is farther from or nearer to the luminous body. And:— Of various spots equally distant from the luminous body those will always be in the highest light on which the rays fall at the smallest angles: The outline of the shadow as it falls on inequalities in the surface will be seen with all the contours simi-lar to those of the body that casts it, if the eye is placed just where the centre of the light was.

The shadow will look darkest where it is farthest from the body that casts it. The sha-dow c d, cast by the body in shadow a b, which is equally distant in all parts, is not of equal depth because it is seen on a back ground of varying brightness.

C. A. 124 a; 383 a] 192.

On the out-lines of cast shadows (192—195).

I termini · di quella · ōbra · diriuativa · sa-rāno · più · distinti ·, della · quale · la sua per-cussione · fia piv propīqua ²all'ombra ori-ginale.

The edges of a derived shadow will be most distinct where it is cast nearest to the primary shadow.

C. A. 363 a; 1136 a] 193.

Quāto più l'onbra diriuativa si remove dall'ōbra ²primitiva, più si uaria da essa primitiva col³li sua termini.

As the derived shadow gets more dis-tant from the primary shadow, the more the cast shadow differs from the primary shadow.

C. A. 146 b; 434 a] 194.

DE ŌBRE CHE MAI SŌ TERMINATE.

²Quāto il lume sarà maggiore ³del corpo ōbroso, tanto li ter⁴mini dell'onbre di tal corpo ⁵sarā più confusi.

OF SHADOWS WHICH NEVER COME TO AN END.

The greater the difference between a light and the body lighted by it, the light being the larger, the more vague will be the outlines of the shadow of that object.

191. 1. dimossterra mai [de] duniforme osscurita. 2. locho . . settale locho . . al. 3. chorpo. 4. dimosstera . . chiarara oppiu osschura cheffia circhunda. 5. chāpo . . osschuro oppiu chiaro [ecqua] per la 8ª. 6. quessto . . chanpo[sia] . ara . . parte. 7. oppiu . . esara "piv remoto o" piu vicino [orremo]. 8. to al . . infralli . . disstan. 9. tia al . . dimossterra. 10. angholi. 12. dimossterra cholli. 13. sellochio si pō. 14. dimosstra . . osscura. 15. chorpo. 17. asse equidisstāte chorpo. 19. iscurita. 20. chāpo.
192. 1. disstinti.
193. 1. dellōbra. 2. chol.
194. 2. magore. 6. ara. 7. cōfusil termini . . percu.

191. Compare the three diagrams on Pl. VI, no 1 which, in the original accompany this section.

[6]Quell'ōbra dirivatiua avrà più [7]cōfusi li termini della sua percus[8]sione nella pariete, la quale [9]è più remota dal suo corpo ōbroso.

The derived shadow will be most confused towards the edges of its interception by a plane, where it is remotest from the body casting it.

W. 232*b*]

195.

Che causa è quella che fa li [2]termini dell'ōbra cōfusi e in[3]gnoti?

[4]Se'l'è possibile di dare termi[5]ni spediti e noti alli cōfini [6]delle ōbre.

What is the cause which makes the outlines of the shadow vague and confused?

Whether it is possible to give clear and definite outlines to the edges of shadows.

Ash. I. 5*b*]

196.

QUEL CORPO CHE È PIV PROPĪQUO [2]AL LUME FA MAGGIORE ŌBRA, E PERCHÈ?

[3]Se uno obietto · antiposto a uno particulare · lume fia di propīqua vi[4]cinità ·, vedrai a quello fare ōbra grādissima nella cōtra[5]posta · pariete: e quāto · piv allōtanerai detto obbietto dal lu[6]me, tāto si diminvirà la forma d'essa ōbra.

PERCHÈ L'ONBRA MAGGIORE CHE LA SUA [8]CAGIONE SI FA DI DISCORDĀTE PROPORTIONE.

[9]La discordantia della proportione dell'ōbra grāde piv che la sua [10]cagione nascie, perchè il lume ·, sendo · minore · che l'obietto, nō può esse[11]re di equale distātia alle stremità · d'esso obbietto, e quella parte ch'è piv [12]distate piv cresce che le propīque, e però piv cresce...

PERCHÈ L'ONBRA MAGGIORE CHE LA SUA CAGIONE [14]À TERMINI CŌFUSI.

[15]Quell'aria che circūscrive il lume è quasi di natura d'esso lume per chia[16]rezza

THE BODY WHICH IS NEAREST TO THE LIGHT CASTS THE LARGEST SHADOW, AND WHY?

If an object placed in front of a single light is very close to it you will see that it casts a very large shadow on the opposite wall, and the farther you remove the object from the light the smaller will the image of the shadow become. On the relative size of cast shadows (196. 197).

WHY A SHADOW LARGER THAN THE BODY THAT PRODUCES IT BECOMES OUT OF PROPORTION.

The disproportion of a shadow which is larger than the body producing it, results from the light being smaller than the body, so that it cannot be at an equal distance from the edges of the body[11]; and the portions which are most remote are made larger than the nearer portions for this reason[12].

WHY A SHADOW WHICH IS LARGER THAN THE BODY CAUSING IT HAS ILL-DEFINED OUTLINES.

The atmosphere which surrounds a light is almost like light itself for brightness and

195. 1. chausa ecquella cheffa. 2. chōfusi. 4. selle. 5. ennoti.

196. 1. che piv. 2. alume . . magiore. 3. se î . . a î partichulare. 4. acquelo . . chōtra. 5. ecquāto. 7. magiore chella. 8. chagione . . dischordāte. 9. dischordantia. 10. chagione . . ilume . . po. 11. ecquella. 13. magiore. 15. circhūscriue

196. 11. 12. H. LUDWIG in his edition of the old copies, in the Vatican library—in which this chapter is included under Nos. 612, 613 and 614 alters this passage as follows: *quella parte ch'è piu propinqua piu cresce che le distanti*, although the Vatican copy agrees with the original MS. in having *distante* in the former and *propinque* in the latter place. This supposed amendment seems to me to invert the facts.

Supposing for instance, that on Pl. XXXI No. 3. *f* is the spot where the light is that illuminates the figure there represented, and that the line behind the figure represents a wall on which the shadow of the figure is thrown. It is evident, that in that case the nearest portion, in this case the under part of the thigh, is very little magnified in the shadow, and the remoter parts, for instance the head, are more magnified.

e per colore, e quāto piv si allōtana, piv perde sua similitudine, e la [17]cosa che fa grande ōbra è vicina al lume e truovasi alluminata · dal lume [18]e dal'aria luminosa, ōde quest'aria lascia i termini · confusi del' ōbra.

colour; but the farther off it is the more it loses this resemblance. An object which casts a large shadow and is near to the light, is illuminated both by that light by the luminous atmosphere; hence this diffused light gives the shadow ill-defined edges.

E. 31*b*]

197.

Quel luminoso di lunga [2]e stretta figura fa [3]li termini dell'ōbra diri[4]vativa piv confusi [5]che il lume sperico, e [6]questo è quel che cō[7]tradicie alla propo[8]sitione sequēte: Quel[9]l'ōbra avrà li termini [10]più noti che fia più [11]vicina all'onbra pri[12]mitiva, o voi dire il [13]corpo ōbroso, ma [14]di questo è cavsa la [15]figura lūga del [16]luminoso *a c* ecc.

A luminous body which is long and narrow in shape gives more confused outlines to the derived shadow than a spherical light, and this contradicts the proposition next following: A shadow will have its outlines more clearly defined in proportion as it is nearer to the primary shadow or, I should say, the body casting the shadow; [14]the cause of this is the elongated form of the luminous body *a c*, &c.[16].

E. 32*a*]

198.

DE ŌBRE CORROTTE.

Effects on cast shadows by the tone of the back ground.

[2]Ōbre corrotte sō dette [3]quelle che sō vedute [4]da parieti chiare o al[5]tro luminoso. ¶[6]Quell'ōbra si dimostra [7]più oscura che è in [8]canpo più biāco. ¶[9]Li termini di quell'ō[10]bra diriuatiua sarā più noti [11]che fien più vici[12]ni all'ōbra primitiva.¶ [13]L'ōbra dirivativa [14]avrà li termini del[15]la sua impressione pi[16]v noti, li quali si ta[17]gliano infra ango[18]li più equali nella [19]sua pariete.

[20]Quella parte d'u[21]na medesima ōbra [22]si dimostrerà piv [23]oscura che avrà cō[24]tra se più oscuri [25]obietti; E si dimo[26]strerà me[27]no oscura che fia [28]veduta da obbiet[29]to più chiaro; E [30]quello obietto chia[31]ro che fia maggiore, pi[32]v rischiarerà;

[34]e quello [35]obietto [36]oscuro [37]che fia [38]di mag[39]giore qu[40]ātità, più [41]oscure[42]rà l'ōbra [43]diriuati[44]va nel [45]sito della [46]sua percus[47]sione.

OF MODIFIED SHADOWS.

Modified shadows are those which are cast on light walls or other illuminated objects.

A shadow looks darkest against a light background. The outlines of a derived shadow will be clearer as they are nearer to the primary shadow. A derived shadow will be most defined in shape where it is intercepted, where the plane intercepts it at the most equal angle.

Those parts of a shadow will appear darkest which have darker objects opposite to them. And they will appear less dark when they face lighter objects. And the larger the light object opposite, the more the shadow will be lightened.

And the larger the surface of the dark object the more it will darken the derived shadow where it is intercepted.

ilume ecquasi . . percia. 16. reza . .. chalore ecquāto . ella. 17. alume . . aluminata da. 18. chonfusi.
197. 1. lungha. 2. esstretta fighura. 4. chonfusi. 5. spericho. 6. quessto ecquel . . chō. 7. traddicie. 9. ara. 13. chorpo. 14. quessto echavsa. 15. fighura lūgha.
198. 1. chorrocte. 2. ōbra chorrotte. 3. chessō. 4. pariete. 6. dimosstra. 7. osscura. 8. chanpo . . biancho. 10. bra "diriuatiua" sara. 14. ara. 15. inpresione. 17. angho. 19. par"i"ete. 22. dimosterra. 23. osschura che ara. 24. trasse . . osscuri. 25. Essi. 26. sterra [piu] me. 27. osschura. 30. cquello. 31. cheffia magiore. 32. rissciarera. 33. [ech]. 35. osschuro. 37. cheffia. 38. ma. 39. givre q̄. 41. osscure. 45. perchu.

197. 14—16. The lettering refers to the lower diagram, Pl. XLI, No. 5.

Ash. I. 13*b*]

199.

OPINIONE D'ALCUNI CHE UN TRIĀGOLO NŌ FACCI IN VNA PARIETE ALCUN' ŌBRA.

OF THE OPINION OF SOME THAT A TRIANGLE CASTS NO SHADOW ON A PLANE SURFACE.

[3] Sono stati alcuni · matematici · che ànno · tenvto per fermo che uno triāgolo, che abbia [4] la basa volta · verso el lume, nō facci in vna pariete · alcuna ōbra ·, la qual [5] cosa prouano diciēdo : così, nessuno corpo sperico minore [6] che lume può givgnere alla metà · col' ōbra : le linie · radiose sono rette, [7] adūque poniamo · il lume sia *g · h* · e 'l triāgolo sia *l · m n*; e la pariete sia · *i · k* : dica[8]no il lume · *g* · vedere · la faccia del triāgolo · *l · n* · e la parte della pariete · *i · q* ·, [9] e così · *h* · vede · come · *g* · la faccia · *l · m* · e poi vede · *m · n* · e la pariete · *p · k* ·, e se [10] essa tutta la pariete è vista dal lume · *g · h* · cō-uiene essere il triāgolo sāza ōbra, e che [11] non à ōbra · nō la può dare : la qual cosa pare ī questo caso credibile se 'l triāgolo [12] *n · p · g* · nō fusse visto da 2 lumi · *g · h* ·, ma · *i · p* e così *g · k* · nōn è ciasuno per se [13] visto se nō da uno solo · lume ·, cioè *i · p* · nō può esser visto da · *h · g*; *k* · nō sarà mai [14] visto da · *g* · adūque · *p · q* · fia piv chiaro il doppio che dua visiui spati che tēgā d'ōbra.

Certain mathematicians have maintained that a triangle, of which the base is turned to the light, casts no shadow on a plane; and .this they prove by saying [5] that no spherical body smaller than the light can reach the middle with the shadow. The lines of radiant light are straight lines [6]; therefore, suppose the light to be *g h* and the triangle *l m n*, and let the plane be *i k*; they say the light *g* falls on the side of the triangle *l n*, and the portion of the plane *i q*. Thus again *h* like *g* falls on the side *l m*, and then on *m n* and the plane *p k*; and if the whole plane thus faces the lights *g h*, it is evident that the triangle has no shadow; and that which has no shadow can cast none. This, in this case appears credible. But if the triangle *n p g* were not illuminated by the two lights *g* and *h*, but by *i p* and *g* and *k* neither side is lighted by more than one single light: that is *i p* is invisible to *h g* and *k* will never be lighted by *g*; hence *p q* will be twice as light as the two visible portions that are in shadow.

A disputed proposition.

C. A. 30*b*; 96*b*]

200.

[3] Quel loco è piv ōbroso che da mag[4]gior soma di razzi ōbrosi veduto fia [5] quel loco · che sarà [6] percosso da piv g[7]rosso angolo fat[8]to da razzi ōbrosi, [9] fia piv scuro; [10] *a* · fia di doppia osc[11]urità · che · *b* · perch[12]è è doppia base [13] nascie in pari dist[14]ātia [15] quel loco sarà piv luminoso · che da mag[16]gior somma di razzi luminosi ripercosso fia [17] *d* · è il principio dell' onbra · *d · f* ·, e tignie poco [18] in · *c* ·; *d · e* · è mezza · l' onbra · *d · f*; e piv tignie [19] nella percussione · *b* · di · *f* · e tutto lo intervallo [20] ōbroso *e* interamēte tignie di se il loco *a*.

A spot is most in the shade when a large number of darkened rays fall upon it. The spot which receives the rays at the widest angle and by darkened rays will be most in the dark; *a* will be twice as dark as *b*, because it originates from twice as large a base at an equal distance. A spot is most illuminated when a large number of luminous rays fall upon it. *d* is the beginning of the shadow *d f*, and tinges *c* but a little; *d e* is half of the shadow *d f* and gives a deeper tone where it is cast at *b* than at *f*. And the whole shaded space *e* gives its tone to the spot *a*.

On the relative depth of cast shadows (200—202).

199. 1. dalchuni cun . . faci. 3. Estati alchuni . . che ī triāgolo cheabi. 4. facinvna. 5. cosa [riprouo ī questa forma] prouano. 6. po [avere] givgnere. 7. ilume. 8. facia . . dela. 9. facia . . esse. 10. esse . . dalume . . ōbreche. 11. nona ōbr . . po. 12. fussi. 13. da ī solo . po. 14. vsto da . . charo . . dopio . . spatio.

120 1. ettinta [del cholore] delli chontra se posti chorpi ōbrosi e luminosi. 2. della chiareza oscurita. 3. Quelocho . ma. 4. razi. 5. qel locho . . chessara. 6. perchosso. 7. fa. 8. razi. 9. schuro. 10. dopia ossc. 12. dopia ossc. 13. nasscie. 15. locho . . ma. 16. razi . . riperchosso. 17. pocho. 18. d . e . he . meza. 19. perchussione . . ettutto. 20. illocho.

199. 5—6. This passage is so obscure that it would be rash to offer an explanation. Several words seem to have been omitted.

200. The diagram here referred to is on Pl. XLI, No. 2.

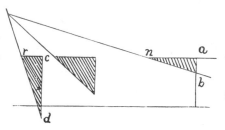

¶ Tãto·quãto·*a·b·*ẽtra in · *c · d* ²tanto · *a n* · fia piv scuro che ³*c · r*.¶

A n will be darker than *c r* in proportion to the number of times that *a b* goes into *c d*.

¶ Quanto · l' onbra fatta dall' obbietto · sopra la pariete ²sarà minore · che la sua cagione, tanto esso obbietto ³fia · alluminato · da piv deboli razzi · luminosi¶ ⁴*d · e ·* è

The shadow cast by an object on a plane will be smaller in proportion as that object is lighted by feebler rays. Let *d e* be the object and *d c* the plane surface; the

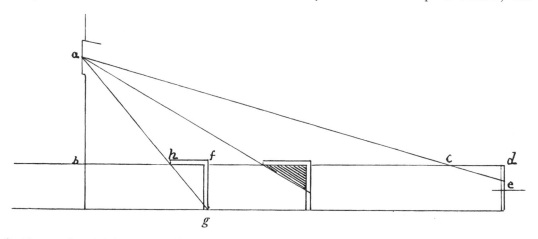

l' obietto · *d · c* si è la pariete ‖ tanto · quãto · *d · e ·* entra ⁵in · *f · g ·* tante volte · fia · piv lume in · *f · h ·* che in · *d · c ·*¶ ⁶Quanto il razzo · luminoso · fia · piv debole, tãto ⁷fia piv lontano · dal suo · spiracolo.

number of times that *d e* will go into *f g* gives the proportion of light at *f h* to *d c*. The ray of light will be weaker in proportion to its distance from the hole through which it falls.

202. ₁. [tanto] Quanto. ₂. chella sua chagione. ₃. razi. ₄. qua . d . e. ₅. pivllume. ₆. razo. ₇. spiracholo.

FIFTH BOOK ON LIGHT AND SHADE.

203.

MODO · DOVE · DEBBONO TERMI²NARE · L'ONBRÉ ·
FATTE DALI OBBIETTI.

³Se l'obieto · fia · questa mōtagna · qui ·
figurata · e'l lume fusse il pūto ·
a ·, ⁴dico che · da · b · d · e si-
milmēte da · c · f · nō fia lume · se
nō per ra⁵zzi · reflessi ·, e questo ·
nasce · che i razzi · luminosi · nō
s'adoprano se · non per ⁶linia ·
recta: e quel · medesimo fanno i secondi ·
razzi · che sono · reflessi.

OF THE WAY IN WHICH THE SHADOWS CAST
BY OBJECTS OUGHT TO BE DEFINED.

If the object is the mountain here figured, *Principles of*
and the light is at the point *a,* *reflection (203. 204).*
I say that from *b d* and also from
c f there will be no light but from
reflected rays. And this results
from the fact that rays of light
can only act in straight lines;
and the same is the case with the secondary
or reflected rays.

204.

Li termini dell'onbra dirivativa son ²cir-
cundati dai colori delli obbieti allumi³nati
circūstāti ⁴al corpo luminoso, causatore
di essa ⁵ōbra.

The edges of the derived shadow are
defined by the hues of the illuminated ob-
jects surrounding the luminous body which
produces the shadow.

205.

DE RIVERBERATIONE.

²Le riverberationi · sono cavsate · da corpi
di chiara qualità · di piana e semidēsa .
superfitie, le ³quali, percosse dal lume
a similitudine · del balzo · della palla, lo riper-
cuotono · nel primo · obbietto.

OF REVERBERATION.

Reverberation is caused by bodies of a *On rever-*
bright nature with a flat and semi opaque *beration.*
surface which, when the light strikes upon
them, throw it back again, like the rebound
of a ball, to the former object.

203. 3. fussi. 4. essimilmēte. 5. nasscie. 6. fano . . razi chessono.
204. 2. circhundati de. 3. nati li [quali circūdano] circhūsstāti. 4. chausatore dessa.
205. 2. chavsate . . chorpi. 3. perchosse dal lume quelo assimilitudine del bazo . . riperchuotano. 5. chorpi dēsi . si vestano

DOVE NŌ PUÒ · ESSERE RINVERBERATIONE
LUMINOSA.

WHERE THERE CAN BE NO REFLECTED LIGHTS.

[5]Tutti i corpi dēsi · rivestono · le loro superfitie di uarie qualità di lume · e ōbre; [6]i lumi · sono · di due nature ·, l'uno · si domāda originale · l'altro · derivatiuo; [7]originale · dico · essere quello · che diriva da vāpa · di foco o dal lume · del sole [8]o d'aria : lume · dirivatiuo · fia il lume · reflesso; ma per tornare alla [9]promessa · difinizione · dico · che riverberatione luminosa · nō fia da quella [10]parte del corpo · che fia · volta a corpi ōbrosi, come lochi scuri ·, prati [11]di varie altezze d'erbe ·, boschi · verdi · o secchi · i quali ·, benchè la parte di ciascu[12]no ramo volta al lume originale · si veste della qualità · d'esso lume ·, niēte [13]di meno · e' sono · tāte l'onbre fatte da ciascuno · ramo · per se · e tāte l'onbre fatte dal[14]l'uno · ramo sull'altro che in soma ne risulta · tale · oscurità che il lume v'è [15]per niēte ·, onde nō possono · simili obbietti · dare · a corpi opposti · alcuno lume [16]riflesso.

All dense bodies have their surfaces occupied by various degrees of light and shade. The lights are of two kinds, one called original, the other borrowed. Original light is that which is inherent in the flame of fire or the light of the sun or of the atmosphere. Borrowed light will be reflected light; but to return to the promised definition: I say that this luminous reverberation is not produced by those portions of a body which are turned towards darkened objects, such as shaded spots, fields with grass of various height, woods whether green or bare; in which, though that side of each branch which is turned towards the original light has a share of that light, nevertheless the shadows cast by each branch separately are so numerous, as well as those cast by one branch on the others, that finally so much shadow is the result that the light counts for nothing. Hence objects of this kind cannot throw any reflected light on opposite objects.

H.² 28 b]

206.

PROSPECTIVA.

PERSPECTIVE.

Reflection on water (206. 207).

[2]L'onbre over · le cose [3]spechiate nell'acqu[4]a movēte, cioè co[5]m' onde piccole, sē-[6]pre sarā · maggiori [7]che la cosa di fo[8]ri, donde nasce.

The shadow or object mirrored in water in motion, that is to say in small wavelets, will always be larger than the external object producing it.

Br. M. 93 b]

207.

Inpossibile è · che la cosa · spechiata sopra [2]dell'acqua · sia simile in figura al-

It is impossible that an object mirrored on water should correspond in form to the

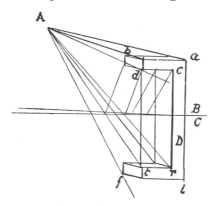
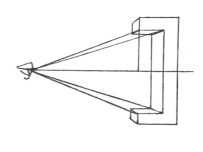

l'obbietto che [3]si spechia, essendo il centro dell'ochio sopra [4]la superfitie dell'acqua.

object mirrored, since the centre of the eye is above the surface of the water.

le loro. 7. dicho . . focho o dalume. 8. ilume . refresso. 9. dicho . . dacquella. 10. chorpo cheffia . . achorpi . . chome. 11. alteze . . bossci . verdi ossechi . . ciasscu. 12. vessta. 13. ciasscuno . . ettante. 14. isscurita che lume. 15. po simili . . chorpi . . alchuno. 16. refresso.
206. 2. chose. 3. achu. 5. pichole. 6. magiore. 7. chella chosa. 8. nascce.

207. *A* stands for *ochio* [eye], *B* for *aria* [air], *C* for *acqua* [water], *D* for *cateto* [cathetus].—In the original MS. the second diagram is placed below line **13**.

⁵Quel che di sopra si manifesta nella figura ⁶fatta qui da parte, nella quale si uede l'oc⁷chio uedere la superfitie · *a · b*, e non la può ⁸poi vedere in · *l f* · e in *r t*, vede ⁹la superfitie del simulacro in *r t* e non la ¹⁰vede nella cosa · reale *c d*: adunque ¹¹è inpossibile vedere quel ch'è detto di sopra, ¹²se l'ochio non è situato nella superfitie dell'a¹³cqua, come si mostra qui di sotto.

This is made plain in the figure here given, which demonstrates that the eye sees the surface *a b*, and cannot see it at *l f*, and at *r t*; it sees the surface of the image at *r t*, and does not see it in the real object *c d*. Hence it is impossible to see it, as has been said above unless the eye itself is situated on the surface of the water as is shown below[13].

S. K. M. III. 37*b*]

208.

SPECHIO.

²Se la alluminata fia della ³grādezza della cosa allumi⁴nāte e di quella dou'esso lu⁵me si reflette · tal propor⁶tione avrà la qualità del lume ⁷reflesso · col lume mezzano, ⁸quale · avrà esso · lume se-cōdo ⁹col primo, essēdo essi corpi ¹⁰piani e biāchi.

THE MIRROR.

If the illuminated object is of the same size as the luminous body and as that in which the light is reflected, the amount of the reflected light will bear the same proportion to the intermediate light as this second light will bear to the first, if both bodies are smooth and white.

Experiments with the mirror (208—210).

W. 232*b*]

209.

Descrivi come nessū corpo in se è ter-minato nello ²spechio ma lo termina l'ochio, che dētro a tale spechio ³lo vede, inperochè, se tu rappresenti il tuo viso nel⁴lo spechio, la parte è simile al tutto, ⁵conciossiachè la parte è tutta per tutto lo spechio, ed è ⁵tutta in ogni parte del medesimo spechio, e il simile ac⁷cade di tutto il simulacro di tutto l'obietto cōtra po⁸sto a quello spechio ecc.

Describe how it is that no object has its limitation in the mirror but in the eye which sees it in the mirror. For if you look at your face in the mirror, the part resembles the whole in as much as the part is every-where in the mirror, and the whole is in every part of the same mirror; and the same is true of the whole image of any ob-ject placed opposite to this mirror, &c.

C. A. 139*b*; 419*b*]

210.

Nessuno omo vedrà la similitudine ²del-l'altr'omo sopra lo spechio nel propio ³loco · dove si riferiscie, perchè ciascuno ⁴obietto cade sopra ⁵lo spechio īfra equali ⁶angoli, e se l'omo, che vede l'altro nello spechio, ⁷non è posto colla linia delle spetie, nō lo vedrà ⁸nel loco dove cade, e s'egli entra nelle linie, ⁹egli occupa l'altr'omo e mette · se medesimo ¹⁰sopra la sua similitudine: ¹¹*n o* sia lo spechio · *b* · sia

No man can see the image of another man in a mirror in its proper place with regard to the objects; because every object falls on [the surface of] the mirror at equal angles. And if the one man, who sees the other in the mirror, is not in a direct line with the image he will not see it in the place where it really falls; and if he gets into the line, he covers the other man and puts himself in the place occupied

207. 1. chella chosa. 2. infigra. 3. sisspechia. 4. dellacq "a". 5. manifessta. 6. dapparte. 7. po. 9. nolla. 12. sellochio. 13. qua . . mossstra.

208. 2. sella. 3. grādeza. 4. edidi quella douessolu. 5. rifretta. 6. ara. 7. refresso . . mezano. 8. ara. 10. ebbianchi.

209. 1. desscriui . . etterminato. 2. mallo . . attale. 3. inperochessettu rapresenti. 4. spechio [il tutto ettutta] la . . essimile al tuchō. 5. chonciossia chella . . ettutta . . losspechio. 7. chade di tutto il simulacro . . cōtrapps. 8. sta acquale.

210. 1. vedera. 3. locho. 4. chade. 6. nelo. 7. cola . . vedera. 8. nelocho . . esseli. 9. elli ochupa. 16. tocha. 17. tochera

l'ochio dell'amico tuo · ¹²d · sia il tuo ochio; ¹³l'ochio del tuo amico ti pare in · a : e all'amico par ¹⁴che'l tuo sia in c ¹⁵e la īter-¹⁶segatione delle linee visuali · si fa in · m · e qualūque tocca ¹⁷in m · toccherà l'ochio dell'altro omo che fia aperto; ¹⁸Se toccherai l'ochio ¹⁹dell'altr'omo sopra ²⁰lo spechio parrà al' ²¹altro che tocchi il tuo.

by his image. Let *n o* be the mirror, *b* the eye of your friend and *d* your own eye. Your friend's eye will appear to you at *a*, and to him it will seem that yours is at *c*, and the intersection of the visual rays will occur at *m*, so that either of you touching *m* will touch the eye of the other man which shall be open. And if you touch the eye of the other man in the mirror it will seem to him that you are touching your own.

E. 2 *b*]　　　　　　　　　　211.

DELL'ONBRA O SUO MOTO.

OF THE SHADOW AND ITS MOTION.

Appendix:—
On shadows
in movement
(211. 212).

²Se li 2 ōbrosi che l'ū dopo l'altro son in³fra la finestra e la pariete con alquā⁴to spatio s'interponghino, ⁵l'onbra dell'onbroso, che sarà vicina alla ⁶pariete del muro, sarà mobile, se l'ō⁷broso propinquo alla finestra fia in ⁸moto traversale a essa finestra; prova⁹si e siā li due ōbrosi *a b* interpo¹⁰sti infra la finestra *n m* e la pari¹¹ete *o p*, con alquanto spatio interpo¹²sto infra loro il qŭale è lo spatio *a b*; ¹³dico che se l'ōbroso *a* si mo-verà in¹⁴verso *s* che l'ōbra dello ōbroso *b*, la quā¹⁵le è *c*, si mo-verà in · *d*.

When two bodies casting shadows, and one in front of the other, are between a window and the wall with some space between them, the shadow of the body which is nearest to the plane of the wall will move if the body nearest to the window is put in transverse motion across the window. To prove this let *a* and *b* be two bodies placed between the window *n m* and the plane surface *o p* with sufficient space between them as shown by the space *a b*. I say that if the body *a* is moved towards *s* the shadow of the body *b* which is at *c* will move towards *d*.

E. 30 *b*]　　　　　　　　　　212.

DEL MOTO DELLA ŌBRA.

OF THE MOTION OF SHADOWS.

²Senpre il moto della ōbra è più ³velo-cie che il moto del corpo, che ⁴la genera, essēdo il luminoso īmobile; provasi e sia il lumi⁵noso *a* e l'ōbroso *b* e l'ōbra *d*; ⁶Dico che in pari tēpo si moue l'onbro⁷so *b* in *c*, che il *d* onbra si move ī ⁸*e*, e quella proportione è da ve⁹locità a velocità fatta in medesi¹⁰mo tēpo, quale è da lunghezza ¹¹di moto a lunghezza di moto; a¹²dūque pella proportione che à la ¹³lūghezza del moto fatto dall'ōbro¹⁴so *b* insino in *c* colla lūghezza ¹⁴del moto fatto dall'ōbra *d* in *e*,

The motion of a shadow is always more rapid than that of the body which produces it if the light is stationary. To prove this let *a* be the luminous body, and *b* the body casting the shadow, and *d* the shadow. Then I say that in the time while the solid body moves from *b* to *c*, the sha-dow *d* will move to *e*; and this pro-portion in the rapidity of the move-ments made in the same space of time, is equal to that in the length of the space moved over. Thus, given the proportion of the space moved over by the

. . cheffia. *Lines* 18—21, *are placed in the margin opposite lines* 3—5. 20. spechi. 21. tochi.
211. 1. ossuo. 2. delli. 3. fralla finesstra ella. 4. sinterponghino [disellonbra]. 5. chessara. 6. mobile sello. 8. finesstra. 9. essia. 10. infralla finesstra n m ella. 11. interpos. 12. infralloro il quale he. 13. dicho chessellōbroso. 14. chellobra. 15. le he *c*.
212. 2. eppiu. 3. chorpo chel. 4. gienera "essēdo il luminoso ī mobile" provasi essia. 5. ellōbroso *b* ellōbra. 6. Dicho. 8. ecquella . . he da. 10. dallungheza. 11. allunghezza. 14. cholla lūgheza. 16. predecte. 18. Masse. 19. all moto .

[16]tale ànno infra loro le predette ve[17]locità de' moti.

[18]Ma se il luminoso sarà equale in ve[19]locità al moto dello ōbroso, allora l'onbra [20]e l'onbroso fieno infra loro di moti · equali; [21]E se il luminoso sarà più velocie dello ō[22]broso ·, allora il moto dell'ōbra sarà più tar[23]do che'l moto dello ōbroso.

[24]Ma se il luminoso fia più tardo che l'onbroso, [25]allora l'ōbra sarà più velocie che l'ōbroso.

body *b* to *c*, to that moved over by the shadow *d* to *e*, the proportion in the rapidity of their movements will be the same.

But if the luminous body is also in movement with a velocity equal to that of the solid body, then the shadow and the body that casts it will move with equal speed. And if the luminous body moves more rapidly than the solid body, the motion of the shadow will be slower than that of the body casting it..

But if the luminous body moves more slowly than the solid body, then the shadow will move more rapidly than that body.

20. ellonbroso fiē infralloro . . ecquali. 21. Essellluminoso. 23. da chel. 24. Masse . . chellonbroso. 25. alora . . chellōbroso.

SIXTH BOOK ON LIGHT AND SHADE.

C. 7 a (9 b)]

213.

PROSPETTIVA.

PERSPECTIVE.

The effect of rays passing through holes (213. 214).

²Se farai passare i razzi del sole per lo spiracolo in forma di stella · vedrai belli effetti di prospettiua ³in nella percussione fatta dal passato sole.

If you transmit the rays of the sun through a hole in the shape of a star you will see a beautiful effect of perspective in the spot where the sun's rays fall.

A. 64 b]

214.

²Nessuno · spiraculo · può trasmutare · il concorso · de razzi · luminosi ī modo che per lunga ³distantia · non porgino · all'obietto la similitudine della · lor cagione; ⁴jnpossibile · è · che i razzi · luminosi · passati · per paralello · non dimostrino nell' obbietto · la forma ⁵della · loro · cagione; ⁶perchè tutti li effetti · de' corpi · luminosi · son dimostratori · delle · loro · cagioni; la luna di forma ⁷naviculare · passata dallo spiracolo figurerà nell' obieto uno corpo naviculare.

⁸Perchè l'ochio vede le cose distāti maggiori ⁹che nō le misura · sulla · pariete?

No small hole can so modify the convergence of rays of light as to prevent, at a long distance, the transmission of the true form of the luminous body causing them. It is impossible that rays of light passing through a parallel [slit], should not display the form of the body causing them, since all the effects produced by a luminous body are [in fact] the reflection of that body: The moon, shaped like a boat, if transmitted through a hole is figured in the surface [it falls on] as a boat-shaped object. [8] Why the eye sees bodies at a distance, larger than they measure on the vertical plane?.

213. 2. seffarai . . razi . . spiracholo . . vederai . . prosspettiua [in esso sole]. 2. inella perchussione.
214. 1. [ogni spirachulo per lunga disstantia . porgie allobiecto la forma]. 2. spirachulo potrassmutare . il chonchorso . . imodo.
3. disstantia . . porghino allobiecto [la forma] la . . chagione. 4. razi. 5. non *is wanting in the original* . chagione.
6. chorpi . . chagioni. 7. navichulare . . spiracholo [alo] figurera . . î corpo. 8. chose.

213. In this and the following chapters of MS. C the order of the original paging has been adhered to, and is shown in parenthesis. Leonardo himself has but rarely worked out the subject of these propositions. The space left for the purpose has occasionally been made use of for quite different matter. Even the numerous diagrams, most of them very delicately sketched, lettered and numbered, which occur on these pages, are hardly ever explained, with the exception of those few which are here given.

214. This chapter, taken from another MS. may, as an exception, be placed here, as it refers to the same subject as the preceding section.

8. In the MS. a blank space is left after this question.

C. 5 a (11 b)]　　　　　　　　**215.**

La larghezza · e lunghezza · dell' onbra · e del lume ·, benchè · per li scorti · si facci · piv stretta · e più · corta, [2]non diminuirà · nè crescierà · la qualità · e quantità · di sua chiarezza o scurità.

[3]L' ofitio · dell' onbra · e del lume · diminvito · per li scorti · sarà · da onbrare e l' altro · da luminare [4]jl contraposto · corpo secondo · la qualità · e quātità che a esso · corpo · appare.

[5]Quanto · piv · l' onbra · diriuatiua s' auicinerà · ai sua penvltimi · stremi ·, di tanta maggiore · scurezza · apparirà: [6]g · z · è dopo la intersegatione · sol ueduto · dalla parte dell' onbra · y · z · che piglia · per ītersegatione l' onbra · m · n · [7]e per dirittura · l' onbra · a · m: onde ha · due tanti più · ōbra · che g · z ·: y · x uede · per intersegatione · n · o · e per [8]diretto · n · m · a ·, onde x · y si dimostra · auere · 3 · tanti · più · ōbra · che z · g: x · f · vede per ītersegatione [9] · o · b · e per diretto · vede o · n · m · a; onde · diremo adunque · che l' onbra ch' è tra · f · x sarà 4 tanti piv [10]scura · che · l' onbra · z · g · perch' è vista da 4 tanti piv obra

[11]a · b · sia la parte dell' onbra primitiua, · b · c fia il lume primitiuo, · d sia · il loco della intersegatione, [12]f · g · sia l' onbra diriuatiua · f · e · il lume diriuatiuo.

[13]E questo · uole essere nel principio · della dimostratione.

Although the breadth and length of lights and shadow will be narrower and shorter in foreshortening, the quality and quantity of the light and shade is not increased nor diminished.

[3]The function of shade and light when diminished by foreshortening, will be to give shadow and to illuminate an object opposite, according to the quality and quantity in which they fall on the body.

[5]In proportion as a derived shadow is nearer to its penultimate extremities the deeper it will appear. g z beyond the intersection faces only the part of the shadow [marked] y z; this by intersection takes the shadow from m n but by direct line it takes the shadow a m hence it is twice as deep as g z. Y x, by intersection takes the shadow n o, but by direct line the shadow n m a, therefore x y is three times as dark as z g; x f, by intersection faces o b and by direct line o n m a, therefore we must say that the shadow between f x will be four times as dark as the shadow z g, because it faces four times as much shadow.

Let a b be the side where the primary shadow is, and b c the primary light, d will be the spot where it is intercepted, f g the derived shadow and f e the derived light.

And this must be at the beginning of the explanation.

On gradation of shadows (215. 216).

C. 4 b (12 a)]　　　　　　　**216.**

Quella parte della superfitie · de' corpi · che fia · percossa da maggiore · angolo delle spetie de' · contra se posti corpi · piv si tignierà [2]in nel color di quelle: 8 di sotto · è maggiore āgolo che · 4, perchè la sua basa · a · n · è maggiore che · e · n basa di 4 [3]Questa figura di sotto vol' essere terminata · da · a · n · e · 4 · e · 8. [4]Quella parte · dell' alluminato ·

That part of the surface of a body on which the images [reflection] from other bodies placed opposite fall at the largest angle will assume their hue most strongly. In the diagram below, 8 is a larger angle than 4, since its base a n is larger than e n the base of 4. This diagram below should end at a n 4 8. [4]That portion of the

215. 1. largeza . ellungeza . . schorti . . pivsstrecta . eppiu . chorta. 2. cressciera . . osschurita. 3. lissċhorti . . . e[llaltro] dalluminare. 4. chontrapossto chorpo sechondo . . chorpo. 5. "pen" vltimi . . magiore scureza. 6. dellonbra [z] . y . z piglia. 9. adumque . . sara. 10. schura . che. 11. lume [diriuatiuo] "primitiuo". 13. ecquesto.

216. 1. chorpi . cheffia . perchossa da magiore . . chontra . . chorpi. 2. inel cholor diquele . . magiore . . magiore. 3. a . n . he . 4 . he 8. 4. circhunda la perchussione . . percusiō.

215. In the original MS. the text of No. 252 precedes the one given here. In the text of No. 215 there is a blank space of about four lines between the lines 2 and 3. The diagram given on Pl. VI, No. 2 is placed between lines 4 and 5. Between lines 5 and 6 there is another space of about three lines and one line left blank between lines 8 and 9. The reader will find the meaning of the whole passage much clearer if he first reads the final lines 11—13. Compare also line 4 of No. 270.

216. The diagram originally placed between lines 3 and 4 is on Pl. VI, No. 3. In the diagram given above line 14 of the original, and here printed in the text, the words *corpo luminoso* [luminous body] are written in the circle *m*, *luminoso* in the circle *b* and *ombroso* [body in shadow] in the circle *o*.

che circunda · la percussione dell' onbra fia · piv · luminosa, la quale · sarà · più a essa percussione uicina. [5] Siccome vna · cosa toccata · da maggior sōma · di razzi luminosi · si fa piv chiara, cosi quella si farà · piv scura che da maggior [6] sōma di razzi ōbrosi sia percossa.

[7] 4 Sia la parte dell' alluminato · 4 · 8 · che circūda la percussione dell' onbra · g · e · 4, e fia esso [8] loco · 4 · piv luminoso · perchè lì uede minor sōma d' onbra che nō fa · nel loco · 8 ·, perchè 4 [9] vede solamēte l' ōbra · i · n ·, e · 8 · vede ed è percosso dall' onbra · a · e · e dal' ōbra [10] i · n · ch' è 2 tāti piv scura, e questo medesimo accade quādo [11] l' aria col sole metterai in loco dell' ōbra · e del lume.

[12] Il concorso · dell' onbra, nata · e terminata · infra propinque · et piane · superfitie di pari · qualità · e retta oppositione, [13] avrà più scuro fine che principio · jl quale · terminerà · infra la · percussione de' luminosi razzi.

[14] Quella proportione troverai di oscurità infra l' ōbre diriuatiue · a · n ·, quale fia quella della vicinità de' corpi luminosi m · b, che le cavsano, [15] e se essi corpi luminosi fieno di pari grandezza ancora troverai tal proportione delle percussioni de' cierchi luminosi e l' ōbre qual' è quella della distantia d' essi corpi luminosi.

illuminated surface on which a shadow is cast will be brightest which lies contiguous to the cast shadow. Just as an object which is lighted up by a greater quantity of luminous rays becomes brighter, so one on which a greater quantity of shadow falls, will be darker.

Let 4 be the side of an illuminated surface 4 8, surrounding the cast shadow g e 4. And this spot 4 will be lighter than 8, because less shadow falls on it than on 8. Since 4 faces only the shadow i n; and 8 faces and receives the shadow a e as well as i n which makes it twice as dark. And the same thing happens when you put the atmosphere and the sun in the place of shade and light.

[12] The distribution of shadow, originating in, and limited by, plane surfaces placed near to each other, equal in tone and directly opposite, will be darker at the ends than at the beginning, which will be determined by the incidence of the luminous rays.

You will find the same proportion in the depth of the derived shadows a n as in the nearness of the luminous bodies m b, which cause them; and if the luminous bodies were of equal size you would still farther find the same proportion in the light cast by the luminous circles and their shadows as in the distance of the said luminous bodies.

C. 4a (12b)] 217.

QUELLA · PARTE · DEL REFLESSO · FIA · PIV · CHIARA · DELLA QUALE I RAZZI · DELLA REFLESSIONE FIEN PIÙ CORTI.

[2] La oscurità · fatta · nella percussione · dell' onbroso · concorso · avrà · conformità · col suo principio, la quale [3] fia · nata · e finita · infra · propinque e piane · superfitie · di pari · qualità e retta · oppositione.

THAT PART OF THE REFLECTION WILL BE BRIGHTEST WHERE THE REFLECTED RAYS ARE SHORTEST.

[2] The darkness occasioned by the casting of combined shadows will be in conformity with its cause, which will originate and terminate between two plane surfaces near together, alike in tone and directly opposite each other.

5. Sichome . . chosa tocha da magior . . razi . . Chosi . . pivsschura . . magior. 6. razi . . perchossa. 7. circhūda la perchussione . . effia. 8. locho . . locho. 9. i . n . he . 8 . . perchoso . . a . e . he dallōbra. 10. schuro . . achade. 11. chol sole meterai ilocho. 12. chonchorso . . etterminata. 13. ara . . infralla . perchussione. 14. troverrai di osschurita infrallōbre . . luminosi "m. b." chelle chavsano. 15. essehessi . . grandeza anchora . . perchussioni luminosi dello. 16. bri quale quella.
217. 1. refresso . razi . chorti. 2. osscurita facta per"ne"la perchussione . . comchorsso . ara . chonformita . chol. 3. effinita . .

217. Diagrams are inserted before lines 2 and 4.

⁴Quanto maggiore fia · il corpo · lumi-noso · tanto più ’l corso delli onbrosi e lumi-nosi razzi · fia insieme misto; ⁵l’effetto · della · sopra detta propositione · accade · perchè · doue · si truoua · essere · maggiore · somma · di razzi · luminosi ⁶lì si è · maggior · lume · e doue · n’è meno ·, mīnor lume · ne resulta · onde i razzi ōbrosi · si uēgono a mischiarsi īsieme.

[4]In proportion as the source of light is larger, the luminous and shadow rays will be more mixed together. This result is pro-duced because wherever there is a larger quantity of luminous rays, there is most light, but where there are fewer there is least light, consequently the shadow rays come in and mingle with them.

C. 3 b (13 a)] **218.**

Di tutte · le proportioni · ch’io farò s’in-tende · che ’l mezzo che si trova · infra corpi · sia per se equale; ²Quanto · minore · fia · il corpo · luminoso · tanto · più · distinto · fia il concorso · dell’onbroso.

³Quando · due ōbre · opposte, nascienti · da ū medesimo · corpo fieno l’una all’altra · per oscurità duplicate ⁴e per figura · simili i due lumi ·, causa · di quelle ·, fieno · infra loro · di dupplicato diametro e di-stantia da esso corpo ⁵onbroso · l’uno all’altro duplice; ⁶Se l’obietto fia mosso cō tardità dināzi al corpo luminoso e la percussione dell’onbra d’esso obbietto sia lontana da esso obbi⁷etto: tal proportione avrà · il moto dell’ōbra diriuativa · col moto della primitiva · qua-le · avrà lo spatio che tra l’ob-bietto ⁸e lume · con quello che tra l’obbietto · e la percussione dell’onbra ī modo che movēdosi l’obietto cō. tardità, l’ōbra fia veloce.

In all the proportions I lay down it must be understood that the medium between the bodies is always the same. [2]The smaller the luminous body the more distinct will the transmission of the shadows be.

[3]When of two opposite shadows, produ-ced by the same body, one is twice as dark as the other though similar in form, one of the two lights causing them must have twice the diameter that the other has and be at twice the distance from the opaque body. If the object is lowly moved across the luminous body, and the shadow is intercepted at some distance from the object, there will be the same relative pro-portion between the motion of the derived shadow and the motion of the primary sha-dow, as between the distance from the object to the light, and that from the object to the spot where the shadow is intercepted; so that though the object is moved slowly the shadow moves fast.

C. 3 a (13 b)] **219.**

Quel corpo luminoso · parrà di minore splendore jl quale · da piv · luminoso · campo · circundato fia.

²Ho trovato · che quelle stelle che sō piv · presso all’orizōte appariscā di maggiore figura che l’altre perchè esse vedono e sō vedute ³da maggior sōma del corpo solare che quādo esse sō sopra di noi ·, e per ueder piv sole esse àño maggior lume e ’l corpo che

A luminous body will appear less bril-liant when surrounded by a bright back-ground.

[2]I have found that the stars which are nearest to the horizon look larger than the others because light falls upon them from a larger proportion of the solar body than when they are above us; and having more light from the sun they give more light, and the bodies

ecpiane . . errecta. 4. chorpo . . chorso . . missto. 5. decta . . achade . . razi. 6. magior . . razi siuēgano a misticharsi.
218. 1. proportione . . mezo del chessi. 2. chorpo . . disstinto . . fiel chonchorso dall. 3. due "ōbre" oposite nascienti . . chorpo [onbroso] fia . . iscurita duplicata. 4. infralloro di dupplichoto diamitro . . chorpo. 6. obiecto chō . . ella per-chussione . . obbiecto. 7. eto . . ara il . . chol . . ara . . trallobietto. 8. trallobbiecto ella perchussione . . chō.
219. 1. chorpo . . chanpo circhundato. 2. chessō . . aparisscā di magiore . . chellaltre hesse vegano essō. 3. hesse . . hesse ano

218. There are diagrams inserted before lines 2 and 3 but they are not reproduced here. The diagram above line 6 is written upon as follows: at *A lume* (light), at *B obbietto* (body), at *C ombra d'obbietto* (shadow of the object).

219. Between lines 1 and 2 there is in the original a large diagram which does not refer to this text.

[4]sarà piv luminoso si dimostra di maggiore figura, come si mostra il sole nella nebbia sopra di noi che par maggiore, [5]essēdo sanza nebbia, e colla nebbia diminvisce; [6]Nessuna · parte del corpo · luminoso · mai · fia · veduta dalla · piramidal pura ombra diriuativa.

which are most luminous appear the largest. As may be seen by the sun through a mist, and overhead; it appears larger where there is no mist and diminished through mist. No portion of the luminous body ˙ is ever visible from any spot within the pyramid of pure derived shadow.

C. 2 *b* (14 *a*)] **220.**

Il corpo che riceve i razzi solari · passati · infra le sottili ramificationi delle piante, a lungo andare · nō farà piv d'un'ōbra.
[2]Se'l corpo onbroso · e luminoso fieno di sperica retondità·, tal proportione · avrà la basa · della · luminosa · [3]piramide col suo · corpo·, quale · à · la basa dell'onbrosa · piramide · col suo · corpo onbroso.
[4]Quanto · la percussione ·, fatta dall'onbroso · concorso · nella · contra se posta · pariete, fia più distante al corpo · luminoso e piv [5]propinqua · a sua · diriuatione, tanto · più scure · e di termini · più distinti appariranno.

A body on which the solar rays fall between the thin branches of trees far apart will cast but a single shadow.
[2]If an opaque body and a luminous one are (both) spherical the base of the pyramid of rays will bear the same proportion to the luminous body as the base of the pyramid of shade to the opaque body.
[4]When the transmitted shadow is intercepted by a plane surface placed opposite to it and farther away from the luminous body than from the object [which casts it] it will appear proportionately darker and the edges more distinct.

C. 2 *a* (14 *b*)] **221.**

Il corpo alluminato · dai solari · razzi · passati · per le grosse ramificationi delle piāte · farā tāte ōbre · quāt'è il nvmero de'rami che infra'l sole [2]e esse interposti · sono.
¶[3]La percussione · delli onbrosi · razzi nati da piramidal corpo ōbroso ·, sarà di biforcata figura · e uaria oscurità nelle sue pūte¶ [4]jl lume · che sarà maggior della pūta · e minor della basa · del contra se · posto

A body illuminated by the solar rays passing between the thick branches of trees will produce as many shadows as there are branches between the sun and itself.
Where the shadow-rays from an opaque pyramidal body are intercepted they will cast a shadow of bifurcate outline and various depth at the points. A light which is broader than the apex but narrower than the base

magior . . el [ume] chorpo. 4. magiore figura [Macq] come . . magiore. 5. cholla . . diminvisscie. 6. chorpo.
220. 1. "il chorpo che riciev[ono] "e"" J razi . . infralle . . ramifichatione . . allungo. 2. elluminoso . . sphericha . . ara. 3. chol . . chorpo . . chol . . chorpo. 4. perchussione facta . . chonchorso . . chontrassepossta . . disstante alchorpo . . eppiv. 5. assua . . schure . . termī piu disstinti.
221. 1. chorpo . . razi . . per"le" grosse ramificatione . . paāte fara . . in fral sole esse interpossti. 3. perchussione . . razi . . chorpo . . biforchuta . . osscurita | propō. 4. chessara magior . . ēminor . . chontrasse . possto . . chorpo . . chellonbroso

220. The diagram which, in the original, is placed above line 2, is similar to the one, here given on page 73 (section 120). — The diagram here given in the margin stands, in the original, between lines 3 and 4.
221. Between lines 2 and 3 there are in the original two large diagrams.

piramidal · corpo · onbroso ·, farà · che l'on-
broso · cavserà ⁵in sua percussione ōbra · di
biforcata · figura · e uaria · qualità di scu-
rezza.

⁶Se 'l corpo · onbroso ·, minor del lumi-
noso ·, fa due · onbre · e il corpo · ōbroso ·,
simile al luminoso, e il maggiore · ne fa vna,
è cōue⁷niēte cosa · che 'l corpo pirami-
dale ·, che à parte · di se · minore · parte pari
e parte maggiore dal luminoso, faccia ōbra
biforcata.

of an opaque pyramidal body placed in front
of it, will cause that pyramid to cast a
shadow of bifurcate form and various de-
grees of depth.

If an opaque body, smaller than the light,
casts two shadows and if it is the same size
or larger, casts but one, it follows that a
pyramidal body, of which part is smaller,
part equal to, and part larger than, the lumi-
nous body, will cast a bifurcate shadow.

. chausera. *Here in the margin:* p̄rop̄o (proposition). 5. perchussione . . biforchuta . . disscureza. 6. chorpo . . onbre e
hel chorpo . . luminoso e hel magiore . . vna echōue. *Here in the margin:* coñe. 7. chosa chelchorpo . . magiore dal . .
faccōbra biforchata.

1

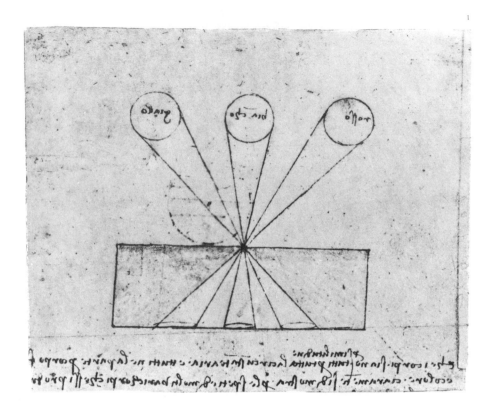

2

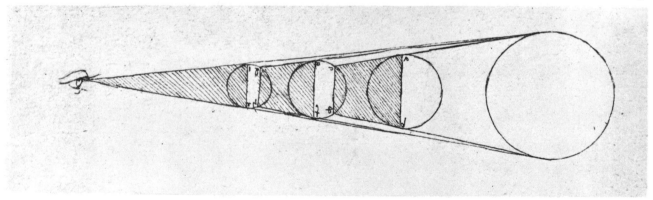

3

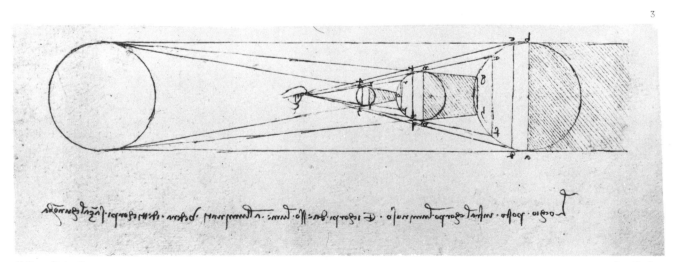

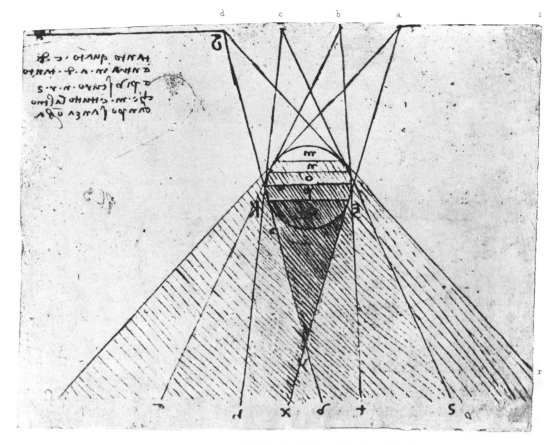

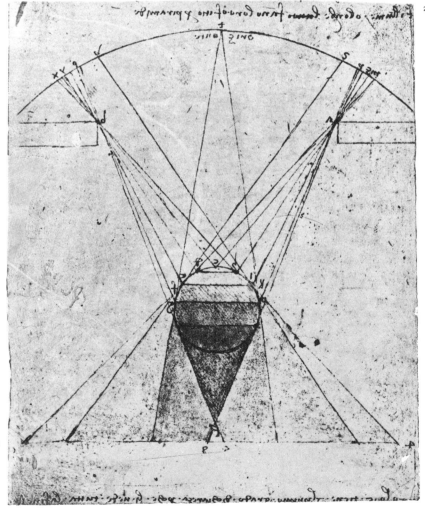

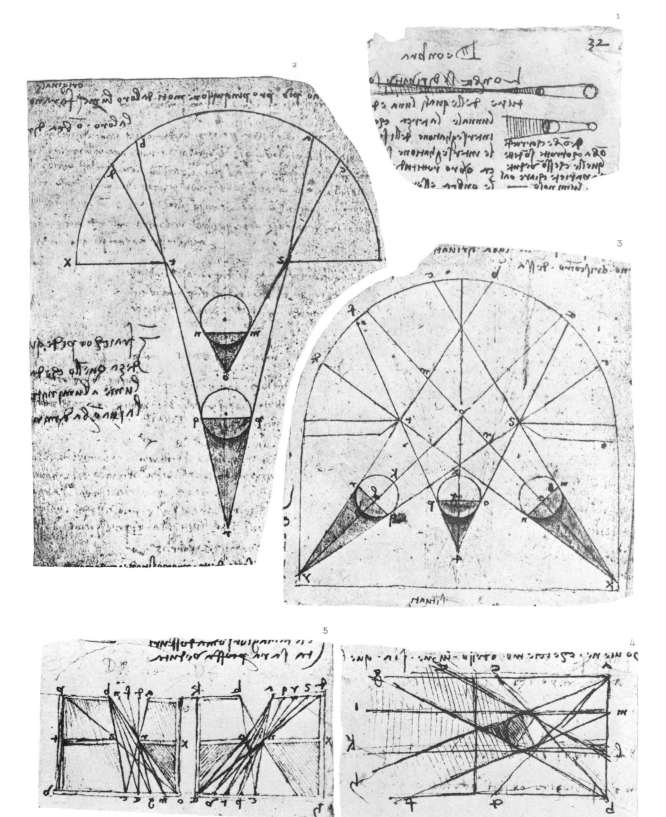

Héliog Dujardin.

Imp Eudes.

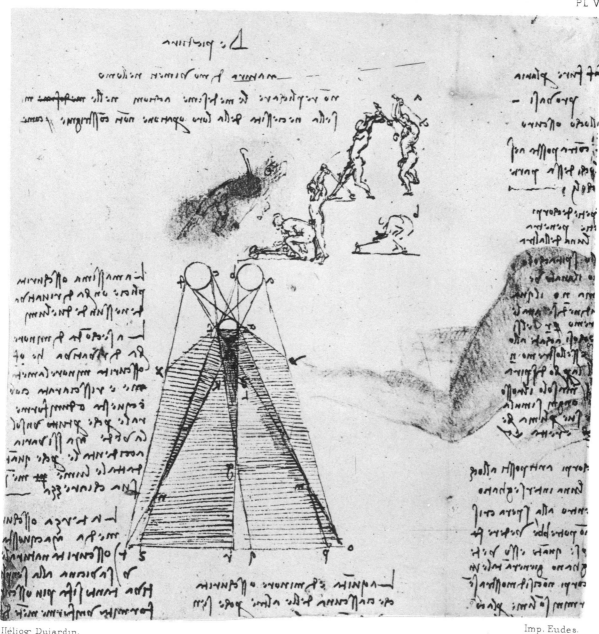

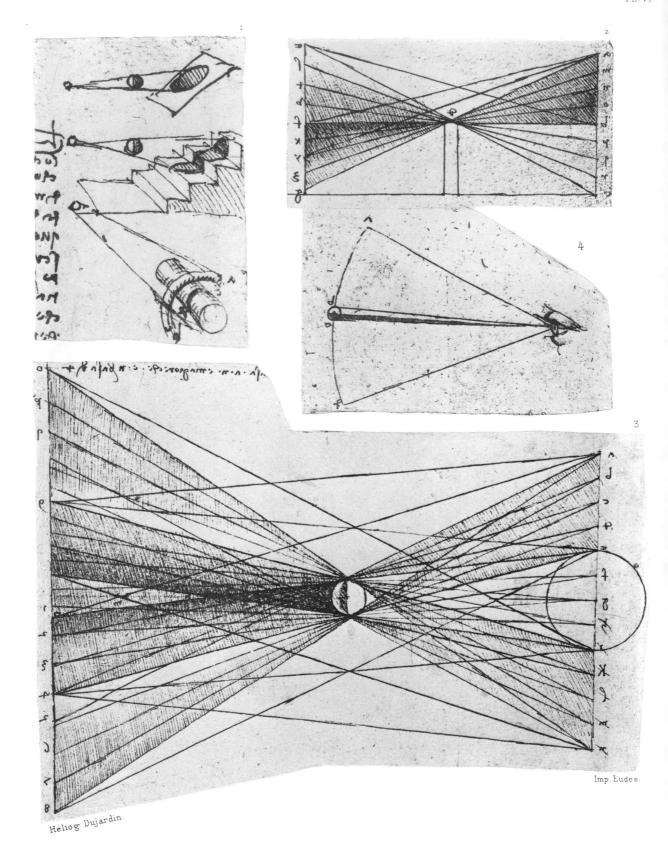

Imp. Eudes.

1

2

4

3

5

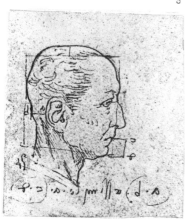

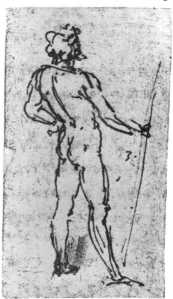

Héliog. Dujardin.

Imp. Eudes

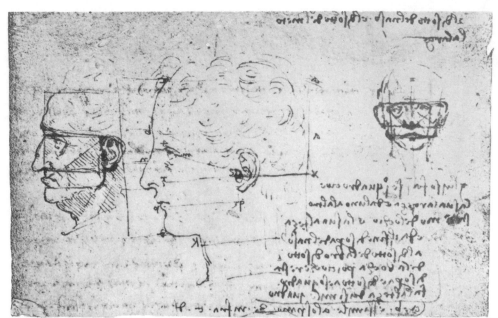

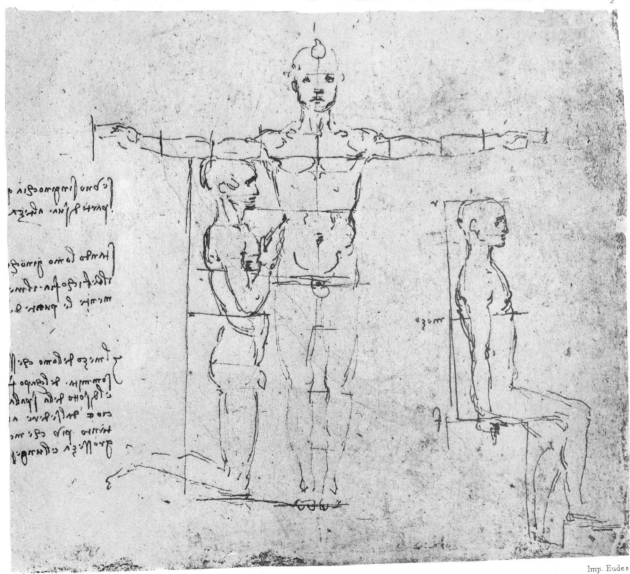

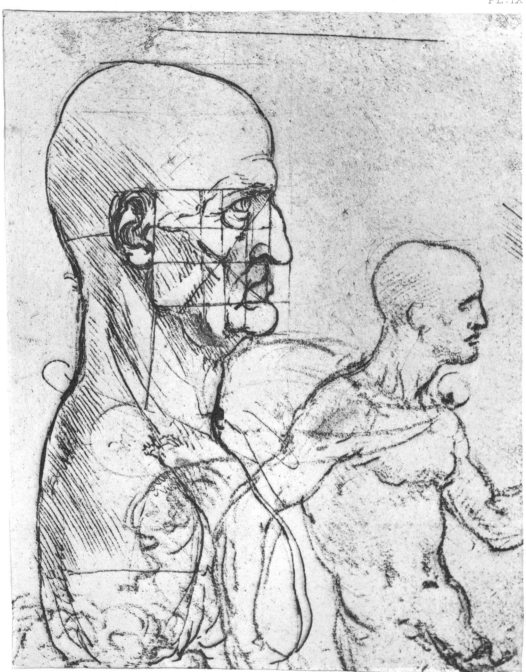

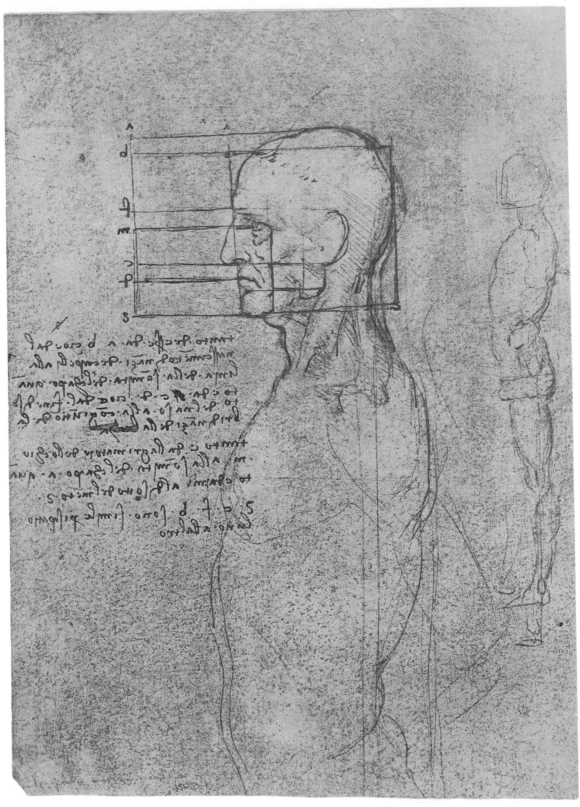

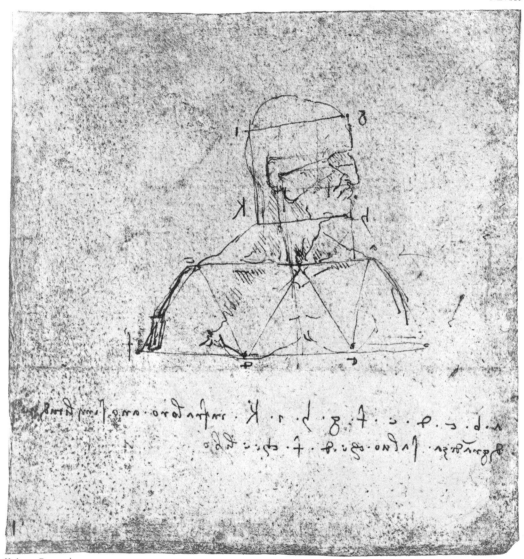

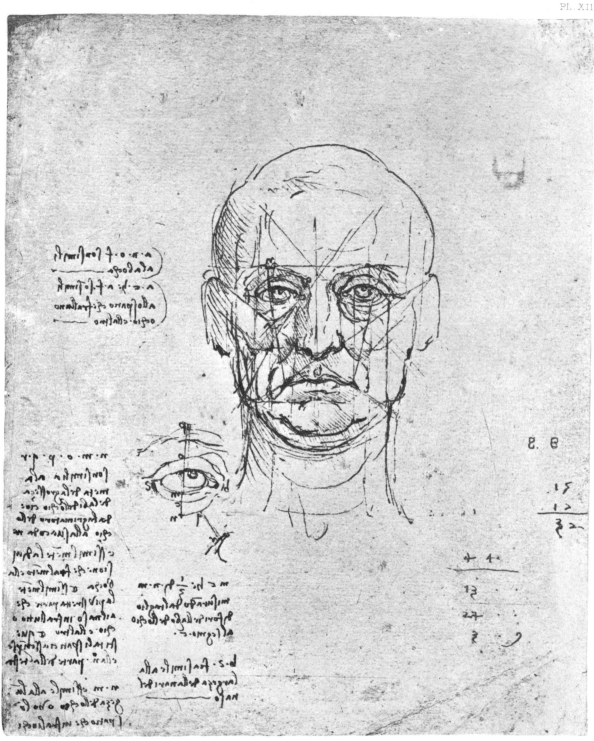

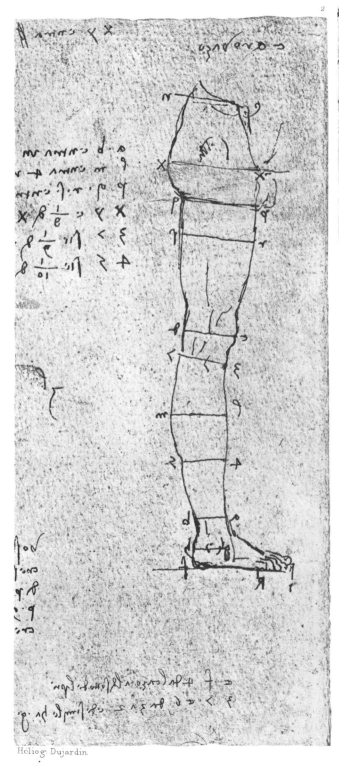

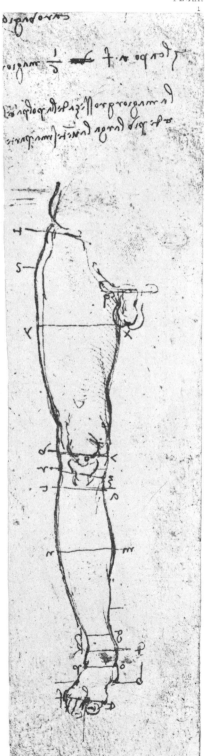

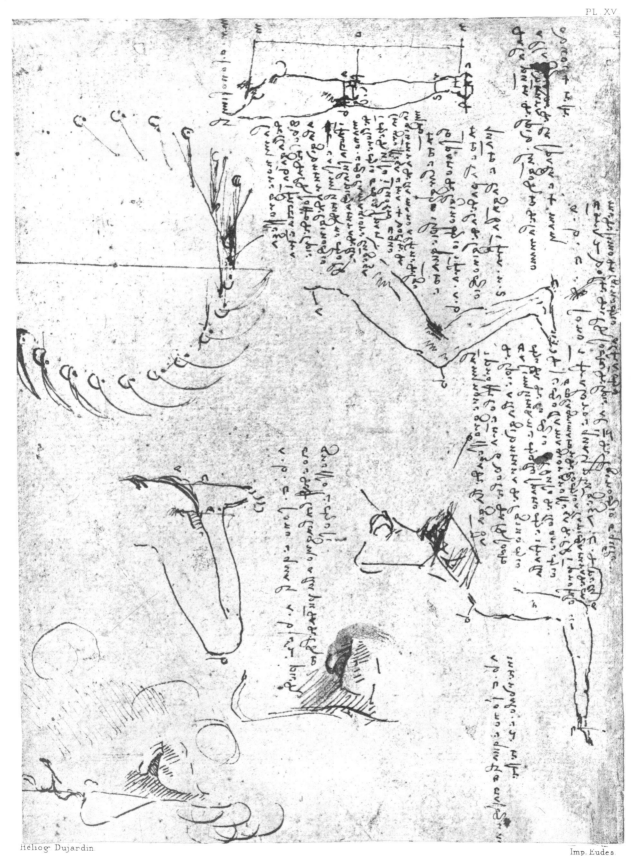

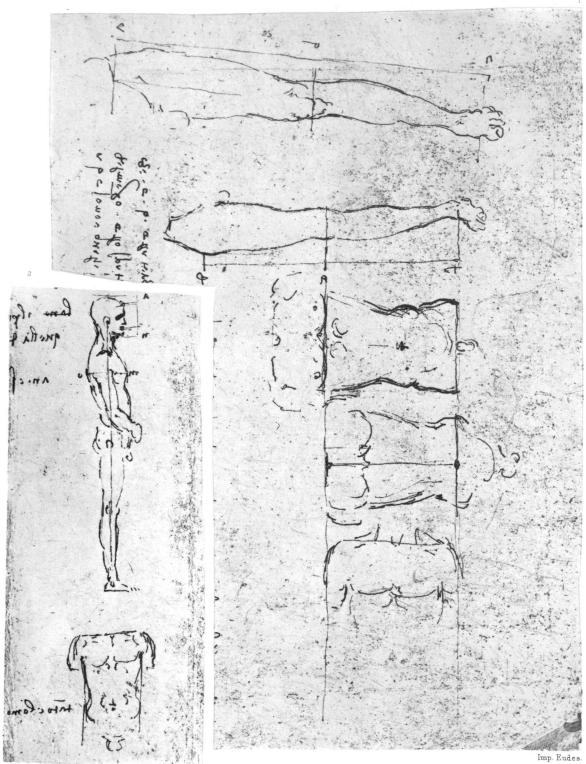

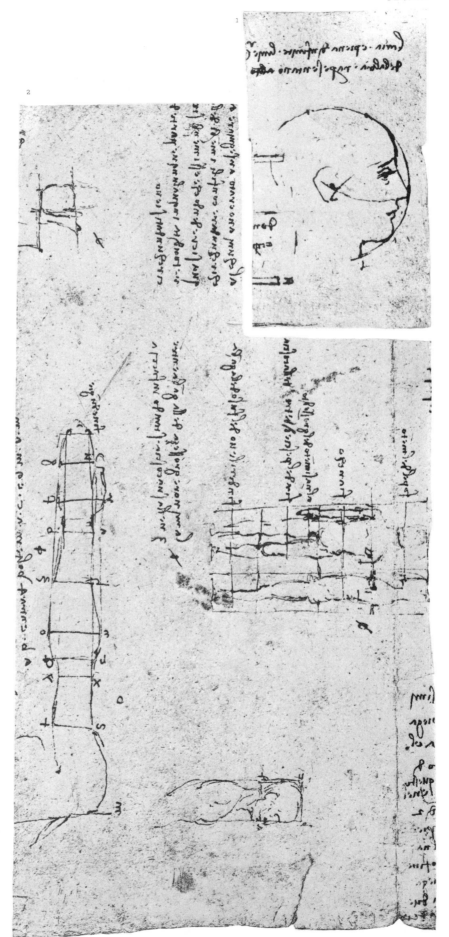

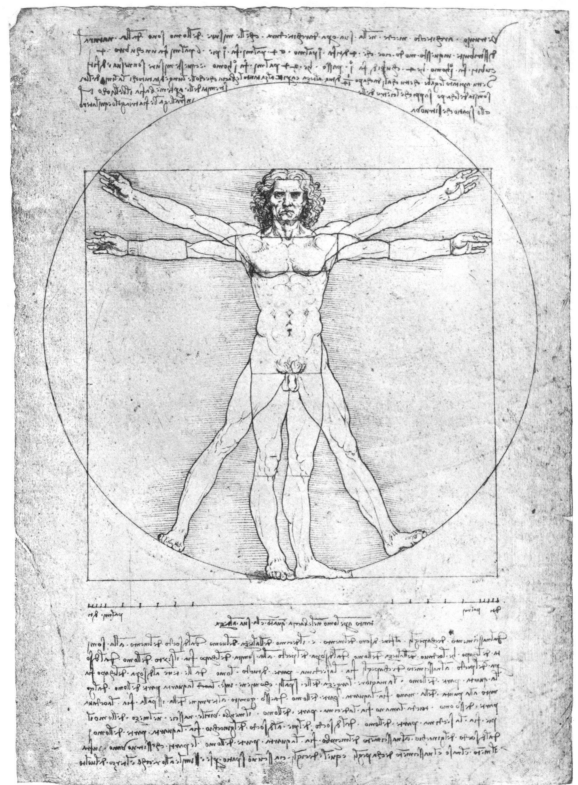

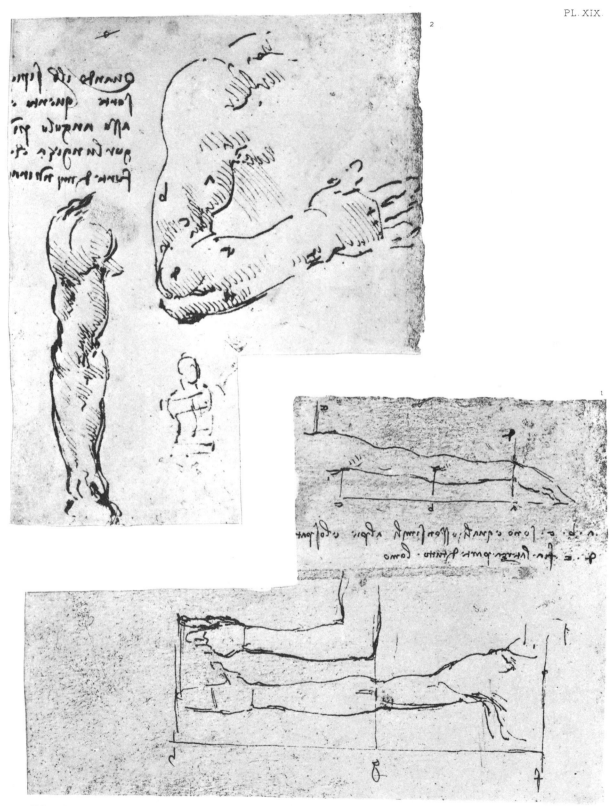

Héliog. Dujardin

Imp. Eudes.

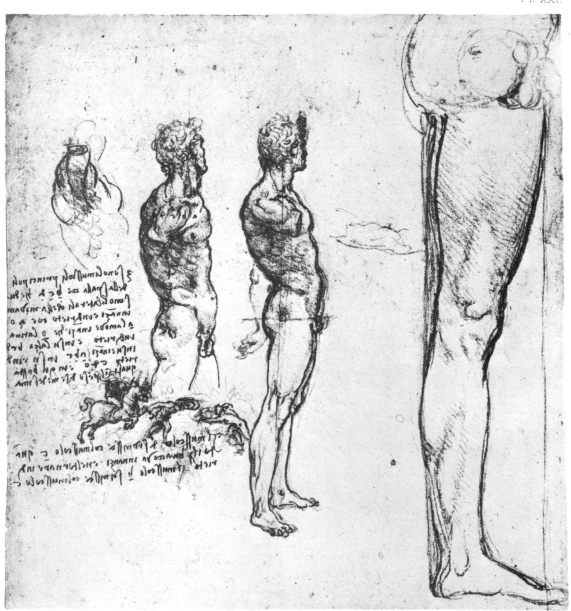

1

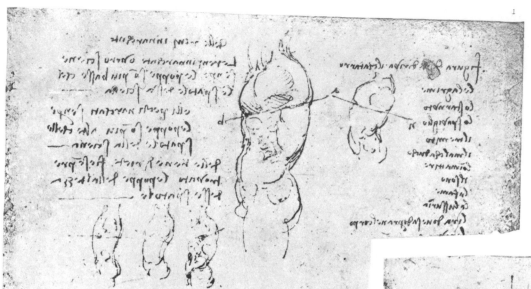

4

2

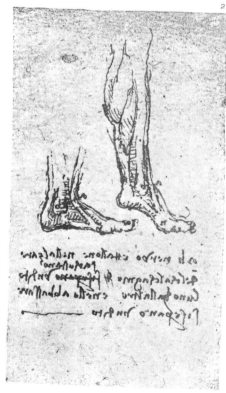

3

Héliog. Dujardin.

Imp. Eudes.

1

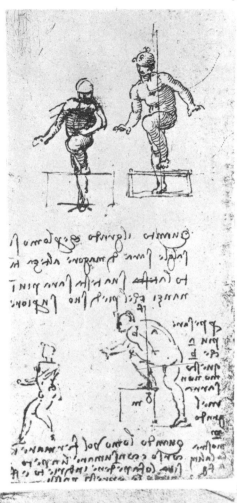

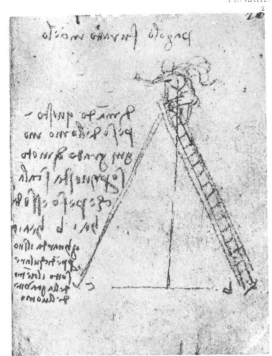

3

4

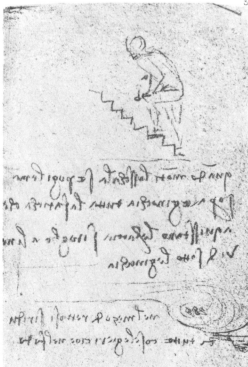

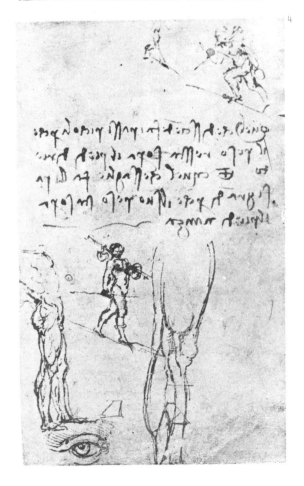

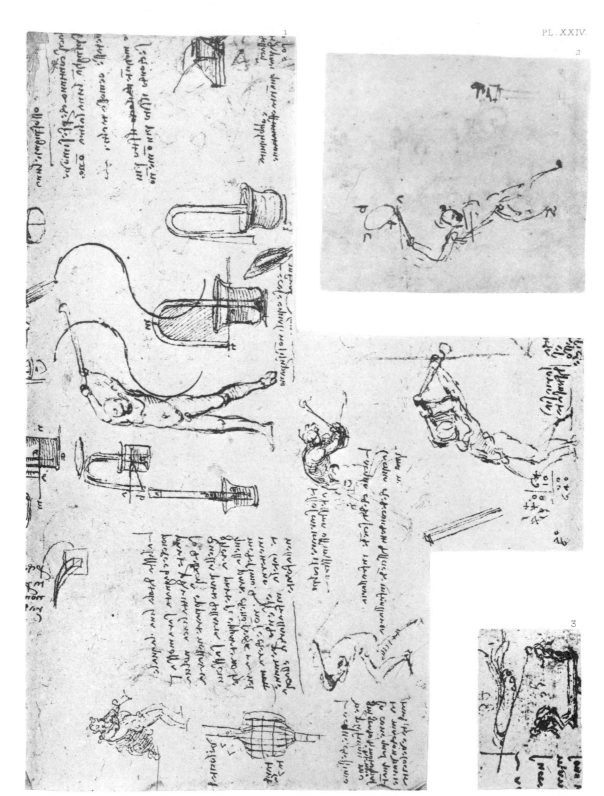

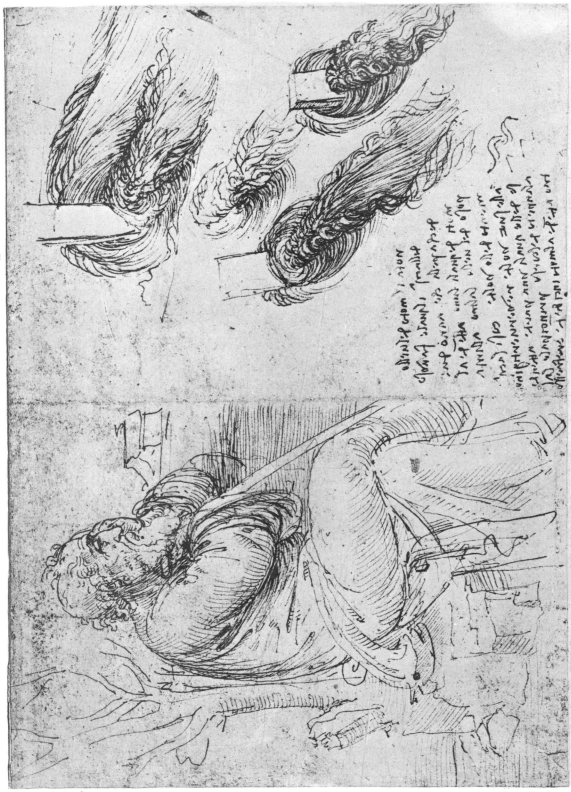

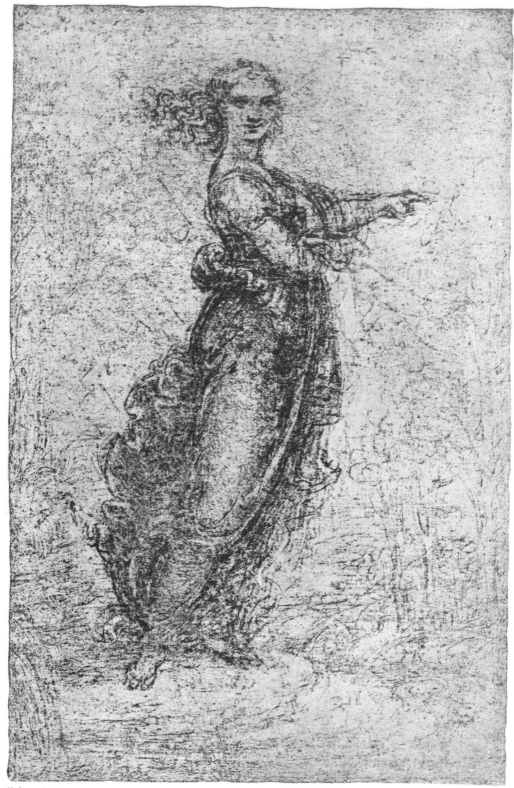

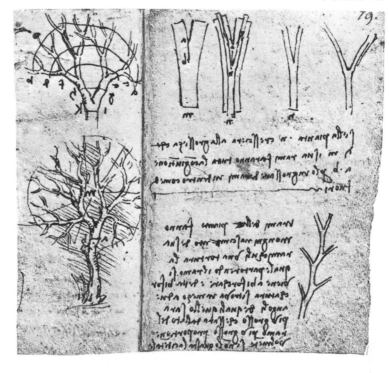

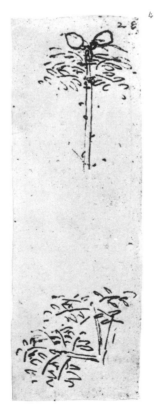

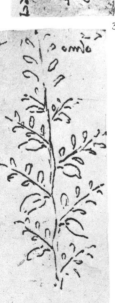

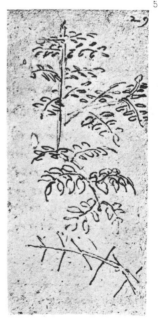

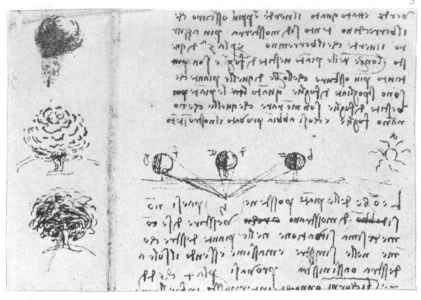

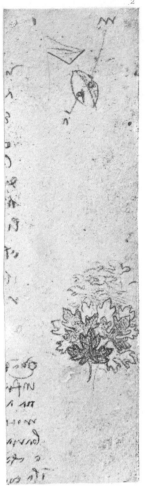

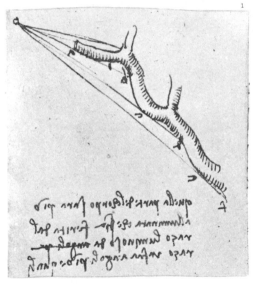

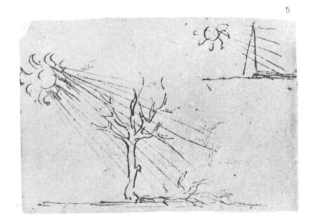

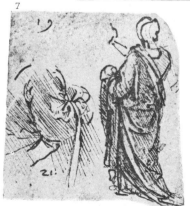

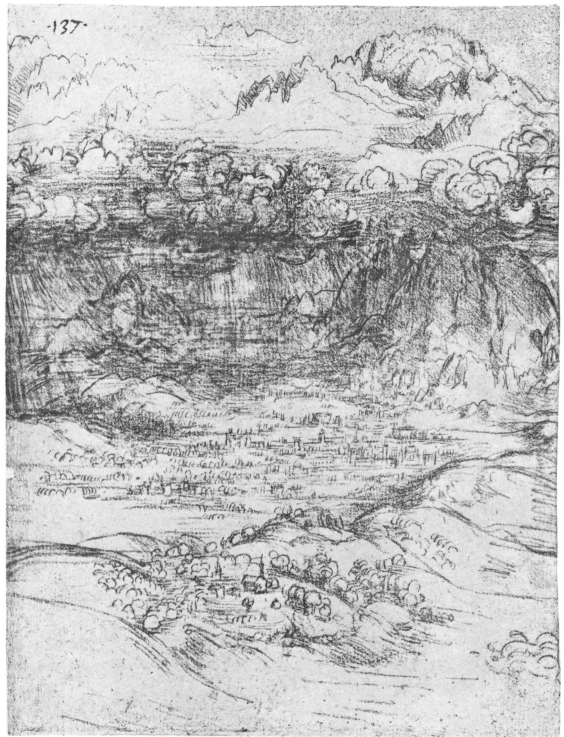

·137·

Héliog. Dujardin.

Imp. Eudes.

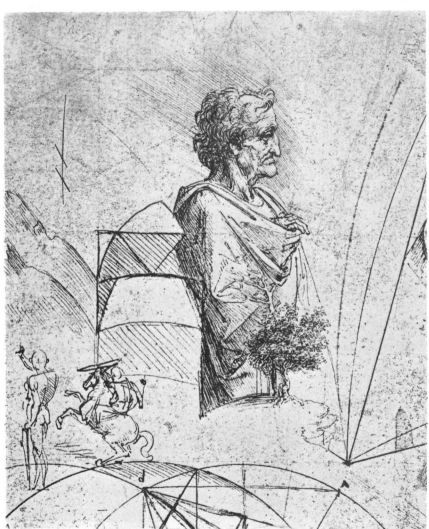

Héliog. Dujardin.

Imp. Eudes.

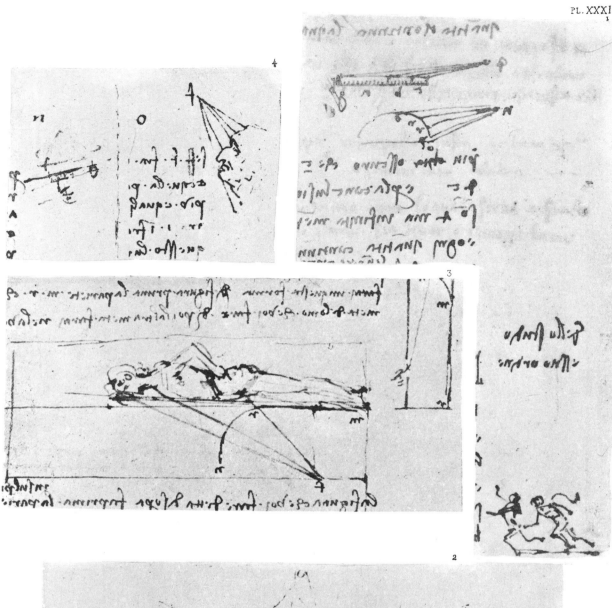

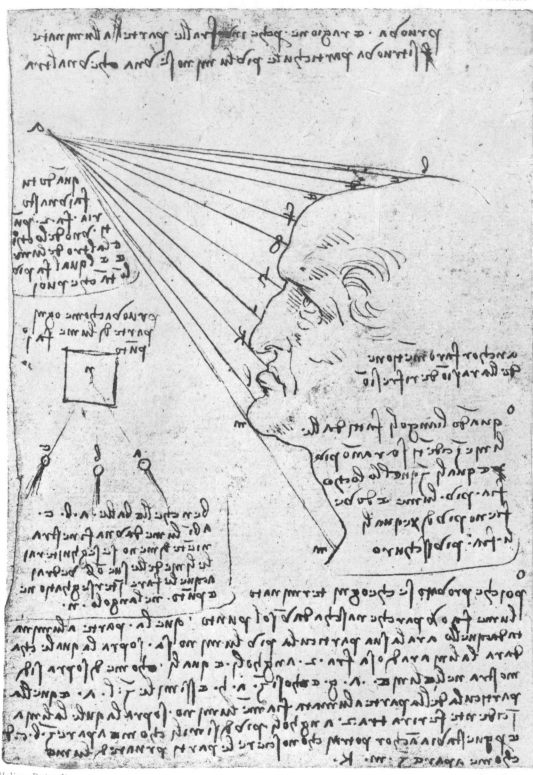

Imp. Eudes.

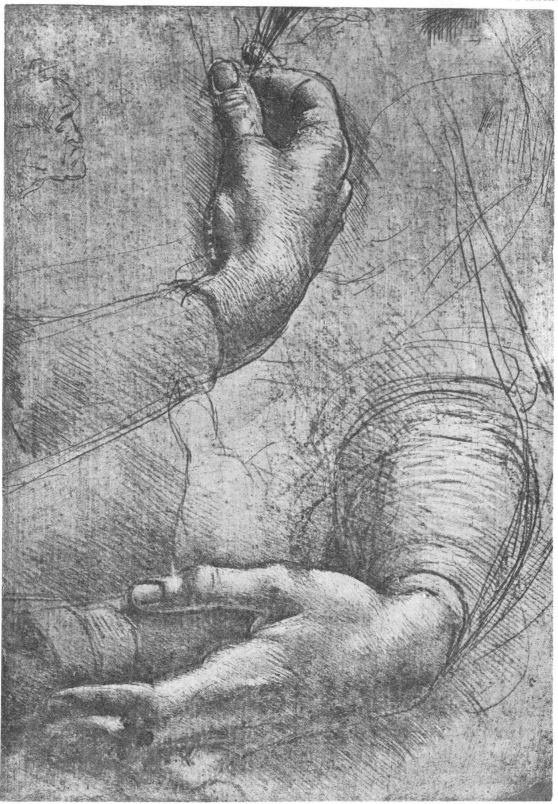

Héliog. Dujardin.

Imp. Eudes.

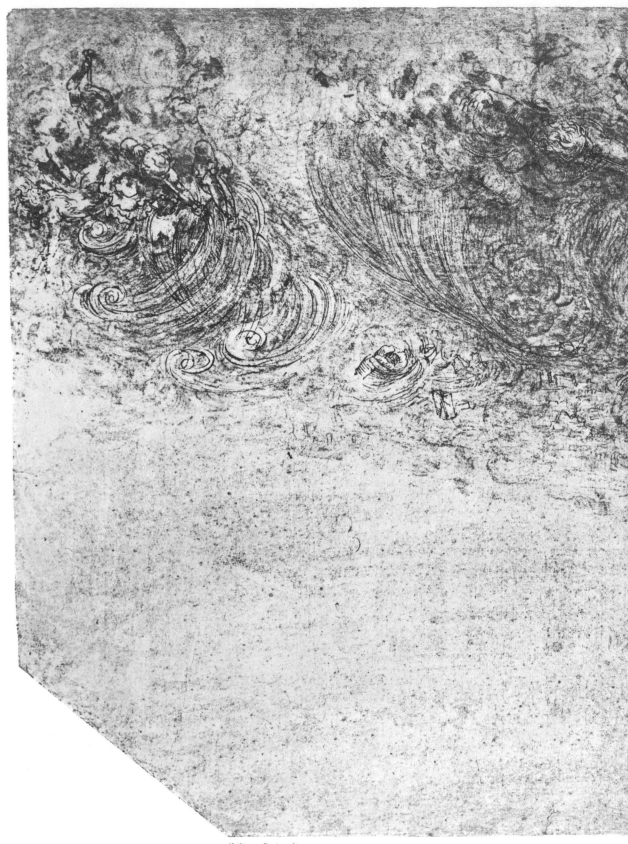

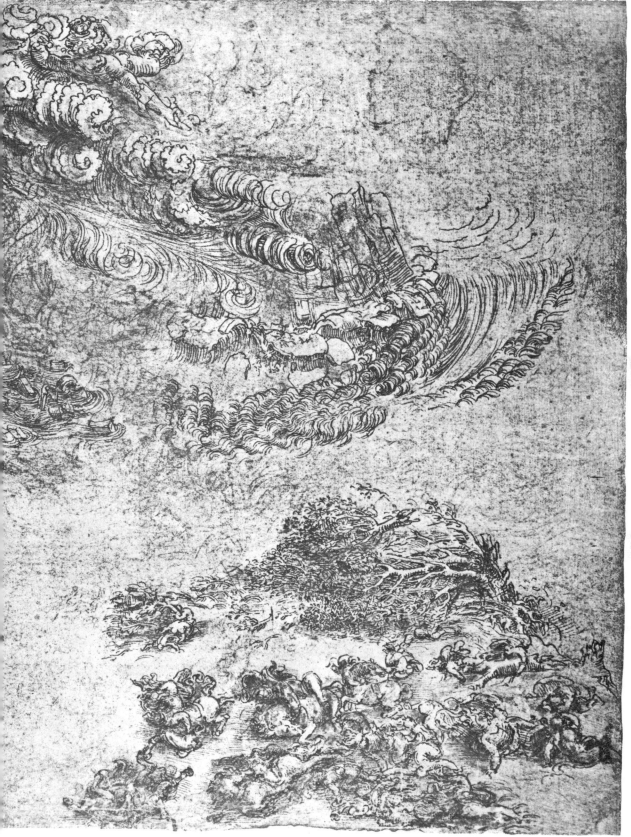

Imp. Eudes.

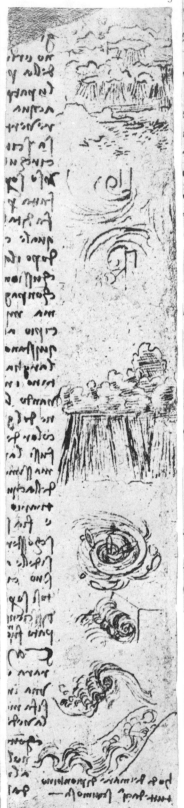

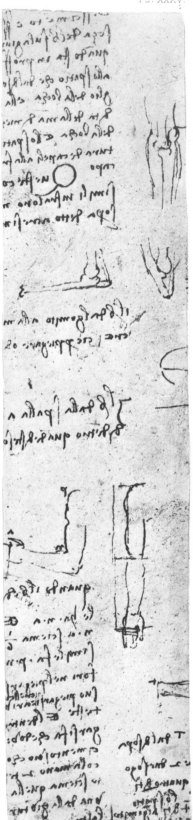

IV.

Perspective of Disappearance.

The theory of the "Prospettiva de' perdimenti" would, in many important details, be quite unintelligible if it had not been led up by the principles of light and shade on which it is based. The word "Prospettiva" in the language of the time included the principles of optics; what Leonardo understood by "Perdimenti" will be clearly seen in the early chapters, Nos. 222—224. It is in the very nature of the case that the farther explanations given in the subsequent chapters must be limited to general rules. The sections given as 227—231 "On indistinctness at short distances" have, it is true, only an indirect bearing on the subject; but on the other hand, the following chapters, 232—234, "On indistinctness at great distances," go fully into the matter, and in chapters 235—239, which treat "Of the importance of light and shade in the Perspective of Disappearance", the practical issues are distinctly insisted on in their relation to the theory. This is naturally followed by the statements as to "the effect of light or dark backgrounds on the apparent size of bodies" (Nos. 240—250). At the end I have placed, in the order of the original, those sections from the MS. C which treat of the "Perspective of Disappearance" and serve to some extent to complete the treatment of the subject (251—262).

PERSPECTIVA DE' PERDIMĒTI [2]CHE FĀ LI STREMI
DE' CORPI O[3]PACHI.

[4] Se inuisibili son li veri stremi de' corpi
opachi [5]in qualunche minima distantia,
maggiormente [6]sarā invisibili nelle lūghe
distātie; ¶e se [7]per li termini si cognosce
la uera figura di cias[8]cū corpo opaco e
mācādo per distantia la [9]cognitiō d'esso
tutto, maggiormēte mancherà [10]la cognitione
delle sue parti e termini.

OF THE DIMINISHED DISTINCTNESS OF THE OUT-
LINES OF OPAQUE BODIES.

If the real outlines of opaque bodies are
indistinguishable at even a very short distance,
they will be more so at long distances; and,
since it is by its outlines that we are able to
know the real form of any opaque body, when
by its remoteness we fail to discern it as a
whole, much more must we fail to discern
its parts and outlines.

*Definition
(222. 223).*

DELLA PROSPETTIVA DIMINUTRICE [2]DELLI CORPI
OPACHI.

[3] Infra li corpi opachi d'equal magni-
tudine [4]tal fia la diminutione delle lor figure
in ap[5]parētia qual' è quella delle lor distantie
dal[6]l' ochio che le vede, ma tale propor-
tione è [7]cōuersa ¶ perchè dove la distantia
è mag[8]giore, il corpo opaco si dimostra
minore [9]e dove la distantia è minore, esso
corpo si [10]dimostrerà maggiore, e di qui
nasce la pro[11]spectiva liniale e in seguito
converrà ¶ogni [12]corpo per lunga distā-
tia perde prima quel[13]la parte di quel corpo,
la quale in se è più [14]sottile come dire:
d'un cavallo si perderā pri[15]ma le ganbe
che la testa, perchè le gā[16]be son più sottili
d'essa testa, e prima si per[17]derà il collo
che il busto, per la medesima ragio[18]ne
detta; adūque seguita che l'ultima parte

OF THE DIMINUTION IN PERSPECTIVE OF OPAQUE
OBJECTS.

Among opaque objects of equal size the
apparent diminution of size will be in pro-
portion to their distance from the eye of the
spectator; but it is an inverse proportion, since,
where the distance is greater, the opaque body
will appear smaller, and the less the distance
the larger will the object appear. And this is
the fundamental principle of linear perspec-
tive and it follows:—[11]every object as it
becomes more remote loses first those parts
which are smallest. Thus of a horse, we
should lose the legs before the head, because
the legs are thinner than the head; and the
neck before the body for the same reason.
Hence it follows that the last part of the
horse which would be discernible by the eye
would be the mass of the body in an oval

222. 2. cheffālisstremi de chorpi op. 4. chorpi oppachi. 5. disstantia. 6. disstātie esse. 7. chogniosscie . . fighura. 8. chū . .
oppacho e māchādo. 9. magiormēte. 10. chognitione . . parte || "ettermini" adunque.

223. 1. prosspectiva diminuitrice. 3. Infralli chorpi oppachi . . magnitudi. 4. diminuitione. 5. Quale "qu''lla delle. 6. chelle.
7. chonversa. 8. chorpo oppacho si dimosstra. 9. chorpo. 10. dimossterra . . nasscie. 11. seguita chonve "ra" (?) ogni.
12. chorpo . . lungha. 14. chome . . chavallo. 15. ghanbe [che il cho] chella tessa. 16. soctile dessa tessta. 17. chollo . .

[19]che della cōgnitione del cavallo fia al-l'ochio riser[20]vata sarà il busto restato in forma ovale, [21]ma più tosto traente al colonnale e perderas[22]si prima la grossezza che la lunghezza per la anti[23]detta 2ª conclusione ecc.

[24]Se l'ochio è in[25]mobile, la prospet-[26]tiva termina [27]la sua distanti[28]a in punto; [29]ma se l'ochio [30]si move per ret[31]ta linia la pro[32]spettiva ter[33]mina in linia, [34]perchè è prova[35]to la linia es[36]sere gienera[37]ta dal moto del [38]pūto e il no[39]stro vedere ··· [41]e per [42]questo seguita [43]che chi move il ve[44]dere, move il pū[45]to e chi mo[46]ve il pūto, giene[47]ra la linia ecc.

form, or rather in a cylindrical form and this would lose its apparent thickness before its length—according to the 2nd rule given above, &c. [23].

If the eye remains stationary the perspective terminates in the distance in a point. But if the eye moves in a straight [horizontal] line the perspective terminates in a line and the reason is that this line is generated by the motion of the point and our sight; therefore it follows that as we move our sight [eye], the point moves, and as we move the point, the line is generated, &c.

Ash. I. 23 a] **224.**

[2]Ogni · forma · corporea ·, ī quāto · allo ofi-tio · dell'ochio ·, si divide · in 3 parti · cioè [3]corpo · figura · e colore: la similitudine · corporea s'astēde piv lontana dalla [4]sua · origine ·, che nō fa il colore · o la figura ·, di poi · il colore s'astēde piv che la figura, [5]ma questa regola nō si osserua da corpi luminosi.

Every visible body, in so far as it affects the eye, includes three attributes; that is to say: mass, form and colour; and the mass is recognisable at a greater distance from the place of its actual existence than either colour or form. Again, colour is discernible at a greater distance than form, but this law does not apply to luminous bodies.

An illustration by experiment.

[6]La propositione · di sopra · è molto bene dimostrata · e cōfermata · dalla speriēza, inpe-ro[7]chè, se tu · vedrai uno · uomo · da presso ·, tu conoscerai · la qualità · del corpo ·, la qua-lità della [8]figura, e similmēte · del colore ·, e, se quello s'allontana da te alquāto spatio, tu nō conoscierai [9]chi quello · si sia · perchè māca · la qualità · della figura: se s'astēderà ācora · piv lōtano [10]nō potrai disciernere · il colore suo: anzi ti parrà uno corpo oscuro · di piv lontano ti parà [11]un minimo corpo retōdo · e scuro retōdo parrà · perchè · la distātia diminv[12]isce tanto le particulari mēbra · che non ne · apparisce se non la maggiore · massa; [13]la ragione è questa · Noi sappiamo chiaro · che tutte · le similitudini · delle cose ētrano [14]nella inpressiua per uno · piccolo · spiracolo · dell'ochio: adūque · se tutto · l'orizzōte a · d [15]ētra per simile · spi-racolo ·, sendo il corpo · b · c · una minimis-sima parte d'esso orizzōte, [16]che parte avrà

The above proposition is plainly shown and proved by experiment; because: if you see a man close to you, you discern the exact appearance of the mass and of the form and also of the colouring; if he goes to some distance you will not recognise who he is, because the character of the details will disappear, if he goes still farther you will not be able to distinguish his colouring, but he will appear as a dark object, and still farther he will appear as a very small dark rounded object. It appears rounded because distance so greatly diminishes the various details that nothing remains visible but the larger mass. And the reason is this: We know very well that all the images of objects reach the senses by a small aperture in the eye; hence, if the whole horizon a d is admitted through such an aperture, the object b c being but a very small fraction of this horizon what space can it fill in that

bussto. 18. chellultima. 21. tossto . . cholonale e perdera. 22. grosseza chella . . perle anti. 24. sellochio he. 25. la perspc. 27. disstanti . . puncto. 29. Massellochio . . rec. 39. sstro. 40. [ecc]. 41. elnpūto e per. 42. quessto. 45. [li qual] e chi. **224.** 1. [le similitudine delle chorpi f]. 2. chorporea. 3. cholore. 5. macquesta. 6. chōfermata. 7. chessettu . vederai . ī . homo . . chonoscierai. 8. essimilmēte . . esse quelo . . datte. 9. chicquello . . mācha. 10. cholore . . para ī chorpo . . para. 11. in minimo chorpo . . escuro [di forma quasi] retōdo para. 12. isscie . . none apariscie . . magiore. 13. ecquesta . . sapiamo . .

223. 23. Compare line 11.
224. The diagram belonging to this passage

is placed between lines 5 and 6; it is No. 4 on Pl. VI.

egli · a occupare della minima rappresēta-
tione di si grāde emisperio; [17] e perchè i corpi
luminosi · sono · piv · potēti · īfra · le tenebre ·
che nessun altro · corpo, [18] è neciessario che ·,
essendo lo spiracolo della vista assai tene-
broso, com'è la natura [19] di tutti i busi ·, che
le spetie de' corpi lōtani si cōfondino īfra
tāta luce del [20] cielo, e se pure appariscano,
che paiano oscure e nere come fa ogni
corpo piccolo [21] visto nel chiarore dell'aria.

minute image of so vast a hemisphere? And
because luminous bodies have more power
in darkness than any others, it is evident
that, as the chamber of the eye is very dark,
as is the nature of all colored cavities, the
images of distant objects are confused and
lost in the great light of the sky; and if
they are visible at all, appear dark and black,
as every small body must when seen in the
diffused light of the atmosphere.

E. 79b]

225.

DELL'ARIA ĪTERPOSTA ĪFRA L'OCHIO E L'OBIETTO VISIBILE.

[3] L'obbietto si dimostrerà tanto più o
meno [4] noto in una medesima distātia,
quāto l'ari[5]a, interposta infra l'ochio e esso
obbietto, [6] sarà più o mē rara; Adunque
conoscē[7]do io che la maggiore o minore
quantità del[8] l'aria interposta infra l'ochio
e l'obietto rē[9]de all'ochio più o mē confusi
li termi[10]ni · d'essi corpi, tu farai li perdi-
mēti [11] delle notitie d'essi corpi tanto nella
me[12]desima proportione infra loro quale è
[13] quella delle loro distātie dall'ochio d'esso
[14] risguardatore.

OF THE ATMOSPHERE THAT INTERPOSES BETWEEN THE EYE AND VISIBLE OBJECTS.

An object will appear more or less
distinct at the same distance, in proportion
as the atmosphere existing between the eye
and that object is more or less clear.
Hence, as I know that the greater or less
quantity of the air that lies between the eye
and the object makes the outlines of that
object more or less indistinct, you must
diminish the definiteness of outline of those
objects in proportion to their increasing dis-
tance from the eye of the spectator.

A guiding rule.

L. 77b]

226.

Quando io fussi in vn sito di mare
[2] equalmēte distante
infra la spiaggia [3] e'l
mōte, molto piv lūgo
mostra essere [4] quello
della spiaggia che
quello del mōte.

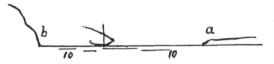

When I was once in a place on the sea,
at an equal distance
from the shore and the
mountains, the distance
from the shore looked
much greater than that
from the mountains.

An experiment.

Br. M. 115a]

227.

Se ti porrai uno corpo [2] ōbroso dināti alli
ochi per spatio di 4 dita, [3] e ch'egli sia · minore
che non è dall'una all'al[4]tra · luce,
· non occuperà il uedere d'alcuna
[5] cosa che sia dopo quella; [6] nes-
suna cosa situata dopo il uisiuo
[7] obietto dell'ochio nō può essere
occupa[8]ta · da esso obbietto, se
sarà mino[9]re che lo spatio che
sta · infra le luci.

If you place an opaque object in front of
your eye at a distance of four fingers' breadth,
if it is smaller than the space be-
tween the two eyes it will not inter-
fere with your seeing any thing
that may be beyond it. No object
situated beyond another object
seen by the eye can be concealed
by this [nearer] object if it is smal-
ler than the space from eye to eye.

On indi-stinctness at short distan-ces (227—231).

chettutte . le similitudine . delle chose. 14. ala inpresiua . . picholo . . settutto lorizōte. 15. b . c . ī . . orizōte. 16. ara . . ochupare
dela . . rapresētatione. 17. chorpo. 18. spiracho. 19. chelle . . chōfondino infrattāta. 20. esse . . apariseano . . paino eñere.
225. 1. infrallochio. 2. ellobietto. 3. dimossterra . . ōmeno. 4. noto nuna . . disstātia. 5. interpossta . . obbiecto. 6. chonossiē
7. chella. 8. interpossta . . ellobietto. 9. chonfusi. 11. chorpi. 12. infralloro quale he. 13. disstātie. 14. rissghuardatore.
226. 2. disstante infralla spiagga. 3. mosstra.
227. 1. setti porai ī chorpo. 2. ispatio. 3. echella . sia . . alla. 4. ochupera. 5. chosa chessia. 6. chosa. 7. ochupa. 9. chello
ispatio.

H.² 23a] 228.

L'ochio nō conprende il propī-
²quo · angolo luminoso.

The eye cannot take in a lumin-
ous angle which is too close to it.

C. 12a] 229.

Quella · parte · della pariete · alluminata ·
fia · piv · luminosa ²che da piv · grosso an-
golo luminoso alluminata fia; E quel loco
da detti razzi osseruerà meno ³la conveniēte
qualità · del lume che da piv grosso · angolo
ōbroso adombrata fia.

That part of a surface will be better lighted
on which the light falls at the greater angle.
And that part, on which the shadow falls at
the greatest angle, will receive from those rays
least of the benefit of the light.

E. 15a] 230.

DELL'OCHIO.

²Li termini di quel corpo antiposto alla
pu³pilla dell'ochio si dimostrerā tanto meno
noti ⁴quanto e' sarāno più vicini a essa
popilla; ⁵provasi per lo stremo del
corpo n antiposto ⁶alla popilla d, la
quale popilla nel uedere es⁷so termine
vede ancora tutto lo spatio a c, ⁸che
è di là da esso termine, e le spetie
che vengono ⁹da esso spatio · si mi-
schiano colle spetie di tal ter¹⁰mine
e così l'una spetie cōfonde l'altra¹¹e
tale cōfusione priva la popilla della notitia
di tal termine.

OF THE EYE.

The edges of an object placed in front
of the pupil of the eye will be less distinct
in proportion as they are closer to the
eye. This is shown by the edge of
the object n placed in front of the pupil
d; in looking at this edge the pupil
also sees all the space a c which is
beyond the edge; and the images
the eye receives from that space are
mingled with the images of the edge,
so that one image confuses the other,
and this confusion hinders the pupil from
distinguishing the edge.

Br. M. 188a] 231.

I termini di quella cosa saranno manco
noti li quali sarā più vicini agli ochi, ²se-
guita che gli termini più remoti saran più
noti; ³infra li corpi minori della popilla delli
ochi ⁴quelli sarā māco noti, che sarā più
vicini ⁵a essa lucie.

The outlines of objects will be least clear
when they are nearest to the eye, and there-
fore remoter outlines will be clearer. Among
objects which are smaller than the pupil of
the eye those will be less distinct which are
nearer to the eye.

228. 1. 2. R.
229. 1. piv . [luminosa] . luminosa [che da magiore soma]. 2. Ecquel locho. . razi . 3. chonveniete.
230. 2. chorpo antipossti. 3. dimossterrā. 5. chorpo n antipossto. 7. anchora . . losspatio. 8. lesspetie che vengh''a''. 9. mi-
stano cholle. 10. chosi . . chōfonde. 11. attal chōfusione . . termi''ne''.
231. 1—5. *The writing runs from left to right.* 1. qlla cosa seran mancho note a qual sera piu vicina. 2. seran. 3. infralli chorpi.
4. sara mācho nota chessara . . vicina.

H.² 1 a] **232.**

Le cose vicine all' ochio pare²rāno di maggiore obbietto che le di³stāti.

⁴Le cose vedute cō du' ochi parirāno ⁵piv rotonde, che quelle che cō uno ⁶ochio vedute fieno.

⁷Le cose vedute īfra il lume ⁸e l' ōbra parirāno di maggior relie⁹vo.

Objects near to the eye will appear larger than those at a distance.

Objects seen with two eyes will appear rounder than if they are seen with only one.

Objects seen between light and shadow will show the most relief.

<div style="float:right">On indistinctness at great distances (232—234).</div>

C. A. 173 b; 520 b] **233.**

DE PICTURA.

²Tanto si perde · della uera cognitione della figura, quanto per distantia ³diminvisce della sua grandezza.

OF PAINTING.

Our true perception of an object diminishes in proportion as its size is diminished by distance.

A. 8 b] **234.**

PROSPETTIVA.

²Perchè le cose da lontano paiono · al' ochio · grandi e la ripruova fatta · nella ³pariete le dimostra piccole.

PROSPETTIVA.

⁵Domādo quāto · l' ochio · può vedere lontano · un corpo · che nō sia · luminoso ⁶come dire una mōtagnia; vedrassi assai, se 'l sole fia · di là · da lei e vedrassi ⁷più · o meno · lontana · secōdo · dove fia il sole · nel cielo.

PERSPECTIVE.

Why objects seen at a distance appear large to the eye and in the image on the vertical plane they appear small.

PERSPECTIVE.

I ask how far away the eye can discern a non-luminous body, as, for instance, a mountain. It will be very plainly visible if the sun is behind it; and could be seen at a greater or less distance according to the sun's place in the sky.

A. 2 a] **235.**

Il corpo ōbroso ·, che fia · veduto · per la linia · della incidētia del lume, nō dimostrerà ²di se · all' ochio · alcuna eminēte parte; ³esenpli gratia · sia · il corpo · ōbroso · a ·, c · sia il lume ·, c · m · e cosi · c · n · siano ⁴le linie jncidēti luminose, cioè quelle · linie · che trāsferiscono · il lume al corpo ⁵a: l' ochio sia in

An opaque body seen in a line in which the light falls will reveal no prominences to the eye. For instance, let a be the solid body and c the light; c m and c n will be the lines of incidence of the light, that is to say the lines which transmit the light to the object a. The eye being at the point b, I say

<div style="float:right">The importance of light and shade in the perspective of distance appearance (235—239).</div>

232. 1—6 R. 2. maggiore . . chelle dis. 4. la chosa veduta . . chō. 5. retonde checquelle chechō. 6. ochi. 7. chose . . infrallume. 8. ellōbra . . magior.

233. 2. cognitione "dela figura" della cosa Quanto. 3. diminvisscie . . sua [propia] grandeza.

234. 2. chose dallontano paiano . . grande. 3. pichole. 5. po . . chorpo. 6. chome dire ĩ montagnia vederassi . . dallei evederassi. 7. sechōdo.

235. 1. chorpo . . cheffia . . dimostera. 2. alchuna. 3. chorpo . . echosi. 4. Incidēte luminosa . . trāsferisschano . . chorpo.

234. The clue to the solution of this problem (lines 1—3) is given in lines 4—6, No. 232. Objects seen with both eyes appear solid since they are seen from two distinct points of sight separated by the distance between the eyes, but this solidity cannot be represented in a flat drawing. Compare No. 535.

nel pūto · *b* ·, dico che vedēdo il lume · *c* tutta la parte *m · n* ⁶che quelli rilieui che ui sono sarāno tutti alluminati: adūque l'ochio posto j̄ *c* ⁷nō ui potrà vedere ōbra · e lume ·, nō la ⁸vedēdo ogni parte li parà d'uno colore ⁹ōde le differētie delle parti eminēti ¹⁰e globose non aparirāno.

that since the light *c* falls on the whole part *m n* the portions in relief on that side will all be illuminated. Hence the eye placed at *c* cannot see any light and shade and, not seeing it, every portion will appear of the same tone, therefore the relief in the prominent or rounded parts will not be visible.

Ash. I. *21 a*] 236.

DE PITTURA.

²L' onbre · le quali · tu discernerai · con dificultà e · i loro · termini · nō puoi · conoscere anzi con cō³fuso · givditio · lo pigli · e trascrivi in nella · tua · opera, nō le farai finite overo terminate, ⁴che la · tua · opera · fia di legniosa · resultatione.

OF PAINTING.

When you represent in your work shadows which you can only discern with difficulty, and of which you cannot distinguish the edges so that you apprehend them confusedly, you must not make them sharp or definite lest your work should have a wooden effect.

E. *17 a*] 237.

PITTURA.

²Noterai nel tuo ritrarre come infra ³le ōbre sono ōbre insēsibili d'oscurità ⁴e di figura e questo si prova per la 3ª ⁵che dicie¶ le superfitie globulenti sō ⁶di tante varie oscurità e chiarezza, quā⁷te sō le uarietà delle oscurità e chia⁸rezze che le stan per obbietto.

OF PAINTING.

You will observe in drawing that among the shadows some are of undistinguishable gradation and form, as is shown in the 3ʳᵈ [proposition] which says: Rounded surfaces display as many degrees of light and shade as there are varieties of brightness and darkness reflected from the surrounding objects.

E. *3 a*] 238.

DE ŌBRE E LUME.

²Vedi tu che ritrai dell' opere di na³tura, le quātità le qualità e le ⁴figure de' lumi e onbre di cias⁵scun muscolo e nota nelle lū⁶ghezze della lor figura a qual musco⁷lo si dirizzano colla rettitudine de⁸lle lor linie ciētrali.

OF LIGHT AND SHADE.

You who draw from nature, look (carefully) at the extent, the degree, and the form of the lights and shadows on each muscle; and in their position lengthwise observe towards which muscle the axis of the central line is directed.

Ash. I. *25 b*] 239.

Quella · cosa ·, che per chiarezza fia · piv · simile alla · luce ·, ²fia veduta · piv · da lontano e di maggiore · forma che non si ³richiede alla qualità del corpo · in detta · distātia.

An object which is [so brilliantly illuminated as to be] almost as bright as light will be visible at a greater distance, and of larger apparent size than is natural to objects so remote.

5. inel . . dicho. 6. checquelli . . alluminate . . j̄[e]c. 7. ellume nolla. 8. cholore. 9. diferētie. 10. globbose.
236. 2. dissciernerai chon difichulta . . poi [dissciernere] "chonossciere" anzi chon chō. 2. ettrasscrisse inella . . nolle. 3. chella.
237. 2. chome infral. 3. dosscurita. 4. fighura ecquesto. 5. cheddicie . . globbulenti. 6. osschurita. 7. tosō . . osschurita. 8. chelle.
238. 1. ellume. 3. elle. 4. fighure. 5. scun musscholo. 6. gheze. 7. dirizano cholle.
239. 1. chosa . . chiareza. 2. dallontano . . magiore. 3. chorpo.

E. 32 b]　　　　　　　　　　**240.**

Quell' onbra si dimostrerà più oscu²ra che fia circundata da più ³splendida biāchezza e de conver⁴so sarà meno evidēte dov' ella è giene⁵rata in più oscuro canpo.

A shadow will appear dark in proportion to the brilliancy of the light surrounding it and conversely it will be less conspicuous where it is seen against a darker background.

The effect of light or dark backgrounds on the apparent size of objects (240—250).

I.¹ 17 b]　　　　　　　　　　**241.**

DE PROSPETTIVA COMUNE.

¶²Quella cosa d'uniforme grossezza ³e colore che sarà veduta in cā⁴po di disuniforme colore si dimos⁵trerà di disuniforme grossezza¶

⁶E se una cosa d'uniforme grossezza ⁷e di uarii colori sarà veduta in cā⁸po d'uniforme colore, essa cosa ⁹si dimostrerà di uaria grossezza, ¹⁰e quanto i colori del canpo o della cosa ¹¹nel canpo veduta sarà di colori ch'abbino ¹²maggiore varietà, allora le grossezze par¹³rāno · piv varie, ancora che le cose ¹⁴nel canpo vedute sieno di pari grossezza.

OF ORDINARY PERSPECTIVE.

An object of equal breadth and colour throughout, seen against a background of various colours will appear unequal in breadth.

And if an object of equal breadth throughout, but of various colours, is seen against a background of uniform colour, that object will appear of various breadth. And the more the colours of the background or of the object seen against the ground vary, the greater will the apparent variations in the breadth be though the objects seen against the ground be of equal breadth [throughout].

J.¹ 18 a]　　　　　　　　　　**242.**

¶Quella cosa oscura che fia veduta in cāpo ²chiaro · essa si dimostrerà minore ch'essa ³non è¶

⁴Quella cosa chiara ⁵si dimostrerà di maggiore figura ⁶che sarà veduta in canpo di piv oscuro ⁷colore.

A dark object seen against a bright background will appear smaller than it is.

A light object will look larger when it is seen against a background darker than itself.

C. A. 124 b; 383 b]　　　　　　**243.**

DEL LUME.

²Quel corpo luminoso, che si trouerà essere occupato ³da piv grossa aria, apparirà di minore grādezza, ⁴come si dimostra nella luna o sole occupati dalla ⁵nebbia.

OF LIGHT.

A luminous body when obscured by a dense atmosphere will appear smaller; as may be seen by the moon or sun veiled by mists.

DEL LUME.

⁷Infra i corpi luminosi d'equal grandezza distantia e splēdore quello ⁸si dimostrerà di maggiore · forma ·, il quale da più oscuro · canpo circhū⁹dato · fia.

OF LIGHT.

Of several luminous bodies of equal size and brilliancy and at an equal distance, that will look the largest which is surrounded by the darkest background.

DEL LUME.

¹¹Jo trouo · che ciascuno · corpo luminoso, veduto · nella folta · e spessa ¹²nebbia ·,

OF LIGHT.

I find that any luminous body when seen through a dense and thick mist diminishes

240. 1. dimostera piu osscu. 2. cheffia circhundata dappiu. 3. biāchezza [e de chon ver]. 4. dovella giene. 5. osschuro chanpo.
241. 1. prospectiva. 2. grosseza. 3. chessara. 5. tera . . grosseza. 6. esse . . grosseza. 7. vari[a] colore. 8. cholore. 9. dimosterra . . grosseza. 11. colori cabino. 12. magiore . . grosseze pa. 13. chelle. 14. grosseza.
242. 1. Quala . . oscura fia . . chāpo. 2. dimosterra. 4. Quala . . chiara [sara veduta in]. 5. [canpo di] si dimosterra . . magiore. 6. chessara . . chanpo . . osscuro. 7. cholore.
243. 2. chorpo . . chessi troverra . . ochupato. 3—5 R. 3. arie aparira. 5. cheme si dimosstra . . ossole ochupati. 7. chorpi . . essprēdore. 8. dimosstra di magiore . . dappiu osschuro chanpo circhū. 11. checciasscuno chorpo . . esspessa. 12. dimi-

quanto più · s'allontana dall'occhio · più · diminuisce, e cosi ¹³fa · il sole di dì come la luna · e li altri immortali lumi di notte. E quã¹⁴do l'aria · è pura quanto · essi lumi · più · s'allontanano · dall'occhio, ¹⁵più pare si faccino · di maggiore · forma.

in proportion to its distance from the eye. Thus it is with the sun by day, as well as the moon and the other eternal lights by night. And when the air is clear, these luminaries appear larger in proportion as they are farther from the eye.

F. 22 a]

244.

Quella parte dello obbietto oscuro d'uniforme grosse²zza si dimostrerà più sottile che fia veduta in cãpo ³più luminoso.

⁴e è il corpo dato oscuro in se e d'uniforme gros⁵sezza, *a b* e *c d* son cãpi oscuri più l'uno che l'altro, ⁶*b c* è canpo luminoso come se fusse vn loco percosso ⁷da vno spiracolo di sole in una camera oscura; dico, ⁸che l'obietto *e g* parrà più grosso in · ⁹*e f* che in *g h* perchè *e f* à 'l canpo più oscuro che esso ¹⁰*g h*; ancora la parte *f g* parrà sottile per esse¹¹re veduta dall'ochio *o* in campo *b c* che è chiaro. ¹²La parte del corpo luminoso d'uniforme grossezza ¹³e splendore parrà esser piu grossa che fia veduta ¹⁴iñ canpo più oscuro e questo luminoso essere ĩfocato.

That portion of a body of uniform breadth which is against a lighter background will look narrower [than the rest].

[4] *e* is a given object, itself dark and of uniform breadth; *a b* and *c d* are two backgrounds one darker than the other; *b c* is a bright background, as it might be a spot lighted by the sun through an aperture in a dark room. Then I say that the object *e g* will appear larger at *e f* than at *g h*; because *e f* has a darker background than *g h*; and again at *f g* it will look narrower from being seen by the eye *o*, on the light background *b c*. [12] That part of a luminous body, of equal breadth and brilliancy throughout, will look largest which is seen against the darkest background; and the luminous body will seem on fire.

Ash. I. 3 *b*]

245.

COME · I CORPI ACCOMPAGNATI DA ONBRA E LUME ²SEMPRE · VARIANO · I LOR TERMINI DAL COLORE E LUME ³DI QUELLA COSA CHE CÕFINA · COLLA SUA SUPERFITIE.

⁴Se vedrai · uno corpo · che la · parte · alluminata · campeggi e termini ĩ campo oscuro ⁵la parte d'esso · lume che parrà · di maggiore · chiarezza · fia · quella ⁶che terminerà coll'oscuro in *d*. E se detta · parte · alluminata · cõfina col ⁷canpo chiaro ·, il termine d'esso · corpo · alluminato parrà men chiaro che prima ⁸e la · sua · somã chiarezza apparirà ĩfra al termine del campo *m · f* e l'onbra; E questo ⁹medesimo accade all'õbra, imperochè 'l termine di quella · parte del corpo

WHY BODIES IN LIGHT AND SHADE HAVE THEIR OUTLINES ALTERED BY THE COLOUR AND BRIGHTNESS OF THE OBJECTS SERVING AS A BACKGROUND TO THEM.

If you look at a body of which the illuminated portion lies and ends against a dark background, that part of the light which will look brightest will be that which lies against the dark [background] at *d*. But if this brighter part lies against a light background, the edge of the object, which is itself light, will be less distinct than before, and the highest light will appear to be between the limit of the background *m f* and the shadow. The same thing is seen with regard to the dark [side],

nuisscie e chosi. 13. chome . . altrimortali . . Ecquã. 14. eppura.

244. 1. barte . . obbiecto osscuro. 2. seza . . dimosterra . . cheffia veduto. 4. e he il . . duniforma. 5. seza ab he . . osscuri piu lūcellaltro. 6. fussi . . percoso. 7. spiracol di sole nuna . . osscura. 8. chellobietto. 11. veduto . . chia"ro". 13. essplendore . . eser. 14. osscuro ecquesto . . esere ĩ "focato".

245. 1. achompagniati . . ellume. 2. cholore ellume. 3. chosa . . cholle. 4. ĩ chorpo . chella . . champegi ettermini . . oschuro. 5. parira . . chiareza. 6. chetterminera cholloschuro . . Esse . . col. 7. chanpo . . para. 8. chiareza . . champo. 9. achade.

244. The diagram to which the text, lines 1—11, refers, is placed in the original between lines 3 and 4, and is given on Pl. XLI, No. 3. Lines 12 to 14 are explained by the lower of the two diagrams on

Pl. XLI, No. 4. In the original these are placed after line 14.

245. In the original diagram *o* is inside the shaded surface at the level of *d*.

aonbrato che ¹⁰cāpeggia in loco chiaro in *l*, parrà di molta maggiore oscurità che 'l resto; E se ¹¹detta ōbra·termina·in·campo·oscuro, il termine dell'onbra parrà ¹²piv·chiaro che prima·e la soma sua scurezza·fia·infra detto termine e'l lume ¹³nel punto·*o*.

inasmuch as that edge of the shaded portion of the object which lies against a light background, as at *l*, looks much darker than the rest. But if this shadow lies against a dark background the edge of the shaded part will appear lighter than before, and the deepest shade will appear between the edge and the light at the point *o*.

C. A. 124 *a*; 383 *a*]

246.

Quel corpo ōbroso si dimostrerà di minore grādezza, il quale da più·luminoso cāpo fia circūdato, ²e quel luminoso si dimostrerà maggiore che cōfinerà cō piv·oscuro cāpo ³come si dimostra nell'altezze degli edifiti la notte, quādo dirieto a quelli vāpeggia che subito par ⁴che 'l vāpeggiādo diminivsca l'edifitio di sua·altezza: e di qui nasce che essi ⁵edifizi paiono maggiori quādo è nebbia o notte che quādo l'aria è purificata e alluminata.

An opaque body will appear smaller when it is surrounded by a highly luminous background, and a light body will appear larger when it is seen against a darker background. This may be seen in the height of buildings at night, when lightning flashes behind them; it suddenly seems, when it lightens, as though the height of the building were diminished. For the same reason such buildings look larger in a mist, or by night than when the atmosphere is clear and light.

G. 12 *b*]

247.

DE' LUMI INFRA L' ŌBRE.

²Quando ritrai alcuno corpo, ³ricordati quando fai paragō ⁴della potētia de' lumi delle sua ⁵parti alluminate che spesso l'o-⁶chio s'inganna, parēdogli più chi⁷aro quello ch'è mē chiaro, e la ⁸cavsa nascie mediante li pa⁹ragoni delle parti che cōfinano ¹⁰con loro, perchè se avrā due par¹¹ti di chiarezza inc¹²guali e che la mē chiara confi¹³ni con parti oscure e la pi¹⁴v chiara cōfini cō parti chia¹⁵re chom'è il celo o simili chiarez¹⁶ze allora quella ch'è mē chi¹⁷ara o vo dire lucida, parà pi¹⁸v lucida e la più lucida parrà ¹⁹più oscura.

ON LIGHT BETWEEN SHADOWS.

When you are drawing any object, remember, in comparing the grades of light in the illuminated portions, that the eye is often deceived by seeing things lighter than they are. And the reason lies in our comparing those parts with the contiguous parts. Since if two [separate] parts are in different grades of light and if the less bright is conterminous with a dark portion and the brighter is conterminous with a light background—as the sky or something equally bright—, then that which is less light, or I should say less radiant, will look the brighter and the brighter will seem the darker.

C. A. 124 *a*; 383 *a*]

248.

Infra le cose di pari·oscurità·che dopo lunga e pari distantia situate sieno, quella apparirà più oscura, che piv alta da terra ²collocata·fia.

Of objects equally dark in themselves and situated at a considerable and equal distance, that will look the darkest which is farthest above the earth.

10. chāpegia illocho . . para . . magiore . ischurita Esse. 11. ɪn champo oschuro . . parira. 12. ella . . scureza.
246. 1. dimosterra . . grādeza. 2. dimosterra magiore . . osscuro. 3. alteze . . vāpegia. 4. che vāpegiādo dimivisca . . alteza . nasscie. 5. paiano magiori.
247. 5. parte. 6. parendoli. 7. ara quelle . . ella. 9. parte. 10. colloro . . arā. 11. ti d[equale] di chiareza inne. 12. chella. 13. parte osscure ella 14. parte. 15. ossimili . . chiare. 18. ella piu lucia. 19. osscura.
248. 1. Infralle chose . . osschurita . eppari disstantia . . hoschura . . datterra.. 2. chollochata.

A. 64 b]

249.

PRUOVA · COME I CORPI LUMINOSI ²PAIONO DI
LONTANO · MAGGIORI · CHE NŌ SONO.

³Se porrai · 2 · candele acciese · appresso ·
l'una · all' altra ¹/₂ · braccio · e allontanerati da
esse 200 · braccia vedrai ⁴per l'accrescimēto ·
di ciascuno · farsi · uno · solo · corpo luminoso
· de' due lumi · e parrà uno solo ⁵lume ·
grande · uno braccio.

PRUOVA A VEDERE · LA UERA GRĀDEZZA ⁷DE'
CORPI LUMINOSI.

⁸Se vuoi · vedere la vera grādezza · d'essi
corpi luminosi · abbi una assetta · sottile e
faui uno buso quāto sareb⁹be uno piccolo pū-
tale · di strīga · e ponitela · tāto · presso · al-
l'ochio · quāto · puoi · ī modo che riguardādo
¹⁰per esso buso · il sopra · detto · lume · tu gli
vegga · assai · spatio · d'aria · dintorno e cosi
leuādo · e ponēdo ¹¹cō prestezza essa · asse ·
dal tuo · ochio · cosi chō prestezza vedrai ·
cresciere · esso · lume.

TO PROVE HOW IT IS THAT LUMINOUS BODIES
APPEAR LARGER, AT A DISTANCE, THAN THEY ARE.

If you place two lighted candles side by
side half a braccio apart, and go from them to
a distance 200 braccia you will see that by
the increased size of each they will appear
as a single luminous body with the light of
the two flames, one braccio wide.

TO PROVE HOW YOU MAY SEE THE REAL SIZE
OF LUMINOUS BODIES.

If you wish to see the real size of these
luminous bodies take a very thin board and
make in it a hole no bigger than the tag of
a lace and place it as close to your eye as
possible, so that when you look through this
hole, at the said light, you can see a large
space of air round it. Then by rapidly mov-
ing this board backwards and forwards be-
fore your eye you will see the light increase
[and diminish].

C. 24 a (6 b)]

250.

Propositions
on perspec-
tive of dis-
appearance
from MS. C.
(250—262).

Infra i corpi di pari qualità che sien
dall'occhio equalmēte · distanti, quello · ap-
parirà di minor figura ²che da piv luminoso ·
campo circundato fia.

¶³Ogni corpo evidēte fia da lume e ōbra
circūdato.¶ ¶⁴Quel corpo d'equale rotōdità,
che da lume ⁵e ōbra circūdato fia, parrà avere
tanto piv ⁶grande l'una parte che l'altra
quāto fia piv ⁷alluminata l'una che l'altra.¶

Of several bodies of equal size and equally
distant from the eye, those will look the smal-
lest which are against the lightest background.

Every visible object must be surrounded by
light and shade. A perfectly spherical body
surrounded by light and shade will appear to
have one side larger than the other in pro-
portion as one is more highly lighted than
the other.

C. 23 a (7 b)]

251.

PROSPETTIVA.

²Nessuno evidēte corpo · può dagli umani ·
ochi · essere ben conpreso · e ben giudicato
³se nō per la uarietà del canpo · doue · li
stremi · d'essi · corpi · terminano e cōfinano,
⁴e nessuna cosa · inquāto · a liniamēti · de'
sua · stremi · apparirà · essere · da essi cāpi di-
uisa; ⁵la luna benchè · sia molto · distante ·

PERSPECTIVE.

No visible object can be well understood
and comprehended by the human eye ex-
cepting from the difference of the background
against which the edges of the object termi-
nate and by which they are bounded, and no
object will appear [to stand out] separate
from that background so far as the outlines
of its borders are concerned. The moon,

249. 1. chome i chorpi. 2. paiano .. magiori. 3. porai .. chandele .. apresso . ¹/₂ . br. e alontanerati 200 br. vederai. 4. la-
cresscimēto .. | no solo chorpo [di] luminoso .. parra ī solo. 5. grande . ī . br [esse]. 6. grādeza. 7. chorpi. 8. se volli
vedere . grādeza . chorpi .. abbi ī assetta .. effaui ī buso .. sare. 9. be ī picholo ... pōela. 10. tulli vega .. chosi.
11. chō presteza .. chosi chō .. prestezza vederai cresciere.
250. 1. Chessien. 2. dappiu .. circhundato. 3. Onni .. dallume .. circhūdato. 4. chorpo .. retōdita .. dallume. 5. circhūdato.
6. chellaltra. 7. aluminata .. chellaltra.
251. 1. prospettiua. 2. po dali .. essere "[ben]" chonprese. 3. chanpo .. lisstremi .. chorpi .. chōfinano. 4. chosa .. alnia-

dal corpo del sole quā⁶do per le eclissi · si
truoui · infra li ochi · nostri · e'l sole, perchè
essa lu⁷na canpeggia sopra il sole ·, appare ali
ochi vmani congivnta · e appiccata con esso
⁸sole.

though it is at a great distance from the sun,
when, in an eclipse, it comes between our
eyes and the sun, appears to the eyes of men
to be close to the sun and affixed to it, because
the sun is then the background to the moon.

C. 5 a (11 b)]　　　　　　　　　**252.**

Quel corpo · luminoso · parrà · piv splen-
dido il quale da più oscure tenebre · circun-
dato · fia.

A luminous body will appear more bril-
liant in proportion as it is surrounded by
deeper shadow.

C. 1 b (15 a)]　　　　　　　　　**253.**

I retti termini de' corpi parrāno · rotti che
termineranno in loco · tenebroso rigato da
percussione di luminosi razzi.

The straight edges of a body will appear
broken when they are conterminous with a
dark space streaked with rays of light.

C. 1 a (15 b)]　　　　　　　　　**254.**

Infra i corpi d'equal grādezza e distātia
quello · che fia · piv · alluminato parrà all'ochio
· piv propīquo e maggiore.

Of several bodies, all equally large and
equally distant, that which is most brightly
illuminated will appear to the eye nearest
and largest.

C. 14 b (16 a)]　　　　　　　　　**255.**

Se molti corpi luminosi · fieno veduti di
lontan paese, benchè infra loro sien diuisi
parranno insieme vniti e cōgivnti.

If several luminous bodies are seen from
a great distance although they are really se-
parate they will appear united as one body.

C. 14 a (16 b)]　　　　　　　　　**256.**

Se molti corpi ōbrosi di quasi congiunta ·
vicinità fieno veduti · in cāpo · luminoso · in ·
lunga distātia parrāno separati da grāde
intervallo.

If several objects in shadow, standing very
close together, are seen against a bright back-
ground they will appear separated by wide
intervals.

C. 21 b (17 a)]　　　　　　　　　**257.**

Ĵnfra le cose d'equal grādezza · e colore ·
quella · che fia · piv lontana parrà piv · chiara
e di minore figura.

Of several bodies of equal size and tone,
that which is farthest will appear the lightest
and smallest.

mēti . . aparira.　5. [Il . sole lume ealtre ste] la luna . . chorpo b . pe"r" le clissi.　6. nosstri . sole [e che essa luna chāpe]
perche.　7. chāpegia . . apare chongivnta . e appichata chon esso.
252. 1. chorpo . . parra [di magiore] piv splendido [che] jl . . osschure . . circhundato.
253. 1. chorpi . . Chettermineranno illocho . tenebroso [limato] "rigato" da perchussione . . razi.
254. 1. chorpi . . grādeza . . Quello . cheffia . . para . . magiore.
255. 1. chorpi . . paesse . . infralloro . . parano . . vnite e chōgivnte.
256. 1. chorpi . . chongiunta . . chāpo . . illunga.
257. 1. Ĵfralle chose . . grādeza . . cholore . . cheffia.

252. The diagram which, in the original, is
placed after this text, has no connection with it.

253. 254. Here again the diagrams in the origi-
nal have no connection with the text.

C. 12 a] **258.**

Infra le cose d'equal grandezza · bian-
chezza di cāpo e longitudine · quella · che fia ·
di più · chiara superfitie apparirà · di maggior
figura; ²Il ferro d'equal grossezza · mezzo
īfocato · ne fa proua, īperochè essa parte ·
īfocata · pare · più · grossa che 'l resto.

Of several objects equal in size, brightness
of background and length that which has the
flattest surface will look the largest. A bar of
iron equally thick throughout and of which
half is red hot, affords an example, for the
red hot part looks thicker than the rest.

C. 8 b] **259.**

Infra i corpi · d'equale · grandezza · e lon-
gitudine · e d'equale · figura · e oscurità · quella
apparirà ²di minor grandeza · che da più ·
luminoso · canpo · circundata fia.

Of several bodies of equal size and
length, and alike in form and in depth of
shade, that will appear smallest which is sur-
rounded by the most luminous background.

C. 8 b] **260.**

QUELLA · PARTE · DELLA PARIETE · FIA · PIV
OSCURA · O LUMINOSA · CHE DA PIV · GROSSO ·
ANGOLO · OSCURO O LUMINOSO FIA PERCOSSO.

²La sopra detta · propositione · chiara-
mēte in questa · forma · si pruova : diciamo
m · q · essere il corpo luminoso e cosi ³*f · g* ·

DIFFERENT PORTIONS OF A WALL SURFACE WILL
BE DARKER OR BRIGHTER IN PROPORTION AS
THE LIGHT OR SHADOW FALLS ON THEM AT A
LARGER ANGLE.

The foregoing proposition can be clearly
proved in this way. Let us say that *m q* is
the luminous body, then *f g* will be the opaque

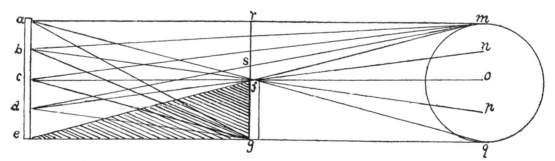

sarà · il corpo ōbroso : e *a · e* · sia la nomi-
nata pariete, doue sopra detti āgoli percuo-
tono, li rappresentādo la natura ⁴e qualità di
loro base : ora · ¶*a* · fia piv luminoso che *b* ·
la basa dell'angolo · *a* · è piv · grossa che
quella ⁵di · *b* · e però fa piv · grosso āgolo,
il quale · fia · *a · m · q* ; e la piramide · *b · p · m*
fia piv stretta, e più sottile sia ⁶quella · *m*
· *o · c* e così di mano in mano, quāto piv
s'appressa a *e* fieno le piramidi piv strette
e piu oscure; ⁷Quel pūto della pariete · fia
· di minore chiarezza nel quale la grossezza

body; and let *a e* be the above-mentioned plane
on which the said angles fall, showing [plainly]
the nature and character of their bases. Then :
a will be more luminous than *b*; the base
of the angle *a* is larger than that of *b* and
it therefore makes a greater angle which will
be *a m q*; and the pyramid *b p m* will be
narrower and *m o c* will be still finer, and
so on by degrees, in proportion as they are
nearer to *e*, the pyramids will become nar-
rower and darker. That portion of the wall
will be the darkest where the breadth of the

258. 1. Infralle chose . . grandeza biancheza | "cāpo" ellongitudine. Quella cheffia . di piu . piana superfitie aparira . . magior.
 2. fero . . grosseza . mezo īfochato . . īfochata.
259. 1. chorpi . . grandeza ellongitudine . . osschurita. Quella [cheffia] apparira. 2. grandeza . . dappiu . . chanpo circhundata.
260. 1. osschura olluminosa . . dappiu . . osscuro olluminoso [fia perchosso]. 2. chorpo . . chosi. 3. chorpo . . douessopra . .
 perchuotano. 4. ecqualita . . hora. 5. āgolo [ōde] il . . ella piramide. 6. echosi dimanonoimano . . sapressa . . piramide

della piramide ōbrosa supera la grossez⁸za della luminosa.

⁹Nel pūto · *a* · fia di tāta · potētia la piramide luminosa quāto la ōbrosa, perchè la basa · *f* · *g* · è simile alla basa · *r* · *f*; E nel pūto ¹⁰*d* · la piramide luminosa fia tanto piv · sottile che la ōbrosa ·, quāto la basa · *s* · *f* · è minore che la basa · *f* · *g*.

¹¹Diuidi la sopra detta propositione in due figure cioè una colle piramidi ōbrose e luminose e l'altra colle ¹²luminose.

pyramid of shadow is greater than the breadth of the pyramid of light.

At the point *a* the pyramid of light is equal in strength to the pyramid of shadow, because the base *f g* is equal to the base *r f*. At the point *d* the pyramid of light is narrower than the pyramid of shadow by so much as the base *s f* is less than the base *f g*.

Divide the foregoing proposition into two diagrams, one with the pyramids of light and shadow, the other with the pyramids of light [only].

C. 13*b*]

261.

Infra l'onbre · di pari qualità · Quella che fia · piv · propinqua · all'ochio apparirà · di minore · oscurità.

Among shadows of equal depth those which are nearest to the eye will look least deep.

C. 10*a*]

262.

Quanto · di maggiore splendore fia · il corpo · luminoso · di tanta maggiore oscurità · fieno · l'onbre · fatte da' corpi da esso alluminati.

The more brilliant the light given by a luminous body, the deeper will the shadows be cast by the objects it illuminates.

. . osschure. 7. chiareza . . quale [la piramide] la grosseza . . grosse. 9. essimile. 10. chella ōbrosa. 11. cioe ĩ chole piramide . . ellaltra chole.
261. 1. Infrallonbre . . cheffia . . Apparira . . hosscurita.
262. 1. magiore \ "splendore" . . . chorpo . . magiore osschurita . . lonbr . . chorpi.

V.

Theory of colours.

Leonardo's theory of colours is even more intimately connected with his principles of light and shade than his Perspective of Disappearance and is in fact merely an appendix or supplement to those principles, as we gather from the titles to sections 264, 267, and 276, while others again (Nos. 281, 282) are headed Prospettiva.

A very few of these chapters are to be found in the oldest copies and editions of the Treatise on Painting, and although the material they afford is but meager and the connection between them but slight, we must still attribute to them a special theoretical value as well as practical utility—all the more so because our knowledge of the theory and use of colours at the time of the Renaissance is still extremely limited.

263.

DE PICTURA.

[2]Il colore dello alluminato participa [3]del colore dello alluminante.

OF PAINTING.

The hue of an illuminated object is affected by that of the luminous body.

264.

DE ONBRA.

¶[2]La superfitie d'ogni opaco participa [3]del colore del suo obbietto¶.

OF SHADOW.

The surface of any opaque body is affected by the colour of surrounding objects.

265.

L'onbra participa sēpre del color del suo obbietto.

A shadow is always affected by the colour of the surface on which it is cast.

266.

Il simvlacro inpresso nello spechio participa del co[2]lore del predetto specchio.

An image produced in a mirror is affected by the colour of the mirror.

267.

DE ŌBRA E LUME.

[2]Ogni · parte · della · superfitie ·, che · circūda · i corpi, [3]si trasmuta ī parte del colore · di quella · cosa · che gl'è posta per obietto.

OF LIGHT AND SHADE.

Every portion of the surface of a body is varied [in hue] by the [reflected] colour of the object that may be opposite to it.

263. 2. cholore . . 3. cholore . . alluminancte.
264. 2. oppacho. 3. cholore . . obbieto.
265. obbiecto.
266. 1. delcho.
267. 1. ellume. 2. circhūda . i chorpi. 3. trassmuta . . cholore . . chelle posta. 5. settu porai uno[palla da] uno chorpo . speri-

Esēplo.

⁵Se tu porrai·uno corpo·sperico·ī mezzo a vari obietti, ⁶cioè che da una·parte·sia·lume·del·sol'e·dall'opposita parte sia·uno·muro ⁷alluminato dal sole·, il quale·sia verde o d'altro colore, il piano dove si posa ⁸sia·rosso·, dai 2·lati·traversi·sia scuro: vedrai il natura⁹le colore·di detto corpo participare de'colori·che li sono per obietto; ¹⁰Il più potēte fia il luminoso; Il secondo fia quello·della pariete allumina¹¹ta·, Il terzo quello·dell'ōbra·, Rimane poi una quātità, che participa del colo¹²re delli·stremi.

Example.

If you place a spherical body between various objects that is to say with [direct] sunlight on one side of it, and on the other a wall illuminated by the sun, which wall may be green or of any other colour, while the surface on which it is placed may be red, and the two lateral sides are in shadow, you will see that the natural colour of that body will assume something of the hue reflected from those objects. The strongest will be [given by] the luminous body; the second by the illuminated wall, the third by the shadows. There will still be a portion which will take a tint from the colour of the edges.

E. 17 a] 268.

La superfitie d'ogni corpo opaco ²participa del colore del suo obbietto ³Ma cō tanta maggiore o minore ⁴inpressione quāto esso obietto·⁵fia più vicino o remoto o di ⁶maggiore o minore potētia.

The surface of every opaque body is affected by the colour of the objects surrounding it. But this effect will be strong or weak in proportion as those objects are more or less remote and more or less strongly [coloured].

W. 240 b] 269.

Pittura.

²La superfitie d'ogni corpo opaco participa del ³colore del suo obbietto.
⁴Cō tanta maggiore potētia si tignie la superfitie del corpo ⁵opaco·del color del suo obbietto quāto li razzi ⁶delle spetie di tali obbietti feriscono essi corpi ⁷infra angoli più equali.
⁸E tanto più si tigne la superfitie de' corpi opachi del colore ⁹del suo obieto quāto tal superfitie è più biāca e'l colore dello ¹⁰obietto più luminoso o alluminato.

Of painting.

The surface of every opaque body assumes the hues reflected from surrounding objects.
The surface of an opaque body assumes the hues of surrounding objects more strongly in proportion as the rays that form the images of those objects strike the surface at more equal angles.
And the surface of an opaque body assumes a stronger hue from the surrounding objects in proportion as that surface is whiter and the colour of the object brighter or more highly illuminated.

W. L. 145; B a] 270.

Delli razzi che portā per l'aria le spetie de'corpi.

¶²Tutte le parti minime delle spetie penetrā ³l'una l'altra sanza occupatione l'una

Of the rays which convey through the air the images of objects.

All the minutest parts of the image intersect each other without interfering with

cho īmezo . . sia î muro. 7. cholore. 8. schuro . vederai [detto chorpo] al natura. 9. cholore . . chorpo . . cholori. 10. iluminoso . . sechondo.

268. 1. chorpooppacho. 2. del cholore del cholore del suo obbiecto. 3. Ma[cqua] tanta . . ōminore. *In the margin:* 4. chō. 5. orremoto. 6. ōminore.

269. 2. oppacho. 4. magiore. 5. oppacho . . razi. 6. feriscano. 8. Ettanto. 9. biācha. 10. aluminato.

270. 1. razi . . lesspetie de chorpi. 3. ochupatione. 4. essia . . spiracholo. 5. risscōtro. 6. losstremo. 7. le[spemo nō pò . . attale.

270. 13. This probably refers to the diagram given under No. 66.

dell'altra;¶ ⁴pruovasi e sia *r* l'un de'lati dello spiracolo ⁵a riscōtro del quale sia *s* ochio, il quale ve⁶de lo stremo inferiore *o* della linia *n o,* il qua⁷le stremo nō può mādare la similitudine di se a tale ⁸ochio · *s* · ch'ello nō tocchi esso stremo *r,* e' l si⁹mile fa *m* mezzo d'essa linia e cosi accade allo ¹⁰stremo superiore *n* all'ochio · *u* ·, e se lo stremo *n* ¹¹è rosso *u* ochio nō vedrà in tal labro di spira¹²colo *r* il colore verde di *o,* ma solo il rosso ¹³di *n* per la 7ᵃ di questo, dove dicie ogni simula¹⁴cro māda fori di se spetie sue per linia bre¹⁵vissima ¶la quale per neciessità è retta ecc.

each other. To prove this let *r* be one of the sides of the hole, opposite to which let *s* be the eye which sees the lower end *o* of the line *n o.* The other extremity cannot transmit its image to the eye *s* as it has to strike the end *r* and it is the same with regard to *m* at the middle of the line. The case is the same with the upper extremity *n* and the eye *u.* And if the end *n* is red the eye *u* on that side of the holes will not see the green colour of *o,* but only the red of *n* according to the 7th of this where it is said: Every form projects images from itself by the shortest line, which necessarily is a straight line, &c.

C. A. 178*a*; 536*a*]

271.

PICTURA.

OF PAINTING.

²La superfitie d'ogni corpo participa del colore del suo obbietto. ³Li colori delli obbietti alluminati s'imprimono nelle superfitie l'ū del'altro ⁴in tāti vari siti quāte son le uarietà delle situationi di tali ob⁵bietti; ⁶*o* è l'obbietto azzurro alluminato e vede solo sanza altra ⁷conpagnia lo spatio *b c* della spera biā⁸ca *a b c d e f,* e la tignie di colore azzurro; ⁹*m* è l obbietto giallo il quale allumina ¹⁰lo spatio *a b* in cōpagnia dello *o* azzur¹¹ro e lo tigne in colore verde ¶per la 2ᵃ ¹²di questo che prova lo azzurro e giallo fa¹³re verde bellissimo ecc¶ · e'l rimanēte si dirà ¹⁴nel libro della pictura; E in questo libro si pro¹⁵verà facciēdo penetrare la spetie de' corpi e co¹⁶lori delle cose alluminate dal sole per piccolo ¹⁷spiracolo rotondo in loco oscuro ī pa¹⁸riete piana in se bianca ecc.

¹⁹Ma ogni cosa fia sotto sopra.

The surface of a body assumes in some degree the hue of those around it. The colours of illuminated objects are reflected from the surfaces of one to the other in various spots, according to the various positions of those objects. Let *o* be a blue object in full light, facing all by itself the space *b c* on the white sphere *a b c d e f,* and it will give it a blue tinge. *m* is a yellow body reflected onto the space *a b* at the same time as *o* the blue body, and they give it a green colour (by the 2nd [proposition] of this which shows that blue and yellow make a beautiful green &c.) And the rest will be set forth in the Book on Painting. In that Book it will be shown, that, by transmitting the images of objects and the colours of bodies illuminated by sunlight through a small round perforation and into a dark chamber onto a plane surface, which itself is quite white, &c.

But every thing will be upside down.

C. A. 44*b*; 137*b*]

272.

Quel che ²fa l'ōbra ³nō la ue⁴de.

⁵Perchè l'ōbre ⁶son fatte ⁷da lumino⁸so gignitor' e ⁹circūdato¹⁰re del'ōbre. ¹¹L'ombra fatta dal luminoso *e* che è ¹²giallo,

That which casts the shadow does not face it, because the shadows are produced by the light which causes and surrounds the shadows. The shadow caused by the light *e,*

Combination of different colours in cast shadows.

8. chella g nō tochi · · stremo [o]r. 9. chosi achade. 10. essello. 11. errosso · · la [pr]bro. 12. cholo · · ogni.
271. 2. obbiecto. 3. obbiecti "alluminati" ṣinpremano. 4. quāto. 5. bietta. 6. ellobbietto azzurro "alluminato". 7. Losspatio bc dulla. 8. cha · · ella. 9. ellobbietto gialloiquale. 10. losspatio. 11. ello tugnie in cholore. 12. azzuro eguale. 15. chorpiecho. 16. picholo. 17. spiracholo retondo ilocho osschuro. 18. biancha. 19. ōnchosa.

viene a essere [13]azzurra perchè è l'onbra del corpo [14]a fatta sopra il pauimēto in b, nel[15]la quale è veduta dal luminoso azzur[16]ro, e così l'onbra fatta dal lumi[17]noso d che è azzurró fia gialla nel [18]sito c per essere veduta dal lumi[19]noso giallo, e 'l canpo circūdatore [20]d'esse onbre b c sarà (oltre al suo [21]natural colore) tinto d'un colore mi[22]sto di giallo e d'azzurro perchè è vedu[23]to e alluminato da luminoso giallo [24]e da luminoso azzurro in ū medesimo [25]tenpo.

[26]Onbre di uari co[27]lori secondo i lu[28]mi da loro veduti. [29]Quel lume che fa l'ōbra nō [30]la [31]uede.

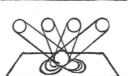

which is yellow, has a blue tinge, because the shadow of the body a is cast upon the pavement at b, where the blue light falls; and the shadow produced by the light d, which is blue, will be yellow at c, because the yellow light falls there and the surrounding background to these shadows b c will, besides its natural colour, assume a hue compounded of yellow and blue, because it is lighted by the yellow light and by the blue light both at once.

Shadows of various colours, as affected by the lights falling on them. That light which causes the shadow does not face it.

The effect of colours in the camera obscura (273. 274).

C. A. 187 II a; 562a]

273.

Li termini d'ogni color che [2]passā per spiracoli sō più [3]evidēti che i loro mezzi.

[4]Li termini delle spetie [5]di qualūche colore che per stretto [6]spiraculo penetrano ī loco o[7]scuro fien sēpre di più potē[8]te colore che il suo mezzo.

The edges of a colour(ed object) transmitted through a small hole are more conspicuous than the central portions.

The edges of the images, of whatever colour, which are transmitted through a small aperture into a dark chamber will always be stronger than the middle portions.

W. L. 145; D b]

274.

DELLA INTERSEGATIONE DELLE SPETIE [2]NELLA POPILLA DELL' OCHIO.

[3]La intersegatione delle spetie nello introito della popilla [4]nō s'infondono l'una nell'altra in quello spatio dove tale interse[5]gatione le vniscie, e questo si manifesta perchè se li razzi [6]del sole passā per li dua vetri che sieno infra loro in cōtatto, de [7]quali uetri l'un sia azzurro e l'altro giallo, allora il razzo [8]in esso penetrato non si tignierà d'azzurro nè di giallo, ma di [9]bellissimo verde, e il medesimo accaderebbe all'ochio se le spe[10]tie de' colori giallo e verde nella intersegatiō da lor fatta in[11]fra se nello introito della popilla s'avessino a infondere l'una ne[12]l'altra, la qual cosa non accadendo tal mistione noñ è in essere.

OF THE INTERSECTIONS OF THE IMAGES IN THE PUPIL OF THE EYE.

The intersections of the images as they enter the pupil do not mingle in confusion in the space where that intersection unites them; as is evident, since, if the rays of the sun pass through two panes of glass in close contact, of which one is blue and the other yellow, the rays, in penetrating them, do not become blue or yellow but a beautiful green. And the same thing would happen in the eye, if the images which were yellow or green should mingle where they [meet and] intersect as they enter the pupil. As this does not happen such a mingling does not exist.

272. 6. facte. 11. del. 12. giallo vede lonbre viene a essere. 13. azurra. 15. del . . azur. 16. chosi. 17. azzuro. 21. naturā colore. 22. eddazzuro. 26. cho. 27. sechondo. 28. dalloro. 29. Quellume cheffa.

273. 2. isspiracoli. 3. illoro. 5. cholore . . istretto. 6. spirachulo . . illocho os.

274. 1. interseghatione. 3. interseghatione. 4. sinfondano . . intersegha. 5. ecquessto . . selli razi [solari]. 6. passa . . inchōtacto. 7. azurro ellaltro . . il raz. 8. azurro. 9. achaderebbe . . selle. 10. cholori gialli . . interseghatiō dallor. 11. frasse

272. In the original diagram we find in the circle e "*giallo*" (yellow) and the cirle d "*azurro*" (blue) and also under the circle of shadow to the left "*giallo*" is written and under that to the right "*azurro*".

In the second diagram where four circles are placed in a row we find written, beginning at the left hand, "*giallo*" (yellow), "*azurro*" (blue), "*verde*" (green), "*rosso*" (red).

NATURA DELLI RAZZI CHE SI CŌPŌGONO [14]DELLE SPETIE DE' CORPI E LORO ĪTER-SEGATIONE.

OF THE NATURE OF THE RAYS COMPOSED OF THE IMAGES OF OBJECTS, AND OF THEIR INTERSECTIONS.

[15]La rettitudine delli razzi che portā per l'aria la figura [16]e color de' corpi donde si partono nō tingono di se l'aria, nè ancora possono tignie[17]re l'uno l'altro nel cōtatto della loro intersecatione, ma sol tin[18]gono il loco dove eglino perdono il loro essere perchè tale loco ve-[19]de ed è veduto dal' origine d'essi razzi, e nessuna altra cosa che circuisca [20]essa origine può essere veduta da loco dove tale razzo taglian[21]dosi resta destrutto, quivi lasciādo la preda da lui portata.

[22]E questo si prova per la 4ᵃ de colori de' corpi dove dicie la su[23]perfitie d'ogni corpo opaco participa del colore del suo obbi[24]etto; adūque è concluso che il loco che mediāte il razzo [25]che porta le spetie vede ed è veduto dall'origine di tale [26]spetie si tinga del colore d'esso obbietto.

The directness of the rays which transmit the forms and colours of the bodies whence they proceed does not tinge the air nor can they affect each other by contact where they intersect. They affect only the spot where they vanish and cease to exist, because that spot faces and is faced by the original source of these rays, and no other object, which surrounds that original source can be seen by the eye where these rays are cut off and destroyed, leaving there the spoil they have conveyed to it.

And this is proved by the 4th [proposition], on the colour of bodies, which says: The surface of every opaque body is affected by the colour of surrounding objects; hence we may conclude that the spot which, by means of the rays which convey the image, faces—and is faced by the cause of the image, assumes the colour of that object.

Ash. I, 22a]

275.

OGNI ŌBRA FATTA DAL CORPO ŌBROSO MINORE DEL LUME ORIGINALE [2]MĀDERA · LE ŌBRE DIRIVATIVE TĪTE DEL COLORE DELLA LORO · ORIGINE.

ANY SHADOW CAST BY AN OPAQUE BODY SMALLER THAN THE LIGHT CAUSING THE SHADOW WILL THROW A DERIVED SHADOW WHICH IS TINGED BY THE COLOUR OF THE LIGHT.

[3]L'origine · dell'ōbra · e · f · sia · n, e · fia tīta in suo colore ‖ l'origine · di · h · e sia ‖ o [4]e fia similmēte tīta ī suo colore, e così il colore di · v · h · fia tīto nel · colore di · p · [5]perchè nasce da lui · ‖ e l'ōbra del triāgolo · z · k · y fia tīta nel colore di ϙ perchè [6]diriva da lui · ; [7]Tanto quāto · c · d · [8]entra in · a · d · tanto [9]è piv scuro · n · r · s [10]che · m · e tutto l'altro [11]canpo sanza ōbra; · f · g · è 'l primo grado di lume perchè quivi allumina · tutta · la finestra · a · d · [12]e così nel corpo ōbroso · m · e · è di simil chiarezza; z · k · y · è vno triāgolo [13]che cōtiene · in se il primo

Let n be the source of the shadow e f; it will assume its hue. Let o be the source of h e which will in the same way be tinged by its hue and so also the colour of v h will be affected by p which causes it; and the shadow of the triangle z k y will be affected by the colour of q, because it is produced by it. [7]In proportion as c d goes into a d, will n r s be darker than m; and the rest of the space will be shadowless [11]. f g is the highest light, because here the whole light of the window a d falls; and thus on the opaque body m e is in equally high light; z k y is a triangle which includes the

On the colours of derived shadows (275. 276).

. . popila. 12. chosa non achadendo tal [fusione] "mistione". 13. razi chessi cōpōghano. 14. chorpi elloro interseghatione. 15. fighura. 16. e cholor de chorpi "donde si partano" nō si tinghano . . anchora possā. 17. intersechatione Massol. 18. ghano il locho dove e perdano illoro · · locho. 19. de "ede veduto da" lorigine . . razi e nessussuna . . chosa che circhuissca. 20. dallocho do tale razo. 21. ressta desstrutto "quivi" lassciādo . . dallui. 22. ecquesto . . cholori de chorpi. 23. chorpo oppacho . . cholore. 24. ecto . . choncluso. ilocho. 25. veduta. 26. tingha.
275. 1. delume. 3. sie · n effia . . sie. 4. effia . . nel cholore. 10. ettutto. 11. alumina . tucta. 12. chiareza f . z . k.

275. The diagram Pl. III, No. 1 belongs to this chapter as well as the text given in No. 148. Lines 7—11 (compare lines 8—12 of No. 148) which are written within the diagram, evidently apply to both sections and have therefore been inserted in both.

grado d'onbra, perchè in esso triāgolo nō capita [14]il lume · *a · d*; *x · h* · è 'l 2° grado d'ōbra perchè egli non allumina se non ¹/₃ [15]della · finestra · cioè · |||*c · d* ·; *h · e* fia il terzo grado d'ōbra perchè · egli uede [16]i dua terzi della finestra · *b · d* · · *e · f* fia l'ultimo grado d'ōbra perchè [17]l'ultimo grado di lume della finestra allumina nel loco di · *f*.

deepest shadow, because the light *a d* cannot reach any part of it. *x h* is the 2nd grade of shadow, because it receives only ¹/₃ of the light from the window, that is *c d*. The third grade of shadow is *h e*, where two thirds of the light from the window is visible. The last grade of shadow is *b d e f*, because the highest grade of light from the window falls at *f*.

W. L. 145; C*a*] **276.**

DELLI COLORI DELL' ŌBRE DIRIVATIVE [2]SENPLICI.

OF THE COLOURS OF SIMPLE DERIVED SHADOWS.

[3]Li colori dell' ōbre diriuatiue fiē [4]senpre participanti delli colori de cor[5]pi che le rischiarano: pruouasi [9]e sia il corpo onbroso interposto [10]infra la pariete *s c t d* e li lu[11]minosi *d e* azzurro e · *a b* rosso; [12]dico *d e* luminoso azzurro ve[13]de tutta la pariete *s c t d* ecciet[14]to *o p*, il quale occupa l'onbra del [15]corpo ōbroso *q r*, come mostrā [16]le linie rette *d q o*, *e r p*; E il simi[17]le accade del luminoso *a b*, il quale [18]vede tutta la pariete *s c t d* ecciet[19]to il loco occupato dall' ōbroso *q r* co[20]me mostrā le linie *d q o e e r p*; [21]adūque si cōclude che

l'onbra *n m* [22]vede il luminoso azzurro *d e* e nō [23]potendo vedere il luminoso *a b* rosso [24]*n m* · resta vn'ōbra azzurra in cāpo [25]rosso misto d'azzurro, perchè in campo [26]*s c t d* vede l'uno e l'altro luminoso, [27]ma nell'ōbre nō vede se nō vn sol lu[28]minoso e per questo tale ōbra è ōbra me[29]zzana, perchè se tale ōbra nō fusse veduta [30]da nessun luminoso essa sarebbe ōbra [31]massima ecc.; Ma nell'onbra *o p* nō ve[32]de il luminoso azzurro, perchè il corpo *q r* [33]colla sua interpositione

The colour of derived shadows is always affected by that of the body towards which they are cast. To prove this: let an opaque body be placed between the plane *s c t d* and the blue light *d e* and the red light *a b*, then I say that *d e*, the blue light, will fall on the whole surface *s c t d* excepting at *o p* which is covered by the shadow of the body *q r*, as is shown by the straight lines *d q o e r p*. And the same occurs with the light *a b* which falls on the whole surface *s c t d* excepting at the spot obscured by the shadow *q r*; as is shown by the lines *d q o*, and *e r p*. Hence we may conclude that the shadow *n m* is exposed to the blue light *d e*; but, as the red light *a b* cannot fall there, *n m* will appear as a blue shadow on a red background tinted with blue, because on the surface *s c t d* both lights can fall. But in the shadows only one single light falls; for this reason these shadows are of medium depth, since, if no light whatever mingled with the shadow, it would be of the first degree of darkness &c. But in the shadow at *o p* the blue light

13. chōtiene. 14. ilume . . dōbra percheli . . alumina. 15. dela . . percheli . . dela. 17. dela . . alumina . . locho.
276. 1. cholori. 3. cholori. 4. cholori. 5. chelle risciarano. 6. [essia il luminoso azzurro *de* il qual]. 7. [le allvmina il chanp la pariete sc.] 8. [t d cholla dilatatione a b c d d e c d]. 9. essia il chorpo . . interpossto. 10. infralla . . elli. 11. azzurro he . ab. 12. dicho. 14. ochupa. 15. chorpo . . chome mosstrā. 19. locho ochupato . . cho. 20. mosstra . . *o* hee. 21. addūque si chōclude chellonbra. 22. iluminoso. 24. ressta . . chāpo. 25. missto da dazurro . . chanpo. 26. ellaltro. 29. settale . . fussi. 30. sarabe. 32. iluminoso. 33. lielo. 35. tigngnie . . tal. 36. ressta inchāpo. 37. dazurro errosso. 38. del

276. In the original diagram Leonardo has written within the circle *q r corpo ōbroso* (body in shadow); at the spot marked *A*, *luminoso azzurro* (blue luminous

body); at *B*, *luminoso rosso* (red luminous body). At *E* we read *ombra azzurra* (blue tinted shadow) and at *D ombra rossa* (red tinted shadow).

glielo proibi³⁴scie; Ma sol ui vede il lume rosso *a b* il ³⁵quale lo tignie di color rosso e cosi ta³⁶le ōbra rosseggiäte resta incāpo mi³⁷sta d'azzurro e rosso.

³⁸L'onbra del *q r* in *o p* ³⁹mediante il luminoso azzurro *d e* ⁴⁰è rossa e l'ōbra d'esso *q r* mediā⁴¹te il rosso luminoso *a b* è azzurra ⁴²in *ō p̄*; adunque diremo che ⁴³il lume azzurro fa in questo caso ⁴⁴fare l'onbra dirivativa rossa al cor⁴⁵po onbroso *q̄ r̄* e che'l lume rosso ⁴⁶fa fare al medesimo ōbroso l'ōbra ⁴⁷dirivativa azzurra, ma l'onbra ⁴⁸primitiua nō fia d'esso colore ma ⁴⁹fia mista di rosso e azzurro.

⁵⁰Le ōbre dirivative sarā d'equal ⁵¹oscurità se le nascono da ⁵²lumi d'equale potētia e distā⁵³tia; pruoua . .

does not fall, because the body *q r* interposes and intercepts it there. Only the red light *a b* falls there and tinges the shadow of a red hue and so a ruddy shadow appears on the background of mingled red and blue.

The shadow of *q r* at *o p* is red, being caused by the blue light *d e*; and the shadow of *q r* at *o' p'* is blue being caused by the red light *a b*. Hence we say that the blue light in this instance causes a red derived shadow from the opaque body *q' r'*, while the red light causes the same body to cast a blue derived shadow; but the primary shadow [on the dark side of the body itself] is not of either of those hues, but a mixture of red and blue.

The derived shadows will be equal in depth if they are produced by lights of equal strength and at an equal distance; this is proved[53].

F. 23 *a*] **277.**

Nessū bianco o nero ²è trāsparēte.

No white or black is transparent.

F. 75 a] **278.**

PICTURA.

²Perchè il bianco non è colore, ma è inpotentia ricettiva ³d'ogni colore, quando esso è in cāpagna alta tutte le su⁴e ōbre sono azzurre; e questo nasce per la 4ª che ⁵dice: la superfitie d'ogni opaco participa del colo⁶re del suo obbietto; Adūque tal bianco essendo pri⁷vato del lume del sole per interpositiō di qualche obbietto ⁸infra messo infra 'l sole e esso biāco, resta adunque ⁹tutto il biāco che vede il sole e l'aria participante ¹⁰del colore del sole e dell'aria, e quella parte che non ue¹¹de il sole, resta onbrosa participante del colore dell'aria, e se ¹²tal biāco non vedesse la verdura della cāpagnia ī¹³sino all'orizzonte, nè ancora vedesse la biāchezza di tale ¹⁴orizzōte, sanza dubbio esso biāco parrebbe essere ¹⁵del senplice colore del quale si mostra essere l'aria.

OF PAINTING.

[2]Since white is not a colour but the neutral recipient of every colour[3], when it is seen in the open air and high up, all its shadows are bluish; and this is caused, according to the 4th [prop.], which says: the surface of every opaque body assumes the hue of the surrounding objects. Now this white [body] being deprived of the light of the sun by the interposition of some body between the sun and itself, all that portion of it which is exposed to the sun and atmosphere assumes the colour of the sun and atmosphere; the side on which the sun does not fall remains in shadow and assumes the hue of the atmosphere. And if this white object did not reflect the green of the fields all the way to the horizon nor get the brightness of the horizon itself, it would certainly appear simply of the same hue as the atmosphere.

[dea]qr[m]in. 40. errosso ellōbra. 42. direno. 43. llume . . inquessto chaso. 44. lonbra [azzu] "dirivativa" rossa al chor. 48. cholore. 49. missta. 51. osschurita selle nasschano. 52. eddisstā.

277. 2. he.

278. 4. azzurro ecquessto nassce. 5. oppaco. 6. biancho. 7. interpositiode. 8. biācho. 9. ellaria. 10. ecquella parte che ue. 11. resta "onbrosa" . . dellaria esse. 12. biācho . . vedessi. 13. orizonte neacora vedesse . . biācheza. 14. orizōte biācho parrebbe.

53. The text is unfinished in the original.

278. 2. 3. *il bianco non è colore ma è inpotentia ricettiva d'ogni colore* (white is not a colour, but the neutral recipient of every colour). LEON BATT.

ALBERTI *"Della pittura"* libro I, asserts on the contrary: *"Il bianco e 'l nero non sono veri colori, ma sono alteratione delli altri colori"* (ed. JANITSCHEK, p. 67; Vienna 1877).

C. A. 192 *b*; 571 *b*] **279.**

On grada-
tions in the
depth of co-
lours
(279. 280).

Perchè il nero dipinto in cōfine del biāco ²nō mostra piv nero che dove confina col ³nero, nè il biācho nō mostra più biā⁴co in cōfine del nero che del biāco, co⁵me fan le spetie passate per ispiraculo ⁶o per termine d'alcuno ostaculo opaco . . .

Since black, when painted next to white, looks no blacker than when next to black; and white when next to black looks no whiter than white, as is seen by the images transmitted through a small hole or by the edges of any opaque screen. . .

C. A. 181 *b*; 546 *b*] **280.**

DE COLORI.

²De colori d'equal bianchezza quel si mostrerà ³più candido che sarà in campo più oscuro; ⁴E 'l nero si mostrerà più tenebroso che fia in cā⁵po di maggior bianchezza.

⁶E'l rosso si dimostrerà più focoso che sarà ⁷in cāpo più giallo, e così farà tutti li colori cir⁸cundati da loro retti · contrari colori.

OF COLOURS.

Of several colours, all equally white, that will look whitest which is against the darkest background. And black will look intensest against the whitest background.

And red will look most vivid against the yellowest background; and the same is the case with all colours when surrounded by their strongest contrasts.

A. 19 *b*] **281.**

PROSPETTIVA.

On the re-
flection of
colours
(281—283).

²Ogni corpo · sanza colore · si colorisce tutto · o in parte · in nel colore cōtra se ³posto; ⁴questo · si uede per isperiēza · inpero · chè ogni · corpo · che spechia · si tignie nel co⁵lore che gli è per obbietto; E quel corpo che si tignie in parte · si è il bianco, e quella ⁶parte che fia luminata da rosso parrà rossa ed ogni altro colore luminoso o ōbroso.

PERSPECTIVE.

Every object devoid of colour in itself is more or less tinged by the colour [of the object] placed opposite. This may be seen by experience, inasmuch as any object which mirrors another assumes the colour of the object mirrored in it. And if the surface thus partially coloured is white the portion which has a red reflection will appear red, or any other colour, whether bright or dark.

PROSPETTIVA.

⁸Ogni · corpo · opaco · sanza · colore participa · di quel colore ch'egli à · per obietto; ⁹questo · accade a uno mvro biāco.

PERSPECTIVE.

Every opaque and colourless body assumes the hue of the colour reflected on it; as happens with a white wall.

279. 1. biacho. 4. cho . . biācho. 5. pasate. 6. ostachulo oppacho.
280. 2. biancheza cholori . . mosstera. 3. chandido . . chanpopiu osschuro. 4. mosstera . . cheffia. 5. magior. 6. dimosstera . . fochoso. 7. chosi . . cholori. 8· chundati . . cholori.
281. 1. pro. 2. cholore . . colorisscie . . inel cholore chōtra. 4. [ogni] questo . si . . chorpo chesspechia . . nel cho. 5. chorpo chessi . . biancho checquela. 6. para. 7. pro. 8. chorpo oppacho . . cholore . . cholore chellia. 9. quessto achade a ĩ muro biācho.

281. 282. The title line of these chapters is in the original simply *"pro"*, which may be an abbreviation for either *Propositione* or *Prospettiva*—taking Prospettiva of course in its widest sense, as we often find it used in Leonardo's writings. The title *"pro"* has here been understood to mean *Prospettiva*, in accordance with the suggestion afforded by page 10ᵇ of this same MS., where the first section is headed *Prospettiva* in full (see No. 94), while the four following sections are headed merely *"pro"* (see No. 85).

A. 20 a] **282.**

PROSPETTIVA.

²Quella · parte del corpo · ōbroso · che fia · alluminata · māderà · all' ochio la similitudine delle ³sue particule · piv · disciernibili · e spedite · che quella che si troverà nel l' onbra.

PROSPETTIVA.

⁵I razzi · solari ripercossi · sopra · lo spechio · quadro · risalterāno nel distāte obbietto di rotōda forma.

PROSPETTIVA.

⁷Ogni corpo biāco e opaco · si tignie in parte della similitudine de colori che li sono per obbietto.

PERSPECTIVE.

That side of an object in light and shade which is towards the light transmits the images of its details more distinctly and immediately to the eye than the side which is in shadow.

PERSPECTIVE.

The solar rays reflected on a square mirror will be thrown back to distant objects in a circular form.

PERSPECTIVE.

Any white and opaque surface will be partially coloured by reflections from surrounding objects.

Ash. I. 3 a] **283.**

QUAL PARTE DEL COLORE ²RAGIONEVOLMĒTE DEVE ESSERE ³PIÙ BELLA.

⁴Se · a · fia · il lume · b fia · alluminato · per linia · da esso lume, ⁵c che nō può vedere esso lume ·, vede solo · la parte alluminata ⁶la quale parte diciamo che sia rossa ·; Essendo così il lume ch'ella ⁷gitterà alla parte somiglierà alla sua cagione e tignierà ī rosso ⁸la faccia · c · e se · c fia ancora · lui rosso · vedrai essere molto ⁹piv bello · che · b · e se · c · fusse giallo · vedrai lì crearsi · uno · colo¹⁰re cāgiāte jfra · giallo · e rosso.

WHAT PORTION OF A COLOURED SURFACE OUGHT IN REASON TO BE THE MOST INTENSE.

If a is the light, and b illuminated by it in a direct line, c, on which the light cannot fall, is lighted only by reflection from b which, let us say, is red. Hence the light reflected from it, will be affected by the hue of the surface causing it and will tinge the surface c with red.

And if c is also red you will see it much more intense than b; and if it were yellow you would see there a colour between yellow and red.

Ash. I. 2 b] **284.**

COME IL BELLO DEL COLORE ²DEVE ESSERE JN SU LUMI.

³Se noi · vediamo · la qualità · de' colori · essere · conoscivta · mediāte ³il lume · è da giudicare · che dov' è · piv lume · quivi si vegga piv la vera ⁴qualità · del colore · alluminato ·, e dov' è · più tenebre il colore tignersi ⁵nel colore d'esse tenebre, adūque · tu · pittore ricordāti · dimostrare ⁵la verità de' colori ī su le · parti · alluminate.

WHY BEAUTIFUL COLOURS MUST BE IN THE [HIGHEST] LIGHT.

Since we see that the quality of colour is known [only] by means of light, it is to be supposed that where there is most light the true character of a colour in light will be best seen; and where there is most shadow the colour will be affected by the tone of that. Hence, O Painter! remember to show the true quality of colours in bright lights.

On the use of dark and light colours in painting (284—286).

282. 1. pro. 2. chorpo . . cheffia. 3. partichule . piv . [spe] . . esspedite . . chessi. 4. pro. 5. razi . . riperchossi . . los-spechio . . retōda. 6. pro. 7. chorpo biācho e opacho . . cholori.

283. 1. cholore. 2. deessere. 3. belle. 4. ilume. 6. chessia. 7. gitera . . sumigliera . . ettigniera. 8. esse . c fianchora . . vederai. 9. esse . e . fussi gialo vedra . . crearsi . ī . cholo. 10. re chāgiāte.

284. 2. deessere. 4. giudichare . . vega. 6. richordati. 7. cholori . . parte.

285.

Quella · cosa · che fia · dipinta di biāco . ²cō nero · apparirà di migliore rilievo · ³che alcun' altra ·, e però ricordo a te · pictore · che vesti le tue figure di colori pi⁴v chiari · che puoi che se le farai di colore oscuro sieno di poco rilievo e ⁵di poca evidētia da lōtano—e quest'è per l'onbre di tutte le cose che sono · scure; ⁶e se farai una vesta scura poco di vario · fia da lumi · al' ōbre e ne colori chiari vi fia grāde vario.

An object represented in white and black will display stronger relief than in any other way; hence I would remind you O Painter! to dress your figures in the lightest colours you can, since, if you put them in dark colours, they will be in too slight relief and inconspicuous from a distance. And the reason is that the shadows of all objects are dark. And if you make a dress dark there is little variety in the lights and shadows, while in light colours there are many grades.

286.

PICTURA.

²Li colori posti nelle onbre parteciperā³no tanto più o meno della lor natural ⁴bellezza quanto essi sarāno in minore o in maggio⁵re oscurità.

⁶Ma se li colori sarā situati in i⁷spatio luminoso, allora essi si mostrerā di ⁸tanto maggiore bellezza quanto il luminoso fia ⁹di maggiore splēdore.

OF PAINTING.

Colours seen in shadow will display more or less of their natural brilliancy in proportion as they are in fainter or deeper shadow.

But if these same colours are situated in a well-lighted place, they will appear brighter in proportion as the light is more brilliant.

AVERSARIO.

¹¹Tante sono le varietà de' colori delle ōbre quāto sono ¹²le uarietà de' colori che ànno le cose aōbrate.

THE ADVERSARY.

The variety of colours in shadow must be as great as that of the colours in the objects in that shadow.

RISPOSTA.

¹⁴Li colori posti nell'onbre mostrerāno ¹⁵infra loro tanta minor varietà, quāto l' ō¹⁶bre che vi ·son situate fieno più oscure, ¹⁷e di questo è testimonio quelli che dalle pi¹⁸azze riguardano dentro alle porte delli tē¹⁹pi onbrosi, doue le pitture vestite di ²⁰vari colori appariscono tutte uesti²¹te di tenebre.

²²Adunque in lunga distantia tutte l'ō²³bre delli vari colori appariscono d'una ²⁴medesima oscurità.

²⁵Delli corpi vestiti d' ōbra e lume la parte ²⁶luminata mostra il suo vero colore.

THE ANSWER.

Colours seen in shadow will display less variety in proportion as the shadows in which they lie are deeper. And evidence of this is to be had by looking from an open space into the doorways of dark and shadowy churches, where the pictures which are painted in various colours all look of uniform darkness.

Hence at a considerable distance all the shadows of different colours will appear of the same darkness.

It is the light side of an object in light and shade which shows the true colour.

287.

On the colours of the rainbow (287. 288).

Fa l' arco cieleste nell' ultimo libro della pictura ma fa ²prima il libro delli colori nati dalla mistiō nelli altri colori, ³acciò che tu possa provare mediante essi colori de' pictori ⁴la gieneratiō de' colori del' arco.

Treat of the rainbow in the last book on Painting, but first write the book on colours produced by the mixture of other colours, so as to be able to prove by those painters' colours how the colours of the rainbow are produced.

285. 1. quela chossa cheffia . . biācho. 2. aparira. 3. alchunaltra . . richordo atte . . cholori. 4. chesse . . cholore osschuro . . pocho. 5. pocha . . ecqueste . . chose sono . scure. 6. esse fara î vesta . . pocho . . gradi.

286. 2. cholori possti. 4. belleza . . "iminore" o in maggi "o". 5. osschurita. 6. Masselli [medesimi] cholori. 7. mosstrerā. 8. magiore . . iluminoso. 9. maggiore [chiarezza] splēdore. 11. cholori. 12. cholori che ā lechose. 14. cholori . nossterrāno. 15. infralloro. 16. eve son . . osschure. 17. ettestimonio. Queli che delle. 18. dellite. 20. cholori aparisschā. 22. lungha disstantta. 23. cholori aparisschano. 24. osschurita. 25. chorpi . . ellume. 26. cholore.

287. 1. fallarcho . . maffa. 2. cholori nati della . . cholori. 3. acio chettu. 4. cholori delarcho.

W. L. 145; A *b*.]

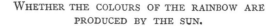

288.

SE LI COLORI DELL'ARCO NASCONO DAL SOLE.

[2]Li colori dell'arco nō nascō [dal sole, perchè ī molti modi si gienerā [3]tali colori sanza sole come accade nell'accostare all'ochio il bicchiere dell'acqua, [4]nel uetro del quale siā le minute vesciche che esser sogliono nelli vetri mal pur[5]gati; le quali vesciche, ancorachè nō si veda il sole, gienerā da vno de' sua [6]lati tutti li colori dell'arco, e questo vedrai nel metter tale bicchiere in[7]fra l'aria e l'ochio tuo in modo che sia in cōtatto con esso ochio e che tale bi[8]cchiere abbia vna parte per la qual penetri el lume dell'aria e dall'altra l'ō[9]bra della pariete laterale di tal finestra destra o sinistra, che nō fa ca[10]so qual lato si sia, e così voltando tal bicchiere intorno vedrai li detti [11]colori intorno a esse vesciche del uetro ecc., e li altri modi diremo a suo [12]loco.

COME L'OCHIO NON À PARTICIPATIONE [14]ALLA GIENERATIŌ DE' COLORI DELL'ARCO.

[15]L'ochio nella sopra detta esperiētia pare auer participatione al[16]li colori dell'arco perchè esse vesciche del uetro nō mostrā da se tali [17]colori se non mediante l'aspetto dell'ochio; Ma se tu poni tal bicchi[18]ere pieno d'acqua sul piano della finestra in modo che dall'opposita par[19]te lo ferischino li razzi solari, allora tu vedrai li predetti colori gie[20]nerarsi nella inpressiō fatta dalli razzi solari penetrati per esso bi[21]cchiere e terminati sopra il pavimēto in loco oscuro a piedi d'essa finestra, e perchè [22]qui nō s'adopera l'ochio, possiā cō ciertezza manifestamēte dire tali co[23]lori non avere parte alcuna dall'ochio.

WHETHER THE COLOURS OF THE RAINBOW ARE PRODUCED BY THE SUN.

The colours of the rainbow are not produced by the sun, for they occur in many ways without the sunshine; as may be seen by holding a glass of water up to the eye; when, in the glass—where there are those minute bubbles always seen in coarse glass—each bubble, even though the sun does not fall on it, will produce on one side all the colours of the rainbow; as you may see by placing the glass between the day light and your eye in such a way as that it is close to the eye, while on one side the glass admits the [diffused] light of the atmosphere, and on the other side the shadow of the wall on one side of the window; either left or right, it matters not which. Then, by turning the glass round you will see these colours all round the bubbles in the glass &c. And the rest shall be said in its place.

THAT THE EYE HAS NO PART IN PRODUCING THE COLOURS OF THE RAINBOW.

In the experiment just described, the eye would seem to have some share in the colours of the rainbow, since these bubbles in the glass do not display the colours except through the medium of the eye. But, if you place the glass full of water on the window sill, in such a position as that the outer side is exposed to the sun's rays, you will see the same colours produced in the spot of light thrown through the glass and upon the floor, in a dark place, below the window; and as the eye is not here concerned in it, we may evidently, and with certainty pronounce that the eye has no share in producing them.

288. 1. selli . . archo nasschā. 2. cholori dellarcho nōnasschā. 3. cholori san"za sole" chome achade nell'achostare . . bichieri . . acqu"a". 4. sia . vessciche . esser solc nelli. 5. ghati . . vesciche anchora . vndesua. 6. cholori dell'archo ecquesto vedera . . bichieri. 7. frallaria ellochio . . chessia in chōtatto a esso. 8. chieri . . penitri. 9. lateral . . finesstra desstra ossinistre . . cha. 10. chosi . . bichieri . . vederai. 11. cholori . vessciche . . [elli altri modi direno assue]. 12. locho. 13. chome. 14. cholori . . archo. 15. essperiētia. 16. cholori . . archo . . vessciche . . mosstrā dasse. 17. cholori sennō . . lasspecto . . Massettu . . bichi. 18. eri . . dacq"a" . . finesstra. 19. ferisschino . . cholorigi. 20. facta . . penetrata. 21. chieri etterminata . . "in locho osscuro" . . finesstra. 22. cierteza cho. 23. alchuna. 24. dalchuno. 26. quali si. 27. cholori.

DELLI COLORI POSTI NELLE PEÑE D'ALCUNO [25]VCCIELLO.

[26]Molti sono li vccielli nelle varie regiõ del mõdo, nelle penne de' quali [27]si vede bellissimi colori gienerarsi nelli lor diuersi movimẽti, [28]come far si vede infra noi alle penne delli pagoni o nelli colli del[29]l'anitre o delle colonbe ecc.

[30]Ancora nelle superfitie delli antichi vetri trovati sotto terra e in ne[31]le radici de' rava-nelli stati lũgo tẽpo ne' fondi delle fonti o altre ac[32]que inmobili, che ciascuna di tal radici è circũdata da tali archi si[33]mili al cieleste; vedesi nell' ũtuosità sparsa sopra l'acqua, ancora [34]nelli razzi solari reflessi dalla superfitie del diamãte o berillo; ã[35]cora nell'angolo fatto dal berillo ogni cosa oscura la [36]qual termini coll'aria o altra cosa chiara è circhũdata da [37]tale arco interposto infra l'aria e detta cosa oscura, e così mol[38]ti altri modi li quali lascio perchè questi sõ bastãti a tal discorso.

OF THE COLOURS IN THE FEATHERS OF CERTAIN BIRDS.

There are many birds in various regions of the world on whose feathers we see the most splendid colours produced as they move, as we see in our own country in the feathers of peacocks or on the necks of ducks or pigeons, &c.

Again, on the surface of antique glass found underground and on the roots of turnips kept for some time at the bottom of wells or other stagnant waters [we see] that each root displays colours similar to those of the real rainbow. They may also be seen when oil has been placed on the top of water and in the solar rays reflected from the surface of a diamond or beryl; again, through the angular facet of a beryl every dark object against a background of the atmosphere or any thing else equally pale-coloured is surroun-ded by these rainbow colours between the atmosphere and the dark body; and in many other circumstances which I will not mention, as these suffice for my purpose.

28. paghoni. 29. oddelle cholonbe. 31. lũgho . . fondi delle fonto . . altra. 32. cque . . ciasscuna . . eccirchũdata dattali. 33. cielesste . . ũduosita . . anchora. 34. refressi . . obberillo. 35. chora . . angholo . . chosa osscura. 36. qual [chaupeg] termini chollaria . . chosa . . ecirchũdata. 37. archo . . infrallaria eddetta . . osschura echosi. 38. lasscio . . basstãti attal disscorso.

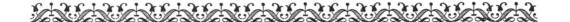

VI.

'Prospettiva de' colori' (Perspective of Colour)

and

'Prospettiva aerea' (Aerial Perspective).

Leonardo distinctly separates these branches of his subject, as may be seen in the beginning of No. 295. Attempts have been made to cast doubts on the results which Leonardo arrived at by experiment on the perspective of colour, but not with justice, as may be seen from the original text of section 294.

The question as to the composition of the atmosphere, which is inseparable from a discussion on Aerial Perspective, forms a separate theory which is treated at considerable length. Indeed the author enters into it so fully that we cannot escape the conviction that he must have dwelt with particular pleasure on this part of his subject, and that he attached great importance to giving it a character of general applicability.

289.

La uarietà · de' colori de' corpi · nō fia in lunga · distantia · conosciuta · se nō in quelle · parti · che dai soli razzi percosse fieno.

The variety of colour in objects cannot be discerned at a great distance, excepting in those parts which are directly lighted up by the solar rays.

General rules (289—291).

290.

Infra i colori · de' corpi nō fia · differentia · in lunga · distantia · nelle · loro · parti onbrose.

As to the colours of objects: at long distances no difference is perceptible in the parts in shadow.

291.

DELLA EVIDĒTIA DE' COLORI.

[2]Quale colore è piv evidēte? quella cosa ch'è piv chiara piv appariscie [3]di lontano; e la · piv scura fa il cōtrario.

OF THE VISIBILITY OF COLOURS.

Which colour strikes most? An object at a distance is most conspicuous, when it is lightest, and the darkest is least visible.

292.

Delli termini dell'ōbre; alcu[2]ni sō fumosi d'insēsibile termine, altri [3]di termini noti.

[4]Nessū corpo opaco è sanza ōbra o lumi se [5]non è nella nebbia, sopra terra coperta di neve, e el [6]simile fa quãdo fiocca in canpagnia essa fia [7]sanza lume e sarà circūdata dalle tenebre.

Of the edges [outlines] of shadows. Some have misty and ill defined edges, others distinct ones.

No opaque body can be devoid of light and shade, except it is in a mist, on ground covered with snow, or when snow is falling on the open country which has no light on it and is surrounded with darkness.

An exceptional case.

289. 1. cholori de chorpi . . illunga . . nō "in" quele . [lor] parti che [ffieno] dai sola razi perchosse.
290. 1. cholori de chorpi . diferentia . llunga.
291. 1. della . . cholori. 2. cholore . . chosa . . apariscie. 3. lontano [allo] ella pivschura . . chōtrario.
292. 1. ōbre [in che alchu]. 2. nisō. 4. nesū chorpo oppacho . . ollumi. 5. nelanebia. 6. fiocha in chanpagniaesa.
 7. circhūdata. 8. ecquesto achade neli.

E questo accade ne' corpi sperici, perchè nelli al⁹tri corpi, che ànno mēbrificatione, le parti ¹⁰ delle mēbra riguardatrici l' una del-l'altra tingo¹¹no l' una l' altra del' accidēte della sua superfitie.

And this occurs [only] in spherical bodies, because in other bodies which have limbs and parts, those sides of limbs which face each other reflect on each other the accidental [hue and tone] of their surface.

Ash. I. 25 *b*]

293.

TUTTI I · COLORI NELLE LONTANE · ŌBRE SONO IGNIORATI E INDISCERNIBILI.

ALL COLOURS ARE AT A DISTANCE UNDISTIN-GUISHABLE AND UNDISCERNIBLE.

An experi- ment. ² Tutti · i colori · in lontano · fieno · nel-l' ōbre · igniorati; perchè la cosa; che non è tocca dal principale ³ lume; non è potēte · a mandare · dī se · all' occhio per l' aria piv · luminosa · la sua similitudine, perchè il minore ⁴ lume · è vinto · dal maggiore; Esenplo: · Noi · vediamo · essendo in vna · casa · che tutti ⁵ i colori · i quali sono nelle · parieti delle · mvra · si ueggono · chiaro e speditamēte, · quādo le finestre ⁶ di detta abitatione · fieno · aperte; e se noi · usciremo · fori · d' essa casa · e riguardaremo vn poco di ⁷ lontano · per dette · finestre · di rivedere · le pitture · fatte sù dette mura · in iscambio d' esse picture ⁸ vedremo · vna cōtinvata · oscurità.

All colours at a distance are undistinguish-able in shadow, because an object which is not in the highest light is incapable of transmitting its image to the eye through an atmosphere more luminous than itself; since the lesser brightness must be absorbed by the greater. For instance: We, in a house, can see that all the colours on the surface of the walls are clearly and instantly visible when the windows of the house are open; but if we were to go out of the house and look in at the windows from a little distance to see the paintings on those walls, instead of the paintings we should see an uniform deep and colourless shadow.

Ash. I. 13*a*]

294.

COME IL PITTORE DEBE METTERE ² IN PRA-TICA LA PROSPETTIVA DE' COLORI.

HOW A PAINTER SHOULD CARRY OUT THE PERSPECTIVE OF COLOUR IN PRACTICE.

The practice of the pro-spettiva de' colori. ³ A volere · mettere questa · prospettiva del uariare e perdere over diminvire la ⁴ propia · essētia de' colori · piglerai di ciēto ī ciento braccia cose poste īfra ⁵ la cāpag-nia come sono · albori case, omini e siti, e ī quāto al ⁶ primo albore avrai uno uetro fermo bene e così sia fermo l' ochio tuo, e ī detto ⁷ vetro disegnerai uno albero sopra

In order to put into practice this per-spective of the variation and loss or diminution of the essential character of colours, observe at every hundred braccia some objects stand-ing in the landscape, such as trees, houses, men and particular places. Then in front of the first tree have a very steady plate of glass and keep your eye very steady, and then, on this plate of glass, draw a tree, tracing it over the form of that tree. Then move it on one

chorpi. 9. mēbrifichatione . parte. 10. riguardatricie . . tingha. 11. nolluna.
293. 1. cholori . . indissciernibili. 2. choloriillontano . . nellɔbre . . chosa . tocha. 3. sua [forma] similitudine. 4. essendo nvna . chasa . chettutti. 5. icholori . . uegono . . esspeditamēte. 6. essenō . ussciremo . . chasa e riguardareno vn pochο di. 7. ischanbio. 8. vederemo chōtinvata oschurita.
294. 2. praticha. 4. cholori . . ciento br . chose. 5. omini [e pianv] essiti. 6. arai ī uetro. 7. vetro [colorissi ī albero p] di-

294. This chapter is one of those copied in the Manuscript of the Vatican library Urbinas 1270, and the original text is rendered here with no other alterations, but in the orthography. H. LUDWIG, in his edition of this copy translates lines 14 and 15 thus: "*Ich finde aber als Regel, dass der zweite um vier*

Fünftel des ersten abnimmt, wenn er nämlich zwanzig Ellen vom ersten entfernt ist (?)". He adds in his commentary: "*Das Ende der Nummer ist wohl jedenfalls verstümmelt*". However the translation given above shows that it admits of a different rendering.

la forma di quello, di poi [8]scosta tāto per traverso che l'albero naturale · cōfini quasi col tuo disegnia[9]to; poi colorisci il tuo · disegnio in modo che per colore e forma stia a paragone [10]l'uno dell'altro e che tutti e 2, chivdēdo uno ochio, paino dipīti sul detto vetro d'una [11]medesima distātia; e questa regola medesima fa degli alberi secō-di [12]e de' terzi di ciēto ī ciēto braccia di mano ī mano; e questi ti servā · come tua auto[13]ri e maestri, sēpre operādo nelle tua opere doue s'appartēgono, e faranno [14]bene fuggir l'opera; ma io trovo per regola · che'l secōdo diminviscie ⁴/₅ del primo [15]quādo fusse lōtano 20 · braccia dal primo.

side so far as that the real tree is close by the side of the tree you have drawn; then colour your drawing in such a way as that in colour and form the two may be alike, and that both, if you close one eye, seem to be painted on the glass and at the same distance. Then, by the same method, represent a second tree, and a third, with a distance of a hundred braccia between each. And these will serve as a standard and guide whenever you work on your own pictures, wherever they may apply, and will enable you to give due distance in those works. [14] But I have found that as a rule the second is ⁴/₅ of the first when it is 20 braccia beyond it.

Ash. I. 10*a*]

295.

DELLA PROSPETTIVA AEREA.

[2]È ci una altra · prospectiva · la quale chiamo aerea, īperochè per la uarietà [3]dell'aria · si può conosciere le diverse distā-tie [4]di uari edifiti, terminati ne' lor nasci-mēti da una sola linia, come sa-[5]rebbe il uedere molti edifiti di là da uno muro, che tutti apparischino so-pra [6]alla stremità di detto mvro d'una medesima grādezza, e tu vo-[7]lessi in pittura · fare parere piv lontano l'uno che l'altro e da figura[8]re una aria vn poco grossa; Tu sai che ī simili arie l'ultime cose viste [9]ī quella, come sono le mōtagnie · per la grā quātità dell'aria · che si truova infra l'ochio [10]tuo · e la mōtagnia · quella pare azzurra quasi del culore del-l'aria quādo il sole [11]è per leuāte; Adūque farai sopra · detto mvro il primo edificio del suo colore, [12]il piv lōtano fa lo meno pro-filato e piv azzurro; quello · che tu vuo che sia piv [13]in là · altrettāto ·, fa lo · altrettāto · piv · azzuro: quello che voi che sia cīque volte [14]piv lōtano ·, fallo · 5 volte più azzuro; e questa regola farà che li edifiti [15]che sopra una linia paiono d'una · medesima grādezza, -chiaramēte si conosciarà [16]qual è piv distāte e quale è maggiore che li altri.

OF AERIAL PERSPECTIVE.

There is another kind of perspective which I call Aerial Perspective, because by the atmosphere we are able to distinguish the variations in distance of different buildings, which

appear placed on a single line; as, for instance, when we see several buildings beyond a wall, all of which, as they appear above the top of the wall, look of the same size, while you wish to represent them in a picture as more remote one than another and to give the effect of a somewhat dense atmosphere. You know that in an atmosphere of equal density the remotest objects seen through it, as mountains, in consequence of the great quantity of atmosphere between your eye and them—appear blue and almost of the same hue as the atmosphere itself [10] when the sun is in the East [11]. Hence you must make the nearest building above the wall of its real colour, but the more distant ones make less defined and bluer. Those you wish should look farthest away you must make proportionately bluer; thus, if one is to be five times as distant, make it five times bluer. And by this rule the buildings which above a [given] line appear of the same size, will plainly be distinguished as to which are the more remote and which larger than the others.

The rules of aerial perspective (295—297).

segnia î albero. 8. chol. 9. Colorisci tuo . . imodo . . cholore efforma. 10. chivdēdo î ochio . . di pīti si detto vetro luna. 11. ecquesta . . dela 12. ciento br . . ecquesti . . serbā . . tua alto. 13. sapartēgano effarano.
295. 2. Ecci î altra. 3. conosciere [la distātia di] le diuersa. 4. da î sola. 5. rebe . . da î muro chettutti apariscino. 6. alla [distāti] stremita . . grādeza echettu. 8. re î aria vn pocho . . Tussai che īsimile . . chose. 9. î quella *these two words written beyond the margin have apparently later been added by Leonardo* . . chessi. 10. ella . . azurra . . cholore. 12. priffilato . . azzurro . . chettu voi chessia. 13. fallo . . azzuro . . voi chessia. 14. azuro . . ecquesta. 15. sopra î linia paiano . . grādeza . . chonosciera. 16. ecquale.

295. 10. 11. *quādo il sole è per leuante* (when the sun is in the East). Apparently the author refers here to morning light in general. H. LUD-

WIG however translates this passage from the Vatican copy *"wenn nämlich die Sonne (dahinter) im Osten steht"*.

Tr. 75]

296.

Il mezzo ch'è infra l'ochio e la cosa vista · trasmuta essa ²cosa · in nel suo · colore, come l'aria azzura fa che le lōtane ³mōtagnie paiono azzure; il uetro rosso fa che ciò che l'ochio ⁴vede dopo · lui · pare · rosso: jl lume che fanno le stelle ⁵d'intorno ase · è occupato per la tenebrosità della notte che si ⁶truova infra l'ochio · e la luminatione d'essa stella.

The medium lying between the eye and the object seen, tinges that object with its colour, as the blueness of the atmosphere makes the distant mountains appear blue and red glass makes objects seen beyond it, look red. The light shed round them by the stars is obscured by the darkness of the night which lies between the eye and the radiant light of the stars.

W. 3]

297.

Fa che la prospettiua de' ²colori non si discordi ³dalle grandezze di qualū⁴che cosa cioè che li ⁵colori diminuischino ⁶tanto della lor natu⁷ra quāto diminuisco⁸no li corpi in diuerse ⁹distantie della loro ¹⁰naturale quātità.

Take care that the perspective of colour does not disagree with the size of your objects, hat is to say: that the colours diminish from their natural [vividness] in proportion as the objects at various distances diminish from their natural size.

Ash. I. 17 a]

298.

COME L'ARIA SI DEBE PIV FARE ²CHIARA QUĀTO PIV LA FAI FINIRE BASSA.

WHY THE ATMOSPHERE MUST BE REPRESENTED AS PALER TOWARDS THE LOWER PORTION.

On the relative density of the atmosphere (298—290).

³Perchè quest' aria è grossa presso alla terra · e quāto piv si leua piv ⁴s'assottiglia; quādo · il sole · è per leuāte, e tu riguarderai il ponēte ⁵participāte di mezzodì e tramōtana, vedrai quel' aria grossa ⁶ricievere piv lume dal sole che la sottile, perchè i razzi trovano più resistētia; ⁷e se il cielo a la vista tua terminerà colla bassa pianvra, quella ⁸parte vltima del cielo · fia veduta per quella aria · piv grossa e piv ⁹bianca, la quale · corromperà la verità del colore che si vedrà ¹⁰pel suo · mezzo, e parrà lì · il cielo piv biāco che sopra te, che la linia visuale ¹¹passa · per meno quātità d'aria corrotta da grossi umori; e se riguarde¹²rai inverso · leuāte·, l'aria ti parrà piv scura, quāto piv s'abbassa, perchè ¹³in detta aria bassa i razzi luminosi meno passano.

Because the atmosphere is dense near the earth, and the higher it is the rarer it becomes. When the sun is in the East if you look towards the West and a little way to the South and North, you will see that this dense atmosphere receives more light from the sun than the rarer; because the rays meet with greater resistance. And if the sky, as you see it, ends on a low plain, that lowest portion of the sky will be seen through a denser and whiter atmosphere, which will weaken its true colour as seen through that medium, and there the sky will look whiter than it is above you, where the line of sight travels through a smaller space of air charged with heavy vapour. And if you turn to the East, the atmosphere will appear darker as you look lower down because the luminous rays pass less freely through the lower atmosphere.

Ash. I. 17 b]

299.

DEL MODO DEL CŌDUCIERE ²IN PITTURA LE COSE LŌTANE.

OF THE MODE OF TREATING REMOTE OBJECTS IN PAINTING.

³Chiaro si uede · essere una aria grossa piv che l'altre, la quale cōfina ⁴colla · terra ·

It is easy to perceive that the atmosphere which lies closest to the level ground is denser

296. 1. infrallochio . . chosa. 2. inel . . chomellaria azura . . chelle. 3. parano azure . . chellochio. 4. Ilume cheffano. 5. asse echo chupato . . dela . . chessi. 6. ella.

297. 1. chella persspectiua. 2. cholori . . disscordi grandeze. 4. chosa . . chelli. 5. cholori diminuisschino. 7. diminuisca. 8. chorpi . . diversi. 9. disstantie.

298. 3. ecquāto . . sassotiglia. 4. ettu. 5. mazodi . . ettramōtana . . vederaia. 6. "dal sole" chella . . razi. 7. esse . . cholla. 9. biancha [il quale] la . . coronpera . . chessi. 10. mezo . parali il . . chella. 11. corotta . . omori esse risghuarde. 12. raza . . schura . . sabassa. 13. razi.

299. 3. esserere î̄ aria . . chellaltre . . chōfina. 4. tera . . ecquāto . . essottile. 5. chose [che ffieno] eleuate . . datte. 6. basseza pocho.

piana, e quāto piv si leua ī alto, piv · è sottile e trāsparēte; ⁵le cose eleuate e grādi, che fieno · da te lontane ·, la lor · ⁶bassezza · poco · fia · veduta: perchè · la uedi · per una · linia che passa infra ⁷l'aria piv · grossa ·, e cōtinvata ·, la sōmità di dette altezze · si trova ⁸essere veduta per una linia, la quale benchè dal cāto dell'ochio tuo ⁹si cavsi in nel' aria grossa · nōdimeno terminādo · nella sōma altezza ¹⁰della · cosa · vista, viene a terminare in aria molto · piv sottile che ¹¹nō fia la sua bassezza; e per questa ragione questa linia quāto piv s'allōtana ¹²da te, di pūto ī punto sēpre mvta qualità di sottile ī sottile aria; adū¹³que tu pittore, quādo fai le m̃otagnie, fa che di colle ī colle sēpre le bassezze sie¹⁴no piv chiare che l' altezze e quāto vi farai piv lontana l' una da l' altra fa le basse¹⁵zze piv chiare, ¹⁶e quāto piv se leverà in alto, piv most¹⁷rerà la verità della forma e colore.

than the rest, and that where it is higher up, it is rarer and more transparent. The lower portions of large and lofty objects which are at a distance are not much seen, because you see them along a line which passes through a denser and thicker section of the atmosphere. The summits of such heights are seen along a line which, though it starts from your eye in a dense atmosphere, still, as it ends at the top of those lofty objects, ceases in a much rarer atmosphere than exists at their base; for this reason the farther this line extends from your eye, from point to point the atmosphere becomes more and more rare. Hence, O Painter! when you represent mountains, see that from hill to hill the bases are paler than the summits, and in proportion as they recede beyond each other make the bases paler than the summits; while, the higher they are the more you must show of their true form and colour.

Leic. 4 a] **300.**

DEL COLORE DELL' ARIA.

²Dico l' azzuro in che si mostra l' aria non essere suo propio colore, ma è cavsato da vmidità cal³da vaporata in minvtissimi e insensibili attomi, la quale piglia dopo se la percussiō de' razzi solari e fassi luminosa ⁴sotto la oscurità delle immēse tenebre della regione del fuoco che di sopra le fa coperchio; e questo vedrà, come vid' io, chi ādrà so⁵pra Mōboso, giogo dell' alpi che diuidono la Francia dalla Italia, la qual montagnia a la sua basa che parturisce ⁶li 4 fiumi che rigā per 4 aspetti contrari tutta l' Europa, e nessuna montagnia à le sue base in simile al⁷tezza, questa si leua in tanta altura che quasi passa tutti li nuvoli e rare volte vi cade neve, ma sol grādi⁸ne d'istate quando li nvvoli sono nella maggiore altezza, e questa grandine vi si cōserua in modo che se nō ⁹fusse la retà del caderui e del montarui nvuoli, che non accade 2 volte in vna età, egli ui sarebbe altissima quātità di

OF THE COLOUR OF THE ATMOSPHERE.

I say that the blueness we see in the atmosphere is not intrinsic colour, but is caused by warm vapour evaporated in minute and insensible atoms on which the solar rays fall, rendering them luminous against the infinite darkness of the fiery sphere which lies beyond and includes it. And this may be seen, as I saw it by any one going up[5] Monboso, a peak of the Alps which divide France from Italy. The base of this mountain gives birth to the four rivers which flow in four different directions through the whole of Europe. And no mountain has its base at so great a height as this, which lifts itself almost above the clouds; and snow seldom falls there, but only hail in the summer, when the clouds are highest. And this hail lies [unmelted] there, so that if it were not for the absorption of the rising and falling clouds, which does not happen twice in an age, an enormous mass of ice would

On the colour of the atmosphere (300—307).

7. chōtinvata . lassomita . . alteze. 8. chāto. 9. chavsi inel . . some alteza. 10. atterminare. 11. basseza. 12. datte . . qualita [daria] di sottile. 13. basseze. 14. lalteze ecquāto. 15. ze piv chiare + 16. *The two last lines, which are headed by +, are written on the margin.* 17. stera . . dela.

300. 2. dicho lazuro inchessi . . cholore . . chavsato . . chal. 3. attimi . . pigla . . perchussiō . . razi . . effassi. 4. osscurita . . fuocho "che di sopra le facoperchio" ecquesto. 5. gogo . . diuitano la franca . . alla . . patrurissce. 6. aspeti . . alle. 7. teza . . nvuoli . . chade. 8. magore alteza ecquesta . . imodo chesse. 9- fussi "la reta del caderui e del montarui nvuoli" che non achade [del s] 2 volte vna . . eui sarebbe . . di diacco inalzato "da li gradi della grāndine il.

300, 5. With regard to the place spoken of as *M̄oboso* (compare No. 301 line 20) its identity will be discussed under Leonardo's Topographical notes in Vol. II.

7. *reta* here has the sense of *malanno*.

diaccio inalzato da li gradi della grādine il qua[10]le di mezzo luglio vi trovai grossissimo · e vidi l' aria sopra di me tenebrosa e'l sole che percotea la mōta[11]gnia essere piv luminoso quiui assai che nelle basse pianure, perchè minor grossezza d' aria s' interponea in[12]fra la cima d' esso mōte e 'l sole; Ancora per esenplo del colore dell' aria allegheremo il fumo nato di legne [13]secche e vecchie il quale vscendo de' camini pare forte azzureggiare quādo si trova infra l' ochio e 'l loco [14] oscuro, ma quādo monta in alto e s' interpone infra l' ochio e l' aria alluminata, inmediate si dimostra [15] di colore cenerognolo, e questo accade perchè non à piv oscurità dopo se, ma in loco di quella aria lu[16]minosa; e se tal fumo sarà di legne verdi e giovani allora non penderà in azzurro, perchè nō [17]sendo transparente e piē di superchia vmidità, esso fa vfitio di condensata nvuo lache piglia in se lumi e ōbre ter[18]minate, come se solido corpo fusse; El simile fa l' aria che la troppa vmidità rende biāca e la [19]poca infusa col caldo la rēde oscura, di color di scuro azzuro, e questo ci basta in quāto alla di[20]finitione del colore dell' aria; Benchè si potrebbe ancora dire che se l' aria avesse per suo naturale colo-[21]re esso azzuro transparente, seguirebbe che doue s' interponesse maggior quantità d' aria infra [22] l' ochio e l' elemēto del foco, che quiui si comporrebbe il suo azzuro con maggiore oscurità, come si vede [23]nelli vetri azzurri e ne' zaffiri li quali si mostrā tanto piv oscuri, quāto essi son piv grossi; E l' a[24]ria in questo caso adopera in retto contrario, conciosiachè dove piv in quātità s' in[25]terpone infra l' ochio e la spera del foco, quiui ci si mostra più biancheggiante; e questo accade [26]inverso l' orizzonte; equāto minor soma d' aria s' interpone infra l' ochio e la spera del foco tanto piv [27]oscuro azzurro, ci si mostra, ancorachè noi stiamo nelle basse pianvre; Adunque segue pur quel che io di[28]co che l' aria piglia l' azzuro mediante li corpuscoli dell' umidità che pigliano li razzi luminosi del sole; [29]vedesi ancora la differētia nelli attomi di poluere o nelli attomi del fumo ne' razzi solari, che passā per li [30]spiraculi delle parieti in lochi oscuri, che l' un razzo pare essere cenerino

be piled up there by the hail, and in the middle of July I found it very considerable. There I saw above me the dark sky, and the sun as it fell on the mountain was far brighter here than in the plains below, because a smaller extent of atmosphere lay between the summit of the mountain and the sun. Again as an illustration of the colour of the atmosphere I will mention the smoke of old and dry wood, which, as it comes out of a chimney, appears to turn very blue, when seen between the eye and the dark distance. But as it rises, and comes between the eye and the bright atmosphere, it at once shows of an ashy grey colour; and this happens because it no longer has darkness beyond it, but this bright and luminous space. If the smoke is from young, green wood, it will not appear blue, because, not being transparent and being full of superabundant moisture, it has the effect of condensed clouds which take distinct lights and shadows like a solid body. The same occurs with the atmosphere, which, when overcharged with moisture appears white, and the small amount of heated moisture makes it dark, of a dark blue colour; and this will suffice us so far as concerns the colour of the atmosphere; though it might be added that, if this transparent blue were the natural colour of the atmosphere, it would follow that wherever a larger mass air intervened between the eye and the element of fire, the azure colour would be more intense; as we see in blue glass and in sapphires, which are darker in proportion as they are larger. But the atmosphere in such circumstances behaves in an opposite manner, inasmuch as where a greater quantity of it lies between the eye and the sphere of fire, it is seen much whiter. This occurs towards the horizon. And the less the extent of atmosphere between the eye and the sphere of fire, the deeper is the blue colour, as may be seen even on low plains. Hence itfol lows, as I say, that the atmosphere assumes this azure hue by reason of the particles of moisture which catch the rays of the sun. Again, we may note the difference in particles of dust, or particles of smoke, in the sun beams admitted through holes into a dark chamber, when the former will look ash grey

10. mezo . . grossimo . . tenenebrosa ellsole. 11. luminosi . . grosseza. 12. allegereno. 13. seche e vechie le quale vsscendo . . azuregare . . locho. 14. osscuro macquādo . . essinterpone . . ellaria. 15. ecquesto achade . . osscurita . . il locho. 16. essettal . . govane alora . · azzuro. 17. trasparente . . contensata . . biglia. 18. chome . . chorpo fussi . . chella tropa vmidita la rende biācha ella. 19. pocha . . chaldo . . osscura . . ecquesto . . bassta inquād. 20. finition . . chessellaria avessi. 21. azzuro . . sinterponessi magor. 22. ellemēto del focho . . magore osscurita. 23. azzurri . . osscuri . . Ella. 24. concosia. 25. nterpone . . ella . . focho . . mosstra . . bianchegiante . . ecquesto achade. 26. lorizonte ecquāto . . soma . . ella . . focho. 27. osscuro azzuro . . stlano. 28. cho chellaria . . lazurro . . corpusscoil. . . razi. 29. anchora

e l'altro del fumo ³¹sottile pare essere di bellissimo azzurro; Vedesi ancora nell'ōbre oscure delle mōtagne remote ³²dall'ochio, l'aria che si trova infra l'ochio, e tale ōbra parere molto azzurra e nella parte luminosa di ³³tal mōtagnie nō uariarsi troppo dal primo colore; ma chi ne vol uedere le vltime prove tin³⁴ga vna asse di diuersi colori fra li quali sia messo bellissimo nero e sopra tutti sia data sottile ³⁵e transparēte biacca, allora si uedrà la chiarezza di tal biacca non si mostrare sopra nessun ³⁶colore di piv bello azzurro che sopra il nero, ma diasi sottile e ben macinata.

and the thin smoke will appear of a most beautiful blue; and it may be seen again in in the dark shadows of distant mountains when the air between the eye and those shadows will look very blue, though the brightest parts of those mountains will not differ much from their true colour. But if any one wishes for a final proof let him paint a board with various colours, among them an intense black; and over all let him lay a very thin and transparent [coating of] white. He will then see that this transparent white will nowhere show a more beautiful blue than over the black —but it must be very thin and finely ground.

Leic. 36 a]

301.

È sperienza che mostra, come l'aria à dopo se tenebre e però pare azzurra; ²sia fatto fumo di legnie secche in poca quantità sopra il quale fumo ³percotā li razzi solari, e dopo questo fumo poni vna pezza di uellu-⁴to nero che nō sia visto dal sole, e uedrai tutto quel fumo ⁵che s'oppone infra l'ochio e la oscurità mostrarsi in co⁶lor di bellissimo azzurro, e se in loco del ueluto metti panno biāco, el fumo, cioè ⁷el tropofu-⁸mo, inpedi⁹sce e'l poco nō forma la perfezione d'e¹⁰sso azzurro · ¹¹onde la me¹²diocre ¹³dispo¹⁴sitione ¹⁵di fu¹⁶mo forma bello azzurro; ¹⁷come l'acqua soffiata a uso d'attomi in loco scuro doue passi la spera del sole fa esso razzo azzurro ¹⁸e massime essendo tale acqva destillata e'l fumo sottile fa azzurro; quest'è detto per mostrare che ¹⁹l'azzurro · dell'aria è causato di oscurità che è sopra di lei, e dannosi li predetti esempli a chi nō confermasse ²⁰la speriētia di Mōboso.

Experience shows us that the air must have darkness beyond it and yet it appears blue. If you produce a small quantity of smoke from dry wood and the rays of the sun fall on this smoke, and if you then place behind the smoke a piece of black velvet on which the sun does not shine, you will see that all the smoke which is between the eye and the black stuff will appear of a beautiful blue colour. And if instead of the velvet you place a white cloth smoke, that is too thick smoke, hinders, and too thin smoke does not produce, the perfection of this blue colour. Hence a moderate amount of smoke produces the finest blue. Water violently ejected in a fine spray and in a dark chamber where the sun beams are admitted produces these blue rays and the more vividly if it is distilled water, and thin smoke looks blue. This I mention in order to show that the blueness of the atmosphere is caused by the darkness beyond it, and these instances are given for those who cannot confirm my experience on Monboso.

F. 18 a]

302.

Quando il fumo di legne secche si troua ²infra l'ochio di chi lo vede e altro loco oscuro ³esso pare azzurro; ⁴adunque l'aria si fa azzurra per le tene⁵bre che essa à dopo se; E se tu guardi inver⁶so l'orizzonte

When the smoke from dry wood is seen between the eye of the spectator and some dark space [or object], it will look blue. Thus the sky looks blue by reason of the darkness beyond it. And if you look towards the horizon of the sky, you will see the atmo-

la diuerētia attimi . . attimi . . razi. 30. pariete illochi osscuri che lun "razo" pare essere cenenereo ellaltro. 31. accurro . . nellobre osscure. 32. chessi . . tale ōbr . . molta azzurro. 33. del. 34. fralli . . essopra. 35. ettransparēte biacha . . chiareza . . biacha. 36. chessopra . . ebben.

301. 1. mostra. 2. seche pocha. 3. perchota . . razi . . peza. 4. vissto. 5. chessoppone infrallochio ella osscurita. 6. azuro essellocho . . meti pano biācho effumo coe. 9. el pocho . . de. 10. so azzurro. 13. disspo. 16. azzurro. 17. dattimi ilocho . . accurro. 18. masime . . desstillata . . accurro. 19. lazurro . . e chaussato da osscurita . . dassi . . essenpli . . confermassi. 20. essperiētia.

302. 2. di cillo vede . . locho. 3. azzurro [ettāto piu quāte piu scuro]. 5. Essettu. 6. lorizonte . . non es. 7. ecquesto nasscie.

del celo, tu vedrai l' aria non esse⁷re azzurra, e questo nascie per la sua gros⁸sezza; e così in ogni grado che tu ⁹alzi l' ochio sopra esso orizzonte insino al ¹⁰celo che ti sta di sopra, tu troverai l' aria ¹¹farsi più oscura, e questo è che mē soña ¹²d' aria s' interpone infra l' ochio tuo e esse ¹³tenebre; E se tu ti troverai sopra vn al¹⁴to mōte, l' aria si farà tanto più oscura ¹⁵sopra di te, quanto essa è fatta più sottile ¹⁶infra te e dette tenebre, e così seguiterà in ¹⁷ogni grado d' altezza tanto che al fine re¹⁸sterà tenebrosa.

¹⁹Quel fumo parrà più azzurro che nasce-²⁰rà da più secche legne e che sarà più presso al²¹la sua cagione, e che è veduto in più oscu²²ro canpo, dandovi sù il lume del sole.

sphere is not blue, and this is caused by its density. And thus at each degree, as you raise your eyes above the horizon up to the sky over your head, you will see the atmosphere look darker [blue] and this is because a smaller density of air lies between your eye and the [outer] darkness. And if you go to the top of a high mountain the sky will look proportionately darker above you as the atmosphere becomes rarer between you and the [outer] darkness; and this will be more visible at each degree of increasing height till at last we should find darkness.

That smoke will look bluest which rises from the driest wood and which is nearest to the fire and is seen against the darkest background, and with the sunlight upon it.

C. 18 a] 303.

Quella·cosa·tenebrosa·parrà·più azzurra·che infra se·e l' ochio·maggior soña d' aria luminosa interposta·fia, ²come·per el color·del cielo dimostrar si può.

A dark object will appear bluest in proportion as it has a greater mass of luminous atmosphere between it and the eye. As may be seen in the colour of the sky.

H.² 29 b] 304.

L' aria è azzurra per le tenebre che a di ²sopra, perchè nero e biāco fa azzurro.

The atmosphere is blue by reason of the darkness above it because black and white make blue.

Br. M. 169 a] 305

La mattina la nebbia è piv folta inverso l' altezza che nella ²sua bassezza, perchè il sole l' attrae in alto, onde li edifiti grā³di, ancora che ti sia lontana la cima quāto il fondameto, essa ⁴cima ti fia ignota; E per questo il celo si dimostra più oscu⁵ro inverso l' altezza e inver l' orizzonte e non azzurreggia, anzi è tra ⁶fumo e poluere.

⁷L' aria infusa colle nebbie è interamēte privata d' azzurro, ma solo ⁸pare di quel colore de' nvgoli che biācheggiano quādo 'l tēpo è sereno; e quā⁹to piv rigvardi verso l' occidēte tu la troverai ¹⁰piv oscura e piv lucida e chiara verso l' oriēte; E le verdure de¹¹lle cāpagnie in mezzana nebbia azzurreggiano alquāto, ma ne¹²greggiano nella piv grossa.

In the morning the mist is denser above than below, because the sun draws it upwards; hence tall buildings, even if the summit is at the same distance as the base have the summit invisible. Therefore, also, the sky looks darkest [in colour] overhead, and towards the horizon it is not blue but rather between smoke and dust colour.

The atmosphere, when full of mist, is quite devoid of blueness, and only appears of the colour of clouds, which shine white when the weather is fine. And the more you turn to the west the darker it will be, and the brighter as you look to the east. And the verdure of the fields is bluish in a thin mist, but grows grey in a dense one.

8. sezza [Esse] e cosi . . chettu. 9. [le] alzi orizonte. 10. chetti . . troverai. 11. osscuro escquesto. 13. Essetu . . troverrai. 14. osscura. 15. effatta. 16. infratte. 17. nogni . . dalteza. 19. para . . azurro . . nassce. 20. ra di piu seche. 21. cagone . . osscu.

303. 1. chosa . . azuıra . . in frasse . ellochio . . magior . . interpossta. 2. chome . . cholor . . dimosstrar.

304. 1—2. R. 2. sapra . . biācho . . azurro.

305. 1. lalteza. 2. bāsseza. 4. ingnota . . osscu. 5. lalteza . . lorizɔnte . . azuregia . . ettra. 7. dazurro. 8. biāchegano . . sereno ecqua. 9. rissrgvadi . . troverai. 10. osscura . . ciara . Elle. 11. mezana . . accuregiano. 12. gregiano.

[13] Li edifizi inver ponēte sol ci dimostrā la lor parte lumino[14]sa, poichè'l sole si scopre, e'l resto le nebbi lo occultano; [15] Quādo il sol s'inalza e caccia le nebbie e si comīcia a rischiarare i colli da quel[16]la parte donde esse si partono, e' fansi azzurri e fumano inver[17]so le nebbi fuggiēti e li edifiti mostrano lumi e ōbre, e nelle nebbie [18] mē folte mostrā solo i lumi e nelle piv folte niēte; e questo è [19] quādo il moto della nebbia si parte traversalmēte, e allora i ter[20]mini d'essa nebbia saranno poco evidenti coll'azzurro dell'aria [21] e inverso la terra parrà quasi poluere che s'iñalzi; [22] Quanto l'aria sarà piv grossa, li edifiti delle città · e li alberi [23] delle cāpagnie parrāño piv rari, perchè sol si mo[24]streranno i piv eminēti e grossi.

[25] Le tenebre [26] tingono o[27]gni cosa [28] del lor colore, [29] e quāto piv [30] la cosa si par[31]te da esse tene[32]bre piv si uede [33] del suo vero e natural co[34]lore. [35] I mōti fieno rari, perchè sol si dimostrā quelli che ànno mag[36]giore intervalli, perchè in tal ispatio la grossezza mvltiplica in [37] modo che fa chiarezza tale che la oscurità de' collisi diuide e si [38] spedisce bene inverso la sua altezza: ne' colli piccoli e vicini non [39] se ne interpone tāta e però māco si discernono e mē nelle lor bassezze.

The buildings in the west will only show their illuminated side, where the sun shines, and the mist hides the rest. When the sun rises and chases away the haze, the hills on the side where it lifts begin to grow clearer, and look blue, and seem to smoke with the vanishing mists; and the buildings reveal their lights and shadows; through the thinner vapour they show only their lights and through the thicker air nothing at all. This is when the movement of the mist makes it part horizontally, and then the edges of the mist will be indistinct against the blue of the sky, and towards the earth it will look almost like dust blown up. In proportion as the atmosphere is dense the buildings of a city and the trees in a landscape will look fewer, because only the tallest and largest will be seen.

Darkness affects every thing with its hue, and the more an object differs from darkness, the more we see its real and natural colour. The mountains will look few, because only those will be seen which are farthest apart; since, at such a distance, the density increases to such a degree that it causes a brightness by which the darkness of the hills becomes divided and vanishes indeed towards the top. There is less [mist] between lower and nearer hills and yet little is to be distinguished, and least towards the bottom.

G. 53*b*] **306.**

La superfitie d'ōgni [2] corpo participa [3] del color [4] che l'allumina,—[5] e del color dell'a[6]ria che infra l'oc[7]chio e esso corpo [8] s'interpone, cioè [9] del color del mez[10]zo transpa[11]rēte interposto [12] īfra la cosa e l'occhio, e [13] īfra li colori di me[14]desima qualità [15] il secondo sarà del [16] medesimo colore [17] del primo, e ques[18]to nascie per la mul[19]tiplicatione del color [20] del mezzo interpo[21]sto infra la cosa e [22] l'ochio.

The surface of an object partakes of the colour of the light which illuminates it; and of the colour of the atmosphere which lies between the eye and that object, that is of the colour of the transparent medium lying between the object and the eye; and among colours of a similar character the second will be of the same tone as the first, and this is caused by the increased thickness of the colour of the medium lying between the object and the eye.

13. sol si dimosstra. 14. sisscopre, el ressto . . nebie ochultano. 15. sol "sinalza" caccia . . rissciarare e colli dacq. 16. partano effarsi azzuri effumano. 17. nebiefugiēti elli . . nebie. 18. solo e lumi . . ecquesto. 19. e ter. 20. sarano pochi . . chol azurro. 21. para . . chessiñalzi. 22. elli. 23. parano. 24. sterrannoe. 26. tingano. 33. vero "e natural" co. 35. E mōti . . sol s dimostra quelgli . . ma. 36. ispati . . grosseza. 37. cheffa ciareza . . chella osscurita . . vi diuide essi. 38. spedissce . . alteza . . picholi . . no. 39. discernano. *On the margin between lines* 35 *and* 36: | mera

 purifi
 catione.

306. 2. chorpo. 3. del color del color. 4. chellalumina. 6. infralloc. 7. chorpo. 10. zo [chessi] transpa. 11. interpossto. 12. īfralla . . ellocchio. 13. infralli color. 14. qualita ma. 15. sechondo. 16. cholore. 17. ecques. 18. nasscie. 20. mezo. 21. ssto infralla.

De pictura.

[2]Infra i colori che nō sono azzurri quello in lū[3]ga distantia participerà · più d'azzurro il [4]quale sarà piv vicino al nero e così de [5]converso si mostrerà per lūga distantia nel [6]suo propio colore, il quale sarà piv dis [7]simile a detto nero.

[8]Adunque il uerde delle campagnie si trans[9]mvterà piv in azzurro che nō fa il giallo o biā[10]co e così de cōuerso il giallo e 'l biāco māco [11]si transmuta che lo verde, e 'l rosso māco.

Of painting.

Of various colours which are none of them blue that which at a great distance will look bluest is the nearest to black; and so, conversely, the colour which is least like black will at a great distance best preserve its own colour.

Hence the green of fields will assume a bluer hue than yellow or white will, and conversely yellow or white will change less than green, and red still less.

307. 2. azurri . . illū. 3. dazurro. 5. montera . . disstantia. 6. cholore . . di. 7. dicto. 9. azuro. 10. biācho māc
11. chello . . mācho.

VII.

On the Proportions and on the Movements of the Human Figure.

Leonardo's researches on the proportions and movements of the human figure must have been for the most part completed and written before the year 1498; *for* LUCA PACIOLO *writes, in the dedication to Ludovico il Moro, of his book* Divina Proportione, *which was published in that year:* "Leonardo da venci . . . hauēdo gia cō tutta diligētia al degno libro de pictura e movimenti humani posto fine".

The selection of Leonardo's axioms contained in the Vatican copy attributes these words to the author: "e il resto si dirà nella universale misura del huomo". (MANZI, *p.* 147; LUDWIG, *No.* 264). LOMAZZO, *again, in his* Idea del Tempio della Pittura Milano 1590, cap. IV), *says:* "Lionardo Vinci . . . dimostrò anco in figura tutte le proporzioni dei membri del corpo umano".

The Vatican copy includes but very few sections of the "Universale misura del huomo" *and until now nothing has been made known of the original MSS. on the subject which have supplied the very extensive materials for this portion of the work. The collection at Windsor, belonging to her Majesty the Queen, includes by far the most important part of Leonardo's investigations on this subject, constituting about half of the whole of the materials here published; and the large number of original drawings adds greatly to the interest which the subject itself must command. Luca Paciolo would seem to have had these MSS. (which I have distinguished by the initials* W. P.) *in his mind when he wrote the passage quoted above. Still, certain notes of a later date—such as Nos.* 360,

362 and 363, from MS. E, written in 1513—14, sufficiently prove that Leonardo did not consider his earlier studies on the Proportions and Movements of the Human Figure final and complete, as we might suppose from Luca Paciolo's statement. Or else he took the subject up again at a subsequent period, since his former researches had been carried on at Milan between 1490 and 1500. Indeed it is highly probable that the anatomical studies which he was pursuing with so much zeal between 1510—16 should have led him to reconsider the subject of Proportion.

H.¹ ₃₁ ᵇ] 308.

Ciascuno homo nel terzo año ²è la Every man, at three years old is half the
metà della sua altezza ultima. full height he will grow to at last.

[handwritten note: ⌐ we still use this as a soft rule of thumb]*

C. A. 157 a; 463 a] 309.

Se l'omo · di · 2 braccia è piccolo · quello If a man 2 braccia high is too small, one
di quattro è troppo grāde · essendo la uia of four is too tall, the medium being what
²di mezzo laudabile ·; il mezzo jfra · 2 · e 4 · is admirable. Between 2 and 4 comes 3;
si è · 3 : adūque · piglia · un omo ³ di 3 · brac- therefore take a man of 3 braccia in height
cia · e quello · misura · colla regola ch'io ti and measure him by the rule I will give you.
darò; se tu mi diciessi, io mi potrei ⁴ īgā- If you tell me that I may be mistaken, and
nare, givdicādo · vno bene proportionato · judge a man to be well proportioned who
che sarebbe · il cōtrario, a questa ⁵parte io does not conform to this division, I answer
rispōdo · che tu debi vedere · molti omini di that you must look at many men of 3 brac-
3 · braccia e quella maggiore quā⁶tità · che cia, and out of the larger number who are
sono · cōformi di mēbra: sopra uno di quelli alike in their limbs choose one of those who are
di migliore gratia · piglia tue misure; ⁷la lū- most graceful and take your measurements. The
ghezza · della mano è ¹/₃ di braccio e ētra length of the hand is ¹/₃ of a braccio [8 inches]
9 volte nell'omo · e così la testa · e dalla fō- and this is found 9 times in man. And the
tanella ⁸ della gola alla spalla · e dalla spalla · face [7] is the same, and from the pit of the
alla tetta · e dal'una all'altra tetta · e da throat to the shoulder, and from the shoulder
ciascuna ⁹tetta · alla fontanella. to the nipple, and from one nipple to the other,
 and from each nipple to the pit of the throat.

308. 1. homo he nel. 2. ella meta . ∴ alteza "ultima."
309. 1. 2 br e picholo . . ettropo. 2. mezo laldabile il mezo . . piglia î omo. 3. di 3 br . ecquello . . cioti . . settu. 4. giudi-
 chādo . . sarebe . . acquesta. 5. irispōdo chettu . . di 3. br . ecquella . . settu. 6. chessono chōformi di mēbrisopra î di.
 7. lūgeza . . ¹/₃ di br e . . dala. 8. ala . . dala spala . . ala. 9. teza alla.

309. 7. The account here given of the *braccio* *Testa* must here be understood to mean the
is of importance in understanding some of the face. The statements in this section are illustrated
succeeding chapters. in part on Pl. XI.

Proportions of the head and face (310—318).

Lo spatio ch'è infra 'l taglio della bocca e 'l prīcipio · del naso è la settima · parte del uolto;

[2] lo spatio · ch'è dalla bocca al di sotto · del mēto · *c d,* fia · la quarta · parte · del uolto; e simile alla larghezza della bocca;

[3] lo spatio ch'è dal mēto · al principio di sotto del naso *e f,* fia la terza · parte del uolto; e simile al naso · e alla fronte;

[4] lo spatio · ch'è dal mezzo · del naso al di sotto · del mēto *g h,* fia · la metà · del volto;

[5] lo spatio ch'è dal principio di sopra del naso, dove prīcipiano le ciglia, *i k,* al di sotto del mento, fia i due terzi del uolto;

[6] lo spatio · ch'è · infra 'l taglio della bocca e 'l prīcipio del mento di sopra *l m,* cioè dou'esso mēto finiscie terminādo col labro di sotto[7] della bocca, fia la terza parte dello spatio ch'è dal taglio d'essa bocca · al di sotto del mēto e la dodecima parte del uolto; [8] dal di sopra · al di sotto · del mēto *m n* fia la · sesta · parte del uolto, e fia la cinquāta quatroesima parte dell'omo;

[9] dallo ultimo sporto del mēto alla gola *o p* fia simile allo spatio, ch'è dalla bocca al di sotto del mēto e la quarta parte del uolto;

[10] lo spatio · ch'è dal di sopra della gola al prīcipio di sotto *q r,* fia la metà · del uolto · e la diciottesima parte dell'omo;

[11] dal mento · al dirieto del collo *s t* è quel medesimo · spatio · ch'è infra la bocca · e 'l nascimēto · de'capegli cioè [12] i tre quarti · della · testa;

[13] dal mēto alla ganascia *v x* è mezza testa ed è simile alla grossezza del collo · in proffilo;

[14] la grossezza del collo entra vna volta · e 3/4 dal ciglio · alla nuca.

The space between the parting of the lips [the mouth] and the base of the nose is one-seventh of the face.

The space from the mouth to the bottom of the chin *c d* is the fourth part of the face and equal to the width of the mouth.

The space from the chin to the base of the nose *e f* is the third part of the face and equal to the length of the nose and to the forehead.

The distance from the middle of the nose to the bottom of the chin *g h,* is half the length of the face.

The distance from the top of the nose, where the eyebrows begin, to the bottom of the chin, *i k,* is two thirds of the face.

The space from the parting of the lips to the top of the chin *l m,* that is where the chin ends and passes into the lower lip of the mouth, is the third of the distance from the parting of the lips to the bottom of the chin and is the twelfth part of the face. From the top to the bottom of the chin *m n* is the sixth part of the face and is the fifty fourth part of a man's height.

From the farthest projection of the chin to the throat *o p* is equal to the space between the mouth and the bottom of the chin, and a fourth of the face.

The distance from the top of the throat to the pit of the throat below *q r* is half the length of the face and the eighteenth part of a man's height.

From the chin to the back of the neck *s t,* is the same distance as between the mouth and the roots of the hair, that is three quarters of the head.

From the chin to the jaw bone *v x* is half the head and equal to the thickness of the neck in profile.

The thickness of the head from the brow to the nape is once and 3/4 that of the neck.

310. 1. in fral [la bocha] taglio . . bocha. 2. bocha . . mēto "cd" fia . . uolto" e simile alla largeza della bocha". 3. naso "e f" fia . . uolto "essimile al naso ella [testa] fronte". 4. mezo . . mēto "g h". fia. 5. ciglia "i k" al. 6. bocha . . d sopra "l m" cioe . . cholabro. 7. bocha . . bocha . . mēto "ella [vētunesima] dodecima parte del uolto". 8. mēto "m n" fia . . uolto "effia la cinquāta, quatrocsima parte, dellomo". 9. dalo . . gola "o p" fia . . alo . . bocca . . ella. 10. sotto "q r" fia . . ella di sollesima. 11. diriecto del chollo "s t" e quel . . infralla bocha il nassimēto del chapegli. 13. alla ganasscia "v x" . e meza testa eddissimile . . chollo. 14. chollo . . nucha.

310. The drawings to this text, lines 1—10 are on Pl. VII, No. 1. The two upper sketches of heads, Pl. VII, No. 2, belong to lines 11—14, and in the original are placed immediately below the sketches reproduced on Pl. VII, No. 1.

A. 62 b]

311.

Tanto è dall' una · appiccatura · dell' ore-
chio · all'altra ·, quāto è dalle givnture delle
ciglia al mēto; ²tanto · è grāde la bocca
d' ū bel uolto, quāto è dalla diuisiō de' labri
al di sotto del mēto.

The distance from the attachment of one
ear to the other is equal to that from the
meeting of the eyebrows to the chin, and in
a fine face the width of the mouth is equal
to the length from the parting of the lips to
the bottom of the chin.

A. 63 a]

312.

Il taglio overo spigolo del labro ²di
sotto · della · bocca · è il mezzo ifra ³il di sotto
del naso · e 'l di sotto del mēto.

⁵Il uiso fa ī se uno quadro, cioè ⁶la
sua larghezza è da l'uno al'altro ⁷stremo
del ochio, e la sua altezza ⁸è da il fine
di sopra del naso ⁹al di sotto del labro di
sotto ¹⁰della bocca, poi ciò che resta ¹¹di
sopra e di sotto a esso quadro ¹²fa l'altezza
d' ū simile quadro ¹³¶a · b è simile allo spa-
tio · ch'è · infra · c · d · ¹⁴d · n · e cosi n · c · | e
similmēte · s · r ‖ q · p · ‖ ¹⁵h · k · sono · infra
loro simili.¶

¹⁶Tāto è da m · s · quāto è dal di sotto
del naso · al mēto; ¹⁷l' orechio · è appūto tāto
lūgo, quāto il naso; ¹⁸tāto è da x · s quāto
dal naso al mēto; ¹⁹il taglio della bocca ī
proffilo si dirizza all'āgolo della mascella;
²⁰tāto deb'essere alto l'orechio, quāt'è dal
di sotto del naso ²¹al di sopra del coper-
chio · dell'ochio; ²²tanto è lo spatio · ch'è
infra li ochi, quāto la grādezza d'un ochio;
²³l' orechio cade nel mezzo · del collo · in
proffilo; ²⁴tāto · è · da 4 · a 5 · quāto · è da ·
s · a · r.

The cut or depression below the lower lip
of the mouth is half way between the bottom
of the nose and the bottom of the chin.

The face forms a square in itself; that
is its width is from the outer corner of one
eye to the other, and its height is from the
very top of the nose to the bottom of the
lower lip of the mouth; then what remains
above and below this square amounts to the
height of such another square. $a\,b$ is equal to
the space between $c\,d$; $d\,n$ in the same way
to $n\,c$, and likewise $s\,r$, $q\,p$, $h\,k$ are equal
to each other.

It is as far between m and s as from the
bottom of the nose to the chin. The ear
is exactly as long as the nose. It is as far
from x to s as from the nose to the chin.
The parting of the mouth seen in profile
slopes to the angle of the jaw. The ear
should be as high as from the bottom of the
nose to the top of the eye-lid. The space
between the eyes is equal to the width of an
eye. The ear is over the middle of the neck,
when seen in profile. The distance from 4
to 5 is equal to that from s to r.

W. P. 119 a]

313.

$(a \cdot b)$ è simile a $(c \cdot d)$.

$(a\,b)$ is equal to $(c\,d)$.

311. 1. apichatura . . da [pi] le . . dele. 2. bocha . . dala.
312. 1. delabro. 2. bocha . . mezo. 4. [la large]. 5. se î quadro. 6. largeza. 7. alteza. 9. delabro. 10. dela bocha. 13. essi-
mile alo. 14. essimilmente. 16. tāto [te] e. 17. apūto . . lugo quāto. 19. bocha . . diriza al . . masscella. 20. esere.
21. choperchio. 22. ellosspatio . . quāda la grādelza. 23. chade . . mezo . . chollo.
313. essimile.

312. See Pl. VIII, No. 1, where the text of lines
3—13 is also given in facsimile.

313. See Pl. VII, No. 3. Reference may also be
made here to two pen and ink drawings of heads
in profile with figured measurements, of which
there is no description in the MS. These are given
on Pl. XVII, No. 2.—A head, to the left, with part
of the torso [W. P. 5 a], No. 1 on the same plate
is from MS. A 2 b and in the original occurs on a
page with wholly irrelevant text on matters of
natural history. M. RAVAISSON in his edition of
the Paris MS. A has reproduced this head and

discussed it fully [note on page 12]; he has how-
ever somewhat altered the original measurements.
The complicated calculations which M. RAVAISSON
has given appear to me in no way justified. The
sketch, as we see it, can hardly have been intended
for any thing more than an experimental attempt
to ascertain relative proportions. We do not find
that Leonardo made use of circular lines in any
other study of the proportions of the human head.
At the same time we see that the proportions of this
sketch are not in accordance with the rules which
he usually observed (see for instance No. 310).

W. P. 7a] 314.

Il capo *a f* · è ¹/₆ · maggiore · che 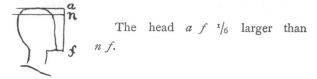 The head *a f* ¹/₆ larger than
n · *f*. *n f*.

V. IV. 16] 315.

Dal ciglio alla cōgiuntione ²del labro From the eyebrow to the junction of the
col mēto · e la punta ³della · masciella · e 'l lip with the chin, and the angle of the jaw
fine di sopra dello ⁴orecchio · colla · tenpia · and the upper angle where the ear joins the
fia uno qua⁵drato · perfetto; E ciascuna fac- temple will be a perfect square. And each
cia ⁶per se · è mezza · testa. side by itself is half the head.

⁷E 'l cauo · dell' osso · della · guancia ⁸si The hollow of the cheek bone occurs
truova · ī mezzo · fralla punta del ⁹naso · e 'l half way between the tip of the nose and
confine · della · masciella ·, ch'è ¹⁰la · punta · di the top of the jaw bone, which is the lower
sotto · dello · orecchio ¹¹ in nella · figurata · angle of the setting on of the ear, in the
stella; frame here represented.

¹²dal cantone dell' osso · dell' ochio allo From the angle of the eye-socket to the
¹³orecchio · è tanto · spatio quanto è la ¹⁴lun- ear is as far as the length of the ear, or
ghezza · dello · orecchio ·, o vuoi · il ¹⁵terzo · the third of the face.
della testa.

W. Pr. 12] 316.

Tanto · dev' essere · da · *a b* cioè dal ²na- From *a* to *b*—that is to say from the
scimēto dināzi · de' capelli alla ³linia · della · roots of the hair in front to the top of the
sōmita · del capo, quā⁴to è da · *c · d* · cioè dal · head—ought to be equal to *c d*;—that is from
fine di sot⁵to · del naso · alla · cōgiūtiō de' lab⁶bri the bottom of the nose to the meeting of
dināzi della bocca; ⁷tanto è dal lagrimatoio the lips in the middle of the mouth. From
dell' occhio ⁸ · *m* · alla sōmita · del capo · *a* · the inner corner of the eye *m* to the top of
quā⁹to è da | *m* | al di sotto del mēto · *s* · the head *a* is as far as from *m* down to
¹⁰*s · c · f · b* · sono · simili per spatio ¹¹l' uno · the chin *s*. *s c f b* are all at equal distances
all' altro. from each other.

W. P. 5a] 317.

Dalla sommità del capo al di sotto del From the top of the head to the bottom
mēto ¹/₈, ²dal nascimēto de' capelli al mento of the chin is ¹/₈, and from the roots of the
³è ¹/₉ dello spatio ch'è da esso nascimēto hair to the chin is ¹/₉ of the distance from
a terra. ⁴La maggior larghezza del uolto the roots of the hair to the ground. The
 greatest width of the face is equal to the

314. Il capo [v q] a f ¹/6 . magiore.
315. 1. cōgiunctione. 2. chol . . ella. 3. massciella. 4. cholla . . fia ī qua. 5. perfecto Ecciasscuna. 6. meza tessta. 7. chauo.
8. īmezo. 9. chonfine della massciella. 10. lla . . disocto . . orechio. 11. issella. 12. chantone. 13. ettanto . . ella.
14. lungeza. 15. tessta.
316. 1. deessere. 2. nasscimēto. 3. chapo. 4. diso. 5. dela. 6. bocha. 7. ochio. 8. chapo. 10. simile perispatio.
317. 1. dalasomita del chapo. 2. chapelliti ella mento. 3. nasscimēto atterra. 4. magior largeza . . essimile. 5. dala bocha al

315. See Pl. IX. The text, in the original is 22¹/₂ centimetres wide by 29 long, and is numbered
written behind the head. The handwriting would 127 in the top right-hand corner.
seem to indicate a date earlier than 1480. On **316.** The drawing in silver-point on bluish
the same leaf there is a drawing in red chalk of tinted paper—Pl. X—which belongs to this chapter
two horsemen of which only a portion of the upper has been partly drawn over in ink by Leonardo
figure is here visible. The whole leaf measures himself.

è simile allo spatio ⁵ch'è dalla bocca al nascimēto de' capelli ed è ⁶ ¹/₁₂ del tutto. ⁷Dalla sommità dell'orechio alla sommità del capo fia ⁸simile allo spatio ch'è dal di sotto del mento al lagrima⁹tojo delli occhi, E simile allo spatio ch'è dalla punta ¹⁰del mento a quella · della mascella ed è la ¹/₁₆ ¹¹parte del tutto. ¹²Il picciuolo che si trova · infra 'l buso dell'orecchio ¹³inverso · il naso · fia mezzo infra la nuca e 'l ciglio; ¹⁴La grossezza del collo in profilo è simile ¹⁵allo spatio ch'è dal mēto alli occhi e simile allo ¹⁶spatio ch'è dal mēto alla mascella e ētra ¹⁷15 volte · in tutto l'omo.

space between the mouth and the roots of the hair and is ¹/₁₂ of the whole height. From the top of the ear to the top of the head is equal to the distance from the bottom of the chin to the lachrymatory duct of the eye; and also equal to the distance from the angle of the chin to that of the jaw; that is the ¹/₁₆ of the whole. The small cartilage which projects over the opening of the ear towards the nose is half-way between the nape and the eyebrow; the thickness of the neck in profile is equal to the space between the chin and the eyes, and to the space between the chin and the jaw, and it is ¹/₁₅ of the height of the man.

W. P. 3; Ia]

318.

a · b ·, c · d ·, e · f ·, g · h ·, i · k · infra loro · ànno similitudine ²di grādezza · saluo · che · d · f · ch'è libero.

a b, c d, e f, g h, i k are equal to each other in size excepting that d f is accidental.

Tur. 7]

319.

¶a · n · o · f · son simili ²alla bocca.¶
³¶a · c · e a · f · sō simili ⁴allo spatio ch'è fra l'uno ⁵ochio e l'altro.¶
⁶n · m · o · p · q · r ⁷son simili alla ⁸metà della grossezza ⁹de labri dell'ochio, cioè ¹⁰da lagrimatojo dell'o¹¹chio alla sua coda, ¹²e similmēte la diui¹³sione ch'è fra 'l mēto e la ¹⁴bocca, e similmēte ¹⁵la piv stretta parte che ¹⁶à il naso, infra l'uno o¹⁷chio e l'altro; e que¹⁸sti tali spati ciascū per se ¹⁹è la nᵒ parte della testa; ²⁰n · o è simile alla lū²¹ghezza dell'ochio ovvero lo ²²spatio ch'è infra li ochi; ²³m c è ¹/₃ di · n · m, ²⁴misurādo dal taglio ²⁵di fori del labro dell'ochio ²⁶al segnio · c ·; ²⁷b · s · fia simile alla ²⁸larghezza delle nari del ²⁹naso.

a n o f are equal to the mouth.
a c and a f are equal to the space between one eye and the other.
n m o p q r are equal to half the width of the eye lids, that is from the inner [lachrymatory] corner of the eye to its outer corner; and in like manner the division between the chin and the mouth; and in the same way the narrowest part of the nose between the eyes. And these spaces, each in itself, is the 19th part of the head. n o is equal to the length of the eye or of the space between the eyes.
m c is ¹/₃ of n m measuring from the outer corner of the eyelids to the letter c. b s will be equal to the width of the nostril.

Proportions of the head seen in front (319—321).

Tur. 11]

320.

Lo spatio ch'è infra i ciētri delle ²popille dell'ochio è ¹/₃ del uolto; ³lo spatio, ch'è infra li stremi del⁴li ochi inver li orechi,

The distance between the centres of the pupils of the eyes is ¹/₃ of the face. The space between the outer corners of the eyes,

nasimēto elechapelli. 7. della somita . . somita del chapo. 9. ochi. 10. acquella . . massciella. 12. pincierolo chessi. 13. mezo infralla nucha. 14. grosseza chollo inproffilo essimile. 15. alosspatio . . ochi essimile. 16. maschiella.
318. 1. ano. 2. grādeza.
319. 2. ala bocha. 3. c he a. 4. fralluno. 5. ellaltro. 6. simile. 7. simili a alla. 8. dela grosseza. 10. lagrimatoro. 11. coda ne. 12. essimilmēte. 13. ella. 14. bocha essimilmēte. 16. infralluno. 17. ellaltro. 18. ciascū. 19. ellañ. 20. n m essimile. 21. gezo dellochio ovolo. 23. c · he ¹/₂. 28. largheza dellanari.
320. 2. popille. 3. infralli . . de. 5. cholla. 6. chello ricieve poste. 7. vmezo. 8. magiore largeza . . abia. 10. apichatura

318. See Pl. XI.
319. See Pl. XII.

19. la nᵒ parte. This singular notation seems to mean decima nona (nineteenth).

cioè dove ⁵l'ochio termina colla cassa del-
l'osso ⁶che lo ricieve, le code di fori, fia
⁷v̄ mezzo volto.

⁸La maggiore larghezza, che abbia ⁹il
uolto per la linia degli ochi, fia ¹⁰quãt'è
dall' appiccatura dināzi de' ca¹¹pegli al taglio
della bocca.

that is where the eye ends in the eye socket
which contains it, thus the outer corners, is
half the face.

The greatest width of the face at the
line of the eyes is equal to the distance from
the roots of the hair in front to the parting
of the lips.

W. P. 3; II] **321.**

Il naso farà · 2 · quadrati ·, cioè · la lar-
ghezza · del naso nelle narici entra · 2 · volte ·
dalla punta · del · naso · al principio · delle
ciglia, ²e similmēte ī profilo tāto · fia · dalla ·
strema · parte della narice, doue si cōgivgnie ·
colla · guācia ·, alla pūta · d'esso · naso ·, quāto
il naso è largo in fa³cia da l'una · al'altra ·
narice; ⁴se diuiderai · in 4 · parti · equali ·
tutta la lunghezza · del naso, cioè dalla ·
sua · pūta · all'appiccatura delle ciglia: tu · tro-
verai · ⁵che una delle parti ētra dal di sopra
delle narici al di sotto della · pūta · del naso
e la superiore · parte ētra · dal lagrimatojo
dell' ochio all'a⁶ppiccatura · delle · ciglia: e le ·
2 parti di mezzo · fieno tāto grādi quāto ·
è · l'ochio · dal lagrimatojo · alla · coda · d'esso
· ochio.

The nose will make a double square;
that is the width of the nose at the nostrils
goes twice into the length from the tip of
the nose to the eyebrows. And, in the same
way, in profile the distance from the extreme
side of the nostril where it joins the cheek
to the tip of the nose is equal to the width
of the nose in front from one nostril to the
other. If you divide the whole length of the
nose—that is from the tip to the insertion
of the eyebrows, into 4 equal parts, you will
find that one of these parts extends from
the tip of the nostrils to the base of the
nose, and the upper division lies between
the inner corner of the eye and the insertion
of the eyebrows; and the two middle parts
[together] are equal to the length of the eye
from the inner to the outer corner.

W. P. 1*b*] **322.**

Il dito grosso del piè è la sesta · parte ·
d'esso piè, tolgliendo · la misura in profilo
di dētro dōde esso dito na-
scie ²dalla polpa del petto
del piè · insino alla · sua stre-
mità *a · b;* ed è simile allo
spatio ch'è dalla bocca · al
di sotto del mēto; ³se fai · il
piè · in profilo di fora ·, fa
nasciere · il piccolo · dito · ai tre quarti della ·
lunghezza d'esso piè, e troverai lo spatio
⁴ch'è dal principio d'esso dito insino all'ul-
timo sporto del dito grosso.

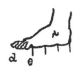

The great toe is the sixth part of the
foot, taking the measure in profile, on the
inside of the foot, from where
this toe springs from the ball
of the sole of the foot to its
tip *a b;* and it is equal to the
distance from the mouth to
the bottom of the chin. If you
draw the foot in profile from the
outside, make the little toe begin at three quar-
ters of the length of the foot, and you will find
the same distance from the insertion of this toe
as to the farthest prominence of the great toe.

. . de cha. 11. bocha.

321. 1. quatrati . . lungheza . . nelle anarise entera . . dala pūta. 2. essimilmēte | "ī proffilo" tanto . . narisa . . chōgivgnie.
 cholla. 3. dalluna allaltra anarisa. 4. dinisterai . . parte . . lungeza . . apichatura. 5. che ī̇ dele . . anarise . . ella lagrima-
 toro. 6. pichatura . . elle . . mezo . . lagrimatoro . alla . choda.

322. 1. ella . . dito [si po] nascie. 2. bocha. 3. seffai . . nassciere . il picholo . . lungeza. 4. allultimo [spatio] sporto . . gro.

320. There are, with this section, two sketches
of eyes, not reproduced here.

321. The two bottom sketches on Pl. VII,

No. 4 face the six lines of this section.—With
regard to the proportions of the head in profile see
No. 312.

W. P. 8 a]

323.

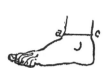
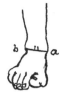

Tāto è ī v̄ medesimo
²homo lo spatio · che è
īfra ³ · a · b · quāto · c · d.

For each man respec-
tively the distance between
a b is equal to c d.

W. P. 1 a]

324.

Il piè · è · tanto · piv · lungo · che la · mano ·,
quanto · è la grossezza · del bracio ·
alla · givntura · della · mano · cioè
dou' eli è piv · sottile, ²stando in faccia;

³Ancora · troverai · il piè · essere ·
tanto · maggiore · della · mano · quanto
· è dall' appiccatura · di dentro · del
piccolo · dito del piè · all' ultimo ⁴ spor-
tamento · del dito grosso ·, togliendo la
misura · per la lunga · dirittura · del piè;

⁵La palma · della mano ·
sanza · le dita · entra · due ·
volte · nel piè · sanza le sue dita;

⁶Se tu terrai · la mano ·
coi sua diti · diritti e stretti
· insieme ·, trouerai · quella ·
essere larga · quāto la maggior
larghezza · del piede cioè doue
⁷si cōgiugnie coi sua · diti;

⁸E se tu · misuri dalla · pūta ·
della nocca del piè di dretro ·
alla · pūta del dito · grosso ·
trouerai questa misura · essere ·
grāde ⁹quāto · è tutta · la mano;

¹⁰Dalla givntura del piè · di
sopra · all' appiccatura · de' sua
diti di sopra · è tanto · quāto
dal' appiccatura della · mano ·
alla pūta ¹¹del suo · dito · grosso;

¹²La minore · larghezza della
mano · è simile · alla minore ·
larghezza del piè · infra la sua
appiccatura · colla gāba e 'l
prīcipio de' diti sua.

¹³La larghezza del calcagnio · nel suo ·
disotto · è simile alla grossezza dello bra-
cio, dove · si givgnie colla mano di dentro,

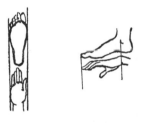

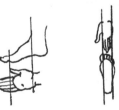

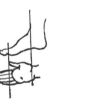

The foot is as much longer than the hand Relative proportions of the hand and foot
as the thickness of the arm at the wrist
where it is thinnest seen facing.

Again, you will find that the foot
is as much longer than the hand as
the space between the inner angle of
the little toe to the last projection of
the big toe, if you measure along the
length of the foot.

The palm of the hand without the fingers
goes twice into the length of
the foot without the toes.

If you hold your hand
with the fingers straight out
and close together you will
find it to be of the same
width as the widest part of the
foot, that is where it is joined
onto the toes.

And if you measure from the
prominence of the inner ancle
to the end of the great toe you
will find this measure to be as
long as the whole hand.

From the top angle of the
foot to the insertion of the toes
is equal to the hand from
wrist joint to the tip of the
thumb.

The smallest width of the
hand is equal to the smallest
width of the foot between its joint
into the leg and the insertion of
the toes.

The width of the heel at the lower
part is equal to that of the arm where
it joins the hand; and also to the leg

324. 1. ettanto piv . lung . chella . . ella grosseza. 3. magiore . . apichatura . . picholo. 4. tollendo. 6. settutterrai . . choi . . esstretti . . magiore largeza del piedi. 7. cho sua. 8. essettu . . pūta [del pie] . della noce. 9. ettutta. 10. apichatura . . apichatura. 12. largeza [del pie] "della mano" . essimile . . largeza . . infralla sua apichatura cholla. 13. largeza del chalchagnio . . grosseza essimile . . givgnie chol suo bracio di dentro Essimile. 14. facia. 16. mezo . . grādeza . . bocha

E simile [14]dove la ganba in faccia è piv sottile;

[15]Lo spatio · che à · il piv · lungo · dito del piè infra 'l principio · della · sua diuisione dal dito grosso · alla sua · stremità è la quarta parte del piè,[16]cioè dal mezzo · del suo · polo di dētro · alla sua · punta, Ed è simile alla grādezza della bocca: E lo spatio ch'è infra la bocca e 'l mento; [17]è simile · allo spatio ch'è infra le nocche e delle 3 dita di mezzo e le prime givnture d'esse, stando la mā distesa, [18]e simile allo nodo del dito grosso della mano al prīcipio della . sua · vnghia, stādo disteso, ed è la quarta parte [19]della mano e del uolto;

[29]Lo spatio ch'è infra li stremi de' poli dentro e fori de' piedi, detti talloni ouero nocche · o burelle del piè *a b* fia simile alto [21]spatio · ch'è infra la bocca e 'l lagrimatojo dell'ochio.

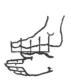
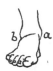
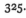
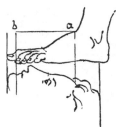

where it is thinnest when viewed in front.

The length of the longest toe, from its first division from the great toe to its tip is the fourth of the foot from the centre of the ancle bone to the tip, and it is equal to the width of the mouth. The distance between the mouth and the chin is equal to that of the knuckles and of the three middle fingers and to the length of their first joints if the hand is spread, and equal to the distance from the joint of the thumb to the outset of the nails, that is the fourth part of the hand and of the face.

The space between the extreme poles inside and outside the foot called the ancle or ancle bone *a b* is equal to the space between the mouth and the inner corner of the eye.

W. P. 4*b*] **325.**

Relative proportions of the foot and of the face (325—327). Il piè dal suo · nascimēto · colla ganba insino · alla stremità del dito · grosso · è simile allo spatio [2]ch'è infra 'l principio di sopra del mēto, al nascimēto de' capegli *a · b*, e simile a cinque sesti del uolto.

The foot, from where it is attached to the leg, to the tip of the great toe is as long as the space between the upper part of the chin and the roots of the hair *a b*; and equal to five sixths of the face.

W. P. 7*a*] **326.**

a d è vna testa, [2]*c b* è vna testa, [3]i quatro minori diti son dal di sopra del'unghie al di sotto grossi a v̄ modo e sono $1/_{13}$ del piè.

a d is a head's length, *c b* is a head's length. The four smaller toes are all equally thick from the nail at the top to the bottom, and are $1/_{13}$ of the foot.

W. P. 3, II] **327.**

Tutto il piè · entra dal gomito · alla givntura della mano · e · dal gomito all'appiccatura di dētro del braccio · diuerso la poppa,

The whole length of the foot will lie between the elbow and the wrist and between the elbow and the inner angle of the arm

. Ello . . infralla bocha. **17.** Essimile . noche . . dimezo della elle . . lama. **18.** essimile alla nocha . . vnglia. **20.** infralli . . effori . . ouero noci [di] . o bu relle de pie "a b". **21.** la boga el lagrimatorio.

325. **1.** nasscimēto . cholla . . essimile alla allospatio. **2.** nasscimēto de chapeglia. **6.** esimia.

326. **3.** minor . . son grossi dal . . ungie.

327. **1.** apichatura . . bracio diuer la popa. **2.** ettanto . . chapo magiore alteza . chapo . . effigurato il pie entra 3 volte. *Here the text breaks off.*

326. See Pl. XIV, No. 1, a drawing of a foot with the text in three lines below it.

quãdo · il braccio sta piegato; ²Il piè è tanto grãde quãto tutto · il capo · dell'omo, cioè dal di sotto del mēto alla maggiore altezza del capo nel modo che qui è figurato.

towards the breast when the arm is folded. The foot is as long as the whole head of a man, that is from under the chin to the topmost part of the head[2] in the way here figured.

W. P. 7 a]

328.

La maggior grossezza della polpa della gãba è nel terzo della sua altezza a b ²ed è piv larga la uētesima parte che la maggiore larghezza del piè.

³a c è mezza testa, ed è simile a d b e all'appiccatura de' ⁴cinque diti · e f, ⁶d k diminviscie il sesto · in nella gãba g · h · ⁷g h è ¹/₃ della testa; ⁸m n crescie il sesto di a · e ed è 7/₁₂ della testa; ⁹o · p è minore ¹/₁₀ di d · k ed è 6/₁₇ della testa, ¹⁰a si è il mezzo infra b q ed è ¹/₄ dell'omo, ¹¹r si è mezzo infra s · b; ¹²il cauo del ginochio di fori r è piv · alto che 'l cavo di dētro · a, ¹³la metà della grossezza della gãba da piè, ¹⁴r si trova in mezzo infra il gobbo s · e il piano b; ¹⁵v è in mezzo infra t · b · ¹⁶la grossezza della coscia ī faccia è simile alla maggiore ¹⁷larghezza della faccia del uiso cioè ²/₃ dello spatio ch'è ¹⁸dal mēto alla sōmità del capo; ¹⁹z · r è 5/₆ di 7 · v. ²⁰m n è simile a · 7 · v ed è ¹/₄ di r b, ²¹x y entra · 3 · in r · b · e in r · s;

²²a · b entra in c · f 6, e 6 in c · n ed è simile a g · h · | i k, ²³l m entra 4 in d · f, e 4 in · d · n, ed è ³/₇ del piè, ²⁴p q · r · s entra 3 in d · f e 3 in b n, ²⁵x y è ¹/₈ di x f ed è simile a | n · q, ²⁶3 7 si è ¹/₉ di n f, ²⁷4 5 si è ¹/₁₀ di n f;

Proportions of the leg (328—331).

The greatest thickness of the calf of the leg is at a third of its height a b, and is a twentieth part thicker than the greatest thickness of the foot.

a c is half of the head, and equal to d b and to the insertion of the five toes e f. d k diminishes one sixth in the leg g h. g h is ¹/₃ of the head; m n increases one sixth from a e and is 7/₁₂ of the head. o p is ¹/₁₀ less than d k and is 6/₁₇ of the head. a is at half the distance between b q, and is ¹/₄ of the man. r is half way between s and b[11]. The concavity of the knee outside r is higher than that inside a. The half of the whole height of the leg from the foot r, is half way between the prominence s and the ground b. v is half way between t and b. The thickness of the thigh seen in front is equal to the greatest width of the face, that is ²/₃ of the length from the chin to the top of the head; z r is 5/₆ of 7 to v; m n is equal to 7 v and is ¹/₄ of r b, x y goes 3 times into r b, and into r s.

[22]a b goes six times into c f and six times into c n and is equal to g h; i k l m goes 4 times into d f, and 4 times into d n and is ³/₇ of the foot; p q r s goes 3 times into d f, and 3 times into b n; [25]x y is ¹/₈ of x f and is equal to n q. 3 7 is ¹/₉ of n f; 4 5 is ¹/₁₀ of n f[27].

328. 1. magior grosseza . . alteza. 2. parte [del] chella magiore largeza. 3. meza T ed esimile ha . . apichatura. 5. g h i. 8. cresscie. 9. della T. 10. infra b ede ¹/₄. 10. mezo. 11. mezo. 12. difori "r" e . . chelchavo. 13. grosseza. 14. mezo . . gobo. 15. imezo. 16. grosseza cosscia . . facia essimile magiore. 17. largezza . . facia. 18. somita del chapo. 20. essimile ha. 22. entra [6]. 3 . in. c . f . "6 e 6 in c . n" ed e simile ha g. 25. h . ha. 28. [Il]. 31. cinarsi. 33. chosi. 34. cazo.

327. 2. *nel modo che qui è figurato.* See Pl. VII, No. 4, the upper figure. The text breaks off at the end of line 2 and the text given under No. 321 follows below. It may be here remarked that the second sketch on W. P. 3 II has in the original no explanatory text.

328. The drawing of a leg seen in front Pl. XIII, No. 1 belongs to the text from lines 3—21. The measurements in this section should be compared with the text No. 331, lines 1—13, and the sketch of a leg seen in front on Pl. XV.

11. b is here and later on measured on the right side of the foot as seen by the spectator.

22—35. The sketch illustrating these lines is on Pl. XIII, No. 2.

22. a b *entra in* c f 6 e 6 in c n. Accurate measurement however obliges us to read 7 for 6.

25. y is not to be found on the diagram and x occurs twice; this makes the passage very obscure.

22—27. Compare with this lines 18—24 of No. 331, and the sketch of a leg in profile Pl. XV.

²⁹Vo sapere quāto vno ³⁰crescie leuādosi in pūta ³¹di piè, e nel chinarsi quāto ³²*p · g* diminviscie e quāto *n q* ³³cresca e così la piega del piè;

³⁴*e f* 4 dal cazzo al di sotto del piè ³⁵3 7 è 6 da 3 a 2 ed è simile a *g · h ·* et *i · k.*

I want to know how much a man increases in height by standing on tip-toe and how much *p g* diminishes by stooping; and how much it increases at *n q* likewise in bending the foot.

[34]*e f* is four times in the distance between the genitals and the sole of the foot; [35]3 7 is six times from 3 to 2 and is equal to *g h* and *i k.*

B. 3] **329.**

Il piè dalla · punta al calcagnio ētra 2 volte ²dal calcagnio al ginochio, cioè dove l'osso della ³ganba si cōgivgnie con quello della coscia.

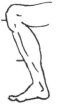

The length of the foot from the end of the toes to the heel goes twice into that from the heel to the knee, that is where the leg bone [fibula] joins the thigh bone [femur].

W. P. 7*b*] **330.**

a n b son simili, ²*c n d* son simili · *n · c* fia 2 piè; ³*n d* fia 2 piè.

a n b are equal; *c n d* are equal; *n c* makes two feet; *n d* makes 2 feet.

W. P. 8*a*] **331.**

m · n · o sono simili; ²la minore grossezza ³della gāba ī faccia ētra ⁴8 volte dal di sotto del piè ⁵alla givntura del ginochio, ⁶e à similitudine col braccio ⁷ī faccia sul' appiccatura della ⁸mano · e colla maggiore lūghezza ⁹dell'orechio e · coi · 3 spati, ¹⁰ī che è diuiso il uolto, e que¹¹sta grossezza ētra · 4 volte da¹²la giūtara della mano al fine del go¹³mito; ¹⁴tāto è largo il piè, quāto è ¹⁵lo spatio del ginochio īfra · *a · b*; ¹⁶tāto è la padella del ginochio, ¹⁷quāto è la gāba īfra *r · s.*

¹⁸La minore grossezza della gāba ¹⁹ī proffilo ētra 6 volte dal di sotto ²⁰del piè

m n o are equal. The narrowest width of the leg seen in front goes 8 times from the sole of the foot to the joint of the knee, and is the same width as the arm, seen in front at the wrist, and as the longest measure of the ear, and as the three chief divisions into which we divide the face; and this measurement goes 4 times from the wrist joint of the hand to the point of the elbow. [14]The foot is as long as the space from the knee between *a* and *b*; and the patella of the knee is as long as the leg between *r* and *s.*

[18]The least thickness of the leg in profile goes 6 times from the sole of the foot

35. simile he g.
329. 1. dala chalcagnio. 3. chōgivgnie chon.
330. 2. som simili.
331. 2. grosseza. 5. ala. 6. chol br. 7. apichatura. 8. chola . . magiore lūgeza. 9. e co . 3. 10. īche diuiso. 11. grosseza.
 14. largho. 16. padela. 18. grosseza. 19. socto. 21. chollo . . infralla. 22. choda. 23. cholla magiore grosseza del br ī.

34. *e f 4 dal cazo.* By reading *i* for *e* the sense of this passage is made clear.

35. 2 is not to be found in the sketch which .renders the passage obscure. The two last lines are plainly legible in the facsimile.

330. See the lower sketch, Pl. XIV, No. 1.
331. See Pl. XV. The text of lines 2—17 is to

the left of the front view of the leg, to which it refers. Lines 18—27 are in the middle column and refer to the leg seen in profile and turned to the left, on the right hand side of the writing. Lines 20—30 are above, to the left and apply to the sketch below them.

Some farther remarks on the proportion of the leg will be found in No. 336, lines 6, 7.

alla givntura del ginochio, ²¹e à similitudine collo spatio, ch'è īfra la ²²coda del'ochio al buso dell'orechio, ²³e colla maggior grossezza del braccio ī profilo, ²⁴e col lagrimatojo del'ochio al'appiccatura de' capelli.

²⁵*a·b·c·*sonō īfra loro equali per lūghezza: *c·d·*²⁶ētra 2 volte dal di sotto del piè al ¹/₂ del ginochio e quel ²⁷medesimo dal ginochio al fiāco.

²⁸*a·b·c·*sono equali, *a·*b | è 2 piedi, ²⁹cioè dal calcagnio alla pūta del dito ³⁰grosso.

to the knee joint and is the same width as the space between the outer corner of the eye and the opening of the ear, and as the thickest part of the arm seen in profile and between the inner corner of the eye and the insertion of the hair.

a b c [*d*] are all relatively of equal length. *c d* goes twice from the sole of the foot to the centre of the knee and the same from the knee to the hip.

[28] *a b c* are equal; *a* to *b* is 2 feet— that is to say measuring from the heel to the tip of the great toe.

W. P. 6; I*a*]

332.

Se vno s'inginochia, quello stremerà la quarta ²parte di sua altezza;

³Stando l'omo ginochioni colle mani al petto ⁴il bellico fia·il mezzo di sua·altezza e simil⁵mente le punte de' gomiti;

⁶Il mezzo dell'omo che sede, cioè dal sedere alla ⁷sommità·del capo, fia il braccio di sotto della poppa ⁸e 'l di sotto della spalla; essa parte sedēte, ⁹cioè dal sedere al di sopra del capo, fia ¹⁰tanto piv che mezzo l'omo, quanto è la ¹¹grossezza e lunghezza de testiculi.

In kneeling down a man will lose the fourth part of his height.

When a man kneels down with his hands folded on his breast the navel will mark half his height and likewise the points of the elbows.

Half the height of a man who sits—that is from the seat to the top of the head— will be where the arms fold below the breast, and below the shoulders. The seated portion —that is from the seat to the top of the head—will be more than half the man's [whole height] by the length of the scrotum.

On the central point of the whole body.

W. P. 6; I*b*]

333.

Il cubito·è la quarta·parte dell'altezza· dell'omo ed è simile·alla maggior larghezza delle spalle; ²dal'una givntura delle· spalle·all'altra·fia·due·teste ³e 'l simile· fia dalla somità del petto·all'ombelico; ⁴dalla detta·sōmità·al nascimēto del mēbro ·è vna testa.

The cubit is one fourth of the height of a man and is equal to the greatest width of the shoulders. From the joint of one shoulder to the other is two faces and is equal to the distance from the top of the breast to the navel. [9]From this point to the genitals is a face's length.

The relative proportions of the torso and of the whole figure.

W. P. 6; II*a*]

334.

Dalle·radici de' capegli·alla sōmità del petto·*a b* fia la sesta·parte dell'altezza· dell'omo ²e questa·misura·fia simile.

From the roots of the hair to the top of the breast *a b* is the sixth part of the height of a man and this measure is equal.

The relative proportions of the head and of the torso.

24. colagrimator .. apichatura de "ca pelli". 25. a . b . c [d] .. lūgeza. 26. disocto .. equl. 27. fiācho. 29. pūda. 30. grōssoe chosi.

332. 2. alteza. 3. cholle. 4. belicho .. mezo .. alteza .. essimil. 6. mezo .. chessede. 7. chapo fia il br di .. popa. 9. chapo. 10. mezo .. ella. 11. ellungeza de testichuli.

333. 1. chupido .. ella .. alteza .. magior largeza. 2. dalluna .. spalli. 3. pecto .. onbellicho. 4. nasscimēto .. e vna T.

334. 1. chapegli .. petto "a b" fia. 3. [e] tanto . è .. spalli. 4. bellicho . ecquesta .. nasscimēto. 6. Il br dove sispicha ..

332. See Pl. VIII, No. 2.

333. Compare with this the sketches on the other page of the same leaf. Pl. VIII, No. 2.

4. *dalla detta somità.* It would seem more accurate to read here *dal detto ombilico.*

334. The three sketches Pl. XIV, No 2 belong to this text.

³Tanto · è · dal'ultima · parte · delle · spalle · all'altra, quanto è dalla somità dell petto ⁴al bellico · e questa · parte · entra · quattro volte · dal di sotto del piè al nascimēto ⁵di sotto del naso.

⁶Il braccio, dove si spicca dalla spalla dināzi, entra · 6 uolte · in nello spatio ch'è infra l'uno e l'altro ⁷stremo delle spalle · e 3 volte nella testa dell'omo, e quattro nella lunghezza del piè, ⁸e tre nella mano dentro e fori.

From the outside part of one shoulder to the other is the same distance as from the top of the breast to the navel and this measure goes four times from the sole of the foot to the lower end of the nose.

The [thickness of] the arm where it springs from the shoulder in front goes 6 times into the space between the two outside edges of the shoulders and 3 times into the face, and four times into the length of the foot and three into the hand, inside or outside.

W. P. 6; II δ] **335.**

The relative proportions of the torso and of the leg (335. 336).

a b c sono equali e son simili allo spatio · ch'è · dall'appiccatura del braccio col petto e l'appiccatura ²del mēbro ·, e lo spatio ch'è dalla pūta de' diti della mano al fopello del braccio, e al mezzo del petto, e sappi ³che · *c · b ·* è la terza parte che à la lunghezza dell'omo dalla spalla a terra; ⁴*d · e · f ·* son simili infra loro · e son simili alla maggior larghezza · delle spalle.

a b c are equal to each other and to the space from the armpit of the shoulder to the genitals and to the distance from the tip of the fingers of the hand to the joint of the arm, and to the half of the breast; and you must know that *c b* is the third part of the height of a man from the shoulders to the ground; *d e f* are equal to each other and equal to the greatest width of the shoulders.

W. P. 5 a] **336.**

— Foppel del mēto — ²fianco — ³al nascimēto del grosso dito — ⁴fin del pescie di dētro della coscia — ⁵fin del rilevo del fuso della gāba; ⁶la minore grossezza della gāba entra ⁷3 nella sua coscia · stando in faccia.

—Top of the chin—hip—the insertion of the middle finger. The end of the calf of the leg on the inside of the thigh.—The end of the swelling of the shin bone of the leg. [6] The smallest thickness of the leg goes 3 times into the thigh seen in front.

W. P. 2 a] **337.**

The relative proportions of the torso and of the foot.

Il busto · *a · b ·* fia · nella più sottile parte uno · piè: e da · *a · b ·* fiā · 2 piè, che fiā · 2 · quadrati, ²al cavallo; la piv sottile sua · parte entra · 3 · volte nella lūghezza · che fa 3 · quadrati.

The torso *a b* in its thinnest part measures a foot; and from *a* to *b* is 2 feet, which makes two squares to the seat—its thinnest part goes 3 times into the length, thus making 3 squares.

W. P. 7 a] **338.**

The proportions of the whole figure (338—341).

L'omo a giaciere ²arriva a ¹/₉ di sua ³altezza.

A man when he lies down is reduced to ¹/₉ of his height.

inello . . ellaltro. 7. spalli . . lungeza.

335. 1. dalla . pichatura . . chol . . e lla [b] pichatura. 2. ello . . a fobello . mezo . essapi. 3. ella . . alla largeza dellomo . . atterra. 4. infralloro . . largeza . . spali.

336. 1. fopel. 2. fiancho. 3. nasimēto. 5. fin de. 6. grosseza . . entre.

337. 1. fi "a" nel pi . . î . che fia. 2. chavallo . . lūgeza.

338. 1. diacere. 2. ariva. 3. alteza.

335. See Pl. XVI, No. 1.
3. *lunghezza*, in MS. *larghezza.*
336. See Pl. XVII, No. 2, middle sketch.
337. See Pl, VII, No. 2, the lower sketch.

1. *Il busto . . uno piè.* This is less plainly shown in the sketch which accompanies the text than in No. 5. (W. 104). *da* a b *fiā* 2 *piè.* For 2 read perhaps 2¹/₂; but the whole passage is obscure.

W. P. 7 b] **339.**

Il buco dell' orechio, la nascita della spalla,
²quella del fiāco e del piè son perpēdiculare
linia; ³a n · è simile a · m · o.

The opening of the ear, the joint of the
shoulder, that of the hip and the ancle are in
perpendicular lines; a n is equal to m o.

C. A. 350 a; 1089 a] **340.**

Dal mento insino al nascimēto de' ca-
pelli si è ¹/₁₀ parte dalla figura; ²della givn-
tura della palma della mano j̄sino alla som-
mità del dito lungo ¹/₁₀ parte, ³dal mēto
alla sommità del capo · ¹/₈ parte, ⁴e dalla for-
ciella alla soṁita del petto si è ¹/₆ parte, ⁵e
dalla forciella del petto · j̄nsino alla sommità
del capo ¹/₄ parte, ⁶e dal mēto alle nari
del naso ¹/₃ parte del uolto, ⁷e quel mede-
simo dalle nari al ciglio e dal ciglio al nasci-
mēto de' capegli, ⁸e 'l piè è ¹/₆ parte, ⁹e'l
gomito ¹/₄ parte, ¹⁰larghezza di spalle ¹/₄
parte.

From the chin to the roots of the hair
is ¹/₁₀ of the whole figure. From the joint
of the palm of the hand to the tip of the
longest finger is ¹/₁₀. From the chin to the
top of the head ¹/₈; and from the pit of the
stomach to the top of the breast is ¹/₆, and
from the pit below the breast bone to the
top of the head ¹/₄. From the chin to the
nostrils ¹/₃ part of the face, the same from
the nostrils to the brow and from the brow
to the roots of the hair, and the foot is
¹/₆, the elbow ¹/₄, the width of the shoul-
ders ¹/₄.

W. P. 5 a] **341.**

Larghezza di spalle ¹/₄ del tutto, ²dalla
snodatura della spalla alla mano ¹/₃, ³dal
taglio del labro di sotto all'omero ⁴della
spalla · uno piè.
⁵La maggiore grossezza · dell'omo dal
petto alla schiena ⁶entra 8 volte nell'omo ed
è simile allo ⁷spatio ch'è dal mēto alla
soṁità del capo.
⁸La maggior larghezza è nelle spalle, e
entra 4.

The width of the shoulders is ¹/₄ of the
whole. From the joint of the shoulder to
the hand is ¹/₃, from the parting of the lips
to below the shoulder-blade is one foot.
The greatest thickness of a man from
the breast to the spine is one 8ᵗʰ of his
height and is equal to the space between the
bottom of the chin and the top of the head.
The greatest width is at the shoulders
and goes 4.

W. P. 7 b] **342.**

Tanto è l'omo sotto i bracci quāto lo
spatio de' fiāchi.

²Tanto · è l'omo largo ne' fiāchi quāt'è
dal sōmo d'essi fiāchi ³al di sotto delle
natiche, stādo l'omo di pari peso sopra i

The width of a man under the arms is
the same as at the hips.

A man's width across the hips is equal to
the distance from the top of the hip to the
bottom of the buttock, when a man stands

The torso
from the
front and
back.

339. 1. [lane] il puso . . la nasc . . spala. 2. fiācho . . . perpēdichulare. 3. ha . m.
340. 1. nassimēto de chapelli . dela. 2. dala . . dela . . lungho. 4. dala forciella dellalla. 6. allianari. 7. dalanari . . nasimēto.
 9. egomito. 10. largeza dispale.
341. 1. il trezo: *written on the margin* . largeza. 4. spalla . î̄ . pie. 5. magiore grosseza . . sciena. 6. [essimile]. 7. somita
 del chapo. 8. largeza [delle] e . . spalli.
342. 1. i br quāto. 2. sumo. 4. somita di. 5. spalli. 6. mezo infralla.

339. See Pl. XVI, No. 2, the upper sketch.
342. The lower sketch Pl. XVI, No. 2, is drawn by the side of line 1.

2 sua piè, ⁴e 'l medesimo spatio · fia da essa soṁità de' fiãchi alla givntura ⁵delle spalle; ⁶la cintura overo il di sopra de fiãchi fia · in mezzo infra la ⁷givntura delle spalle e 'l di sotto delle natiche.

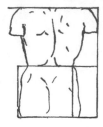

equally balanced on both feet; and there is the same distance from the top of the hip to the armpit. The waist, or narrower part above the hips will be half way between the arm pits and the bottom of the buttock.

Ven. (121) ⁿᵒ ¹ ·A· 343.

Vitruvius' scheme of proportions.

Vetruuio · architecto mette nella sua · opera · d'architectura ·, che le misure dell'omo · sono · dalla · natura ²distribuite · in questo · modo · cioè · che · 4 diti fã · uno palmo · e 4 palmi · fã · uno pie ·, 6 palmi fã un cubito · 4 ³cubiti · fã · uno uomo · e 4 · cubiti fã uno · passo · e 24 palmi · fã uno uomo · e queste misure son ne' sua edifiti; ⁴Se tu apri tãto le gãbe · che tu cali da capo ¹/₁₄ di tua altezza e apri e alzi tanto le braccia che colle lunghe dita tu tochi la linia della ⁵soṁità del capo, sappi che 'l ciẽtro delle stremità delle aperte mẽbra fia il bellico ⁶e lo spatio che si truoua infra le gãbe, fia triãgolo equilatero.

⁷Tanto apre l'omo nelle braccia · quãto · è la · sua · altezza.

⁸Dal nascimento · de' capegli · al fine di sotto del mento · è · il decimo dell'altezza · del uomo; dal di sotto · del mento · alla · soṁi⁹tà · del capo · è · l'octauo · dell'altezza · dell'omo: dal di sopra · del petto · alla · soṁità · del capo · fia il · sexto dell'omo; dal di so¹⁰pra · del petto al nasci-mẽto de' capegli · fia · la settima · parte · di tutto · l'omo; dalle · tette al di sopra · del capo fia ¹¹la · quarta · parte · dell'omo: la maggiore · larghezza · delle · spalle · contiene · in se la quarta parte dell'omo ·, dal go¹²mito · alla punta · della · mano · fia la · quinta · parte · dell'omo: da esso · gomito · al ter-mine della · spalla · fia la octaua ¹³parte · d'esso omo: tutta · la mano · fia la decima ·

Vitruvius, the architect, says in his work on architecture that the measurements of the human body are distributed by Nature as follows: that is that 4 fingers make 1 palm, and 4 palms make 1 foot, 6 palms make 1 cubit; 4 cubits make a man's height. And 4 cubits make one pace and 24 palms make a man; and these measures he used in his buildings. If you open your legs so much as to decrease your height ¹/₁₄ and spread and raise your arms till your middle fingers touch the level of the top of your head you must know that the centre of the outspread limbs will be in the navel and the space between the legs will be an equilateral triangle.

The length of a man's outspread arms is equal to his height.

From the roots of the hair to the bottom of the chin is the tenth of a man's height; from the bottom of the chin to the top of his head is one eighth of his height; from the top of the breast to the top of his head will be one sixth of a man. From the top of the breast to the roots of the hair will be the seventh part of the whole man. From the nipples to the top of the head will be the fourth part of a man. The greatest width of the shoulders contains in itself the fourth part of the man. From the elbow to the tip of the hand will be the fifth part of a man; and from the elbow to the angle of the armpit will be the eighth part of the man. The whole hand will be the tenth párt of

343. 1. mecte . . chelle. 2. disstribuite . inquessto . . fa . î . palmo . . fa î pie . . fa un chubito. 3. fa î homo . he. 4. chubidi fa î passo he . . fa î homo . ecqueste. 4. Settu . . chettu chali da chapo . . alza . . cholle lunge. 5. chapo . . bellicho. 6. ello . . chessi . . infralle alteza . . disocto. 7. nele . . ella. 8. nasscimento de chapegli . . somi. 9. chapo . hè . . pecto . . somita del chapo. 10. sectima . . tucto pecto . . nasscimẽto de chapegli . . sectima . . chapo. 11. largeza . . spalli chontieno . . se [la oct] la quarta. 12. isspalla. 13. tucta . . nasscie . . mezo. 14. sectima . . socto . . socto.

343. See Pl. XVIII. The original leaf is 21 centi-mètres wide and 33¹/₂ long. At the ends of the scale below the figure are written the words *diti* (fingers) and *palmi* (palms). The passage quoted from Vitruvius is Book III, Cap. 1, and Leonardo's drawing is given in the editions of Vitruvius by FRA GIOCONDO (Venezia 1511, fol., Firenze 1513, 8ᵛᵒ·) and by CESARIANO (Como 1521).

parte · dell' omo: il menbro · virile · nascie · nel mezzo dell' omo; il ¹⁴piè · fia la settima · parte · dell' omo; dal di sotto · del piè · al di sotto del ginochio · fia · la quarta · parte · dell' omo; ¹⁵dal di sotto · del ginochio · al nascimēto del membro · fia · la quarta parte · dell' omo: le parti che si truovano · infra ¹⁶il mēto · e 'l naso e 'l nascimēto de' capegli e quel de' cigli · ciascūno spatio · per se è simile all' orechio ed è 'l terzo del uolto.

the man; the beginning of the genitals marks the middle of the man. The foot is the seventh part of the man. From the sole of the foot to below the knee will be the fourth part of the man. From below the knee to the beginning of the genitals will be the fourth part of the man. The distance from the bottom of the chin to the nose and from the roots of the hair to the eyebrows is, in each case the same, and like the ear, a third of the face.

Ash. I; 12 a] **344.**

Da *b · a ·* è una testa e così da · *c · a,* ²e questo · accade quādo jl gomito ³fa · angulo · recto.

From *b* to *a* is one head, as well as from *c* to *a* and this happens when the elbow forms a right angle.

The arm and head.

W. P. 8 a] **345.**

Dalla pūta · del piv · lūgo dito della mano ²alla giv̄tura della spalla è 4 mani ³o vuoi 4 teste.
⁴*a · b · c* sono equali e ciascuno ⁵intervallo · è 2 · teste.

From the tip of the longest finger of the hand to the shoulder joint is four hands or, if you will, four faces.
a b c are equal and each interval is 2 heads.

Proportions of the arm (345—349).

B. 3 b] **346.**

La mano īsino doue si cōgivgnie col osso ²del braccio ētra 4 volte dalla pūta del piv ³lungo dito īsino alla giv̄tura della spalla.

The hand from the longest finger to the wrist joint goes 4 times from the tip of the longest finger to the shoulder joint.

W. P. 4 a] **347.**

a · b · c · sono equali · e son simili al piè e lo spatio ch'è dalla tetta · al mamolino, ²*d · e* fia · la terza parte di tutto · l'omo ·
f · g è la quarta · parte dell' omo ed è simile a *g · h ·* e simile al cubito.

a b c are equal to each other and to the foot and to the space between the nipple and the navel *d e* will be the third part of the whole man.
f g is the fourth part of a man and is equal to *g h* and measures a cubit.

15. socto . . chessi. 16. nasscimēto de chapegli ciasscūno . . essimile allorecheel.
344. 1. e î T cio. 2. ecquesto achade.

345. 1. dala . delā. 2. dela spala. 4. ciaschuno. 5. intervalo.
346. 1. chol.
347. 1. esson. 3. ella essimile ha . . essimile al chupido.

344. See Pl. XLI, No. 1.
345. Lines 1—3 are given on Pl. XV below the front view of the leg; lines 4 and 5 are below again, on the left side. The lettering refers to the bent arm near the text.
347. See Pl. XIX, No. 1.
1. *mamolino* (=*bambino*, little child) may mean here the navel.

a b · entra 4 volte in *a · c* · e 9 in *a · m*; ¶la maggiore grossezza del braccio in³fra ’l gomito · e la mano entra 6 in *a · m* ¶ ⁴ed è simile a · *r · f* · ; ⁵la maggiore grossezza del braccio · infra la spalla e ’l go⁶mito entra 4 da *c · m* · ed è simile · *h · n · g*; ⁷la minore grossezza del braccio sopra ’l gomito *x · y* · non è ra⁸dice quadrata, ma è simile al mezzo dello spatio *h* · 3 ⁹che si trova infra la givntura del braccio dētro ¹⁰e la givntura della mano;

¹¹La grossezza del braccio sulla mano ¹²entra · 12 volte in tutto il braccio, ¹³cioè dalla punta de’ diti insino ¹⁴alla givntura della spalla, cioè ¹⁵3 nella mano e 9 nel braccio;

¹⁶Il braccio piegato è 4 teste;

¹⁷Il braccio dalla spalla al gomito ¹⁸nel piegarsi crescie ¹⁹di sua lunghezza · cioè la lunghezza ²⁰dalla spalla · al gomito, e esso ac²¹crescimēto è simile alla gro²²ssezza del braccio sulla giuntura della mā, ²³quādo sta in proffilo, e simile ²⁴allo spatio ch’è dal di sotto del mēto al ta²⁵glio della bocca, e la grossezza delle 2 ²⁶dita della mā di mezzo, e la grādezza ²⁷della bocca, e lo spatio ch’è dalla appicca²⁸tura de’ capelli alla fronte, e la somità del ²⁹capo; Queste cose nominate sō ³⁰simili infra loro ma nō simili al ³¹sopra detto accrescimēto del braccio.

³²Il braccio dal gomito alla mano mai ³³crescie per piegare o dirizarsi;

³⁴Il braccio dalla spalla alla givntura ³⁵di dētro quād’è disteso;

³⁶Quando il braccio è disteso *p · n* · è simi³⁷le a · *n · a*; E quando si piega ³⁸*n · a* · sciema ¹/₆ di sua lūghezza e ’l ³⁹simile fa · *p · n*; E ’l gomito di ⁴⁰fori nel piegarsi crescie ¹/₇, e questo nel ⁴¹suo piegarsi crescie e ariva alla lūghezza di 2 ⁴²teste, E ’l

a b goes 4 times into *a c* and 9 into *a m*. The greatest thickness of the arm between the elbow and the hand goes 6 times into *a m* and is equal to *r f*. The greatest thickness of the arm between the shoulder and the elbow goes 4 times into *c m*, and is equal to *h n g*. The smallest thickness of the arm above the elbow *x y* is not the base of a square, but is equal to half the space *h* 3 which is found between the inner joint of the arm and the wrist joint.

[11] The width of the wrist goes 12 times into the whole arm; that is from the tip of the fingers to the shoulder joint; that is 3 times into the hand and 9 into the arm.

The arm when bent is 4 heads.

The arm from the shoulder to the elbow in bending increases in length, that is in the length from the shoulder to the elbow, and this increase is equal to the thickness of the arm at the wrist when seen in profile. And the space between the bottom of the chin and the parting of the lips, is equal to the thickness of the 2 middle fingers, and to the width of the mouth and to the space between the roots of the hair on the forehead and the top of the head[29]. All these distances are equal to each other, but they are not equal to the above-mentioned increase in the arm.

The arm between the elbow and wrist never increases by being bent or extended.

The arm, from the shoulder to the inner joint when extended.

When the arm is extended, *p n* is equal to *n a*. And when it is bent *n a* diminishes ¹/₆ of its length and *p n* does the same. The outer elbow joint increases ¹/₇ when bent; and thus by being bent it increases to the length of 2 heads. And on the inner

349. 2. magiore grore grosseza . . in ī. 3. ella. 4. essimile ha r. 5. magore . grosseza del br infralla . ego. 7. grosseza . . br sopral gomito "x . y" . non. 8. mezo . . "h . 3". 9. chessi . . infral [br di dentro] la . . del br. 10. ella. 11. grosseza . . br . 12. il br. 14. ala . . coe. 15. nel br. 16. 4 T. 17. brcio. 18. il nel . . cresscie. 19. lungeza . . lungheza. 20. de dalla . essoa. 21. cresscimēto essimile. 22. seza del br sula. 23. essimile. 25. bocha ella grosseza. 26. mezo ella grandeza. 27. bocha ello . . apicha. 28. chapelli . . ella somita. 29. nominato. 31. acresimēdo del br. 32. il br. 33. cresscie. 34. Il br. 36. il bre . . essimi. 37. le ha . n . a Ecquondo. 38. lūgeza. 39. Ell e | "questo". 40. cresscie. 41. piegarsi | "cresscie" e . . lūgeza. 42. dentro ne nel. 43. esso br era dal na. 44. chollatera al. 45. tesste e mezo. 46. ¹/₂ T e. 47. col-

348. Compare Pl. XVII. Lines 1—10 and 11—15 are written in two columns below the extended arm, and at the tips of the fingers we find the words: *fine d’unghie* (ends of the nails). Part of the text —lines 22 to 25—is visible by the side of the sketches on Pl. XXXV, No. 1.

29. *Queste cose.* This passage seems to have been written on purpose to rectify the foregoing lines. The error is explained by the accompanying sketch of thē bones of the arm.

dentro nel suo pie[43]garsi fa che dove esso braccio era dal nas[44]cimento suo collaterale al suo fine[45] colla mano, 2 teste e mezzo, piega-[46]to sciema quella ¹/₂ Testa e torna due, [47]vna dalla giṽtura al suo fĩ colla-terale, [48]l'altra infino alla mā.

[49]Il braccio piegato avrà 2 teste dal di sopra [50]della spalla al gomito e 2 da esso go[51]mito al nascimēto de' quatro diti [52]sulla palma della mano; lo spatio, [53]ch'è da esso nasci-mēto de' 4 diti al gomito, [54]mai si muta per alcuna mutatione [55]del braccio.

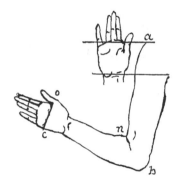

[56]Se questo braccio si dirizzerà, elli ca-lerà il 3° dello [57]spatio ch'è infra *b · n*, e se sia diritto e pie[58]gherassi, crescierà la metà

di *o c*; [59]tanto è dalla spalla al gomito, quanto [60]è dal prīcipio dentro del grosso dito a esso gomito [61]*a b c*.

[62]La minore grossezza del braccio in proffilo *z · c* entra 6 [63]dal nodello della mano al foppello del gomito disteso [64]e 14 in tutto il braccio e è 42 in tutto l'omo suo; [65]la maggiore grossezza del braccio in prof-filo è simile [66]alla maggiore grossezza del braccio in facia; ma l'una [67]è posta nel terzo del braccio dalla givntura alla metà, l'altro [68]nel terzo della givntura alla mano.

side, by bending, it is found that whereas the arm from where it joins the side to the wrist, was 2 heads and a half, in bending it loses the half head and measures only two: one from the [shoulder] joint to the end [by the elbow], and the other to the hand.

The arm when folded will measure 2 faces up to the shoulder from the el-bow and 2 from the elbow to the inser-tion of the four fingers on the palm of the hand. The length from the base of the fingers to the elbow never alters in any position of the arm.

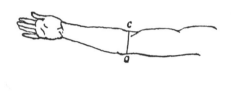

If the arm is extended it decreases by ¹/₃ of the length between *b* and *n*; and if — being extended — it is bent, it will increase the half of *o c*. [59]The length from the shoulder to the elbow is the same as from the base of the thumb, inside, to the elbow *a b c*.

[62]The smallest thickness of the arm in profile *z c* goes 6 times between the knuckles of the hand and the dimple of the elbow when extended and 14 times in the whole arm and 42 in the whole man[64]. The greatest thickness of the arm in profile is equal to the greatest thickness of the arm in front; but the first is placed at a third of the arm from the shoulder joint to the elbow and the other at a third from the elbow towards the hand.

59—61. The figure sketched in the margin is however drawn to different proportions.

62—64. The arm sketch on the margin of the MS. is identically the same as that given below on Pl. XX which may therefore be referred to in this place. In line 62 we read therefore *z c* for *m n*.

W. P. 7 b]

349.

[2] Tanto è dalla sōmità della spalla alla pūta del gomito, quanto da essa [3] punta · alla givntura delle 4 minor dita colla palma della mano, [4] e ciascuna parte è 2 teste.

[5] a · e è simile alla palma della mā; r · f · e · o · g · son simili a una mezza testa, [7] e ciascuno entra 4 da · a · b · e da · b · c: [8] da · c · m · è ¹/₂ testa; m · n · è ¹/₃ testa, ētra [9] 6 · in c · b · e in · b · a; [10] a · b · sciema ¹/₇ di sua lūghezza, quādo jl braccio · si [11] distēde: c · b · mai · fa mvtatione, [12] o · fia senpre · il mezzo infra · a · s.

[14] y · l · è la polpa del braccio ed è vna testa, e quādo · jl braccio si piega, [15] essa polpa diminviscie ²/₅ di sua lūghezza, [16] o · a in nel piegare · diminviscie ¹/₆, e similmente [17] o · r.

[18] a · b · è ¹/₇ di r · c; [19] f · s · si è ¹/₈ di · r · c e ciascuna di queste [20] 2 · misure sono le piv grosse del braccio; [21] k · h · è la piv sottile parte che sia infra la spalla e 'l gomito [22] ed è ¹/₈ di · tutto il braccio · r · c · [23] o · p · è ¹/₅ di · r · l ·; c · z, entra 13 · ī r · c.

From the top of the shoulder to the point of the elbow is as far as from that point to the joints of the four fingers with the palm of the hand, and each is 2 faces.

[5] a e is equal to the palm of the hand, r f and o g are equal to half a head and each goes 4 times into a b and b c. From c to m is ¹/₂ a head; m n is ¹/₃ of a head and goes 6 times into c b and into b a; a b loses ¹/₇ of its length when the arm is extended; c b never alters; o will always be the middle point between a and s.

y l is the fleshy part of the arm and measures one head; and when the arm is bent this shrinks ²/₅ of its length; o a in bending loses ¹/₆ and so does o r.

a b is ¹/₇ of r c. f s will be ¹/₈ of r c, and each of those 2 measurements is the largest of the arm; k h is the thinnest part between the shoulder and the elbow and it is ¹/₈ of the whole arm r c; o p is ¹/₅ of r l; c z goes 13 times into r c.

Br. Mus. 44 a]

350.

The movement of the arm (350—354).

Nelle piegature vltime delle giunture di qualūque [2] mēbro si sciupa ogni rilieuo in cōcauità, e così [3] ogni concavità dell'ultime dette piegature [4] si fa in colmo, quādo el mēbro è nel ultima sua [5] dirittura; e qui spesse volte si fā grādissimi erro[6]ri chi non à tale sciētia e si fida tanto del suo ingegno e nō ricorre alla imitatione [7] del naturale, e tal varietà si fa piv nel mezzo [8] de' lati che dināzi, e piv dirieto che ne lati.

In the innermost bend of the joints of every limb the reliefs are converted into a hollow, and likewise every hollow of the innermost bends becomes a convexity when the limb is straightened to the utmost. And in this very great mistakes are often made by those who have insufficient knowledge and trust to their own invention and do not have recourse to the imitation of nature; and these variations occur more in the middle of the sides than in front, and more at the back than at the sides.

W. 197]

351.

Quando il braccio si piega in agolo nel suo gomito · genera angolo d'alcuna [2] sorte; quanto esso angolo si farà piv acuto, tanto i mvscoli di dentro [3] a esso angolo si

When the arm is bent at an angle at the elbow, it will produce some angle; the more acute the angle is, the more will the muscles within the bend be shortened; while

349. 1. trezo. 3. cholla. 4. 2 T. 5. essimile. 6. r . f . he . o g . . a ī meza. 7. ciasschuno. 8. 1/2 T m . n . e 1/3 T. 9. b . en . b. 10. lūgeza . . Il br . si. 12. senpr. 13. [o . y . qua]. 14. ella . . del br ed . . Il br . si. 15. diminvisscie e 2/5 di sua lūgeza. 16. inel . . diminvisscie 1/2 essimile. 19. sie [ī] 1,8 . quesste . . lo . . del br. 21. ella . . chessia infralla . . ellomito. 22. il br.

350. 1. gunture. 2. si scrubia. 3. piegature ogni cōca. 4. vita si fa. 6. tale essciētia | "e ssi fida tanto del suo ingegno" e no. 7. ettal . . mezo.

351. 1. il br . . gomito egnero — angulo. 2. quento esso angulo . . mvsscoli. 3. asso angolo piv brieuielli musscoli apositi.

349. See Pl. XX where the text is also seen from lines 5—23.
351. See Pl. XIX, No. 2.

fanno piv brieui, e li muscoli opposti si far-
anno di ma⁴ggior lunghezza che in ordinario
· come dire nello esenplo; *d c e* ⁵forte
diminviranno: *b n* forte s'allargherà.

the muscles outside will become of greater
length than before. As is shown in the
example; *d c e* will shrink considerably; and
b n will be much extended.

Ash. I; 25 II a]

352.

PITTURA.

²Il braccio · dove · si uolta · tira dirieto ·
la sua · spalla a mezzo la schiena.

OF PAINTING.

The arm, as it turns, thrusts back its
shoulder towards the middle of the back.

C. A. 44 b; 137 b]

353.

10 sono li moti principa²li · della mano,
cioè in ³dentro, in fori, destro e ⁴sinistro,
circūvolvbile, ⁵in sù e in giù, chiudere ⁶e
aprire, dilatatione e ⁷restrinsione delle sua
dita.

The principal movements of the hand
are 10; that is forwards, backwards, to right
and to left, in a circular motion, up or down,
to close and to open, and to spread the
fingers or to press them together.

C. A. 98 b; 308 a]

354.

DEL MOTO DELLE DITA DELLE MANI.

²Li moti delli diti sono · principali cioè
³astendere e piegare: l'astendere e pie-
⁴gare si uaria in modi, cioè alcuna ⁵volta
si piega tutto d'un pezzo sopra la ⁶prima
giuntura, alcuna volta si piega ⁷o dirizza
mezzo sopra la 2ª giū⁸tura, e alcuna volta
si piega tutto ⁹in se e nel medesimo tempo
si piega in tut¹⁰te le sue 3 giunture, e se
alle 2 prime ¹¹giunture sarà proibito il pie-
gamento, ¹²allora la 3ª giūtura sarà piegata
con mag¹³giore facilità, che nc mai si
potrà piega¹⁴re per se sola, essendo libere
l'altre giunture, ¹⁵e essa nō si pieghino tutte
le 3 giū¹⁶ture; Oltre alli predetti moti ce
ne à ¹⁷4 altri principali, de' quali 2 sono fra
sù ¹⁸e giù, e 2 altri tra qua e là, e ciascū
di que¹⁹sti è fatto colla sua senplice corda;
Di ²⁰questi ne seguita infiniti altri moti fatti
sē²¹pre cō 2 corde; e lasciata vna d'esse
corde ²²va ripigliando l'altra; fu fatto le
corde ²³grosse di dentro al dito e le sottili
di fori; fu ²⁴fatto le corde di dentro a ogni
giūtu²⁵ra e di fori no.
²⁶Della potētia che fà le 3 ²⁷corde den-
tro alli diti nelle ²⁸3 giūture.

OF THE MOTIONS OF THE FINGERS.

The movements of the fingers principally
consist in extending and bending them. This
extension and bending vary in manner; that
is, sometimes they bend altogether at the first
joint; sometimes they bend, or extend, half
way, at the 2ⁿᵈ joint; and sometimes they
bend in their whole length and in all the
three joints at once. If the 2 first joints
are hindered from bending, then the 3ʳᵈ joint
can be bent with greater ease than before;
it can never bend of itself, if the other
joints are free, unless all three joints are
bent. Besides all these movements there are
4 other principal motions of which 2 are up
and down, the two others from side to
side; and each of these is effected by a single
tendon. From these there follow an infi-
nite number of other movements always
effected by two tendons; one tendon ceasing
to act, the other takes up the movement. The
tendons are made thick inside the fingers and
thin outside; and the tendons inside are atta-
ched to every joint but outside they are not.
[26] Of the strength [and effect] of the
3 tendons inside the fingers at the 3 joints.

4. gor lungeza chellin. 5. he *b n* . . sallargera.
352. mezo . . sciena.
353. 3. desstro. 4. sinisstro. 5. ciudere. 7. resstrinsione.
354. 1. delli. 2. coe. 3. asstendere e pieghare . . eppie. 4. ghare . . coe. 5. piegha . . pezo. 6. guntura . . piegha. 7. [mezo]
o diriza mezo 2ª gū. 8. piegha. 9. piegha in tu. 10. gunture esse. 11. gunture . . piegamento [il]. 12. alora . . guntura.
13. gore . . che p⁽ᵃ⁾. 14. gunture. 15. 3 gū. 18. e gu e . . qua ella. 19. effatto. 27. ellasciato. 23. elle. 24. chorde
. . gutu. 26. cheffā. 28. gūture.

354. 26. This head line has, in the original, no text to follow.

E. 17a] 355.

The move-
ment of the
torso
(355—361).

Nota la uariatione della spalla in tutti li mo²ti del · braccio intra sù e giù, in dentro, infora, ³indirieto, ināti, e così ne' moti revertigi⁴nosi e qualūche altri moti.

⁵E 'l simile fa del collo, mani e piedi e petto so⁶pra li fianchi ecc.

Observe the altered position of the shoulder in all the movements of the arm, going up and down, inwards and outwards, to the back ànd to the front, and also in circular movements and any others.

And do the same with reference to the neck, hands and feet and the breast above the lips &c.

W. III] 356.

3 sono li muscoli principali ²della spalla cioè b c d, e due ³sono li laterali che la movono ⁴ināzi e indirieto, cioè a o; ⁵a la move ināzi e o la tira ⁶indirieto; e insù l'alza b c d, ⁷insù e ināzi a b c, insù e indi-⁸rieto c d o; e in giù basta ⁹quasi il peso di se medesima;

¹⁰Il muscolo d si vnisce col muscolo c, quā¹¹do il braccio va inanzi, e nel tornare indi¹²rieto il muscolo b s'unisce col muscolo c.

Three are the principal muscles of the shoulder, that is b c d, and two are the lateral muscles which move it forward and backward, that is a o; a moves it forward, and o pulls it back; and b c d raises it; a b c moves it upwards and forwards, and c d o upwards and backwards. Its own weight almost suffices to move it downwards.

The muscle d acts with the muscle c when the arm moves forward; and in moving backward the muscle b acts with the muscle c.

W. A. II; 203b (24)] 357.

DELLE RENI INARCATE.

²Le reni inarcate overo schiene — ³senpre le poppe sō più basse che ⁴le scapule d'essa schiena.

⁵Nelli petti inarcati senpre ⁶le poppe sō più alte che le ⁷scapule della schiena.

⁷Dalle reni diritte fiē sēpre ⁹trovate le poppe dell'altezza ¹⁰d'esse scapule.

OF THE LOINS, WHEN BENT.

The loins or backbone being bent. The breasts are are always lower than the shoulderblades of the back.

If the breast bone is arched the breasts are higher than the shoulderblades.

If the loins are upright the breast will always be found at the same level as the shoulderblades.

W. 215] 358.

a b nervo e tallone nell' alzare ²del calcagnio s'accostano vn dito ³l'uno all'altro e nello abbassare ⁴si separano vn dito.

a b the tendon and ankle in raising the heel approach each other by a finger's breadth; in lowering it they separate by a finger's breadth.

355. 1. spella. 2. del . br . . su eggiu. 3. chosi. 5. chollo . . eppiedi e pecto.
356. 1. musscoli principoli. 2. d he due. 3. chella movano. 4. innāzi . . coe. 8. gu bassta. 10. musscolo . . vnissce . . musscolo. 11. il [p] brracco . . innanzi. 12. musscolo b sunissce col musscolo c.
357. 1. innarchate. 2. innarchate . . sciene. 3. chel. 4. spatole . . sciena. 5. elli pectinarchati. 6. chelle. 7. spatolo della sciena. 8. delle rene diricte fie. 9. trovato. 10. desse spatole.
358. 1. ettallone. 2. chalchagnio [d . si superano] "sachostano".

356. See Pl. XXI. In the original the lettering has been written in ink upon the red chalk drawing and the outlines of the figures have in most places been inked over.

357. See Pl. XXII, No. 1.

358. See Pl. XXII, No. 2. Compare this facsimile and text with Pl. III, No. 2, and p. 152 of MANZI's edition. Also with No. 274 of LUDWIG's edition of the Vatican Copy.

A. 2 a] 359.

Tāto · quāto · la parte dello nvdo · *d* · *a* ·
diminviscie pel posare ·, tāto l'opposita ²parte
crescie: cioè tāto quāto la parte *d* · *a* dimi-
nviscie di sua ³misura · l'opposita parte sopra ·
crescie alla sua · misura; ⁴el bellico mai ·
escie di sua altezza verso il mēbro virile;
e questo ⁵abassamēto · nascie · perchè · la
figura che posa sopra uno piè · quel piè si
fa ciētro ⁶del sopra · posto peso: essēdo ·
così il mezzo delle spalle ui si dirizza di
sopra ⁷vsciēdo fori della sua linia perpē-
diculare, la quale linia passa per i mezzi
super⁸fitiali del corpo, e questa · linia · si
uiene a torcere nella sua superiore stre⁹mità ·
sopra il piè che posa · e i liniamēti traversi
costretti ¹⁰a equali angoli si fanno coi loro
stremi piv bassi ī quella parte che posa
¹¹come appare in · *a* · *b* · *c*.

Just so much as the part *d a* of the
nude figure decreases in this position so
much· does the opposite part increase; that
is: in proportion as the length of the part
d a diminishes the normal size so does the
opposite upper part increase beyond its [nor-
mal] size. The navel does not change its
position to the male organ; and this shrinking
arises because when a figure stands on one
foot, that foot becomes the centre [of gra-
vity] of the superimposed weight. This being
so, the middle between the shoulders is thrust
above it out of. it perpendicular line, and
this line, which forms the central line of
the external parts of the body, becomes bent
at its upper extremity [so as to be] above
the foot which supports the body; and
the transverse lines are forced into such
angles that their ends are lower on the
side which is supported. As is shown at
a b c.

E. 3 a] 360.

PICTURA.

²Nota nelli moti e attitudini delle ³figure
come si variano le mē⁴bra e li lor sētimēti,
perchè le ⁵scapule nelli moti delle braccia
e spalle ua⁶riano assai la schiena, e di que-
⁷sto troverai tutte le cause nel ⁸libro della
mia notomia.

OF PAINTING.

Note in the motions and attitudes of
figures how the limbs vary, and their feeling,
for the shoulderblades in the motions of the
arms and shoulders vary the [line of the]
back bone very much. And you will find all
the causes of this in my book of Anatomy.

Ash. I. 15 a] 361.

DELL'ATTITUDINE.

²La fōtanella · della · gola · cade sopra ·
il piè ·, e gittādo uno · braccio ināti la fōta-
nella escie d'esso · piè, ³e, se la gāba · gitta
· indirieto ·, la fontanella · va ināti, e così si
mvta in ogni attitudine.

OF [CHANGE OF] ATTITUDE.

The pit of the throat is over the feet,
and by throwing one arm forward the pit of
the throat is thrown off that foot. And if
the leg is thrown forward the pit of the
throat is thrown forward; and. so it varies in
every attitude.

359. 1. par dello . . loposita. 2. cresscie . cioe [que] tāto diminvissie. 3. loposita . . sopra [cresscie a] cresscie. 4. belicho . .
essae . . alteza [ag] overo . . ecquesto. 5. nasscie . . sopra ī piș. 6. chosi . . spali . . diriza. 7. vsciēdo . . perpēdichu-
lare. 8. chorpo ecquesta . . torciere la. 9. posa. [ele par] ei . . chostretti. 10. angholi . . fano [be] coloro . . quela. 11. apare.
360. 2. neli . . attitudine. 3. fighure chome . . varianno. 4. elli . . perche les. 5. spatole nelli . . delle br .\· ua. *On the margin:*
.\· esspalli. 6. lassciena. 7. stro troverai . . chavsene.
361. 1. dattitudine. 2. chade . . gittando ī . braccio. 3. esse.

359. See Pl. XXII, No. 3.

E. 20 a] **362.**

PICTURA.

OF PAINTING.

The proportions vary at different ages (362—367).

[2]Descrivi quali sieno li muscoli e quali [3]le corde, che mediante diuersi movimēti di cias[4]cun mēbro si scuoprino o si ascondono o nō [5]faccino nè l'ū nè l'altro, e ricordati che que[6]sta tale actione è inportātissima, e necies[7]sarissima appresso de' pittori e scultori che fā [8]professione di maestri ecc.

[9]E 'l simile farai d'un fanciullo dalla na[10]tiuità insino al tenpo della sua decrepitudi[11]ne per tutti li gradi della sua età come infanti[12]a, pueritia, adolescientia e giovētù ecc.

[13]E in tutti discriverai le mutationi delle mēbra [14]e giunture le quali ingrassano o dimagrano.

Indicate which are the muscles, and which the tendons, which become prominent or retreat in the different movements of each limb; or which do neither [but are passive]. And remember that these indications of action are of the first importance and necessity in any painter or sculptor who professes to be a master &c.

And indicate the same in a child, and from birth to decrepitude at every stage of its life; as infancy, childhood, boyhood, youth &c.

And in each express the alterations in the limbs and joints, which swell and which grow thinner.

E. 19 b] **363.**

O pictore anatomista guarda che la troppa [2]notitia delli ossi, corde e muscoli nō si[3]a cavsa di farti vn pictore legnioso, col [4]volere che li tua ignivdi mostrino tutti li sē[5]timēti loro, adūque, volendo riparare a questo, [6]vedi in che modo li muscoli nelli vechi o magri [7]coprino over vestino le loro ossa, e oltre [8]a questo nota la regola come li medesimi mus[9]coli rienpino li spati superfitiali che infra loro s'ī[10]terpongono; e quali sono li muscoli [11]di che mai si perde la notitia in alcū grado di grassez[12]za, e quali sō li muscoli delli quali per ogni mi[13]nima pinguedine si perde la notitia delli lor cō[14]tatti, e molte son le volte che di più muscoli se [15]ne fa vn sol muscolo nello ingrassare, e molte [16]sō le volte che nel dimagrare o invechiare d'un sol [17]muscolo se ne fā più muscoli, e di questo tal [18]discorso se ne dimostrerà a suo loco tutte le [19]particularità loro, e massime nelli spati [20]interposti infra le giūture di ciascū mēbro ecc.

O Anatomical Painter! beware lest the too strong indication of the bones, sinews and muscles, be the cause of your becoming wooden in your painting by your wish to make your nude figures display all their feeling. Therefore, in endeavouring to remedy this, look in what manner the muscles clothe or cover their bones in old or lean persons; and besides this, observe the rule as to how these same muscles fill up the spaces of the surface that extend between them, which are the muscles which never lose their prominence in any amount of fatness; and which too are the muscles of which the attachments are lost to sight in the very least plumpness. And in many cases several muscles look like one single muscle in the increase of fat; and in many cases, in growing lean or old, one single muscle divides into several muscles. And in this treatise, each in its place, all their peculiarities will be explained—and particularly as to the spaces between the joints of each limb &c.

362. 2. desscrivi . . musscholi equali. 3, chorde. 4. schun . . sisscuoprino ossi asschondono. 5. nellūnellaltro e richordati checquesta. 7. di pichtori esschultori cheffā. 9. fanciullo [al] dalla. 11. chome. 12. adolesscientia. 13. tucti disscriverrai. 14. e giunture e quale ingrassa oddimagra.

363. 1. natomissta ghuarda chella. 2. chorde ēmusscholi. 3. eno chausa . . chol. 4. chelli . . ingnivdi mosstrino. 5. acquessto. 6. musscoli . . magri chu. 7. obprino . . vesstino [le osse] le . . oltri. 8. adi quessto . . reghola. 9. choli . . lisspati . . infrallorossī. 10. terponghono E quali . . musscholi. 11. alchū. 12. ecquali. 13. pinghuedine . . chō. 14. tacti . . molte solle . . muscholi. 15. muscholo. 17. musscholo , . musscholi ed . quessto. 18. disschorso . . dimosstera assuo locho. 19. partichularita. 20. interpossti infralle . . ciassū. 21. Anchora . . mancherai della; — di notare *is wanting*. 22. predeti

363. DE ROSSI remarks on this chapter, in the Roman edition of the Trattato, p. 504: "*Non in questo luogo solo, ma in altri ancora osserverà il lettore, che Lionardo va pungendo quelli che fanno abuso della loro dottrina anatomica, e sicuramente con ciò ha in mira*

il suo rivale Bonarroti, che di anatomia facea tanta pompa." Note, that Leonardo wrote this passage in Rome, probably under the immediate impression of MICHAEL ANGELO's paintings in the Sistine Chapel and of RAPHAEL's Isaiah in Sant' Agostino.

²¹Ancora nō mancherai [di notare] della varietà che fanno ²²li predetti muscoli intorno alle giv̄ture delli mē²³bri di qualūche animale, mediante la diversità de' ²⁴moti di ciascū mēbro, perchè in alcuno lato d' es²⁵se giūture si perde integralmēte la notitia d'essi musco²⁶li per causa dell' accrescimēto o mācamēto della car²⁷ne, della quale tal muscoli son composti ecc.

Again, do not fail [to observe] the variations in the forms of the above mentioned muscles, round and about the joints of the limbs of any animal, as caused by the diversity of the motions of each limb; for on some side of those joints the prominence of these muscles is wholly lost in the increase or diminution of the flesh of which these muscles are composed, &c.

Ash. I. 7 a]

364.

DELLE DIFFERENTI MISURE CH'È DAI PUTTI ²AGLI OMINI.

³Tra li omini · e i putti nitruovo grā diferēza di lūghezze da l'una all'al⁴tra giv̄tura ·, imperochè l'omo à · dalla giūtura della spalla al gomito ⁵e dal gomito alla pūta del dito grosso e da l'vn omero della spalla ⁶all'altra due teste per pezzo, e 'l putto n'à una perchè la natura ci cōpone ⁷prima la grādezza della casa dello ītelletto · che quella delli spiriti ⁸vitali.

OF THE DIFFERENT MEASUREMENTS OF BOYS AND MEN.

There is a great difference in the length between the joints in men and boys for, in man, from the top of the shoulder [by the neck] to the elbow, and from the elbow to the tip of the thumb and from one shoulder to the other, is in each instance two heads, while in a boy it is but one because Nature constructs in us the mass which is the home of the intellect, before forming that which contains the vital elements.

W. 240 b]

365.

DE' PICTURA.

²Quali muscoli sono quelli che si diuidono ³nello inuechiare o ne' giouani che dimagrano? ⁴Quali son li lochi nelle mēbra vmane doue ⁵per nessuna qualità di grassezza mai la carne ⁶non cresce nè per nessū grado di magrezza ⁷mai la carne non diminuisce?

⁸Quel che si ricerca in questa dimanda fia ⁹trouato in tutte le giunture superfitiali delle ¹⁰ossa, come spalla, gomito, giunture delle mā ¹¹e delle dita, fianchi, ginochi, cauigli e dita de' piè ¹²e simili cose, le quali si diranno ai lochi loro; ¹³le maggior grossezze, che acquistino le mēbra, ¹⁴sono in quella parte del muscolo ch'è più dis¹⁵tante ai sua fermamēti.

¹⁶La carne non cresce mai in quella parte del¹⁷li ossi che son vicini alla superfitie de' mēbri.

OF PAINTING.

Which are the muscles which subdivide in old age or in youth, when becoming lean? Which are the parts of the limbs of the human frame where no amount of fat makes the flesh thicker, nor any degree of leanness ever diminishes it?

The thing sought for in this question will be found in all the external joints of the bones, as the shoulder, elbow, wrists, finger-joints, hips, knees, ancle-bone and toes and the like; all of which shall be told in its place. The greatest thickness acquired by any limb is at the part of the muscles which is farthest from its attachments.

Flesh never increases on those portions of the limb where the bones are near to the surface.

musscholi. 24. ciasschū . . alchuno. 25. giūchere . . musscho. 26. accresscimēto o māchamēto. 27. musscholi chonpossti.
364. 1. diferenti. 2. elli. 3. diferēza . . lūgeze. 4. spala. 5. dallun. 6. pezo na î perche. 7. grādeza . . intelleto.
365. 2. musscoli . . chessi diuidano. 3. ōne gouani. 5. grosseza. 6. cresscie . . magreza. 7. diminuissce. 8. chessi ricercha.
9. gunture. 10. gunture. 11. chauichi. 12. essimile. 13. maggor grosseze. 14. e in . . musschulo. 15. al. 16. cressce.

[18]In *b · r d a c e f* mai l'accrescimēto o diminutio[19]ne della carne fa troppa differentia; [20]La natura à posto nel moto dell'omo tutte quel[21]le parti dinanti, le quali, percotēdo l'omo, abbia a [22]sentire doglia, e questo si sente ne' fusi del[23]le ganbe e nella fronte e naso, ed è fatto a cō[24]seruatione dell'omo, inperochè se tale dolore [25]nō fussi preparato in essi mēbri, cierto le molte [26]percussioni in tali mēbra riceuute sarebbero causa della [27]lor distruttione.

[28]Descriui perchè l'ossi delle braccia ganbe son doppi in[29]uerso delle mani e de' piedi;

[30]Doue la carne cresce o diminuisce nelle piegature [31]delle menbra.

At *b r d a c e f* the increase or diminution of the flesh never makes any considerable difference. Nature has placed in front of man all those parts which feel most pain under a blow; and these are the shin of the leg, the forehead, and the nose. And this was done for the preservation of man, since, if such pain were not felt in these parts, the number of blows to which they would be exposed must be the cause of their destruction.

Describe why the bones of the arm and leg are double near the hand and foot [respectively].

And where the flesh is thicker or thinner in the bending of the limbs.

E. 6*b*] 366.

PICTURA.

[2]Ogni parte d'ū tutto sia proportionata [3]al suo tutto ‖ come se vno homo è di [4]figura grossa e corta che il medesimo [5]sia in se ogni suo mēbro, cioè: braccia corte [6]e grosse, mani larghe grosse e corte dita col[7]le sue giūture nel sopra detto modo, e co[8]sì il rimanēte ·; el medesimo intēdo aue[9]re detto delli vniversi animali e piāte [10]così nel diminuire per le proportionalità [11]delle grossezze come nello ingrossarle.

OF PAINTING.

Every part of the whole must be in proportion to the whole. Thus, if a man is of a stout short figure he will be the same in all his parts: that is with short and thick arms, wide thick hands, with short fingers with their joints of the same character, and so on with the rest. I would have the same thing understood as applying to all animals and plants; in diminishing, [the various parts] do so in due proportion to the size, as also in enlarging.

Ash. I. 7*a*] 367.

DELLA CŌUENTIONE DELLE MĒBRA.

[2]E ancora ti ricordo · che tu abbi grāde auertēza · nel dare le mēbra [3]alle figure · che paino, dopo l'essere cōcordāti alla · grādezza del corpo, [4]ācor similmēte all'età, cioè a giovani mēbra cō pochi mvscoli e vene [5]e dilicata superfitie · e rotōde, di grato colore, Ali omini sieno nerbose [6]e piene di mvscoli ·, Ai vechi sieno cō superficie grīze ruvide e venose [7]e nervi molto evidēti.

OF THE AGREEMENT OF THE PROPORTION OF THE LIMBS.

And again, remember to be very careful in giving your figures limbs, that they must appear to agree with the size of the body and likewise to the age. Thus a youth has limbs that are not very muscular not strongly veined, and the surface is delicate and round, and tender in colour. In man the limbs are sinewy and muscular, while in old men the surface is wrinkled, rugged and knotty, and the sinews very prominent.

17. chesson. 18. la cresscimēto. 19. diferentia. 20. possto. 21. parte . . abbia as. 22. ecquesto si [ue] sente. 23. ennaso ed effatto a chō. 24. inperochessi. 26. sarē chausa. 27. desstructione. 28. desscriui . . Iosse . . br. 30. cresce o diminuissce.
366. 2. tucto. 3. suottutto ‖ chome. 4. fighura . . chorta. 5. br corte. 6. chorte dital chol. 7. le sugiūture . . e cho. 8. indēde. 9. eppiāte. 10. chosi. 11.. grosseze chome delle.
367. 1. dela. 2. "[chome]" e anchora ti richordo chettu. 3. ale . . lesere grādeza. 4. acor . . aleta che a. 5. retōde . . cholore.

Come i puttini · àno le givnture cõtrarie alli omini nelle loro grossezze.

[10]I putti piccoli · àno tutte · le giṽture · sottili e li spati, posti fra l'una e l'al[11]tra ·, sono grossi e questo · accade · perchè la pelle sopra le giṽture è sola sã[12]z'altra polpa ed è di natura · di neruo · che cignie e lega īsieme li ossi [13]e la carnosità vmerosa si trova fra l'una · e l'altra givntura [14]inclusa . fra la pelle e l'ossa · ma, perchè l'ossa · sono piv grosse nelle givntu[15]re che īfra le giūture ·, la carne nel crescere dell'omo · viene a lascia[16]re · quella superfluità · che staua fra la pelle · e l'osso: onde la pelle, s'acco[17]sta piv · all'osso e viene a sottigliare le mēbra; e sopra le giū[18]ture, perchè nõ u'è se nõ la cartilaginosa e neruosa pelle, nõ può disec[19]care, e nõ diseccādo · nõ diminuisce ·, onde per queste ragioni i puttini so[20]no sottili nelle giūture · e grossi · infra le giunture come si [21]vede le giunture de' diti, braccia e spalle sottili e concaui busi, e l'omo [22]per lo cõtrario · essere grosso · ī tutte le giṽture, dita, braccia, gãbe e dove [23]i puttini ànno i fori, loro aver di rilieuo.

How young boys have their joints just the reverse of those of men, as to size.

Little children have all the joints slender and the portions between them are thick; and this happens because nothing but the skin covers the joints without any other flesh and has the character of sinew, connecting the bones like a ligature. And the fat fleshiness is laid on between one joint and the next, and between the skin and the bones. But, since the bones are thicker at the joints than between them, as a mass grows up the flesh ceases to have that superfluity which it had, between the skin and the bones; whence the skin clings more closely to the bone and the limbs grow more slender. But since there is nothing over the joints but the cartilaginous and sinewy skin this cannot dry up, and, not drying up, cannot shrink. Thus, and for this reason, children are slender at the joints and fat between the joints; as may be seen in the joints of the fingers, arms, and shoulders, which are slender and dimpled, while in man on the contrary all the joints of the fingers, arms, and legs are thick; and wherever children have hollows men have prominences.

Ash. I. 6*b*] **368.**

Modo di figurare le 18 operationi del'l'omo, [2]fermezza · mouimẽto, corso, [3]ritto, appoggiato, [4]a sedere · chinato · ginochioni · giacēte, sospeso, [5]Portare · esser portato, spīgiere · tirare · battere, [6]essere battuto · aggravare · e levare.

[7][Come debe stare una figura con ū peso in mano [8]Ricordoti.]

Of the manner of representing the 18 actions of man. Repose, movement, running, standing, supported, sitting, leaning, kneeling, lying down, suspended. Carrying or being carried, thrusting, pulling, striking, being struck, pressing down and lifting up.

[As to how a figure should stand with a weight in its hand [8]Remember].

The movement of the human figure (368—375).

A. 28*b*] **369.**

Quello che siede nõ si può leuare in piè, se la parte che dal polo [2]īnanzi · nõ pesa · piv · che quella · che da esso · polo · indirieto, sanza forza di braccia;

A sitting man cannot raise himself if that part of his body which is front of his axis [centre of gravity] does not weigh more than that which is behind that axis [or centre] without using his arms.

6. chõ. 7. nerbi. 8. chome. 9. grosseze. 10. picholi . . elli . . fralluna ellal. 11. ecquesto . achade . . pele essola. 13. ella . . omorosa . . ellaltra. 14. fralla . . ellossa . . nele. 15. cresscere . . lasci. 16. fralla . . ellosso. 17. assottigliare le mēbra [e nelle] esopra. 18. no po dise. 20. infralle. 21. esspali sittilli . . eleomo. 22. br gãbe. 23. ano.

368. 1. operatione. 2. fermeza chorso. 3. Ricto apogiato. 4. assedere . . diaciēte. 6. agravare. 7. stare ī figura . . imano.

369. 1. quelo chessiede . . leuare [dassede] in. 2. brazo. 3. quela che . . locho chonviene magiore. 4. chioe. 6. alchuno . .

368. 8. The original text ends here. **369.** See Pl. XXII, No. 4.

³Quello che mōta ī qualunque loco conviene che dia · di se · maggiore · peso ⁴dināti al piè piv alto · che dirieto, cioè dināti al polo che dirieto a esso · polo, ⁵adūque · l'omo darà di se sēpre · maggiore · peso · inverso · quella · parte dove disidera ⁶moversi che in alcuno · altro · loco;

⁷Quello · che piv · corre · piv pende īuerso · il loco doue corre e da di se maggiore ⁸peso dinanzi · al polo suo · che dopo; quello che corre alla china fa ⁹il suo polo sulle calcagnia, e quello che corre all'erta · lo fa sulle pūte ¹⁰de' piedi ·, e quello che corre alla pianvra lo fa prima ai calcagni e poi ¹¹nelle · punte de' piedi;

¹²Questo nō porterà il suo peso, se nō ristora colla persona tirata īdirieto ¹³il peso dināzi: ī modo che sēpre il piè che posa · si troui in mezzo del peso.

A man who is mounting any slope finds that he must involuntarily throw the most weight forward, on the higher foot, rather than behind—that is in front of the axis and not behind it. Hence a man will always, involuntarily, throw the greater weight towards the point whither he desires to move than in any other direction.

The faster a man runs, the more he leans forward towards the point he runs to and throws more weight in front of his axis than behind. A man who runs down hill throws the axis onto his heels, and one who runs up hill throws it into the points of his feet; and a man running on level ground throws it first on his heels and then on the points of his feet.

This man cannot carry his own weight unless, by drawing his body back he balances the weight in front, in such a way as that the foot on which he stands is the centre of gravity.

W. An. III, 67 b] 370.

Come fa l'omo a levarsi ²in piedi stādo a sedere ³in terra piana.

How a man proceeds to raise himself to his feet, when he is sitting on level ground.

F. 83 a] 371.

L'omo che camina è piv veloce col ca²po che co' piedi.

³L'uomo che caminādo attraver⁴sa tutto vn sito piano, va ⁵prima alla china e poi altre⁶tanto all'erta.

A man when walking has his head in advance of his feet.

A man when walking across a long level plain first leans [rather] backwards and then as much forwards.

S. K. M. II.² 14 a] 372.

L'omo nel correre dà di se mi²nor peso alle gāmbe che a sta³re fermo; E similmēte ⁴il cavallo che corre sente minor ⁵peso dell'omo ch'esso porta, ⁶ōde molti si fanno maraviglia ⁷che nel corso del cavallo esso

A man when running throws less weight on his legs than when standing still. And in the same way a horse which is running feels less the weight of the man he carries. Hence many persons think it wonderful that, in running, the horse can rest on one single

locho. 7. quelo che . . chore . . locho . . chore magiore. 8. peso [dopo] dinanzi . . quelo che chore. 9. chal chagnia ecquello che chore. 10. ecquello . . chore .·. chal chagni. 11. nell. 12. chola persono. 13. imodo . . imezo.
370. 1. allevarsi. 2. assedere.
371. 4. sa [vn sit] tutto. 5. cina.
372. 2. assta. 4. chorre. 8. regiere. 11. piv he veloce.

371. 3—6. He strides forward with the air of a man going down hill; when weary, on the contrary he walks like a man going up hill.

[8]si possa reggere sopra vn sol [9]piede, ōde si dirà, che 'l pe[10]so in moto traversale, quā[11]to piv è veloce, tāto mē pe[12]sa perpendiculare verso il ciētro.

foot. From this it may be stated that when a weight is in progressive motion the more rapid it is the less is the perpendicular weight towards the centre.

M. 55 a]

373.

Se vno omo, nel pigliare il suo salto [2]sopra loco stabile, salta 3 · braccia, quā[3]do lui nello spiccare del salto sfu[4]gisse indirieto [1]/[3] di braccio che manche[5]rebbe esso poi del primo suo salto, e [6]così se lui fussi aumētato [1]/[3] di [7]braccio quanto accrescierebbe egli del [8]detto salto?

If a man, in taking a jump from firm ground, can leap 3 braccia, and when he was taking his leap it were to recede [1]/[3] of a braccio, that would be taken off his former leap; and so if it were thrust forward [1]/[3] of a braccio, by how much would his leap be increased?

C. A. 178 a; 536 a]

374.

PICTURA.

[2]Quādo l'omo corrēte vol consumare l'inpeto che lo transporta, [3]si prepara a inpetuosità contraria, la qual si gienera col pēdere ī[4]dirieto; provasi, perchè se l'impeto trasporta il mobile cō potentia [5]di 4 e 'l mobile vol tornare e cadere indirieto cō potētia di 4, allo[6]ra l'una potentia consuma l'altra a se cōtraria e l'īpeto si cōsuma.

OF DRAWING.

When a man who is running wants to neutralise the impetus that carries him on he prepares a contrary impetus which is generated by his hanging backwards. This can be proved, since, if the impetus carries a moving body with a momentum equal to 4 and the moving body wants to turn and fall back with a momentum of 4, thèn one momentum neutralises the other contrary one, and the impetus is neutralised.

W. An. II. 203 a]

375.

Quando l'omo vol fermare il suo [2]corso e consumare l'inpeto, nece[3]ssità lo fa pēdere indirieto e fare [4]piccoli e presti passi; [5]senpre il centro del peso dell'omo, che leua [6]l'un de' piedi da terra, resta sopra del centro [7]della pianta del suo piede.

[8]L'uomo che monta sopra le scale [9]dà di se tanto peso inanzi e da costa [10]al più alto piede, che dà contrapeso [11]alla ganba più bassa, onde la fa[12]tica d'essa ganba bassa sol s'astēde [13]in mouere se medesima.

[14]La prima cosa che fa l'omo nel suo mō[15]tare a gradi, esso scarica la gamba che [16]lui vole alzare della grauità del busto che [17]sopra essa ganba si posaua, e ol[18]tre a

When a man wants to stop running and check the impetus he is forced to hang back and take short quick steps. [5]The centre of gravity of a man who lifts one of his feet from the ground always rests on the centre of the sole of the foot [he stands on].

A man, in going up stairs involuntarily throws so much weight forward and on the side of the upper foot as to be a counterpoise to the lower leg, so that the labour of this lower leg is limited to moving itself.

The first thing a man does in mounting steps is to relieve the leg he is about to lift of the weight of the body which was resting on that leg; and besides this, he gives to

Of walking up and down (375—379).

373. 2. locho . . 3 br quā. 3. spichare. 4. gissi . . di br che. 5. del pr suo. 6. chosi sellui. 7. br quanto . . acressciere be.
374. 2. chorrēte . . chello. 3. se pr para. 4. sellinpeto. 5. chadere. 6. asse . . ellīpeto.
375. 3. effere. 4. pichole. 5. chelleua. 6. piedi ti terra. 7. piedi. 8. lesscale. 10. piedi. 12. ticha . . sasstēde. 14. chosa. 15. scharicha. 16. bussto. 17. posaua [onde talga] . e ol. 18. adiquesto . . charicha. 22. piedi. 23. appogga. 24. cossca

375. See Pl. XXIII, No. 1. The lower sketch to the left belongs to the four first lines. Lines 5—31 refer to the two upper figures, and the lower figure to the right is explained by the last part of the chapter.

questo carica l'opposita ganba di [19]tuttc il resto della quantità dell'omo insieme cō [20]l'altra ganba, dipoi alza la gamba e pone il [21]piè di sopra di quel grado, ove esso si uole leua[22]re: fatto questo esso rende al piede alto tutto [23]l'altro peso del busto e della ganba, e appoggia [24]la mano sopra la coscia e caccia la testa inā[25]zi e fa il mouimēto inuerso la punta del piede [26]superiore, alzando con prestezza il calcagno del pie[27]de inferiore, e con quello inpeto si leua in alto e nel [28]medesimo tenpo distende il braccio, ch' egli appoggiaua sopra [29]il ginochio, il qual distendimēto di braccio spigne il bus[30]to e la testa in alto e così dirizza la schiena incur[31]uata;

[32]Quanto il grado, che per l'omo si [33]sale, sarà di maggiore altezza tā[34]to la sua testa sarà più ī[35]nanzi che 'l piede suo superiore; [36]per pesare [37]più *a* [38]che *b*; [39]quest'o[40]mo non [41]sarà [42]nel [43]grado · [44]*m*, [45]mostra [46]la li[47]nia [48]*g f*.

the opposite leg all the rest of the bulk of the whole man, including [the weight of] the other leg; he then raises the other leg and sets the foot upon the step to which he wishes to raise himself. Having done this he restores to the upper foot all the weight of the body and of the leg itself, and places his hand on his thigh and throws his head forward and repeats the movement towards the point of the upper foot, quickly lifting the heel of the lower one; and with this impetus he lifts himself up and at the same time extends the arm which rested on his knee; and this extension of the arm carries up the body and the head, and so straightens the spine which was curved.

[32]The higher the step is which a man has to mount, the farther forward will he place his head in advance of his upper foot, so as to weigh more on *a* than on *b*; this man will not be on the step *m*. As is shown by the line *g f*.

S. K. M. II.² 20a]

376.

[2]Dimādo questo [3]peso dell'omo in o[4]gni grado di moto [5]sopra questa scala, [6]che peso esso dà [7]a *b* e a · *c*.

[8]Guarda la linia [9]perpendiculare [10]sotto il ciētro [11]della gravità [12]dell'uomo.

I ask the weight [pressure] of this man at every degree of motion on these steps, what weight he gives to *b* and to *c*.

[8]Observe the perpendicular line below the centre of gravity of the man.

H.² 27a]

377.

Quādo mōti la scala, se poggi le mā [2]sopra le ginochia, tutta la fatica che [3]acquistano le braccia si toglie ali ner[4]vi di sotto le ginochia.

In going up stairs if you place your hands on your knees all the labour taken by the arms is removed from the sinews at the back of the knees.

L. 27b]

378.

Il nerbo che dirizza la gamba, il quale è [2]congiunto colla padella del ginochio, sē[3]te tanto più fatica a leuare l'omo in alto [4]quanto essa gamba è piv piegata, e il mus-

The sinew which guides the leg, and which is connected with the patella of the knee, feels it a greater labour to carry the man upwards, in proportion as the leg is more bent; and the muscle which acts

echacca. 25. effa . . piedi. 26. chon presteza. 27. di. 28. il br chelli apogaua. 29. di br spigne. 30. ella . . diriza lassciena. 32. lvmosi. 33. salgle . . magore alteza. 35. piedi. 41. sarra. 42. inel.
376. 1—7 R. 7. ha *b* he a *c*. 8. ghuarda iliuo. 9. pérpēdichulare.
377. 1—6 R. 1. lasschala se pogi. 2. sopra e ginochia . . faticha. 3. aquisstano.
378. 1. chi. 2. congunto chol [ginoc] la. 3. faticha alleuare . . altoq. 4. elmuss. 5. diriza . . cheffa la cosscia. 6. conguntione

376. See Pl. XXIII, No. 2. Lines 8—12 are, in the original, written in ink.

377. See Pl. XXIII, No. 3.
379. See Pl. XXIII, No. 4.

⁵colo il quale dirizza l'angolo che fa la coscia ⁶nella congiuntione ch'ella fa col busto, è mē ⁷difficile e à a leuare māco peso, perchè li mā⁸ca il peso della coscia e oltre a questo à mi⁹glori muscoli perchè son quelli che fāno le na¹⁰tiche.

upon the angle made by the thigh where it joins the body has less difficulty and has a less weight to lift, because it has not the [additional] weight of the thigh itself. And besides this it has stronger muscles, — being those which form the buttock.

W. 3 a]

379.

Quel che disciēde fa i passi piccoli, perchè ²il peso resta sopra il piede dirie³to; E quel che sale fa li pas⁴si grādi, perchè il suo peso sta sopra ⁵il piè dinanzi.

A man coming down hill takes little steps, because the weight rests upon the hinder foot, while a man mounting takes wide steps, because his weight rests on the foremost foot.

E. 15 a]

380.

DEL MOTO UMANO.

²Quādo tu vuoi fare l'omo motore d'al-³cuno peso, considera che li moti sono ²da essere fatti per diuerse linie, cioè o di ⁵basso in alto con senplice moto, come ⁶fa quel che chinandosi piglia il peso che ⁷dirizzandosi vole alzare; O quādo ⁸si uole schiacciare alcuna cosa diri⁹eto overo sospignere ināti o voi ¹⁰tirare inbasso con corda che passa per car¹¹rucole, Qui si ricorda che 'l peso del¹²l'omo tira tanto quāto il cientro della ¹³gravità sua è fori del ciētro del suo sostē¹⁴tacolo ¶e ¹⁵a questo s'a¹⁶giugne la for¹⁷za che ¹⁸fā le gan-¹⁹be e la schie²⁰na piega²¹ta nel suo ²²dirizzarsi.¶

OF THE HUMAN BODY IN ACTION.

When you want to represent a man as moving some weight consider what the movements are that are to be represented by different lines; that is to say either from below upwards, with a simple movement, as a man does who stoops forward to take up a weight which he will lift as he straightens himself. Or as a man does who wants to squash something backwards, or to force it forwards or to pull it downwards with ropes passed through pullies [10]. And here remember that the weight of a man pulls in proportion as his centre of gravity is distant from his fulcrum, and to this is added the force given by his legs and bent back as he raises himself.

On the human body in action (380—388).

Mz. 13 a (17)]

381.

¶L'uomo ancor lui à ma²ggior soma di forza ³nelle ganbe che nō ⁴si richiede al peso suo, e che ciò ⁵si è vero, posa in piedi l'o⁶mo sopra la litta e poi metti ⁷vn altro homo adosso, e ve⁸drai quanto più si profonda; ⁹Di poi li lieua l'omo da dosso ¹⁰e fallo saltare in alto a dirit¹¹tura quāto esso può e troue¹²rai la stāpa del suo pie¹³de essersi più profondata nel ¹⁴salto che coll'omo adosso; adū¹⁵que qui per 2 modi è prouato l'omo ¹⁶aver più forza il doppio che non si richiede a sostenere se medesimo.¶

Again, a man has even a greater store of strength in his legs than he needs for his own weight; and to see if this is true, make a man stand on the shore-sand and then put another man on his back, and you will see how much he will sink in. Then take the man from off his back and make him jump straight up as high as he can, and you will find that the print of his feet will be made deeper by the jump than from having the man on his back. Hence, here, by 2 methods it is proved that a man has double the strength he requires to support his own body.

. . bussto. 7. dificile. 8. cha . . cosscia . . adiquesto. 9. musscoli . . quelle cheffano.

379. 1. chedissciēde . . piccoli. 2. ressta . . piedi. 3. Ecquel chessaglie fallipa. 5. dinanza.

380. 1. de. 3. alchuno, chonsidera. 5. baso . . senplici. 6. facquel . . ched. 7. Occquādo. 8. isstracinare alchuna chosa. 9. sosspigniere. 10. chorda . . per cha. 11. ruchola . . richorda. 14. tacholo. 17. chef. 18. faleghan. 19. be esscie. 20. piegha. 22. dirizarsi.

380. 10. Compare the sketch on page 198 and on 201 (S. K. M. II.¹ 86 b).

C. A. 341 a; 1052 a] 382.

DE PICTURA.

²Se tu ài a figurare vno homo che moui o che leui ³o tiri o porti vno peso simile al suo, in che modo ⁴li debi accōciare le ganbe sotto alla sua persona?

OF PAINTING.

If you have to draw a man who is in motion, or lifting or pulling, or carrying a weight equal to his own, in what way must you set on his legs below his body?

A. 30 b] 383.

DELLA · FORZA · DELL' OMO.

²L' omo ·, tirando · vno · peso · in bilancia · cō se ·, nō può · tirare · se nō tanto · quāto · pesa lui, ³e s'egli à a leuare · egli leuerà tāto · piv · che nō pesa · quāto · lui avāza · la comvne · forza ⁴delli · altri omini ‖ la maggior · forza · che possa · fare l' omo · con pari prestezza ⁵e movimēto · si è quādo · lui · fermerà · i piedi · sopra · l' una · delle teste · delle bilācie · e pō- ⁶tera le spalle · in qualche · cosa stabile: questo · leuerà · dal- l' oposita · testa · della · bilācia ⁷tāto · peso · quāto lui · pesa · e · tāto · peso · quāto · lui · a forza porta in sulle spalle.

OF THE STRENGTH OF MAN.

A man pulling a [dead] weight balanced against himself cannot pull more than his own weight. And if he has to raise it he will [be able to] raise as much more than his weight as his strength may be more than that of other men. The greatest force a man can apply, with equal velocity and impetus, will be when he sets his feet on one end of the ba- lance [or lever] and then presses his shoulders against some stable body. This will raise a weight at the other end of the balance [lever], equal to his own weight and [added to that] as much weight as he can carry on his shoulders.

S. K. M. III. 58 b] 384.

Nessuno ²animale può sē³plicemēte mo- vere piv peso ⁴che sia la soma · che si tro⁵va · fori del ciētro del suo sostenta- culo.

No animal can simply move [by its dead weight] a greater weight than the sum of its own weight outside the centre of his fulcrum.

S. K. M. I.² 7] 385.

Quello che uol · trarre · assai da lunga · coll' arco · debbe ²tirarsi · tutto insù ū piè, leuādo l' altro · tāto · lōn- tano da ³quello · che facci debito cō- trapeso alla persona che si gitta ⁴fori del primo piè, e non tēga · di- steso īteramēte il braccio, ⁵e accio chè possa meglio sostenere la fa- tica, tēga all' arco v̄ legnio che ⁶a

A man who wants to send an arrow very far from the bow must be stan- ding entirely on one foot and raising the other so far from the foot he stands on as to afford the requisite counter- poise to his body which is thrown on the front foot. And he must not hold his arm fully extended, and in order that he may be more able to bear the

381. 2. gor soma di forza [che nō si]. 3. [richiede] nelle ganbe ne nō. 4. cio *is wanting*. 6. sopralabita e pōmetti. 10. effalo. 12. rai esse la. 13. di essersi. 16. riciede assossenere.

382. 2. affigurare . . chelleui. 3. ottiri . . enche. 4. achōciare.

383. 2. chōse nōpo. 3. essiliallenare . li . . chomvne. 4. magior . . chompari presteza. 6. lesspalli . . chosa. 7. ettanto.

384. 2. po. 4. chessia la soma chessi truo. 6. sosttentachulo.

385. 1. uuol . . dallunga chollarcho. 2. insurū. 3. quuello cheffacci chessi. 4. desteso. 5. meglio sostenere la . . archo.

382. In the MS. this question remains unanswered.
383. 7. The stroke at the end of this line finishes in the original in a sort of loop or flou- rish, and a similar flourish occurs at the end of the previous passage written on the same page.

M. RAVAISSON regards these as numbers (compare the photograph of page 30ᵇ in his edition of MS. A). He remarks: *"Ce chiffre 8 et, à la fin de l' alinéa précédent, le chiffre 7 sont, dans le manuscrit, des renvois."*

vso di tenieri vada dalla mano · alla pop-
pa, e quãdo ⁷vuol lassare, subito a v̄
tēpo salti īnāti ⁸e distēda il braccio del-
⁹l'arco e lassi la corda, ¹⁰e se cō destrezza
¹¹farà ogni cosa ¹²in un tēpo, farà as-
¹³sai via.

strain he must hold a piece of wood which
there is in all crossbows, extending from
the hand to the breast, and when he wishes
to shoot he suddenly leaps forward at the same
instant and extends his arm with the bow and
releases the string. And if he dexterously does
every thing at once it will go a very long way.

Leic. 8 a] **386.**

···Quando due omini ²sono in nelli stremi
opposití d'vn pancone posto in bilancia in-
sieme coll'equal peso delli omini, e che l'ū
di lo³ro voglia spiccare vn salto in alto ·
allora esso salto sarà fatto in giù dal suo
stremo di pancone ⁴e l'omo non si leuerà
mai in alto, ma resterà nel suo sito insino che
l'opposito omo li ribatte il pãcō ne' ⁵piedi.

When two men are at the opposite ends
of a plank that is balanced, and if they are
of equal weight, and if one of them wants
to make a leap into the air, then his leap
will be made down from his end of the plank
and the man will never go up again but
must remain in his place till the man at the
other end dashes up the board.

W. 1 a] **387.**

Dello scaricare il colpo ²a destra o si-
nistra.

Of delivering a blow to the right or
left.

C. A. 344 b; 1066 a] **388.**

Perchè l'inpeto nō si può inmediate con-
sumare ma si\\\\\\\\\²endo per qualunche linia;
l'inpeto adunque acquistato per la linia
³ *a b c d* si consuma per la linia *d e*, ma
non è in tãto che nō ui res⁴ti parte della sua
potētia, alla qual potētia, aggiunto il moto
⁵della linia *d e* colla forza, del suo motore,
è necessario, che si ⁶moltiplichi l'inpeto
alla percussione e più che non avrebbe fa⁷tto
il senplice inpeto nato dal moto *d e*.

⁸L'uomo che à · a dare grã percussione
colla sua arme ⁹si dispone con tutta la sua
potentia in contraria parte a quella ¹⁰dov'è
il loco che da lui debbe essere percosso ·,
e perchè la cosa ¹¹che piv si move si fa
più potēte sopra della cosa che tal mo¹²to
impedisce.

Why an impetus is not spent at once [but
diminishes] gradually in some one direction?
The impetus acquired in the line *a b c d* is
spent in the line *d e* but not so completely
but that some of its force remains in it and
to this force is added the momentum in the
line *d e* with the force of the motive power,
and it must follow than the impetus multi-
plied by the blow is greater that the simple
impetus produced by the momentum *d e*.

[8]A man who has to deal a great blow
with his weapon prepares himself with all his
force on the opposite side to that where the
spot is which he is to hit; and this is be-
cause a body as it gains in velocity gains
in force against the object which impedes its
motion.

6. pop"a" eghuãdo. 7. vuo. 8. praccio. 10. esse chō destreza. 11. fara ōni. 12. nun.
386. 2. inelli . oposití . chellundilor. 3. spichare . . allorara. 4. ellomo . . chello.
387. 2. ossinistra.
388. 1. linpeto [no] nō sipo. 2. acquisstato. 4. sti parte . . agunto. 6. perchussione . . arebbe. 7. senplice [moto] inpeto.
8. che a . . perchussione cholla. 9. disspone . . acquella. 10. locho che dallui . . perchosso . . perchella. 11. chettal.
12. inpedissce.

386. See Pl. XXIV, No. 3.
387. Four sketches on Pl. XXIV, No. 1 belong
to this passage. The rest of the sketches and notes
on that page are of a miscellaneous nature.

388. 1. The paper has been damaged at the
end of line 1. The sketch No. 2 on Pl. XXIV
stands, in the original, between lines 7 and 8.
Compare also the sketches on Pl. LIV.

On hair falling down in curls.

Nota il moto del liuello ²dell' acqua, il quale fa a vso ³de' capelli, che ànno due ⁴moti, de' quali l'uno attēde al ⁵peso del uello, l'altro al linia⁶mento delle volte; così l'acqua ⁷à le sue volte revertigino⁸se, delle quali vna parte attende ⁹al inpeto del corso principale, l'al¹⁰tro attēde al moto incidēte e reflesso.

Observe the motion of the surface of the water which resembles that of hair, and has two motions, of which one goes on with the flow of the surface, the other forms the lines of the eddies; thus the water forms eddying whirlpools one part of which are due to the impetus of the principal current and the other to the incidental motion and return flow.

DELLE NATURE DELLE · PIEGHE DE' PANNI.

OF THE NATURE OF THE FOLDS IN DRAPERY.

On draperies (390—392).

¶ ²Quella parte · della piega · che si trova · piv lontana · dai sua costretti ³stremi · si riducierà più in sua · prima · natura; ¶

⁴Naturalmēte ogni · cosa · desidera · mātenersi · in suo · essere; ⁵Il panno · perchè è di equale · densità · e spessitudine, sì nel suo ⁶rouescio · come nel suo · diritto ·, disidera · di stare · piano: onde ⁷quando · lui · è da qualche · piega o falda · costretto · a lasciare ⁸essa planitia ·, osserua · la natura · della forza · in quella · parte ⁹di se dov' elli è · piv · cōstretto ·, e quella · parte ch' è piv · lontana ¹⁰a essi costrignimēti · troverai riducersi · piv alla · prima ¹¹sua · natura · cioè dello · stare disteso · e āpio.

That part of a fold which is farthest from the ends where it is confined will fall most nearly in its natural form.

Every thing by nature tends to remain at rest. Drapery, being of equal density and thickness on its wrong side and on its right, has a tendency to lie flat; therefore when you give it a fold or plait forcing it out of its flatness note well the result of the constraint in the part where it is most confined; and the part which is farthest from this constraint you will see relapses most into the natural state; that is to say lies free and flowing.

ESĒPLO.

EXAMPLE.

¹³Sia · a · b · c · la piega · del panno · detto di sopra: a · c · sia il lo¹⁴co · doue · esso · panno piegato è costretto · io ti pro¹⁵posi, che Quella · parte · del pāno che era piv lontana · ai costretti stremi ¹⁶si ridurebbe piv · in nella · sua · prima · natura.

¹⁷Adunque · b · trouādosi · piv · lontano · da · a · c · li la piega ¹⁷a · b · c · fia piv · larga · che in nessun altro · suo · loco.

Let a b c be the fold of the drapery spoken of above. a c will be the places where this folded drapery is held fast. I maintain that the part of the drapery which is farthest from the plaited ends will revert most to its natural form.

Therefore, b being farthest from a and c in the fold a b c it will be wider there than anywhere else.

389. 1. deliello. 2. acq"a". 3. chapelli. 6. lacq"a". 7. alle . . reveruertigino. 10. refresso.
390. 1. piege. 2. chessi . . chostretti. 4. chosa . . suo . sessere. 5. espessitudine. 6. riuerscio chome. 7. offalda . cosstretto allasciare. 9. chōstretto . ecquella. 10. chosstrignimēti. 11. āplio. 13. a b sia. 14. cho chōstretto. 15. chostretti. 16. inella. 18. locho.

389. See Pl. XXV. Where also the text of this passage is given in facsimile.
390. See Pl. XXVIII, No. 6, and compare the

drawing from Windsor Pl. XXX for farther illustration of what is here stated.

13. *a c sia.* In the original text *b* is written instead of *c*—an evident slip of the pen.

Ash. I. 17*b*]　　　　　　　**391.**

DELLE POCHE PIEGHE NE' PĀNI.

²Come le figure, essēdo vestite di mā-
tello, nō debono tāto mostrare · lo nvdo
³che 'l mātello paia ī sulle · carni, se già ·
tu nō volessi · che 'l ⁴mātello · fusse · sulle
carni, īperochè tu debi pensare che tra 'l mante-
⁵llo · e le carni sono altre vesti che īpe-
discono lo scoprire e 'l pare⁶re la forma
delle mēbra · sopra il mātello; e quelle mē-
bra che fai ⁷discoprire · fa · le in modo
grosse che li apparisca sotto il mātello altre
⁷vestimēta, ma solo farai scoprire la quasi
uera grossezza delle mēbra ⁹a una · nīfa o
uno āgielo, i quali si figurano · vestiti di sot-
tili vestimēti ¹⁰sospīti e īpressi dal soffiare
de' uēti sopra le mēbra · di dette figure.

OF SMALL FOLDS IN DRAPERIES.

How figures dressed in a cloak should
not show the shape so much as that the
cloak looks as if it were next the flesh;
since you surely cannot wish the cloak to
be next the flesh, for you must suppose that
between the flesh and the cloak there are other
garments which prevent the forms of the limbs
appearing distinctly through the cloak. And
those limbs which you allow to be seen you
must make thicker so that the other garments
may appear to be under the cloak. But only give
something of the true thickness of the limbs to a
nymph [9] or an angel, which are represented in
thin draperies, pressed and clinging to the limbs
of the figures by the action of the wind.

Ash. I. 18*a*]　　　　　　　**392.**

Come a uno pāno non si deve dare
cōfusione di molte pieghe, anzi ne fa so-
²lamēte doue colle mani
o colle braccia sono rite-
nvte, il resto sia ³lasciato
cadere sēplicemēte doue
lo tira sua natura, e nō
sia ītra⁴versato lo ignvdo
da troppi liniamēti o rōpi-
mēti di pieghe;
　⁵Come i pāni si debō
ritrare di naturale, cioè se
uorai fare pāno lano usa
le ⁶'pieghe secōdo quello,
e se sarà seta o pāno fino
o da vilani o di lino o di
ue⁷lo, va diuersificādo · a
ciascuno · le sue pieghe,
e nō fare abito come
molti ⁸fāno sopra i mo-
delli coperti di carte o
corami sottili · che t'īganneresti forte.

You ought not to give to drapery a
great confusion of many folds, but rather only
introduce them where they
are held by the hands or
the arms; the rest you may
let fall simply where it is
its nature to flow; and do
not let the nude forms be
broken by too many de-
tails and interrupted folds.
　How draperies should
be drawn from nature: that
is to say if you want to re-
present woollen cloth draw
the folds from that; and if
it is to be silk, or fine cloth
or coarse, or of linen or of
crape, vary the folds in
each and do not represent
dresses, as many do, from
models covered with pa-
per or thin leather which will deceive you greatly.

391. 4. fussi sule . . īperochettu . . chettra. 5. elle charni . īpedischano lo scorire. 6. cheffai. 7. fa . lle imodo . . chellia-
parisca. 8. massolo . . grosseza. 9. o ī agielo.

392. 1. a ī pāno nōn si de dare . . piege. 2. cholle . . o cholle. 3. chadere . . e nō sua ītra. 4. lo nvdo . . tropi. 5. coi pani
. . pano lano. 6. pege sechōdo . . pano fine. 7. diuersifichādo a ciaschuno . . piege . . come mol. 8. fano . . modeli
. chettīganeresti.

　391. The little pen and ink drawing from Windsor
(W. 102), given on Pl. XXVIII. No. 7, clearly illus-
trates the statement made at the beginning of this
passage; the writing of the cipher 19 on the same

page is in Leonardo's hand; the cipher 21 is certainly not.
　9. *Una nīfa.* Compare the beautiful drawing of
a Nymph, in black chalk from the Windsor col-
lection, Pl. XXVI.

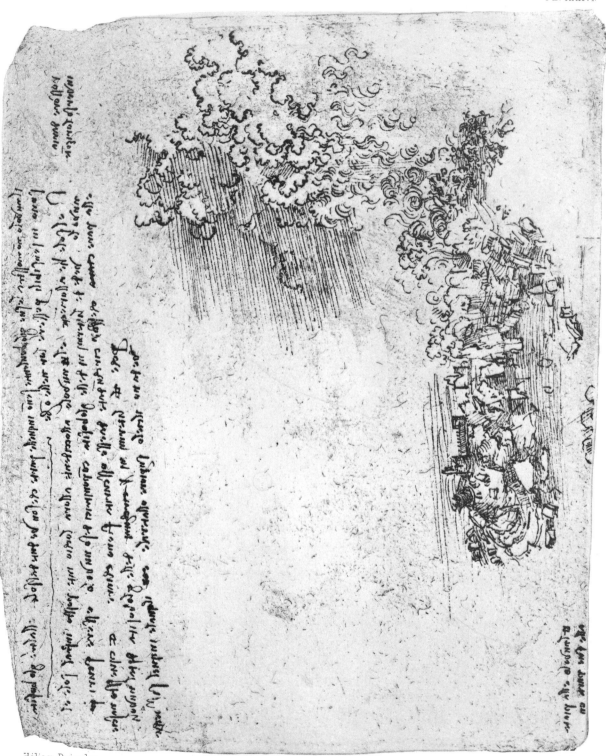

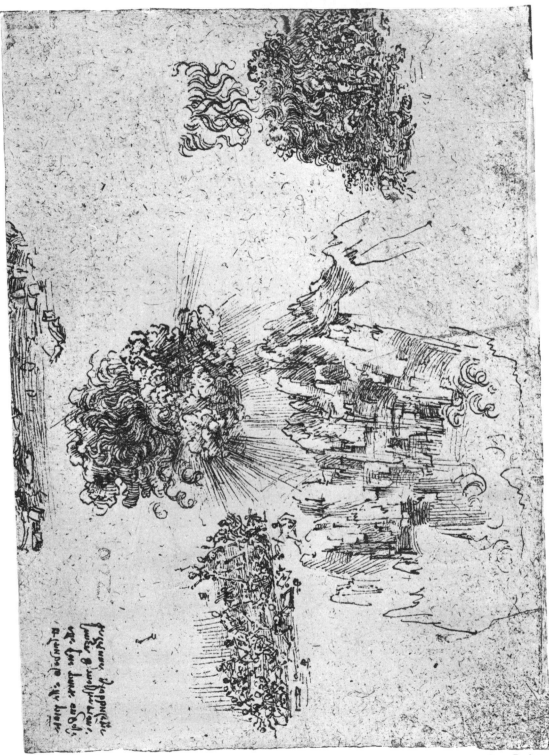

tutte le parte della sua grossezza de eguali moto, ma quella
fia di piu tardo discenso et fia piu remota dalla linea centrale
della sua grossezza / e questo nascie p le pte piu remot
del centro e piu mixta co laria et quella ch e vicina
al mezzo je p questo si fa piu lieue e quato e piu lieue piu si
fa tarda e il medesmo intendasi del fumo nel moto suo
contrario a ello dellaqua ————

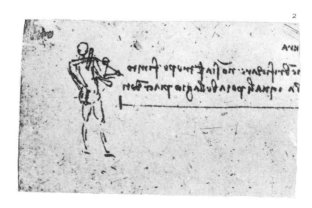

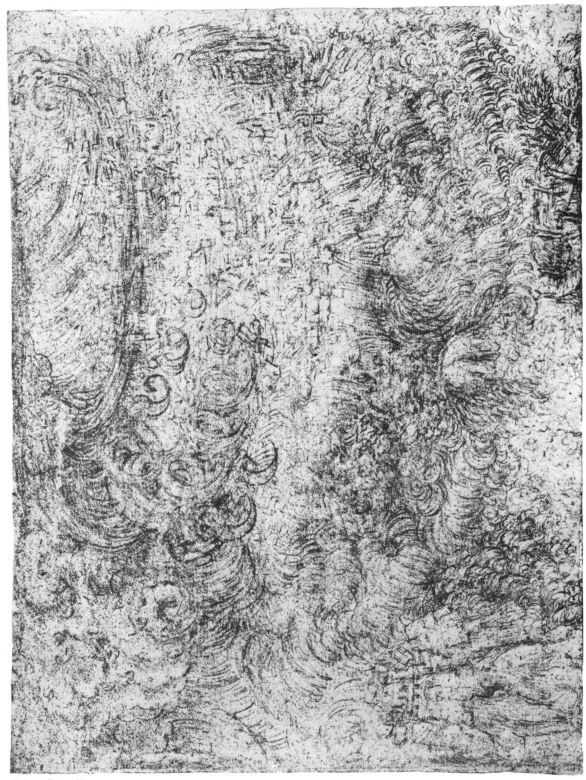

Heliog. Dujardin.

Imp. Eudes.

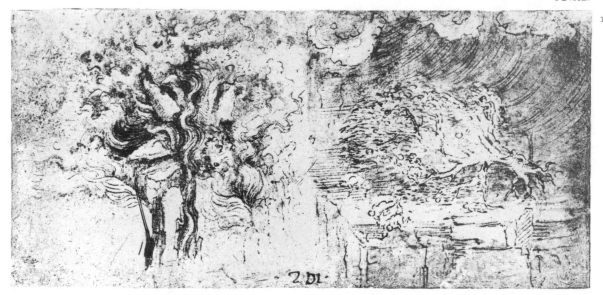

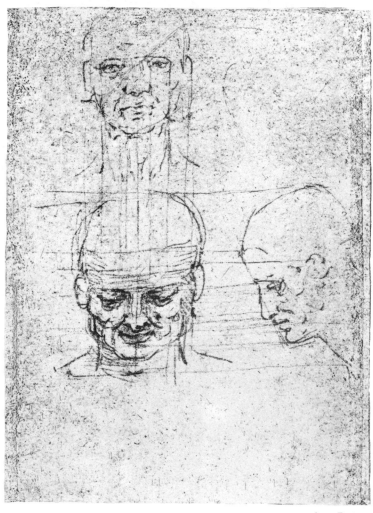

Héliog. Dujardin.

Imp. Eudes.

1

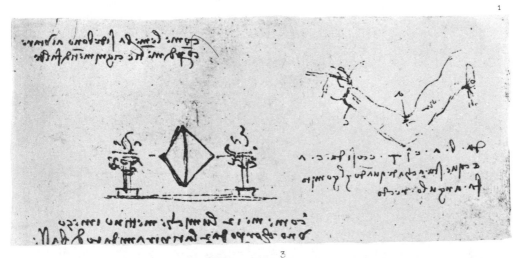

3

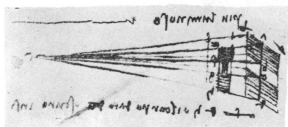

2

4

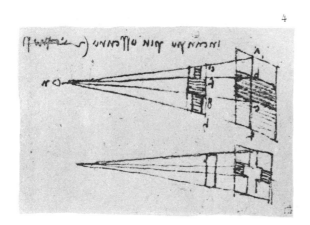

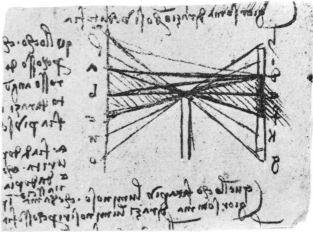

5

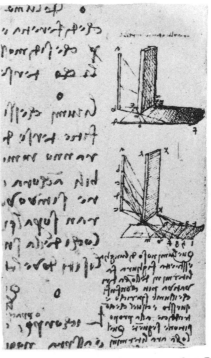

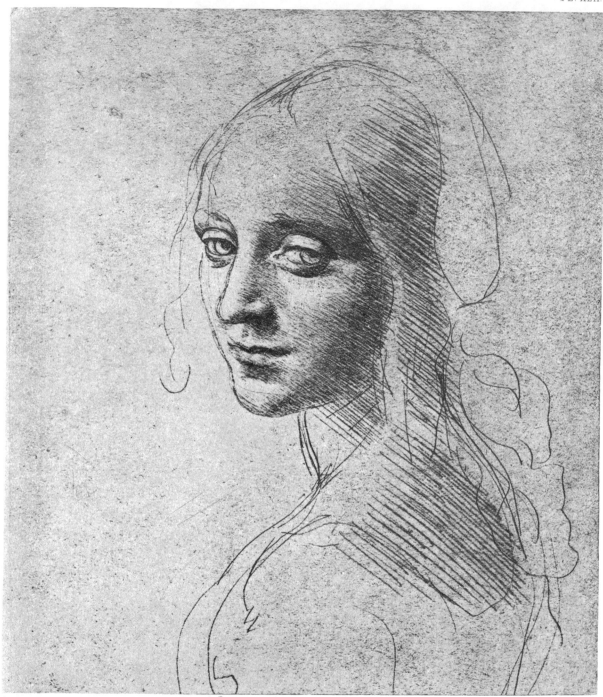

Héliog. Dujardin.

Imp. Eudes.

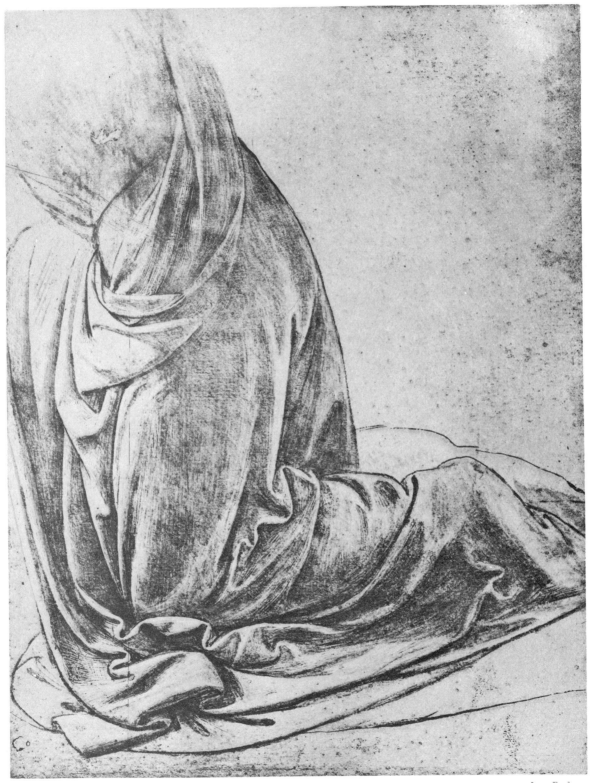

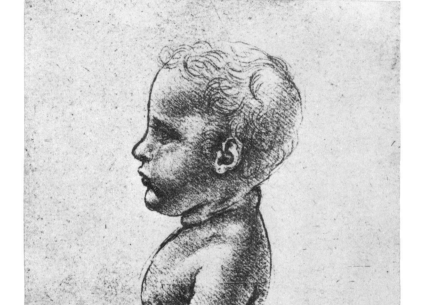

Héliog. Dujardin.

Imp. Eudes.

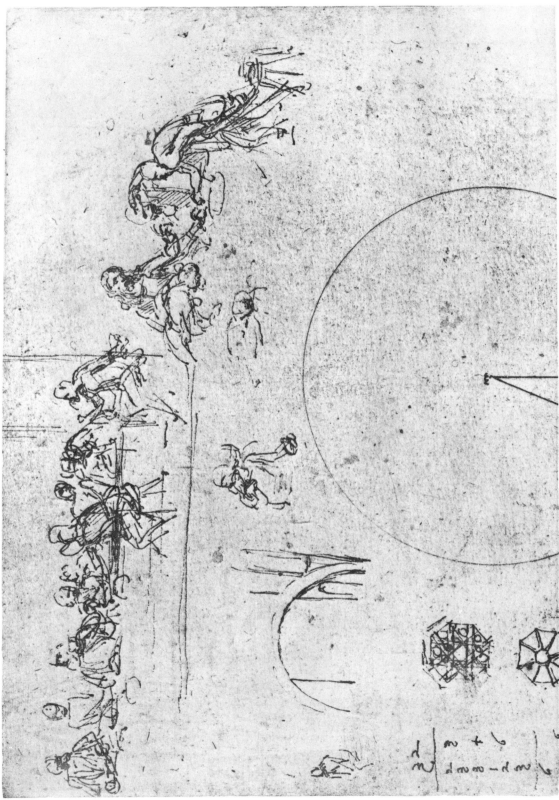

Héliog. Dujardin.

Imp. Eudes.

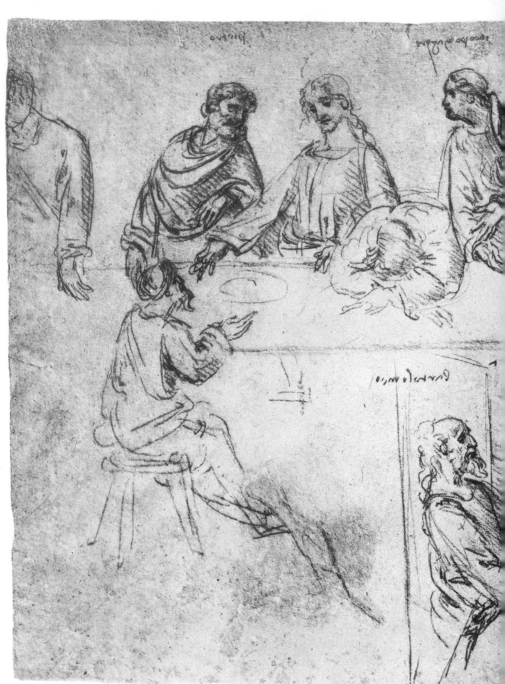

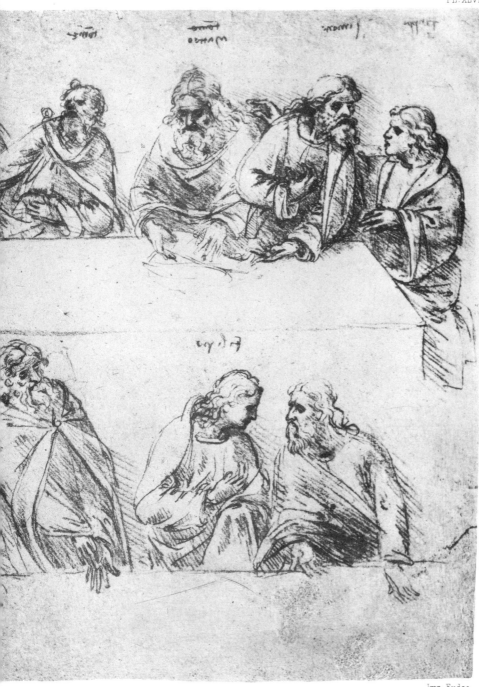

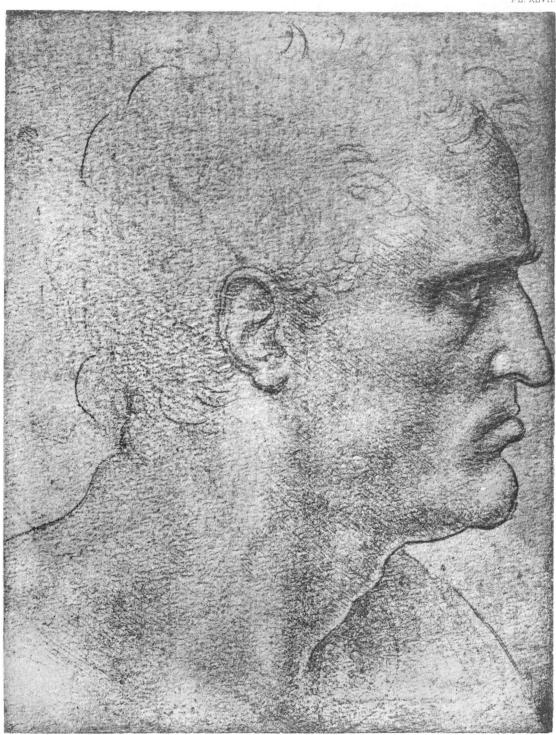

Heliog. Dujardin.

Imp. Eudes.

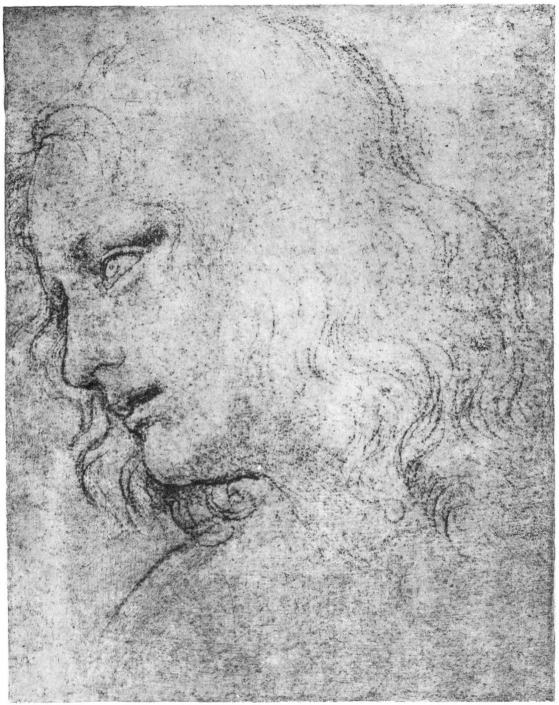

Héliog. Dujardin.

Imp. Eudes.

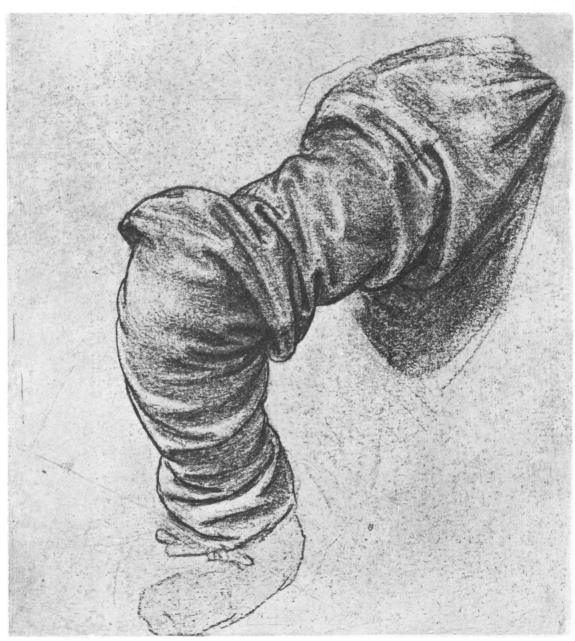

Heliog. Dujardin.

Imp. Eudes

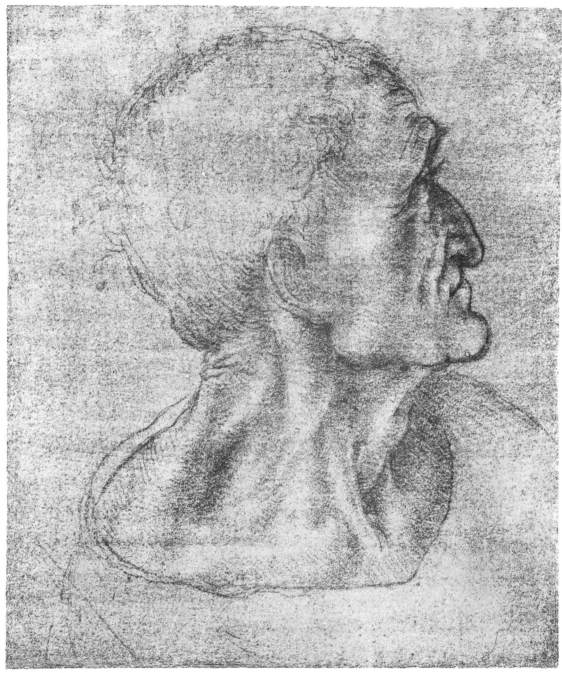

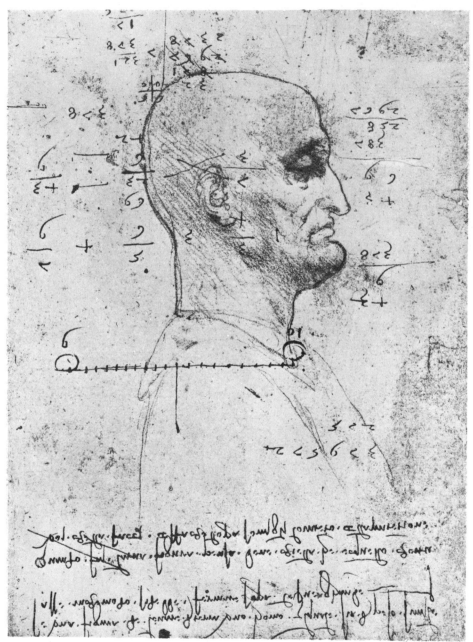

1

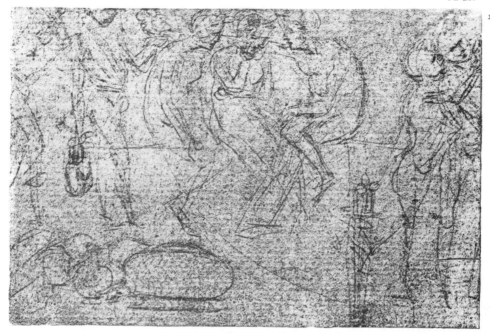

2

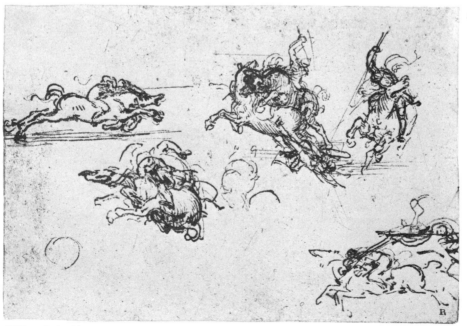

Héliog. Dujardin. Imp. Eudes.

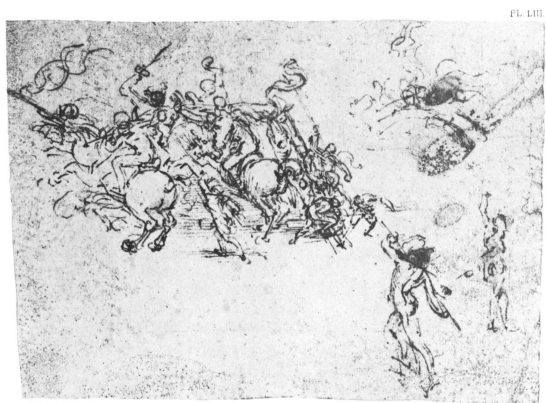

Héliog. Dujardin.

Imp. Eudes

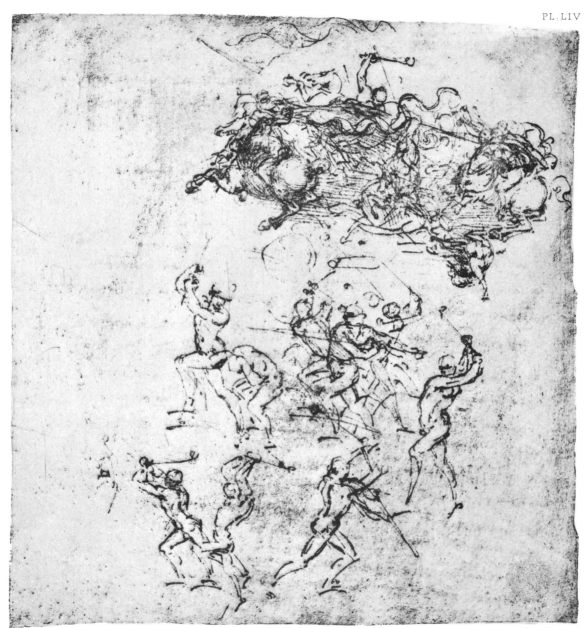

Héliog. Dujardin.

Imp. Eudes.

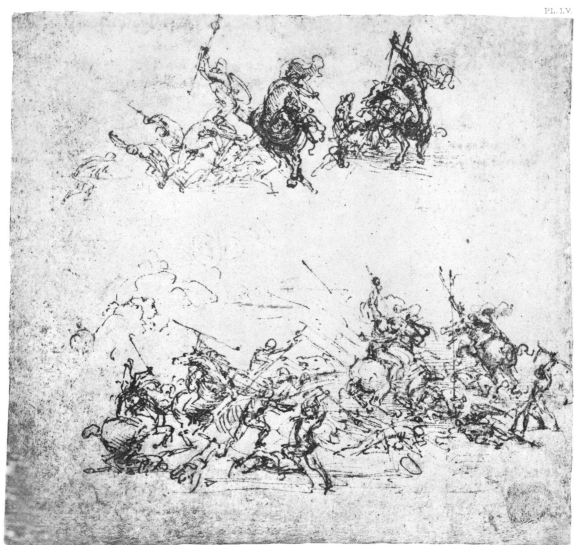

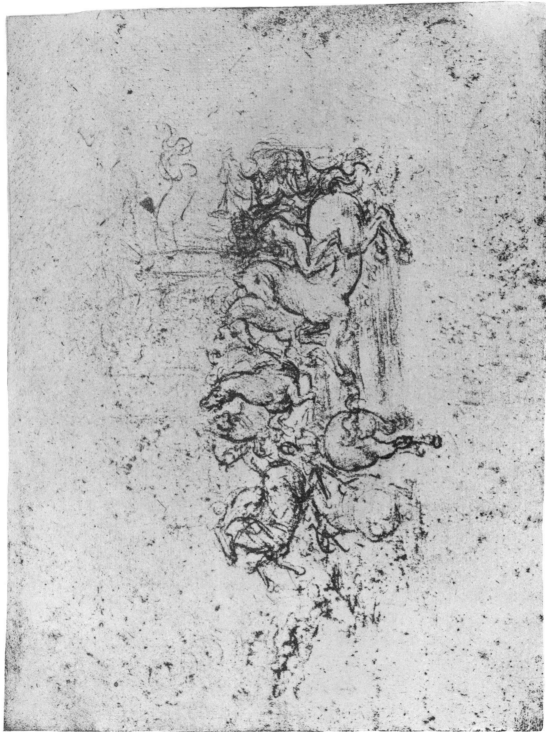

Héliog. Dujardin.

Imp. Eudes.

Plate LVI is reproduced on the following two pages.

Helio g. Dujardin.

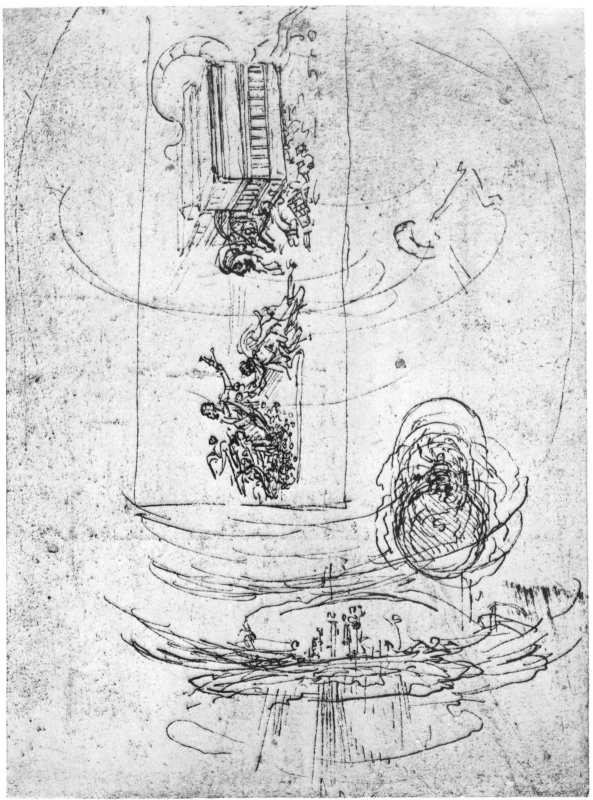

Héliog. Dujardin.

Imp. Eudes.

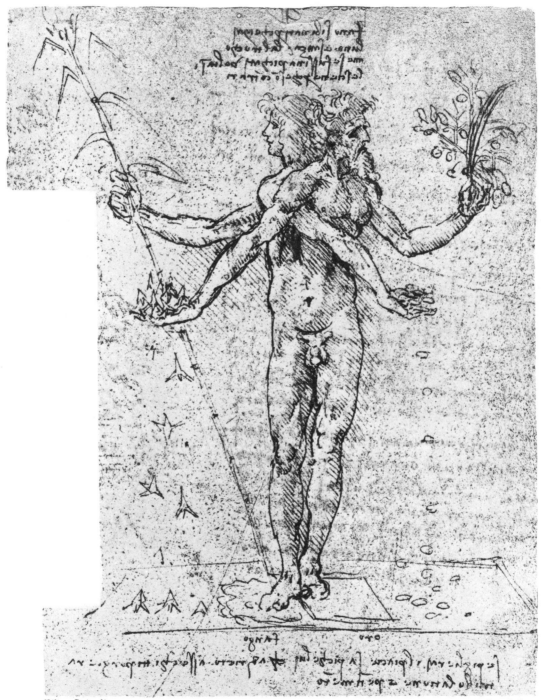

Pl. LX

1

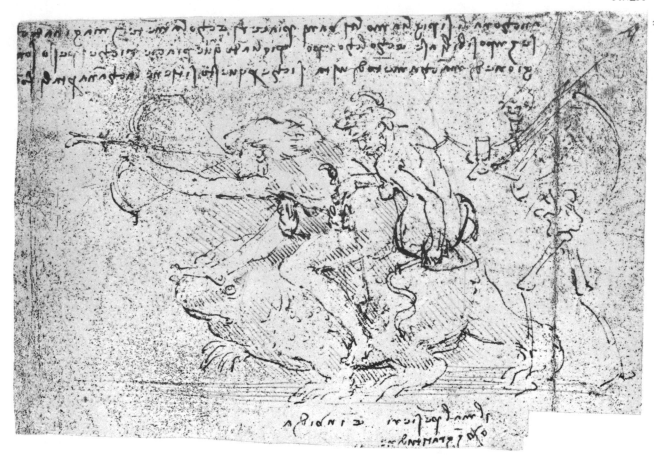

2

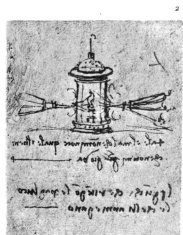

4

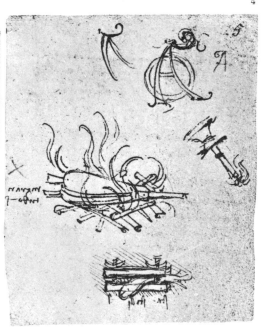

3

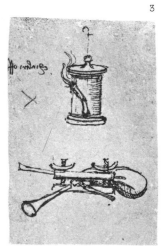

Heliog. Dujardin.

Imp Eudes

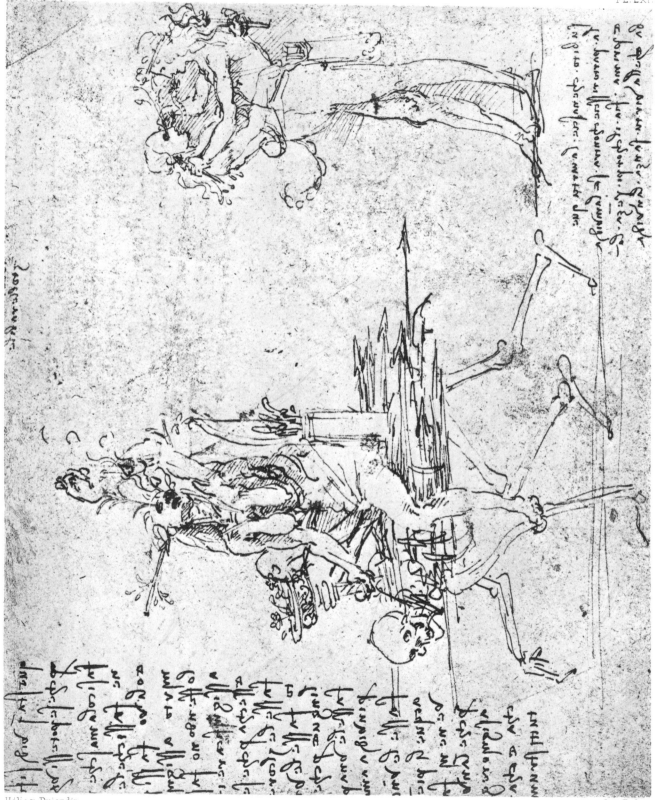

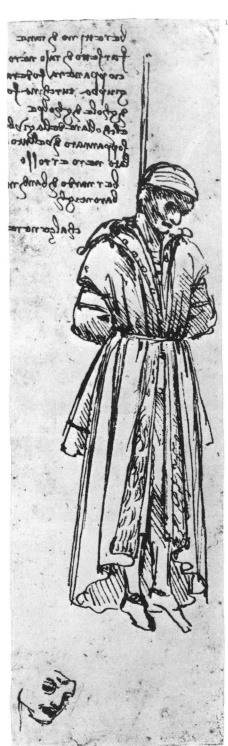

1

Helio§. Dujardin

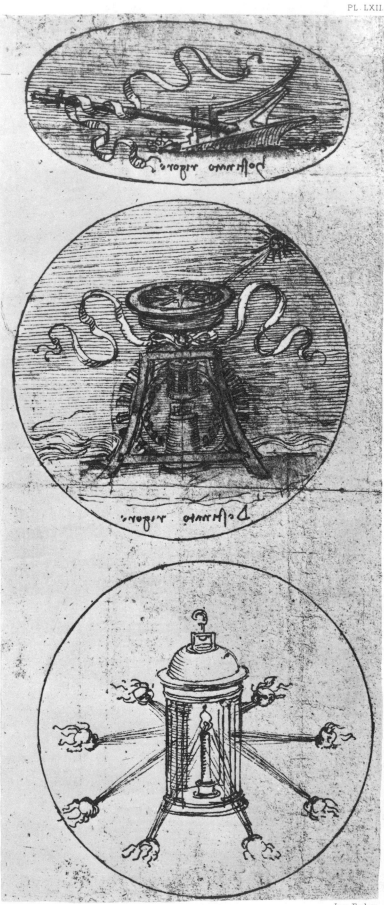

Imp. Eudes.

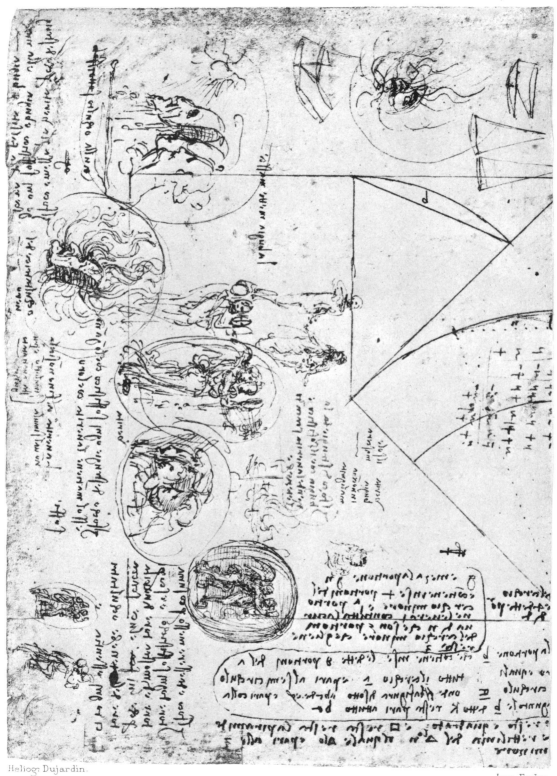

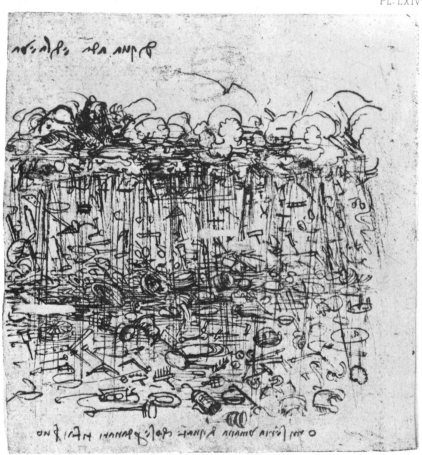

Héliog. Dujardin

Imp. Eudes

VIII.

Botany for Painters and Elements of Landscape Painting.

The chapters composing this portion of the work consist of observations on Form, Light and Shade in Plants, and particularly in Trees summed up in certain general rules by which the author intends to guide the artist in the pictorial representation of landscape.

With these the first principles of a Theory of Landscape painting are laid down— a theory as profoundly thought out in its main lines as it is lucidly worked out in its details. In reading these chapters the conviction is irresistible that such a Botany for painters is or ought to be of similar importance in the practice of painting as the principles of the Proportions and Movements of the human figure i. e. Anatomy for painters.

There can be no doubt that Leonardo, in laying down these rules, did not intend to write on Botany in the proper scientific sense—his own researches on that subject have no place here; it need only be observed that they are easily distinguished by their character and contents from those which are here collected and arranged under the title 'Botany for painters'. In some cases where this division might appear doubtful,—as for instance in No. 402—the Painter is directly addressed and enjoined to take the rule to heart as of special importance in his art.

The original materials are principally derived from MS. G, in which we often find this subject treated on several pages in succession without any of that intermixture of other matters, which is so frequent in Leonardo's writings. This MS., too, is one of the latest; when it was written, the great painter was already more than sixty years of age, so we can scarcely doubt that he regarded all he wrote as his final views on the subject. And the same remark applies to the chapters from MSS. E and M which were also written between 1513—15.

For the sake of clearness, however, it has been desirable to sacrifice—with few exceptions—the original order of the passages as written, though it was with much reluctance and only after long hesitation that I resigned myself to this necessity. Nor do I mean to impugn the logical connection of the author's ideas in his MS.; but it

will be easily understood that the sequence of disconnected notes, as they occurred to Leonardo and were written down from time to time, might be hardly satisfactory as a systematic arrangement of his principles. The reader will find in the Appendix an exact account of the order of the chapters in the original MS. and from the data there given can restore them at will. As the materials are here arranged, the structure of the tree as regards the growth of the branches comes first (394—411) and then the insertion of the leaves on the stems (412—419). Then follow the laws of Light and Shade as applied, first, to the leaves (420—434), and, secondly, to the whole tree and to groups of trees (435—457). After the remarks on the Light and Shade in landscapes generally (458—464), we find special observations on that of views of towns and buildings (465—469). To the theory of Landscape Painting belong also the passages on the effect of Wind on Trees (470—473) and on the Light and Shade of Clouds (474—477), since we find in these certain comparisons with the effect of Light and Shade on Trees (e. g.: in No. 476, 4. 5; and No. 477, 9. 12). The chapters given in the Appendix Nos. 478 and 481 have hardly any connection with the subjects previously treated.

393.

ALBERI.

² Bassi, ³ alti, ⁴ rari, ⁵ spessi cioè di foglie, ⁶ scuri, ⁷ chiari, ⁸ rossi, ⁹ ramificāti insù, ¹⁰ chi diritti all' ochio, ¹¹ chi in giù, ¹² gābi biāchi, ¹³ a chi trapare l' aria ¹⁴ a chi no, ¹⁵ chi è trito di posta, ¹⁶ chi è raro.

TREES.

Small, lofty, straggling, thick, that is as Classifica-to foliage, dark, light, russet, branched at the ᵗⁱᵒⁿ ᵒᶠ ᵗʳᵉᵉˢ. top; some directed towards the eye, some downwards; with white stems; this transparent in the air, that not; some standing close together, some scattered.

394.

Tutti i rami delli alberi in ogni grado della loro ² altezza givnti insieme sono equali alla gro³ssezza del loro pedale.

⁴ Tutte le ramificationi · dell' acque in ogni ⁵ grado di loro lunghezza ·, essendo d' equal ⁶ moto, sono equali alla grossezza del loro ⁷ principio.

All the branches of a tree at every stage The relative of its height when put together are equal in ᵗʰⁱᶜᵏⁿᵉˢˢ ᵒᶠ ᵗʰᵉ ᵇʳᵃⁿᶜʰᵉˢ thickness to the trunk [below them]. ᵗᵒ ᵗʰᵉ ᵗʳᵘⁿᵏ

All the branches of a water [course] at ⁽³⁹³⁻³⁹⁶⁾. every stage of its course, if they are of equal rapidity, are equal to the body of the main stream.

395.

Ogni · āno, che i rami delle ² piante ànno dato fine alla ³ loro maturità, essi ànno ⁴ cō-posto, givti insieme, ⁵ altrettanta grossezza, quā⁶to è la grossezza del suo pe⁷dale, e in ogni grado della ⁸ sua ramificatione tu tro-⁹verai la grossezza di detto ¹⁰ pedale come è · i k: ¹¹ g h: e f: c d: a b · ¹² tutti saranno equali infra ¹³ loro, non essendo l' albero stor-¹⁴piato, · altremēti la regola ¹⁵ falla.

¹⁶ Tutti i rami ànno le di¹⁷ritture che si dirizzano ¹⁸ al ciētro dell' albero m.

Every year when the boughs of a plant [or tree] have made an end of maturing their growth, they will have made, when together, a thickness equal to that of the main stem; and at every stage of its ramification you will find the thickness of the said main stem; as: i k, g h, e f, c d, a b, will always be equal to each other; unless the tree is pollard—if so the rule does not hold good.

All the branches have a direction which tends to the centre of the tree m.

393. 1—16 R. 6. chiari. 9. ramifichāti. 13. achistrapar laria. 14. achinno. 15. chi ettrito di posta.
394. 2. alteza. 3. sseza. 5. lungeza. 6. mo sono . . grosseza.
395. 1. ogniano che rami. 3. maturta. 5. groʃseza. 6. grosseza. 7. ella. 8. ramifichatione. 9. grosseza. 10. il pedale come
he i k. 13. lloro . . sto "r". 14. piāti. 15. nōfalla. 17. chessi dirizano.

395. The two sketches of leafless trees one above another on the left hand side of Pl. XXVII, No. 1, belong to this passage.

M. 79 a] **396.**

Se la pianta · *n* crescierà alla grossezza
²di *m*, i sua rami faranno tutta la cōgiū-
tione ³*a · b* per lo ingrossare de' rami in-
dentro come di ⁴fuori.

The law of ⁵I rami delle piante fanno ⁶in ogni na-
proportion scimento de' sua ⁷ramiculi vna tortura la
in the ⁸quale, partorendo il ramo, si ⁹viene a bi-
growth of forcare, e detta bifor¹⁰catura si trova in
the branches mezzo a due ¹¹angoli, de' quali quello sarà
(396—402). ¹²piv grosso che sarà dal lato del ¹³ramo
piv grosso, proportione¹⁴volmēte, se nō lo
guasta l'accidētale.

If the plant *n* grows to the thickness
shown at *m*, its branches will correspond [in
thickness] to the junction *a b* in consequence
of the growth inside as well as outside.

The branches of trees or plants have a
twist wherever a minor branch is given off;
and this giving off the branch forms a fork;
this said fork occurs between two angles of
which the largest will be that which is on
the side of the larger branch, and in pro-
portion, unless accident has spoilt it.

G. 34 b] **397.**

Nessū gobbo ²è ne rami, che ³nō ui
sia dato a⁴lcun ramo, il ⁵quale è mā-
cato;

 ⁶Crescono più li ramiculi ⁷inferiori de' rami
del⁸le piāte, che li superio⁹ri, e questo sol
nasci¹⁰e perchè l'umore che li nu¹¹triscie,
per aver lui gravi¹²tà, è più facilmē¹³te allo
ingiù che allo insù, ¹⁴e ancora perchè quelli
che vē¹⁵gono allo īgiù si discostan ¹⁶da
l'ōbra ch'è inverso il cētro ¹⁷della piāta;
¹⁸quāto li rami sō ¹⁹più vechi, tanta mag-
²⁰gior diferētia è da ²⁶li sua ramiculi ²²di
sopra a quelli ²³di sotto e i quali sieno
del ²⁴medesimo anno o epoca.

There is no boss on branches which has
not been produced by some branch which has
failed.

The lower shoots on the branches of trees
grow more than the upper ones and this
occurs only because the sap that nourishes
them, being heavy, tends downwards more
than upwards; and again, because those
[branches] which grow downwards turn away
from the shade which exists towards the
centre of the plant. The older the branches
are, the greater is the difference between
their upper and their lower shoots and in
those dating from the same year or epoch.

G. 35 a] **398.**

DELLI MARGINI DELLI ²ALBERI.

³Li margini delli alberi crescō pi⁴v in
grossezza che nō richiede il umo⁵re distri-
buito che le nutriscie.

OF THE SCARS ON TREES.

The scars on trees grow to a greater
thickness than is required by the sap of the
limb which nourishes them.

G. 13 a] **399**

Quella pianta osseruerà ²il suo accre-
scimēto cō ³più diritta linia, la quale ⁴ge-
nera più minuta ra⁵mificatione.

The plant which gives out the smallest
ramifications will preserve the straightest line
in the course of its growth.

396. 1. sella . . cressciera . . grosseza [che]. 7. ramichuli. 9. biforchare. 10. chatura . . mezo. 12. chessara. 14. lacidētale.
397. 1—24 R. 6. cresca. 8. chelli. 9. ecquesto sol nassci. 10. lomore chelli. 12. facilmaltimē. 13. ingu, 14. perche que che
 vē. 15. grno allo. 20. gor. 22. acquelli. 23. e ī qua del. 24. annaepoca.
398. 1—5 R. 1. delle margini. 3. le . . crescā . . omo. 4. v groseza . . illomo. 5. re distrebito chelle nutrisscie.
399. 1—5 R. 2. accresscimēto.

396. The sketches illustrating this are on the
right hand side of Pl. XXVII, No. 1, and the text
is also given there in facsimile.

397. The sketch accompanying this in the MS. is
so effaced that an exact reproduction was impossible.

399. This passage is illustrated by two partly
effaced sketches. One of these closely resembles
the lower one given under No. 408, the other also
represents short closely set boughs on an upright
trunk.

G. 14*a*] **400.**

DELLA RAMIFICATIONE.

²Senpre il principio della ramifi-
³catione à la linia cētrₐle della sua
gro⁴ssezza, che si dirizza alla linia
cētrale ⁵della pianta.

OF THE RAMIFICATION.

The beginning of the ramifica-
tion [the shoot] always has the cen-
tral line [axis] of its thickness direct-
ed to the central line [axis] of the
plant itself.

G. 37*a*] **401.**

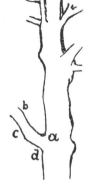

Senpre li rami nello sepa²rarsi
dal fusto fāno vna ³basa con una
globosità,⁴ come si mostra in *a b c d*.

In starting from the main stem
the branches always form a base with
a prominence as is shown at *a b c d*.

G. 33*a*] **402.**

PERCHÈ MOLTE VOLTE LI LEGNAMI NŌ ²SŌ
DIRITTI NELLE LOR UENE.

³Quādo li rami, che succedono il secōdo
anno so⁴pra del ramo dell'anno passato,
nō ànno le ⁵grossezze simili sopra li rami
antecedēti, ma ⁶sono dal lato, allora il
uigore di quel ramo ⁷di sotto si torce al
nutrimēto de quel ch'è più al⁸to, ancora-
chè esso sia vn poco dal lato;
⁹Ma se tali ramificationi avrā equalità
¹⁰nel loro crescere, le uene del loro fusto
¹¹sarā diritte e equidistāti in ogni grado
d'altez¹²za della loro pianta.
¹³Adūque tu pittore, che non ài tale
regole, per ¹⁴fuggire il biasimo delli intē-
denti sii vago di ¹⁵ritrare ogni tua cosa
di naturale e nō dispre¹⁸zzare lo studio
come fanno i guadagnatori.

WHY, VERY FREQUENTLY, TIMBER HAS VEINS
THAT ARE NOT STRAIGHT.

When the branches which grow the se-
cond year above the branch of the preceding
year, are not of equal thickness above the
antecedent branches, but are on one side,
then the vigour of the lower branch is diver-
ted to nourish the one above it, although it
may be somewhat on one side.
But if the ramifications are equal in their
growth, the veins of the main stem will be
straight [parallel] and equidistant at every
degree of the height of the plant.
Wherefore, O Painter! you, who do not
know these laws! in order to escape the blame
of those who understand them, it will be
well that you should represent every thing
from nature, and not despise such study as
those do who work [only] for money.

400. 1—5 R. 3 chatione a [il centro] "la linia cētrale" della. 4. se chessi diriza.
401. 1—4 R. 1. sepr. 2. fano.
402. 3. sucedano. 5. grosseze simile. 7. notrimēto. 8. pocho. 9. Massettale ramificatione ara. 10. neiloro cresciere . . fussto.
 11. dalte. 14. sia vago. 18. zare.

E. 6*b*] **403.**

DELLA RAMIFICATIONE [2]DELLE PIÃTE.

OF THE RAMIFICATIONS OF PLANTS.

The direc-
tion of
growth
(403—407).

[3]Le piãte, che assai si dilatano, ànno li angoli [4]delle partitioni che separano le loro ra[5]mificationi tanto più ottusi, quãto el na[6]scimento loro è più basso, cioè più vi[7]cino alla parte più grossa e più vecchia del[8]l'albero: adunqve nella parte piv giova-[9]ne dell'albero li ãgoli delle sua ramificatio-[10]ni sono più acuti.

The plants which spread very much have the angles of the spaces which divide their branches more obtuse in proportion as their point of origin is lower down; that is nearer to the thickest and oldest portion of the tree. Therefore in the youngest portions of the tree the angles of ramification are more acute.

G. 32*b*] **404.**

Li stremi delle ramificatiõ delle piãte, [2]se nõ sõ superati dal peso de' frutti, si volta[3]no ĩverso il celo quãto è possibile;

[4]Le parti diritte delle lor foglie stanno volte [5]inverso il celo per ricevere il nutrimẽto de[6]lla rugiada che cade la notte;

[7]Il sole dà spirito e vita alle piãte [8]e la terra coll'umido le notrisce; [9]intorno a questo caso io provai già a [10]lasciare solamẽte vna mi[11]nima radice a vna zucca e quella tenevo [12]nutrita coll'acqua, e tale zucca cõ-dusse a per[13]fezione tutti li frutti ch'ella, potè poi [14]gene-rare, li quali furono circa 60 z[15]ucche, di quelle lunghe, e posi la mẽte cõ dili[16]gen-tia a tale vita e cognobbi che la rugiada [17]della notte era quella che col suo umido pe[18]netrava abondantemẽte per l'appi-[19]ccatura delle sua grã foglie al nutrimẽto [20]d'essa piãta colli sua figliuoli—overo uo-[21]va che ànno a producere li sua figliuoli.

[22]La regola delle foglie nate nel ramo vltimo [23]dell'ãno sarà nelli 2 rami fra-telli in contra[24]rio moto, cioè che voltandosi intorno il nascimẽ[25]to delle foglie il loro ramo in modo che la 6ª foglia [26]di sopra

The tips of the boughs of plants [and trees], unless they are borne down by the weight of their fruits, turn towards the sky as much as possible.

The upper side of their leaves is turned towards the sky that it may receive the nourishment of the dew which falls at night.

The sun gives spirit and life to plants and the earth nourishes them with moisture. [9]With regard to this I made the experiment of leaving only one small root on a gourd and this I kept nourished with water, and the gourd brought to perfection all the fruits it could produce, which were about 60 gourds of the long kind, and I set my mind diligently [to consider] this vitality and perceived that the dews of night were what supplied it abundantly with moisture through the insertion of its large leaves and gave nourishment to the plant and its offspring —or the seeds which its offspring had to produce—[21].

The rule of the leaves produced on the last shoot of the year will be that they will grow in a contrary direction on the twin branches; that is, that the insertion of the leaves turns round each branch in such a

403. 1. delle ramifichatione. 3. angholi. 4. partitiõ chesseperano. 6. baso. 9. ãgholi . . ramifichatio. 10. achuti.
404. 4. parte stão. 6. rugada che chade. 8. ella. 9. acquesto. 10. allassciare. 11. zucha ecquella. 12. zuzza. 13. fezzione.
14. circha. 15. ucc. 16. attaln . . chella rugada. 18. abondamẽte. 19. chatura. 20. overo ho. 21. va [delli] che . .

403. Compare the sketches on the lower portion of Pl. XXVII, No. 2.

404. A French translation of lines 9—12 was given by M. RAVAISSON in the *Gazette des Beaux*

Arts, Oct. 1877; his paper also contains some valuable information as to botanical science in the ancient classical writers and at the time of the Renaissance.

nasce sopra la sesta di sotto, e 'l moto [27]del loro voltarsi è, se l'ū volta inuerso la sua cōpagna [28]a destra, l'altra li si volta a sinistra; [29]la foglia è tetta over poppa del ramo o fru[31]to che nasce nell'anno che viene.

way, as that the sixth leaf above is produced over the sixth leaf below, and the way they turn is that if one turns towards its companion to the right, the other turns to the left, the leaf serving as the nourishing breast for the shoot or fruit which grows the following year.

G. 5 a]

405.

Li rami più bassi delle piā[2]te che fā grā foglie e frutti [3]gravi come noci, fichi e si[4]mili sempre si dirizzano alla [5]terra.
[6]Senpre li rami nascono so[7]pra la foglia.

The lowest branches of those trees which have large leaves and heavy fruits, such as nut-trees, fig-trees and the like, always droop towards the ground.
The branches always originate above [in the axil of] the leaves.

G. 4 b]

406.

I ramiculi superiori delli [2]rami laterali delle piāte [3]costā più al lor ramo mae[4]stro che nō fā quelli di sotto.

The upper shoots of the lateral branches of plants lie closer to the parent branch than the lower ones.

G. 35 b]

407.

Senpre li rami più bassi, [2]poich'elli ànno generato [3]l'angolo della lor sepera[4]tione del suo fusto, si pi[5]egano in basso

The lowest branches, after they have formed the angle of their separation from the parent stem, always bend downwards so

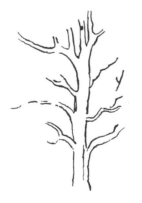 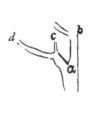 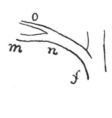

per nō si ser[6]rare adosso alli altri ra[7]mi che sopra lui s'accodano [8]nel medesimo fusto

as not to crowd against the other branches which follow them on the same stem and

figloli. 23. dellano . . sarāno. 24. coe. 25. folie . . chella. 26. sessta. 27. sellū . . il suo cōpagno. 28. adesstra . . assini-stra. 29. he. 31. nascce il. 32. lannō. *Lines* 29—32 *are written in margin.*
[4]05. 1—7 R. 2 poglie. 3. coci. 4. dirizano. 6. nascca.
406. 1—4 R. maes. 4. que di.
407. 1—21 R. 5. si se. 7. sacodano. 8. fussto. 9. podere. 10. che lli nutrisce. 11. mosstra. 13. affatto [lāgolo] ilato.

e [9]per potere meglio pigliare [10]l'aria che li nustrisce—[11]come mostra l'angolo *b a c* [12]che il ramo *a c* poich'elli [13]à fatto il lato dell'an[14]golo *a c*, si piega in ba[15]sso in *c d* e il ramicu[16]lo *c* si secca per l'essere [17]suo di sottile.

[18]Senpre il ramo maestro va di sotto [19]come mostra il ramo *f* [20]*n m*, che nō va per *f* [21]*n o*.

to be better able to take the air which nourishes them. As is shown by the angle *b a c;* the branch *a c* after it has made the corner of the angle *a c* bends downwards to *c d* and the lesser shoot *c* dries up, being too thin.

The main branch always goes below, as is shown by the branch *f n m*, which does not go to *f n o*.

G. 36*a*] **408.**

The forms of trees (408—411).

L'olmo senpre mette più lun[2]ghezza nelli vltimi rami del me[3]desimo anno che in quelli che [4]sō più bassi, e questo fa la [5]natura, perchè i rami più al[6]ti sō quelli che ànno a cresce[7]re la quātità dell'albero e quel[8]li di sotto ànno a seccare, [9]perchè nascono nell'onbra e il [10]loro accrescimēto sarebbe [11]inpedimēto dello introito [12]de' razzi solari e dell'aria in-[13]fra essa ramificatiō mae[14]stra di tal piāta.

[15]Li rami maestri inferio[16]ri si piegano piv che i superio[17]ri, per essere più obbliqui che [18]essi superiori e ancora perchè sō [19]maggiori e piv vecchi.

The elm always gives a greater length to the last branches of the year's growth than to the lower ones; and Nature does this because the highest branches are those which have to add to the size of the tree; and those at the bottom must get dry because they grow in the shade and their growth would be an impediment to the entrance of the solar rays and the air among the main branches of the tree.

The main branches of the lower part bend down more than those above, so as to be more oblique than those upper ones, and also because they are larger and older.

G. 36*b*] **409.**

Vniversalmente [2]quasi tutte le rettitu[3]dini delle piāte s'in[4]curvano tenēdo la [5]parte convessa diver[6]so mezzodì, e le loro [7]ramificazioni son [8]più lunghe e grosse e piv [9]spesse a esso mezzodì [10]che a tramōtana, [11]e questo nascie perchè 'l [12]sole tira l'umore in[13]verso quella super-fitie del[14]la pianta la quale li è [15]più vicina.

[16]E questo s'os[17]serua se nō [18]lì è ocupato [19]il sole dall'al[20]tre piāte.

In general almost all the upright portions of trees curve somewhat turning the convexity towards the South; and their branches are longer and thicker and more abundant towards the South than towards the North. And this occurs because the sun draws the sap towards that surface of the tree which is nearest to it.

And this may be observed if the sun is not screened off by other plants.

G. 51*a*] **410.**

Il ciriegio è di natura dell' a[2]bete nella sua ramifica[3]tione fatta a gradi intor[4]no a

The cherry-tree is of the character of the fir tree as regards its ramification placed

14. piegha. 16. secha per lesere. 17. disutile. 18. Senpre maesstro. 19. ramo f.

408. 2. ggheza neli. 4. ecquesto. 5. perche rami. 6. cressce. 7. eque. 8. anno | assechare. 9. nasscano. 10. acresscimēto. 15. maesstri. 16. chesuperiori. 18. esse. 19. magori . . vechi.

409. 1—20 (R). 2. tucte. 3. dine. 6. mezodi ella. 7. ramificazione. 10. attramōtana. 11. ecquesto nasscie. 12. lomore. 16. ecquesto os. 18. ochupato. 19. ecquesto si manifessta. 20. nelle piante chessono. 21. spesse rimōde (?) che ro (?). 22. mettano ōgni 3 anni.

410. 1—13 R. 1. ciriego . . de a. 4. allor fussto elli. 5. nasscano . . ho. 7. ella soma. 9. piramide cipr. 10. latera dal mezo.

lor fusto ·, e li su⁵a rami nascono a 4 o ⁶a cinque o 6 a riscontro ⁷l'un dell'altro, e la sōma ⁸delli stremi ramiculi ⁹conpone piramide ¹⁰dal mezzo in ¹¹sù; e il noce e la quercia ¹²dal mezzo in sù cōpone v¹³na mezza spera.

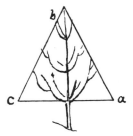

in stages round its main stem; and its branches spring, 4 or five or 6 [together] opposite each other; and the tips of the topmost shoots form a pyramid from the middle upwards; and the walnut and oak form a hemisphere from the middle upwards.

G. 88 b]

411.

Per il ramo del ²noce che solo è ³percosso e battu⁴to quäd'elli à ⁵cōdotto a perfe⁶ctione . . .

The bough of the walnut which is only hit and beaten when it has brought to perfection . . .

G. 33 a]

412.

DEL NASCIMĒTO DE' RAMI NELLE PIĀTE.

²Tale è il nascimēto delle ramificationi delle ³piāte sopra i lor rami prīcipali qual' è quella de⁴l nascimēto delle foglie sopra li ramiculi del me⁵desimo āno d'esse foglie, le quali foglie āno ⁶quattro modi di procedere, l'una più alta che l'altra; ⁷il primo più vniuersale è, che senpre la sesta di sopra ⁸nasce sopra la sesta di sotto, e il secondo ⁹è che le 2 terze di sopra sō sopra le due terze di ¹⁰sotto, e 'l terzo modo è che la 3ª di ¹¹sopra è sopra la 3ª di sotto.

OF THE INSERTION OF THE BRANCHES ON PLANTS.

Such as the growth of the ramification of plants is on their principal branches, so is that of the leaves on the shoots of the same plant. These leaves have [6]four modes of growing one above another. The first, which is the most general, is that the sixth always originates over the sixth below[8]; the second is that two third ones above are over the two third ones below[10]; and the third way is that the third above is over the third below[11].

The insertion of the leaves (412—419).

11. ecquerch. 12, mezo. 13. meza.
411. 1—6 R. 1. della. 2. chessolo he.
412. 1. nascimēto. 2 Tale he il . . ramifichatīoni. 3. quel e quella. 4. nasscimēto . . ramichuli. 5. dessimo āno desse foglie le.
 6. proccedere . . chellaltro. 7. eprimo . . he chessenpre. 8. nassce . . sessta. 9. he che 2. 10. hechella. 11. essopra.

411. The end of the text and the sketch in red chalk belonging to it, are entirely effaced.

412. See the four sketches on the upper portion of the page reproduced as fig. 2 on Pl. XXVII.

6. *Quattro modi* (four modes). Only three are described in the text, the fourth is only suggested by a sketch.

This passage occurs in MANZI's edition of the Trattato, p. 399, but without the sketches and the text is mutilated in an important part. The whole passage has been commented on, from MANZI's version, in Part I of the *Nuovo Giornale Botanico Italiano*, by Prof. G. UZIELLI (Florence 1869, Vol. I). He remarks as to the 'four modes': "*Leonardo, come si vede nelle linie seguenti dà solo tre esempli. Questa ed altre inessattezze fanno desiderare, sia esaminato di*

nuovo il manoscritto Vaticano". This has since been done by D. KNAPP of Tübingen, and his accurate copy has been published by H. LUDWIG, the painter. The passage in question occurs in his edition as No. 833; and there also the drawings are wanting. The space for them has been left vacant, but in the Vatican copy '*niente*' has been written on the margin; and in it, as well as in LUDWIG's and MANZI's edition, the text is mutilated.

8. *la sesta di sotto.* "*Disposizione* 2/5 *o* 1/5. *Leonardo osservò probabilmente soltanto la prima*" (UZIELLI).

9—10. *terze di sotto:* "*Intende qui senza dubbio parlare di foglie decussate, in cui il terzo verticello è nel piano del primo*" (UZIELLI).

11. 3ª *di sotto:* "*Disposizione* 1/2" (UZIELLI).

G. 27 a] 413.

DESCRITIŌ DELL'OLMO.

²Questa ramificatione dell'olmo ³à il maggiore ramo nella sua frōte, ⁴e 'l minore è il primo ed il penvltimo ⁵quādo la maestra è diritta;

⁶Il nascimēto da l'una foglia all'al⁷tra è la metà della maggior lūghez⁸za della foglia alquāto māco, ⁹perchè le foglie fāno interual¹⁰lo ch'è circa al 3° della larghez-¹¹za di tal foglia.

¹²L'olmo à le ¹³sue foglie ¹⁴più presso ¹⁵alla ¹⁶cima del suo ¹⁷ramo, che al ¹⁸nascimēto e le ¹⁹lor larghezze ²⁰poco varia²¹no, e so-no risguar²²dandole di vn me²³desimo aspetto.

A DESCRIPTION OF THE ELM.

The ramification of the elm has the largest branch at the top. The first and the last but one are smaller, when the main trunk is straight.

The space between the insertion of one leaf to the rest is half the extreme length of the leaf or somewhat less, for the leaves are at an interval which is about the 3rd of the width of the leaf.

The elm has more leaves near the top of the boughs than at the base; and the broad [surface] of the leaves varies little as to [angle and] aspect.

G. 28 a] 414.

Le foglie del noce, conpartite per ²tutto il ramiculo di quell'anno, ³sō tanto più distanti l'una ⁴dall' altra e cō maggiore nu-⁵mero, quāto il ramo, doue ⁶tal ramicolo nascie, è più giova⁷ne, e son tāto più vicine ne' ⁸loro nascimēti e di minore nu⁹mero, quanto il ramiculo do¹⁰ve nascono è nato in ramo pi¹¹v vechio; nascono li sua fru¹²tti in istremo del suo ramiculo, ¹³e li sua rami maggiori son di sotto ¹⁴al lor ramo, doue nascono; ¹⁵e questo accade perchè la grauità del ¹⁶suo umore è più atta a di-scende¹⁷re che a mōtare, e per questo li ¹⁸rami che nascō sopra di loro, ¹⁹che vanno inverso il celo, son pi²⁰ccoli e sottili, e quādo il ra²¹miculo guarda inverso il celo, le ²²foglie sue si dilatano ²³dal suo stre-²⁴mo con eguale partitiō colle lor ²⁵cime e se 'l ramiculo guarda all'o²⁶rizzonte, le foglie restano ispia²⁷nate, e questo nasce perchè le foglie ²⁸universalmente tengono il riverscio ²⁹loro volto alla terra.

³⁰I ramiculi sō ³¹tanto mino³²ri quanto essi na³³scono più vici³⁴ni al nascimē³⁵to del ramo che ³⁶li produce.

In the walnut tree the leaves which are distributed on the shoots of this year are further apart from each other and more numerous in proportion as the branch from which this shoot springs is a young one. And they are inserted more closely and less in number when the shoot that bears them springs from an old branch. Its fruits are borne at the ends of the shoots. And its largest boughs are the lowest on the boughs they spring from. And this arises from the weight of its sap which is more apt to descend than to rise, and consequently the branches which spring from them and rise towards the sky are small and slender[20]; and when the shoot turns towards the sky its leaves spread out from it [at an angle] with an equal distribution of their tips; and if the shoot turns to the horizon the leaves lie flat; and this arises from the fact that leaves without exception, turn their underside to the earth[29].

The shoots are smaller in proportion as they spring nearer to the base of the bough they spring from.

413. 3. magore. 4. eil p° el il. 5. maestra. 6. nasscimēto dalluna. 7. ella . . magor lūge. 8. mācho. 9. fano. 10. large. 12—15. Lolmo alle sue foglie piu presso la cima alla. 17.—23. ramo chellnasscimēto el lor largeze pocho variano di risguardare a vn medesimo asspetto.

414. 2. anno e. 3. distante lun. 4. magiore. 6. nasscie . . goua. 8. nasscimēti. 10. nasscano. 11. nassono. 13. elli . . magori. 14. nascano. 15. ecquesto acade che. 16. omore . . atto . . disscende. 20. choli essotili ecquado. 22. dilata . . eguali. 26. rizonte. 27. ecquesto nassce chelle. 28. tengano . . iriverscio. 31. tanto [p] mino. 32. ri quanto e na. 33. nascā.

413. See Pl. XXVII, No. 3. Above the sketch and close under the number of the page is the word 'olmo' (elm).

414. See the two sketches on Pl. XXVII, No. 4. The second refers to the passage lines 20—30.

G. 16 b] **415.**

DEL NASCIMĒTO DELLE FOGLIE SO²PRA LI SUOI RAMI.

OF THE INSERTION OF THE LEAVES ON THE BRANCHES.

³Non diminviscie la grossezza di nes⁴sū ramo dallo spatio, ch'è da foglia ⁵a foglia, se nō quāto è la grossezza ⁶del-l'ochio ch'è sù essa foglia, ⁷la qual grossezza māca al ⁸ramo, che succiede, insino al⁹l'altra fo-glia.

¹⁰A messo la natura le foglie delli vlti¹¹mi rami di molte piāte in modo, che senpre la se¹²sta foglia è sopra la prima, e così segue ¹³suc-cessiuamēte, se la regola non è inpe¹⁴dita, e questo à fatto per 2 vtilità d'e¹⁵sse piāte, e la prima è perchè, nascendo ¹⁶il ramo e 'l frutto nell'āno seguēte dalla ¹⁷gemella vena o ochio ch'è sopra in cōtatto dell'a¹⁸ppicatura della foglia, l'acqua che bagnia ¹⁹tal ramo possa disciendere a nutrire ²⁰tal gemella col fer-marsi la goccia nella ²¹concavità del nascimēto d'essa foglia; e il ²²secōdo giovamēto è che, nasciēdo tali ra²³mi l'anno seguēte, l'uno nō copre l'altro perchè ²⁴nascono volti a cinque aspetti li 5 rami, ²⁵e 'l sesto nasce sopra il primo assai remoto.

The thickness of a branch never diminishes within the space between one leaf and the next excepting by so much as the thick-ness of the bud which is above the leaf and this thickness is taken off from the branch above [the node] as far as the next leaf.

Nature has so placed the leaves of the latest shoots of many plants that the sixth leaf is always above the first, and so on in succession, if the rule is not [accidentally] interfered with; and this occurs for two useful ends in the plant: First that as the shoot and the fruit of the following year spring from the bud or eye which lies above and in close contact with the in-sertion of the leaf [in the axil], the water which falls upon the shoot can run down to nourish the bud, by the drop being caught in the hollow [axil] at the insertion of the leaf. And the second advantage is, that as these shoots develop in the following year one will not cover the next below, since the 5 come forth on five different sides; and the sixth which is above the first is at some distance.

G. 30 b] **416.**

DELLE RAMIFICATIŌI DELLE ²PIĀTE COLLE LORO FOGLIE.

OF THE RAMIFICATIONS OF TREES AND THEIR FOLIAGE.

³Le ramificationi delle piante, al-cune ⁴come l'olmo sono larghe e sotti⁵li a uso di mano aperta in iscor⁶to, e queste si mostrā nelle lor ⁷quātità: di sotto si mostrā dalla par⁸te supe-riore; e quelle che sō più al⁹te si mo-strā di sotto, e quelle di ¹⁰mezzo in vna parte di sotto e vna ¹¹di sopra; e la parte di sopra è in istre¹²mo d'essa ramificatione, e que¹³sta parte di mezzo è la più scor¹⁴tata, che nessuna altra di que¹⁵lle, che sono volte colle pūte in¹⁶verso te; e d'esse parti di mez¹⁷zo dell'altezza della piāta la

The ramifications of any tree, such as the elm, are wide and slender after the manner of a hand with spread fingers, foreshortened. And these are seen in the distribution [thus]: the lower por-tions are seen from above; and those that are above are seen from below; and those in the middle, some from below and some from above. The upper part is the extreme [top] of this ramification and the middle portion is more fore-shortened than any other of those which are turned with their tips towards you. And of those parts of the middle of

415. 1—9 R. 1. nascimēto. 3. diminvisscie. 4. daffoglia. 5. affoglia ella grossezza. 7. grosseza mācha. 10. deli. 11. rami [delle] di . . piante che. 13. sucessiuamēte sella. 14. ecquesto affatto. 15. ella . . naciendo. 16. nellano. 17. vena ochio. 18. pichatura. 20. gocca. 21. nasscimēto. 22. govamēto he che nassciēdo. 24. nasscano . . asspetti.
416. 4. essotti. 5. ausso. 6. ecqueste. 8. ecquelle. 9. mosstrā . . ecquelle. 11. ella. 12. ecquesta. 13. mezo ella. 15. ches-

pi¹⁸v lunga sarà inverso li stremi d'e¹⁹ssi alberi e farà queste tali rami²⁰ficatiō come le foglie della felce ²¹saluatica · che nasce per l'argine de' fi²²vmi.

²³Altre ramificatiō sō tonde come ²⁴ son quelle delli alberi che mettono li ²⁵ramiculi e foglie che la sesta è sopra ²⁶la prima, altre son rare e tras²⁷parēti come il salice e simili.

the height of the tree, the longest will be towards the top of the tree and will produce a ramification like the foliage of the common willow, which grows on the banks of rivers.

Other ramifications are spherical, as those of such trees as put forth their shoots and leaves in the order of the sixth being placed above the first. Others are thin and light like the willow and others.

G. 29 a] **417.**

Vedi nel ramo inferiore del sā²buco il quale mette le foglie a 2 ³a due, incrociādo le poste l'u⁴na sopra dell'altra, e se 'l fusto va dirit⁵to inverso il celo, questo ordine nō ⁶māca mai, e le maggiori sue foglie ⁷sō nella parte più grossa del fusto, ⁸e le minori nella parte più sottile, ⁹cioè inverso la cima; Ma per torna¹⁰re al ramo di sotto dico che le foglie ¹¹delle quali le lor poste aueano a incro¹²ciarsi secondo il ramo di sopra, esse essē¹³do costrette alla legie delle foglie che ¹⁴ànno a voltare la parte del lor diritto ¹⁵inverso il celo per piglare la rugiada la ¹⁶notte, è necessario che tali poste si pie¹⁷ghino e nō facciā piv crociamento.

You will see in the lower branches of the elder, which puts forth leaves two and two placed crosswise [at right angles] one above another, that if the stem rises straight up towards the sky this order never fails; and its largest leaves are on the thickest part of the stem and the smallest on the slenderest part, that is towards the top. But, to return to the lower branches, I say that the leaves on these are placed on them crosswise like [those on] the upper branches; and as, by the law of all leaves, they are compelled to turn their upper surface towards the sky to catch the dew at night, it is necessary that those so placed should twist round and no longer form a cross.

G. 27 b] **418.**

Senpre la foglia volgie il suo ²dritto inverso il cielo acciò pos³sa meglio ricevere con tutta la ⁴sua superfitie la rugiada che cō len⁵to moto discende dall'aria, e ta⁶li foglie sono in modo cōparti⁷te sopra le loro piāte che l'una oc⁸cupa l'altra il mē che sia possibile ⁹col'interzarsi l'una sopra dell'altra, ¹⁰come si uede fare all'edera ¹¹che copre li muri e tale intreccia¹²mēto serue a due cose, cioè al la¹³sciare l'intervalli che l'aria e 'l sole pos¹⁴sā penetrare infra loro, la ¹⁵2ª ragione è che le goccie che ca¹⁶giano della prima foglia possā ca¹⁷dere sopra la 4ª e la sesta de¹⁸li altri alberi.

A leaf always turns its upper side towards the sky so that it may the better receive, on all its surface, the dew which drops gently from the atmosphere. And these leaves are so distributed on the plant as that one shall cover the other as little as possible, but shall lie alternately one above another as may be seen in the ivy which covers the walls. And this alternation serves two ends; that is, to leave intervals by which the air and sun may penetrate between them. The 2nd reason is that the drops which fall from the first leaf may fall onto the fourth or—in other trees—onto the sixth.

sono. 16. parte di me. 17. alteza. 18. lungha. 19 effara. 20. felice. 21. nassce. 24. mettano. 25. effolie chella.
417. 2. bucho il qualle. 3. in cro [se] cīado. 4. essel fussto va diri. 6. mācha mai elle magor sue foglie so. 7. fussto. 8. elle. 9. coe. 11. aueano inocro. 12. esē. 16. notte . . posste. 17. facia . . cruciamento.
418. 2. acco po. 4. sia . . rugada che colen. 5. etta. 7. chelluna. 9. col rinterzarsi. 11. chopre . . ettale interza. 12. coe. 13. chellaria el sole po. 14. loro ellaria la. 15. ragione he che. 16. possa. 17. ell'a sessta.

417. See Pl. XXVII, No. 5.

G. 33 b] **419.**

Ogni ramo e ogni frutto nasce sopra il na²scimēto della sua foglia, la quale li scusa ma³dre col porgierli l'acqua delle piogge e l'umidi⁴tà della rugiada che li cade la notte di sopra, e ⁵molte volte li toglie li superchi calori delli razzi ⁶del sole.

Every shoot and every fruit is produced above the insertion [in the axil] of its leaf which serves it as a mother, giving it water from the rain and moisture from the dew which falls at night from above, and often it protects them against the too great heat of the rays of the sun.

M. 77 b] **420.**

Quella parte del corpo sarà piv ²al-luminata che fia ferita dal ³razzo luminoso ⁴infra angoli piv equali.

That part of the body will be most illum-inated which is hit by the luminous ray com-ing between right angles.

Light on branches and leaves (420—422).

G. 8 a] **421.**

Le piāte giovani ànno le foglie ²più trāsparēti e piv poli³ta scorza che le vechie, è in i⁴specie il noce è più chiaro di ⁵maggio che di settenbre.

Young plants have more transparent leaves and a more lustrous bark than old ones; and particularly the walnut is lighter coloured in May than in September.

G. 24 a] **422.**

DEL COLOR ACIDĒTALE ²DELLI ALBERI.

³Li colori accidentali delle frō⁴de delli alberi sono 4, cioè ōbra, lu⁵me, lustro e transparētia.

OF THE ACCIDENTS OF COLOURING IN TREES.

The accidents of colour in the foliage of trees are 4. That is: shadow, light, lustre [reflected light] and transparency.

DELLA DIMOSTRATIŌ ⁷DELLI ACCIDENTI.

⁸Delle parti accidentali delle ⁹foglie delle piāte in lunga distā¹⁰tia si farà vn misto il quale p¹¹arteciperà più di quello ac-¹²cidēte che sarà di maggiore figu¹³ra.

OF THE VISIBILITY OF THESE ACCIDENTS.

These accidents of colour in the foliage of trees become confused at a great distance and that which has most breadth [whether light or shade, &c.] will be most conspicuous.

G. 10 a] **423.**

DELL' ŌBRA DELLA FOGLIA.

²Alcuna volta la foglia à 3 accidēti ³cioè onbra, lustro e transparētia, ⁴come se'l lume fussi in n · alla foglia ⁵s, e l'occhio in m che vedrà · a · allumi⁶nato, b aōbrato, c trans-parente.

OF THE SHADOWS OF A LEAF.

Sometimes a leaf has three accidents [of light] that is: shade, lustre [reflec-ted light] and transparency [transmitted light]. Thus, if the light were at n as regards the leaf s, and the eye at m, it would see a in full light, b in sha-dow and c transparent.

The proportions of light and shade in a leaf (423—426).

419. 1. onni . . ongni . . nassce. 2. liscusa. 3. ellumidi. 4. chelli. 5. taglie.
420. 1. chorpo. 3. razo luminoso da [angoli p.]. 4. razi infra.
421. 1—5 R. 1. govane an. 2. trāsparēte. 3. chelle. 5. magio.
422. 1—13 R. 1. de color. 4. ce. 5. lusstro ettransparētia. 10. il qua p. 12. magore.
423. 1—6 R. 1. fogla. 2. foglia a. 3. coe. 5. sellocchia . . vedera.

420. See Pl. XXVIII, No. 1.

G. 10 *b*] **424.**

La foglia di superfitie cōcava, ²veduta da riverscio di sotto ī sù, ³alcuna volta si mostrerà mez⁴za ōbrosa e mezza trāsparēte, ⁵come *o · p* sia la foglia e 'l ⁶lume *m* e l'ochio *n*, il quale ve⁷drà · *o* · aōbrato perchè il lume ⁸nō la percote infra angoli equa⁹li nè da ritto nè da riuerscio; ¹⁰e 'l *p* · fia alluminato da ritto, ¹¹il quale lume traspare nel suo ¹²riverscio.

A leaf with a concave surface seen from the under side and up-side-down will sometimes show itself as half in shade, and half transparent. Thus, if *o p* is the leaf and the light *m* and the eye *n*, this will see *o* in shadow because the light does not fall upon it between equal angles, neither on the upper nor the under side, and *p* is lighted on the upper side and the light is transmitted to its under side.

G. 3 *a*] **425.**

Ancorachè le foglie di pulita ²superfitie sieno in grā par³te d'ū medesimo colore da ritto a ⁴loro riverscio, elli accade che ⁵quella parte ch'è veduta dall'aria ⁶participa del colore d'essa aria, e ⁷tanto più pare participar d'esso ⁸colore d'aria, quanto l'ochio l'è ⁹piv propīquo e la vede più in i¹⁰scorto ‖ e vniversalmēte le sue ¹¹ōbre si dimostrā più oscu¹²re nel diritto che nel riverscio, ¹³per il paragō che lì è fatto da lustri ¹⁴che con tale ōbra cōfinano.

¹⁵Il riverscio della foglia, ā¹⁶corachè in se il suo colore sia ¹⁷il medesimo che del diritto, si ¹⁸dimostra di più bel colore, il qua¹⁹le colore à vn verde participā²⁰te di giallo, e questo accade quā²¹do tal foglia è interposta infra

Although those leaves which have a polished surface are to a great extent of the same colour on the right side and on the reverse, it may happen that the side which is turned towards the atmosphere will have something of the colour of the atmosphere; and it will seem to have more of this colour of the atmosphere in proportion as the eye is nearer to it and sees it more foreshortened. And, without exception the shadows show as darker on the upper side than on the lower, from the contrast offered by the high lights which limit the shadows.

The under side of the leaf, although its colour may be in itself the same as that of the upper side, shows a still finer colour—a colour that is green verging on yellow—and this happens when the leaf is placed between

G. 2 *b*] **426.**

l'ochio e 'l lume, che l'alumina ²dalla opposita parte.

³E le sue onbre son ⁴nelli medesimi siti che es⁵se erā dalla opposita parte; ⁶adū-que tu pittore, quando ⁷fai li alberi d'apresso, ricordati ⁸che, sendo coll'ochio alquāto ⁹sotto l'albero, che ti accaderà ve¹⁰dere le sue foglie dal diritto e da¹¹l riuerscio, e le parti diritte ¹²sarā tanto più azzurre quāt' elle ¹³fiē vedute più in iscorto e una ¹⁴medesima foglia alcuna volta ¹⁵mostra vna parte da ritto e ¹⁶vna da riverscio e per questo ti ¹⁷bisognia farla di due colori.

the eye and the light which falls upon it from the opposite side.

And its shadows are in the same positions as those were of the opposite side. Therefore, O Painter! when you do trees close at hand, remember that if the eye is almost under the tree you will see its leaves [some] on the upper and [some] on the under side, and the upper side will be bluer in proportion as they are seen more foreshortened, and the same leaf sometimes shows part of the right side and part of the under side, whence you must make it of two colours.

424. 1—12 R. 3. vōta simosstrera. 4. meza trassparēte. 6. ellochio. 8. nola. 9. le ne. 10. alluminata. 11. il qua lume.
425. 1—21 R. 1. anchora chelle. 2. grā pa. 4. achade. 9. ella. 11. osscu. 12. re dal diritto. 13. chellefatto dallustri. 14. confina. 17. diritto esi. 19. colore ‖‖‖ vn. 20. gallo ecquesto achade. 21. to tal foglio.
426 1—17 R. 1. ellume chellalumina. 4. [adun] elle. 9. achadera. 11. e he le parte. 12. azure. 13. e vn. 15. mosstra.

424. See Pl. XXVIII, No. 2, the upper sketch on the page. In the original they are drawn in red chalk.

G. 3 *b*]　　　　　　　　　**427.**

L'onbre che sō nelle foglie trāspa²renti, vedute da riverscio, son quelle ³medesime ōbre che· son dal diritto d'essa ⁴foglia, la quale traspare da riverscio ⁵insieme colla parte luminosa, ma ⁶il lustro mai può trasparere.

The shadows in transparent leaves seen from the under side are the same shadows as there are on the right side of this leaf, they will show through to the underside together with lights, but the lustre [reflected light] can never show through.

Of the transparency of leaves (427—429).

G. 4 *a*]　　　　　　　　　**428.**

Quando l'una verdura è dirieto all'al²tra, li lustri delle foglie e le ³lor trasparētie si dimostrā di maggiore po⁴tētia che quelle che cōfinano colla chia⁵rezza dell'aria.

⁶E se 'l sole allumina le foglie sanza ⁷che s'inframettono infra lui e l'ochio e ⁸sanza che esso ochio veda il sole, ⁹allora li lustri delle foglie e lor traspa¹⁰rentie sono eccessive.

¹¹Molto è vtile il fare alcune rami¹²ficationi basse, le quali sieno scure e cā¹³peggino in verdure alluminate che siē ¹⁴alquanto remote ¹⁶dalle verdure oscure vedute di sotto; ¹⁷quella parte è piv oscura ch'è piv vicina ¹⁸all'ochio o ch'è più distāte dall'aria luminosa.

When one green has another [green] behind it, the lustre on the leaves and their transparent [lights] show more strongly than in those which are [seen] against the brightness of the atmosphere.

And if the sun illuminates the leaves without their coming between it and the eye and without the eye facing the sun, then the reflected lights and the transparent lights are very strong.

It is very effective to show some branches which are low down and dark and so set off the illuminated greens which are at some distance from the dark greens seen below. That part is darkest which is nearest to the eye or which is farthest from the luminous atmosphere.

G. 4 *b*]　　　　　　　　　**429.**

Nō finger mai foglie transparēti ²al sole, perchè son confuse e questo ac³cade perchè sopra la trasparētia d'una ⁴foglia vi si stanpirà l'onbra d'una al⁵tra foglia che li sta di sopra, la quā⁶le ōbra è di termini spediti e di te⁷rminata oscurità, e alcuna vol⁸ta è mezza o terza parte d'essa ⁹foglia che à ōbra, e così tale ra¹⁰mificatione è cōfusa ed è da fu¹¹gire la sua imitatione.

¹²Quella foglia è mē trasparente ¹³che piglia il lume infra āgoli più ¹⁴disformi.

Never paint leaves transparent to the sun, because they are confused; and this is because on the transparency of one leaf will be seen the shadow of another leaf which is above it. This shadow has a distinct outline and a certain depth of shade and sometimes is [as much as] half or a third of the leaf which is shaded; and consequently such an arrangement is very confused and the imitation of it should be avoided.

The light shines least through a leaf when it falls upon it at an acute angle.

G. 8 *a*]　　　　　　　　　**430.**

Le ōbre delle piāte nō son mai ²nere, perchè dove l'aria pene³tra non può essere tenebre.

The shadows of plants are never black, for where the atmosphere penetrates there can never be utter darkness.

The gradations of shade and colour in leaves (430—434).

427. 1. dellonbre chessō.　4. quale \\\\\ sspa \\\\ da.

428. 3. trasparētie . . magore.　4. cōfinanno.　5. reza.　6. essel.　7. chessinframettano . . ellochio.　9. lusstri . . ellor.　10. ecesiue. 11. fare ver alcune.　12. base . . sure.　13. pegino.　14. alquando remote dalle prime.　15. [che si ē] delle verdure osscure. 16. delle.　17. osscura.

429. 2. ecquessto.　3. chade . . trasparētia.　5. chelle sta.　12. trasparente.

430. 1—3 R.　3. po.

G. 8 δ] **431.**

Se 'l lume viēne da · *m* [2]e l'occhio sia in · *n* · esso [3]ochio vedrà il color[4]e delle foglie *a b* tutte [5]participare del colore [6]dello *m* cioè dell'aria, e 'l [7]· *b c* sarā vedute da [8]riverscio trasparēti [9]cō bellissimo color ver[10]de partecipāte di giallo;

If the light comes from *m* and the eye is at *n* the eye will see the colour of the leaves *a b* all affected by the colour of *m* —that is of the atmosphere; and *b c* will be seen from the under side as transparent, with a beautiful green colour verging on yellow.

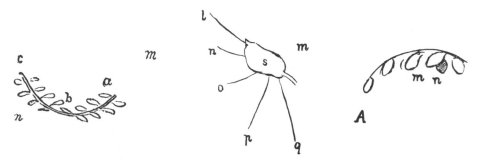

[11]Se *m* · sarà il luminoso [12]alluminatore della foglia · *s* ·, [13]tutti gli occhi che vedranno il [14]riverscio di essa foglia, la ve[15]drā di bellissimo verde chiaro [16]per essere trasparēte;

[17]Molte sō le volte che le poste [18]delle foglie sarā sanza ōbre [19]e ànno il riverscio trasparente [20]e il diritto fia lustro.

If *m* is the luminous body lighting up the leaf *s* all the eyes that see the under side of this leaf will see it of a beautiful light green, being transparent.

In very many cases the positions of the leaves will be without shadow [or in full light], and their under side will be transparent and the right side lustrous [reflecting light].

G. 9a] **432.**

Il salice e altre simili piā[2]te che si tagliano li lor rami [3]ogni 3 o 4 anni, mettono rami [4]assai diritti e la loro ōbra è in[5]verso il mezzo doue nascono [6]essi rami, e inverso li stremi [7]fan poca ōbra per le lor minu[8]te foglie e rari e sottili rami, [9]adunque li rami che si leua[10]no verso il celo avrā poca [11]ōbra e poco rilieuo, e quelli [12]rami, che guardano · dall'orizzōte [13]in giù nascono nella parte [14]oscura dell'ōbra e vēgonsi ris[15]chiarādo appoco insino [16]a loro stremi, e questi mostra[17]no bō rileuo per essere in gra[18]di di rischiaramento in cāpo [19]onbroso.

[20]Quella piāta fia meno onbra[21]ta che avrà più rara ramificati[22]one e rare foglie.

The willow and other similar trees, which have their boughs lopped every 3 or 4 years, put forth very straight branches, and their shadow is about the middle where these boughs spring; and towards the extreme ends they cast but little shade from having small leaves and few and slender branches. Hence the boughs which rise towards the sky will have but little shade and little relief; and the branches which are at an angle from the horizon, downwards, spring from the dark part of the shadow and grow thinner by degrees up to their ends, and these will be in strong relief, being in gradations of light against a background of shadow.

That tree will have the least shadow which has the fewest branches and few leaves.

G. 10_b_]

433.

DELLE FOGLIE OSCURE [2]DINANZI ALLE TRAS-PARĒTI.

[3]Quādo le foglie saranno interposte [4]infra il lume e l' occhio, allora la più vici-[5]na all' occhio sarà più scura · e la più re-[6]mota sarà più chiara, nō cāpeggiādo ne [7]l' aria; e questo accade nelle fogli[8]e che sō dal centro dell' albero [9]ī là cioè inverso il lume.

OF DARK LEAVES IN FRONT OF TRANSPARENT ONES.

When the leaves are interposed between the light and the eye, then that which is nearest to the eye will be the darkest, and the most distant will be the lightest, not being seen against the atmosphere; and this is seen in the leaves which are away from the centre of the tree, that is towards the light.

G. 28_b_]

434.

DE' LUMI DELLE FOGLIE SCURE.

[2]I lumi di quelle foglie sarā più del co-lore del[3]l' aria che in loro si specchia, le quali sono di co[4]lore più oscuro; e questo è causa[5]to perchè il chiaro della parte alluminata coll' oscuro in se conpo[6]ne colore azzurro, e tal chiaro nascie [7]dall' azzurro dell' aria che nella [8]superfitie polita di tal foglie si specchia, ed aumē[9]ta l' azzurro che la detta chiarezza sol generare [10]colle cose oscure.

OF THE LIGHTS ON DARK LEAVES.

The lights on such leaves which are darkest, will be most near to the colour of the atmosphere that is reflected in them. And the cause of this is that the light on the illuminated portion mingles with the dark hue to compose a blue colour; and this light is produced by the blueness of the atmosphere which is reflected in the smooth surface of these leaves and adds to the blue hue which this light usually produces when it falls on dark objects.

DE' LUMI DELLE FOGLIE DI UERDURA TRAENTE AL GIALLO.

[13]Ma le foglie di uerdura traēte al giallo nō [14]ànno nello spechiare dell' aria a fare lustro [15]d' azzurro participante, conciosiachè ¶ogni cosa che appari[16]sce nello specchio participa del colore di tale [17]spechio ¶ adun-que l' azurro dell' aria spechi[18]ato nel giallo della foglia pare verde, perchè azzurro e gia[19]llo insieme misti cōpongono bellisimo color[20]e verde, adunque verdi gialli sarà li lustri del[21]le foglie chiare traenti al color giallo.

OF THE LIGHTS ON LEAVES OF A YELLOWISH GREEN.

But leaves of a green verging on yellow when they reflect the atmosphere do not produce a reflection verging on blue, inasmuch as every thing which appears in a mirror takes some colour from that mirror, hence the blue of the atmosphere being reflected in the yellow of the leaf appears green, because blue and yellow mixed together make a very fine green colour, therefore the lustre of light leaves verging on yellow will be greenish yellow.

Br. M. 114_b_]

435.

Sono li alberi infra loro in nelle cāpagnie di varie nature di uerde, in[2] perochè alcuni

The trees in a landscape are of various kinds of green, inasmuch as some verge

A classification of trees according to their colours.

433. 1—9 R. 2. trasparente. 3. interpossте. 4. infralume ellocchio. 5. ella. 6. cāpegādo. 7. ecquesto achade. 8. chessō. 9. coe.

434. 1. fogle. 3. sisspecohia. 4. osscuro ecquesto. 5. chiaro "della parte alluminata" collosscuro. 6. ettal . . nasscie. 7. azurro. 8. sisspecchia. 9. azurro chella . . ciarеza. 10. osscure. 14. isspechiare . . affare lusstro. 15. concosiache. 18. gallo "della foglia" pare. 20. verdigalli . . lusstri.

435. 1. infralloro inelle. 2. alcuno neggregga . . essimili. 3. giallegia . . e noci . . vite . . verdure ‖‖‖‖‖‖‖‖‖‖. 4. giallegiano con

433. See Pl. XXVIII, No. 2, the lower sketch.

negreggiā, come abeti, pini, cipressi, lauri, bussi e simili, ³alcuni gialleggiā, come sono i noci e peri, viti e verdure ||||||| ⁴alcuni gialleggiano con oscurità come castagni roveri, ⁵alcuni rosseggiano inverso l'autunno come sorbi, melagrani, viti⁶e ciriegi, alcuni biancheggiano come salici, oliui, canne e si-⁷mili.

⁸Sono l'alberi di uarie figure . .

towards blackness, as firs, pines, cypresses, laurels, box and the like. Some tend to yellow such as walnuts, and pears, vines and verdure. Some are both yellowish and dark as chesnuts, holm-oak. Some turn red in autumn as the service-tree, pomegranate, vine, and cherry; and some are whitish as the willow, olive, reeds and the like.

Trees are of various forms . .

G. 12a] 436.

DEL LUME VNIVERSALE ALLU²MINATORE DELLE PIANTE.

The proportions of light and shade in trees (436—440).

³Quella parte della piāta ⁴si dimostrerà vestita d'on⁵bre di minore oscurità, ⁶la quale fia più remota da⁷lla terra.

⁸Provasi, *a p* sia la pi⁹anta, *n b c* sia ¹⁰l'emisperio allumi-nato, ¹¹la parte di sotto del-l'albero ve¹²de la terra *p c* cioè la par¹³te *o ·*, e vede vn poco del¹⁴l'emisperio in *c d*; Ma la ¹⁵parte più alta nella cōcauità ¹⁶ · *a* · è veduta da maggior sōma de¹⁷ll'emisperio, cioè · *b · c ·* e per que¹⁸sto (e perchè nō vede la oscurità ¹⁹della terra) resta più allumi²⁰nata; Ma se l'albero, è spesso ²¹di foglie, come lauro, albatro, bo-²²sso o leccio, allora è variato, ²³perchè an-cora ²⁴che *a* nō veda la ²⁵terra e' uede la ²⁶oscurità delle fo²⁷glie, diuise da mo²⁸lte ōbre ²⁹la quale os³⁰curità riverbe³¹ra insù nelli ri³²versci delle so³³praposte foglie, ³⁴e questi tali al³⁵beri ànno l'onbre tā³⁶to più oscure, ³⁷quanto esse sō ³⁸più vicine al ³⁹mezzo dell'albero.

OF A GENERALLY DISTRIBUTED LIGHT AS LIGHTING UP TREES.

That part of the trees will be seen to lie in the least dark shadow which is farthest from the earth.

To prove it let *a p* be the tree, *n b c* the illuminated hemi-sphere [the sky], the under por-tion of the tree faces the earth *p c*, that is on the side *o*, and it faces a small part of the he-misphere at *c d*. But the highest part of the convexity *a* faces the greatest part of the hemi-sphere, that is *b c*. For this reason—and because it does not face the darkness of the earth—it is in fuller light. But if the tree has dense foliage, as the lau-rel, arbutus, box or holm oak, it will be different; because, although *a* does not face the earth, it faces the dark [green] of the leaves cut up by many shadows, and this darkness is reflected onto the under sides of the leaves immediately above. Thus these trees have their darkest shadows nearest to the middle of the tree.

G. 15a] 437.

DELL'ONBRA DELLA VERDURA.

²Senpre l'onbre delle verdure partecipa-³no dello azzurro e così ogni onbra d'o⁴gni altra cosa, e tanto più ne pi⁵glia quanto ella è più distante dal⁶l'ochio, e meno, quanto ella è più vi⁷cina.

OF THE SHADOWS OF VERDURE.

The shadows of verdure are always some-what blue, and so is every shadow of every object; and they assume this hue more in proportion as they are remote from the eye, and less in proportion as they are nearer.

osscurita come asstagni rove |||||||||||. 5. rossegiano inver laltunno. 6. bianchegiano . . salci . . essi. 8. figure de quali la *here the text breaks off.*

436. 1 — 39 R. 4. dimostera. 5. osscurita. 6. la qua fia. 8. *a b* sia. 9. n b c sia [lorizōte o]. 11. diso dellalbero. 12. coe. 13. pocho. 14. lemissperio . . Malla. 16. magor soma. 17. llemissperio coe . a c . e pe que. 18. osscurita. 20. Massellal-bero esspesso. 22. ollecco . . variato *4.* 23. *4* perche. 28. ōbre [delle vici]. 29. [ne] la quale. 33. praposste. 34. ec-questi. 35. beri allonbre. 36. oscure. 39. meza.

437. 3. accuro . . ongni. 4. chosa ettanto . . ne pil. 5. ellatre piu distanti. 6. ellahc. 10. lazurro. 12. mosstrano. 17. [La cosa

[8]Le foglie, che [9]spechiano [10]l'azzurro del-[11]l'aria, senpre [12]si mostrano [13]all'ochio per ta[14]glio.

DELLA PARTE ALLUMINATA [16]DELLE VERDURE E MŌTI.

[18]La parte alluminata si dimostrerà [19]piv in lunga distanza del suo na[20]turale colore, la quale sarà allumi[21]nata da più potente lume.

The leaves which reflect the blue of the atmosphere always present themselves to the eye edgewise.

OF THE ILLUMINATED PART OF VERDURE AND OF MOUNTAINS.

The illuminated portion, at a great distance, will appear most nearly of its natural colour where the strongest light falls upon it.

G. 28 b]

438.

LI ALBERI CHE SONO ALLUMINATI [2]DAL SOLE E DALL'ARIA.

[3]Li alberi alluminati dal sole e dal-l'aria, avendo [4]le foglie di colore oscuro, sarā da vna parte [5]alluminati dall'aria e per questo tale allu[6]minatione participa d'azzurro, e dall'altra parte [7]saranno allu-minati dall'aria e dal sole, e quella [8]parte che l'ochio vedrà alluminata dal sole fia lustra.

OF TREES THAT ARE LIGHTED BY THE SUN AND BY THE ATMOSPHERE.

In trees that are illuminated [both] by the sun and the atmosphere and that have leaves of a dark colour, one side will be illuminated by the atmosphere [only] and in consequence of this light will tend to blue-ness, while on the other side they will be illuminated by the atmosphere and the sun; and the side which the eye sees illuminated by the sun will reflect light.

Ash. I. 4 a]

439

DEL FIGURARE UNO SITO SELUAGGIO.

[2]Li alberi e l'erbe, che sono · piv rami-ficati di sottili rami, deono [3]avere minore oscurità · d'ōbra: quell'albero e quelle erbe, che avrāno maggiori [4]foglie, fieno cagiō di maggiorc ōbra.

OF DEPICTING A FOREST SCENE.

The trees and plants which are most thickly branched with slender branches ought to have less dark shadow than those trees and plants which, having broader leaves, will cast more shadow.

E. 18 b]

440.

PICTURA.

[2]Nella situatione dell'ochio, il qual uede [3]alluminata quella parte delle piante che [4]veggono il luminoso, mai fia veduta al-[5]luminata l'una pianta come l'altra ·; [6] pruo-vasi e sia l'ochio c che vede [7]le due piante

ON PAINTING.

In the position of the eye which sees that portion of a tree illuminated which turns towards the light, one tree will never be seen to be illuminated equally with the other. To prove this, let the eye be c which sees

alluminata re]. 18. aluminata si dimosstrerra. 19. illungha. 20. cholore. 21. potente [cholore] lume.

438. 3. Deli alberi . . eddallaria. 4. osscuro. 5. alluminate alluminate dallaria . . talle. 6. dazurro. 7. alluminate . . ecquella. 8. chellochio . . lusstra.

439. 1. î sito seluagio. 2. li alberi [erbe] ellerbe chessono piv ramifiga[ndi]ti. 3. osscurta . . arāno magiore. 4. chagiō di magiore.

440. 4. veghano. 5. chome. 6. essia. 8. dicho chettale. 9. vedera. 11. chome . . inperochecquell albero. 12. dimossterra.

440. The two lower sketches on the left of Pl. XXVIII, No. 3, refer to lines 21—23. The upper sketch has apparently been effaced by Leonardo himself.

b d, le quali sono allu[8]minate dal sole *a*; dico che tale occhio *c* [9]non vedrà li lumi essere della medesima [10]proportione alla sua ōbra nell'vno albero [11]come nell'altro ·; inperochè quell'albero, ch'è [12]più vicino al sole, si dimostrerà tanto pi[13]v ōbroso che quell che n'è più remo[14]to, quāto l'uno albero è più vicino al cō[15]corso de' razzi solari che vēgono all' ochio [16]che l'altro ecc.

[17]Vedi che dell'albero *d* nō si uede dall'occhio *c* [18]altro che ōbra, e dal medesimo occhio *c* si [19]vede l'albero *b* mezzo alluminato e mezzo [20]aōbrato.

[21]L'albero che è veduto sotto: l'ochio vede [22]la cima . d'esso albero stare dētro alla cir[23]culatione che fanno li sua rami.

[24]Ricordati, o pictore, che tanto sono varie le [25]oscurità dell'onbre in una medesima spe[26]tie di piante, quante son varie le rarità [27]o densità delle loro ramificationi.

the two trees *b d* which are illuminated by the sun *a*; I say that this eye *c* will not see the light in the same proportion to the shade, in one tree as in the other. Because, the tree which is nearest to the sun will display so much the stronger shadow than the more distant one, in proportion as one tree is nearer to the rays of the sun that converge to the eye than the other; &c.

You see that the eye *c* sees nothing of the tree *d* but shadow, while the same eye *c* sees the tree *b* half in light and half in shade.

When a tree is seen from below, the eye sees the top of it as placed within the circle made by its boughs[23].

Remember, O Painter! that the variety of depth of shade in any one particular species of tree is in proportion to the rarity or density of their branches.

E. 19 a] **441.**

The distribution of light and shade with reference to the position of the spectator (441—443).

Le ōbre delle piāte, poste ne' paesi, nō [2]si dimostrano vestite di se cō [3]medesima situatione nelle piante destre co[4]me nelle sinistre, e massime essendo il sole a [5]destra o a sinistra; provasi per la 4 che di[6]cie ¶li corpi oppachi, interposti infra 'l lume [7]e l'ochio, si dimostrā tutti ōbrosi, e per la 5[a] ¶l'o[8]chio interposto infra 'l corpo opaco e lu[9]me vede il corpo opaco tutto alluminato, [10]e per la 6[a] ¶l'ochio e 'l corpo opaco, interposto infra le [11]tenebre e'l lume, fia veduto mezzo ōbroso e mezzo lu[12]minoso.

The shadows of trees placed in a landscape do not display themselves in the same position in the trees on the right hand and those on the left; still more so if the sun is to the right or left. As is proved by the 4th which says: Opaque bodies placed between the light and the eye display themselves entirely in shadow; and by the 5th: The eye when placed between the opaque body and the light sees the opaque body entirely illuminated. And by the 6th: When the eye and the opaque body are placed between darkness and light, it will be seen half in shadow and half in light.

G. 9 b] **442.**

DELL'ERBE DE' PRATI.

[2]Delle erbe che pigliā l'onbre delle [3]piāte, che nascono infra esse, quelle [4]che

OF THE HERBS OF THE FIELD.

Of the plants which take a shadow from the plants which spring among them, those

13. checquell. 14. al chō. 15. chorso . . vēghano. 16. chellaltro. 18. eddal. 19. emezo. 21. Labro. 23. chulatione cheffanno. 24. Richordati . . chettanto . . le [le ō]. 25. [bre] osscurita dellonbre nuna. 27. oddensita . . ramifichationi.

441. 1. posste. 2. si [debbō] dimosstrano [circhu] vestite. 3. dess!re cho. 4. sinisstre. 5. dessta o assinisstra . . cheddi. 6. chorpi . . interpossti. 7. ellochio si dimosstra tutte ōbrose. 8. interpossto . . oppacho ollu. 9. oppacho. 10. chorpo opacho . . infralle. 11. ellume . . mezo . . mezo.

442. 1—21 R. 1. delie erbe . . piglia . . dellepi 2. 3. nasscano . . esse (quelle *is wanting*). 5. minate . . ellerbe. 6. āonbrate.

441. See the figure on the right hand side of Pl. XXVIII, No. 3. The first five lines of the text

are written below the diagram and above it are the last eight lines of the text, given as No. 461.

sō di quà dall'ōbra ànno li festuchi allu-
[5]minati in cāpo ōbroso, e l'erbe, che [6]loro
ànno onbrate, [7]àño li festuchi oscuri ī [8]cāpo
chiaro, cioè nel cāpo ch'è di là da [9]l'on-
bra.

DELLE PIĀTE CHE SONO [12]INFRA L'OCHIO E 'L LUME.

[13]Delle piāte ·, che sono infra l'ochio e
'l lume, [14]la parte dināti fia chiara, la qual
[15]chiarezza fia mista di ramificatiō di fo-
[16]glie trasparēti (per essere vedute da river-
[17]scio) cō foglie lustre vedute dal di[18]ritto,
e il loro canpo di sotto e dirieto [19]sarà
di verdura oscura, per essere aō[20]brata
dalla parte dināti della detta piāta, [21]e
questo accade nelle piāte più alte del-
l'ochio.

which are on this side [in front] of the
shadow have the stems lighted up on a back-
ground of shadow, and the plants on which
the shadows fall have their stems dark on
a light background; that is on the back-
ground beyond the shadow.

OF TREES WHICH ARE BETWEEN THE EYE AND THE LIGHT.

Of the trees which are between the eye
and the light the part in front will be light;
but this light will be broken by the rami-
fications of transparent leaves—being seen
from the under side—and lustrous leaves—
being seen from the upper side; and the
background below and behind will be dark
green, being in shadow from the front por-
tion of the said tree. This occurs in trees
placed above the eye.

G. 19b]

443.

DOVE SI DE' RITRARRE [2]LI PAESI.

[3]Li paesi si debbono ritrarre in modo,
che [4]li alberi siē mezzo alluminati e mezzo
a[5]ōbrati, ma meglio è farli quādo il so[6]le
è occupato da nvvoli, che allora li [7]alberi
s'aluminano da lume vniversale [8]del celo
e da ōbra vniversale della terra, [9]e questi
sō tāto più oscuri nelle [10]lor parti, quāto
esse parti sō più pres[11]so al mezzo del-
l'albero e della terra.

FROM WHENCE TO DEPICT A LANDSCAPE.

Landscapes should be represented so that
the trees may be half in light and half in
shadow; but it is better to do them when
the sun is covered with clouds, for then
the trees are lighted by the general light of
the sky, and the general darkness of the
earth. And then they are darkest in certain
parts in proportion as those parts are nearest
to the middle of the tree and to the earth.

G. 20b]

444.

DELLE PIĀTE MERI[2]DIONALI.

[3]Quādo il sole è all'oriēte, le pi[4]ante
meridionali e settētriona[5]li ànno quasi
tanto di lume quā[6]to d'ōbra; Ma tāto mag-
gior sō[7]ma di lume quāto esse son pi[8]v
occidētali, e tāto ma[9]gior sōma d'ōbra
quāto esse [10]sō più oriētali.

OF TREES TO THE SOUTH.

When the sun is in the east the trees to
the South and to the North have almost as
much light as shadow. But a greater share
of light in proportion as they lie to the
West and a greater share of shadow in pro-
portion as they lie to the East.

DELLI PRATI.

[12]Stādo il sole all'oriēte, le ver[13]dure de'
prati e altre piccole piā[14]te sō di bellissima
verdura per esse[15]re trasparēti al sole, il che
non ac[16]cade ne' prati occidētali, e le erbe
[17]meridionali e settētrionali sō [18]di mediocre
bellezza di verdura.

OF MEADOWS.

If the sun is in the East the verdure of
the meadows and of other small plants is
of a most beautiful green from being trans-
parent to the sun; this does not occur in
the meadows to the West, and in those to
the South and North the grass is of a mo-
derately brilliant green.

The effects
of morning
light
(444—448).

8. chāpo . . coe. 10. chessono. 13. chessono. 14. ella qual. 15. chiarezza di fol. 16. trassparēti . . vedete. 17. lusstre.
19. osscura. 21. ecquesto achade.
443. 1—11 R. 1. si de ritrarre. 3. debō . . chel. 4. mezi . . ēmezo. 6. ochupato. 9. ecquesti . . osscuri. 10. esse parte . . pre. 11. mezo.
444. 1—18 R. 3. sole he. 5. li anquasi. 6. Mattāto magor so. 8. ettanto. 9. gor. 13. pichole. 14. ese. 15. sole il ce none a.
16. chade . . elli. 17. essettētrionali.

445.

4 ASPETTI DE' PAESI.

[2]Quando il sole è all'oriēte, tutte [3]le parti alluminate delle piāte sō [4]di bellissima verdura, e questo ac[5]cade, perchè le foglie alluminate dal [6]sole dētro [7]alla metà dell'orizzonte, [8]cioè la metà oriē-tale, sō [9]trasparēti·, [10]e dētro al semicircolo occidē[11]tale le verdure ànno tristo colore; [12]e l'aria vmida e turba, di color [13]di oscura cenere, per non es[14]sere trasparēte come la oriē[15]tale, la quale è lucida e tā[16]to più quāto essa è più vmida.

[17]Le ōbre delle piāte oriētali [18]occupano grā parte della pianta [19]e sono tanto più oscure quāto [20]li alberi sō più spessi di foglie.

OF THE 4 POINTS OF THE COMPASS [IN LANDSCAPES].

When the sun is in the East all the portions of plants lighted by it are of a most lively verdure, and this happens because the leaves lighted by the sun within the half of the horizon that is the Eastern half, are transparent; and within the Western semicircle the verdure is of a dull hue and the moist air is turbid and of the colour of grey ashes, not being transparent like that in the East, which is quite clear and all the more so in proportion as it is moister.

The shadows of the trees to the East cover a large portion of them and are darker in proportion as the foliage of the trees is thicker.

446.

DEGLI ALBERI ORIĒTALI.

[2]Stādo il sole all'oriēte, li alberi ve[3]duti inverso esso oriēte avran[4]no il lume che li circunderà, d'into[5]rno alle sue ōbre, eccetto diuer[6]so la terra, saluo se l'albero nō fus·[7]si stato rimōdo l'anno passato; [8]E gli alberi meridionali e settē[9]trionali saranno mezzi ōbrosi e mez[10]zi luminosi, e più e mē on-brosi[11]o luminosi secōdo che sarā [12]più e meno oriētali o occi[13]dētali.

[14]L'occhio alto o basso varia [15]le ōbre e li lumi nelli alberi, inpero[16]chè l'ochio alto vede li alberi, cō po[17]che ōbre e il basso con assai ōbre.

[18]Tanto sō varie le verdure [19]delle piāte quāto sō varie [20]le loro spetie.

OF TREES IN THE EAST.

When the sun is in the East the trees seen towards the East will have the light which surrounds them all round their shadows, excepting on the side towards the earth; unless the tree has been pruned [below] in the past year. And the trees to the South and North will be half in shade and half in light, and more or less in shade or in light in proportion as they are more or less to the East or to the West.

The [position of] the eye above or below varies the shadows and lights in trees, inasmuch as the eye placed above sees the tree with the little shadow, and the eye placed below with a great deal of shadow.

The colour of the green in plants varies as much as their species.

447.

DEL'ŌBRE DELLI ALBERI.

[2]Stādo il sole all'oriēte, li alberi occi-[3]dētali all'ochio ‖ si dimostrano di po[4]chissimo rilievo e quasi d'insēsi[5]bile dimostra-

OF THE SHADOWS IN TREES.

The sun being in the East [to the right], the trees to the West [or left] of the eye will show in small relief and almost imper-

445. 1 - 20 R. 1. asspetti. 3. parte. 4. ecquesto. 6. sole [in tutto lorizo] dētro . . orizonte. 8. coe. 10. gemice ocidē. 11. an. 12. alluria . . etturba. 13. osscura cenere [elliari] per nōn e. 15. he lucida ettā. 18. ochupano. 19. essono . . osscure.

446. 1—20 R. 1. āberi. 3. aran. 4. chelli. 5. eccepto. 6. sellalbero non fu. 8. essettē. 9. sara mez ōbrosi. 10. i luminos e piu. 11. olluminosi secōche. 12. ho occi. 14. obbasso. 15. elli.

447. 1—22 R. 2. oci. 4. ecquasi. 5. per laria. 7. he molto. 11. chatione . . achade chelie. 12. militudine . . ellume. 13. vē-

tione, perchè l'aria, che in⁶fra l'occhio e esse piante s'interpone, ⁷è molto fvsca, per la 7ª di questo; ⁸e sō privati d'ōbra, e bēchè l'ōbra ⁹sia in ciascuna diuisiō ¹⁰di ramifi¹¹catione, egli accade che le si¹²militudini dell'ōbra e lume, che ¹³vēgono all'ochio, sien cōfuse e ¹⁴miste insieme e per la loro piccola ¹⁵figura nō si possano cōprēdere; ¹⁶E li lumi prīcipali sō nelli ¹⁷mezzi delle piāte e le ōbre inver¹⁸so li stremi, e le loro separationi ¹⁹sō diuise dal'ōbre delli interualli d'esse ²⁰piāte, quādo le selue sono spesse ²¹d'alberi, e' nelli rari termini po²²co si vedono.

ceptible gradations, because the atmosphere which lies between the eye and those trees is very dense [7], see the 7ᵗʰ of this — and they have no shade; for though a shadow exists in every detail of the ramification, it results that the images of the shade and light that reach the eye are confused and mingled together and cannot be perceived on account of their minuteness. And the principal lights are in the middle of the trees, and the shadows towards the edges; and their separation is shown by the shadows of the intervals between the trees; but when the forests are thick with trees the thin edges are but little seen.

G. 22 b]

448.

DELLI ALBERI ORIĒTALI.

²Stādo il sole all'oriēte, li sua alberi ³sono oscuri inverso il mezzo e li loro stremi sō luminosi.

OF TREES TO THE EAST.

When the sun is in the East the trees are darker towards the middle while their edges are light.

L. 87 a]

449.

LE COSE POSTE NEL LUME MAL SI DISCIERNONO, ²MA FRA LUME E ŌBRA SPICHERĀ BENE.

³Per ritrare paesi fa che 'l sol sia a mezzodì e volta⁴ti a ponēte o a levāte e ritrai, e se ti volte⁵rai a settētrione, tutte le cose che sarā poste ⁶per questa linia fiē sanz' ōbre, e massime quelle ⁷che sarā piv propinque all'ōbra del tuo capo; ⁸e se ti volterai a mezzodì, ogni cosa per quella ⁹linia fia tutto ōbrosa; ¹⁰tutte le piāte, che fiē verso il sole, che avranno per suo ¹¹canpo l'aria, fieno oscure, e l'altre piā¹²te, che cāpeggieranno in tale oscurità, fiē nere ¹³in mezzo e chiare inverso li stremi.

OBJECTS IN HIGH LIGHT SHOW BUT LITTLE, BUT BETWEEN LIGHT AND SHADOW THEY STAND OUT WELL.

To represent a landscape choose that the sun shall be at noon and look towards the West or East and then draw. And if you turn towards the North, every object placed on that side will have no shadow, particularly those which are nearest to the [direction of the] shadow of your head. And if you turn towards the South every object on that side will be wholly in shadow. All the trees which are towards the sun and have the atmosphere for their background are dark, and the other trees which lie against that darkness will be black [very dark] in the middle and lighter towards the edges.

The effects of midday light.

gano. 14. pichola. 15. possā cōplēdere. 17. mezi . . elle. 18. elle lor seperationi. 22. vedano.
448. 1—3 R. 3. osscuri . . mezo chelli.
449. 1—13 R. 1. lecho . . ello nel . . disciernano. 2. frallume. 3. amezo [e volta. 4. alleuāte . . esetti. 5. assettatrione . . chessarā. 6. masime quele. 8. essetti 10. cheffiē . . cheārā. 11. osscure chelaltre. 12. chāpegieranno. 13. imezo.

447. 7. *per la 7ª di questo.* This possibly referred to something written on the seventh page of this note book marked *G*. Unfortunately it has been cut out and lost.

G. 25*b*] **450.**

DELLA TRAFORATIŌ [2]DELLE PIATE IN SE.

OF THE SPACES [SHOWING THE SKY] IN TREES THEMSELVES.

The appea-rance of trees in the distance (450. 451).

[3]La traforatione dell'aria nelli cor[4]pi delle piante e la traforatione [5]delle piāte infra l'aria in lunga [6]distantia non si dimostrano alli occhi, [7]perchè, doue con fatica si conprēde il tutto, [8]con difficultà si conoscono le parti—ma [9]fassi vn misto confuso, il qual parti[10]cipa più di quel ch'è maggior sōma; [11]li traforamēti dell'albero sono di par[12]ticule d'aria alluminata, le quali sō [13]assai minori della piāta, e però pri[14]ma si perdono di notitia che essa pian[15]ta, ma nō resta per questo che esse nō [16]vi sieno, onde per neciessità si fa vn mi[17]sto d'aria e di scuro del' albero onbroso, il [18]quale insieme cōcorre all'ochio che 'l ue[19]de.

The spaces between the parts in the mass of trees, and the spaces between the trees in the air, are, at great distances, invisible to the eye; for, where it is an effort [even] to see the whole it is most difficult to discern the parts. — But a confused mixture is the result, partaking chiefly of the [hue] which predominates. The spaces between the leaves consist of particles of illuminated air which are very much smaller than the tree and are lost sight of sooner than the tree; but it does not therefore follow that they are not there. Hence, necessarily, a compounded [effect] is produced of the sky and of the shadows of the tree in shade, which both together strike the eye which sees them.

DELLI ALBERI CHE OCCUPANO LE TRA[21]FORA-TIONI L'UN DELL'ALTRO.

OF TREES WHICH CONCEAL THESE SPACES IN ONE ANOTHER.

[22]Quella parte dell'albero sarà mē trafora[23]ta, alla quale s'oppone dirietro infra [24]l'albero, e l'aria maggior somma d'altro al[25]bero, come nel albero *a* nō si occupa tra[26]foratione, nè

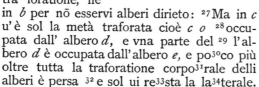

That part of a tree will show the fewest spaces, behind which a large number of trees are standing between the tree and the air [sky]; thus in the tree *a* the spaces are not concealed nor in

in *b* per nō esservi alberi dirieto: [27]Ma in *c* u'è sol la metà traforata cioè *c o* [28]occupata dall' albero *d*, e vna parte del [29] l'albero *d* è occupata dall'albero *e*, e po[30]co più oltre tutta la traforatione corpo[31]rale delli alberi è persa [32] e sol ui re[33]sta la la[34]terale.

b, as there is no tree behind. But in *c* only half shows the spaces filled up by the tree *d*, and part of the tree *d* is filled up by the tree *e* and a little farther on all the spaces in the mass of the trees are lost, and only that at the side remains.

G. 26*b*] **451.**

DE' ALBERI.

OF TREES.

[2]Quali termini dimostrano le piāte [3]remote dall'aria che si fa lor cāpo?

[4]Li termini, che ànno le ramificatiō deli al[5]beri coll'aria alluminata, quanto più sō [6]remoti più si fanno in figura tra[7]ēte allo sperico, e quanto più son [8]vicine più dimostrāsi remote da [9]tale spericità, come *a* albero primo, che [10]per essere lui vicino

What outlines are seen in trees at a distance against the sky which serves as their background?
The outlines of the ramification of trees, where they lie against the illuminated sky, display a form which more nearly approaches the spherical on proportion as they are remote, and the nearer they are the less they appear in this spherical form; as in the first tree *a* which, being near to the eye,

450. 4. ella. 5. lungha. 6. allocchi. 7. faticha si conplēde il tuto. 8. conosce. 10. maggor soma co. 14. perdano. 16. mis. 18. cōcore. 20. ochupano. 23. sopone. 24. ellaria magor. 25. ocupa. 26. nō esser a alberi. 27. trofaroto coe. 28. ocupato. 31. deli.

451. 2. dimostrino. 3. remo dall aria chessi. 4. cheāle. 5. collarialluminata. 7. spericho. 8. dimostrā remote. 9. albero P°

451. The sketch No. 4, Pl. XXVIII, belongs to this passage.

all'ochio, ¹¹dimostra la vera figura ¹²della sua ramificatione, la ¹³quale si diminuiscie quasi in *b*, ¹⁴e al tutto si perde in *c*, doue non che li ra¹⁵mi d'essa pianta si vedono, ma tut¹⁶ta la pianta cō grā fatica si conosce. ¹⁷¶Ogni corpo onbroso, il quale sia di qua¹⁸lunque figura si voglia, in lunga distā-¹⁹tia pare essere sperico;¶ E questo ²⁰nascie perchè, s'elli è vn corpo quadra²¹to, in breuissima distātia si perdono li ango²²li sua, e poco piv si perde più di lati mi²³nori che restano, e così prima che si ²⁴perda il tutto si perde le parti per esse²⁵re minor del tutto, come l'uomo, ch'è in tal²⁶le aspetto, perde prima le ganbe, braccia e tes²⁷ta che 'l busto, di poi perde prima li ²⁸stremi della lunghezza che della larghezza e ²⁹quādo son fatti equali sarebbe □, se li an³⁰goli vi restassino, ma non ui restando è tondo.

displays the true form of its ramification; but this shows less in *b* and is altogether lost in *c*, where not merely the branches of the tree cannot be seen but the whole tree is distinguished with difficulty. Every object in shadow, of whatever form it may be, at a great distance appears to be spherical. And this occurs because, if it is a square body, at a very short distance it loses its angles, and a little farther off it loses still more of its smaller sides which remain. And thus before the whole is lost [to sight] the parts are lost, being smaller than the whole; as a man, who in such a distant position loses his legs, arms and head before [the mass of] his body, then the outlines of length are lost before those of breadth, and where they have become equal it would be a square if the angles remained; but as they are lost it is round.

I.₁ 37*b*]

452.

La stanpa dell'onbra di qualūque cor-²po di uniforme grossezza mai sarà simile ³al corpo, donde ella nascie.

The image of the shadow of any object of uniform breadth can never be [exactly] the same as that of the body which casts it.

The cast shadow of trees (452. 453).

Br. M. 114*a*]

453.

Tutti li alberi, veduti diuerso il sole, sono oscuri verso il ²mezzo, la quale oscurità fia della figura del suo albero, quādo fia ³diuiso dalli altri.

⁴Le onbre diriuatiue delli alberi, veduti dal sole, sono oscure quāto quel⁵la del mezzo delli alberi.

⁶L'onbra diriuatiua delli alberi, mai fia di minor somma che la somma d'esso al-⁷bero, ma fia tanto maggiore quāto il sito dove si taglia fia piv obbliquo īuerso ⁸il cētro del mōdo.

⁹Quella onbra sarà piv stretta inverso il mezzo dell'albero, del quale il suo albero fia ¹⁰di più rara ramificatione.

All trees seen against the sun are dark towards the middle and this shadow will be of the shape of the tree when apart from others.

The shadows cast by trees on which the sun shines are as dark as those of the middle of the tree.

The shadow cast by a tree is never less than the mass of the tree but becomes taller in proportion as the spot on which it falls, slopes towards the centre of the world.

The shadow will be densest in the middle of the tree when the tree has the fewest branches.

che. 12. le. 14. perde *c*. 15. vedino mattu. 16. faticha. 17. onbro. 18. lungha. 19. spericho Ecquessto. 20. nasscie. 21. innbreuissima . . perdono. 23. nori che resstano. 24. parte. 26. le essetto perde . . brca e tes. 27. bussto. 28. lungeza . . largeza ec. 29. sarebe □, selli.
452. 2. grosseza Mai. 3. nasscie.
453. 1. osscuri. 2. mezo . . osscurita. 4. solessono osscure. 5. mezo dellalberi. 6.' chella. 7. maffia . . magore. 9. mezo. 10. [pi] di piu. 11. ogngni . . mezo . . tutti. 13. obra . . vesstita . . parte. 14. dacquella. 15. ecquesto . . dacquella . .

452. See Pl. XXVIII, No. 5.
453. The three diagrams which accompany this text are placed, in the original, before lines 7—11.

At the spots marked *B* Leonardo wrote *Albero* (tree). At *A* is the word *Sole* (sun), at *C Monte* (mountain) at *D piano* (plain) and at *E cima* (summit).

¹¹Ogni ramo à 'l mezzo dell'onbra di qualunche ramo e per cōseguēza di tutto ¹²il suo albore.

¹³La figura di qualunche ōbra di ramo o d'albero fia vestita di parti luminose ¹⁴da quella parte, donde viene il lume, la quale alluminatione fia della figura ¹⁵dell'onbre, e questo fia per ispati d'ū miglio da quella parte che si trova il ¹⁶sole.

¹⁷S'elli accade che alcū nvuolo in alcuna parte aonbra qualche parte de' colli, ¹⁸li alberi sua fanno māca mvtatione che in loco piano, perchè essi alberi su colli ¹⁹son piv spessi di rami, perchè manco mettono per anno che ne' piani, onde essi rami per ²⁰essere oscuri di natura e per essere pieni d'onbre, le onbre de' nvuoli nō li possono ²¹piv oscurare, e i piani che si interpongono infra li alberi, che non ànno preso al²²cuna onbra, forte si transmutano della lor chiarezza, e massimamente quelli ²³che son vari dal verde cioè terreni lauorati o ruine di mōti o loco di sterilità e sasso; ²⁴dove li alberi confinano coll'aria, essi paiono d'ū medesimo colore—²⁵se già non fussino molto propinqui e di foglie spesse, come il pino e simili alberi; ²⁶quādo tu vedrai li alberi per quel uerso che li allumina il sole, tu li vedrai quasi d'una medesima ²⁷chiarezza · e le ōbre che dentro vi sono fieno occupate dalle foglie alluminate, che infra l'ochio tuo e ²⁸l'onbre s'interpōgono.

Every branch participates of the central shadow of every other branch and consequently [of that] of the whole tree.

The form of any shadow from a branch or tree is circumscribed by the light which falls from the side whence the light comes; and this illumination gives the shape of the shadow, and this may be of the distance of a mile from the side where the sun is.

If it happens that a cloud should anywhere overshadow some part of a hill the [shadow of the] trees there will change less than in the plains; for these trees on the hills have their branches thicker, because they grow less high each year than in the plains. Therefore as these branches are dark by nature and being so full of shade, the shadow of the clouds cannot darken them any more; but the open spaces between the trees, which have no strong shadow change very much in tone and particularly those which vary from green; that is ploughed lands or fallen mountains or barren lands or rocks. Where the trees are against the atmosphere they appear all the same colour—if indeed they are not very close together or very thickly covered with leaves like the fir and similar trees. When you see the trees from the side from which the sun lights them, you will see them almost all of the same tone, and the shadows in them will be hidden by the leaves in the light, which come between your eye and those shadows.

ALBERI VICINI.

²⁹Li alberi, che infra 'l sole e l'ochio s'interpongono—dopo le onbre, che diuerso il loro ciētro si dilatano, ³⁰si uedrà il uerde delle lor foglie trasparēte, la qual transparētia fia interrotta in molte ³¹parti dalle foglie e rami onbrati, che infra te e loro s'interpōgono, o nelle lor parti superiori ³²da molti lustri di foglie fieno accōpagnate.

TREES AT A SHORT DISTANCE.

When the trees are situated between the sun and the eye, beyond the shadow which spreads from their centre, the green of their leaves will be seen transparent; but this transparency will be broken in many places by the leaves and boughs in shadow which will come between you and them, or, in their upper portions, they will be accompanied by many lights reflected from the leaves.

chessi. 17. achade. 18. iloco "spatio" piani perche. 19. mettano "per anno" che . . esse ramp. 20. lessere ossuri e pere essere le onbr de . . possano. 21. osscurare . . chessi interpongano infralli. 22. chiareza e massimamenti. 23. coe . . lauolati or uine "e" . . loco sterilita essasso sia. 24. paiono. 25. molti. 26. essimili. 26. chelli. 27. ciareza . . elle . . ochupate delle . . infrallochio tuo ellonbre. 28. sinterpongano. 29. li abri . . ellochio sinterpongano . . il suo ciētro. 30. traasparēte. 31. parte . elloro interpōgano . . parte. 32. lusstri. 32. acōpagnate.

29. The heading *alberi vicini* (trees at a short distance) is in the original manuscript written in the margin.

B. M. 172 *b*] 454.

Li alberi delle canpagnie poco spiccano l'uno dall'altro, perchè le lor parti luminate [2]confinano sopra le luminate dopo loro, e in questo è poco differētia da' lumi a l'ōbre.

The trees of the landscape stand out but little from each other; because their illuminated portions come against the illuminated portions of those beyond and differ little from them in light and shade.

G. 6 *a*] 455.

Delli alberi veduti di sotto [2]e cōtro al lume l'un dopo l'al[3]tro vicinamēte: la parte vlti[4]ma del primo sarà transparēte [5]e chiara in grā parte e can[6]peggierà nella parte oscura [7]dell' albero secondo, e così farān tut[8]ti successiuamēte che sarā situ[9]ati colle predette cōditioni.
[10]*s* sia il lume, *r* sia [11]l'ochio, *c d n* sia l'albero [12]primo, *a b c* sia il secondo; dico [13]che *r* occhio vedrà la parte [14]*c f* in grā

Of trees seen from below and against the light, one beyond the other and near together. The topmost part of the first will be in great part transparent and light, and will stand out against the dark portion of the second tree. And thus it will be with all in succession that are placed under the same conditions.
Let *s* be the light, and *r* the eye, *c d n* the first tree, *a b c* the second. Then I say that *r*, the eye, will see the portion *c f*

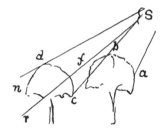

parte trasparēte [15]e chiara per il lume *s*, che la ve[16]de dall'opposita parte, e ve[17]drala in canpo scuro *b c*, perchè [18]tale oscurità è l'onbra dell'albero [19]*a b c*;
[20]Ma se l'occhio è situato in *t*. [21]esso vedrà *o p* oscuro nel canpo chi[22]aro *n g*.
[23]Delle parti [24]ōbrose traspa[25]rēti delli alberi [26]la più vicina [27]a te è più oscu-[28]ra.

in great part transparent and lighted by the light *s* which falls upon it from the opposite side, and it will see it, on a dark ground *b c* because that is the dark part and shadow of the tree *a b c*.
But if the eye is placed at *t* it will see *o p* dark on the light background *n g*.
Of the transparent and shadowy parts of trees, that which is nearest to you is the darkest.

W. VI.] 456.

Quella parte dell'albero, che campeggia [2]diuerso l'onbra, è tutta d'un colore e do-[3]ve li alberi overo rami sō piv spes[4]si ivi è piv scuro, perchè lì māco [5]si stāpa l'aria; Ma dove li ra[6]mi cāpeggiano sopra altri ra[7]mi, quivi le parti luminose [8]si dimostrā piv chiare e le foglie [9]lustre per lo sole che l'allumina.

That part of a tree which has shadow for background, is all of one tone, and wherever the trees or branches are thickest they will be darkest, because there are no little intervals of air. But where the boughs lie against a background of other boughs, the brighter parts are seen lightest and the leaves lustrous from the sunlight falling on them.

454. 1. pocho spichano . . parte. 2. pocho diferētia.
455. 1—28 R. 4. del p° sara. 6. pegiera . . osscura. 7. albero 2° e . . tu. 8. sucessiuamēte. 12. p°, *a b c* sia il 2° dicho. 13. vedera. 14. gra. 15. i lume chella. 16. oposita. 18. talle osscurita. 20. sellochio. 21. osscuro. 23. parte. 24. trasspa. 25. rēte deli.
456. 1—9 R. 1. chanpegia. 2. ettuttā . . cholore. 3. albri[so]overo . . spe. 4. mācho. 5. stāpissce. 6. cāpegiano. 7. parte. 8. dimostra . . chiari. 9. chellalumina.

G. 27 *b*] **457.**

Nelle cōpositioni delli alberi frō²duti sia auertito di nō replicare ³troppe volte vn medesimo colore ⁴d'una piāta, che canpeggi sopra ⁵il medesimo colore dell' altra pi⁶anta, ma varialo cō verdura ⁷più chiara o piv oscura o più ⁸verde.

In the composition of leafy trees be careful not to repeat too often the same colour of one tree against the same colour of another [behind it]; but vary it with a lighter, or a darker, or a stronger green.

Br. M. 113 *b*] **458.**

On the treatment of light for landscapes (458—464).

Piv bello azzurro ànno i paesi, quādo per li tenpi belli el sole è a mezzodì che in nessuna ²altra età del dì, perchè l'aria è disgrossata d'umori e risguardando per quell'aspetto tu vedi li al³beri belli in verde nei loro stremi e l'onbre inverso il mezzo oscure, e nelle lunghe distantie l'aria che

The landscape has a finer azure [tone] when, in fine weather the sun is at noon than at any other time of the day, because the air is purified of moisture; and looking at it under that aspect you will see the trees of a beautiful green at the outside and the shadows dark towards the middle; and in

⁴s'interpone infra te e loro si fa piv bella quādo dopo lei è cosa piv oscura, e però l'azzurro è bellissimo.¶ ⁵Le cose, vedute per quel uerso che 'l sol'allumina, non ti mostrerā le sue onbre ‖ Ma se tu sei ⁶piv basso d'esso sole, tu uedrai quel che dal sole nō fu veduto e cio sarà tutto onbroso; ⁷le foglie delli alberi, che s'interpōgono infra te e 'l sole, son di due colori prīcipali ⁸cioè verde bellissimo, lustro e specchiamēto dell'aria che allumina che nō può essere ⁹veduto dal sole, e le onbrose che sol uedono la terra, e le piv oscure che da altro che ¹⁰da oscurità sō circūdate. ¹¹Molto sono piv belli li alberi infra le

the remoter distance the atmosphere which comes between you and them looks more beautiful when there is something dark beyond. And still the azure is most beautiful. The objects seen from the side on which the sun shines will not show you their shadows. But, if you are lower than the sun, you can see what is not seen by the sun and that will be all in shade. The leaves of the trees, which come between you and the sun are of two principal colours which are a splendid lustre of green, and the reflection of the atmosphere which lights up the objects which cannot be seen by the sun, and the shaded portions which only face the earth,

457. 2. repricare. 7. osscura.

458. 1. accurro . . paessi. 2. dissgrossata domori . . rissguardando . ' asspetto. 3. inverde loro estremi ellonbre . . oscure . . disstantie. 4. infratte elloro . . chosa. 5. chose . . mossterā . . Massetusse. 6. eco sara. 7. chessinterpōgano . . ellsole . . di [tre] "2" colori. 8. coe . . lusstro esspecchiamēto . . allumina ch"e" nō poteessere. 9. elle onbrose chessol uedano . . elle piv osscure. 10. osscurita. 11. infralle . . chessono . . ette. 12. tusse . . elloro ecquesto accade. 13. lisstremi . . trāsparēte.

458. At *S*, in the original is the word *Sole* (sun) and at *N parte di nuvolo* (the side of the clouds).

canpagnie, che sono infra 'l sole e te, [12]che quelli ai quali tu sei infra 'l sole e loro, e questo accade che quelli, che sono diuer[13]so il sole, mostrano inverso li stremi le lor foglie trāsparēti, e chi non è trasparē[14]te, cioè insù li stremi, lustro vero, e che l'onbre sono oscure per[15]chè da niente sono occupate.

[16]Li alberi, ai quali tu ti interponi infra 'l sole e loro, non ti si mostreranno se nō [17]col loro chiaro e naturale colore, il quale per se non è molto eccessiuo e oltre a questo al[18]cuni lustri, li quali per non essere in cāpo troppo vario dalla loro chiarezza, fieno di poca evidē[19]tia, e se sei piv basso di loro siti, potranno mostrare ancora con quelle parti, [20]le quali il sole nō vide, che fieno onbrose.

[21]Pel uēto.

[22]Ma se sarai da quella parte, d'onde il uēto spira, tu vedrai li alberi di molto mag[23]giore chiarezza che per altri versi nō uedresti, e questo accade perchè esso vēto di[24]scopre i roversci delle foglie, le quali in tutte sono molto piv biācheggiāti che dal loro [25]diritto, e sopra tutto fieno chiarissime se 'l uento trae da quella regi[26]one, donde si trova il sol di sopra alla quale tu abbi volte le schiene.

and the darkest which are surrounded by something that is not dark. The trees in the landscape which are between you and the sun are far more beautiful than those you see when you are between the sun and them; and this is so because those which face the sun show their leaves as transparent towards the ends of their branches, and those that are not transparent—that is at the ends—reflect the light; and the shadows are dark because they are not concealed by any thing.

The trees, when you place yourself between them and the sun, will only display to you their light and natural colour, which, in itself, is not very strong, and besides this some reflected lights which, being against a background which does not differ very much from themselves in tone, are not conspicuous; and if you are lower down than they are situated, they may also show those portions on which the light of the sun does not fall and these will be dark.

In the Wind.

But, if you are on the side whence the wind blows, you will see the trees look very much lighter than on the other sides, and this happens because the wind turns up the under side of the leaves, which, in all trees, is much whiter than the upper sides; and, more especially, will they be very light indeed if the wind blows from the quarter where the sun is, and if you have your back turned to it.

Br. M. 114 b] **459.**

Quādo il sole è occupato da nvgoli, le cose sono di poca evidētia [2]perchè è poco differentia infra i lumi e l'onbre delli alberi e delli edifiti, per [3]essere alluminati dalla chiarezza dell'aria che circūda ī modo le cose, [4]che poche sono l'onbre e quel[5]le poche si uanno perdēdo in modo che i lor termini se ne vanno ī fumo.

When the sun is covered by clouds, objects are less conspicuous, because there is little difference between the light and shade of the trees and of the buildings being illuminated by the brightness of the atmosphere which surrounds the objects in such a way that the shadows are few, and these few fade away so that their outline is lost in haze.

G. 11 b] **460.**

De' alberi e loro lume.

Of trees and lights on them.

[2]Il · uero modo da pratico nel figurare le [3]canpagnie o vo' dire paesi colle sua

The best method of practice in representing country scenes, or I should

14. coe insulli stremi lusstro [e nelle parte] vero e chellonbe . . osscure. 15. ochupate. 16. tutti . . elloro . . mossterranno 17. loro "ciaro e" naturale . . a di quessto. 18. lusstri . . dalloro" ciarezza" fieno di pocha. 19. tia essesse . . mos. strare . . parte. 20. le quale il son novide cheffieno. 21. Massessarai . . ma. 22. gore chiareza . . uedressti ecquesto achade . . vēto dis. 23. li quali. 24. biācheggiāti. 25. essopra . . dacquella. 26. alle . . lessciene.

459. 1. ochupato . . pocha. 2. e po diferentia . . ellonbre. 3. dalla grādeza dellaria che circhūda. 4. [che pocha diferētia da loro lumi chen] che posono . . ecque. 5. che lor . . ifumo.

460. 1—8 R. 1. elloro. 2. modi. 5. ochupato . . accoche.

⁴piante si è dello elegiere che al cielo ⁵sia occupato il sole, acciochè esse can⁶pagnie ricevino lume vniversale e nō ⁷il particulare del sole, il quale fa l'onbre ⁸tagliate e assai differēti dalli lumi.

say landscapes with their trees, is to choose them so that the sun is covered with clouds, so that the landscape receives an universal light and not the direct light of the sun, which makes the shadows sharp and too strongly different from the lights.

E. 19 a] **461.**

PICTURA.

²Li paesi, fatti nella figuratione del uerno, ³nō debbono dimostrare le sue mōtagnie azzur⁴re come far si uede alle mōtagnie dell' e⁵state, e questo si prova per la 4ª ⁶di questo che dicie ¶Infra le montagnie, vedu-⁷te inlūga distantia, Quella si dimostrerà ⁸di colore più azzurro, la qual fia ī ⁹se più oscura; adūque essendo le piāte ¹⁰spogliate delle lor foglie si dimostrerā ¹¹di colore più azzurro, la qual fia ī ¹²se più oscura, adūque, essendo le piāte ¹³spogliate delle lor foglie, si dimostrerā di color ¹⁴berrettino, essendo che le foglie son di color ¹⁵verde, e tāto quāto il uerde è piv oscuro che ¹⁶il berrettino, tanto si dimostrerā più azzur¹⁷ro il uerde che il berrettino; e per la 2ª di que¹⁸sto ¶l'onbre delle piāte, uestite di foglie, son ¹⁹tanto più oscure che l'ōbre di quelle piante che ²⁰sono spogliate di foglie, quāto le piāte, ²¹vestite di foglie, son mē rare che quelle che nō ²²ànno foglie, e così abbiā provato il nostro ītēto.
²³La difinitione ²⁴del colore azzur²⁵ro dell' aria dà ²⁶sentētia, perchè li ²⁷paesi sō più az²⁸zurri di state che ²⁹di verno.

OF PAINTING.

In landscapes which represent [a scene in] winter. The mountains should not be shown blue, as we see in the mountains in the summer. And this is proved [5] in the 4th of this which says: Among mountains seen from a great distance those will look of the bluest colour which are in themselves the darkest; hence, when the trees are stripped of their leaves, they will show a bluer tinge which will be in itself darker; therefore, when the trees have lost their leaves they will look of a gray colour, while, with their leaves, they are green, and in proportion as the green is darker than the grey hue the green will be of a bluer tinge than the gray. Also by the 2nd of this: The shadows of trees covered with leaves are darker than the shadows of those trees which have lost their leaves in proportion as the trees covered with leaves are denser than those without leaves—and thus my meaning is proved.
The definition of the blue colour of the atmosphere explains why the landscape is bluer in the summer than in the winter.

C. A. 181 b; 546 b] **462.**

DE' PICTURA.

²Se infra l'ochio e l'orizzonte s'in³terpone l'obliquità del colle decli⁴nante inuerso l'ochio, il quale ochio ⁵si troui circa il mezzo della altezza d'essa declina⁶tione, al-

OF PAINTING IN A LANDSCAPE.

If the slope of a hill comes between the eye and the horizon, sloping towards the eye, while the eye is opposite the middle of the height of this slope, then that hill will

461. 2. fighuratione. 3. dimosstrare. 4, chome [le] far . . delles. 5. ecquesto si prova [perche lialberi] per. 6. quessto cheddicie [Infralle. 7. inllūgha disstantia . . dimossterra. 8. [piu] di cholore piu . . fia [piv] ī. 9. osschura adūque. 10. dimossterra. 11. [piu] di cholore . . fia piv ī. 12. osschura adūque. 13. dimosterā di cholor. 14. berrectino . . cholli . . color. 15. ettāto . . eppiu osscuro. 16. berrectino . . dimossterra. 18. son [piu]. 19. osscuro chellōbre. 20. piāte [pri]. 22 nano . . echosi. 24. cholore. 28. di sstāte.
462. 2. ellorizonte. 3. cholle. 5. cecea il mezo "della alteza" dessa. 6. tale [paese] "collo" aquistera. 7. osscurita edequal.

461. 5. 6. *Per la 4ª di questo.* It is impossible to ascertain what this quotation refers to. *Questo* certainly does not mean the MS. in hand, nor any other now known to us. The same remark

applies to the phrase in line 15: *per la 2ª di questo.*
462. The quotation in this passage again cannot be verified.

lora tale colle acquisterà [7] oscurità in ogni grado della sua longitu[8]dine; Provasi per la 7ª di questo che di[9]cie: quella pianta si dimostrerà più oscu[10]ra la quale fia veduta piv di sotto; [11]la propositione [12]è verificata perchè tal colle mostrerà dal mezzo [13]in sù tutte le sue piāte nelle parti che sō [14]tanto alluminate dalla chiarezza del cielo quanto la parte che è [15]aōbrata dalle oscurità della terra, per la qual co[16]sa è neciessario che tali piante sieno di medi[17]ocre oscurità; e da quel sito inverso le radi[18]ci del colle senpre tali piante vāno rischiarādo [19]per la cōversa della 7ª e per essa 7ª, e quando tali [20]piāte più s'avicinano alla sōmità di [21]tal colle, è neciessario a quelle farsi più os[22]cure; Ma tale oscurità non è proportionata [23]alla distantia per la 8ª di questo che dicie: [24]quella cosa si dimostrerà più oscura che si tro[25]va in più sottile aria, e per la 10ª: quella si dimostre[26]rà più oscura che confina in cāpo più chiaro.

increase in darkness throughout its length. This is proved by the 7th of this which says that a tree looks darkest when it is seen from below; the proposition is verified, since this hill will, on its upper half show all its trees as much from the side which is lighted by the light of the sky, as from that which is in shade from the darkness of the earth; whence it must result that these trees are of a medium darkness. And from this [middle] spot towards the base of the hill, these trees will be lighter by degrees by the converse of the 7th and by the said 7th: For trees so placed, the nearer they are to the summit of the hill the darker they necessarily become. But this darkness is not in proportion to the distance, by the 8th of this which says: That object shows darkest which is [seen] in the clearest atmosphere; and by the 10th: That shows darkest which stands out against a lighter background.

I[1] 48 b]

463.

DE' PAESI.

[2] I colori oscuri dell'onbre delle mōtagne [3] nelle lunghe distantie pigliano piv bello [4] azzurro e più senplice, che nō fanno le [5] loro parti luminose, e di qui nasce quā[6]do il sasso della mōtagnia rosseggia che le sue [7] parti luminose son di bissa, e quāt è piv [8] alluminata piv si farà del suo propio co[9]lore.

OF LANDSCAPES.

The colours of the shadows in mountains at a great distance take a most lovely blue, much purer than their illuminated portions. And from this it follows that when the rock of a mountain is reddish the illuminated portions are violet (?) and the more they are lighted the more they display their proper colour.

H.[2] 20 a]

464.

Quel loco sarà piv [2]luminoso che dalle mō[3]tagnie fia più remoto.

A place is most luminous when it is most remote from mountains.

G. 19 b]

465.

ŌBRE E LUME DELLE CITTÀ.

[2] Quādo il sole è all'oriēte e l'ochio [3]stia sopra il mezzo di una città esso o[4]chio

OF LIGHT AND SHADOW IN A TOWN.

When the sun is in the East and the eye is above the centre of a town, the eye will

On the treatment of light for views of towns (465—469).

9. dimosstera piu osscu. 10 disocto ad. 11. dunque ||||||||||||||| la proposstione. *The word here scratched through and illegible seems to have been* diremo. 12. mossteral mezzo. 13. in giututte nelle puedi chesso. 14. alluminate | "dalla ciarezza" del . . che. 15. osscurita. 16. chettali. 17. osscurita. 18. cholle . . vano rissiarādo. 19. coversa . . 7ª quando. 20. piāte quāto piu . . somita. 21. cholo enneciessario acquelle. 22. scure Mattale osscurita. 24. dimosstera piu osscura. 25. dimosste. 26. osscura . . chāpo.

463. 2. oscure. 3. lunge. 4. azzuro . . fanno lele. 5. parte. 6. chelle. 7. parte. 8. propie.

464. 1—3 R.

465. 1—8 R. 1. ellume. 2. ellochio. 3. mezo. 4. vedera. 5. mezi. 6. mezo. 7. onale nella. 8. ella.

vedrà la parte meridionale d'es⁵sa città aver li tetti mezzo ōbrosi e ⁶mezzo luminosi e così la settētri-⁷onale, e la oriētale fia tutta ōbrosa ⁸e la occidētale fia tutta luminosa.

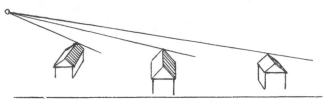

see the Southern part of the town with its roofs half in shade and half in light, and the same towards the North; the Eastern side will be all in shadow and the Western will be all in light.

C. A. 157 a; 463 a] **466.**

Delle case d'una città, di che si conoscono le diuisioni delle case per il rischiarare che fa ī basso la ²nebbia; se l'ochio è piv alto che le case, li lumi visuali in nello īteruallo ch'è tra ³casa e casa si uāno profoṇḍado in nebbia piv grossa, e però sendo mē trasparēte pare ⁴piv biāca, e se le case sono piv alte l'una che l'altra ·, sēpre si discierne piv il ue⁵ro nell'aria piv sottile, onde le case paiono piv scure quāto piv s'alzano; ⁶n · o · p · q sieno le qualità dell'aria grossa di umori, a sia l'ochio, la casa b · c parà piv chiara ⁷in fondo e perchè è in aria piv · grossa, le linie c · d · f

Of the houses of a town, in which the divisions between the houses may be distinguished by the light which fall on the mist at the bottom. If the eye is above the houses the light seen in the space that is between one house and the next sinks by degrees into thicker mist; and yet, being less transparent, it appears whiter; and if the houses are some higher than the others, since the true [colour] is always more discernible through the thinner atmosphere, the houses will look darker in proportion as they are higher up. Let $n\ o\ p\ q$ represent the various density of the atmosphere thick with moisture, a being the eye,

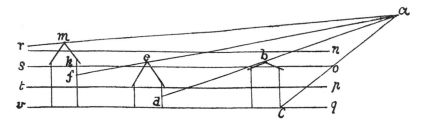

parāno chiare a uno modo, e bēchè f ⁸sia piv distāte che · c, egli è eleuato in aria piv sottile, se le case b · e sono d'una me-⁹desima · altezza, perchè ànno a diuidere per chiarore, variato di nebbia; questo è solo perchè la linia ¹⁰del ochio, che nascie alta, si ua col suo fine profoṇḍado in aria piv bassa e grossa in · d · ¹¹che ī · b: · e così la linia · a · f · si truova piv bassa · ī · f · che in · c, e la casa f · in e si truo¹²va dalla linia · e · k insino a · m · andare piv scura che la sōmità degli ātiposti edifiti.

the house $b\ c$ will look lightest at the bottom, because it is in a thicker atmosphere; the lines $c\ d\ f$ will appear equally light, for although f is more distant than c, it is raised into a thinner atmosphere, if the houses $b\ e$ are of the same height, because they cross a brightness which is varied by mist, but this is only because the line of the eye which starts from above ends by piercing a lower and denser atmosphere at d than at b. Thus the line $a\ f$ is lower at f than at c; and the house f will be seen darker at e from the line $e\ k$ as far as m, than the tops of the houses standing in front of it.

466. 1. dele chessi conocie le diuisioni delle case per risciarare cheffa. 2. chelle . . le lume visuale inelo. 3. inebbia. 4. biācha esse. 5. paiano . . nelaria. 6. omori . . ciara. 7. perche en aria . . la linia . . a ī modo. 9. ano alteza . . ciarore nebia . . lini. 10. chol. 11. chosi. 12. ha *m* . . somita.

E. 3*b*]

467.

DELLE CITTÀ O ALTRI EDIFITI ²VEDUTI DA SERA O MATTINA NELLA ³NEBBIA.

⁴Delli edifizi veduti in lunga distātia ⁵da sera o mattina ī nebbia o aria grossa solo si dimo⁶stra la chiarezza delle lor parti alluminate dal sole ⁷che si trova inverso l'orizzonte, e le parti delli ⁸detti edifizi, che nō son vedute dal sole, restano quasi del ⁹colore di mediocre oscurità di nebbia.

PERCHÈ LE COSE PIÙ ALTE ¹¹POSTE NELLE DISTĀTIE SON PIÙ OSCU¹²RE CHE LE BASSE ANCORA ¹³CHÈ LA NEBBIA SIA VNIFORME Ī GROSSEZZA.

¹⁴Delle cose, poste nella nebbia o altra aria grossa o per ¹⁵vapore o fumo o distantia, quella fia tanto più nota quā¹⁶to ella sarà più alta; E delle cose d'equale al¹⁷tezza quella parrà più oscura che canpeggia in ¹⁸più profonda nebbia, come accade all'ochio *h* ¹⁹che vedēdo *a b c*, torri d'eguale altezza infra loro, che vede ²⁰*c* sōmità della prima torre in *r*, bassezza di due gradi ²¹di profondità nella nebbia, e vede la sōmità della torre ²²di mezzo *b* in vn sol grado di nebbia; adūque *c* sōmità si ²³dimostra più oscura che la sōmità della torre · *b* ecc.

OF TOWNS OR OTHER BUILDINGS SEEN IN THE EVENING OR THE MORNING THROUGH THE MIST.

Of buildings seen at a great distance in the evening or the morning, as in mist or dense atmosphere, only those portions are seen in brightness which are lighted up by the sun which is near the horizon; and those portions which are not lighted up by the sun remain almost of the same colour and medium tone as the mist.

WHY OBJECTS WHICH ARE HIGH UP AND AT A DISTANCE ARE DARKER THAN THE LOWER ONES, EVEN IF THE MIST IS UNIFORMLY DENSE.

Of objects standing in a mist or other dense atmosphere, whether from vapour or smoke or distance, those will be most visible which are the highest. And among objects of equal height that will be the darkest [strongest] which has for background the deepest mist. Thus the eye *h* looking at *a b c*, towers of equal height, one with another, sees *c* the top of the first tower at *r*, at two degrees of depth in the mist; and sees the height of the middle tower *b* through one single degree of mist. Therefore the top of the tower *c* appears stronger than the top of the tower *b*, &c.

G. 22*b*]

468.

DELLI FUMI DELLE CITTÀ.

²Li fumi sō ueduti melio e più ³espediti nelle parti oriēta⁴li che nelle occidētali, stādo ⁵il sole all'oriēte, e questo ⁶nascie per due cavse, e la prima ⁷è che il sole traspare colli su⁸a razzi nelle particule di tal ⁹fumo e le rischiara e falle ¹⁰evidenti, la secōda è che li ¹¹tetti delle case, veduti all'o¹²riēte in tal tenpo, sono ōbro¹³si perchè la loro obliquità nō ¹⁴può essere allu-

OF THE SMOKE OF A TOWN.

Smoke is seen better and more distinctly on the Eastern side than on the Western when the sun is in the East; and this arises from two causes; the first is that the sun, with its rays, shines through the particles of the smoke and lights them up and makes them visible. The second is that the roofs of the houses seen in the East at this time are in shadow, because their obliquity does not allow of their

467. 2. dassera ōmattina. 3. nebbia [in lungha disstantia]. 4. [Le chose che] li . . vedutti . . lungha disstātia. 5. dassera . . dimos. 6. parte. 7. chessi . . elle parte. 9. cholore . . osscurita. 11. disstantie . . osschu. 12. chelle . . ancho. 13. chella . . grosseza. 14. chose . . nebia. 15. ossumo o disstantia. 16. ta ella . . Eddelle chose. 17. osschura e chanpeggia. 18. chome achade hallochio e h. 19. torre . . infralloro che ve. 23. dimosstra . . o schura chella.
468. 1—18 R. 3. esspediti parte. 5. ecquesto. 6. ella pª. 8. rizi . . partichule. 9. elle risciara essalle. 14. po. 15. achade.

minata dal [15]sole, e il simile accade nella [16]poluere e l'una e l'altra è tā[17]to più luminosa quanto ella è più [18]dēsa, ed è più densa inverso il mezzo.

being illuminated by the sun. And the same thing occurs with dust; and both one and the other look the lighter in proportion as they are denser, and they are densest towards the middle.

G. 23a]

469.

DEL FUMO E POLVERE.

OF SMOKE AND DUST.

[2]Stādo il sole all'oriēte, il fumo [3]delle città nō sarà veduto allo [4]occidente, perchè esso no[5]n è veduto penetrato dalli [6]razzi solari, nè veduto ī cāpo [7]scuro, perchè li tetti del[8]le case mostrano all'occhio [9]quella medesima parte che [10]si mostra al sole, e per que[11]sto cāpo chiaro tal fumo po[12]co si uede.

[13]Ma la poluere in simile [14]aspetto si dimostra oscu[15]ra più che 'l fumo per esser lei [16]di materia più densa [17]ch'è 'l fumo, ch'è materia vmida.

If the sun is in the East the smoke of cities will not be visible in the West, because on that side it is not seen penetrated by the solar rays, nor on a dark background; since the roofs of the houses turn the same side to the eye as they turn towards the sun, and on this light background the smoke is not very visible.

But dust, under the same aspect, will look darker than smoke being of denser material than smoke which is moist.

E. 6b]

470.

DEL UĒTO DIPĪTO.

OF REPRESENTING WIND.

The effect of wind on trees (470—473).

[2]Nella figuratione del uēto, oltre al pie[3]gare de' rami e il rouersciare le sue [4]foglie inverso lo auenimēto [5]del uēto, si debbe figurare li ra[6]nugolamēti della sottil poluere mista chol[7]la intorbidata aria.

In representing wind, besides the bending of the boughs and the reversing of their leaves towards the quarter whence the wind comes, you should also represent them amid clouds of fine dust mingled with the troubled air.

Br. M. 172b]

471.

Descriui i paesi con vēto e con acqua e cō tramōtare e leuare del sole.

Describe landscapes with the wind, and the water, and the setting and rising of the sun.

VĒTO.

THE WIND.

[2]Tutte le foglie che pendevano a terra, nel piegare de' lor ramiculi, insieme con esso [3]ramo a rovesciate si dirizzano col corso de' vēti, e qui la prospettiua loro fa contrario offitio, [4]inperochè, se l'albero è tra te e 'l nascimēto del uēto, le parti delle foglie che son diuerso te [5]danno la lor naturale dimostratione e le opposite, che avevano a volgere le punte in [6]contraria parte, son per lo loro arrovesciamēto volte colle pūte inverso te.

All the leaves which hung towards the earth by the bending of the shoots with their branches, are turned up side down by the gusts of wind, and here their perspective is reversed; for, if the tree is between you and the quarter of the wind, the leaves which are towards you remain in their natural aspect, while those on the opposite side which ought to have their points in a contrary direction have, by being turned over, their points turned towards you.

16. eleuana ele altro ettā. 17. tu piu . . elle piu. 18. mezo.

469. 1—17 R. 6. razi. 7. schuro . . de. 10. mosstra. 12. cho. 13. Malla. 14. asspetto si dimosstra ocssu.

470. 2. fighuratione. 3. ghare. 4. auenimēto [delle sue]. 5. foglie] del . . fighurare. 6. nugholamēti . . soctil . . chol.

471. 1. a cq "a" . . elleuare. 2. atterra. 3. dirizano . . ecqui la prosspettiua. 4. inperochesse . . parte . . chesson. 5. dimos-stratione elle oposite. 6. arovesciamēto.

C. A. 78 a; 228 a] 472.

L'alberi percossi dal corso de' vēti si piegano inverso ²il loco dove tal uēto si move, e passato che è il uēto ³si piegano in contrario moto, cioè nel moto reflesso.

Trees struck by the force of the wind bend to the side towards which the wind is blowing; and the wind being past they bend in the contrary direction, that is in reverse motion.

B. M. 277 b] 473.

¶ Quella parte dell'albero, ch'è piv ²remota dalla potentia che lo percuote, piv è offesa da essa ³percussione, perchè è maggiore lieua, onde la natura in questo ⁴caso à proveduto collo ingrossarli in quella parte oue ⁵piv possono esser offesi, e massime nelli alberi che cresco⁶no in grāde altezza, come abeti e simili.

That portion of a tree which is farthest from the force which strikes it is the most injured by the blow because it bears most strain; thus nature has foreseen this case by thickening them in that part where they can be most hurt; and most in such trees as grow to great heights, as pines and the like.

F. 35 a] 474.

Scriui come li nugoli si cōpongono e come si risol²uono, e che causa leua li uapori.

Describe how the clouds are formed and how they dissolve, and what cause raises vapour.

Light and shade on clouds (474—477).

W. VI.] 475.

Tanto sono le ōbre de' nuvoli più chiare ²quanto essi son piv vicini all'orizzōte.

The shadows in clouds are lighter in proportion as they are nearer to the horizon.

B. M. 172 b] 476.

Quando i nvuoli s'interpongono infra 'l sole e l'ochio tutti li stremi delli ²loro globi sono chiari · e inverso il mezzo sono oscuri,

When clouds come between the sun and the eye all the upper edges of their round forms are light, and towards the middle they

472. 1. perchossi dal chorso . . pieghino. 2. locho . . eppassato. 3. pieghino . . refresso.
473. 2. della . . chello perchote. 3. perchussione magiore. 4. chaso . . chollo. 5. possano . . cressca. 6. alteza . . essimili.
474. 1. cōpongano. 2. uano.
475. 1. chiare. 2. vicine . . orizonte.
476. 1. sinterpongano . . solle ellochio . . lisstremi. 2. globbi . . mezo . . osscuri. 3. chade. 4. datte . . ecquesto . . acchade

473. Compare the sketch drawn with a pen and washed with Indian ink on Pl. XL, No. 1. In the Vatican copy we find, under a section entitled '*del fumo*', the following remark: *Era sotto di questo capitulo un rompimento di montagna, per dentro delle quali roture scherzaua fiame di fuoco, disegnate di penna et ombrate d'acquarella, da uedere cosa mirabile et uiua* (Ed. MANZI, p. 235. Ed. LUDWIG, Vol. 1, 460). This appears to refer to the left hand portion of the drawing here given from the Windsor collection,

and from this it must be inferred, that the leaf as it now exists in the library of the Queen of England, was already separated from the original MS. at the time when the Vatican copy was made.

475. The drawing belonging to this was in black chalk and is totally effaced.

476. A drawing in red chalk from the Windsor collection (see Pl. XXIX), representing a landscape with storm-clouds, may serve to illustrate this section as well as the following one.

e questo ac³cade perchè inverso i superiori detti stremi sono veduti dal sole piv alto [4]di loro e da te piv basso, e questo medesimo accade nelle poste de' rami [5]delle piäte: e ancora si fanno in parte chiari così i nvvoli come li alberi per es⁶sere alquāto transparenti e nelli stremi si mostra piv sottigliezza.

[7]Ma quando l'ochio si trova infra 'l nuvolo e 'l sole, el nugolo fa l'opposito [8]che prima facea, perchè li stremi delle sua globulenze sono oscuri [9]e inverso il mezzo son chiari, e questo accade perchè tu vedi quella par¹⁰te che ancora il sole vede in faccia e perchè essi stremi ànno del transparē¹¹te e rendono all'ochio quelle parti che dopo lor s'ascōdono che nō sendo ve[12]dute dal sole come le parti che li son volte, è neciessario che sieno al¹³quāto piv oscure; ancora può essere che tu uedi le minvtie d'esse glo¹⁴bulentie dal lato di sotto, e 'l sole le uede di sopra, e perchè esse nō sono situate ¹⁵in modo che abbino a rendere chiarezza del sole come prima facea, ¹⁶però sono oscure.

¹⁷I nuvoli neri, che spesse volte si ueggono sopra i chiari e allumina¹⁸ti dal sole, sono ōbrati dalli altri nuvoli che infra loro e 'l sole s'inter¹⁹pongono.

²⁰Ancora le globbosità de' nvuoli, che àño il sole in faccia, ²¹mostrano i sua termini oscuri, perchè campeggiano ²²col canpo chiaro; e che questo sia vero guarderai la sō²³mità di tutto il nuvolo ch'è chiara perchè cāpeggia nell'az²⁴zurro dell'aria, ch'è piv scura che 'l nuvolo.

are dark, and this happens because towards the top these edges have the sun above them while you are below them; and the same thing happens with the position of the branches of trees; and again the clouds, like the trees, being somewhat transparent, are lighted up in part, and at the edges they show thinner.

But, when the eye is between the cloud and the sun, the cloud has the contrary effect to the former, for the edges of its mass are dark and it is light towards the middle; and this happens because you see the same side as faces the sun, and because the edges have some transparency and reveal to the eye that portion which is hidden beyond them, and which, as it does not catch the sunlight like that portion turned towards it, is necessarily somewhat darker. Again, it may be that you see the details of these rounded masses from the lower side, while the sun shines on the upper side and as they are not so situated as to reflect the light of the sun, as in the first instance they remain dark.

The black clouds which are often seen higher up than those which are illuminated by the sun are shaded by other clouds, lying between them and the sun.

Again, the rounded forms of the clouds that face the sun, show their edges dark because they lie against the light background; and to see that this is true, you may look at the top of any cloud that is wholly light because it lies against the blue of the atmosphere, which is darker than the cloud.

W. 231a]

477.

DE' NUVOLO FUMO E POLVERE E FIÄME DI FORNO O FORNACIE ĪFOCATA.

²Il nuvolo nō mostra le sue globulentie se nō in quelle parti che son vedute dal sole, e l'altre globosità ³sono insensibili pel essere lor nelle ōbre.

OF CLOUDS, SMOKE AND DUST AND THE FLAMES OF A FURNACE OR OF A BURNING KILN.

The clouds do not show their rounded forms excepting on the sides which face the sun; on the others the roundness is imperceptible because they are in the shade.

. . posste. 5. eanchora . . pere. 6. transsparente . . mosstra. 7. Ma cquando. 8. lisstremi . . globbulenze . . osscure. 9. mezo . . chiare ecquesto achade. 11. rendano . . parte . . sasscōde. 12. la parte chelli . . chessieno. 13. po . . chettu. 15. chellabbino arrendere chiareza. 16. osscure. 17. enuoli . . chesspresse . . uegano. 18. nvoli . . infralloro. 19. pongano. 20. globbosita. 21. mosstrano e sua . . osscuri . . canpegiano. 23. cāpegia nella. 24. nuvollo.
477. 1. eppoluere effiāme . . ifochata. 2. mosstra . . parte . . ellaltre. 3. per essere. 4. sole he all . . elle . . intepossto infra-

477. The text of this chapter is given in facsimile on Pls. XXXVI and XXXVII. The two halves of the leaf form but one in the original. On the margin close to lines 4 and 5 is the note: *rossore* *d'aria inverso l'orizonte*—(of the redness of the atmosphere near the horizon). The sketches on the lower portion of the page will be spoken of in No. 668.

⁴Se 'l sole è all'oriēte e le nuvole al-l'occidente, allora l'ochio, interposto infra 'l sole ⁵e 'l nuvolo, vede li termini delle globo-sità cōponitrici d'esso nuvolo essere scuri ⁶e le parti che son circūdate da esse oscu-rità fieno chiare; E questo nascie ⁷perchè li termini delle globosità di tali nuvoli ⁸ve-dono il cielo superiore e laterale, il quale in quel si spechia.

⁹E 'l nuvolo e la piāta ¹⁰à le sue parti onbrose ¹¹sanza dimostrazione ¹²d'alcuna globulētia.

If the sun is in the East and the clouds in the West, the eye placed between the sun and the clouds sees the edges of the rounded forms composing these clouds as dark, and the portions which are surrounded by this dark [edge] are light. And this occurs because the edges of the rounded forms of these clouds are turned towards the upper or lateral sky, which is reflected in them.

Both the cloud and the tree dis-play no roundness at all on their shaded side.

C. A. 346 a; 1072 a] **478.**

I pittori s'ingānano molte volte ²faciēdo le acque nelle qua³li fanno vedere a loro quel ⁴che vede l'omo; Ma l'acqua ⁵vede l'obietto per uno lato ⁶e l'omo lo uede per l'altro, e ⁷spesse volte accade ⁸che 'l pittore vedrà ⁹vna cosa di sotto e co-sì vn me¹⁰desimo corpo · veduto dināzi ¹¹e dirieto, di sopra e di sotto, ¹²perchè l'acqua gli mostra il simv¹³lacro dell'obietto in un mo¹⁴do, e l'ochio lo uede in vn altro.

Painters often deceive themselves, by representing water in which they make the water reflect the objects seen by the man. But the water reflects the object from one side and the man sees it from the other; and it often happens that the painter sees an object from below, and thus one and the same object is seen from hind part before and upside down, because the water shows the image of the object in one way, and the eye sees it in another.

On images reflected in water.

E. o'] **479.**

Li colori di mezzo all'arco si mischiano infra loro.

²L'arco in se nō è nella pioggia, nè etiā nell'ochio che ³lo vede, benchè si gieneri dalla pioggia, dal sole e dall'ochio. ⁴L'arco cieleste.è senpre veduto da quelli ochi, ⁵li quali s'interpōgono infra la pioggia e 'l cor-⁶po del sole; adunque stando il sole all'ori-ente e ⁷la pioggia all'occidēte, esso arco si gienera nella piog⁸gia occidētale.

The colours in the middle of the rain-bow mingle together.

The bow in itself is not in the rain nor in the eye that sees it; though it is generated by the rain, the sun, and the eye. The rain-bow is always seen by the eye that is be-tween the rain and the body of the sun; hence if the sun is in the East and the rain is in the West it will appear on the rain in the West.

Of rainbows and rain (479. 480).

E. o''] **480.**

Quando l'aria si converte in pioggia, ²essa farebbe vacuo, se l'altra aria ³nō lo proibisce col suo socorso, la ⁴quale fa con

When the air is condensed into rain it would produce a vacuum if the rest of the air did not prevent this by filling its place, as

sole. 5. vedede . . deso. 6. ella parte chesson circhūdata . . osschurita . . Ecquessto. 7. tal. 8. vedano . . ellaterale [cir] il . . sisspechia. 9. ella. 10. alle . . parte. 11. dimostracione. 12. dalchuna globbulētia.

478. 1. singannammolte. 2. nelle q"a". 3. allei. 4. M"a" laqua. 6. ellomo . . perllaltro es. 7. spesse . . achade chella. 8. [equa ue] . . chel pitore vedera. 9. chosa. 10. veduto. 13. lacro[nu] dell'obietto numo. 14. ellochio . . vede nvn.

479. 1. cholori di mezo allarcho simistano infrallori. 2. Larcho in se nō nella. 3. llo. 4. Larcho cielesste essenpre . . dacquelli. 5. sinterpōghano infralla. 6. alloriente el. 7. allocidēte esso archo.

480. 1. chonverte. 2. vachuo sellaltra. 3. nollo broibisce chol suo sochorso. 4. chon . . ecque. 5. sto he quel . . nasscie dissta.

īpetuoso moto, e que⁵sto è quel vēto che nascie d'esta⁶te insieme colle furiose pioggie.

it does with a violent rush; and this is the wind which rises in the summer time, accompanied by heavy rain.

G. 37*b*]

481.

Of flower seeds.

Tutti li fiori che ueggono il sole, ²conducono il lor seme, li altri ³no, cioè quelli che sol uedono la ⁴reflessione del sole.

All the flowers which turn towards the sun perfect their seeds; but not the others; that is to say those which get only the reflection of the sun.

6. cholle.
481. 1. ueghano. 2. conducano . . elli. 3. coecquelli . . uedano. 4. refressione.

IX.

The Practice of Painting.

It is hardly necessary to offer any excuses for the division carried out in the arrangement of the text into practical suggestions and theoretical enquiries. It was evidently intended by Leonardo himself as we conclude from incidental remarks in the MSS. (for instance No 110). The fact that this arrangement was never carried out either in the old MS. copies or in any edition since, is easily accounted for by the general disorder which results from the provisional distribution of the various chapters in the old copies. We have every reason to believe that the earliest copyists, in distributing the materials collected by them, did not in the least consider the order in which the original MS. lay before them.

It is evident that almost all the chapters which refer to the calling and life of the painter—and which are here brought together in the first section (Nos. 482—508) —may be referred to two distinct periods in Leonardo's life; most of them can be dated as belonging to the year 1492 or to 1515. At about this later time Leonardo may have formed the project of completing his Libro della Pittura, *after an interval of some years, as it would seem, during which his interest in the subject had fallen somewhat into the background.*

In the second section, which treats first of the artist's studio, the construction of a suitable window forms the object of careful investigations; the special importance attached to this by Leonardo is sufficiently obvious. His theory of the incidence of light which was fully discussed in a former part of this work, was to him by no means of mere abstract value, but, being deduced, as he says, from experience (or experiment) was required to prove its utility in practice. Connected with this we find suggestions for the choice of a light with practical hints as to sketching a picture and some other precepts of a practical character which must come under consideration in the course of completing the painting. In all this I have followed the same principle of arrangement in the text as was carried out in the Theory of Painting, thus the suggestions for the Perspective of a picture, (Nos. 536—569), are followed by the theory of light and shade for the practical method of optics (Nos. 548—566) and this by the practical precepts or the treatment of aerial perspective (567—570).

In the passage on Portrait and Figure Painting the principles of painting as applied to a bust and head are separated and placed first, since the advice to figure painters must have some connection with the principles of the treatment of composition by which they are followed.

But this arrangement of the text made it seem advisable not to pick out the practical precepts as to the representation of trees and landscape from the close connection in which they were originally placed—unlike the rest of the practical precepts—with the theory of this branch of the subject. They must therefore be sought under the section entitled Botany for Painters.

As a supplement to the Libro di Pittura *I have here added those texts which treat of the Painter's materials,—as chalk, drawing paper, colours and their preparation, of the management of oils and varnishes; in the appendix are some notes on chemical substances. Possibly some of these, if not all, may have stood in connection with the preparation of colours. It is in the very nature of things that Leonardo's incidental indications as to colours and the like should be now-a-days extremely obscure and could only be explained by professional experts—by them even in but few instances. It might therefore have seemed advisable to reproduce exactly the original text without offering any translation. The rendering here given is merely an attempt to suggest what Leonardo's meaning may have been.*

LOMAZZO tells us in his Trattato dell'arte della Pittura, Scultura ed Architettura (Milano 1584, libro II, Cap. XIV): "Va discorrendo ed argomentando Leonardo Vinci in un suo libro letto da me (?) questi anni passati, ch'egli scrisse di mano stanca ai prieghi di LUDOVICO SFORZA duca di Milano, in determinazione di questa questione, se è più nobile la pittura o la scultura; dicendo che quanto più un'arte porta seco fatica di corpo, e sudore, tanto più è vile, e men pregiata". *But the existence of any book specially written for Lodovico il Moro on the superiority of Painting over sculpture is perhaps mythical. The various passages in praise of Painting as compared not merely with Sculpture but with Poetry, are scattered among MSS. of very different dates.*

Besides, the way, in which the subject is discussed appears not to support the supposition, that these texts were prepared at a special request of the Duke.

I.

MORAL PRECEPTS FOR THE STUDENT OF PAINTING.

G. 25 a]

482.

NOTITIA DEL GIOVANE DI²SPOSTO ALLA
PICTURA.

A WARNING CONCERNING YOUTHS WISHING TO
BE PAINTERS.

³Molti sono li omini che àn desiderio ed
amo⁴re al disegnio, ma nō dispositione, e
questo ⁵fia conosciuto nelli putti, li quali
sono sē⁶za diligētia e mai finiscono con ōbre
le lor co⁷se.

Many are they who have a taste and
love for drawing, but no talent; and this
will be discernible in boys who are not dili-
gent and never finish their drawings with
shading.

How to
ascertain the
dispositions
for an arti-
stic career.

Ash. I. 18 a]

483.

Il giovane debe · prima · īparare prospet-
tiua, ²poi le misure d'ogni cosa, ³poi [disegni?]
di mano di bō maestro · per suefarsi a bone
mēbra, ⁴poi di natura per cōfermarsi le
ragioni delle cose īparate, ⁵poi vedere uno
tēpo l'opere di mano di diversi maestri,
⁶poi · fare · abito · al mettere ī pratica e ope-
rare l'arte.

The youth should first learn perspective,
then the proportions of objects. Then he
may copy from some good master, to ac-
custom himself to fine forms. Then from
nature, to confirm by practice the rules he
has learnt. Then see for a time the works
of various masters. Then get the habit of
putting his art into practice and work.

The course
of instruc-
tion for an
artist
(483—485).

482. 1—7 R. 1. del [pi] govane. 4. ecquesto. 6. ma finiscano.
483. 2. pole . . doni. 3. poi di. 4. chōfermarsi . . dele. 5. tēpo di mano. 6. all . . praticha.

483. The Vatican copy and numerous abridge-
ments all place this chapter at the beginning of
the *Trattato*, and in consequence DUFRESNE and all
subsequent editors have done the same. In the Va-
tican copy however all the general considerations
on the relation of painting to the other arts are
placed first, as introductory.

Ash. I, 2*b*] **484.**

ORDO DEL RITRARE.

²Ritrai pri³ma · disegni · di buono mae-
stro fatto sul' ⁴arte e sul naturale · e nō di
pratica, poi ⁵di rilievo in cōpagnia del di-
segnio ⁶tratto da esso rilievo ·, poi di buono
⁷naturale, il quale debbi mettere ī uso.

OF THE ORDER OF LEARNING TO DRAW.

First draw from drawings by good masters
done from works of art and from nature,
and not from memory; then from plastic
work, with the guidance of the drawing done
from it; and then from good natural models
and this you must put into practice.

Ash. I. 25*b*] **485.**

PRECETTI DI PICTURA.

²Il pictore debbe prima · suefare · la mano
col ritrarre · disegni · di mano di bō mae-
stro ³e fatta detta · suefatione ·, col givditio
del suo precettore ·, debbe di poi suefarsi ·
col ritrarre ⁴cose di rilievo bone · cō quelle
regole che di sotto · si dirà.

PRECEPTS FOR DRAWING.

The artist ought first to exercise his hand
by copying drawings from the hand of a good
master. And having acquired that practice,
under the criticism of his master, he should
next practise drawing objects in relief of a
good style, following the rules which will
presently be given.

Ash. I. 10*a*] **486.**

DEL RITRARE.

The study of
the antique
(486. 487).
²Qual è meglio o ritrare di naturale o
³d'ātico, o qual è piv fatica o i proffili ⁴o
l'onbra · e' lumi?

OF DRAWING.

Which is best, to draw from nature or
from the antique? and which is more difficult
to do outlines or light and shade?

C. A. 145*b*; 431*a*] **487.**

L'imitatione · delle cose antiche · è piv
laudabile · che quella delle · moderne.

It is better to imitate [copy] the antique
than modern work.

484. 2. del ritrare "di naturale" ritrai. 4. arte sul . . praticha. 5. chōpagnia.
485. 2. chol . . maesstro. 3. e¨atta . . chol . . chol. 4. chose. 5. chō.
486. 3. dāticho . . faticha.
487. 1. chose . . laldabile chelle.

486. 487. These are the only two passages in
which Leonardo alludes to the importance of an-
tique art in the training of an artist. The question
asked in No. 486 remains unanswered by him and
it seems to me very doubtful whether the opinion
stated in No. 487 is to be regarded as a reply to
it. This opinion stands in the MS. in a connection
—as will be explained later on—which seems to
require us to limit its application to a single special
case. At any rate we may suspect that when Leonardo
put the question, he felt some hesitation as to the
answer. Among his very numerous drawings I have
not been able to find a single study from the
antique, though a drawing in black chalk, at Wind-
sor, of a man on horseback (Pl. LXXIII) may per-
haps be a reminiscence of the statue of Marcus
Aurelius at Rome. It seems to me that the dra-
pery in a pen and ink drawing of a bust, also at
Windsor, has been borrowed from an antique
model (Pl. XXX). G. G. ROSSI has, I believe,
correctly interpreted Leonardo's feeling towards the
antique in the following note on this passage in
MANZI's edition, p. 501: "*Sappiamo dalla storia, che
i valorosi artisti Toscani dell'età dell'oro dell'arte studia-
rono sugli antichi marmi raccolti dal Magnifico LORENZO
DE' MEDICI. Pare che il Vinci a tali monumenti non
si accostasse. Quest' uomo sempre riconosce per maestra
la natura, e questo principio lo stringeva alla sola
imitazione di essa.*"—Compare No. 10, 26—28 foot-
note.

L. 79 a]

488.

DE PITTURA.

²Necessaria cosa è al pittore, ³per essere bon membrificato⁴re nell'attitudine e gesti ⁵che far si possono per li nudi, ⁶di sapere la notomia de' ner⁷ui, ossi, mvscoli e lacerti, ⁸per sapere nelli diuersi moui⁹menti e forze qual neruo ¹⁰o muscolo è di tal mouimēto ¹¹causa, e solo quelli fare ¹²euidenti · e ingrossati, e nō ¹³li altri per tutto, come mol¹⁴ti fanno, che per parere grā ¹⁵disegniatore fanno i loro ¹⁶ignvdi legnosi e sanza gra¹⁷tia che pare a vederli v̄ ¹⁸sacco di noci piv presto che ¹⁹superficie vmana o vero ²⁰vn fascio di rauanelli più ²¹presto che muscolosi nvdi.

OF PAINTING.

It is indispensable to a Painter who would be thoroughly familiar with the limbs in all the positions and actions of which they are capable, in the nude, to know the anatomy of the sinews, bones, muscles and tendons so that, in their various movements and exertions, he may know which nerve or muscle is the cause of each movement and show those only as prominent and thickened, and not the others all over [the limb], as many do who, to seem great draughtsmen, draw their nude figures looking like wood, devoid of grace; so that you would think you were looking at a sack of walnuts rather than the human form, or a bundle of radishes rather than the muscles of figures.

The necessity of anatomical knowledge (488. 489).

Ash. I. 8 b]

489.

COME AL DIPINTORE · È NECESSARIO SAPERE LA INTRĪ²SICA FORMA DELL' OMO.

³Quello dipītore ·, che · avrà · cognitione · della natura de' nervi ·, mvscoli e lacierti, ⁴saprà · bene · nel movere uno mēbro quāti · e quali nerui ne son cagio⁵ne ·, e quale mvscolo gōfiādo è cagione · di raccortare · esso · nervo · e quale corde ⁶convertite · ī sotilissime cartilagini · circondano e raccogliono · detto mvscolo: e così ⁷sarà · diuerso e vniversale · dimostratore di uari muscoli mediāte · i vari effetti delle ⁸figure · e nō farà · come · molti · che ī diuersi atti sempre fāno quelle medesime ⁹cose dimostrare · in braccia, schiene, petto, gābe · le quali cose nō si debbono mettere īfra i piccioli · errori.

HOW IT IS NECESSARY TO A PAINTER THAT HE SHOULD KNOW THE INTRINSIC FORMS [STRUCTURE] OF MAN.

The painter who is familiar with the nature of the sinews, muscles, and tendons, will know very well, in giving movement to a limb, how many and which sinews cause it; and which muscle, by swelling, causes the contraction of that sinew; and which sinews, expanded into the thinnest cartilage, surround and support the said muscle. Thus he will variously and constantly demonstrate the different muscles by means of the various attitudes of his figures, and will not do, as many who, in a variety of movements, still display the very same things [modelling] in the arms, back, breast and legs. And these things are not to be regarded as minor faults.

C. A. 196 b; 586 b]

490.

DELLO STUDIO E SUO ORDINE.

¹Dico che prima si debbe imparare le mēbra e sua travagliamēti, e finita ²tal no-

OF STUDY AND THE ORDER OF STUDY.

I say that first you ought to learn the limbs and their mechanism, and having this

How to acquire practice.

488. 4. giessti. 6. di ner. 7. mvsscoli ella certi. 9. efforze. 10. omusscolo he di. 11. essolo quelgli. 16. inudi . . essanza. 17. vuederi. 18. sacho. 20. fasscio. 21. musscolosi.

489. 2. sicha. 3. ara . . ellacierti. 4. movere ī mēbro . . ecquali. 5. ecqualle . . sgōfiādo e chagione . . racortare . . ecquale. 6. sotilisime cartilagine e racholano . . chosi. 8. chome. 9. sciene.

490. dello studio essuo ordine *is written on the margin.* 1. essua. 2. seguitale. 3. conpone lesstorie. 4. accaso. 5. coe. 6. facia

490. This passage has been published by Dr. M. JORDAN, *Das Malerbuch des L. da Vinci*, p. 89; his reading however varies slightly from mine.

titia si debbe seguitare li atti secondo li accidenti che accadano all'omo, ³e 3° conporre le storie, lo studio delle quali sarà fatto dalli atti natura⁴li, fatti a caso mediante li loro accidēti, e por lì mēte per le strade piazze ⁵e cāpagnie, e notarli cō brieue discritione di liniamēti, cioè che per una testa ⁶si faccia vno o e per uno braccio una linia retta e piegata, e 'l simile si faccia delle gā⁷be e busto, e poi tornādo alla casa fare tali ricordi in perfetta forma; ⁸Dice l'aversario che per farsi pratico e fare opere assai ch'elli è meglio che 'l tēpo primo dello ⁹studio sia messo in ritrarre vari conponimēti, fatti per carte o muri per di¹⁰uersi maestri, e in quelli si fa pratica veloce e bono abito, al quale si rispō¹¹de che questo abito sarebbe bono, essendo fatto sopra opere di boni componimēti e di ¹²studiosi maestri; e perchè questi tali maestri son sì rari che pochi se ne trova, è piv ¹³sicuro andare alle cose naturali che a quelle d'esso naturale cō grā peggio¹⁴ramēto imitate e fare tristo abito, perchè chi può andare alla fonte nō vada ¹⁵al uaso.

knowledge, their actions should come next, according to the circumstances in which they occur in man. And thirdly to compose subjects, the studies for which should be taken from natural actions and made from time to time, as circumstances allow; and pay attention to them in the streets and *piazze* and fields, and note them down with a brief indication of the forms; [5] thus for a head make an o, and for an arm a straight or a bent line, and the same for the legs and the body, [7] and when you return home work out these notes in a complete form. The Adversary says that to acquire practice and do a great deal of work it is better that the first period of study should be employed in drawing various compositions done on paper or on walls by divers masters, and that in this way practice is rapidly gained, and good methods; to which I reply that the method will be good, if it is based on works of good composition and by skilled masters. But since such masters are so rare that there are but few of them to be found, it is a surer way to go to natural objects, than to those which are imitated from nature with great deterioration, and so form bad methods; for he who can go to the fountain does not go to the water-jar.

Ash. I. 7*b*] 491.

QUALE REGOLA SI DE' DARE A PUTTI PITTORI.

WHAT RULES SHOULD BE GIVEN TO BOYS LEARNING TO PAINT.

Industry and thoroughness the first conditions (491—493.)

²Noi conosciamo chiaramēte che la vista è delle veloci operationi che sia, ³ed in vn pūto vede īfinite forme: niēte di meno nō cōprende se non una cosa ⁴per volta; Poniamo caso tu lettore guarderai in vna occhiata tutta questa ⁵carta scritta, e subito giudicherai quella esser piena di uarie lettere, ⁶ma non conoscierai in questo tēpo che le lettere sieno, nè che voglino dire, ⁷ōde ti bisogna fare a parola a parola · verso per uerso, a voler avere ⁸notitia d'esse lettere; Ancora se vorai mōtare all'altezza d'uno

We know for certain that sight is one of the most rapid actions we can perform. In an instant we see an infinite number of forms, still we only take in thoroughly one object at a time. Supposing that you, Reader, were to glance rapidly at the whole of this written page, you would instantly perceive that it was covered with various letters; but you could not, in the time, recognise what the letters were, nor what they were meant to tell. Hence you would need to see them word by word, line by line to be able to understand the letters. Again, if you wish to go to the top of a building you must go up step by step; otherwise it will be

. . per îbr una . . facia. 7. ebbussto. 8. effare . . tēpo pº dello. 10. maesstri. 11. te che. 12. maesstri. 13. acquelle . . pego. 14. po . . nō \|\|\|\|\|\|\|\|.

491. 1. quella regola. 2. chonosciano . . chella . . operatione chessia. 3. cōplende se nonc ī cosa. 4. chaso . . innvna. 5. charta . . essubito. 6. chonoscierai . . volino. 7. fare apparola . . versso per. 8. Anchora . . alteza. 9. chonuera. 10. chosi dicho

Lines 5—7 explained by the lower portion of the sketch No. 1 on Pl. XXXI.

edifitio ⁹ti conuerrà · salire a grado · a grado ·,
latrimēti fia īpossibile peruenire ¹⁰alla sua ·
altezza; così dico a te · il quale la natura ·
volgie · a questa · arte, ¹¹se vuoi aver vera
notitia · delle · forme delle cose ·, comīciarai
alle parti¹²cule · di quelle · e non ādare · alla
seconda ·, se prima · non ài bene nella me-
moria ¹³e nella pratica · la prima; E se altro
farai, gitterai via il tēpo o vera¹⁴mēte allū-
gherai assai lo studio; E ricordoti ch'īpari
prima la deligēza ¹⁵che la prestezza.

impossible that you should reach the top.
Thus I say to you, whom nature prompts to
pursue this art, if you wish to have a
sound knowledge of the forms of objects
begin with the details of them, and do not
go on to the second [step] till you have the
first well fixed in memory and in practice.
And if you do otherwise you will throw
away your time, or certainly greatly prolong
your studies. And remember to acquire
diligence rather than rapidity.

Ash. I. 8a]　　　　　　　492.

COME SI DEBE PRIMA INPARARE LA DILIGĒZA
²CHE LA PRESTA · PRATICA.

³Quando tu disegniatore vorrai fare bono
· e vtile studio · vsa nel tuo disegnia⁴re fare
adagio · e givdicare īfra i lumi quali e quāti
tēghino il primo gra⁵do di chiarezza, e si-
milmēte īfra l'onbre quali sieno quelle che
sono più schu⁶re · che l'altre e in che modo
si mischiano īsieme · e le quātità, parago-
nare ⁷l'una choll'altra · i liniamēti · a che
parte si dirizzino, e nelle linie quāta parte
⁸d'esse torcie per vno o altro verso, e dove
più o meno evidēti e se sia larga ⁹o sottile,
ed in ultimo · che le tue ōbre e lumi sieno
uniti sāza tra¹⁰tti o segni, a uso di fumo:
E quādo · tu avrai fatto la mano · e 'l giv-
ditio a que¹¹sta diligēza · verati fatto più
presto · che tu nō te ne avederai.

HOW THAT DILIGENCE [ACCURACY] SHOULD FIRST
BE LEARNT RATHER THAN RAPID EXECUTION.

If you, who draw, desire to study well
and to good purpose, always go slowly to
work in your drawing; and discriminate in
the lights, which have the highest degree of
brightness, and to what extent and likewise
in the shadows, which are those that are
darker than the others and in what way
they intermingle; then their masses and the
relative proportions of one to the other.
And note in their outlines, which way they tend;
and which part of the lines is curved to one
side or the other, and where they are more
or less conspicuous and consequently broad
or fine; and finally, that your light and shade
blend without strokes and borders [but]
looking like smoke. And when you have
thus schooled your hand and your judgment
by such diligence, you will acquire rapidity
before you are aware.

C. A. 181b; 546b]　　　　　493.

VITA DEL PICTORE NE PAESI.

²Al pittore è neciessario la matematica
appartenēte a essa ³pictura, e la priuatione
di cōpagni che son alieni dalli lo⁴ro studi,
e ciervello mutabile secondo la uariatione
delli ⁵obbietti, che dinanti se li oppongono

OF THE LIFE OF THE PAINTER IN THE COUNTRY.

A painter needs such mathematics as be-
long to painting. And the absence of all
companions who are alienated from his stu-
dies; his brain must be easily impressed by
the variety of objects, which successively come

The artist's
private life
and choice
of company
(493. 494).

atte . . acquesta. 11. uolli chose comīciati. 12. sechonda . . nonnai . . memori"a". 13. praticha . . Esse. 14. allūgerai
. . richordoti. 15. presteza.
492. 2. chella . . praticha. 4. givdichare. 5. chiareza essimilmēte . . qul sieno . . chessono. 6. sinmischano . . elle. 7. chol-
laltra e . . drizino. 8. dessa . . e cosi larga. 9. ossotile [quando] ed . . ellumi . . saza. 10. ossegni . . arai . . acque.
11. fatta presto . . nōtte.
493. 1. pictore [filosafo]ne. 2. [la] al pitore . . le matematiche apartenēte nessa. 3. Ella . . cōpagnie chesson allieni. 5. op-

493. In the title line Leonardo had originally
written *del pictore filosafo* (the philosophical painter),
but he himself struck out *filosofo*. Compare in

No. 363 *pictora notomista* (anatomical painter). The
original text is partly reproduced on Pl. CI.

e remoto da altre cu⁶re; E se nella contē-
platione e difinitione d'ū caso se ne l'ī⁷ter-
pone vn secondo caso come accade, quādo
l'obbietto ⁸muove il senso, allora di tali
casi si debbe giu⁹dicare quale è di più fati-
cosa difinitione, e quello ¹⁰seguitare insino
alla sua vltima chiarezza, e poi ¹¹seguitare
la difinitione dell'altro; E sopra tutto essere
¹²di mēte equale alla natura che à la super-
fitie dello spechio, ¹³la quale si trasmuta in
tanti vari colori, quāti sono li ¹⁴colori delli
sua obbiecti; e le sue cōpagnie abbino
¹⁵similitudine con lui in tali studi e, nō le tro-
vando, ¹⁶vsi cō se medesimo nelle sue cō-
templationi, che ¹⁷in fine nō troverrà più
vtile conpagnia.

before him, and also free from other cares [6].
And if, when considering and defining one
subject, a second subject intervenes—as hap-
pens when an object occupies the mind, then
he must decide which of these cases is the
more difficult to work out, and follow that
up until it becomes quite clear, and then
work out the explanation of the other [11].
And above all he must keep his mind as
clear as the surface of a mirror, which as-
sumes colours as various as those of the
different objects. And his companions should
be like him as to their studies, and if such
cannot be found he should keep his specu-
lations to himself alone, so that at last he will
find no more useful company [than his own].

Ash. I. 8a] **494.**

DELLA · VITA DEL PITTORE NEL SUO STUDIO.

OF THE LIFE OF THE PAINTER IN HIS STUDIO.

²Acciochè la prosperità · del corpo · nō
guasti quella · dello ingegno, ³il pittore ovvero
disegniatore debe essere · solitario ·, e mas-
sime quādo è intēto ⁴alle speculationi · e
considerationi · che continvamente apparēdo
dināzi ⁵agli ochi che danno materia alla me-
moria d'esser bene riservate; E se tu ⁶sarai
solo tu sarai tutto tuo, e se sarai acom-
pagniato da uno solo cōpagnio ⁷sarai mezzo
tuo, e tāto meno quanto sarà maggiore la
indiscretione della ⁸sua pratica; e se sarai
con piv · caderai in più simile incōueniēte
e se ⁹tu volessi dire, io farò a mio modo,
mi tirerò ī parte per potere meglio specu-
¹⁰lare le forme delle cose naturali, dico
questo potersi mal fare, perchè nō po¹¹tresti
fare che spesso nō prestassi orechi alle lor
ciācie, E, non si potendo servi¹²re · a 2 si-
gnori ·, tu faresti male · l'ufitio ¹³della cō-
pagnia e peggio l'effetto ¹⁴della speculatione
dell'arte: e se tu ¹⁵dirai io mi tirerò tāto ī
parte che le lor ¹⁶parole nō peruenirāno e
nō mi darāno īpacio, io ī questa parte ti
dico che tu ¹⁷sarai tenvto matto; ma vedi
che così faciēdo tu saresti pur solo; ¹⁸e se

To the end that well-being of the body
may not injure that of the mind, the painter
or draughtsman must remain solitary, and
particularly when intent on those studies and
reflections which will constantly rise up be-
fore his eye, giving materials to be well stored
in the memory. While you are alone you
are entirely your own [master] and if you have
one companion you are but half your own,
and the less so in proportion to the indis-
cretion of his behaviour. And if you have
many companions you will fall deeper into
the same trouble. If you should say: "I
will go my own way and withdraw apart, the
better to study the forms of natural objects",
I tell you, you will not be able to help
often listening to their chatter. And so, since
one cannot serve two masters, you will badly
fill the part of a companion, and carry out
your studies of art even worse. And if you
say: "I will withdraw so far that their words
cannot reach me and they cannot disturb
me", I can tell you that you will be thought
mad. But, you see, you will at any rate be
alone. And if you must have companions

ponghano erremoti. 6. Esse . . chaso. 7. chaso . . achade. 8. [di talc i] di tali. 9. [e ppiu] e di . . ecqual. 10. seghui-
tare . . eppoi. 11. siguitare . . Essopra. 13. trassmuta. 14. elle. 15. collui . . ennolle. 16. vsi chōse . . cōtemplatione.
494. 2. Acciochella . . incigno. 4. isspechulatione . e chonsideratione . che chontinvamene. 5. algli . . Essettu. 6. tussarai . .
esse . . achompagniato da ī solo. 7. mezo. 8. praticha esse . . chon . . chaderai . . inchōueniēte esse. 9. spechu. 10. chose
naturale. 11. chesspesso . . prestasi. 13. chōpagnia e pegio. 14. dela . . essettu. 15. dirai imi . . chelle. 16. queparte
. . chettu. 17. mato . . chosi. 18. esse . . chōpagnia. 19. giovare ver chonferimēto . . achade . . spechula. 20. tione.

6—11. Leonardo here seems to be speaking of
his own method of work as displayed in his MSS.

and this passage explains, at least in part, the
peculiarities in their arrangement.

pure vorai cōpagnia pigliala del tuo istu-
dio: questa [19]ti potrà giovare · a aver quel
conferimēto · che accade · dalle varie specula[20]tioni: ogni altra cōpagnia · ti potrebbe esser assai dānosa.

ship find it in your studio. This may assist
you to have the advantages which arise from
various speculations. All other company
may be highly mischievous.

Ash. I. 9a]

495.

S'EGLI È MEGLIO · A DISEGNARE Ī CŌPAGNIA O NO.

[2]Dico e confermo che 'l disegniare ī cōpagnia è molto meglio che solo, per molte
ragioni, [3]la prima è che tu ti vergognerai
d'essere visto · nel numero de' disegniatori
essēdo īsofficiēte, [4]e questa vergognia · fia
cagione di bono studio · ; secōdariamēte la
īuidia bona ti stimv[5]lerà a essere nel nvmero
de' piv laudati di te, chè l'altrui lode ti sproneraño; L'altra è che tu piglie[6]rai de' tratti
di chi fa meglio di te, e se sarai meglio degli
altri farai profito di schifare i man[7]camenti,
e l'altrui laude accresceraño tua virtù.

OF WHETHER IT IS BETTER TO DRAW WITH COMPANIONS OR NOT.

I say and insist that drawing in company
is much better than alone, for many reasons.
The first is that you would be ashamed to
be seen behindhand among the students,
and such shame will lead you to careful
study. Secondly, a wholesome emulation
will stimulate you to be among those who
are more praised than yourself, and this praise
of others will spur you on. Another is that
you can learn from the drawings of others
who do better than yourself; and if you are
better than they, you can profit by your contempt for their defects, while the praise of
others will incite you to farther merits.

The distribution of time for studying (495—497).

Ash. I. 9b]

496.

DELLO STUDIARE INSINO QUĀDO TI DESTI [2]O NĀZI T'ADORMĒTI NEL LETTO ALLO SCURO.

[3]ò in me provato essere di nō pocca
vtilità, quādo ti truovi allo scuro nel letto
[4]andare colla inmaginativa repetēdo · i liniamēti superfitiali delle forme [5]per l'adrieto
studiate, o altre cose notabili da sottili
speculatione cōprese, [6]ed è questo · propio uno
atto laudabile e vtile a confermarsi le cose
nella memoria.

OF STUDYING, IN THE DARK, WHEN YOU WAKE, OR IN BED BEFORE YOU GO TO SLEEP.

I myself have proved it to be of no small
use, when in bed in the dark, to recall in fancy
the external details of forms previously studied, or other noteworthy things conceived
by subtle speculation; and this is certainly an
admirable exercise, and useful for impressing
things on the memory.

Ash. I. 8b]

497.

DI CHE TĒPO · SI DEVE STUDIARE LA ELETIONE DELLE COSE.

[2]Le veglie · della · invernata · devono · essere da' giovani · vsate nelli studi delle [3]cose ·
aparechiate · l'estate, cioè · tutti li nvdi che

OF THE TIME FOR STUDYING SELECTION OF SUBJECTS.

Winter evenings ought to be employed
by young students in looking over the things
prepared during the summer; that is, all the

495. 1. chōpagnia ōno. 2. dicho e confermo . . chōpagnia . . chessolo. 3. chettutti insoficiēte [secondaria sia]. 4. ecquesta . .
bonasti stimv. 5. laldati . . lade . . Laltra chettu. 6. esse . . scifare. 7. lalde.

496. 2. schuro. 3. Oime . . pocha . . alo. 4. chollo. 5. chose. 6. propio ī atto laldabile . . chonfirmarsi le chose.

497. 2. istudi delle. 3. chose . . lastate cioe chettutti . . lastate; *convienti is wanting in the original.* 4. effare. 5. praticha.

495. The contradiction by this passage of the
foregoing chapter is only apparent. It is quite clear,
from the nature of the reasoning which is here
used to prove that it is more improving to work

with others than to work alone, that the studies of
pupils only are under consideration here.

497. An injunction to study in the evening occurs
also in No. 524.

ài fatti · l'estate, convienti ⁴ riducierli · īsieme · e fare · eletione · delle migliori mēbra e corpi ⁵ di quegli · e metterli · in pratica e bene a mēte.

drawings from the nude done in the summer should be brought together and a choice made of the best [studies of] limbs and bodies among them, to apply in practice and commit to memory.

DELLE · ATTITUDINI.

⁷ Di poi · alla · seguēte · state farai eletione · di qualchevno che stia bene ⁸ in su la vita · e che nō sia · allevato · ī givboni ·, a ciò la persona nō sia strana ⁹ dalla sua · natura ·, e a quello · farai · fare atti legiadri e galāti e se ¹⁰ questo · nō mostrassi bene · i mvscoli dētro ai termini delle mēbra, nō mō¹¹t'a niente, bastiti auere · sol da questo · le bone attitudini, e le mēbra ¹² ricorreggi chō quelle · che studiasti · la invernata.

OF POSITIONS.

After this in the following summer you should select some one who is well grown and who has not been brought up in doublets, and so may not be of stiff carriage, and make him go through a number of agile and graceful actions; and if his muscles do not show plainly within the outlines of his limbs that does not matter at all. It is enough that you can see good attitudes and you can correct [the drawing of] the limbs by those you studied in the winter.

S. K. M. III. 24 b]

498.

On the productive power of minor artists (498—501).

Tristo è quel discepolo che ² non avāza il suo maestro.

He is a poor disciple who does not excel his master.

G. 25 a]

499.

Non è laudabile quel pittore che nō fa bene ² se non vna cosa sola, come vno nudo, te³sta, panni o animali, o paesi o simili pa⁴rticulari, inperochè non è si grosso in⁵giegnio che, uoltatosi a vna cosa sola e que⁶lla senpre messa in opera, no la facci bene.

Nor is the painter praiseworthy who does but one thing well, as the nude figure, heads, draperies, animals, landscapes or other such details, irrespective of other work; for there can be no mind so inept, that after devoting itself to one single thing and doing it constantly, it should fail to do it well.

Ash. I. 10 a]

500.

COME IL PITTORE NON È LAUDABILE ² SE QUELLO NON È UNIVERSALE.

³ D'alcuni · si può chiaramēte dire · che si ingānano ·, i quali chiamano bono maestro ⁴ quello pittore, jl quale sol fa bene · una testa · o vna · figura: Cierto non è grā ⁵ fatto · che studiādo una sola cosa · il tēpo · della

THAT A PAINTER IS NOT ADMIRABLE UNLESS HE IS UNIVERSAL.

Some may distinctly assert that those persons are under a delusion who call that painter a good master who can do nothing well but a head or a figure. Certainly this is no great achievement; after studying one

6. attitudine. 8. nō sia stra. 9. acquello . . esse. 11. dacquesto . . attitudine. 12. richoregi chō . . studiassti.
498. 1. trissto . . disciepolo. 2. maesstro.
499. 1. laldabile. 2. none vna. 3. ossimili. 4. rtichulare. 5. ecque.
500. 1. laldabile. 2. secquelo. 3. alchuni si po . . chessi. 4. quelo . . bene ī̂ testa . . e non. 5. studiādo ī̂ sola chosa . . vēgi

499. In MANZI's edition (p. 502) the painter G. G. BOSSI indignantly remarks on this passage. "*Parla il Vince in questo luogo come se tutti gli artisti avessero quella sublimità d'ingegno capace di abbracciare tutte le cose, di cui era egli dotato.*" And he then mentions the case of CLAUDE LORRAIN. But he overlooks the fact that in Leonardo's time landscape painting made no pretensions to independence but was reckoned among the details (*particulari*, lines 3, 4).

· sua vita · che noñ vēghi a qualche ⁶perfec-
tione ·, ma conosciēdo noi · che la · pittura ·
abraccia e contiene · in se · tutte ⁷le cose
che produce la natura ·, e che cōduce l'acci-
dētale operatione delli omini ⁸e in vltimo ·
ciò che si può cōprendere cogli ochi, mi
pare uno tristo maestro ⁹quello · che solo
una figura fa bene: Or nō vedi tu quāti
e quali atti sieno solo fac¹⁰ti da li omini ·
Nō vedi quāti diuersi animali e così albori,
erbe, fiori, ¹¹varietà di siti mōtuosi e piani ·,
fōti, fiumi ·, città, edifiti publici e privati, ¹²stru-
mēti opportuni all'vso vmano ·, vari abiti e
ornamēti · e arti; tutte queste ¹³cose appar-
tēgono d'essere di pari operazione e bōtà
vsate da quello ¹⁴che tu vogli chiamare bō
pittore.

single thing for a life-time who would not have
attained some perfection in it? But, since we
know that painting embraces and includes in
itself every object produced by nature or re-
sulting from the fortuitous actions of men,
in short, all that the eye can see, he seems
to me but a poor master who can only do
a figure well. For do you not perceive how
many and various actions are performed by
men only; how many different animals there
are, as well as trees, plants, flowers, with many
mountainous regions and plains, springs and
rivers, cities with public and private buildings,
machines, too, fit for the purposes of men,
divers costumes, decorations and arts? And
all these things ought to be regarded as of
equal importance and value, by the man who
can be termed a good painter.

Ash. I. 10*b*]

501.

DELLA TRISTA · SCUSATIONE FATTA DA QUELLI
CHE FALSAMENTE ²E ĪDEGNIAMĒTE SI FĀNO CHIA-
MARE PITTORI.

OF THE MISERABLE PRETENCES MADE BY THOSE
WHO FALSELY AND UNWORTHILY ACQUIRE THE
NAME OF PAINTERS.

³Ecci vna cierta gieneratione di pittori
i quali per loro · poco studio ⁴bisognia che
vivino sotto la bellezza d'oro e d'azzurro, i
quali cō sō⁵ma stoltitia · allegano · nō met-
tere · iñ opera le bone cose · per tristi ⁶pa-
gamēti ·, che saprebbono · ancora bē loro fare
come vn altro, ⁷quādo · fussino bene pagati;
Or vedi, giēte stolta ·, nō sāno questi ⁸tali
tenere · qualche opera bona, diciēdo questa
è da bō premio ⁹e questa è da mezzano,
e questa è di sorte, e mostrare d'avere
opera ¹⁰da ogni premio.

Now there is a certain race of painters
who, having studied but little, must need
take as their standard of beauty mere gold
and azure, and these, with supreme conceit,
declare that they will not give good work
for miserable payment, and that they could
do as well as any other if they were well
paid. But, ye foolish folks! cannot such
artists keep some good work, and then say:
this is a costly work and this more moderate
and this is average work and show that they
can work at all prices?

Ash. I. 9*b*]

502.

COME NELLE OPERE D'ĪPORTĀTIA L'OMO NŌ SI
DE' FIDARE TĀ²TO DELLA SUA MEMORIA CHE
NŌ DEGNI RITRARE DI NATURALE.

HOW, IN IMPORTANT WORKS, A MAN SHOULD
NOT TRUST ENTIRELY TO HIS MEMORY WITHOUT
CONDESCENDING TO DRAW FROM NATURE.

³Quello maestro · il quale · si dessi ad
intēdere di potere riseruare ī se tutte le
forme ⁴e li · effetti della natura · certo · mi
parebbe · questo essere ornato · di molta igno-
rāza, ⁵cōciosia cosa chè detti effetti sono
īfiniti, e la memoria nostra non è di tāta
capacità ⁶che basti: Adūque tu · pittore

Any master who should venture to boast A caution
that he could remember all the forms and against one-
effects of nature would certainly appear to sided study.
me to be graced with extreme ignorance, in-
asmuch as these effects are infinite and our
memory is not extensive enough to retain
them. Hence, O! painter, beware lest the

acqualche. 6. chonociēdo . . chella . . chontiene. 7. chose. 8. chōplendere cholgli . . pare ī tristo. 9. sola ī figura . .
ecquaatti. 10. fiori [chāpagnie]. 12. tutte que. 13. chose apartengano . . dacquello. 14. chettu . . pitore.
501. 1. cheffalsa. 4. beleza . . azurro . . cōso. 5. chose. 6. chesse perebono anchora . . chome. 7. istolto . nō sano.
502. 3. Quelo maesstro. 4. elli . . parebe. 5. chosa . . dette . . ella. 6. chella chupidita. 7. guadagni . . chellonore . . richezze.

guarda · che la cupidità del guadagnio nō superi ī te l'ono⁷re dell'arte ·, chè il guadagno dell'onore è molto maggiore che l'onore delle richezze, ⁸sicchè per queste ed altre ragioni che si potrebbō dire · attenderai · prima col disegno ⁹a dare con dimostratiua forma all'occhio · la intētione, e la īuentione fatta ī prima ¹⁰nella tua imaginatiua ·, di poi va leuādo e ponēdo tāto che tu ti sadisfaccia, ¹¹di poi fa acōciare omini vestiti o nudi nel modo che īsul opera ài ordinato, ¹²e fa che per misura · e grādezza, sotto posto alla prospettiva, che nō passi niēte ¹³dell'opera che bene nō sia cōsiliata dalla ragione e dalli effetti naturali, ¹⁴e questa fia la uia da farti onore della tua arte.

lust of gain should supplant in you the dignity of art; for the acquisition of glory is a much greater thing than the glory of riches. Hence, for these and other reasons which might be given, first strive in drawing to represent your intention to the eye by expressive forms, and the idea originally formed in your imagination; then go on taking out or putting in, until you have satisfied yourself. Then have living men, draped or nude, as you may have purposed in your work, and take care that in dimensions and size, as determined by perspective, nothing is left in the work which is not in harmony with reason and the effects in nature. And this will be the way to win honour in your art.

G. 5 b] 503.

DELLA VARIETÀ DELLE FIGURE.

OF VARIETY IN THE FIGURES.

How to acquire universality (503—506).

²Il pictore debbe cercare d'essere vni³uersale, perchè gli manca assai di degnità ⁴a fare vna cosa bene e l'altra male, cō⁵me molti che solo studiano nello ignu⁶do misurato e proportionato, e nō ricer⁷cā la sua varietà, perchè può vno omo esse⁸re proportionato e essere grosso e cort⁹o o lungo e sottile o mediocre, e chi ¹⁰di questa varietà nō tiene cōto fa senpre ¹¹le figure sue in stāpa che pare essere tut¹²ti fratelli, la qual cosa merita grā riprēsi¹³one.

The painter should aim at universality, because there is a great want of self-respect in doing one thing well and another badly, as many do who study only the [rules of] measure and proportion in the nude figure and do not seek after variety; for a man may be well proportioned, or he may be fat and short, or tall and thin, or medium. And a painter who takes no account of these varieties always makes his figures on one pattern so that they might all be taken for brothers; and this is a defect that demands stern reprehension.

Ash. I. 4a] 504.

¶COME PER TUTTE VIE SI PUÒ IMPARARE.¶

HOW SOMETHING MAY BE LEARNT EVERYWHERE.

²Questa · benigna · natura ne provede ī modo che per tutto ³il mōdo tu trovi dove imitare.

Nature has beneficently provided that throughout the world you may find something to imitate.

G. 5 b] 505.

DELL'ORDINE DEL FARSI VNIVERSALE.

OF THE MEANS OF ACQUIRING UNIVERSALITY.

²Facile cosa è a ³l'omo farsi vniuersale, imperochè tutti ⁴li animali terrestri ànno similitudine di mē⁵bra, cioè muscoli nerui e ossa, e ⁶nulla si uariano se nō in lūghezza o in ⁷grossezza come sarà dimostrato nella

It is an easy matter to men to acquire universality, for all terrestrial animals resemble each other as to their limbs, that is in their muscles, sinews and bones; and they do not vary excepting in length or in thickness, as

8. ragione chessi .. chol. 9. chon .. ella. 10. valleuādo .. chettutti. 12. effa. 14. ecquesta.
503. 2. cerchare. 3. Mancha. 4. se affare .. ellaltra. 5. chessolo .. iniv. 7. chā la .. perche e po vno. 8. chort. 9. lungho essottile. 11. tu. 12. fratelle.
504. 1. chome per tutti via si po. 2. benignia.
505. 2. cosa he a chi ssa farsi [vniuersale]. 3. farsi poi vniuersale inperochetti. 4. terrestri ā similitudine di me. 5. bra [mussco]

8 natomia; ecci poi li animali d'acqua · che
9 son di molte varietà, delli quali nō persua-
10 derò il pittore che ui faccia regola, per-
11 chè son quasi d'infinite varietà, e cosi li
12 animali insetti.

will be shown under Anatomy. But then there are aquatic animals which are of great variety; I will not try to convince the painter that there is any rule for them for they are of infinite variety, and so is the insect tribe.

Ash. I. 31 b]

506.

PITTURA.

2 Lo ingiegnio del pittore vol essere a similitudine · dello · spechio ·, jl quale · senpre
3 si trasmuta nel colore · di quella · cosa ch'eli à per obietto ·, e di tāte simili4tudini s'enpie · quāte sono le cose che li sono. contraposte; Adūque co5nosciēdo · tu · pittore nō potere esser · bono · se nō sei · vniversale · maestro di 6cōtrafare · colla · tua · arte · tutte le qualità · delle · forme · che produce la natura, 7le quali nō saprai · fare, se nō le vedi ·, e ritenerle nella mēte; Onde andādo 8tu per cāpagnie · fa che 'l tuo givditio si uolti a vari obietti e di mano ī ma9no riguardare or questa cosa ora quell'altra, faciēdo vn fascio di uarie 10cose · elette e scielte infra le mē bone; E nō facci come alcuni pitto11ri, i quali ·, stāchi colla lor fantasia, dismettono l'opera e fāno esercitio 12col andare · a sollazzo, riserbandosi vna stāchezza nella mente, la quale, 13nō che veghino, non porgono ī mente · varie cose, ma spesse volte scontrādo 14li amici e parēti, essendo · da quelli salutati ·, nō che li vedino · o sentino, 15e non altrementi sono cognioscivti ·, come se vi scontrassino altre tāt' aria.

PAINTING.

The mind of the painter must resemble a mirror, which always takes the colour of the object it reflects and is completely occupied by the images of as many objects as are in front of it. Therefore you must know, Oh Painter! that you cannot be a good one if you are not the universal master of representing by your art every kind of form produced by nature. And this you will not know how to do if you do not see them, and retain them in your mind. Hence as you go through the fields, turn your attention to various objects, and, in turn look now at this thing and now at that, collecting a store of divers facts selected and chosen from those of less value. But do not do like some painters who, when they are wearied with exercising their fancy dismiss their work from their thoughts and take exercise in walking for relaxation, but still keep fatigue in their mind which, though they see various objects [around them], does not apprehend them; but, even when they meet friends or relations and are saluted by them, although they see and hear them, take no more cognisance of them than if they had met so much empty air.

Ash. I. 9 a]

507.

DE' GIOCHI CHE DEBONO FARE I DISEGNIATORI.

2 Quando · vorete · o voi disegniatori · pigliare coi giochi qualche utile · sollazzo
3 è da vsare · senpre cose · al proposito · della · vostra · professione ·, cioè del fare bono
4 giudicio di ochio, del sapere givdicare la uerità delle larghezze e lūghezze delle cose
5 e per suefare lo ingiegnio · a simili · cose

OF GAMES TO BE PLAYED BY THOSE WHO DRAW.

When, Oh draughtsmen, you desire to find relaxation in games you should always practise such things as may be of use in your profession, by giving your eye good practice in judging accurately of the breadth and length of objects. Thus, to accustom your mind to such things, let one of

Useful games and exercises (507. 508).

coe musscoli. 6. seno illūgeza. 7. dimostrao. 8. dacq"a". 9. deli. 10. pichttore.

506. 2. assimilitudine. 3. cholore .. chosa. 4. tudine .. quāti .. chose .. chontraposte .. cho. 5. se nōse. 6. cōtraffare cholla. 8. chāpagnie. 10. esscielte .. infralle .. faci chome alchu. 11. re i quali stāchi cholla .. dismettano .. effano. 12. chol .. assollazo .. stācheza. 13. no che vegino o porgn ī mente . varie chose . schōtrādo. 14. ossentino. 15. chogniioscivti chome se li schontrasino altre tātaria.

507. 2. choi .. nutile sollazo. 3. chose. 4. givdichare .. largeze ellūgeze .. chose. 5. assimile chose faccia ī diuoi. 6. chaso

· faccia uno di uoi · una · linia recta [6]a caso su vno mvro · e ciascuno di voi tēga una sottile · festuca o paglia in mano [7]e ciascuno · tagli · la sua · alla · lunghezza · che li · pare · la prima linia, stādo · lontani [8]per ispatio di braccia · 10 ·, e poi ciascuno vada · allo esenplo a misurare cō quella la sua [9]givditiale misura: E quello · che piv s'avvicina colla sua misura alla lunghezza de[10]llo esēplo fia superiore e uincitore e acquisti da tutti il premio, che ināzi da uoi [11]fu · ordinato ·; Ancora si debbe · pigliare misure scortate, cioè pigliare uno [12]dardo o altra caña, e riguardare dināzi a se una cierta distātia ·, e ciascuno [13]col suo givditio stimi quāte volte quella misura · entri ī quella distātia, ācora a chi [14]tira meglio una linia di uno braccio, e sia riprovata con filo tirato ·; E simili giochi sono [15]cagione di fare bono jvditio d'ochio, il quale è 'l prīcipale atto della pittura.

you draw a straight line at random on a wall, and each of you, taking a blade of grass or of straw in his hand, try to cut it to the length that the line drawn appears to him to be, standing at a distance of 10 braccia; then each one may go up to the line to measure the length he has judged it to be. And he who has come nearest with his measure to the length of the pattern is the best man, and the winner, and shall receive the prize you have settled beforehand. Again you should take forshortened measures: that is take a spear, or any other cane or reed, and fix on a point at a certain distance; and let each one estimate how many times he judges that its length will go into that distance. Again, who will draw best a line one braccio long, which shall be tested by a thread. And such games give occasion to good practice for the eye, which is of the first importance in painting.

Ash. I. 13 a] **508.**

MODO D'AUMĒTARE E DESTARE LO ĪGIEGNIO [2]A VARIE ĪUĒTIONI.

A WAY OF DEVELOPING AND AROUSING THE MIND TO VARIOUS INVENTIONS.

[3]Nō resterò però di mettere ītra questi precietti una nova īuētione di specula[4]tione, · la quale · bēchè paia · piccola · e quasi degnia di riso, nōdimeno è di [5]grāde vtilità · a destrare lo ingegno a varie invētioni, e questa · è · se tu [6]riguarderai in alcuni mvri inbrattati di uarie machie o pietre di uari misti, [7]se avrai a īuentionare qualche sito · potrai · lì · uedere similitudine di diuersi paesi, [8]ornati di mōtagnie, fiumi, sassi, albori, pianvre, grādi valli e colli [9]in diuersi modi, · ancora vi potrai vedere diuerse battaglie e atti prōti di [10]figure ·, strane arie di uolti · e abiti · e infinite cose ·, le quali potrai ri[11]durre in ītegra · e bona · forma ·, e īterviene ī simili mvri e misti come del suono [12]di cāpane · che ne' loro tochi vi troverai ogni nome e vocabolo che tu ī[13]maginerai.

I cannot forbear to mention among these precepts a new device for study which, although it may seem but trivial and almost ludicrous, is nevertheless extremely useful in arousing the mind to various inventions. And this is, when you look at a wall spotted with stains, or with a mixture of stones, if you have to devise some scene, you may discover a resemblance to various landscapes, beautified with mountains, rivers, rocks, trees, plains, wide valleys and hills in varied arrangement; or again you may see battles and figures in action; or strange faces and costumes, and an endless variety of objects, which you could reduce to complete and well drawn forms. And these appear on such walls confusedly, like the sound of bells in whose jangle you may find any name or word you choose to imagine.

6. sunvno . . ciasschuno . . tēga ī sottile . festucha . . imano. 7. e ciasschuno . talgli . . lungeza . chelli. 8. di br. 10 . . chō. 9. Ecquello . . savisina cholla . . lungeza. 10. premio di che. 11. Anchora . . schontate. 11. pigliare ī. 12. chāna . . asse ī cierta. 14. meglio īlinia dī br essia . . chon . . Essimili. 15. chagione.
508. 3. precietti ī nova . . spechula. 4. pichola. 5. longiegmo . . ecquesta . . settu. 6. miscti. 7. arai. 8. vale e cholli. 11. dure . . del so. 12. viroverai . . vocavlo chettu i.

II.

THE ARTIST'S STUDIO.—INSTRUMENTS AND HELPS FOR THE APPLICATION OF PERSPECTIVE.—ON JUDGING OF A PICTURE.

Ash. I. 19 *b*]

509.

Le stāze overo abitationi piccole raviā lo ingegno et le grādi lo suiano.

Small rooms or dwellings discipline the mind, large ones weaken it.

On the size of the studio.

B. M. 171 b]

510.

Quāto piv grosso fia il muro ²minore fia il lume.

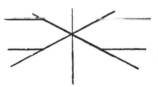

The larger the wall the less the light will be.

On the construction of windows (510—512).

B. 20 *b*]

511.

Modi di vari lumi dati per varie forme di finestre alle canove: la piv disutile ²è

The different kinds of light afforded in cellars by various forms of windows. The

509. 1. abitatione pichole . . logiēgnio . lossuianυ.
510. 2. ilume.
511. 1. chanove. 2. freda . . pivtile ella . . chalda. 3. ella . . mezana.

511. From a reference to the notes on the right light for painting it becomes evident that the observations made on cellar-windows have a direct bearing on the construction of the studio-window.

In the diagram *b* as well as in that under No. 510 the window-opening is reduced to a minimum, but only, it would seem, in order to emphasize the advantage of walls constructed on the plan there shown.

la finestra · *a* · e la piv fredda · la più vtile è la piv luminosa e piv calda e che vede

least useful and the coldest is the window at *a*. The most useful, the lightest and warmest

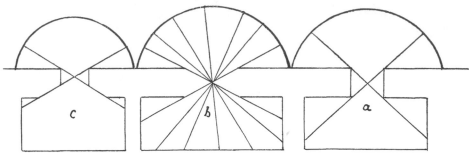

³piv · cielo è la finestra · *b*: la finestra · *c* · è di mezzana vtilità.

and most open to the sky is the window at *b*. The window at *c* is of medium utility.

Ash. I. 29*a*] 512.

FINESTRA DEL PITTORE E SUA CŌMODITÀ.

OF THE PAINTER'S WINDOW AND ITS ADVANTAGE.

²Il pittore, che vsa imitatione del naturale, debbe · avere · v̄ lume · il quale lui ³possa

The painter who works from nature should have a window, which he can raise

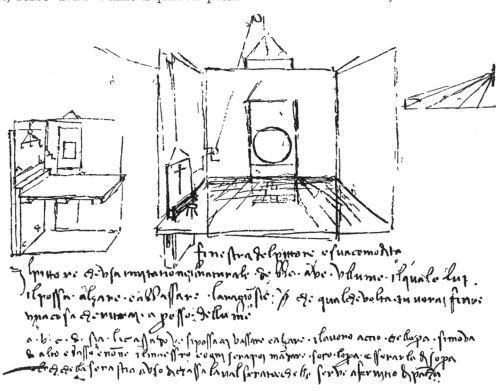

512. 1. comodita. 2. imitatione il naturale . . vllume. 3. il possa . . finre. 5. chassa . . abassare . . i lauoro . . chellopera. 6. enōne

512. See Pl. XXXI, No. 2. In this plate the lines have unfortunately lost their sharpness, for the accidental loss of the negative has necessitated a reproduction from a positive. But having formerly published this sketch by another

process, in VON LÜTZOW's *Zeitschrift für bildende Kunst* (Vol. XVII, pg. 13) I have reproduced it here in the text. The sharpness of the outline in the original sketch is here preserved but it gives it from the reversed side.

· alzare · e abbassare ·; la ragiō si è: che qualche volta · tu vorai finire ⁴vna cosa che ritrai · a presso · del lume;

⁵a · b · c · d · sia la cassa, dove si possa abbassare e · alzare · il lauoro, acciochè l'opera · si mova ⁶da alto e basso e non il maestro; e ogni sera puoi mādare sotto · l'opera · e serrarla di sopra, ⁷che la sera stia a vso di cassa laqual serrata che le serve a seruitio di pāca

and lower. The reason is that sometimes you will want to finish a thing you are drawing, close to the light.

Let *a b c d* be the chest on which the work may be raised or lowered, so that the work moves up and down and not the painter. And every evening you can let down the work and shut it up above so that in the evening it may be in the fashion of a chest which, when shut up, may serve the purpose of a bench.

Ash. I. 15b]

513.

¶Quale lume è bono per ritra²re di naturale: o alto o basso ³o grāde o piccolo o potēte grā⁴de, o potēte piccolo o grā⁵de debole o piccolo e debole?¶

Which light is best for drawing from nature; whether high or low, or large or small, or strong and broad, or strong and small, or broad and weak or small and weak?

On the best light for painting (513—520).

A. 23a]

514.

DELLA QUALITÀ DEL LUME.

²Il lume grande · e alto e nō troppo potente · fia · quello · che renderà le particule · de' corpi · molto · grate.

OF THE QUALITY OF THE LIGHT.

A broad light high up and not too strong will render the details of objects very agreeable.

Ash. I. 2b]

515.

COME DEBE ESSERE ALTO IL LUME ²DA RITRARE DI NATURALE.

³Il lume da ritrare di naturale · vole essere a tramōtana ·, aciò nō facci ⁴mutatione, e se lo · fai a mezzodì · tieni finestra īpanāta · aciò il sole, ⁵alluminādo tutto il giorno, quella nō facci mutatione ·; L'altezza del lume ⁶de' essere ī modo · situato · che ogni corpo · facci tāto lūga per terra la sua ⁷ōbra quāto · è la sua · altezza.

THAT THE LIGHT FOR DRAWING FROM NATURE SHOULD BE HIGH UP.

The light for drawing from nature should come from the North in order that it may not vary. And if you have it from the South, keep the window screened with cloth, so that with the sun shining the whole day the light may not vary. The height of the light should be so arranged as that every object shall cast a shadow on the ground of the same length as itself.

il maesstro e . . poi . . esserarla. 7. loch chella . . chassa la ualserata chelle . . pācha.
513. 3. picholo. 4. picholo. 5. picolo he debole.
514. 2. lume . . partichule de chorpi.
515. 3. attramōtana. 4. essello fai a mezo . di. 5. alūminādo . . Lalteza. 6. imodo . . faci . . luga. 7. alteza.

513. The question here put is unanswered in the original MS.

Ash. I. 2 a]

516.

Della qualità · dell'aria ²al'ōbre e lumi.

³Quel corpo · farà maggiore · differēza · dal' ombre ai lumi · che si trove⁴rà · essere · visto · da maggiore · lume ·, come lume di sole o la nocte il ⁵lume del foco: e questo · è poco · da usare j̄ pittura, j̄perochè l'opere ⁶rimāgono · crude e sanza grazia.

⁷Quel corpo ·, che si troverà j̄ mediocre lume, fia in lui poca differēza ⁸dai · lumi · all' ombre, e questo accade sul fare della sera o quādo è nuvolo ⁹e queste opere sono dolci · e àcci gratia · ōgni qualità di volto, sicchè ī ōgni ¹⁰cosa · li strēmi sono vitiosi : il troppo lume fa crudo ·, il troppo scuro nō la¹¹scia vedere: il mezzano è bono.

THE KIND OF LIGHT REQUISITE FOR PAINTING LIGHT AND SHADE.

An object will display the greatest difference of light and shade when it is seen in the strongest light, as by sunlight, or, at night, by the light of a fire. But this should not be much used in painting because the works remain crude and ungraceful.

An object seen in a moderate light displays little difference in the light and shade; and this is the case towards evening or when the day is cloudy, and works then painted are tender and every kind of face becomes graceful. Thus, in every thing extremes are to be avoided: Too much light gives crudeness; too little prevents our seeing. The medium is best.

De' lumi piccoli.

¹³Ancora · i lumi · fatti da piccole finestre fanno grā differēza da lumi al' ōbre ·, e massime se la ¹⁴stāza da quelle · alluminata fia grāde, e questo non è bono a usare.

Of small lights.

Again, lights cast from a small window give strong differences of light and shade, all the more if the room lighted by it be large, and this is not good for painting.

Ash. I. 28 b]

517.

Pittura.

¶⁹Quella · aria · luminosa · che penetra · e passa · per le · per⁻forate ¹⁰parieti · alle · oscure · abitationi · farà il lo⁻co · tanto ¹¹meno che tenebroso ·, Quanto · essa · perforatura'· entra ¹²ī nelle · parieti · che circūdano · e coprono · il lor pavimento. ¶

Painting.

The luminous air which enters by passing through orifices in walls into dark rooms will render the place less dark in proportion as the opening cuts into the walls which surround and cover in the pavement.

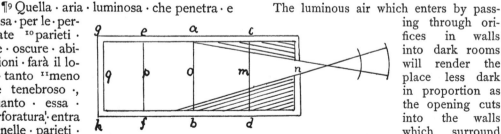

516. 2. ellumi. 3. diferēza . . chessi. 4. magiore . . chome. 5. ecquesto i e pocho . . jpero chellopere. 6. rimāgano . . essanza.
7. Quell chessi . . mediocle . . pocha diferēza. 8. ecquesto acade . . nvolo. 9. aci. 10. tropo . . il [poco] tropo. 11. mezano. 12. picholi. 13. pichole . . fano . . diferēza. 14. dacquella aluminata . . ecquesto.

517. 1 [Quell'aria luminosa ce per perforate pariete [entra] penetra e pasa 2 inelle osschure . abitatione fara i illoco 3 tanto . meno . che ttenebroso . quāto esso perfo4ramēto entra . inelle . pariete che circhun5dano e choprano . il pavimēto . Quanto to esso 6 perforamento e minore che lle pariete che circhū7dano e choprano il pavimēto]. — 9. perlle. 10. pariete . . oschure . . locho. 11. chettenebroso. 12. inelle . pariete . che circhūdano . e choprano . iloro.

A. 2 a] **518.**

QUALITÀ · DI LUME.

[2]Tāto · quanto · *a · b* · ētra
· in · *c · d* · tāte volte è più
[3]luminoso · che · *c · d* ·, e simile-
mēte · tāte volte · quanto · il
[4]pūto *e* entra · in *c · d* · tāte
uolte · è piv · luminoso che ·
c · d, [5]e questo · lume · è bono
per quelli che tagliano · lauori
sottili.

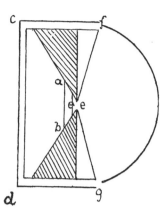

OF THE QUALITY OF LIGHT.

In proportion to the num-
ber of times that *a b* goes
into *c d* will it be more lumi-
nous than *c d*. And similarly,
in proportion as the point *e*
goes into *c d* will it be more
luminous than *c d;* and this
light is useful for carvers of
delicate work [5].

Ash. I. 18 a] **519.**

¶Come la pittura debe essere vista da
una sola finestra, come appare per cagione [2]de'

corpi · così fatti; **Ø** se tu voli fare in

vn altezza vna · palla tonda ti bi[3]sognierà
farla lunga · a questa similitudine, e star tāto
īdirieto · ch'ella scortādo [4]apparisca · tōda. ¶

That the light should fall upon a picture
from one window only. This may be seen
in the case of objects in this form. If you
want to represent a round ball at a certain
height you must make it oval in this shape,
and stand so far off as that by foreshorten-
ing it appears round.

Ash. I. 15 a] **520.**

DELLA · ELETIONE DELL'ARIA [2]CHE DÀ GRATIA
AI VOLTI.

[3]Se avrai una corte da potere · a · tua ·
posta · coprire cō tēda · lina · questo lume
fia [4]bono ·, overo quādo voi ritrare vno
ritralo a cattivo tēpo o sul fare della sera,
[5]faciendo stare il ritratto colla schiena ·
accosto · a vno · de' mvri d'essa · corte;
[6]poni · mēte per le strade · sul fare della

OF SELECTING THE LIGHT WHICH GIVES MOST
GRACE TO FACES.

If you should have a court yard that you
can at pleasure cover with a linen awning that
light will be good. Or when you want to take a
portrait do it in dull weather, or as evening
falls, making the sitter stand with his back to one
of the walls of the court yard. Note in the
streets, as evening falls, the faces of the

518. 2. [a. b.] . 3. essimile mēte. 5. ecquesto.
519. 1. da î sola . . apre . . chagione. 2. chosi . . settu . . alteza. 3. acquesta.
520. 3. arai î corte. 4. cativo tēpo sol. 5. cholla sciena . achosto. 6. chattivo. 7. dolcieza . . illoro . . arai î corte. 8. acomodata.

518. M. RAVAISSON in his edition of the Paris
MS. A remarks on this passage: *"La figure porte
les lettres* f *et* g, *auxquelles rien ne renvoie dans l'ex-
plication; par conséquent, cette explication est incomplète.
La figure semblerait, d'ailleurs, se rapporter à l'effet de
la réflexion par un miroir concave."* So far as I can see
the text is not imperfect, nor is the sense obscure.
It is hardly necessary to observe that *c d* here indicate

the wall of the room opposite to the window *e* and the
semicircle described by *f g* stands for the arch of the
sky; this occurs in various diagrams, for example
under 511. A similar semicircle, Pl. III, No. 2 (and com-
pare No. 149) is expressly called *'orizonte'* in writing.

5. For the same reason a window thus constructed
would be convenient for an illuminator or a miniature
painter.

sera i volti · d' omini e doñe, quãdo è cat-
tivo [7]tēpo · quãta · gratia e dolcezza si · uede
in loro; adūque · tu · pittore avrai una corte
[8]accommodata coi mvri tīti in nero cō
alquãto sporto di tetto sopra esso mvro,
[9]e sia larga di braccia 10 e lūga 20 e alta
10, e quãdo è sole conviene coprire cō tēda,
opur [10]ritrare una opera sul fare della
sera · quãdo è nvuolo o nebbia e questo è
[11]perfecta aria.

men and women, and when the weather is
dull, what softness and delicacy you may per-
ceive in them.　Hence, Oh Painter! have a
court arranged with the walls tinted black
and a narrow roof projecting within the
walls.　It should be 10 braccia wide and
20 braccia long and 10 braccia high and
covered with a linen awning; or else paint
a work towards evening or when it is cloudy
or misty, and this is a perfect light.

A. 1 *a*]　　　　　　　**521.**

On various
helps in
preparing a
picture
(521—530).

Per ritrare uno ignudo · di naturale o
altra cosa [2]vsa · tenere · ī mano uno filo
con vno piōbo, per potere · vedere li scōtri
delle cose.

To draw a nude figure from nature, or
any thing else, hold in your hand a plumb-
line to enable you to judge of the relative
position of objects.

Ash. I, 6*b*]　　　　　　　**522.**

DEL RITRARE VNA COSA.

[2]Fa che, quãdo ritrai, che tu moui alcū
prīcipio di linia che tu guardi per tutto il
corpo, [3]che tu ritrai ·, qualūque · cosa · si
scōtri · per la dirittura della · prīcipiata ·
linia.

OF DRAWING AN OBJECT.

When you draw take care to set up a
principal line which you must observe all
throughout the object you are drawing; every
thing should bear relation to the direction of
this principal line.

Ash. I. 11*b*]　　　　　　　**523.**

DEL MODO DEL RITRARRE UNO SITO CORETTO.

[2]Abbi uno uetro grãde come uno mezzo
foglio regale e quello · ferma bene dinã[3]zi
ali occhi tua, cioè tra l' ochio e la cosa che
tu vuoi ritrare ·, e dipoi ti poni lontano [4]col
ochio · al detto · vetro ²/₃ di braccio, e ferma
la testa con vno strumēto [5]ī modo nō
possi · mouere pūto la testa; dipoi serra o
ti copri uno ochio ·, e col pe[6]nello o cō
lapis a matita macinata segnia ī sul vetro
ciò che di là appa[7]re, e poi lucida cō la carta
dal uetro e spoluerizzala sopra bona carta
e dipīgi[8]la, se ti piace, vsando bene poi la
prospettiva aerea.

OF A MODE OF DRAWING A PLACE ACCURATELY.

Have a piece of glass as large as a half
sheet of royal folio paper and set thus firmly
in front of your eyes that is, between your eye
and the thing you want to draw; then place
yourself at a distance of ²/₃ of a braccia
from the glass fixing your head with a machine
in such a way that you cannot move it at all.
Then shut or entirely cover one eye and with a
brush or red chalk draw upon the glass that
which you see beyond it; then trace it on
paper from the glass, afterwards transfer it
onto good paper, and paint it if you like,
carefully attending to the arial perspective.

A ĪPARARE A FARE BENE UNO POSARE.

[10]Se tu vuoi suefare bene alle rette e
bone posature delle figure forma uno quadro
[11]over telaro ·, dētro riquadrato · cō fila · īfra

HOW TO LEARN TO PLACE YOUR FIGURES CORRECTLY.

If you want to acquire a practice of good
and correct attitudes for your figures, make
a square frame or net, and square it out

9. essia . . dibr 10 . . equãdo esso lē coprire. 10. ritrare î opera . . nebia.
521. ritrare î īnudo . . chosa. 2. mano î filo chon.
522. 1. 1. chosa. 2. cchettu . . alchū . . i chorpo. 3. chettu . . chosa . . schōtra.
523. 1.ritrarre [ī sito. 2. abi î uetro . . chome î mezo . . ecquello. 3. ella. 4. efferma. 5. sera ottutti copri î ochio e chol.

523. Leonardo is commonly credited with the
invention of the arrangement of a plate of glass
commonly known as the "vertical plane." Professor
E. VON BRÜCKE in his "*Bruchstücke aus der Theorie*

der bildenden Künste," Leipzig 1877, pg. 3, writes on
this contrivance. *Unsere Glastafel ist die sogenannte
Glastafel des Leonardo da Vinci, die in Gestalt einer
Glastafel vorgestellte Bildfläche.*"

l'ochio tuo · e lo nudo che ritrai, [12] e que'
medesimi quadri farai sulla carta dove voi
ritrare detto nvdo sotti[13]lemēte ·, dipoi poni
una pallotta di ciera in vna parte della
rete che ti serva [14] per una mira, la quale
senpre nel riguardare lo nudo scōtrerai
nella fōtanel[15]la della gola, e se fusse volto
dirieto scōtrala con uno de' nodi del collo,
[16] e queste fila t'īsegnierā in tutte le parti
del corpo che ī ciascuno atto si tro[17]vano
sotto la fontanella della gola, sotto li āgoli
delle spalle, sotto le tette, fiā[18]chi e altre
parti del corpo; e le linie traverse della
rete · ti mostrano [19] quāto è piv alto nel
posare sopra una gāba che l'altra, e così i
fiāchi e le gi[20]nochia e i piedi ·, ma ferma
senpre · la rete per linia perpēdiculare, e in
effet[21]to · tutte le parti che tu vedi che lo
nvdo piglia della rete · fa che 'l tuo nvdo
[22] disegniato pigli della rete disegniata; i
quadri disegniati possono essere [23] tāto mi-
nori che quelli della rete quāto · tu volli ·
che la tua figura sia minore [24] ch'è la · na-
turale; dipoi tieni a mēte nello figurare ·
che farai la regola dello [25] scōtro delle mē-
bra come te le mostrò la rete ·, la quale
debe essere alta [26] 3 braccia e mezzo e larga
· 3 · distāte da te braccia 7 e presso allo
nvdo uno braccio.

with thread; place this between your eye and
the nude model you are drawing, and draw
these same squares on the paper on which
you mean to draw the figure, but very deli-
cately. Then place a pellet of wax on a
spot of the net which will serve as a fixed
point, which, whenever you look at your
model, must cover the pit of the throat; or,
if his back is turned, it may cover one of
the vertebrae of the neck. Thus these
threads will guide you as to each part of
the body which, in any given attitude will
be found below the pit of the throat, or
the angles of the shoulders, or the nipples,
or hips and other parts of the body; and
the transverse lines of the 'net will show
you how much the figure is higher over
the leg on which it is posed than over
the other, and the same with the hips,
and the knees and the feet. But always fix
the net perpendicularly so that all the divi-
sions that you see the model divided into
by the net work correspond with your
drawing of the model on the net work you
have sketched. The squares you draw may
be as much smaller than those of the net
as you wish that your figure should be
smaller than nature. Afterwards remember
when drawing figures, to use the rule of the
corresponding proportions of the limbs as
you have learnt it from the frame and net.
This should be 3 braccia and a half high and
3 braccia wide; 7 braccia distant from you
and 1 braccio from the model.

6. chō . . matite . . apa. 7. esspoluerezza. 8. airea. 9. affare bene î. 10. settu . . ai retti e boni posati fo"r"ma î quadro. 11. telaro . . chō . . ello. 12. sala charta. 13. poni î balotta . . chetu serva. 14. per î miera . . scōterai nela fontane. 15. esse fussi . . scōtralo chon. 17. fontanela dela . . dele spali sottotette. 18. chorpo elle . . tīmostrano. 19. sopra î gāba . . chosi. 20. effe. 21. chettu . . chello. 22. dela . . possano. 23. minore . . chella. 24. cheella . . nelo . . cheffarai. 25. schōtro . . chome. 26. 3 br e mezo ellarga . . datte br 7 . . nvdo î br.

6. The word *lapis* is never used by Leonardo in
the sense of pencil as is shown in the following
passage from A. CONDIVI, *Vita di Michel-Agnolo Buo-
narotti*, Chap. XVIII: "*Ma egli* (Michelangelo in 1495)
*non avendo che mostrare, prese una penna (perciocchè
in quel tempo il lapis non era in uso) e con tale leggiadria gli
gli dipinse una mano, che ne restò stupefatto.*"

10. 11. 13. *quadro . telaro . . rete.* The invention
of this contrivance is to be ascribed to LEON BATTISTA
ALBERTI who describes it in the first Book '*Della
Pittura:*' "*Egli è uno velo sotilissimo tessuto raro, tinto di
quale a te piace colore, distinto con fili piu grossi in quanti
a te piace paralleli; qual velo pongo tra l'occhio et la*

*cosa veduta, tale che la piramide visiva penetri per la
rarità del velo.*" (ed. JANITSCHEK, pg. 101). On this
the editor notes (pg. 237): "*Im lateinischen Text be-
tont ausdrücktich Alberti, dass er der Erfinder des 'Velo'
sei" ("cujus ego usum nunc primum adinveni"*).

This is farther confirmed by VASARI: "*L'anno poi
1457, che fu trovato l'utilissimo modo di stampare i
libri da GIOVANNI GUITTEMBERG germano; trovò
LEON BATTISTA a quella similitudine, per via d'uno
strumento, il modo di lucidare le prospettive naturali e
diminuire le figure, ed il modo parimente da potere ri-
durre le cose capricciose, utili all'arte, e bello affatto.*"
(Ed. SANSONI, 1878, II, 540).

A. 1 *b*]

524.

MODO · DI RITRARE DI NOTTE
UNO RILIEUO.

[2]Fache metti una carta, non
troppa [3]lucida, infra rilieuo · e
lume e av[4]rai bono ritrare.

A METHOD OF DRAWING AN
OBJECT IN RELIEF AT NIGHT.

Place a sheet of not too
transparent paper between the
relievo and the light and you
can draw thus very well.

A. 42 *b*]

525.

Se voli fare · una figura · ī sù uno mvro ·,
il qual muro sia in iscorto [2]e la · figura che
ui dipignierai · paia in propia · forma e spic-
cata [3]da · esso · mvro ·, farai in questo · modo:
fa da avere · una · sottile piastra [4]di ferro ·
e fali uno piccolo spiraculo nel mezzo ·
il quale sia [5]rotōdo ·, e accostavi · uno ·
lume · ī modo · che lo tocchi col suo · mezzo,

If you want to represent a figure on a
wall, the wall being foreshortened, while the
figure is to appear in its proper form,
and as standing free from the wall, you
must proceed thus: have a thin plate of iron
and make a small hole in the centre; this
hole must be round. Set a light close to
it in such a position as that it shines through

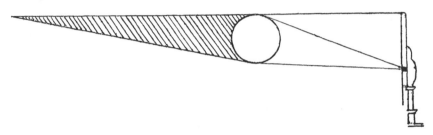

dipoi [6]poni quello corpo o figura ·, che piv
ti piace ·, apresso a detto mvro [7]ī modo ·
lo tocchi ·, e segnia · la sua · ōbra ī detto mvro
e pōi la ōbra e da [8]lei sua · lumi ·, e fa ·
che quello che vorà vedere detta · figura ·
stia [9]a quello medesimo spiracolo ·, doue
stette in prima · il lume, [10]e nō ti potrai
mai persuadere che detta figura · nō sia
spiccata dal mvro.

the central hole, then place any object or
figure you please so close to the wall that
it touches it and draw the outline of the
shadow on the wall; then fill in the shade
and add the lights; place the person who is
to see it so that he looks through that same
hole where at first the light was; and you
will never be able to persuade yourself that
the image is not detached from the wall.

524. 1. notte ī rilieuo. 2. fa che metta . . charta nonō tropa. 3. lume ea.
525. 1. fare ī figura īsununo mvro . [m] il. 2. ella . . esspichata. 3. vedere ī . sottile. 4. difere effale ī picholo spirachulo nel
mezo. 5. retōdo . e achosta vi . ī lume . . chello tochi chol suo mezo. 6. quelo chorpo offigura. 7. tochi essegnia. 8. effa
che quello. 9. [al]a quelo . . spiracholo . disspichata.

524. Bodies thus illuminated will show on the
surface of the paper how the copyist has to distri-
bute light and shade.

　525. *uno piccolo spiracolo nel mezzo.* M. RAVAISSON,
in his edition of MS. A (Paris), p. 52, reads *nel
muro*—evidently a mistake for *nel mezzo* which is
quite plainly written; and he translates it *"fait lui
une petite ouverture dans le mur,"* adding in a note:

*"les mots 'dans le mur' paraissent être de trop. Leonardo
a dû les écrire par distraction."* But '*nel mezzo*' is
clearly legible even on the photograph facsimile
given by Ravaisson himself, and the objection he
raises disappears at once. It is not always wise
or safe to try to prove our author's absence of
mind or inadvertence by apparent difficultie s in
the sense or connection of the text.

A. 38 b] **526.**

A FARE · UNA · FIGURA · IN v̄ MURO · DI 12 BRACCIA ²CHE APPARISCA D'ALTEZZA DI 24 BRACCIA.

³Se voli fare · una · figura · o altra cosa · che apparisca d'altezza di 24 braccia ⁴farai · in questa · forma: figura · prima · la pariete · m · r · colla ⁵metà del'omo · che voi · fare: dipoi l'altra metà: farai nella volta · m · n · ⁶la figura che voi · fare detta di sopra;—fa prima la pariete in sul piā d'una sala ⁷della forma · che à · il mvro · colla · volta dov'ài a fare la tua ⁸figura ·, dipoi · farai dirieto a essa · pariete · la figura · disegniata ī pro⁹ffilo · di che grādezza ti piace, e tira tutte le sue linie al pūto f ¹⁰e nel modo · ch'elle · si tagliano · sulla pariete · m · n · così le figura ¹¹sul mvro che à similitudine colla pariete ·, e avrai tutte l'altezze e spor¹²ti della · figura, e le larghezze over grossezze che si trovano nel mvro ¹³diritto · m · r ·, faraile in propia · forma, imperochè, nel fugire del mvro, ¹⁴la figura · diminvisce per se medesima; la figura · che va nella volta¹⁵ti bisognia · diminvirla, come se ella fussi diritta, la quale dimi-¹⁶nvitione · ti bisognia fare ī sù una sala bē piana · e lì sarà ¹⁷la figura che leverai dalla pariete · r · n con le sue vere grossezze ¹⁸e bisogna ridiminuirla in sù una pariete di rilievo e fia bō modo.

TO DRAW A FIGURE ON A WALL 12 BRACCIA HIGH WHICH SHALL LOOK 24 BRACCIA HIGH.

If you wish to draw a figure or any other object to look 24 braccia high you must do it in this way. First, on the surface m r draw half the man you wish to represent; then the other half; then put on the vault m n [the rest of] the figure spoken of above; first set out the vertical plane on the floor of a room of the same shape as the wall with the coved part on which you are to paint your figure. Then, behind it, draw a figure set out in profile of whatever size you please, and draw lines from it to the point f and, as these lines cut m n on the vertical plane, so will the figure come on the wall, of which the vertical plane gives a likeness, and you will have all the [relative] heights and prominences of the figure. And the breadth or thickness which are on the upright wall m n are to be drawn in their proper form, since, as the wall recedes the figure will be foreshortened by itself; but [that part of] the figure which goes into the cove you must foreshorten, as if it were standing upright; this diminution you must set out on a flat floor and there must stand the figure which is to be transferred from the vertical plane r n [17] in its real size and reduce it once more on a vertical plane; and this will be a good method [18].

526. 1. affare . i̊ figura . . 12 br. 2. aparissca dalteza. 3. fare . i̊ . figura . . chosa che aparischa . . 24 br. 4. forma . [di] . figura . . chola. 5. nela. 6. pariete "insul . . . sala". 7. chessta . . cholo. 8. laffigura. 9. grādeza . . ettira . . pupūto . f. 10. sula. 11. assimilitudine cholla . . arai . . alteze esspor. 12. largeze . grosseze chessi. 13. farai. 14. le figura diminvite. 15. chomesse. 16. insuruna. 17. dala . . chon le sue | "vere" grosseze. 18. e ridiminuirle insuruna . . effia.

526. See Pl. XXXI. 3. The second sketch, which in the plate is incomplete, is here reproduced and completed from the original to illustrate the text. In the original the larger diagram is placed between lines 5 and 6.

1. 2. C. A. 157ᵃ; 463ᵃ has the similar heading: '*del cresciere della figura*', and the text begins: "*Se voli fare* 1 ᵃ *figura grande* b c" but here it breaks off. The translation here given renders the meaning of the passage as I think it must be understood. The MS. is perfectly legible and the construction of the sentence is simple and clear; difficulties can only arise from the very fullness of the meaning, particularly towards the end of the passage.

17. *che leverai dalla pariete* r n. The letters refer to the larger sketch, No. 3 on Pl. XXXI.

18. Leonardo here says nothing as to how the image foreshortened by perspective and thus produced on the vertical plane is to be transferred to the wall; but from what is said in Nos. 525 and 523 we may conclude that he was familiar with the process of casting the enlarged shadow of a squaring net on the surface of a wall to guide him in drawing the figure.

Pariete di rilievo; "*sur une paroi en relief*" (RAVAISSON). "*Auf einer Schnittlinie zum Aufrichten*" (LUDWIG). The explanation of this puzzling expression must be sought in No. 545, lines 15—17.

A. 42 a] 527.

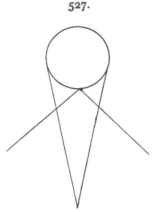

²Se uolessi · fare · vna figura di cuba dimostratione īn v̄ ²cā-tone di mvro ·, fa prima · la cosa ī propia · forma e levala īsulla pariete, ³ch'essa somigli al can-tone dove à essere figurato detto corpo.

If you would to draw a cube in an angle of a wall, first draw the object in its own proper shape and raise it onto a verti-cal plane until it resembles the angle in which the said object is to be represented.

Ash. I. 4 a] 528.

Perchè la pictura pare meglio ²nello spe-chio · che fori?

Why are paintings seen more correctly in a mirror than out of it?

Ash. I. 11 a] 529.

COME LO SPECHIO È 'L MAESTRO DE' PITTORI.

HOW THE MIRROR IS THE MASTER [AND GUIDE] OF PAINTERS.

²Quādo voi vedere ·, se la · tua · pittura · tutta īsieme à conformità colla cosa ³ritratta di naturale, abbi vno spechio · e faⱴi dētro specchiare la cosa viua, e pa⁴ragona la cosa · spechiata · colla tua pittura ·, e cōsidera bene se 'l subietto ⁵dell'una · e l'altra simili-tudine · à · cōformità īsieme · e sopra tutto lo spechio; ⁶lo spechio si de' pigliare · per suo · maestro, cioè · lo spechio · piano, īpero · ch'ī sulla sua ⁷superficie · le cose ànno similitudine colla pittura ī molte parti; cioè tu vedi la ⁸pittura fatta sopra a uno piano dimostrare cose che paiono rilevate, e lo spechio ⁹sopra uno piano fa quel medesimo; · La pittura è vna sola superfitic e lo specchio ¹⁰quel medesimo ·; La pittura è īpalpabile ī quāto che quello che pare tōdo ¹¹e spiccato nō si può circūdare colle mani,

When you want to see if your picture corresponds throughout with the objects you have drawn from nature, take a mirror and look in that at the reflection of the real things, and compare the reflected image with your picture, and consider whether the subject of the two images duly corresponds in both, particularly studying the mirror. You should take the mirror for your guide—that is to say a flat mirror—because on its surface the objects appear in many respects as in a painting. Thus you see, in a painting done on a flat surface, objects which appear in relief, and in the mirror—also a flat surface— they look the same. The picture has one plane surface and the same with the mirror. The picture is intangible, in so far as that which appears round and prominent

527. 1. fugura [chuba] di chuba. 2. chātone . chosa . . īsu pariete.
528. 1. megli. 2. ch ᵉfori.
529. 2. sella . . conformita cholla cossa. 3. abi . . effaui . . speciare. 4. chola. 5. ellaltra . . chōformita . . essopra. 6. maesstro . . ī perrochīsula. 7. anno . . chola . . imolte. 8. a ī̃ piano . . chose che paiano. 9. sopra ī̃ piano paiano fa. 11. esspi-

I understand the concluding lines of this passage as follows: If you draw the upper half a figure on a large sheet of paper laid out on the floor of a room (*sala bē piana*) to the same scale (*con le sue vere grosseze*) as the lower half, already drawn upon the wall (lines 10, 11) you must then reduce them on a '*pariete di rilievo*,' a curved vertical plane which serves as a model to reproduce the form of the vault.

e lo spechio fa il simile; ^{12}E se tu conosci che lo spechio per mezzo de liniamēti e ōbre e lumi ti fa parere ^{13}le cose dispiccate e avēdo tu fra i tua colori l'ombre e lumi piv potēti ^{14}che quelli dello spechio · cierto, se li saprai bē comporre īsieme, la tua pitura ^{15}parrà ācora lei una cosa naturale vista ī vno grāde spechio.

cannot be grasped in the hands; and it is the same with the mirror. And since you can see that the mirror, by means of outlines, shadows and lights, makes objects appear in relief, you, who have in your colours far stronger lights and shades than those in the mirror, can certainly, if you compose your picture well, make that also look like a natural scene reflected in a large mirror.

Ash. 1. 7b] 530.

DEL GIVDICARE LA TUA PITTURA.

^{2}Noi sappiamo chiaro · che li errori · si conoscono · piv · in altrui opere che nelle sue, ^{3}e spesso riprēdendo · li altrui · piccoli · errori · ignorerai i tua grādi, et per ^{4}fugire · simile · ignorāza · fa che · prima · sii · bono · prospectiuo ·, dipoi abbi in^{5}tera · notitia · delle misure dell' omo · e d'altri animali: e ācora bono archi^{6}tetto · cioè · ī quāto · s'apartiene alla forma · delli edifiti · e dell'altre co^{7}se che sono sopra · la terra, che sono īfinite · forme; di quāte ^{8}piv avrai notitia piv · fia laudabile · la tua · operatione ·, e in quella che tv non ài pratica ^{9}nō recusare · il ritrarle · di naturale:—ma per tornare · alla promessa di sopra ^{10}dico ·, che nel tuo dipīgiere · che tu debi tenere uno spechio · piano e spesso ri^{11}guardarai dētro l'opera tua ·, la quale ui fia · veduta · per lo contrario e par^{12}ratti di mano · d'altro · maestro e lì givdicherai meglio l'errori che altri^{13}mēti; È ancora · bono spesso leuarsi · e pigliar un poco d'altro sollaz^{14}zo ·, perchè · nel ritornare alle cose tu ài migliore ivditio, chè lo stare ^{15}saldo · sul' opera · ti fa · forte · īgannare; ancora · è bono lo alontanarsi, ^{16}perchè l'opera · pare minore e piv si cōprende in vna occhiata e ^{17}meglio · si conoscie · le discordāti e sproportionate mēbra ^{18}e colori delle cose.

OF JUDGING YOUR OWN PICTURES.

We know very well that errors are better recognised in the works of others than in our own; and that often, while reproving little faults in others, you may ignore great ones in yourself. To avoid such ignorance, in the first place make yourself a master of perspective, then acquire perfect knowledge of the proportions of men and other animals, and also, study good architecture, that is so far as concerns the forms of buildings and other objects which are on the face of the earth; these forms are infinite, and the better you know them the more admirable will your work be. And in cases where you lack experience do not shrink from drawing them from nature. But, to carry out my promise above [in the title]— I say that when you paint you should have a flat mirror and often look at your work as reflected in it, when you will see it reversed, and it will appear to you like some other painter's work, so you will be better able to judge of its faults than in any other way. Again, it is well that you should often leave off work and take a little relaxation, because, when you come back to it you are a better judge; for sitting too close at work may greatly deceive you. Again, it is good to retire to a distance because the work looks smaller and your eye takes in more of it at a glance and sees more easily the discords or disproportion in the limbs and colours of the objects.

chato . . po circhūdare cholle . . ello. 12. Esse tu . . mezo . . ellumi. 13. chose dispichate . . cholori. 14. delo . . chompore. 15. para . . lei ī cosa.

530. 1. givdichare. 2. sapiamo . . chelli . . chonioscano. 3. piccioli. 4. sia. 5. āchora. 6. ala . . cho . | . chessono . . terachessono. 8. arai . . laldabile . . chettv . . praticha. 9. rechusare . . allo. 10. dicho chettu . . tenere ī spechio . . esspesso. 11. guardarai . . chontrario e parr. 12. elli . . lerori. 13. anchora se bono . . speso . . pocho . . sola. 14. ale chose tuuai . . chello. 15. anchora īganare. 16. chōplende. 17. chonoscie le dischordāti. 18. cholori.

531.

DEL MODO DEL BENE ĪPARARE A MĒTE.

On the management of works (531. 532).

²Quãdo tu vorrai · sapere vna · cosa studiata bene a mēte · tieni questo modo, cioè ³ quãdo · tu ài disegnato vna · cosa medesima tãte volte, che te la · paia avere a mēte, ⁴pruova · a farla · sãza · lo esēpio · e abbi lucidato sopra vno uetro sottile e pia⁵no · lo esēplo · tuo e porrai lo · sopra la cosa ·, che ài fatta sãza ⁶lo esēplo, e nota bene dove il lucido non si scõtra col · disegnio tuo e dove truo⁷vi auere errato · lì tieni a mēte di non errare piv, ãzi ritorna allo esēplo a ritra⁸re tãte volte quella · parte errata che tu l'abbi bene nella imaginatiua, e se ⁹per lucidare una cosa tu nõ potessi avere vetro piano, tolli una carta sottilissima ¹⁰di capretto e bene vnta e poi secca, E quãdo l'avrai adoperata a uno disegnio, ¹⁰potrai colla spugnia · cancellarla e fare il secondo.

OF A METHOD OF LEARNING WELL BY HEART.

When you want to know a thing you have studied in your memory proceed in this way: When you have drawn the same thing so many times that you think you know it by heart, test it by drawing it without the model; but have the model traced on flat thin glass and lay this on the drawing you have made without the model, and note carefully where the tracing does not coincide with your drawing, and where you find you have gone wrong; and bear in mind not to repeat the same mistakes. Then return to the model, and draw the part in which you were wrong again and again till you have it well in your mind. If you have no flat glass for tracing on, take some very thin kidts-kin parchment, well oiled and dried. And when you have used it for one drawing you can wash it clean with a sponge and make a second.

532.

COME IL PITTORE DEBBE ESSER VAGO D'UDIRE ²NEL FARE DELL'OPERA SUA GIVDITIO D'OGNI OMO.

³Ciertamē non è · de recusare ·, in mētre che l'omo dipignie, il givditio di ciascuno, ⁴īperochè noi conosciamo · che l'omo bēchè nõ sia · pittore ·, avrà notitia della forma ⁵dell' altr' omo e bē givdicherà s'egli è gobbo o à una spalla alta o bassa o s'elli à grã bocca ⁶o naso ed altri mãcamēti; e se noi conosciamo li omini potere con uerità givdica⁷re l'opere della natura ·, quãto magiormēte ci conuerrà confessare questi potere ⁸givdicare · li nostri errori, chè sai quãto l'omo s'ingãna nell' opere sua; E se non lo ⁹conosci · in te, consideralo in altrui e farai profitto delli altrui ¹⁰errori ·, sicchè sia vago cõ patiētia · vdire le altrui · openioni e cõ¹¹sidera bene e pēsa bene · se 'l biasimatore à cagione o no di biasimarti: E se troui di si, ¹²raccõcia · e se troui di no · fa la vista no l'avere īteso, o tu li mostra · per ragione — s'elli è ¹³omo che tu stimi — la ragione come lui s'inganna.

THAT A PAINTER OUGHT TO BE CURIOUS TO HEAR THE OPINIONS OF EVERY ONE ON HIS WORK.

Certainly while a man is painting he ought not to shrink from hearing every opinion. For we know very well that a man, though he may not be a painter, is familiar with the forms of other men and very capable of judging whether they are hump backed, or have one shoulder higher or lower than the other, or too big a mouth or nose, and other defects; and, as we know that men are competent to judge of the works of nature, how much more ought we to admit that they can judge of our errors; since you know how much a man may be deceived in his own work. And if you are not conscious of this in yourself study it in others and profit by their faults. Therefore be curious to hear with patience the opinions of others, consider and weigh well whether those who find fault have ground or not for blame, and, if so amend; but, if not make as though you had not heard, or if he should be a man you esteem show him by argument the cause of his mistake.

531. 2. chosa. 3. disegniato î chosa. 4. affarla . . abi . . sopra î uetro. 5. poralo. 6. chol. 7. erato . . erare. 8. erata chettu labi . . esse. 9. lucidare î cosa . . tolli î carta. 10. secha . . larai a î disegnio. 10. chãnellarla effare il sechondo.
532. 1. duldire. 3. ederechusare . . chellomo . . givdito di ciaschuno. 4. chonosciano . . chellomo . . avera. 5. a î spalla . . osselli . . bocha. 6. machamēti . . ali . . chen . . givdicha. 7. chonuera chonfessare. 8. chessai . . Esse nollo. 9. chonsideralo . . effarai. 10. chõ . . vldire li . . chõ. 11. biassimatore a chagione Esse. 12. rachõcia . . esse . . ottu. 13. chettu . . chome.

Ash. I. 21 a]　　　　　　**533.**

COME · NELLE · COSE · PICCOLE NŌ S'INTĒDE ·
LI ERRORI · COME NELLE GRĀDI.

²Nelle · cose · di minvta · forma · nō si ·
può conprendere · la qualità del suo errore,
³come · delle · grandi; e la · ragione si è che,
se questa · cosa · piccola · fia fatta a simili-
tudine ⁴d'un omo · o d'altro · animale ·, le
sue parti · per la immensa · diminvtione · nō
possono essere · ricercate ⁵con quello debito ·
fine · dal suo · operatore · che si conuerebbe ·,
ōde nō rimane finita, ⁶non essendo · finita
nō puoi conprēdere i suoi · errori · E-
senpio: Riguarderai da lontano ⁷vno omo ·
per ispatio · di 300 · braccia, e con diligiēza
givdicherai se quello è bello ⁸o brutto ·,
o s'eli è mostruoso · o di comvne qualità:
vedrai · che con sōmo · tuo · sforzo · nō ti
⁹potrai · persuadere a dare givditio, e la
ragione · si è che per la sopra · detta · distātia
questo · uomo ¹⁰diminviscie · tāto ·, che nō si
può comprēdere le qualità delle particule,
¶ e se voli ben vede¹¹re · detta · diminvitione ·
dell'omo sopradetto · pōnti · vno · dito · presso.
all' ochio · vno palmo ¹²e tanto · alza · e ab-
bassa detto · dito · che la · sua · superiore ·
stremità termini sotto i piedi della figura ·
¹³che tu · riguardi: e vedrai · apparire vna
incredibile diminuitione ·, e per questo spesse
¹⁴volte si dubita la formadell'amico da lontano.

HOW IN SMALL OBJECTS ERRORS ARE LESS EVI-
DENT THAN IN LARGE ONES.

In objects of minute size the extent of
error is not so perceptible as in large ones;
and the reason is that if this small object
is a representation of a man or of some
other animal, from the immense diminution
the details cannot be worked out by the ar-
tist with the finish that is requisite. Hence
it is not actually complete; and, not being
complete, its faults cannot be determined.
For instance: Look at a man at a distance
of 300 braccia and judge attentively whether
he be handsome or ugly, or very remarkable
or of ordinary appearance. You will find
that with the utmost effort you cannot per-
suade yourself to decide. And the reason is
that at such a distance the man is so much
diminished that the character of the details
cannot be determined. And if you wish to
see how much this man is diminished [by
distance] hold one of your fingers at a span's
distance from your eye, and raise or lower
it till the top joint touches the feet of the
figure you are looking at, and you will see
an incredible reduction. For this reason we
often doubt as to the person of a friend at
a distance.

On the
limitations
of painting
(533—535.)

Ash. I. 25 b]　　　　　　**534.**

PERCHÈ LA PITTURA NŌ PUÒ MAI PARERE
²SPICCATA · COME LE COSE NATURALI.

³Li pittori spesse volte · cadono · in
disperatione del loro · imitare il naturale,
⁴vedēdo · le loro · pitture · non avere quel
rilieuo · e quella · vivacità che ànno le ⁵cose
· vedute · nello spechio, allegādo loro avere
colori che per chiarezza ⁶o per iscurità
avanzano di gran lūga la qualità de'lumi ·
e ōbre · della cosa · vista ⁷nello spechio ·,
accusādo in questo caso · la loro · igniorāza
e nō la ragione ·, perchè ⁸nō la conoscono;
Impossibile è che la cosa . pīta apparisca di
tale · rilievo ⁹che s'assomigli · alle cose dello
spechio · bēchè l'una e l'altra sia in sù

WHY A PAINTING CAN NEVER APPEAR
DETACHED AS NATURAL OBJECTS DO.

Painters often fall into despair of imitating
nature when they see their pictures fail in
that relief and vividness which objects have
that are seen in a mirror; while they allege
that they have colours which for brightness
or depth far exceed the strength of light and
shade in the reflections in the mirror, thus
displaying their own ignorance rather than
the real cause, because they do not know it.
It is impossible that painted objects should
appear in such relief as to resemble those
reflected in the mirror, although both are
seen on a flat surface, unless they are seen

533. 1. chome . . chose pichole . . erori chome. 2. chose . . chonplendere la qualita [dello errore] del. 3. chome . . ella . .
chesse cquesta chosa pichola . . assimilitudine. 4. domo . o . . imensa . . posono . . ricierche. 5. chon . . chonuerebbe.
6. poi chonprēdere. 7. 300. br. e chon dilegiēza [riguarderai] givdicherai secquello ebbello. 8. esseli e mosstruoso . . cho-
mvne . . vedèrai . . chon somo tuo sforto. 9. ella . . decta. 10. diminvissce chomprēdere . . partichule. 11. vno [span]
palmo. 12. ettanto . . chella . . dela. 13. chettu . . vederai . . vno. 14. amicho dallontano.
534. 1. po. 2. sichata . chome le chose. 3. chagiano . . inaturale. 4. ecquella . . anno. 5. chose . . cholori . . chiareza.
6. chosa. 7. acusando chaso. 8. chonoschano. 8. Inpossibile . chella chosa . . apparischa. 9. sasomigli . . chose . . benchelluna

vna · superfitie, [10]saluo se fia vista · cō ū solo ·
ochio · e la ragiō si è, ʃ 2 ‖ ochi che vedono
l'una cosa [11]dopo l'altra come · *a · b*
· che vede *n · m · · m* · nō può occu-
pare · interamēte · *n* · perchè la [12]basa
delle linie visuali è si larga · che vede
· il corpo secondo dopo · il primo ·,
Ma se chiv[13]di vn ochio come · *s* · il
corpo *f* occuperà *r* perchè la linia
visuale nascie in un solo [14]pūto · e
fa basa nel primo corpo, dōde il
secondo di pari grādezza mai fia
visto.

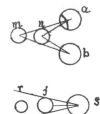

with only one eye; and the reason is that
two eyes see one object behind another as *a*
and *b* see *m* and *n*. *m* cannot
exactly occupy [the space of] *n*
because the base of the visual lines
is so broad that the second body
is seen beyond the first. But if you
close one eye, as at *s* the body *f*
will conceal *r*, because the line of
sight proceeds from a single point
and makes its base in the first body,
whence the second, of the same size,
can never be seen.

Ash. I. 16*b*] **535.**

PERCHÈ DI 2 COSE DI PARI GRĀDEZZA [2]PARRÀ
MAGGIORE LA DIPĪTA CHE QUELLA DI RILIEUO.

WHY OF TWO OBJECTS OF EQUAL SIZE A PAINTED
ONE WILL LOOK LARGER THAN A SOLID ONE.

[3]Questa · ragione · nō fia di facile dimo-
stratione · come molte altre, ma pure [4]m'i-
giegnierò di sadisfare, se nō in tutto, in
qualche parte; la prospettiva dimi[5]nvita ·
ci dimostra per ragione ·, che le cose quāto ·
piv alōtanono dal' ochio [6]piv diminvi-
scono ·, e queste ragioni bē sono cōferme
dalla · esperiēza; [7]adūque · le linie visuali che
si trouano īfra l'obietto · e l'occhio ·, quādo
s'astēdono [8]alla superfitie della · pittura ·,
tutte si tagliano · a uno medesimo termine;
E le [9]linie che si truouano īfra l'ochio · e
la scoltura · sono di uari termini e lū-
[10]ghezze: quella linia ch'è piv · lūga · s'a-
stēde sopra uno mēbro piv · lōtano che li
[11]altri e però quel mēbro pare minore ·, essē-
doui molte linie più lūghe che [12]l'altre, e per
cagione che le molte particule piv lōtane
l'una che l'altra essē[13]do piv lontane, cō-
uiene che apparischino minori, apparēdo
minori, vēgo[14]no a fare per loro dimi-
nvire minore tutta la sōma dello obi-
etto; E que[15]sto nō accadēdo nella
pittura per le linie terminate a vna mede-
sima [16]distātia cōuiene che sieno sāza

The reason of this is not so easy to de-
monstrate as many others. Still I will en-
deavour to accomplish it, if not wholly, at
any rate in part. The perspective of dimi-
nution demonstrates by reason, that objects
diminish in proportion as they are farther
from the eye, and this reasoning is confirmed
by experience. Hence, the lines of sight
that extend between the object and the eye,
when they are directed to the surface of a
painting are all intersected at uniform limits,
while those lines which are directed towards
a piece of sculpture are intersected at va-
rious limits and are of various lengths. The
lines which are longest extend to a more
remote limb than the others and therefore
that limb looks smaller. As there are num-
erous lines each longer than the others—
since there are numerous parts, each more
remote than the others and these, being farther
off, necessarily appear smaller, and by ap-
pearing smaller it follows that their dimi-
nution makes the whole mass of the object
look smaller. But this does not occur in
painting; since the lines of sight all end at

ellaltra sia insunvna. 10. seffia . . chō . vegano luna chosa. 11. chome . . po . ochupare. 12. essi . . chorpo sechondo.
13. ochupera . . nascienvnsono. 14. effa . . neprimo chorpo . . sechonda . . grādeza.
535. perche [i̍ due]. 2. grādeza. 2. para . . quela. 5. chelle. 6. diminvischono . ecqueste ragione . . cōferme dalla dalla.
7. lini . . chessi . . sastēdano. 8. ala . . a i medesimo . . Elle. 9. chessi . . ella. 10. geze . quela . . ssasstēde sopra i̍
mēbro. 11. quēmēbro . . lūge. 12. chagione che ne. 13. apariscino . vēga. 14. affare . . soma . . Ecque. 15. achadēdo

534. This passage contains the solution of
the problem proposed in No. 29, lines 10—14.
Leonardo was evidently familiar with the law of
optics on which the construction of the stereoscope
depends. Compare E. VON BRÜCKE, *Bruchstücke aus
der Theorie der bildenden Künste*, pg. 69: "*Schon
Leonardo da Vinci wusste, dass ein noch so gut gemaltes

*Bild nie den vollen Eindruck der Körperlichkeit geben
kann, wie ihn die Natur selbst giebt. Er erklärt dies
auch in Kap. LIII und Kap. CCCXLI* (ed. DU FRESNE)
*des 'Trattato' in sachgemässer Weise aus dem Sehen mit
beiden Augen.*"

Chap. 53 of DU FRESNE's edition corresponds to
No. 534 of this work.

diminvitione; adūque le particule [17]nō diminvite · nō diminviscono · la sōma dello obbietto, e per questo nō [18]diminuiscie la pittura come la scoltura.

the same distance there can be no diminution, hence the parts not being diminished the whole object is undiminished, and for this reason painting does not diminish, as a piece of sculpture does.

Ash. I. 4b]

536.

COME SI DEBBE PORRE ALTO IL PŪTO.

[2]Il pūto · debbe essere · alto · all' altezza · dell' occhio d'uno homo · comvnale, [3]e l'ultimo della pianura che cōfina · col cielo · debbe · essere · fatto all' [4]altezza d'esso termine della terra col cielo ·, saluo che le [5]mōtagnie · che sono libere.

HOW HIGH THE POINT OF SIGHT SHOULD BE PLACED.

The point of sight must be at the level of the eye of an ordinary man, and the farthest limit of the plain where it touches the sky must be placed at the level of that line where the earth and sky meet; excepting mountains, which are independent of it.

On the choice of a position (536. 537).

Ash. I. 25b]

537.

DEL MODO DI RITRARE FIGURE PER ISTORIE.

[2]Senpre il pittore debbe · cōsiderare in nella · pariete · la quale à a istoriare [3]l'altezza del sito · doue vuole · collocare · le sue · figure ·, e ciò che lui ri[4]trae di naturale a detto proposito, e stare tāto coll'occhio · piv basso che la cosa · che lui [5]ritrae ·, quāto detta cosa · sia messa · in opera piv alta · che l'ochio del riguar[6]dante ·, 'altremēte · l'opera · fia · reprovabile.

OF THE WAY TO DRAW FIGURES FOR HISTORICAL PICTURES.

The painter must always study on the wall on which he is to picture a story the height of the position where he wishes to arrange his figures; and when drawing his studies for them from nature he must place himself with his eye as much below the object he is drawing as, in the picture, it will have to be above the eye of the spectator. Otherwise the work will look wrong.

Ash. I. 12b]

538.

DEL PORRE UNA FIGURA PRIMA NELLA STORIA.

[2]La prima figura in nela storia · farai tāto minore che 'l naturale, quante braccia [3]tu la figuri lontana dalla · prima linia, e poi poni l'altre a cōparatione di quella colla regola di sopra.

OF PLACING A FIGURE IN THE FOREGROUND OF A HISTORICAL PICTURE.

You must make the foremost figure in the picture less than the size of nature in proportion to the number of braccia at which you place it from the front line, and make the others in proportion by the above rule.

The apparent size of figures in a picture (538. 539).

nela. 17. diminviscano la soma . . obbieto.
536. 2. alteza. 3. ellultimo . . chol. 4. tera chol . . chelle. 5. chessono.
537. 2. chōsiderare inella. 3. laltezza . . chollochare . . eccio chellui. 4. istare . . chollocchio . . chella chosa . . chellui. 5. chosa . . chellochio.
538. 1. pore ĩ figura. 2. inella . . quante br. 3. dala . . dique. 4. cola.

Tr. 71. 539.

PROSPETTIVA.

²Domādasi · a te pittore · perchè · le figure · da te fatte · ³ in minvta forma · per dimostratione di prospettiva · nō paiano in ⁴ pari · dimostratione · di distātia · grādi · quāto · le naturali leuate di pari ⁵ grādezza . alle dipīte · sopra · la pariete.

⁶ E perchè · le cose apparēti in piccola lontanità · in pari distātia ⁷ apparano maggiori che 'l naturale.

PERSPECTIVE.

You are asked, O Painter, why the figures you draw on a small scale according to the laws of perspective do not appear—notwithstanding the demonstration of distance—as large as real ones—their height being the same as in those painted on the wall.

And why [painted] objects seen at a small distance appear larger than the real ones?

Ash. I. 4 a] 540.

DEL RITRARRE.

The right position of the artist, when painting, and of the spectator (540—547).

² Quādo ài · a ritrarre di ³ naturale · sta · lōtano 3 ⁴ volte · la grādezza della ⁵ cosa che tu ritrai.

OF PAINTING.

When you draw from nature stand at a distance of 3 times the height of the object you wish to draw.

Ash. I. 25 b] 541.

DEL RITRARRE DI RILIEVO.

² Quello che ritrae · di rilieuo si debbe accōciare · in modo · tale · che l' ochio · della figura ³ ritratta · sia · al pari dell' ochio di quello · che ritrae, e questo · si farà a vna testa, ⁴ la quale · avessi · a ritrarre · di naturale ·, perchè vniversalmēte · le figure ovvero ⁵ persone · che scōtri · per le · strade · tutti · ànno i loro occhi all' altezza · de' tua, ⁶ e se li facessi · piv alti o piv · bassi · vedresti a · dissimigliare il tuo ritratto.

OF DRAWING FROM RELIEF.

In drawing from the round the draughtsman should so place himself that the eye of the figure he is drawing is on a level with his own. This should be done with any head he may have to represent from nature because, without exception, the figures or persons you meet in the streets have their eyes on the same level as your own; and if you place them higher or lower you will see that your drawing will not be true.

Ash. I. 19 b] 542.

PERCHÈ I CAPITOLI DELLE FIGURE ² L'UNO SOPRA L'ALTRO È OPERA · DA FUGGIRE.

³ Questo universale vso, il quale si fa per pittori in nelle faccie delle ⁴ cappelle è molto da essere ragionevo!mēte biasimato, īperocchè ⁵ fāno l' una storia ī v̄ piano col suo paese · e edifiti, poi s' alzano uno altro ⁶ grado e fanno una storia e variano il pūto dal primo, e poi la terza ⁷ e la quarta · in modo, ch' una facciata si uede fatta cō 4

WHY GROUPS OF FIGURES ONE ABOVE ANOTHER ARE TO BE AVOIDED.

The universal practice which painters adopt on the walls of chapels is greatly and reasonably to be condemned. Inasmuch as they represent one historical subject on one level with a landscape and buildings, and then go up a step and paint another, varying the point [of sight], and then a third and a fourth, in such a way as that on one wall there are 4 points of sight, which is supreme folly in such painters. We know that the

539. 2. atte . . datte fatte [nō parano in]. 3. [spa] iminvta. 4. pare. 5. gnādeza. 6. chose . . piciola. 7 magiore.
540. 1. ritrare. 2. ai . aritrare. 4. grādeza dela. 5. chosa chettu.
541. 2. achōciare . imodo . . chellochio. 3. ecquesto. 5. chesschōtri . ano . . alteza. 6. esse . . veresti a disimigliare.
542. 1 [come si d] perche i chapitoli. 3. pe . . inele. 4. chappelle. 5. chol . . po salzano î altro. 6. fanno î storia. 7. ella

punti, [8]la quale è so·ña stoltitia di simili maestri; noi sappiamo che 'l [9]punto è posto · al' ochio del riguardatore della storia, e se tu [10]volessi dire · in che modo ò a fare la uita d'uno santo cōpartita [11]in molte storie in vna medesima facia, a questa parte ti rispō-[12]do · che tu debi porre il primo piano · col pūto all' altez[13]za dell' ochio de riguardatori d'essa storia, e īsù detto piano [14]figura la prima storia · grāde [15]e poi, diminvēdo di mano ī ma[16]no le figure e casamēti īsù diuersi colli e pianvre, farai [17]tutto il fornimēto d'essa storia, e 'l resto della faccia ī nella sua [18]altezza farai albori grādi a cōparatione delle figure o āgie[19]li, se fossino al proposito della storia, ovvero vccelli o nvuoli o simi[20]li cose, altrimēti nō te ne īpacciare, ch' ogni tua opera fia falsa.

point of sight is opposite the eye of the spectator of the scene; and if you would [have me] tell you how to represent the life of a saint divided into several pictures on one and the same wall, I answer that you must set out the foreground with its point of sight on a level with the eye of the spectator of the scene, and upon this plane represent the more important part of the story large and then, diminishing by degrees the figures, and the buildings on various hills and open spaces, you can represent all the events of the history. And on the remainder of the wall up to the top put trees, large as compared with the figures, or angels if they are appropriate to the story, or birds or clouds or similar objects; otherwise do not trouble yourself with it for your whole work will be wrong.

A. 40*b*] 543.

QUELLA COSA FATTA IN PROSPETTIVA AVRÀ [2]MIGLIORE EUIDĒTIA · LA QUALE FIA VEDUTA [3]DA LOCO DOV'È FATTA · LA SUA VEDUTA.

[4]Se vorrai · figurare · una · cosa · da presso · che faccia · l' effetto · che fanno le cose · naturali, [5]inpossibile · fia. che la · tua · prospettiua · non apparisca · falsa · cō tutte [6]le bugiarde dimostrationi e discordāti proportioni che si può ima[7]ginare · in vna trista · opera ·, se il riguardatore · d' essa prospettiva nō [8]si truova · col suo · vedere alla propia · distātia e altezza · e dirittura de[9]l' ochio · over pūto che situasti · al fare d' essa · prospettiva : Onde bisognie[10]rebbe fare una · finestra della grādezza · del tuo · volto o veramēte uno [11]buso, dōde tu riguardassi detta opera ·; e se così farai · sanza dubio nessu[12]no l' opera tua ·, essendo bene accōpagniata d' ōbra · e di lumi, farà l' effe[13]tto · che fa il naturale, e nō ti potrai fare credere che esse cose sieno [14]dipīte ·, altremēti · nō te ne inpacciare, se già tu nō facciessi la tua ve[15]duta · al meno ·

A PICTURE OF OBJECTS IN PERSPECTIVE WILL LOOK MORE LIFELIKE WHEN SEEN FROM THE POINT FROM WHICH THE OBJECTS WERE DRAWN.

If you want to represent an object near to you which is to have the effect of nature, it is impossible that your perspective should not look wrong, with every false relation and disagreement of proportion that can be imagined in a wretched work, unless the spectator, when he looks at it, has his eye at the very distance and height and direction where the eye or the point of sight was placed in doing this perspective. Hence it would be necessary to make a window, or rather a hole, of the size of your face through which you can look at the work; and if you do this, beyond all doubt your work, if it is correct as to light and shade, will have the effect of nature; nay you will hardly persuade yourself that those objects are painted; otherwise do not trouble yourself about it, unless indeed you make your view

. . imodo . . fatto. 8. sapiano. 9. essettu. 10. dire che . . affare . . duno s̄c̄o cōpartita. 11. imolte storie nvna . . acquesta. 12. chettu . . pore . alte. 16. chasamēti. 17. dela facia. 18. alteza. 19. vccello . . ossimi. 20. lle cose . . īpaciare. 543. 1. [sē] quella chosa . . prosspettiua ara. 3. locho. 4. vorai . . ī chosa. 4. cheffacia . . cheffa le chose. 5. chella . . prosspettiua . . aparischa . . chō. 6. dimostratione e disschordāte proportine chessi po. 7. prosspettiua. 8. chol . . disstātia e alteza. 9. pūto situasti . . prosspettiua. 10. rebe fare ī̄ finestra . . grādeza . . veramēte ī̄. 11. esse chosi. 12. achōpagniata.

543. In the original there is a wide space between lines 3 and 4 in which we find two sketches not belonging to the text. It is unnecessary to give prominence to the points in which my reading differs from that of M. RAVAISSON or to justify myself, since they are all of secondary importance and can also be immediately verified from the photograph facsimile in his edition.

20 volte · lontana, quāto · è · la maggiore lar-
ghezza o al[16]tezza · della · cosa · che figuri, e
questa · sadisfarà a ogni riguardatore [17]situato
· in ogni · cōtraposta · parte · a detta opera.

[18]Se voli · vedere · la pruova · con breuità ·,
abbi · uno · pezzo d'asta a similitudine [19]d'una ·
colonnetta piccola, che sia · alta · otto · gros-
sezze come la colonna [20]sāza basa o
capitello ·, dipoi · cōpartisci ī sù ū mvro piano
40 spa[21]ti equali, i quali sieno cōformi ali
spati, e sarebbero īfra 40 colonne [22]simili
alla tua piccola colonna, poi fia stabilita
[23]a riscōtro · del mezzo d'essi spati 4 braccia
lōtana [24]dal mvro una sottile banda di ferro
che abbi nel mezzo · uno piccolo buso rotōdo,
[25]della grādezza d'una grossa · perla, e a
questo buso cōgivgni uno lume [26]che tocchi,
poi va ponēdo la tua colonna super ciascū
segnio del muro e se[27]gnia l'ōbre, poni la
ōbra e riguardala pel detto buso del ferro.

at least 20 times as far off as the greatest
width or height of the objects represented,
and this will satisfy any spectator placed
anywhere opposite to the picture.

If you want the proof briefly shown, take
a piece of wood in the form of a little co-
lumn, eight times as high as it is thick, like
a column without any plinth or capital; then
mark off on a flat wall 40 equal spaces,
equal to its width so that between them they
make 40 columns resembling your little
column; you then must fix, opposite the
centre space, and at 4 braccia from the wall,
a thin strip of iron with a small round hole
in the middle about as large as a big pearl.
Close to this hole place a light touching it.
Then place your column against each mark
on the wall and draw the outline of its
shadow; afterwards shade it and look through
the hole in the iron plate.

A. 41a] **544.**

[2]La cosa · diminvita · debe essere · ri-
guardata a quella medesima [3]distantia · e
altezza e dirittura ·, che ponesti · il pūto · del
tuo ochio, altremēti [4]la sciētia · non avrà ·
bono · effetto.

[5]E se nō uoi o nō puoi vsare · simile ·
ragione · per la cagione della pariete [6]dove
dipigni, ch'è a essere veduta · da diuerse ·
persone ·, bisognierebbe diuersi pūti [7]ōde
sarebbe discordāte · e falsa: pōti lōtano · il
meno · 10 · volte · la grādezza della cosa.

¶[8]Il minore · errore · che possi · fare · in
questo · caso · siè · che tu · pōga · tutte [9]le
prime · cose · in propia · forma ·, e in qualūque ·
parte ti porrai ·, le cose [10]vedute · diminvi-
ranno · per se · medesime, saluo · li spati che si
trovano [11]infra corpi · fieno · sanza · ragione ·,
imperochè se ti porrai nel mezzo [12]d'una
dirittura e riguarderai · molte colonne · col-
locate sù per · una linia, [13]vedrai · infra pochi
intervalli · d'esse colonne le colonne toccarsi,
e dopo [14]il toccarsi occuparsi l'una · l'altra
in modo tale, che l'ultima colonna [15]appa-
rirà · poco · fori · della · penvltima: adūque
l'intervali che si tro[16]vano · infra le coloñe ·

A diminished object should be seen from
the same distance, height and direction as
the point of sight of your eye, or else your
knowledge will produce no good effect.

And if you will not, or cannot, act on
this principle—because as the plane on which
you paint is to be seen by several persons
you would need several points of sight which
would make it look discordant and wrong—
place yourself at a distance of at least 10
times the size of the objects.

The lesser fault you can fall into then, will
be that of representing all the objects in the fore-
ground of their proper size, and on whichever
side you are standing the objects thus seen will
diminish themselves while the spaces between
them will have no definite ratio. For, if you
place yourself in the middle of a straight
row [of objects], and look at several columns
arranged in a line you will see, beyond
a few columns separated by intervals, that
the columns touch; and beyond where they
touch they cover each other, till the last
column projects but very little beyond the
last but one. Thus the spaces between the

13. cheffa . . chose. 14. faciessi. 15. magiore largeza. 16. teza . della . chossa . cheffiguri ecquesta . sadisffara. 18. chon . . abi . î . pezo dasste assimilitudine. 19. cholonetta pichola chessia alto . . grossez chome la cholona. 20. chapitelo . . chōpartisci īsunū. 21. chōformi . . farebono . . colone. 22. ala . . pichola cholona . . stabilito | "4 br. lōtano" î tola di fero sottile]. 23. [la quale aci î buso i] arischōtro . del mezo . . 4 br. lōtano. 24. mvro î sottile di fero che abi nel mezo . î picholo . . retōdo. 25. dela grādeza . . acquesto . . cōgivgui î lume. 26. tochi . . colona . . esse. 27. pola . . riguardalo.
544. 1. ella. 2. chosa . . acquella. 3. alteza. 4. lassciētia . . ara. 5. Esse . . poi . . chagione dela. 6. diuersi . . bisognierebe. 7. sarebe disscordāte effalsa . . grādeza dela. 8. erore . . chaso . . chettu. 9. chose . . porai . . chose. 10. lisspati chessi. 11. chorpi . . inperochessetti porai mezo. 12. cholone . cholochate. 13. vederai cholone le cholone tocharsi. 14. il to- charsi ochuparsi . . imodo cholōna. 15. aparira . pocho . . chessi. 16. cholōne . si perdano intera . mēte Esse . . dela.

si perdono · interamēte; E se il tuo modo della [17] prospettiva fia · bono ·, farà · il medesimo · effetto ·, il quale effetto accade [18] nello · stare · presso alla · linia · dove si posano le colõe, e questo modo [19] fia sanza gratia, se la cosa figurata. nõ fia veduta da uno piccolo buco [20] nel mezzo del quale · sia collocato · il tuo · pũto · del uedere ·, e se così [21] farai ·, l'opera tua sarà perfetta e ingannerà i veditori e ueranno le [22] colõe figurate nella forma qui disotto · figurate.

columns are by degrees entirely lost. So, if your method of perspective is good, it will produce the same effect; this effect results from standing near the line in which the columns are placed. This method is not satisfactory unless the objects seen are viewed from a small hole, in the middle of which is your point of sight; but if you proceed thus your work will be perfect and will deceive the beholder, who will see the columns as they are here figured.

[23] A queste l'ochio è nel mezzo nel pũto · a · ed è presso · alle colonne. ¶

Here the eye is in the middle, at the point a and near to the columns.

A. 41 δ] 545.

Se tu nõ puoi fare che li omini, che riguardano · la tua opera, [2] stieno · in vn solo · pũto · tirati indirieto · col ochio, quãdo figuri [3] la tua opera · al meno . 20 volte la maggiore altezza · o larghezza · della tua · opera, [4] e questa · farà nel mutare · l'ochio del riguardatore si poca varietà [5] che apena · si cõprenderà, e fia · assai laudabile;

If you cannot arrange that those who look at your work should stand at one particular point, when constructing your work, stand back until your eye is at least 20 times as far off as the greatest height and width of your work. This will make so little difference when the eye of the spectator moves, that it will be hardly appreciable, and it will look very good.

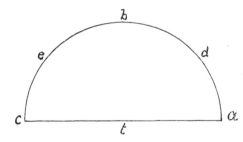

[6] Se 'l punto · sarà · in · t · farai · tu le figure poste sul circulo · d · b · e d'una [7] medesima ·

If the point of sight is at t you would make the figures on the circle d b e all

17. prosspettiva . . achade. 18. nelo . . cholõne ecquesto. 19. chosa . . da ĩ picholo ochio. 20. mezo . . cholochato . . esse chosi . . inganera. 22. cholõne . . nela. 23. acqueste . . mezo . . cholonne 4.

545. 1. 4 settu . . poi fare [questo . vedere]. 2. stieno nvn . . chol. 3. il meno magiore alteza olargeza. 4. ecquesta . . mvntare . . pocha. 5. chõplendera effia . . laldabile. 6. circhulo. 7. grãdeza . . ciasschuna. 8. vederai. 9. chõplen de che

544. The diagram which stands above this chapter in the original with the note belonging to it: "a b è *la ripruova* (a b is the proof) has obviously no connection with the text. The second sketch alone is reproduced and stands in the original between lines **22** and **23**.

grādezza ·, essendo · ciascuna · per esso · al pūto · *t* · a vn medesimo modo; ⁸poni mēte · alla figura · disotto · e vedrai · di no, e perchè la farò minore in *b* che ȷ̄ · *d* · *e*.

⁹Chiaro · si cōprende che, collocādo · 2 cose infra loro · equali, che ¹⁰quella ch'è situata nel terzo · braccio parrà minore che quella ch'è posta ¹¹nel secondo · braccio; questa cosa è piv disputativa · che da vsarla ·, perchè sei presso.

¹²Tutte le prime cose ·, grādi o piccole ch' essi sieno, falle in propia forma ¹³e se le vedrai di lontano faranno la lor debita dimostratione ·, e se le ved¹⁴rai · dapresso diminvirano · per loro medesime.

¹⁵Fa che senpre · la tua pariete ·, sulla quale tu diminvisci le cose ¹⁶vedute, sia fatta della medesima · forma · che il mvro dov'ài ¹⁷a figurare · la medesima · opera.

of one size, as each of them bears the same relation to the point *t*. But consider the diagram given below and you will see that this is wrong, and why I shall make *b* smaller than *d e* [8].

It is easy to understand that if 2 objects equal to each other are placed side by side the one at 3 braccia distance looks smaller than that placed at 2 braccia. This however is rather theoretical than for practice, because you stand close by [11].

All the objects in the foreground, whether large or small, are to be drawn of their proper size, and if you see them from a distance they will appear just as they ought, and if you see them close they will diminish of themselves.

[15]Take care that the vertical plan on which you work out the perspective of the objects seen is of the same form as the wall on which the work is to be executed.

Ash. I. 22*b*

546.

PITTTURA.

²La grādezza · della · figura · dipinta · ti debbe mostrare · a che distanza · ell'è veduta;

OF PAINTING.

The size of the figures represented ought to show you the distance they are seen

³se tu vedi una figura grāde · al naturale sappi ch'ella si dimostra esser presso ⁴all'ochio.

from. If you see a figure as large as nature you know it appears to be close to the eye.

Ash. I. 3*a*]

547·

DOVE · DEBE STARE QUELLO ²CHE RIGUARDA · LA PITUTRA.

³Poniamo · che · *a* · *b* · sia · la pictura · vista ·, e che · *d* · sia · il lume, ⁴Dico, che se ti porrai · infra · *c* · *e* ·, male · cōprenderai la pit-

WHERE A SPECTATOR SHOULD STAND TO LOOK AT A PICTURE.

Supposing *a b* to be the picture and *d* to be the light, I say that if you place yourself between *c* and *e* you will not

cholochādo . 2 chose. 10.; che quala . . terzo br. para . . quela. 11. sechondo . . chosa . . sepreso. 12. chose grāde. pichole chesi. 13. esse vederai farano . . esse . . vede. 15. chessenpre . . sula . . diminvissci le chose. 17. affigurare.
546. 2. grādeza . . ditebbe. 3. settu . . sapi.
547. 4. Dicho chesse . . porai . . cōplenderai la pitura. 5. sessia . . vernichata . . ara. 6. effia . . chagione. 7. chōsterai . . razi

545. 8. The second diagram of this chapter stands in the original between lines 8 and 9.

11. Instead of '*se preso*' (= *sie presso*) M. RAVAISSON

reads '*sempre se*' which gives rise to the unmeaning rendering: '*parceque toujours* . . .'

15. Compare No. 526 line 18.

tura, ⁵e massime · se sia · fatta · a olio o veramēte verniciata ·, perchè avrà lustro ⁶e fia · quasi · di natura · di spechio ·, e per questa cagione · quāto piv t'a⁷ccosterai · al pūto c ·, meno · vedrai ·, perchè · quivi · risaltano i razzi ⁸del lume ·, mādato · dalla · finestra · alla pittura: E se ti porrai infra ⁹e *d* lì fia · bene · operata la tua · vista ·, e massime · quāto · più · t'appresserai ¹⁰al punto · *d* ·, perchè quello loco · è meno · participāte di detta percus¹¹sione de' razzi riflessi.

understand the picture well and particularly if it is done in oils, or still more if it is varnished, because it will be lustrous and somewhat of the nature of a mirror. And for this reason the nearer you go towards the point *c,* the less you will see, because the rays of light falling from the window on the picture are reflected to that point. But if you place yourself between *e* and *d* you will get a good view of it, and the more so as you approach the point *d,* because that spot is least exposed to these reflected rays of light.

8. Essetti . porai. 10 locho. 11. razi rifressi.

III.

THE PRACTICAL METHODS OF LIGHT AND SHADE AND AERIAL PERSPECTIVE.

C. A. 196*b*; 586*b*]

548.

DE' PICTURA: DELLA OSCURITÀ DELLE ŌBRE O UOI DIRE CHIAREZZE DE' LUMI.

OF PAINTING: OF THE DARKNESS OF THE SHADOWS, OR I MAY SAY, THE BRIGHTNESS OF THE LIGHTS.

[Gradations of light and shade.]

²Bēchè li pratici mettino in tutte le cose infuscate, alberi, prati, capelli, barbe ³e peli di 4 sorti chiarezze nel contrafare vn medesimo colore, cioè ⁴prima vn fondamēto oscuro e per 2° vna machia che participa della forma ⁵delle parti; 3° una parte più spedita e più chiara, 4° i lumi più che altre parti ⁶noti di figura·; Ma a me pare che esse varietà sieno infinite sopra vna ⁷quātità continua, la quale in se è diuisibile in īfinito, e così lo provo: ⁸*a g* sia vna quantità cōtinua, *d* sia il lume che l'a⁹llumina; dico per la 4ª che dice ¶che quella parte del ¹⁰corpo alluminato sarà più luminosa che più s'a¹¹uicina alla causa che l'allumina; adunque *g* è ¹²più oscuro che *c* per tāto quāto la linia *d g* è più lunga che la linia ¹³*d c* e per la conclusione che tali gradi di chiarezza o vo'dire di oscurità nō sol ¹⁴sō 4, ma infinitamēte si possono inmaginare, perchè *c d* è quātità cōtinva

Although practical painters attribute to all shaded objects—trees, fields, hair, beards and skin—four degrees of darkness in each colour they use: that is to say first a dark foundation, secondly a spot of colour somewhat resembling the form of the details, thirdly a somewhat brighter and more defined portion, fourthly the lights which are more conspicuous than other parts of the figure; still to me it appears that these gradations are infinite upon a continuous surface which is in itself infinitely divisible, and I prove it thus:—[7]Let *a g* be a continuous surface and let *d* be the light which illuminates it; I say—by the 4th [proposition] which says that that side of an illuminated body is most highly lighted which is nearest to the source of light—that therefore *g* must be darker than *c* in proportion as the line *d g* is longer than the line *d c*, and consequently that these gradations of light— or rather of shadow, are not 4 only, but

548. 2. pratichi . . infusscate. 3. eppelli . . sorte chiareze . . coe. 4. osscura. 5. parte 3ᵃ una . . alte parte. 6. āme. 7. chontinua. 8. q"r"tita . . chella. 11. chellalumina . . g he. 12. piu [chia] osscuro . . lungha chella. 13. chettali . . ciareza osscurita. 14. possano. 16. delle "lūgeze ce anno le" linie chessastēdā . . ettal. 17. ecquella . . lungeze. 18. chessastendano

548. 7. See Pl. XXXI. No. I; the two upper sketches.

[15]e ogni quātità continua è diuisibile in īfinito, adunque infinite son le ua[16]rietà delle lūghezze, che ànno le linie che s'astēdā dal luminoso allo alluminato ¶e tal fia [17]la proportione delli lumi quale è quella delle lunghezze delle linie infra loro, [18]che s'astendono dal centro del luminoso alle parti d'esso obbietto alluminato.

may be conceived of as infinite, because c d is a continuous surface and every continuous surface is infinitely divisible; hence the varieties in the length of lines extending between the light and the illuminated object are infinite, and the proportion of the light will be the same as that of the length of the lines between them; extending from the centre of the luminous body to the surface of the illuminated object.

A. 23 a]

549.

COME IL PICTORE SI DEBBE ACCŌCIARE AL LUME · COL SUO RILIEUO.

HOW THE PAINTER MUST PLACE HIMSELF WITH REFERENCE TO THE LIGHT, TO GIVE THE EFFECT OF RELIEF.

[2]a · b · sia la finestra, · m · sia · il punto del lume ·, dico che in qualunque · parte il pittore · si stia ·, ch'elli starà [3] bene · pure · che

Let a b be the window, m the point of light. I say that on whichever side the painter places himself he will be well placed

On the choice of light for a picture (549—554).

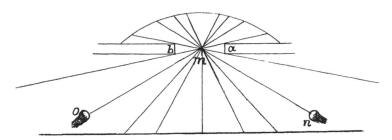

l'ochio · sia · infra · la parte onbrosa · e la luminosa · del corpo · che si ritrae ·, il quale · loco tro[4]uerai ·, ponendoti · infra 'l punto · m · e la · diuisione che fa · l'onbra · dal lume · sopra il corpo ritratto.

if only his eye is between the shaded and the illuminated portions of the object he is drawing; and this place you will find by putting yourself between the point m and the division between the shadow and the light on the object to be drawn.

Ash. I. 14 a]

550.

COME · L'ŌBRE · FATTE DA LUMI PARTICULARI [2]SI DEONO FUGIRE PERCHÈ SONO Ī LORO I FINI SIMILI A PRĪCIPI.

THAT SHADOWS CAST BY A PARTICULAR LIGHT SHOULD BE AVOIDED, BECAUSE THEY ARE EQUALLY STRONG AT THE ENDS AND AT THE BEGINNING.

[3]L'onbre, fatte dal sole o altri lumi particulari ·, sono sēza gratia del cor[4]po · che da quella è accōpagniato, īperocchè cōfusamēte lascia le parti [5]diuise cō euidēte termine d'ōbra da lume, e l'ōbre sono di pari potē[6]tia nel'ultimo che nel prīcipio.

The shadows cast by the sun or any other particular light have not a pleasing effect on the body to which they belong, because the parts remain confuse, being divided by distinct outlines of light and shade. And the shadows are of equal strength at the end and at the beginning.

. . parte. *At the beginning of the text the following is written on the margin in five short lines:* dello oscurita delle ōbre ouoi dire ciareze de lumi.

549. 1. chome . . achōciare . . chol. 2. finesstra . . dicho . . sisstia. 3. chellochio . ella . chorpo chessi . . locho. 4. ella . . cheffa . . chorpo ritracto.

550. 3. chor. 4. dacquella eachōpagniato . . lasscia le parte

551.

COME SI DEBE DARE LUME · ALLE · FIGURE.

²Il lume · debe · essere usato · secōdo che darebbe il natural sito · dove ³fingi · essere la tua · figura, cioè se la · fīgi al sole · fa l'onbre oscure ⁴e grā piazze di lumi · e stāpi l'ōbre e di tutti i circustāti corpi le loro ōbre ⁵in terra; E se la figuri j̄ tristo tēpo, fa poca differentia da lumi a ōbra, ⁶e sanza fare alcuna altr'ōbra ai piedi, E se la figuri ī casa, fa grā ⁷differēza da lumi al'ōbre e ōbra per terra, e se vi figuri finestra īpānata ⁸e abitatione biāca, poca differēza da lumi a ōbre; E se ell'è aluminata ⁹da foco, farai i lumi rosseggiāti e potēti, e scure l'ōbre, e 'l battimēto del'ōbre ¹⁰per li muri o per terra sia terminato, e quāto più s'alōtana dal corpo ¹¹· piv si faccia, āplo e magno; E se fusse alluminata parte dal foco ¹²e parte dall'aria · che quello dell'aria sia più potēte e quello del foco ¹³sia quasi rosso, a similitudine di foco ·, E sopra tutto fa · che le tue figure ¹⁴dipīte abbiano il lume grāde e da alto ·, cioè quel vivo che tu ritrai, ¹⁵j̄perochè le persone che tu · vedi per le strade tutte ànno il lume di sopra e sap¹⁶pi che non è si gran tuo conosciēte · che dādoli i lume di sotto che tu nō ¹⁷durassi fatica a riconoscerlo.

HOW LIGHT SHOULD BE THROWN UPON FIGURES.

The light must be arranged in accordance with the natural conditions under which you wish to represent your figures: that is, if you represent them in the sunshine make the shadows dark with large spaces of light, and mark their shadows and those of all the surrounding objects strongly on the ground. And if you represent them as in dull weather give little difference of light and shade, without any shadows at their feet. If you represent them as within doors, make a strong difference between the lights and shadows, with shadows on the ground. If the window is screened and the walls white, there will be little difference of light. If it is lighted by firelight make the high lights ruddy and strong, and the shadows dark, and those cast on the walls and on the floor will be clearly defined and the farther they are from the body the broader and longer will they be. If the light is partly from the fire and partly from the outer day, that of day will be the stronger and that of the fire almost as red as fire itself. Above all see that the figures you paint are broadly lighted and from above, that is to say all living persons that you paint; for you will seé that all the people you meet out in the street are lighted from above, and you must know that if you saw your most intimate friend with a light [on his face] from below you would find it difficult to recognise him.

552.

DEL DARE CON ARTIFIZIOSI LUMI E ŌBRE ²AIVTO AL FINTO RILIEUO DELLA PITTURA.

³Nell'aumētare · la pittura nel suo · rilieuo vserai fare · infra la finta figura ⁴e quella · cosa · visiua, che ricieve la sua · ōbra, · vna linea di chiaro lume che diuida ⁵la figura dal oscurato · obietto, e nel medesimo · obietto farai ⁶2 parti chiare che mettino

OF HELPING THE APPARENT RELIEF OF A PICTURE BY GIVING IT ARTIFICIAL LIGHT AND SHADE.

To increase relief of a picture you may place, between your figure and the solid object on which its shadow falls, a line of bright light, dividing the figure from the object in shadow. And on the same object you shall represent two light parts which will surround the shadow cast upon the wall

551. 1. ilume.　2. j̄lume . . darebe.　4. piaze . . stāpisci lōbre di.　5. pocha diferentia.　6. essella.　7. diferēza tera esse . . īpanata.　8. diferēza Esse elle.　9. rosegiāti.　10. ecquāto.　11. facia āpla e magnia Esse . . tuto fa chelle.　14. abino . . chettu.　15. chettu . . ano i lume . . essa.　16. chettu.　17. faticha a richonoscerlo.
552. 3. Dellaumētare . . infralla.　4. ciaro.　5. farai [chiaro dopo].　6. imezo.　7. chettu . . chessi.　8. chorpo e massimo . . lebr

552. 6. Compare the two diagrams under No. 565.

in mezzo l'ombra fatta · nel mvro della cōtra-
[7]posta figura;· e vsa spesso fare quelle
mēbra, che tu voi che si partino [8]alquāto
dal loro corpo e massime quādo le braccia
intraversano il petto, di [9]fare che īfra 'l
battimēto dell'ōbra del braccio sul petto e
la propria [10]ōbra del braccio · resti · alquāto
di lume che paia che passi infra lo spatio
ch'è [11]infra 'l petto e 'l braccio, e quādo
tu voi che 'l braccio paia piv distāte dal
[12]petto tāto piv fa detto · lume maggiore,
e senpre fa che tu t'īgiegni [13]d'accomodare
i corpi · in cāpi che la parte d'essi corpi
ch'è oscura [14]termini in cāpo chiaro ·, e la
parte del corpo aluminata termini ī [15]cāpo
· scuro.

by the figure placed opposite[6]; and do this
frequently with the limbs which you wish
should stand out somewhat from the body
they belong to; particularly when the arms
cross the front of the breast show, between the
shadow cast by the arms on the breast and
the shadow on the arms themselves, a little
light seeming to fall through a space between
the breast and the arms; and the more you
wish the arm to look detached from the
breast the broader you must make the light;
always contrive also to arrange the figures
against the background in such a way as
that the parts in shadow are against a light
background and the illuminated portions
against a dark background.

G. 33*b*]

553.

DE SITUATIONE.

[2]Ricordati del situare le fi[3]gure, perchè
altro è lume e onbra, se [4]vna cosa è in ū
loco scuro [5]cō lume particulare, altro [6]vna
cosa in loco · chiaro cō [7]lume particular
del sole, [8]altro vna cosa in loco scu[9]ro cō
lume vniversale della [10]sera o di tēpo
nvoloso, [11]e altro il lume vniversale [12]del-
l'aria alluminata dal sole.

OF SITUATION.

Remember [to note] the situation of your
figures; for the light and shade will be one
thing if the object is in a dark place with
a particular light, and another thing if it is
in a light place with direct sunlight; one
thing in a dark place with a diffused evening
light or a cloudy sky, and another in the
diffused light of the atmosphere lighted by
the sun.

G. 19*a*]

554.

DEL GIUDITIO CHE ÀI A FARE SOPRA VN OPERA
[2]D' Ū PITTORE.

[3]Prima è che tu cōsideri le figure s'el-
l'ànno [4]il rilievo qual richiede il sito e 'l
lume che [5]le allumina; che l'onbre nō siē
quel medesi[6]mo nelli stremi della storia che
nel mezzo, [7]perchè altra cosa è l'essere
circundato dalle [8]ombre, e altro è lo aver
le ōbre da vn sol lato; [9]quelle sō circū-
date dall'ōbre che sono in[10]verso il mezzo
della storia, perchè sono aō[11]brate dalle
figure interposte · fra loro [12]e 'l lume; E
quelle sono aōbrate da vn sol [13]lato, le quali
sono interposte infra lume e [14]la storia,
perchè dove nō vedono il lume vedono [15]la
storia e ui si rappresēta la scurità d'essa
sto[16]ria, e dove nō vedono la storia vedono
lo splē[17]dore del lume, e ui si rappresenta
la sua chi[18]arezza.

OF THE JUDGMENT TO BE MADE OF A PAIN-
TER'S WORK.

First you must consider whether the figures
have the relief required by their situation and
the light which illuminates them; for the
shadows should not be the same at the ex-
treme ends of the composition as in the
middle, because it is one thing when figures
are surrounded by shadows and another when
they have shadows only on one side. Those
which are in the middle of the picture are
surrounded by shadows, because they are
shaded by the figures which stand between
them and the light. And those are lighted
on one side only which stand between the
principal group and the light, because where
they do not look towards the light they face
the group and the darkness of the group is
thrown on them: and where they do not face
the group they face the brilliant light and it
is their own darkness shadowing them, which
appears there.

. . ella. 10. del br . . pai. 11. quāto . . bracio. 12. magiore essenpre fa chettu. 13. dachomodare . . chāpi . . osscura.
14. chāpo . . ella. 15. cāpo chiaro.
553. 1—12 R. 3. altre lume "e onbra" vise. 4. cosa enū loco s[p]curo. 5. particulari altr. 8. illoco dal.

[19]Secōdària è che 'l seminamēto [20]over cōpartitione delle figure siē cōpar[21]tite secōdo il caso nel quale tu vuoi che [22]sia essa storia; Terza che le figure sieno [23]cō prōtitudine intēte al lor particulare.

In the second place observe the distribution or arrangement of figures, and whether they are distributed appropriately to the circumstances of the story. Thirdly, whether the figures are actively intent on their particular business.

Ash. I. 7 a] 555.

DEL DARE I LUMI.

[2]Dà prima una ōbra vniversale · per tutta la parte cōtenēte che nō uede il lume, [3]poi li dà ōbre mezzane e le principali a paragone · l'una · dell'altra ·, [4]e così dà il lume cōtenēte di mezzano · lume, dādoli poi i mezzi e prīcipali [5]similmēte a paragone.

OF THE TREATMENT OF THE LIGHTS.

First give a general shadow to the whole of that extended part which is away from the light. Then put in the half shadows and the strong shadows, comparing them with each other and, in the same way give the extended light in half tint, afterwards adding the half lights and the high lights, likewise comparing them together.

G. 11 b] 556.

DE' ŌBRA NE' CORPI.

The distribution of light and shade (556—559).

[2]Quando figuri le ōbre oscure nelli cor[3]pi ōbrosi, figura senpre la causa di ta[4]le oscurità, e 'l simile farai de' refles[5]si, perchè le ōbre oscure nascono da [6]scuri obbietti e li reflessi da obbi[7]etti di piccola chiarezza, cioè da lumi di[8]minuiti; E tal proportione è [9]dalla parte alluminata de' corpi alla [10]parte rischiarata dal reflesso qua[11]le è dalla causa del lume d'essi cor[12]pi alla causa di tale reflesso.

OF SHADOWS ON BODIES.

When you represent the dark shadows in bodies in light and shade, always show the cause of the shadow, and the same with reflections; because the dark shadows are produced by dark objects and the reflections by objects only moderately lighted, that is with diminished light. And there is the same proportion between the highly lighted part of a body and the part lighted by a reflection as between the origin of the lights on the body and the origin of the reflections.

Ash. I. 19 a] 557.

DE' LUMI E ŌBRE.

[2]Ogni parte del corpo e ogni minima particula · che si truoua · avere alquāto di rilievo [3]io ti ricordo · che guardi a darli i prīcipali del' ōbre e de' lumi.

OF LIGHTS AND SHADOWS.

I must remind you to take care that every portion of a body, and every smallest detail which is ever so little in relief, must be given its proper importance as to light and shade.

554. 1—23 R. 3. guditio . . affare. 3. chettu ; . sellanno. 7. ellessere. 9. chessono. 10. mezo. 11. fralloro. 12. Ecquelle. 13. lume el. 15. lostoria . . rapresēta lasscurita. 17. rapresenta. 18. areza. 19. Secōdaria he chel. 22. chelle.
555. 2. prima l ōbra . . chōtenēte. 3. mezane elle. 4. echesi . . chōtenēte di mezano . . mezi.
556. 1—12 R. 2. osscure. 4. osscurita . . refres. 5. nasscā das. 6. elli refressi. 7. pichola chiareza coe. 8. Ettal . . eda. 10. alla parte risciarata dal refresso. 12. refresso.
557. 2. de chorpo . . partichula chessi. 3. richordo.

Ash. I. 12 *b*]

558.

MODO DEL FARE ALLE FIGURE ²L'OMBRA CŌPAGNIA DEL LUME E DEL CORPO.

³Quãdo fai una figura · e tu vogli vedere se l'onbra è cōpagnia del lume, ⁴ch'ella nō sia o piv · rossa o gialla che si sia la natura dell'essere del colo⁵re che tu volli aōbrar·, farai così : fa ōbra col tuo dito ⁶sopra la parte alluminata e se l'ōbra accidental e da te fatta fia simi⁷le al'ōbra naturale fatta dal dito sopra la tua opera, starà bene, ⁸e puoi col dito piv presso o piv · lōtano fare ōbre piv scure o piv ⁹chiare·, le quali sēpre paragona colla · tua.

OF THE WAY TO MAKE THE SHADOW ON FIGURES CORRESPOND TO THE LIGHT AND TO [THE COLOUR] OF THE BODY.

When you draw a figure and you wish to see whether the shadow is the proper complement to the light, and neither redder nor yellower than is the nature of the colour you wish to represent in shade, proceed thus. Cast a shadow with your finger on the illuminated portion, and if the accidental shadow that you have made is like the natural shadow cast by your finger on your work, well and good; and by putting your finger nearer or farther off, you can make darker or lighter shadows, which you must compare with your own.

Ash. I. 14 *a*]

559.

DEL CIRCŪDARE I CORPI ²CŌ VARI LINIAMĒTI D'ŌBRA.

³Fa · che senpre · l'ombre ·, fatte sopra la superfitie de' corpi da uarii obiecti, ⁴vsino · ondeggiare cō uari torcimēti mediãte la varietà de' mēbra ⁵che fanno l'onbre ·, e della cosa · che ricieve essa ōbra.

OF SURROUNDING BODIES BY VARIOUS FORMS OF SHADOW.

Take care that the shadows cast upon the surface of the bodies by different objects must undulate according to the various curves of the limbs which cast the shadows, and of the objects on which they are cast.

Ash. I. 29 *b*]

560.

DE PICTURA.

²I vari paragoni delle uarie qualità d'ōbre e lumi fanno spesse ³volte [parere] anbiguo e cōfuso al pittore, che vole imitare e cōtrafare le cose, ⁴che uede; la ragion si è Questa : se tu vedi vn panno biāco a parte ⁵vn nero·, cierto · quella · parte · d'esso paño biāco che cōfinerà · col ne⁶ro · apparirà molto · piv candida · che quella che cōfina si cō maggi⁷or biāchezza ·, e la ragiō di questo · si prova · nella · mia · prospettiva.

ON PAINTING.

The comparison of the various qualities of shadows and lights not infrequently seems ambiguous and confused to the painter who desires to imitate and copy the objects he sees. The reason is this: If you see a white drapery side by side with a black one, that part of the white drapery which lies against the black one will certainly look much whiter than the part which lies against something whiter than itself. [7] And the reason of this is shown in my [book on] perspective.

The juxtaposition of light and shade (560. 561).

558. 2. delume. 3. fai ĩ figura . ettu. 4. chela . . chessi . . cholo. 5. chettu . . chol. 6. esse . . datte. 8. e poi chol. 9. laquali.
559. 1. circhūdare i chorpi. 2. fa chessenpre . . chorpi . . obiecti. 4. ondegiare. 5. cheffano . . chosa.
560. 2. parachoni . . fano. 3. volte [parere] anbiguo e chōfuso . . chōtrafare. 4. e uede . . settu . . biācho apare. 5. vnero . . biācho che chōfinera . chol. 6. chandida . . quela che chōfinassi chō. 7. or biācheza . ella.

560. 7. It is evident from this that so early as in 1492 Leonardo's writing in perspective was so far ad-vanced that he could quote his own statements. — As bearing on this subject compare what is said in No. 280.

Ash. I. 4*a*] **561.**

DEL' ŌBRA.

²Doue·l'ōbra cōfina·cō lume abbi ³rispetto dov' è piv chiara o scura e do⁴v'ella è piv · o mē fumosa īuerso lu⁵me, e sopra tutto · ti ricordo che ne' ⁶giovani tu non facci l'onbre termina⁷re come · fa la pietra, perchè la carne ⁸tiene vn poco del trasparēte, come ⁹si uede a guardare in una mano che ¹⁰sia posta fra l'ochio ¹¹e 'l sole, che si vede ¹²rosseggiare · e trasparere luminosa; ¹³et la parte piv colorita · metterai ¹⁴infra i lumi e l'ōbre·, e se tu voli ¹⁵vedere che ōbra si richiede alla tua ¹⁶carne faraivi sù un ōbra · col tuo ¹⁷dito·, e secōdo che la · vuoi piv chiara ¹⁸o scura · tieni il tuo dito piv · presso o lōta¹⁹no dalla · tua pittura e quella cō-trafa.

OF SHADOWS.

Where a shadow ends in the light, note carefully where it is paler or deeper and where it is more or less indistinct towards the light; and, above all, in [painting] youthful figures I remind you not to make the shadow end like a stone, because flesh has a certain transparency, as may be seen by looking at a hand held between the eye and the sun, which shines through it ruddy and bright. Place the most highly coloured part between the light and shadow. And to see what shadow tint is needed on the flesh, cast a shadow on it with your finger, and according as you wish to see it lighter or darker hold your finger nearer to or farther from your picture, and copy that [shadow].

E. 4*a*] **562.**

DE' CĀPI DELLE FIGURE DE' ²CORPI DIPINTI.

On the lighting of the back-ground (562—565).

³Il canpo, che circūda le figure di qua-⁴lunque cosa dipinta, debbe essere piv os-⁵curo che la parte allumina⁶ta d'esse figure e più chiaro che la loro ⁷parte ōbrosa ecc.

OF THE BACKGROUNDS FOR PAINTED FIGURES.

The ground which surrounds the forms of any object you paint should be darker than the high lights of those figures, and lighter than their shadowed part: &c.

Ash. I. 4*a*] **563.**

CHE CĀPO DEBE VSARE IL PITTORE ²ALLE SUA OPERE.

³Poichè per isperiētia si vede che tutti i corp⁴i sono · circondati · da ōbra e lume ⁵vuolsi che tu pittore · accomodi·, che quella parte ch'è alluminata ⁶termini ī cosa oscura, · e così la parte del corpo · aombrata · ter-mini ⁷in cosa · chiara · E questa · regola · darà grāde avmēto a rilevare ⁸le tue figure.

OF THE BACKGROUND THAT THE PAINTER SHOULD ADOPT IN HIS WORKS.

Since experience shows us that all bodies are surrounded by light and shade it is necessary that you, O Painter, should so arrange that the side which is in light shall terminate against a dark body and likewise that the shadow side shall terminate against a light body. And by [following] this rule you will add greatly to the relief of your figures.

561. 2. chō fina cho . . abi. 3. schura. 5. richordo. 7. chome. 8. pocho . . chome. 11. chessi. 12. rossegiare . ettras-parere. 13. cholorita. 14. ellobre . essettu. 16. charne . . chol. 17. essechōdo . . voi. 18. osschura . . il duo . . presso alōta. 19. quela chōtrafa.

562. 1. chāpi . . fighure. 2. chorpi dipincti. 3. circhū le fighure di qual. 4. lūche chosa. 5. schuro che [el lume delle]. 6. fighure . . chella. 7. obrosa.

563. 1. chāpo. 2. ale. 3. perrisperietia . . chettutti i chorp. 4. circhondati . . ellume. 5. chettu pitore . achomodi. 6. osschura e chosi . chorpo. 7. chosa . . Ecquesta.

G. 23*b*]　　　　　　　　　　**564.**

Principalissima parte della pittura son
²li campi delle cose dipinte; nelli qua³li
campi li termini delli corpi naturali ⁴che
ànno in lor curvità convessa senpre ⁵si
conoscono, e le figure di tali corpi in essi
⁶campi, ancorachè li colori de' corpi sieno
⁷del medesimo colore del predetto campo,
e ⁸questo nascie che li termini cōuessi de'
⁹corpi non sono alluminati nel medesimo
¹⁰modo, che dal medesimo lume è allumi-
nato ¹¹il campo, perchè tal termine molte
volte sarà ¹²più chiaro o più oscuro che
esso campo; ¹³Ma se tal termine è del
colore di tal cam¹⁴po, sanza dubbio tal
parte di pittura proibirà ¹⁵la notizia della
figura di tal termine; ¹⁶e questa tale ele-
tione di pittura è da es¹⁷sere schivata
dalli ingiegni de' buoni pictori, ¹⁸concio-
siachè la intentione del pictore è di
¹⁹fare parere li sua corpi di quà dai cam-
pi, ²⁰e in nel sopra detto caso accade il
contrario ²¹nō che in pictura, ma nelle
cose di rilieuo.

A most important part of painting con-
sists in the backgrounds of the objects re-
presented; against these backgrounds the
outlines of those natural objects which are
convex are always visible, and also the
forms of these bodies against the back-
ground, even though the colours of the bo-
dies should be the same as that of the
background. This is caused by the convex
edges of the objects not being illuminated
in the same way as, by the same light, the
background is illuminated, since these edges
will often be lighter or darker than the back-
ground. But if the edge is of the same co-
lour as the background, beyond a doubt
it will in that part of the picture inter-
fere with your perception of the outline,
and such a choice in a picture ought
to be rejected by the judgment of good
painters, inasmuch as the purpose of the
painter is to make his figures appear de-
tached from the background; while in the case
here described the contrary occurs, not only
in the picture, but in the objects themselves.

Ash. I. 19*a*]　　　　　　　　　**565.**

²Come si debbe nelle cose ·, che sono ·
sopra · l'ochio　²et
daccāto ·, le quali · tu
uoli · che parino · di-
scoste ³dal mvro—fare
tra l'ōbra originale
e l'onbra di⁴rivativa
uno lume ī mezzo,
e parrà la cosa di-
spiccata dal mvro.

That you ought, when representing objects
above the eye and on
one side—if you wish
them to look detached
from the wall—to
show, between the sha-
dow on the object and
the shadow it casts a
middle light, so thatthe
body will appear to stand away from the wall.

Ash. I. 15*b*]　　　　　　　　　**566.**

COME I CORPI BIĀCHI SI DEONO FIGURARE.

HOW WHITE BODIES SHOULD BE REPRESENTED.

²Se figurerai uno corpo · biāco esso sia
circūdato · da molt'aria, perchè ³il biāco ·
non à da se · colore · ma si tignie e tras-
mvta ī parte del co⁴lore ·, che li è per obi-

If you are representing a white body let
it be surrounded by ample space, because
as white has no colour of its own, it is tinged
and altered in some degree by the colour
of the objects surrounding it. If you see

564. 2. chanpi delle chose dipincte. 3. chanpi . . chorpi. 4. chonvessa. 5. chognosschano le . . chorpi. 6. chanpi anchora
　　chelli cholori de chorpi. 7. cholore del predecto chanpo ec. 8. quessto nasscie chelli. 9. chorpi. 11. chanpo. 12. oppiu
　　osschuro . . chanpo. 13. Massettal . . cholore . . chan. 15. fighura. 16. ecquesta . . pictura he. 17. scitata. 18. chon-
　　ciossia chella . - eddi. 19. chorpi . . da canpi. 20. decto chaso achade il chontrario. 21. chose.

565. 1. chome . . chose chessono. 2. dachato . . tuuuoli . . di sschasto. 3. almvro . . ellonbra. 4. rivativa î lume īmezo e para
　　la chosa dispichata.

566. 2. figurerai î corpo biaco circhūdato. 3. dasse coloreāssi tignie frasmuta. 4. se vederai î dona [avere il f] vestita. 5. biācho
　　infrana . . quela. 6. imodo . . comel. 7. cheffia. 8. razi. 9. azura . . dona . . pa. 10. azurro se nela . . tera visina.

etto: se vedrai una donna vestita ⁵di biāco · īfra una cāpagnia ·, quella parte di lei che fia veduta ⁶dal sole · il suo colore fia chiaro, in modo che darà ī parte come ⁷il sole noia · alla vista · e quella · parte che fia veduta dalla ⁸aria luminosa per li razzi del sole, tessuti e penetrati īfra essa, ⁹perchè l'aria ī se è azzurra ·, la parte della dōna uista da detta aria par¹⁰rà pēdere in azzurro; se nella superfitie della terra uicina · fiā ¹¹prati, · e che la donna si truoui infra 'l prato alluminato dal sole ¹²e esso sole, vedrai tutte le parti d'esse pieghe, che posso¹³no essere uiste dal prato, tingersi per razzi reflessi in nel colore d'esso ¹⁴prato, e così si ua trasmvtādo in e' colori de' luminosi e nō lumino¹⁵si obietti vicini.

a woman dressed in white in the midst of a landscape, that side which is towards the sun is bright in colour, so much so that in some portions it will dazzle the eyes like the sun itself; and the side which is towards the atmosphere,—luminous through being interwoven with the sun's rays and penetrated by them—since the atmosphere itself is blue, that side of the woman's figure will appear steeped in blue. If the surface of the ground about her be meadows and if she be standing between a field lighted up by the sun and the sun itself, you will see every portion of those folds which are towards the meadow tinged by the reflected rays with the colour of that meadow. Thus the white is transmuted into the colours of the luminous and of the non-luminous objects near it.

Ash. I. 15a]

567.

PERCHÈ I VOLTI DI LŌTANO PAIONO OSCURI.

WHY FACES [SEEN] AT A DISTANCE LOOK DARK.

The methods of aerial

(567—570).

²Noi · vediamo · chiaro che tutte le similitudini delle · cose evidēti, ³che ci sono · per obietto così grādi come piccole, entrano al sēso per la piccola luce ⁴dell' occhio; se per si piccola ētrata passa la similitudine della grādezz adel cielo ⁵e della terra ·, essēdo il uolto dell'omo īfra si grā similitudini di cose · quasi niēte per ⁶la lōtanità che lo diminviscie, quasi occupa si poco d'essa luce che rimane īcōprēsi⁷bile ·, e avēdo a passare dalla superfitie alla īpressiua · per uno mezzo oscuro, cioè il ne⁸rvo voto che pare oscuro ·, quella spetie, nō sēdo di colore potēte, si tignie in quel⁹la oscurità della via, e givta alla īpressiua pare oscura: altra cagione nō si ¹⁰può in nessū modo · allegare, se quel pūto è nero che sta nella luce · lo è, perch'elli è pieno d'uno ¹¹omore trāparēte a vso d'aria e fa l'ufitio che farebbe uno buso fatto in vna asse, e a ri-¹²guardarlo pare nero, e le cose viste · per l'aria chiara e scura si cōfvdono nella oscurità.

We see quite plainly that all the images of visible objects that lie before us, whether large or small, reach our sense by the minute aperture of the eye; and if, through so small a passage the image can pass of the vast extent of sky and earth, the face of a man—being by comparison with such large images almost nothing by reason of the distance which diminishes it,—fills up so little of the eye that it is indistinguishable. Having, also, to be transmitted from the surface to the sense through a dark medium, that is to say the crystalline lens which looks dark, this image, not being strong in colour becomes affected by this darkness on its passage, and on reaching the sense it appears dark; no other reason can in any way be assigned. If the point in the eye is black, it is because it is full of a transparent humour as clear as air and acts like a perforation in a board; on looking into it it appears dark and the objects seen through the bright air and a dark one become confused in this darkness.

PERCHÈ · L'OMO · VISTO A CIERTA DISTĀTIA NON È CONOSCIVTO.

WHY A MAN SEEN AT A CERTAIN DISTANCE IS NOT RECOGNISABLE.

¹⁴La prospettiua · diminvitiua ci dimostra · che quāto · la cosa · è piv lōtana ¹⁵piv si fa piccola, e se tu riguarderai uno uomo che

The perspective of diminution shows us that the farther away an object is the smaller it looks. If you look at a man at a dis-

11. chella dona . . aluminato. 12. vederai tutte [e de sono] le . . pieche che possa. 13. no esse . . tigniera per razi refressi nel ch olore. 14. cholori.

567. 1. pajano. 2. chettutte le similitudine. 3. grade . . pichola . . piciola. 4. picola . . dela. 5. dela tera . . chose. 6. chello . . ocupa . . poca . . īchōprēsi. 7. per î mezo. 8. quelle . . inque. 10. po inesū . . alegare . . luce . e percheli. 11. effa . . farelie î buso fatto nonase. 12. elle . ·. chiara . . cōfōde nela. 13. nōne. 14. chosa. 15. pichola esse . .

sia distāte da te · vna bale[16]strata, e porraiti la finestra d'una · piccola agucchia apresso · al' ochio ·, potrai ve[17]dere per quella molti omini mādare le lor similitudini · all' ochio, e in ū medesimo [18]tēpo tutte capirāno ī detta · finestra ·; adūque se l' omo lōtano una balestra[19]ta māda la sua similitudine all' ochio, che occupa una piccola parte d'una fine[20]stra d'agucchia, come · potrai tu in si piccola figura scorgere o vedere il naso [21]o bocca o alcuna particula d'esso corpo, e nō uedēdosi nō potrai [22]conosciere l'omo che nō mostra le mēbra, le quali fanno li omini di diuerse forme.

tance from you of an arrow's flight, and hold the eye of a small needle close to your own eye, you can see through it several men whose images are transmitted to the eye and will all be comprised within the size of the needle's eye; hence, if the man who is at the distance of an arrow's flight can send his whole image to your eye, occupying only a small space in the needle's eye how can you [expect] in so small a figure to distinguish or see the nose or mouth or any detail of his person? and, not seeing these you cannot recognise the man, since these features, which he does not show, are what give men different aspects.

Ash. I. 4a] 5**68**.

COME · LE FIGURE · PICCOLE DEONO [2]PER RAGIONE · ESSER · FINITE.

[3]Dico · che le · cose che apparirāno · di minvta [4]forma · nascierà che · detta cosa fia lontana dall' occhio; essendo così [5]cōuiene ·, che īfra l' ochio e la cosa · sia molta · aria ·, e la molt' aria [6]īpedisce la evidētia della forma · d' essi obbietti, ōde le minute [7]particule · d' essi · corpi · fiano indiscernibili e nō conosciute; Adūque [8]tu · pittore · farai · le piccole · figure · solamēte acciēnate · e nō finite, e se [9]altrimēti · farai ·, cōtrafarai alli effetti della natura tua · maestra; [10]la cosa · rimāe piccola per la · distātia grāde ch' è fra l' ochio e la cosa, [11]la distātia grāde rīchiude · dentro a se di molta aria: la molta aria fa ī se grosso [12]corpo il quale īpediscie · e tolglie all' ochio le minute particule degli obbietti.

THE REASON WHY SMALL FIGURES SHOULD NOT BE MADE FINISHED.

I say that the reason that objects appear diminished in size is because they are remote from the eye; this being the case it is evident that there must be a great extent of atmosphere between the eye and the objects, and this air interferes with the distinctness of the forms of the object. Hence the minute details of these objects will be indistinguishable and unrecognisable. Therefore, O Painter, make your smaller figures merely indicated and not highly finished, otherwise you will produce effects the opposite to nature, your supreme guide. The object is small by reason of the great distance between it and the eye, this great distance is filled with air, that mass of air forms a dense body which intervenes and prevents the eye seeing the minute details of objects.

G. 53b] 5**69**.

D' ogni figura pos[2]ta in lūga distā[3]tia si perde in pri[4]ma la notitia del[5]le parti più mi[6]nute e nell' ulti[7]mo si riservan le [8]parti massime, [9]priuate della no[10]titia di tutti li stre[11]mi, e restano di [12]figura ovale o [13]sperica di termi[14]ni confusi.

Whenever a figure is placed at a considerable distance you lose first the distinctness of the smallest parts; while the larger parts are left to the last, losing all distinctness of detail and outline; and what remains is an oval or spherical figure with confused edges.

homo chessia . . atte. 16. porati . . piciola aguchia. 17. similitudine . . enū. 18. caperano . . ī balestra. 19. ī pichola. 20. daguchia . . pichola. 21. obocha oalchuna . . deso. 22. le chali fano.
568. 1. Chome . . pichole. 3. dicho . . chose [chessiano di pichola] che aparirāno. 4. chosa . . chosi. 5. chēfra . . chosa . . aria ella. 6. la [forma] evidēsia. 7. partichule . . fieno indisciernibile . . chonosciute. 8. pichole. 10. pichola . . chosa. 11. rīciude . . asse di molta. 12. tolglie . . partichole.
569. 1. dongni. 2 sta in lūgha dissā. 5. lle parte. 7. riserua. 8. parte. 11. resstan. 13. spericha. 14. chonfusi.

W. An. IV. 218b]

570.

PICTURA.

[2] La spessitudine del fumo dall' oriz[3]zonte ingiv̀ è bianca e dall' orizzōte in [4] sù è oscura, e ancora che tal [5] fumo sia in sè d'equal colore, essa equalità si dimostra varia mediante la [7] varietà dello spatio nel qual si trvova.

OF PAINTING.

The density of a body of smoke looks white below the horizon while above the horizon it is dark, even if the smoke is in itself of a uniform colour, this uniformity will vary according to the variety in the ground on which it is seen.

570. 2 lasspessitudine . . ori. 3. biancha . . orizōte. 4. osschura e anchora chettal. 6. dimosstra.

IV.

OF PORTRAIT AND FIGURE PAINTING.

Ash. I. 8*a*] 571.

DEL MODO DELLO ĪPARARE BENE A CŌPORRE
²INSIEME LE FIGURE NELLE STORIE.

³Quādo · tu · avrai inparato · bene di
prospettiva · e avrai a mēte tutte le mēbra
⁴ e corpi delle · cose, sia vago e spesse volte
nel tuo ādarti a spasso ⁵ vedere e conside-
rare i siti · e li atti delli omini in nel parlare,
in nel cōtēdere ⁶ o ridere o zuffare insieme,
che atti fieno in loro ·, che atti faccino i
circū⁷stati ·, i spartitori, i veditori d'esse
cose·, e quelli notare cō brevi se⁸gni in
questa forma su un tuo piccolo libretto,
il quale tu debi sēpre por⁹tar cō teco,
e sia di carte tīte, accio nō l'abbi a scācellare
ma mutare di vechio ¹⁰in v̄ novo, chè·
queste. nō sono cose da essere scācellate
anzi cō grā diligēza ri¹¹serbate·, perchè gli sono
tāte le īfinite forme e · atti delle cose che
la memoria ¹²nōn è capace a ritenerle,
ōde queste riserberai come tua autori e
maestri.

OF THE WAY TO LEARN TO COMPOSE FIGURES
[IN GROUPS] IN HISTORICAL PICTURES.

When you have well learnt perspective
and have by heart the parts and forms of
objects, you must go about, and constantly, as
you go, observe, note and consider the
circumstances and behaviour of men in talk-
ing, quarrelling or laughing or fighting to-
gether: the action of the men themselves
and the actions of the bystanders, who
separate them or who look on. And take
a note of them with slight strokes thus,
in a little book which you should always
carry with you. And it should be of
tinted paper, that it may not be rubbed
out, but change the old [when full] for a new
one; since these things should not be rubbed
out but preserved with great care; for the
forms, and positions of objects are so infi-
nite that the memory is incapable of retaining
them, wherefore keep these [sketches] as
your guides and masters.

Of sketching
figures and
portraits
(571. 572).

571. 1. chōpore. 3. arai . . arai. 4. chorpi . . chose . . esspesse . . ādarti ossobasso. 5. chonsiderare . . inel . . inel. 7. chose
ecquelli. 8. suntuo piciolo. 9. chōtecho essia . . labiaca ciellare. 10. chose . . chācielate anzichōgra. 11. perche eglie tāte
. . chose chella. 12. chapace . . chome tua altori.

571. 8. Among Leonardo's numerous note books
of pocket size not one has coloured paper, so no
sketches answering to this description can be

pointed out. The fact that most of the notes are
written in ink, militates against the supposition that
they were made in the open air.

Ash. I. 9a] 572.

DEL MODO DEL TENERE A MĒTE LA FORMA
D' Ū UOLTO.

²Se uolli avere facilità in tenere a mēte
una · aria d' uno volto ·, īpara · prima a mēte
³di molte teste, occhi, nasi, bocche, mēti ·
e gole · e colli e spalle: e poniamo caso:
J nasi ⁴sono di 10 ragioni ·, dritto ·, gobbo,
cavo, col rilievo più sù o piv giù che ' l mezzo,
aquilino, pari ·, simo · e tōdo e acuto; questi
⁵sono boni in quāto al proffilo; In faccia
i nasi sono di 11 ragioni: equale, grosso in
mezzo, ⁶sottil' in mezzo, la pūta grossa e
sottile nell' appiccatura ·, sottile nel⁷la · pūta
e grosso nell' appiccatura ·, di larghe narici ·
di strette, d' alte e basse, di busi scoperti e
⁸di busi occupati dalla pūta, e così troverai
diversità nelle ⁹altre particole, delle quali ·
cose tu de' ritrare di naturale e metterle a
mēte, ¹⁰overo quādo ài a fare uno volto a
mēte · porta con teco uno piccolo libretto,
doue sieno ¹¹notate simili fationi ·, e quā-
do ài dato una ochiata al uolto della
persona che uoi ¹²ritrare, guarderai poi
ī parte quale naso o bocca se le somi-
glia e fa ui uno piccolo ¹³segnio, per rico-
nescierle poi a casa. De' visi mostruosi
nō parlo perchè sāza fatica ¹⁴si tēgono
a mēte.

OF A METHOD OF KEEPING IN MIND THE FORM
OF A FACE.

If you want to acquire facility for bearing
in mind the expression of a face, first make
yourself familiar with a variety of [forms of]
several heads, eyes, noses, mouths, chins and
cheeks and necks and shoulders: And to put
a case: Noses are of 10 types: straight,
bulbous, hollow, prominent above or below
the middle, aquiline, regular, flat, round or
pointed. These hold good as to profile. In full
face they are of 11 types; these are equal
thick in the middle, thin in the middle, with
the tip thick and the root narrow, or narrow
at the tip and wide at the root; with the
nostrils wide or narrow, high or low, and
the openings wide or hidden by the point; and
you will find an equal variety in the other
details; which things you must draw from
nature and fix them in your mind. Or else,
when you have to draw a face by heart,
carry with you a little book in which you
have noted such features; and when you
have cast a glance at the face of the person
you wish to draw, you can look, in private,
which nose or mouth is most like, or there make
a little mark to recognise it again at home.
Of grotesque faces I need say nothing, because
they are kept in mind without difficulty.

Ash. I. 6b] 573.

IN CHE MODO TU DEBI FARE UNA TESTA ²CHE
LE SUA PARTI SIENO CŌCORDĀTI ³ALLE DEBITE
DIRITTURE.

⁴Per fare vna · testa che le sua · mēbra ·
The position sieno cōcordāti al uolta⁵re e piegare d' una
of the head. testa · tieni · questi modi: tu sai che ochi,
ciglia, ⁶nari di naso, termini della bocca e
i lati del mēto, mascella ⁷gote, orechi e tutte
parti d' uno volto sono d' equale diritture

HOW YOU SHOULD SET TO WORK TO DRAW
A HEAD OF WHICH ALL THE PARTS SHALL
AGREE WITH THE POSITION GIVEN TO IT.

To draw a head in which the features
shall agree with the turn and bend of the
head, pursue this method[5]. You know
that the eyes, eyebrows, nostrils, corners of
the mouth, and sides of the chin, the jaws,
cheeks, ears and all the parts of a face are
squarely and straightly set upon the face[8].

572. 2. mēte ī aria. 3. esspalle . . chaso. 4. chavo *col rilievo piu su o piv gu chel mezo aquilino . . achuto. 5. sono di 1[2] |
ragioni . . imezo. 6. imezo [e grosso nei stremi] la . . essottile nel apichatura. 7. nellapichatura di large anarise . . ebbesse.
8. ochupati . . chosi. 9. partichule . . chose. 10. affare ī volto . . chontecho ī piciolo. 11. simile fatione . ecquādo . .
dato ī ochiata. 12. bocha . . faui ī piciolo. 13. achasa . . faticha. 14. tēgano.
573. 1. fare ī testa. 2. chelle . . sieno [in] chōchordāti. 4. chōcordāti. 5. tussai. 6. anari . . bocha . . masella. 7. volto

573. See Pl. XXXI, No. 4, the slight sketch on
the left hand side. The text of this passage is written by
the side of it. In this sketch the lines seem inten-
tionally incorrect and converging to the right (com-
pare l. 12) instead of parallel. Compare too with

this text the drawing in red chalk from Windsor
Castle which is reproduced on Pl. XL, No. 2.
5—8. Compare the drawings and the text belong-
ing to them on Pl. IX. (No. 315), Pl. X (No. 316),
Pl. XI. (No. 318) and Pl. XII. (No. 319).

⁸poste sopra il uolto; adūque quādo ài fatto il uolto, fa linie ⁹che passino da l' uno canto · dell' ochio · al' altro, e così per la dirittu-¹⁰ra di ciascuno mēbro, e tratte fori de' lati del uolto le stre¹¹mità d'esse · linie, guarda se da destra e da sinistra li spati ¹²ī nel medesimo paralello · sono equali, Ma bē ti ricordo che tu ¹³facci dette linie trarre al pūto della tua veduta.

Therefore when you have sketched the face draw lines passing from one corner of the eye to the other; and so for the placing of each feature; and after having drawn the ends of the lines beyond the two sides of the face, look if the spaces inside the same parallel lines on the right and on the left are equal [12]. But be sure to remember to make these lines tend to the point of sight.

Ash. I. 3 *b*] **574·**

COME · SI DEBBE CONOSCERE ²QUAL PARTE DEL CORPO DE' ÉSSERE ³PIÙ O MENO LUMINOSA CHE L' ALTRE.

HOW TO KNOW WHICH SIDE OF AN OBJECT IS TO BE MORE OR LESS LUMINOUS THAN THE OTHER.

⁴se · *f* · fia · il lume · e la · testa · sarà · il corpo da quello alluminato, ⁵e quella · parte · d'essa testa che riceve · sopra di se il razzo fra · angoli ⁶piv equali · sarà · più · alluminata ·, e quella parte · che riceverà ⁷i razzi · īfra · āgoli · meno equali · fia · meno luminosa ·; E fa ⁸questo · lume · nel suo ofitio · a similitudine del colpo ·, īperochè il ⁹colpo · che caderà īfra equali · āgoli · fia · in primo grado di po-¹⁰tentia, e quando caderà · infra diseguali sarà tāto meno potēte ¹¹che 'l primo · quāto l' āgoli · fieno · più · disformi ·; Esēpli gratia, ¹²se gitterai · una · palla · in un · mvro · che l' estremità sieno equi¹³distanti · da te ·, il colpo caderà · īfra eguali · āgoli, E se ¹⁴gitterai la palla ī detto muro, stādo da una delle sue estremità, ¹⁵la palla caderà infra diseguali · angoli ·, e il colpo nō si ¹⁶appic-cherà.

Let *f* be the light, the head will be the object illuminated by it and that side of the head on which the rays fall most directly will be the most highly lighted, and those parts on which the rays fall most aslant will be less lighted. The light falls as a blow might, since a blow which falls perpendicularly falls with the greatest force, and when it falls obliquely it is less forcible than the former in proportion to the width of the angle. *Exempli gratia* if you throw a ball at a wall of which the extremities are equally far from you the blow will fall straight, and if you throw the ball at the wall when standing at one end of it the ball will hit it obliquely and the blow will not tell.

Of the light on the face (574—576).

W. 1] **575·**

PRUOVA · E RAGIONE · PERCHÈ INFRA LE PARTI ALLUMINATE ²SI TROVANO PARTICULE PIV LUMINOSE VNA CHE VN ALTRA.

THE PROOF AND REASON WHY AMONG THE ILLUMINATED PARTS CERTAIN PORTIONS ARE IN HIGHER LIGHT THAN OTHERS.

³Poichè provato s'è che ogni terminato ⁴lume fa over par che nasca da v̄ sol

Since it is proved that every definite light is, or seems to be, derived from one single

[sop] sono . . diriture. 8. facto. 9. diritu. 10. ciaschuno . . foride [gli] "2" lati. 11. desstra. 12. inel . . ecquale . . richordo chettu. 13. faci . . trare . . dela.

574. 1. chonosscere. 2. chorpo. 3. ōmeno. 4. seff . f . fia . . ella . . chorpo dacquello. 5. ecquella . . razo. 6. ecquella. 7. irazi . . Effa. 8. quessto . . assimilitudine del cholpo iperoche. 9. cholpo . . chadera. 10. chadera. 12. gitterai î paḷḷa. 13. distante atte il cholpo chadera . . E essella. 14. giterai la balla . . da î delle. 15. la pala chadera . . cholpo.

575. 1. infralle parte [l]. 2. [f] si truova partichule. 4. nascha . . quela . . aluminata. 5. dacquello ara . . quale cha. 6. dara

574. See Pl. XXXI. No. 4; the sketch on the right hand side.

575. See Pl. XXXII. The text, here given complete, is on the right hand side. The small circles above the beginning of lines 5 and 11 as well as the circle above the text on Pl. XXXI, are in a

paler ink and evidently added by a later hand in order to distinguish the text as belonging to the *Libro di Pittura* (see Prolegomena. No. 12, p. 3). The text on the left hand side of this page is given as Nos. 577 and 137.

punto ·, quella parte allumina⁵ta da quello
avrà la sua particula piv luminosa ·, sopra
la quale ca⁶derà la linia radiosa fra · 2 · an
goli · equali ·, come di sopra si di⁷mostra
nelle linie · · a · g · e così ȷ̄ · a. h. e simile
ȷ̄. l · a ·, e quella ⁸particula della parte allu-
minata fia mē luminosa · sopra la quale la
linia ⁹ȷ̄cidente ferirà tra · 2 · angoli piv dis-
simili, come appare ȷ̄ · b · c · d, ¹⁰e per que-
sta via ācor potrai conosciere le parti
priuate di lume, ¹¹come appare ȷ̄ · m· k.

¹²Quādo li angoli, fatti dalle ¹³linie ȷ̄-
cidēti, sarāno piv ¹⁴equali ȷ̄ quello loco
¹⁵fia · piv · lume, e dove ¹⁶fieno più disequali
¹⁷lì · fia · piv scuro. ¶

¹⁸ancor farò mētione ¹⁹della ragiō del-
la reflessiō.

point the side illuminated by it will have its
highest light on the portion where the line of
radiance falls perpendicularly; as is shown
above in the lines *a g*, and also in *a h*
and in *l a*; and that portion of the illumi-
nated side will be least luminous, where
the line of incidence strikes it between two
more dissimilar angles, as is seen at *b c d*.
And by this means you may also know
which parts are deprived of light as is seen
at *m k*.

Where the angles made by the lines of
incidence are most equal there will be the
highest light, and where they are most un-
equal it will be darkest.

I will make further mention of the rea-
son of reflections.

Ash. I. 19*a*] **576.**

Dove si debe ²fare cadere ³l'ōbra
sul uolto.

Where the shadow should be on
the face.

W. 1*a*] **577.**

<p style="margin-left:2em">General
suggestions
for historical
pictures
(577—581).</p>

Quādo tu ²fai vna sto³ria · fa · 2 · pū-
⁴ti ·, vno dell' occhio ⁵e l'altro del lum⁶e
el qual fa piv ⁷lōtā che puoi. ¶

When you compose a historical picture
take two points, one the point of sight, and
the other the source of light; and make this
as distant as possible.

Ash. I. 18*b*] **578.**

¶Come le storie nō debbono · essere ·
occupate · e cōfuse di molte figure.

Historical pictures ought not to be
crowded and confused with too many figures.

Ash. I. 26*a*] **579.**

PRECETTI DI PITTURA.

²Il bozzare delle storie sia pronto ·; e'l
mēbrificare · nō sia troppo · finito, ³sia cō-
tenvto · solamēte a siti d'esse mēbra, i quali
poi a bell' agio, piacēdo ti, ⁴le potrai finire.

PRECEPTS IN PAINTING.

Let you sketches of historical pictures
be swift and the working out of the limbs
not be carried too far, but limited to the
position of the limbs, which you can after-
wards finish as you please and at your leisure.

. . angholi . . chome. 7. chosi . . essimile. 8. alumata . . lumino . . qule. 9. angholi . . disimili chome apare. 10. āchor
. . cho nosciere . . pruate. 11. chome apare. 14. [p] equali . . iocho. 16. dixequali. 17. pivsschuro. 18. anchor.
19. rasiōde rifresiō.
576. 2. lattere.
577. 4. delochi"o". 5. delum.
578. occhupate e chōfuse.
579. 2. bozare . . mēbrifichare . . sia [f] tropo. 3. chontenuto.

579. See Pl. XXXVIII. No. 2. The pen and
ink drawing given there as No. 3 may also be
compared with this passage. It is in the Windsor
collection where it is numbered 101.

Ash. I. 2 a]

580.

¶ Sōmo daño è quādo ²l' openione avanza l' opera. ¶

The sorest misfortune is when your views are in advance of your work.

C. A. 157 a; 463 a]

581.

Del cōporre storie; del nō riguardare· le mēbra · delle figure nelle storie ‖ come molti fāno che per fare le figure · ītere, guastano ²ĭ componimēti, e quādo tu fai· la figura · dirieto alla · prima · fa disegniarla tutta, acciochè le sua ³ mēbra ·, che vēgono · apparire · fori delle supertitie · della · prima ·, cāpino · a loro naturale · lūghezza e loco.

Of composing historical pictures. Of not considering the limbs in the figures in historical pictures; as many do who, in the wish to represent the whole of a figure, spoil their compositions. And when you place one figure behind another take care to draw the whole of it so that the limbs which come in front of the nearer figures may stand out in their natural size and place.

Ash. I. 17 b]

582.

Come si deono figurare le età dell'omo, cioè īfantia, pueritia, adolesciē²tia, giovētù, vecchiezza, decrepitudine.

How the ages of man should be depicted: that is, Infancy, Childhood, Youth, Manhood, Old age, Decrepitude.

How to represent the differencies of age and sex (582. 583).

Ash. I. 18 a]

583.

Come i vechi debono essere fatti cō pigri e lēti movimēti e gābe piegate ²nelle ginochia quādo stanno fermo, e piè pari e distāti l' uno dal' altro, sen³do declināti ī basso, la testa īnāzi e chinata e le braccia nō troppo distese.

⁴Come le dōne si deono figurare con atti vergogniosi, gābe īsieme strette, ⁵braccia raccolte īsieme, teste basse e piegate ī traverso.

⁶Come le vechie si debō figurar ardite e prōte, e con rabbiosi movimēti ⁷a uso di furie īfernali, e' movimēti deono apparire piv prōti nelle brac⁸cia e teste che nelle gābe.

⁹I putti piccoli con atti prōti e storti, quādo siedono, e nello star ritto ¹⁰atti timidi e pavrosi.

Old men ought to be represented with slow and heavy movements, their legs bent at the knees, when they stand still, and their feet placed parallel and apart; bending low with the head leaning forward, and their arms but little extended.

Women must be represented in modest attitudes, their legs close together, their arms closely folded, their heads inclined and somewhat on one side.

Old women should be represented with eager, swift and furious gestures, like infernal furies; but the action should be more violent in their arms and head than in their legs.

Little children, with lively and contorted movements when sitting, and, when standing still, in shy and timid attitudes.

580. 1. somo.
581. 1. copore . . nellie . . fano 2 . ichonponimēti ecquādo tuffai le figure . . ale prime fadidisegniar . . acciochella. 3. vēgano aparire . . chapinno . . lūgeza acloco.
582. 1. leta. 2. giuvētu vecieza.
583. 1. ellēti. 2. nele . . stano. 3. enle bracia nōtropo. 4. done . . ati. 5. bracia racholte. 6. e rabbiosi. 7. fure . . aparire . . bra. 9. picioli conati . . segano.

582. No answer is here given to this question, in the original MS.

583. *braccia raccolte.* Compare Pl. XXXIII. This drawing, in silver point on yellowish tinted paper, the lights heightened with white, represents two female hands laid together in a lap. Above is a third finished study of a right hand, apparently holding a veil from the head across the bosom. This drawing evidently dates from before 1500 and was very probably done at Florence, perhaps as a preparatory study for some picture. The type of hand with its slender thin forms is more like the style of the *Vierge aux Rochers* in the Louvre than any later works — as the Mona Lisa for instance.

Come la figura nō fia laudabile ²se ī quella non apparisce atto che ³esprima · la passione dello suo umore.

THAT A FIGURE IS NOT ADMIRABLE UNLESS IT EXPRESSES BY ITS ACTION THE PASSION OF ITS SENTIMENT.

Of representing the emotions. ⁴Quella figura è piv ⁵laudabile che ne ⁶l'atto meglio esprime ⁷la passione del suo ⁸animo.

That figure is most admirable which by its actions best expresses the passion that animates it.

Come si de' fare una figura irata.

HOW AN ANGRY MAN IS TO BE FIGURED.

¹⁰Alla · figura · irata · farai · tenere · uno per li capelli, il capo storto a terra, ¹¹et con uno de' ginochi sul costatò ·, e col braccio destro leuare il pūgnio ¹²in alto: questo · abbi li capelli elleuati ·, le ciglia basse e ¹³strette, i dēti stretti e i · 2 stremi da cāto dalla bocca arcati, il collo grosso e dinā¹⁴zi per lo chinarsi al nimico sia pieno di grīze.

You must make an angry person holding someone by the hair, wrenching his head against the ground, and with one knee on his ribs; his right arm and fist raised on high. His hair must be thrown up, his brow downcast and knit, his teeth clenched and the two corners of his mouth grimly set; his neck swelled and bent forward as he leans over his foe, and full of furrows.

Come si figura uno disperato.

HOW TO REPRESENT A MAN IN DESPAIR.

¹⁶Al disperato farai dare un coltello e colle mani aversi stracciato ¹⁷i vestimēti, e sia una d'esse mani in opera a stracciarsi la ferita, e farla cō piedi ¹⁸stāti e le gābe alquāto piegate, e la persona similmēte ¹⁹inverso terra cō capelli stracciati e sparsi.

You must show a man in despair with a knife, having already torn open his garments, and with one hand tearing open the wound. And make him standing on his feet and his legs somewhat bent and his whole person leaning towards the earth; his hair flying in disorder.

Come debi fare parere ²naturale uno animale fīto.

HOW YOU SHOULD MAKE AN IMAGINARY ANIMAL LOOK NATURAL.

Of representing imaginary animals. ³Tu sai nō potersi fare alcuno animale il quale nō abbia ⁴le sue mēbra,—che ciascuno per se à similitudine cō qual⁵cuno · delli altri animali: adūque se voli fare parere ⁶naturale uno animale, finto da te ·, diciamo che sia uno serpēte, ⁷piglia per la

You know that you cannot invent animals without limbs, each of which, in itself, must resemble those of some other animal. Hence if you wish to make an animal, imagined by you, appear natural—let us say a Dragon, take for its head that of a mastiff or hound, with

584. 1. Chome . . laldabile. 2. nōnaparisce. 3. spriema . . dello sommore. 5. laldabile che choni. 6. latto . . sprieme. 7. pasione. 9. fare ĩ. 10. tenere ĩ per li chapegli il chapo . . attera. 11. chon . . chostato e chol bracio. 12. abi li chapegli. 13. dachāto . . bocha archati il chollo. 14. nimicho. 15. figura ĩ. 16. darsidun choltello e cholle. 17. sia ĩ desse . . asstracciarsi . . effarla cho. 18. elle . . ella. 19. tera cho chapegli straciati essparsi.
585. 2. naturale ĩ. 3. tussai . . alchuno . . abi. 4. assimilitudine chō. 5. chuno. 6. naturale ĩ . . chessia ĩ. 7. testa ĩ . . maschino

585. The sketch here inserted of two men on horseback fighting a dragon is the facsimile of a pen and ink drawing belonging to BARON EDMOND DE ROTHSCHILD of Paris.

testa una di mastino o bracco, e per li the eyes of a cat, the ears of a porcupine,
ochi di gatta, [8]e per l'orecchie d'istrice, e per the nose of a greyhound, the brow of a lion,

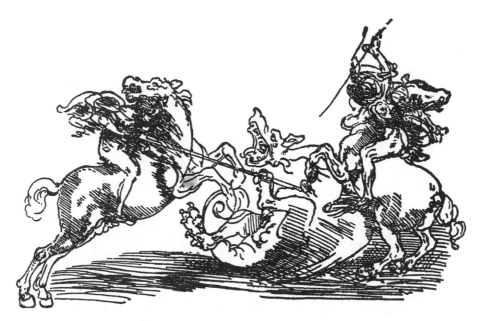

lo naso di ueltro, e ciglia da lione e tēpie the temples of an old cock, the neck of a
[9]di gallo vechio, collo di testudine d'aqua. water tortoise.

A. 23 a]

586.

DELLO INGĀNO CHE SI RICIEVE NEL GIVDITIO
DELLE MĒBRA.

OF THE DELUSIONS WHICH ARISE IN JUDGING
OF THE LIMBS.

[2]Quel pittore · che avrà · goffe mani · le farà simili nelle sua opere ·, e quel medesimo · l'interuerà · in qualūque [3]mēbro ·, se lūgo · studio nō glielo · uieta: adūque · tu pittore · guarda bene · quella parte · che ài · piv brutta [4]nella · tua · persona · e in quella · col tuo · studio fa bono · riparo ·, jperochè se sarai · bestiale · le tue figure · [5]paranno il simile e sanza · ingiegnio ·, e similmēte ogni · parte di bono · e di tristo che ài · in te, si dimo[6]strerà · in parte · in nelle · tue · figure.

A painter who has clumsy hands will paint similar hands in his works, and the same will occur with any limb, unless long study has taught him to avoid it. Therefore, O Painter, look carefully what part is most ill-favoured in your own person and take particular pains to correct it in your studies. For if you are coarse, your figures will seem the same and devoid of charm; and it is the same with any part that may be good or poor in yourself; it will be shown in some degree in your figures.

The selection of forms (586—591).

Ash. I. 8 b]

587.

DELLA · ELETIONE DE' BELLI VOLTI.

OF THE SELECTION OF BEAUTIFUL FACES.

[2]Parmi · nō piccola · grazia quella · di quel · pittore · il quale · fa bone arie alle sua

It seems to me to be no small charm in a painter when he gives his figures a

. . bracho. **8.** per li orechie. **9.** galo . . cholo.
586. 1. delongāno chessi. 2. ara. 3. sellūgo. 4. enquella chol . . jperro . chessessarai. 5. parano . . essanza . essimilmēte . .
trissto. 6. sterra . . inelle.

figure ³la qual gratia ·, chi nō l'à per na-tura·, la può · pigliare · per accidētale · studio · in questa · forma; ⁴guarda · a torre · le parti bone · di molti · volti belli ·, le quali · belle sieno cōferme ⁵piv · per pubblica · fama · che per tuo givditio ·, perchè ti potresti · ingannare · togliēdo visi ⁶che avessino · cō-formità · col tuo ·, perchè spesso pare · che simili cōformità ci piacino, ⁷e se tu fussi brutto eleggieresti volti nō belli e faresti brutti volti come molti pittori, che ⁶spesso le figure somigliano il maestro ·, sichè piglia · le bellezze come dico, e quelle metti a mēte.

pleasing air, and this grace, if he have it not by nature, he may acquire by incidental study in this way: Look about you and take the best parts of many beautiful faces, of which the beauty is confirmed rather by public fame than by your own judgment; for you might be mistaken and choose faces which have some resemblance to your own. For it would seem that such resemblances often please us; and if you should be ugly, you would select faces that were not beautiful and you would then make ugly faces, as many painters do. For often a master's work resembles himself. So select beauties as I tell you, and fix them in your mind.

Ash. I. 19a] **588.**

Delle mēbra di che si debe fare · ele-tione · et di tutte le parti al pro²posito · della pittura.

Of the limbs, which ought to be care-fully selected, and of all the other parts with regard to painting.

Ash. I. 2a] **589.**

In nella eletione delle ²figure sia più tosto ³giētile che secco o lē⁴gnioso.

When selecting figures you should choose slender ones rather than lean and wooden ones.

G. 26a] **590.**

MUSCOLI DELLI ANIMALI.

OF THE MUSCLES OF ANIMALS.

²Le cōcavità interposte infra ³li muscoli nō debbono essere di ⁴qualità che la pelle paja che ve⁵sta due bastoni posti in comū ⁶lor cōtatto come *c*, nec etiam che paiono ⁷dua bastoni alquāto remo⁸ssi da tal cōtatto, e che la ⁹pelle pēda in vano cō curuità la¹⁰rga come *f*, ma che sia ¹¹come *i* posato sopra il grasso ¹²spūgoso interposto nelli angoli ¹³com'è l'angolo *n m o*, il quale an¹⁴golo nascie dal fin del cōtatto de¹⁵lli mvscoli, e perchè la pelle nō può di¹⁶scē-dere in tale angolo, la natura ¹⁷à riēpiuto tale angolo di piccola quan¹⁸tità di grasso spūgoso o vuò dire vi¹⁶scioso con vissi-che minute pie²⁰ne d'aria, la quale in se si cōdensa ²¹ossia rarefa secondo lo accres-cimen²²to o rarefatione della sustantia de' ²³muscoli; alora la cōcavità *i* à ²⁴sempre maggior curvità che 'l muscolo.

The hollow spaces interposed between the muscles must not be of such a character as that the skin should seem to cover two sticks laid side by side like *c*, nor should they seem like two sticks somewhat remote from such contact so that the skin hangs in an empty loose curve as at *f*; but it should be like *i*, laid over the spongy fat that lies in the angles as the angle *n m o*; which angle is formed by the contact of the ends of the muscles and as the skin cannot fold down into such an angle, nature has filled up such angles with a small quantity of spongy and, as I may say, vesicular fat, with minute bladders [in it] full of air, which is condensed or rarefied in them according to the increase or the diminution of the substance of the muscles; in which latter case the concavity *i* always has a larger curve than the muscle.

587. 3. po . . perraccidētale. 4. attorre le par bone. 5. perchetti potressti . inganare. 6. chōformita . . chessimil . . piaccino.
 7. essettu . . ellegieresti . . effaresti brutti voli. 8. somiglano . . beleze.
588. tutte parti.
589. Inella elletione. 3. secho.
590. 1—24 R. 2. interposste. 3. musscoli. 4. chella. 5. cōmū. 6. cōtatto "come c" . . nec chel. 8. echella. 10. rgha . . f m che.

Ash. I. 13 a] **591.**

DEL SERPEGGIARE E BILICO DELLE · FIGURE · E
ALTRI ²ANIMALI.

³Qualūque · figura · tu fai ·, o animale giē-
tile, ricordati di fugire il legnioso, ⁴cioè
ch'elle vadino · cōtrapesādo ossia bilāciando ·
in modo nō paia uno pezzo di legno;
⁵Quelli che vuoi figurare forti, nō li fare
così, saluo il girare della testa.

OF UNDULATING MOVEMENTS AND EQUIPOISE
IN FIGURES AND OTHER ANIMALS.

When representing a human figure or
some graceful animal, be careful to avoid
a wooden stiffness; that is to say make them
move with equipoise and balance so as not to
look like a piece of wood; but those you
want to represent as strong you must not
make so, excepting in the turn of the head.

Ash. I. 6 a] **592.**

DELLA GRATIA · DELLE MĒBRA.

²Le mēbra del corpo debono essere
accomodate cō gratia · al proposito dello
effetto ³che tu vuoi che facia la figura: e
se vuoi far figura · che dimostri · in se leggi-
adria, ⁴debbi fare mēbra gētili e distese · e
sanza dimostrare troppi mvscoli e que' pochi,
che al ⁵proposito · farai dimostrare ·, fa li
dolci cioè di poca evidēza, col'onbre nō
tinte, ⁶e le mēbra ·, massimamēte le braccia,
disnodate, cioè che nessuno mē-
⁷bro nō ui stia ī linia diritta · col
mēbro che si giunge cō seco · E se
'l fiāco, polo dell'o⁸mo, si trova
per lo posare fatto che 'l destro sia
piv · alto del sinistro, farai la gi⁹vtura della
superiore spalla piovere per linia perpēdi-
culare sopra al piv eminente ¹⁰oggetto del
fianco, e sia essa spalla destra più · bassa
che la sinistra, e la fōtanella ¹¹stia sempre
superiore al mezzo della giūtura del piè di
sopra · che posi ·, la gāba che nō posi ab-
bia ¹²il suo ginocchio · piv basso che
l'altro, e presso all'altra gāba; le latitu-
dini della testa e brac¹³cia sono īfinite,
però nō mi estenderò ī darne alcuna
regola ·, pure che sieno facili ¹⁴e grate, con
vari storcimēti ed i uīcolamēti · colle givn-
ture disnodate, acciò nō paiano ¹⁵pezzi di
legno.

OF GRACE IN THE LIMBS.

The limbs should be adapted to the body
with grace and with reference to the effect that ^{How to pose figures.}
you wish the figure to produce. And if you
wish to produce a figure that shall of itself
look light and graceful you must make the
limbs elegant and extended, and without too
much display of the muscles; and those few
that are needed for your purpose you must
indicate softly, that is, not very prominent
and without strong shadows; the limbs,
and particularly the arms easy; that
is, none of the limbs should be in a
straight line with the adjoining parts.
And if the hips, which are the pole
of a man, are by reason of his position,
placed so, that the right is higher than the
left, make the point of the higher shoulder
in a perpendicular line above the highest
prominence of the hip, and let this right
shoulder be lower than the left. Let the pit
of the throat always be over the centre
of the joint of the foot on which the man
is leaning. The leg which is free should have
the knee lower than the other, and near the
other leg. The positions of the head and
arms are endless and I shall therefore not
enlarge on any rules for them. Still, let
them be easy and pleasing, with various turns
and twists, and the joints gracefully bent,
that they may not look like pieces of wood.

12. neli. 15. mvscoe . . po. 17. picola q"a". 18. tita di rasso spugoso evo. 19. viscice. 21. ossi . . acresscimen. 23. muss-
coli. 24. senpre magor.
591. 1. del serpeggiare epili di delle. 3. tuffai . . richordati . . chōtrapesādosio . . imodo . . paia ī pezo di legnie. 5. Queli . . voi.
592. 2. achomodate chō. 3. chettu voi cheffacia . . esse voi . . legadria. 4. distesi . . tropi. 5. fali [solamēte] dolci . . nōtende.
6. bracia. 7. chol . . chessi gugnie cōsecho . Essel. 9. dela . . perpendichulare. 10. ogietto . . fiancho essia . . chella
. . ella. 11. mezo . .·posa . . posa abi. 12. ginochio . . gāba lattitudini . . tessta. 13. astendero. 14. cole. . acio. 15. pizi
di legnio.

C. A. 137a; 415a]　　　　　　　593.

Of appropriate gestures (593—600).

La pictura over le figure · dipīte · debbono esser · fatte ī modo tale · che li ri²guardatori · d' esse · possino cō facilità · conosciere mediāte · le loro ³attitudini · il concetto dell' anima · loro ‖ e se tu ài · a fare parla⁴re vn omo · da bene, fa che li atti · sua · sieno conpagni delle bone ⁵parole, E similmēte · se tu ài · a figurare · vno uomo · bestiale, fa lo ⁶cō movimēti · fieri ·, gittando · le braccia · contro all' auditore, e la testa col ⁷petto, sportāti · fori de' piedi ·, accōpagnino · le mani del parlatore, ⁸A similitudine · del mvto · che vedēdo 2 parlatori ·, benchè · esso sia pri⁹vato · dell' audito ·, niēte di meno · mediāte li effetti e li atti d' essi parlato¹⁰ri · lui · cōprēde · il tema · della loro disputa; Io vidi già · ī Firē¹¹ze vno sordo · accidētale · ʝl quale · se tu · li parlaui · forte ·, lui nō ti intē¹²dea ·, e parlādo · piano · sanza sono di voce · lui t'intēdea solo per lo ¹³menar · delle · labra; or tu mi potresti dire nō mena le labra vno che parla ¹⁴forte · come · piano, · e menādole · l' uno · come l' altro · nō sarà inteso ¹⁵l'altro · come · l'uno ·; a questa · parte · io lascio dare la sētētia alla ¹⁶speriētia, fa parlare vno piano e puoi fare ī mēte · le labra.

A picture or representation of human figures, ought to be done in such a way as that the spectator may easily recognise, by means of their attitudes, the purpose in their minds. Thus, if you have to represent a man of noble character in the act of speaking, let his gestures be such as naturally accompany good words; and, in the same way, if you wish to depict a man of a brutal nature, give him fierce movements; as with his arms flung out towards the listener, and his head and breast thrust forward beyond his feet, as if following the speaker's hands. Thus it is with a deaf and dumb person who, when he sees two men in conversation —although he is deprived of hearing—can nevertheless understand, from the attitudes and gestures of the speakers, the nature of their discussion. I once saw in Florence a man who had become deaf who, when you spoke very loud did not understand you, but if you spoke gently and without making any sound, understood merely from the movement of the lips. Now perhaps you will say that the lips of a man who speaks loudly do not move like those of one speaking softly, and that if they were to move them alike they would be alike understood. As to this argument, I leave the decision to experiment; make a man speak to you gently and note [the motion of] his lips.

Ash. I. 14b]　　　　　　　594.

DEL FIGURARE UNO CHE PARLI INFRA PIV PERSONE.

OF REPRESENTING A MAN SPEAKING TO A MULTITUDE.

²Vserai fare quello ·, che tu voi che infra molte persone parli, di considerare la mate³ria di che lui · à da trattare: e d'accomo-

When you wish to represent a man speaking to a number of people, consider the matter of which he has to treat and adapt

593. 1. facte . . talle chel ri. 2. chō . . conossciere. 3. attitudine il chonciecto . . esse . . affare. 4. dabbene fare chelli . . chonpagni. 5. Essimilmēte . settuai . affigurare . . falli. 6. cho . . chōtro allalditore ella . . chol. 7. achōpagnino. 8. Assimilitudine. 9. auldito . . elli. 10. chōprēde la xtema. 11. settu. 12. parlādi . . sollo per. 13. labra | "or" tu . . portresti di nō. 14. chome . . chome. 15. chome . . acquesta. 16. seriētia . . piano e po fare [p]ōmēte le labra.

594. 1. ī̄ che. 2. vsera . . quelo . chettu. 3. lui attrattare e dachomodare. 4. sela maleria. 5. che cquello . . pigli cole per i 2.

593. The first ten lines of this text have already been published, but with a slightly different reading by Dr. M. JORDAN: *Das Malerbuch Leonardo da Vinci's* p. 86.

594. The sketches introduced here are a facsimile of a pen and ink drawing in the Louvre which Herr CARL BRUN considers as studies for the Last Supper in the church of *Santa Maria delle Grazie* (see Leonardo da Vinci, LXI, pp. 21, 27 and 28 in DOHME's *Kunst und Künstler*, Leipzig, Seemann). I shall not here enter into any discussion of this suggestion; but as a

justification for introducing the drawing in this place, I may point out that some of the figures illustrate this passage as perfectly as though they had been drawn for that express purpose. I have discussed the probability of a connection between this sketch and the picture of the Last Supper on p. 335. The original drawing is 27³/₄ centimètres wide by 21 high.—The drawing in silver point on reddish paper given on Pl. LII. No. 1—the original at Windsor Castle—may also serve to illustrate the subject of appropriate gestures, treated in Nos. 593 and 594.

dare ī lui · li atti apartenenti a essa materia, ⁴ cioè · se l'è materia persuasiua · che li atti sieno al proposito, se l'è materia ⁵ dichiaratatiua per diuerse ragioni, che quello che dice pigli per le dita della ⁶ mano destra uno dito della sinistra avēdone serrate li 2

his action to the subject. Thus, if he speaks persuasively, let his action be appropriate to it. If the matter in hand be to set forth an argument, let the speaker, with the fingers of the right hand hold one finger of the left hand, having the two smaller ones closed; and

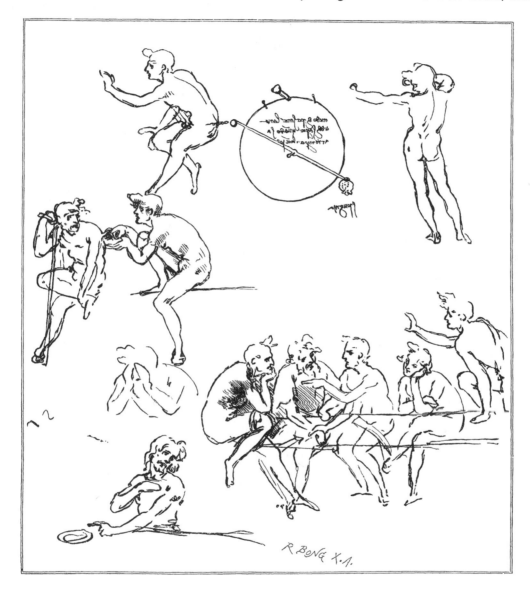

minori, e col viso prōto ⁷ rivolto uerso il popolo colla bocca alquāto aperta che paia che parli; e, se lui ⁸ sederà, che paia che si solleui alquāto ritto e ināzi colla testa ·, e se lo fai ⁹ in piè ·, fa lo alquāto chinarsi col petto e la testa inuerso il popolo, Il ¹⁰ quale

his face alert, and turned towards the people with mouth a little open, to look as though he spoke; and if he is sitting let him appear as though about to rise, with his head forward. If you represent him standing make him leaning slightly forward with body and

6. mano "destra" ī dito dela . . serate le . . prō. 7. chola bocha . . che pai che . . esse. 8. soleui . . chola . . esse. 9. fallo . . chol. 10. figurerati. 11. ati . . effare le boche dalchuno vechio . . delle vl. 12. bocha choi sua stremi vasi.

figurerai tacito e attēto, tutti riguardare
l'oratore ī uolto co¹¹n atti · amiratiui, e fare
le bocche d'alcuno vecchio per maraviglia
delle v¹²dite sentētie tenere la bocca coi
sua stremi · bassi, tirarsi dirietro ¹³molte ·
· pieghe delle guācie ·, e colle ciglia alte nelle
giunture le quali creino ¹⁴molte pieghe per
la fronte; alcuni sedenti colle dita della
mano īsieme tessu¹⁵te tenersi dētro lo stāco
ginochio; altri col' uno ginochio sopra l'al-
tro, ¹⁶sul quale tēga la man, che dētro a
se ricieva il gomito del quale la sua ¹⁷mano
vada a sostener el mēto barbuto d'alcuno
chinato vecchio.

head towards the people. These you must
represent as silent and attentive, all looking
at the orator's face with gestures of admiration;
and make some old men in astonishment at
the things they hear, with the corners of their
mouths pulled down and drawn in, their
cheeks full of furrows, and their eyebrows
raised, and wrinkling the forehead where they
meet. Again, some sitting with their fingers
clasped holding their weary knees. Again,
some bent old man, with one knee crossed
over the other; on which let him hold his
hand with his other elbow resting in it and
the hand supporting his bearded chin.

Ash. I. 5 *b*] **595.**

DELLA COMODITÀ DELLE MĒBRA.

²Inquāto · alla comodità d'esse mēbra
avrai a considerare, che quādo ³tu vorrai
figurare · vno che per qualche accidēte ·
s'abbia a voltare īdietro ⁴o per cāto ·, che tu
nō facci movere i piedi e tutte le mēbra ī
quella parte dove ⁵volta la testa ·, anzi farai
operare cō partire esso svolgimēto in giv̄-
⁶ture, cioè quella del piede, del ginochio e
fiāco e collo; e se poserai sulla gāba destra
⁷farai il ginochio della sinistra piegare ī
dētro · e 'l piè suo fia eleuato alquāto di fori,
⁸e la spalla · sinistra sia alquāto piv bassa
che la destra e la nvca si scōtri a quel
⁹medesimo loco dove è volta la noce di
fori del piè sinistro ·, e la ¹⁰spalla sinistra
sopra la pūta del piè destro in perpēdicolare
linia ·, e sēpre vsa le fi¹¹gure che dove si
volta la testa che nō ui si uolga il petto;
chè la natura per nostra ¹²comodità ci à
fatto il collo che cō facilità · può seruire a
diuerse bande, volendo l'ochio ¹³voltarsi
in vari siti, e a questo · medesimo sono ī
parte obediēti l'altre giūtu¹⁴re, e se fai
l'omo a sedere, e le sue braccia qualche
volta s'auessino adoperare ¹⁵ī qualche cosa
traversa, fa che · il petto si uolga sopra la
giv̄tura del fiāco.

OF THE DISPOSITION OF LIMBS.

As regards the disposition of limbs in
movement you will have to consider that when
you wish to represent a man who, by some
chance, has to turn backwards or to one
side, you must not make him move his feet
and all his limbs towards the side to which
he turns his head. Rather must you make the
action proceed by degrees and through the
different joints; that is, those of the foot,
the knee and the hip and the neck. And if you
set him on the right leg, you must make the
left knee bend inwards, and let his foot be
slightly raised on the outside, and the left
shoulder be somewhat lower than the right,
while the nape of the neck is in a line directly
over the outer ancle of the left foot. And the
left shoulder will be in a perpendicular line
above the toes of the right foot. And always
set your figures so that the side to which
the head turns is not the side to which the
breast faces, since nature for our convenience
has made us with a neck which bends with
ease in many directions, the eye wishing to
turn to various points, the different joints. And
if at any time you make a man sitting with
his arms at work on something which is
sideways to him, make the upper part of
his body turn upon the hips.

.. dirieto. 13. piege dele guāce echole .. nele givunture. 14. pieghe .. sidenti cholle. 15. chol. 16. tēgha .. asse.
17. assostener .. vechio.

595. 2. chomodita .. arai achonsiderare. 3. tu vura .. sabi. 4. chāto . chettu .. faci .. tutte mēbra. 5. anzi fara farai ..
partiri esso sssufolgimēto ī. 6. coe quela .. fiācho echollo . esse .. sula. 8. ella spala .. chella .. nvcha si schōtri.
9. locho. 10. spala .. destro perpēdichulare .. essēpre .. chella .. nosstra. 12. chō .. po .. diuerse voglido. 13. a
voltarsi .. acquesto .. giutu. 14. seffai .. assedere elle .. bracia. 15. chosa .. fiācho.

595. 10, 11. Compare Pl. VII, No. 5. The original drawing at Windsor Castle is numbered — 104 —

A. 28 b]

596.

Quando ritrai li nvdi fa che sempre li ritraga interi, e poi finisci quello mēbro ti pare ²migliore, e quello coll' altre mēbra metti · in pratica, altremēti faresti vso di non ap³piccare · mai · le mēbra bene · insieme.

⁴Non vsar mai fare la testa volta · dove il petto, nè 'l braccio andare come la gāba, ⁵e se la testa si uolta · alla spalla destra · fa le sue parti piv basse dal lato sinistro che dal destro, ⁶e se fai il petto infori fa che, voltandosi la testa sul lato sinistro, che le parti del lato destro ⁷sieno piv alte che le sinistre.

When you draw the nude always sketch the whole figure and then finish those limbs which seem to you the best, but make them act with the other limbs; otherwise you will get a habit of never putting the limbs well together on the body.

Never make the head turn the same way as the torso, nor the arm and leg move together on the same side. And if the face is turned to the right shoulder, make all the parts lower on the left side than on the right; and when you turn the body with the breast outwards, if the head turns to the left side make the parts on the right side higher than those on the left.

W. L. 145 a]

597.

DE PICTURA.

²Natura de' movimēti nell' omo: ³nō replicare le medesime actioni nelle menbra dell' omo ⁴se la neciessità della loro operatione nō ti costrignie, ⁵come si mosstra in *a b*.

OF PAINTING.

Of the nature of movements in man. Do not repeat the same gestures in the limbs of men unless you are compelled by the necessity of their action, as is shown in *a b*.

C. A. 337 b; 1026 b]

598.

Li moti delli omi²ni sieno qual ri³chiede la sua degni⁴tà o viltà.

The motions of men must be such as suggest their dignity or their baseness.

C. A. 341 a; 1051 a]

599.

DE PITTURA.

²Fa che la opera s'assomigli allo intēto e alla intē³tione ·, cioè che quādo fai la tua figura che tu ⁴pēsi bene chi ella è e quello che tu · vuoi ch' ella faci.

OF PAINTING.

Make your work carry out your purpose and meaning. That is when you draw a figure consider well who it is and what you wish it to be doing.

596. 1. chessepreli ritraga . . finissci quelo. 2. ecquelo chollaltre . . inpraticha . . nōna. 3. pichare. 4. vsar [mi] mai . . bracio . . chome. 5. esse . . allasspalla. 6. esseffai . . sulato . . delato.

597. 3. replichare . . nelle [medesime] menbra. 4. sella . . cōsstrignie.

599. 1. chella hopera sasomigli. 3. chettu . . e cquello chettu. 6. affarlo. 7. vechio ho ū giovane a aparere. 8. efichacia. 9. vechio.

596. In the original MS. a much defaced sketch is to be seen by the side of the second part of this chapter; its faded condition has rendered reproduction impossible. In M. RAVAISSON'S facsimile the outlines of the head have probably been touched up. This passage however is fitly illustrated by the drawings on Pl. XXI.

597. See Pl. V, where part of the text is also reproduced. The effaced figure to the extreme left has evidently been cancelled by Leonardo himself as unsatisfactory.

De pittura.

[6]Vno medesimo · effetto · a farlo in pittura operare [7]a vn vecchio o ū giovane à a apparere tāto di ma[8]ggiore efficacia, quāto il giovane è piv potēte [9]che 'l uecchio · e simigliāte farai dal giovane al' īfante.

Of painting.

With regard to any action which you give in a picture to an old man or to a young one, you must make it more energetic in the young man in proportion as he is stronger than the old one; and in the same way with a young man and an infant.

Ash. I. 15 b]

600.

Del porre le mēbra.

[2]Le mēbra, che durano fatica · a farle mvscolose · e quelle che nō s'adoperano, farai [3]sanza muscoli · e dolci.

Of setting on the limbs.

The limbs which are used for labour must be muscular and those which are not much used you must make without muscles and softly rounded.

Dell'atto delle figure.

[5]Farai · le figure in tale · atto · il quale · sia soffitiēte · a dimostrare quel che la [6]figura · à · nell'animo: altrimēte · la tua arte · nō fia · laudabile.

Of the action of the figures.

Represent your figures in such action as may be fitted to express what purpose is in the mind of each; otherwise your art will not be admirable.

600. 2. faticha affarle mvscholose . ecquelle. 3. muscholi. 5. chella . . altre . mente . laldabile.

V.

SUGGESTIONS FOR COMPOSITIONS.

Ash. I. 4 *b*] **601.**

Modo di figurare una battaglia.

²Farai prima il fumo dell'artiglieria, mischiato īfra l'aria · īsieme · colla polvere mossa ³dal movimēto de' cavalli e de' cōbattitori ·, la qual mistione · vserai così: ⁴la polvere perchè è · cosa · terrestre è pōderosa, e bēchè per la sua sottilità facilmēte ⁵si leva e mischia infra l'aria ·, niētedimeno volētieri ritorna · in basso; il suo ⁶sōmo mōtare è fatto dalla · parte · piv · sottile; Adūque lì meno fia veduta, ⁷e parrà quasi di colore d'aria ·; Il fumo che si mischia infra l'aria ⁸īpoluerata ·, quāto piv s'alza a certa · altezza, parirà oscura nuvo⁹la e vedrassi nelle sōmità piv espeditamente ¹⁰il fumo che la polvere; il fumo pēderà ī colore alquāto azzurro, e la polvere trarà ¹¹al suo · colore ·; Dalla parte · che viene · il lume parrà questa mistio¹²ne d'aria fumo e polvere molto · più · lucida · che dall'opposita parte; ¹³i cōbattitori quāto · piv fieno īfra detta turbulentia meno si vedrā¹⁴no, e meno differētia fia dai lor lumi · alle loro · ōbre ·;

Of the way of representing a battle.

First you must represent the smoke of artillery mingling in the air with the dust and tossed up by the movement of horses and the combatants. And this mixture you must express thus: The dust, being a thing of earth, has weight; and although from its fineness it is easily tossed up and mingles with the air, it nevertheless readily falls again. It is the finest part that rises highest; hence that part will be least seen and will look almost of the same colour as the air. The higher the smoke mixed with the dust-laden air rises towards a certain level, the more it will look like a dark cloud; and it will be seen that at the top, where the smoke is more separate from the dust, the smoke will assume a bluish tinge and the dust will tend to its colour. This mixture of air, smoke and dust will look much lighter on the side whence the light comes than on the opposite side. The more the combatants are in this turmoil the less will they be seen, and the less contrast will there be in their lights and shadows. Their faces and figures and their appearance, and the musketeers as well as those near them you must make of a glowing red. And this glow will diminish in proportion as it is remote from its cause.

Of painting battle pieces (601—603).

601. 1. figurare ƚ. 2. fumo "dell artileria" misciato infrallaria . . cholla. 3. chavagli . . chōbattitori. 4. chosa terestre | "e pōderosa" e bēche. 5. levi . . misci . . baso. 6. dala. 7. chessi. 8. alteza. 9. la vederasi. 10. azzuro ella. 11. para.

Farai rosseggia[15]re i volti e le persone e lor aria, e li scoppettieri insieme cō vicini; [16]E detto rossore quāto piv si parte dalla sua cagione piv si perde ·, e le figu[17]re che sono infra · te · e 'l lume, essēdo lōtane, parrāno scure in campo chia[18]ro ·, e le loro gābe quāto piv s'appresserā alla terra mē fieno vedute, [19]perchè la polvere è lì piv grossa e piv spessa: E se farai caualli [20]corrēti fori della turba, fa li nvboletti di polvere distāti l'uno dall'altro, [21]quāto può essere lo īteruallo de' salti fatti dal cavallo e quello nv[22]volo ·, ch'è · piv lontano da detto · cavallo, mē si uegga · anzi sia alto spar[23]so · e raro ·, e 'l piv presso · sia piv euidēte e minore e piv dēso: L'aria [24]sia · piena · di saettume di diverse ragioni: chi mōti ·, chi discēda, [25]qual sia · per linia piana, e le pallotte delli scopietti sieno accōpa[26]gnate da alquāto · fumo dirieto al lor corso · e le prime figure farai [27]poluerose ·, i capelli e ciglia e altri loghi piani atti a sostener la polvere; [28]farai i vīcitori corrēti cō capegli, e altre cose leggiere, sparsi [29]al uēto colle ciglia · basse

The figures which are between you and the light, if they be at a distance, will appear dark on a light background, and the lower part of their legs near the ground will be least visible, because there the dust is coarsest and densest[19]. And if you introduce horses galloping outside the crowd, make the little clouds of dust distant from each other in proportion to the strides made by the horses; and the clouds which are furthest removed from the horses, should be least visible; make them high and spreading and thin, and the nearer ones will be more conspicuous and smaller and denser[23]. The air must be full of arrows in every direction, some shooting upwards, some falling, some flying level. The balls from the guns must have a train of smoke following their flight. The figures in the foreground you must make with dust on the hair and eyebrows and on other flat places likely to retain it. The conquerors you will make rushing onwards with their hair and other light things flying on the wind, with their brows bent down,

Ash. I. 5*a*] **602.**

e caccino i cōtrari mēbri ināzi, cioè · se manderà uno ināzi il piè destro [2]che 'l braccio stāco ācor lui vēga ināzi, e se farai alcuna caduta [3]farai lì segnio dello · isdruciolare · sù per la polvere condotta ī sāguinoso [4]fāgo ·, e dintorno alla mediocre liquidezza della terra farai vedere stampa-[5]te le pedate degli omini e cavalli · di lì passati ·, farai alcuno cavallo [6]strascinare morto il suo signore e dirieto a quello lasciare [7]per la · polvere e fāgo jl segno dello strascinato corpo; farai i vīti e battuti [8]pallidi · colle ciglia alte nella lor cōgiūtione e la carne che resta sopra loro [9]sia abbondāte di dolēti crespe; Le faccie del naso sieno con alquāte grīze [10]partite in arco

and with the opposite limbs thrust forward; that is where a man puts forward the right foot the left arm must be advanced. And if you make any one fallen, you must show the place where he has slipped and been dragged along the dust into blood stained mire; and in the half-liquid earth arround show the print of the tramping of men and horses who have passed that way. Make also a horse dragging the dead body of his master, and leaving behind him, in the dust and mud, the track where the body was dragged along. You must make the conquered and beaten pale, their brows raised and knit, and the skin above their brows furrowed with pain, the sides of the nose with wrinkles going in an arch from the nostrils to the eyes, and make the nostrils drawn up — which is the cause of the lines of which I speak —, and the lips arched upwards and discovering the upper teeth; and the teeth apart as with crying out

12. oposita. 14. vederā. 15. elle . . dararia elli . . covicini. 16. della . . chagione. 17. chessono . . sure in champo. 19. Esse . . chaualli. 20. corēti . . falli. 22. chavalo . . uega. 24. ragione. 25. elle ballotte . . schopietti . . achōpa. 26. giate da . . chorso . elle. 27. chapelli . assostenela. 28. corēti cho chapegli [sparsia] e . . chose legieri. 29. chole.
602. 1. echacci cōtrari . . mandera. 2. stāchoāchor . . esse ffarai alchuna chaduta. 4. ala . . liquideza . . tera . . isstampi. 5. chavalli . . alchuno chavallo. 6. strascinare [il suo chō] morto . . acquello. 7. effango . . strascinato chorpo . . viti "e battuti". 8. palidi . . charne. 9. abondāte. 10. archo dale anarise etterminate nel prencipio . . anari. 11. se alte chagiō . . archate

dalle narici e terminate nel prīcipio dell'occhio; Le nari[11]ci alte, cagiō di dette pieghe, le labra arcate scoprano i dēti di sopra, [12]dēti spartiti in modo di gridare cō lamēto · L'una delle ma[13]ni faccia scudo ai pavrosi ochi, voltādo il di dētro īverso il nimico, [14]L'altra stia a terra a sostenere il leuato busto; Altri farai gridāti colla [15]bocca sbarrata e fugiēti: farai molte sorte d'arme īfra i piedi de' cōbatti[16]tori, come scudi rotti, lancie, spade rotte e altre simili cose ·, farai omini [17]morti, alcuni ricoperti mezzi dalla poluere, altri tutti; La poluere che si [18]mischia coll'uscito sangue cōvertirsi in rosso fango e vedere il sāgue [19]del suo colore correre cō torto corso dal corpo alla poluere; [20]altri morēdo strigniere i dēti, stravolgiere gli ochi, strignere le pugna alla [21]persona e le gābe storte ·; Potrebbesi vedere alcuno disarmato e abba[22]ttuto dal nimico volgersi al nemico cō morsi e graffi e fare crude[23]le e aspra vēdetta · Potresti vedere alcuno cavallo leggiero correre [24]cō i crini sparsi · al vēto īfra i nimici e cō piedi fare molto dāno; [25]vedresti alcuno · stroppiato cadere ī terra farsi copritura col suo scudo, [26]e 'l nemico chinato in basso far forza di dare morte a quello; [27]potrebbesi uedere molti omini caduti ī vn gruppo sopra uno cavallo morto; [28]Vedrai alcuni vīcitori lasciare il cōbattere · e vscire della moltitudine [29]nettādosi colle 2 mani li occhi e le guācie, ricoperte di fāgo, fatto dal lacrima[30]re degli ochi per causa della poluere · Vedresti le squadre del soccorso [31]stare piē di sperāza e suspetto cō le ciglia aguzze, faciēdo a quelle · ōbra colle mani e riguardare [32]īfra la folta e cōfusa caligine dell'essere attēti al comādamēto del Capi[33]tano, e simile il Capitano col bastone levato e corrēte ī verso il socorso [34]mostrare a quelli la parte dov'è di loro caristia · Ed alcū fiume, dentrovi [35]cavalli corrēti, riēpiēdo la circonstāte aqua di turbulēza d'onde, di schivmo [36]e d'acqua cōfusa saltāte īfra l'aria e tra le gābe e corpi de' cavalli [37]E nō fare nessū loco piano se nō le pedate ripiene di sāgue.

and lamentation. And make some one shielding his terrified eyes with one hand, the palm towards the enemy, while the other rests on the ground to support his half raised body. Others represent shouting with their mouths open, and running away. You must scatter arms of all sorts among the feet of the combatants, as broken shields, lances, broken swords and other such objects. And you must make the dead partly or entirely covered with dust, which is changed into crimson mire where it has mingled with the flowing blood whose colour shows it issuing in a sinuous stream from the corpse. Others must be represented in the agonies of death grinding their teeth, rolling their eyes, with their fists clenched against their bodies and their legs contorted. Some might be shown disarmed and beaten down by the enemy, turning upon the foe, with teeth and nails, to take an inhuman and bitter revenge. You might see some riderless horse rushing among the enemy, with his mane flying in the wind, and doing no little mischief with his heels. Some maimed warrior may be seen fallen to the earth, covering himself with his shield, while the enemy, bending over him, tries to deal him a deathstroke. There again might be seen a number of men fallen in a heap over a dead horse. You would see some of the victors leaving the fight and issuing from the crowd, rubbing their eyes and cheeks with both hands to clean them of the dirt made by their watering eyes smarting from the dust and smoke. The reserves may be seen standing, hopeful but cautious; with watchful eyes, shading them with their hands and gazing through the dense and murky confusion, attentive to the commands of their captain. The captain himself, his staff raised, hurries towards these auxiliaries, pointing to the spot where they are most needed. And there may be a river into which horses are galloping, churning up the water all round them into turbulent waves of foam and water, tossed into the air and among the legs and bodies of the horses. And there must not be a level spot that is not trampled with gore.

schoprano. 12. I dēti . . imodo . . chō lamēto [alchuni fara] Luna dele. 13. schudo . . nimicho. 14. atterra assostenere i leuato . . cholla. 15. bocha isbarata effugiēte. 16. chose. 17. alcouni richoperti n ezi dala . . chessi. 18. miscia choll . . chōvertirsi. 19. cholore chore chō . . chorso [super . lo chorp] dal corpo. 20. signiere. 21. elle . . Potrebesi . . alchuno. 22. nimicho . . nimicho chō. 23. asspra . . alchuno chavallo legieri chorere. 24. cho . . echo . . dano. 25. alchuno . . storpiato chadere . . choprituro chol . . schudo. 26. nemicho . . baso . . ecquello. 27. portrebbe ssi . . chaduti . . grupo . . ī chaval. 28. vederai alchuni. 29. netādosi chole . . elle . . ricoperti . . fāgho . . da. 30. per lamor della polvere vederesti . . sochorsi. 31. stare | "piē di sperāza e sospetto"cho . . ayuza . . acquelle . . chole. 32. ed chōfusa chaligine . . chomādamēto . . corēte. 33. acquelli . . alchū. 35. cavali . . circhonstate scivma. 36. eddacqua , . chorp de chavalli. 37. Et

G. 15a] **603.**

DELLE ALLUMINATIONI DELLE [2]PARTI INFIME DELLI CORPI CHE INSIEME [3]RESSERO COME LI OMINI IN BATTAGLIE.

[4]Delli omini e cavalli in battaglia travagliāti;—[5]le lor parti saran tāto più oscure quā[6]to esse fien più vicine alla terra che li so[7]stiene; E questo si pruova per le parieti [8]de' pozzi i quali si fan tanto più oscure quan[9]to esse più si profondano, e questo na[10]scie perchè la parte più profõda de' pozzi vede [11]ed è veduta da minor parte dell'aria lumi[12]nosa che nessuna altra sua parte.

[13]E li pauimēti [14]del medesimo co[15]lore, che ànno le gā[16]be delli predetti [17]omini e cavalli, fi[18]eno senpre più al[19]luminati infra ā[20]goli equali che [21]le altre predet[22]te gābe ecc.

OF LIGHTING THE LOWER PARTS OF BODIES CLOSE TOGETHER, AS OF MEN IN BATTLE.

As to men and horses represented in battle, their different parts will be dark in proportion as they are nearer to the ground on which they stand. And this is proved by the sides of wells which grow darker in proportion to their depth, the reason of which is that the deepest part of the well sees and receives a smaller amount of the luminous atmosphere than any other part.

And the pavement, if it be of the same colour as the legs of these said men and horses, will always be more lighted and at a more direct angle than the said legs &c.

Ash. I. 17a] **604**

DEL MODO DEL FIGURARE UNA NOTTE.

Of depicting night-scenes.

[2]Quella cosa che è priuata īteramēte di luce è tutta tenebre; essendo la [3]notte ·ī simile cōditione se tu vi vogli figurare una storia farai · che, [4]essēdovi uno grāde fuoco, che quella cosa ch'è più propīqua a detto fuoco [5]piv si tīga nel suo colore ·, perchè quella cosa ch'è piv vicina all' obietto piv [6]partecipa della sua · natura ·, e faciēdo · il foco pēdere ī color rosso [7]farai tutte le cose ·, alluminate da quello, ancora loro rosseggiare, [8]e quelle che sono piv lontane · a detto fuoco piv siē tīte dal colore nero [9]della notte ·; le figure che sono tratte al fuoco · appariscono · scure nella [10]chiarezza d'esso foco, perchè quella parte d'essa cosa che vedi · è tinta dalla oscuri[11]tà della notte e nō dalla chiarezza del foco ·, e quelli che si trovano dai lati [12]sieno mezzi oscuri · e mezzi rosseggiāti, e quelli che si possono vedere dopo [13]e' termini delle fiāme · saranno tutti alluminati · di rosseggiāte lume ī cāpo nero ·; jn quāto [14]a li atti farai quelli che lì sono presso farsi scudo colle mani e cō mātelli ripa[15]ro del superchio · calore · e torti

OF THE WAY TO REPRESENT A NIGHT [SCENE].

That which is entirely bereft of light is all darkness; given a night under these conditions and that you want to represent a night scene,—arrange that there shall be a great fire, then the objects which are nearest to this fire will be most tinged with its colour; for those objects which are nearest to a coloured light participate most in its nature; as therefore you give the fire a red colour, you must make all the objects illuminated by it ruddy; while those which are farther from the fire are more tinted by the black hue of night. The figures which are seen against the fire look dark in the glare of the firelight because that side of the objects which you see is tinged by the darkness of the night and not by the fire; and those who stand at the side are half dark and half red; while those who are visible beyond the edges of the flame will be fully lighted by the ruddy glow against a black background. As to their gestures, make those which are near it screen themselves with their hands and cloaks as a

603. 2. parte corpi insiemo. 3. ressro come. 4. chavagli in bactaglia. 5. parte . . oscure. 6. chelli. 7. Ecquessto . . pariete. 8. le quali . . osscure q"a". 9. profondano ecquessto nas. 13. elli. 14. cho. 15. che à le ghā. 17. omi e chavagli. 18. piua. 20. gholi. 22. ghābe.

604. 1. ī notte. 2. chosa . . ettutta. 3. ettu . . ī storia. 4. sēdovi ī . . focho . . propīquo . . focho. 5. cholore . . visina. 6. effaciēdo . il foco . . v̄ cholor. 7. chose aluminate dacquello . . rossegiare [farai]. 8. ecquelle chessono . . focho . . tīti del. 9. chessono . . focho . . apariscino scuri. 10. chiareza foco ettinta. 11. chiareza del foco . . chessi. 12. mezi

col volto ī cōtraria parte mostrare fugire
[16]quelli piv lōtani farai grā parte di loro
farsi colle mani alli ochi, offesi [17]dal super-
chio splēdore.

defence against the intense heat, and with
their faces turned away as if about to retire.
Of those farther off represent several as rai-
sing their hands to screen their eyes, hurt by
the intolerable glare.

B. M. 169 a]

605.

Discrivi uno vē[2]to terrestre e [3]marittimo.
[4]Discriui vna [5]pioggia.

Describe a wind on land and at sea.
Describe a storm of rain.

Of depicting
a tempest
(605. 606).

Ash. I. 14 b]

606.

COME SI DEE FIGURARE UNA FORTUNA.

[2]Se tu uoi figurare una fortuna · cōsidera
e poni bene i sua effetti; Quādo [3]il uēto ·,
soffiādo sopra la superfitie del mare e della
· terra ·, rimove e porta [4]cō seco quelle cose
· che nō sono ferme colla vniuersale · massa,
e per bē [5]figurare · questa fortuna · farai ī
prima li nuvoli spezzati e rotti diriz[6]zarsi
per lo corso del uēto ·, accōpagniati da
l' arenosa polvere leuata [7]da liti marini ·, e
rami e foglie leuati per la potētia del furore
del uēto [8]sparse per l' aria: e ī conpagnia
di quelle molte altre cose leggiere li alberi
[9]e l' erbe piegate a terra, quasi mostrarsi
volere seguire il corso de' vēti [10]coi rami storti
fori del naturale corso e cō le scōpigliate
e rouesciate [11]foglie; gli omini che li si tro-
uano parte caduti e rivolti per li panni e
per la [12]poluere, quasi sieno sconoscivti, e
quelli che restano ritti sieno dopo qual[13]che
albero abbracciati a quello, perchè il uēto
nō li strascini, altri colle [14]mani alli ochi
per la polvere chinati a terra ed i panni
e capelli diritti [15]al corso del uento; Il mare,
turbato e tēpestoso, sia pieno di ritrosa schi-
[16]vma īfra l' eleuate ōde e 'l uēto levato
īfra la cōbattuta aria della [17]schivma piv sot-

HOW TO REPRESENT A TEMPEST. .

If you wish to represent a tempest con-
sider and arrange well its effects as seen,
when the wind, blowing over the face of
the sea and earth, removes and carries with
it such things as are not fixed to the general
mass. And to represent the storm accur-
ately you must first show the clouds scattered
and torn, and flying with the wind, accompanied
by clouds of sand blown up from the sea
shore, and boughs and leaves swept along
by the strength and fury of the blast and
scattered with other light objects through
the air. Trees and plants must be bent to
the ground, almost as if they would follow
the course of the gale, with their branches
twisted out of their natural growth and their
leaves tossed and turned about [11]. Of the
men who are there some must have fallen to
the ground and be entangled in their garments,
and hardly to be recognized for the dust, while
those who remain standing may be behind
some tree, with their arms round it that the
wind may not tear them away; others with
their hands over their eyes for the dust, ben-
ding to the ground with their clothes and
hair streaming in the wind.[15] Let the
sea be rough and tempestuous and full of
foam whirled among the lofty waves, while
the wind flings the lighter spray through
the stormy air, till it resembles a dense
and swathing mist. Of the ships that are

osscuri . . ecquelli . . possano. 13. e termini . . fiame sarano . . icāpo. 14. quellieli sono . comategli aripa. 15. cha-
lore . . chol ulto. 16. queli . . cole mani ali.
605. 1. ī̂ vē. 2. terrette. 4. disscriui.
606. 1. ī̂ fortuna. 2. figurare ī̂. 3. tera. 4. cōsecho . . cholla. 5. nvole spezati . . diri. 6. achōpagniati. 8. isparsi . . legieri
chose li. 9. allera. 10. echole. 11. pani. 12. conoscivti ecqueli. 13. abraciati . . quelli . . stracini . . chole. 14. [2] mani
ali . . attera . . chapegli diriti. 15. ettēpestoso . . sci. 16. infralle . . leuate. 17. avvilupata nelia. 18. alchuni . . facci

606. 8—11. See Pl. XL, No. 2.
11—15. See Pl. XXXIV, the right hand lower sketch.

tile, a vso di spessa ed avviluppata nebbia: i navili, che dētro [18]vi sono, alcuni se ne faccia colla vela rotta e i brani d'essa uētilādo ī[19]fra l'aria ī cōpagnia d'alcuna corda rotta, alcuni alberi rotti ca[20]duti col navilio intrauersato e rotto īfra le tēpestose ōde, cierti omi[21]ni gridāti abbracciare il rimanēte del navilio, farai li nvuoli cacciati [22] da l'īpetuosi venti, battuti nel' alte cime delle mōtagne e fare aquelli avvi[23]luppati, ritrosi, a similitudine dell'ōde percosse nelli scogli; l'aria spauēto[24]sa per le oscure tenebre fatte in nell'aria dalla poluere, nebbia e nvuoli folti.

therein some should be shown with rent sails and the tatters fluttering through the air, with ropes broken and masts split and fallen. And the ship itself lying in the trough of the sea and wrecked by the fury of the waves with the men shrieking and clinging to the fragments of the vessel. Make the clouds driven by the impetuosity of the wind and flung against the lofty mountain tops, and wreathed and torn like waves beating upon rocks; the air itself terrible from the deep darkness caused by the dust and fog and heavy clouds.

G. 6 b] 607.

FIGURATIONE DEL DILUVIO.

TO REPRESENT THE DELUGE.

Of representing the deluge (607—609).

[2]L' aria era oscura per la spessa pioggia, la qual, [3]con obbliqua disciesa, piegata dal trauersal corso [4]de' vēti, facieva onde di se per l'aria, nō altramēti [5]che farsi uegga alla poluere, ma sol si uariaua per[6]chè tale inondatione era traversata dalli liniamē[7]ti che fanno le gocciole dell' acqua che disciēde; ma [8]il colore suo era tinto dal fuoco, [9]gienerato dalle saette fenditrici e squarciatri[10]cie delli nuvoli, e i vampi delle quali percuotea[11]no e aprivano li grā pelaghi delle riēpiute [12]valli, li quali aprimēti mostravano nelli [13]lor vertici le piegate cime delle piante, [14] e Nettuno si vedea in mezzo alle acque col[15]tridēte e vedeasi Eolo colli sua vēti rav[16]uilupare notāti piāte diradicate mi[17]ste colle immēse ōde, l'orizzōte con tutto [18] lo emisperio era turbo e focoso per li ricie[19]vuti vanpi delle continue saette, vedeasi [20]li omini e vccielli che riēpievā di se li gran[21]di alberi, che scoperti dalle dila[22]tate onde cōponitrici delli colli, circūda[23]tori delli grā baratri.

The air was darkened by the heavy rain whose oblique descent driven aslant by the rush of the winds, flew in drifts through the air not otherwise than as we see dust, varied only by the straight lines of the heavy drops of falling water. But it was tinged with the colour of the fire kindled by the thunder-bolts by which the clouds were rent and shattered; and whose flashes revealed the broad waters of the inundated valleys, above which was seen the verdure of the bending tree tops. Neptune will be seen in the midst of the water with his trident, and [15] let Æolus with his winds be shown entangling the trees floating uprooted, and whirling in the huge waves. The horizon and the whole hemisphere were obscure, but lurid from the flashes of the incessant lightning. Men and birds might be seen crowded on the tall trees which remained uncovered by the swelling waters, originators of the mountains which surround the great abysses [23].

W. 158 a] 608.

DILUUIO E SUA DIMOSTRATIONE [2]IN PICTURA.

OF THE DELUGE AND HOW TO REPRESENT IT IN A PICTURE.

[3]Vedeasi la oscura e nvbolosa aria essere conbattuta dal corso di diversi vēti

Let the dark and gloomy air be seen buffeted by the rush of contrary winds and

chola. 19. rotti ch'a. 20. chol. 21. abraciare. 22. battute mōtagne e fare acquegli avi. 23. lupati .. assimilitudine .. neli. 24. ischure .. inell dala .. nebia.

607. 2. osschura. 3. obbliquo discieso peghato .. chorso .. notaltromēti. 5. uegha. 6. deli,. 7. cheffalle ghogeciole .. dissciēde. 8. era [participante del colore] "tinto" del focho. 9. essquartatri. 10. el uápo .. perchotea. 12. mosstravano. 15. pieghate. 14. nechunno .. mezo alla. 15. tridēde evlo cholli. 16. diradichate. 17. cholle inmēse .. chon. 18. emissperio .. effochoso. 19. continvue saecti. 20. cherriēpievā. 21. che [anchora erano] scoperti. 22. delli de colli circhūda. 23. delle grabalatri.

608. 1. essua dimosstratione .. 2. pictura [cōatti apropiati]. 3. osscura .. chonbactuta .. chorso .. vēti "eavilupati della cō-

607. 23. Compare Vol. II. No. 979.

e avviluppati dalla cõtinua pioggia e misti colla gragnuola, li quali or qua ⁴ora là portauano infinita ramificatione delle stracciate piante, miste con ĩfinite foglie; ⁵d'intorno vedeasi le antiche piante diradicate e stracciate dal furor de' venti, vede⁶vasi le ruine de' mõti, già scalzati dal corso de' lor fiumi, ruinare sopra i medesimi fiumi e chiudere le loro valli; ⁷li quali fiumi rĩgorgati allagauano e sõmergieuano le moltissime terre colli lor popo⁸li; ancora avresti potuto vedere nelle sõmità di molti monti essere insieme ridotte molte · ⁹varie spetie d'animali, spauẽtati e ridotti al fin dimesticamẽte in cõpagnia de' fug¹⁰giti omini e donne colli lor figlioli; E le canpagnie coperte d'acqua mostravã le sue õde ¹¹in grã parte coperte di tavole, lettiere, barche, altri vari strumẽti fatti dalla neciessità e pavra ¹²della morte, sopra li quali erã donne, omini colli lor figlioli misti, cõ diuerse lamẽtationi e ¹³pianti spaventati dal furor de' venti, li quali con grãdissima fortuna rivolgievã l'acque ¹⁴sotto sopra e insieme colli morti, da quella annegati, e nessuna cosa più lieve che ¹⁵l'acqua era che nõ fussi coperta di diuersi animali, i quali, fatti tregua, stauano ¹⁶insieme cõ paurosa collegatione, infra quali erã lupi, volpi, serpi e d'ogni sorte fugi¹⁷tori dalla morte; E tutte l'onde percuotitricie lor liti conbattevan quelle colle varie ¹⁸percussioni di diuersi corpi annegati, le percussioni de' quali vccideuano quelli, alli quali ¹⁹era restato vita; Alcune congrega-

dense from the continued rain mingled with hail and bearing hither and thither an infinite number of branches torn from the trees and mixed with numberless leaves. All round may be seen venerable trees, uprooted and stripped by the fury of the winds; and fragments of mountains, already scoured bare by the torrents, falling into those torrents and choking their valleys till the swollen rivers overflow and submerge the wide lowlands and their inhabitants. Again, you might have seen on many of the hill-tops terrified animals of different kinds, collected together and subdued to tameness, in company with men and women who had fled there with their children. The waters which covered the fields, with their waves were in great part strewn with tables, bedsteads, boats and various other contrivances made from necessity and the fear of death, on which were men and women with their children amid sounds of lamentation and weeping, terrified by the fury of the winds which with their tempestuous violence rolled the waters under and over and about the bodies of the drowned. Nor was there any object lighter than the water which was not covered with a variety of animals which, having come to a truce, stood together in a frightened crowd—among them wolves, foxes, snakes and others—fleing from death. And all the waters dashing on their shores seemed to be battling them with the blows of drowned bodies, blows which killed those in whom any life remained [19]. You might have

tinua piogia misti cholla gravza" li quali. 4. ramifichatione di "delle stracciate" [varie] piante [le quali] miste chon ifinite. 5. diradichate esstracinate. 6. sopra e . *On the margin is written* "e chiudere le loro valli". 7. righorghati allaghauano essomergieuano cholli. 8. "li" anchora aressti . . ridotto. 9. dimestichamẽte. 10 Elle chanpagnie choperte . . mosstravã. 11. choperte. 12. choli . . figlio missti chõ. 13. chon. 14. socto . . choli . . dacquella anneghati . . chel. 15. equali [pa] fatti treghua . . ĩ. 16. cholleghatione . . volpe serpe. 17. della . . perchuotritricie. 18. perchussioni . . anneghati le perchussio . . alliq"a". 19. [t]era . . Alchune chongreghatione . . aressti, 20. chon arata . . difendeno li picholi . . era

608. This chapter, which, with the next one, is written on a loose sheet, seems to be the passage to which one of the compilers of the Vatican copy alluded when he wrote on the margin of fol. 36: *"Qua mi ricordo della mirabile discritione del Diluuio dello autore."* It is scarcely necessary to point out that these chapters are among those which have never before been published. The description in No. 607 may be regarded as a preliminary sketch for this one. As the MS. G. (in which it is to be found) must be attributed to the period of about 1515 we may deduce from it the approximate date of the drawings on Pl. XXXIV, XXXV, Nos. 2 and 3, XXXVI and XXXVII, since they

obviously belong to this text. The drawings No. 2 on Pl. XXXV are, in the original, side by side with the text of No. 608; lines 57 to 76 are shown in the facsimile. In the drawing in Indian ink given on Pl. XXXIV we see Wind-gods in the sky, corresponding to the allusion to Aeolus in No. 607 l. 15.—Plates XXXVI and XXXVII form one sheet in the original. The texts reproduced on these Plates have however no connection with the sketches, excepting the sketches of clouds on the right hand side. These texts are given as No. 477. The group of small figures on Pl. XXXVII, to the left, seems to be intended for a *'congregatione d'uomini.'* See No. 608, l. 19.

tioni d'uomini avresti potuto vedere, ²⁰le quali con armata mano difendevano li piccoli siti (che loro erā rimasti) ²¹da lioni, lupi e animali rapaci, che quiui cercavā lor salute; O quanti romori ²²spaventevoli si sentivā per l'aria scura, percossa dal furore de' tuoni e delli fulgori da quelli scacciati, — che per ²³quella ruinosamente scorrevano percotēdo ciò che s'opponea al suo corso; O quāti ²⁴avresti veduti colle propie mani chiudersi li orechi per schifare l'īmēsi romori, fatti ²⁵per la tenebrosa aria dal furore de' uēti misti con pioggia, tuoni cielesti e furore²⁶di saette; Altri nō bastando loro il chiudere delli ochi, Ma colle propie mani ponēdo ²⁷quelle l'una sopra dell'altra, più se li copriuano per nō vedere il crudele stratio fatto del²⁸la vmana spetie dall'ira di dio; O quāti lamenti o quāti spavētati si gittavano dalli scogli; ²⁹Vedeasi le grandi ramificationi delle grā quércie, cariche d'uomini esser portate ³⁰per l'aria dal furore delli inpetuosi venti; Quante erā le barche volte sotto sopra, ³¹ e quelle intere e quelle in pezzi esservi sopra giente travagliandosi per loro scampo ³²con atti e movimēti dolorosi pronosticāti di spavētevole morte; ³³Altri con movimēti disperati si toglievano la uita, disperādosi di nō potere sop³⁴portare tal dolore, de' quali alcuni si gittavano dalli alti scogli, altri si strī³⁵gievano la gola colle propie mani, alcuni pigliavā li propi figlioli e con grā³⁶de rapidità li sbattevā interi, alcuni colle propie sue armi si ferivano e vccideā ³⁷se medesimi, altri gittandosi ginochioni si raccomādauā a dio: o quāte madri piāgie³⁸vano i sua annegati figlioli, quelli tenēti sopra le ginocchia, alzando le braccia aperte in³⁹verso il cielo e con voci, conposte di diversi vrlamēti, riprēdeuā l'ira delli dei ‖ altri ⁴⁰colle mā giunte e le dita insieme tessute mordeuano e cō sanguinosi morsi quel ⁴¹diuoravā, piegandosi col petto alle ginocchia per lo inmēso e insopportabile dolore; ⁴²Vedeāsi li armēti delli animali come cavalli, buoi, capre, pecore ⁴³esser già attornitate dalle acque e essere restate in isola nell'alte cime de' mōti già restrigniersi

seen assemblages of men who, with weapons in their hands, defended the small spots that remained to them against lions, wolves and beasts of prey who sought safety there. Ah! what dreadful noises were heard in the air rent by the fury of the thunder and the lightnings it flashed forth, which darted from the clouds dealing ruin and striking all that opposed its course. Ah! how many you might have seen closing their ears with their hands to shut out the tremendous sounds made in the darkened air by the raging of the winds mingling with the rain, the thunders of heaven and the fury of the thunder-bolts. Others were not content with shutting their eyes, but laid their hands one over the other to cover them the closer that they might not see the cruel slaughter of the human race by the wrath of God. Ah! how many laments! and how many in their terror flung themselves from the rocks! Huge branches of great oaks loaded with men were seen borne through the air by the impetuous fury of the winds. How many were the boats upset, some entire, and some broken in pieces, on the top of people labouring to escape with gestures and actions of grief foretelling a fearful death. Others, with desperate act, took their own lives, hopeless of being able to endure such suffering; and of these, some flung themselves from lofty rocks, others strangled themselves with their own hands, other seized their own children and violently slew them at a blow; some wounded and killed themselves with their own weapons; others, falling on their knees recommended themselves to God. Ah! how many mothers wept over their drowned sons, holding them upon their knees, with arms raised spread out towards heaven and with words and various threatening gestures, upbraiding the wrath of the gods. Others with clasped hands and fingers clenched gnawed them and devoured them till they bled, crouching with their breast down on their knees in their intense and unbearable anguish. Herds of animals were to be seen, such as horses, oxen, goats and swine already environed

rimasi) conarmata ma. 21. lione . . cierchavā. 22. l'aria "scura" perchossa da dal . . dell fulghore . . "dacquelli sati ati" *is written in the margin.* 23. ruinosamenti . . [dacq] perchotēdo . . chessoppone alsocorso. 24. aresti . . cholle . . chiudersi . . isscifare. 25. chon . . effurore. 26. basstando . . chiu . . cholle . . ponē. 28. gittavō delli scoglie. 29. le . . ramificationi . . chariche . . portati. 30. dal [chorso] furore. 31. e quale intere e quale in peze . . schanpo. 32. pronosstichati . . [e dolorosa] morte. 33. Altritri chon . . toglievolla. 34. dolore [alchun] . . delli. 35. gievala ghola cholle . . alchuni . . chon. 36. rapito lissbatteva intera, alchuno cholle . . feria. 37. racomādaua addio. 38. aneghati . . ginocha . . bracia. 39. chon "vo"cie chonposte diderse. 40. cholle . . chelle dite [delle mani] insieme . . morde e chō. 41. pieghandosi chol . . ginochia. 42. vedeasi . . chome chavalli . . chapre pechore. 43. attormitato dclle . . resstati . . mōto. 44. resstrigniersi . . ec-

insieme, e quelli del mezzo eleuarsi in alto e caminare sopra delli altri e fare infra loro grã zuffe, de' quali assai ne morivã per carestia di cibo; [46] E già li uccielli si posauan sopra gli omini e altri animali, nõ [47] trovando più terra scoperta che nõ fusse occupata da viuẽti, già la fame, [48] ministra della morte, avea tolto la uita a grã parte delli animali, quando [49] li corpi morti già leuificati si leuauano dal fondo delle [50] profonde acque e surgievano in alto, E infra le conbattenti onde, sopra le [51] quali si sbattevano l' un nell' altro, e come palle piene di vẽto risaltavã [52] indiretro dal sito della lor percussione, questi si facievã [53] basa de' predetti morti: E sopra queste maladitioni si vedea l'aria [54] coperta di oscuri nuvoli, diuisi dalli serpeggianti moti delle infuriate [55] saette del cielo alluminande or qua or là infra la oscurità [58] delle tenebre.

[57] ¶ Vedesi il moto dell' aria medi[58]ante il moto della poluere, [59] mossa dal corso del cavallo, [60] il moto della quale è tãto velo[61]cie a riẽpiere il uacuo, che [62] di se lascia nell'aria, che [63] di se lo uestiua, quãto [64] è la velocità di tal cavallo [65] a fuggirsi dalla predetta aria.

[66] E ti parrà forse po[67]termi riprendere dell' auere [68] io figurato le uie fatte per l'a-[69]ria dal moto dcl uẽto, concio[70]sia chè 'l uẽto per se nõ si uede [71] infra l'aria; A questa [72] parte si rispõde che non il [73] moto del uẽto, ma il moto [74] delle cose da lui porta-[75]te è sol quel che per l'aria si uede. ¶

by the waters and left isolated on the high peaks of the mountains, huddled together, those in the middle climbing to the top and treading on the others, and fighting fiercely themselves; and many would die for lack of food. Already had the birds begun to settle on men and on other animals, finding no land uncovered which was not occupied by living beings, and already had famine, the minister of death, taken the lives of the greater number of the animals, when the dead bodies, now fermented, where leaving the depth of the waters and were rising to the top. Among the buffeting waves, where they were beating one against the other, and, like as balls full of air, rebounded from the point of concussion, these found a resting place on the bodies of the dead. And above these judgements, the air was seen covered with dark clouds, riven by the forked flashes of the raging bolts of heaven, lighting up on all sides the depth of the gloom.

The motion of the air is seen by the motion of the dust thrown up by the horse's running and this motion is as swift in again filling up the vacuum left in the air which enclosed the horse, as he is rapid in passing away from the air.

Perhaps it will seem to you that you may reproach me with having represented the currents made through the air by the motion of the wind notwithstanding that the wind itself is not visible in the air. To this I must answer that it is not the motion of the wind but only the motion of the things carried along by it which is seen in the air.

Diuisioni.

[77] Tenebre, vento, fortuna [78] di mare, diluvio d' acqua, selue [79] infoccate, pioggia, saette del cie[80]lo, terremoti e ruina di [81] mõti, spianamẽti di città.

[76] The divisions.

Darkness, wind, tempest at sea, floods of water, forests on fire, rain, bolts from heaven, earthquakes and ruins of mountains, overthrow of cities.

quelli . . mezo . . chaminare. 45. effare infralloro . . charesstia dicib. 47. fussi ochupata. 48. ministra 49. leuifichati. 50. essurgievano . . infralle conbattente. 51. fisbattevan . . chome. 52. indireto da sito . . perchussione questi eran [al continuo] si. 53. di . . Essopra. 54. choperta di osscuri . . serpegianti. 55. cielo [le qua] aluminando . . infralla osscurita. 59. cavallo [il]. 60. ettanto. 61. arriẽpieri in vachuo. 62. lasscia . . che [lui]. 63. se il uestiua quanto Quãto. 64. ella . . chavallo. 65. affuggirsi della. 66. [E] Ti. 68. fighurato. 71. infrallaria Acquessta. 72. risspõde . . nõ nil. 74. chose

76. These observations, added at the bottom of the page containing the full description of the deluge seem to indicate that it was Leonardo's intention to elaborate the subject still farther in a separate treatise.

81. *Spianamenti di città* (overthrow of cities). A

considerable number of drawings in black chalk, at Windsor, illustrate this catastrophe. Most of them are much rubbed; one of the least injured is reproduced at Pl. XXXIX. Compare also the pen and ink sketch Pl. XXXVI.

82 ¶ Vēti revertiginosi 83 che portano ac-
qua, 84 rami di piāte e omini infra l' aria ¶

85 ¶ Rami stracciati da vēti 86 misti col
corso de' vē87ti con giente di sopra. ¶

88 ¶ Piāte rotte cariche 89 di gente. ¶

90 ¶ Navi rotte in pezzi 91 battute in
iscogli. ¶

92 Delli armēti, 93 grādine, 94 saette, 95 vēti
re96vertigino97si.

98 Gente che siē sopra piāte che nō si
possō sostenere | alberi e scogli, torri, colli
piē di gēte, barche, tavole, madie 99e altri
strumēti da natare ‖ colli coperti d' uomini
e donne e animali e saette da nvuoli che
alluminīo le cose.

Whirlwinds which carry water [spouts]
branches of trees, and men through the air.

Boughs stripped off by the winds, mingling by
the meeting of the winds, with people upon them.

Broken trees loaded with people.

Ships broken to pieces, beaten on rocks.

Flocks of sheep. Hail stones, thunder-
bolts, whirlwinds.

Peoble on trees which are unable to
to support them; trees and rocks, towers and
hills covered with people, boats, tables,
troughs, and other means of floating. Hills
covered with men, women and animals; and
lightning from the clouds illuminating every
thing.

W. 158b] 609.

DESCRITIONE DEL DILUUIO.

2 Sia inprima figurata la cima d' un aspro
monte con alquanta valle circustante 3 alla
sua basa, e ne' lati di questo si ueda la
scorza del terreno leuarsi insieme 4 colle
minute radici di piccoli sterpi e spogliar di
se grā parte delli circūstanti scogli, 5 ruvi-
nosa disciēda di tal dirupamēto con tur-
bolenza del corso vada percuotēdo e scal-
zando 6 le ritorte e globulenti radici delle
grā piāte, e quelle ruinando sotto sopra,
e le mō7tagnie denudandosi scoprino le pro-
fonde fessure fatte in quelle dalli antichi
8 terremoti, e li piedi delle mōtagnie sieno
in gran parte rincalzate vestite 9 delle rvine
delli arbusti precipitati da lati dell' alte cime
de' predetti 10 mōti, i quali siē misti cō fango,
radici, rami d' alberi cō diuerse foglie infusi
infra esso fango 11 e terra e sassi, E le ruine
d' alcuni monti sien disciese nella profondità
12 d' alcuna valle, e faccisi argine della rin-
gorgata acqua del suo fiume, la quale ar-
13 gine già rotta scorra con grādissime onde,
delle quali le massime percuoti14no e ruinino
le mura delle città e uille di tal valle, E
le ruine degli alti edifiti 15 delle predette
città levino grā poluere, l' acqua si leui in
alto in forma di fumo, o di ravvi16luppati
nuvoli si movino contro alla disciendēte
pioggia; Ma la ringorgata 17 acqua si vada

DESCRIPTION OF THE DELUGE.

Let there be first represented the summit
of a rugged mountain with valleys sur-
rounding its base, and on its sides let the
surface of the soil be seen to slide, together
with the small roots of the bushes, de-
nuding great portions of the surround-
ing rocks. And descending ruinous from
these precipices in its boisterous course,
let it dash along and lay bare the twisted
and gnarled roots of large trees over-
throwing their roots upwards; and let the
mountains, as they are scoured bare, dis-
cover the profound fissures made in them by
ancient earthquakes. The base of the moun-
tains may be in great part clothed and co-
vered with ruins of shrubs, hurled down
from the sides of their lofty peaks, which
will be mixed with mud, roots, boughs of
trees, with all sorts of leaves thrust in
with the mud and earth and stones. And
into the depth of some valley may have fallen
the fragments of a mountain forming a
shore to the swollen waters of its river;
which, having already burst its banks, will
rush on in monstrous waves; and the greatest
will strike upon and destroy the walls of the
cities and farmhouses in the valley [14]. Then
the ruins of the high buildings in these ci-
ties will throw up a great dust, rising up in

[p] dallui. 77. denebre. 78. salue. 79. infochate. 80. lo [ruin] teremoti. 83. porrtano. 84. infralla"ria". 86. corsorso.
90. nave . . pezi. 91. isscoglli. 94. saetti. 98. chessiē . . posō scotenere | albri esscogli. 99. notare . colli [de] . . chose.
609. 1. desscritione. 2. fighurato . . asspro vale circhustante. 3. basa [e di questo] ēne . . lasscorza . . tereno. 4. picholi . .
esspogliar . . "circūstanti" scogli [ella pioggia]. 5. disscēda di . . deruppamēto chon turbole del chorso . . perchotēdo
esschalzando. 6. E gluppolente . . ecquelle . . elle. 7. inquelli. 8. elli . . rinchalzate vestiti. 9. albussti . . dellalalalte . .
prede. 10. equali . . missti fangho . . fangho. 11. etterra essassi Elle . . dalchuni . . disciese. 12. dalchuna effaccisi
. . ringhorghata. 13. chon . . perchuti. 14. runino . . delli Elle. 15. della predetta citti . . laquasi . . ravi. 16. lupali . .
dissciendette Malla ringhorghata . . 17. pelagho . . asse . . chon. 18. perchotendo errisaltando . . cholla fangho. 19. sciu-

609. The sketches on Pl. XXXV 3 stand by the side of lines 14 to 54.

raggirando pel pelago, che dētro a se la rinchiude, e con ritrosi [18]revertiginosi in diuersi obbietti percuotendo e risaltando in aria colla fango[19]sa schiuma, poi ricadendo e faciendo reflettere in aria l'acqua percossa; E le onde [20]circulari che si fuggono dal loco della percussione, caminando col suo inpeto in tra[21]verso sopra del moto dell'altre onde circulari, che contra di loro si muovono e dopo la [22]fatta percussione risalgono in aria sanza spiccarsi dalle lor base; E all'uscita, che l'acqua [23]fa di tal pelago, si uede le disfatte onde distendersi inverso la loro vscita, dopo la [24]quale, cadendo over disciēdendo infra l'aria, acquista peso e moto inpetuoso, [25]dopo il quale, penetrando la percossa acqua, quella apre e penetra con furore alla per[26]cussione del fondo, dal quale poi reflettēdo risalta inverso la superfitie del pelago, ac[27]compagnata dall'aria che con lei si somerse, e questa resta nella uscita colla schiu[28]ma mista cō legniami e altre cose più lievi che l'acqua, intorno alle quali si da prī[29]cipio all'onde che tanto più crescono in circuito, quāto più ac[30]quistano di moto, el qual moto le fa tāto più basse quanto ell'acquistano più [31]larga basa, e per questo sono poco evidenti nel lor consumamēto; Ma se l'onde riperco[32]tono in vari obbietti, allora elle risaltano in dirietro sopra l'auenimento dell'altre onde, osser[33]vando l'accrescimēto della medesima curvità ch'el-l'avrebbero acquistato nell'oservatio[34]ne del già principiato moto; Ma la pioggia nel disciēdere de' sua nvuoli è del medesimo [35]color d'essi nvuoli, cioè della sua parte ōbrosa, se già li razzi solari nō li penetrassino, il che se così [36]fusse, la pioggia si dimostrerebbe di minore oscurità che esso nuvolo, e se li gran pesi delle [37]massime ruine delli grā monti o d'altri magni edifiti ne' lor ruine percuoteranno li grā pelaghi [38]dell'acque, allora risalterà gran quātità d'acqua infra l'aria, il moto della quale sarà fatto per cō[39]trario aspetto a quello che fecie il moto del percussore dell'acque, cioè l'angolo della reflessiō, [40]e fia simile all'angolo della incidētia; Delle cose portate dal corso delle acque quella si dis-[41]costerà più dalle opposite riue che fia più

shape like smoke or wreathed clouds against the falling rain: But the swollen waters will sweep round the pool which contains them striking in eddying whirlpools against the different obstacles, and leaping into the air in muddy foam; then, falling back, the beaten water will again be dashed into the air. And the whirling waves which fly from the place of concussion, and whose impetus moves them across other eddies going in a contrary direction, after their recoil will be tossed up into the air but without dashing off from the surface. Where the water issues from the pool the spent waves will be seen spreading out towards the outlet; and there falling or pouring through the air and gaining weight and impetus they will strike on the water below piercing it and rushing furiously to reach its depth; from which being thrown back it returns to the surface of the lake, carrying up the air that was submerged with it; and this remains at the outlet in foam mingled with logs of wood and other matters lighter than water. Round these again are formed the beginnings of waves which increase the more in circumference as they acquire more movement; and this movement rises less high in proportion as they acquire a broader base and thus they are less conspicuous as they die away. But if these waves rebound from various objects they then return in direct opposition to the others following them, observing the same law of increase in their curve as they have already acquired in the movement they started with. The rain, as it falls from the clouds is of the same colour as those clouds, that is in its shaded side; unless indeed the sun's rays should break through them; in that case the rain will appear less dark than the clouds. And if the heavy masses of ruin of large mountains or of other grand buildings fall into the vast pools of water, a great quantity will be flung into the air and its movement will be in a contrary direction to that of the object which struck the water; that is to say: The angle of reflection will be equal to the angle nf incidence. Of the objects car-

ma . . richadendo effeciendo refrettera . . perchossa Elle. 20. circhulari chessi fugghano del locho . . perchussione chaminando chol. 21. circhulara . . chontra . . movano. 22. perchusione risaliano . . spicharsi . . Ellusscita chellacq"a". 23. pelagho . . disfacte . . vssciti. 24. chadendo . . disscieēdendo infrallaria acquissta. 25. perchossa. 26. chussion . . refcellēdo . . pelagho. 27. chonpagniata . . chon . . ecquessta ressta nella vissci cholla scin. 28. chol . . chose . . lieve chellacquo. 29. allonde [che chol suo] chettanto . . cresschano [quāto] in circhuita. 30. piu [bassa]. 31. largha . . poche . . chonsumamēto Masse . . ripercho. 32. tano . . dirieto. 33. lacresscimēto . . churvita . . arebbe. 34. Malla . . dissiēdere. 35. seggia . . penetrassi . . chosi. 36. fussi . . dimossterrebbe . . osschurita . . hesselli . . della ma. 37. perchoteranno. 38. infrallariael . . perchō. 39. asspecto acquello cheffecie . . perchussore . . langholo . . refressiō. 40. angholo

grave over di maggior quantità; Li ritro⁴²si delle acque nelle sue parti sono tanto più veloci quanto elle son più vicine al ⁴³suo cientro; La cima delle onde del mare discende dināzi alle lor base, battendosi e confregā⁴⁴dosi sopra le globulentie della sua faccia, e tal confregatione, trita in minute particule della ⁴⁵disciendente acqua la qual, con vertendosi in grossa nebbia, si mischia nelli corsi de' uēti a modo di ravilup⁴⁶pato fumo e revolutiō di nuvoli, e la leva al fine infra l'aria e si cōuerte ī nvuoli. ⁴⁷Ma la pioggia, che discende infra l'aria, nell' essere conbattuta e percossa dal corso de'uenti, si fa ⁴⁸rara o densa, secondo la rarità o densità d'essi venti, e per questo si gienera infra l'aria ⁴⁹vna inondatione di traspareti, fatti dalla discesa della pioggia, che è vicina all'ochio che ⁵⁰la vede; L'onde del mare, che percuotono l'obliquità de'monti che collui confinano, saranno schiumose, ⁵¹con uelocità contro al dosso de'detti colli, e nel tornare, indirieto si scōtrano ⁵²nell'auenimēto della secōda onda, e dopo il grā loro strepito tornā con grāde inōdatione ⁵³al mare, donde si partirono; Gran quantità di popoli d'uomini e d'animali diuersi si uedea scaciati ⁵⁴dall' accrescimēto del diluuio inverso le cime de'monti, uicine alle predette acque.

⁵⁵Onde del mare di Piombino ⁵⁶tutta d'acqua schiumosa.

⁵⁷Dell'acqua che risalta, ⁵⁸de vēti di Pionbino a Piōbino || ritrosi, di uēti e di pioggia cō rami e alberi misti coll' aria || votamēti dell'acqua che piove ⁵⁹nelle barche.

ried down by the current, those which are heaviest or rather largest in mass will keep farthest from the two opposite shores. The water in the eddies revolves more swiftly in proportion as it is nearer to their centre. The crests of the waves of the sea tumble to their bases falling with friction on the bubbles of their sides; and this friction grinds the falling water into minute particles and this being converted into a dense mist, mingles with the gale in the manner of curling smoke and wreathing clouds, and at last it, rises into the air and is converted into clouds. But the rain which falls through the atmosphere being driven and tossed by the winds becomes rarer or denser according to the rarity or density of the winds that buffet it, and thus there is generated in the atmosphere a moisture formed of the transparent particles of the rain which is near to the eye of the spectator. The waves of the sea which break on the slope of the mountains which bound it, will foam from the velocity with which they fall against these hills; in rushing back they will meet the next wave as it comes and and after a loud noise return in a great flood to the sea whence they came. Let great numbers of inhabitants—men and animals of all kinds—be seen driven [54]by the rising of the deluge to the peaks of the mountains in the midst of the waters aforesaid.

[55]The wave of the sea at Piombino is all foaming water[58].

Of the water which leaps up from the spot where great masses fall on its surface. Of the winds of Piombino at Piombino. Eddies of wind and rain with boughs and shrubs mixed in the air. Emptying the boats of the rain water.

C. A. 78 a; 228 a] **610.**

Of depicting ²dalle ruine de'mōti sopra le incluse spe-
natural
phenomena
(610. 611).

Lo immēso furore del uēto cacciato The tremendous fury of the wind driven
dalle ruine de'mōti sopra le incluse spe- by the falling in of the hills on the caves

.. delcorso. 41. schosstera .. delle oposite .. cheffia .. retro. 42. acque [quello e piu veloce] nlle .. parte tanto .. velocie. 43. suo cientro "la cima" Delle .. dissciende [la cima] "dināci .. confreghā. 44. globbulentie .. ettal confreghatione .. partichula. 45. dissciente .. miscia. 46. nvuoli [o diseda nebbia] e la .. invuoli. 47. Malla .. infrallaria .. perchossa. 48. eddensa. oddensita .. venti [chella perchotano] e .. quessto .. infrallari"a". 49. innondatione [di sottile] di trasspareti .. dal disscieso. 50. perchote .. monti [chell] che chollui .. sarrano "sciumose". 51. chō [velocie moto per la] con .. cholli .. sisscō. 52. sechōde. 53. eddanima .. scaciere. 54. accrescimēto. 55. hōde. 56. sciumosa. 57. risalta

55. 56. These two lines are written below the bottom sketch on Pl. XXXV, 3. The MS. Leic. being written about the year 1510 or later, it does not seem to me to follow that the sketches must have been made at Piombino, where Leonardo

was in the year 1502 and possibly returned there subsequently (see Vol. II. Topographical notes).

610. See the sketches and text on Pl. XXXVIII, No. 1. Lines 1—16 are there given on the left

lō³che mediante le ruine de' mōti che a caverne ⁴si facievā coperchio.

⁵La pietra, tratta ⁶per l' aria, lascia ⁷nell' ochio che la ⁸vede inpressi⁹one del suo mo¹⁰to, e il medesi¹¹mo fanno le ¹²gocciole dell' ac¹³qua che disciēdo¹⁴no dalli nuvoli ¹⁵quādo pio¹⁶ve.

¹⁷Vn mōte cadente sopra vna città ¹⁸il quale levi polvere in forma di nuvoli, ma ¹⁹il colore di tal polvere sia variato dal colore ²⁰d' essi nvuoli; E dove la pioggia è più fol²¹ta, il color della poluere sia manco euidē²²te, e dove la poluere è più folta, la pioggia ²³sia meno evidēte; E dove la pioggia è mista col ²⁴vēto e colla poluere, i nuvoli creati dalla piog²⁵gia sien più trasparēti che quelli della poluere; ²⁶E quādo le fiāme del fuoco sarā miste con ²⁷nvuoli del fumo e dell' acqua, allora si creā ²⁸nvuoli tenebrosi e molto oppachi; e 'l resto di tal ²⁹discorso si tratterà nel libro de pittura distesa³⁰mēte.

within—by the falling of the hills which served as roofs to these caverns.

A stone flung through the air leaves on the eye which sees it the impression of its motion, and the same effect is produced by the drops of water which fall from the clouds when it [16]rains.

[17]A mountain falling on a town, will fling up dust in the form of clouds; but the colour of this dust will differ from that of the clouds. Where the rain is thickest let the colour of the dust be less conspicuous and where the dust is thickest let the rain be less conspicuous. And where the rain is mingled with the wind and with the dust the clouds created by the rain must be more transparent than those of dust [alone]. [26]And when flames of fire are mingled with clouds of smoke and water very opaque and dark clouds will be formed[28]. And the rest of this subject will be treated in detail in the book on painting.

C. A. 152 a; 451a]

611.

Vedeuasi giēte, che cō gran sollecitu²dine apparecchiavā uettovaglia ³sopra diuerse sorte di navili fatti bre⁴vissimi; dell' onde nō si dimo⁵stravano in que' luoghi dove le te⁶nebrose pioggie colli lor nuvoli ⁷reflettevano.

⁸Ma doue li uāpi gienerati dalle ⁹celesti saette reflettevano, si ve¹⁰devano tanti lustri fatti da' simvla¹¹cri de' lor vāpi, quāte erā l' ō¹²de, che alli ochi de' circustāti poteā ¹³reflettere.

¹⁴Tanto cresceva il nvmero de' si¹⁵mulacri fatti da uāpi delle saette so¹⁶pra l' onde dell' acqua, quanto cre¹⁷scieva la distātia delli ochi lor ris¹⁸guardatori.

People were to be seen eagerly embarking victuals on various kinds of hastily made barks. But little of the waves were visible in those places where the dark clouds and rain were reflected.

But where the flashes caused by the bolts of heaven were reflected, there were seen as many bright spots, caused by the image of the flashes, as there were waves to reflect them to the eye of the spectator.

The number of the images produced by the flash of lightning on the waves of the water were multiplied in proportion to the distance of the spectator's eye.

del [sito dove chadano li grā pesi perchussori delle acque]. 58. chollaria.
610. 1. [Il n] lo . . chacciato. 2. moti. 3. cha "a''sse chaverne. 4. choperchio. 6. lasscia. 7. chella. 12. ghucciole. 13. disciēda. 15. quā piv. 17. chadende. 20. Eddove. 21. poluerere . . mancho. 22. dove [le] . . eppiu. 23. missta chol. 24. cholla. 25. trassparēti checquelgli. 26. Ecquādo [le] le . . fuocho . . misstecho. 27. eddell. 28. ressto. 29. disscorso. . . desstīta.
611. 2. aparechiavā. 4. dellonde "nō" [pocho] si dimos. 6. cholli. 7. refrettevano. 9. cielesste . . refrette. 10. deva . . lusstri. 12. ali . . circhusstāti. 13. refrectere. 14. scresscievano. 16. cres. 17. disstātia. 18. ghardatori. 19. diminuiva [no quāto

hand side, 17—30 on the right. The four lines at the bottom on the right are given as No. 472. Above these texts, which are written backwards, there are in the original sixteen lines in a larger writing from left to right, but only half of this is here visible. They treat of the physical laws of motion of air and water. It does not seem to me that there is any reason for concluding that this

writing from left to right is spurious. Compare with it the facsimile of the rough copy of Leonardo's letter to Ludovico il Moro in Vol. II.

26—28. Compare Pl. XL, 1—the drawing in Indian ink on the left hand side, which seems to be a reminiscence of his observations of an eruption (see his remarks on Mount Etna in Vol II).

[19]E così diminuiva [20]tal numero di simulacri, quāto [21]più s'auicinavano agli ochi che li [22]vedeano, com'è provato nella difi[22]nitione dello splendore della luna [24]e del nostro orizzōte marittimo, [25]quādo il sole ui reflette cō sua [26]razzi, e che l'ochio, che ricieve tal re[27]flessione, sia lontano dal predetto mare.

So also the number of the images was diminished in proportion ·as they were nearer the eye which saw them [22], as it has been proved in the definition of the luminosity of the moon[23], and of our marine horizon when the sun's rays are reflected in it and the eye which receives the reflection is remote from the sea.

piu si]. 20. [facie] tal nume. 24. nosstro . . marictimo. 25. qua quādo . . refrette cho. 26. razi. 27. fre ione.

611. 22. 23. *Com'è provato*. See Vol. II, Nos. 874—878 and 892—901.

VI.

THE ARTIST'S MATERIALS.

612.

Per fare pūte da colorire a secco; la ²tēpera cō vn po' di ciera e nō la secca, ³la qual ciera disoluerai, cō acqua, ⁴che, tenperata la biacca, essa acqua stilla-⁵ta se ne vada in fumo e rimāga la ⁶ciera sola, e farai bone pūte; Ma sap⁷pi che bisogna macinare i co⁸lori colla pietra calda.

Of chalk and paper (612—617).

To make points [crayons] for colouring dry. Temper with a little wax and do not dry it; which wax you must dissolve with water: so that when the white lead is thus tempered, the water being distilled, may go off in vapour and the wax may remain; you will thus make good crayons; but you must know that the colours must be ground with a hot stone.

613.

Il lapis se disfa in vino e in aceto o in acqua²vite, e poi si può ricōgiugnere cō colla dolce.

Chalk dissolves in wine and in vinegar or in aqua fortis and can be recombined with gum.

614.

CARTA DA DISEGNARE ²NERO COLLO SPUTO.

³Togli poluere · di galla · e di vetriolo · e polue⁴rizza ·, e spandi · sopra · carta a vso · di uerni⁵ce poi · scriui cō pēna intīta nello ⁶sputo ·, e farai · nero · come · inchiostro.

PAPER FOR DRAWING UPON IN BLACK BY THE AID OF YOUR SPITTLE.

Take powdered gall nuts and vitriol, powder them and spread them on paper like a varnish, then write on it with a pen wetted with spittle and it will turn as black as ink.

612. 1. assecho. 2. cōvpo di . . cascero (?). 3. acque. 4. biacha . . stila. 6. effara . . Massa. 8. cholla.
613 1. ilapis . . acqʻʻaʻʻ. 2. vte . . ricōgugnere.
614. 2. chollossputo. 4. rizza esspandi . . charta. 5. pena. 6. effarai . . inchiosstro.

Br. M. 174 a]

615.

Se uoi fare lettere scortate, tira la ²carta in telaio e disegnia e poi ta³glia tali lettere e fa passare i razzi ⁴solari per tali spiracoli sopra vn altra car⁵ta tirata, e poi rifa li angoli mācati.

If you want to make foreshortened letters stretch the paper in a drawing frame and then draw your letters and cut them out, and make the sunbeams pass through the holes on to another stretched paper, and then fill up the angles that are wanting.

C. A. 71 b; 209 b]

616.

Questa carta si debbe tigniere di ²fumo di cādela tēperato cō colla dolce, ³e poi inbrattare sottilmēte la foglia di ⁴biacca a olio, come si fa alle lettere ī ⁵istāpa, e poi stampare nel modo co⁶mune, e così tal foglia parrà aōbrata ⁷ne' cavi e alluminata nelli rilieui, il ⁸che interuiene qui al contrario.

This paper should be painted over with candle soot tempered with thin glue, then smear the leaf thinly with white lead in oil as is done to the letters in printing, and then print in the ordinary way. Thus the leaf will appear shaded in the hollows and lighted on the parts in relief; which however comes out here just the contrary.

F. 56 a]

617.

Molto fia bella la carta biāca fissa ²fatta di mistura e latte di gichero colato, ³e fatta tal carta e poi inumidita e pie⁴gata e avviluppata a caso e mista colla mi⁵stura e così lasciata seccare; Ma se la ⁶rōpi auāti ch'ella invmidisca accade a ⁷modo di lasagne, e poi inumidisci ⁸e avviluppa e poi metti in mistura e lascia ⁹seccare;· ancora se tal ¹⁰carta sarà vestita di biāco fisso e tras¹¹parēte e sardonio, e poi sia inumidi¹²ta accio non faccia angoli, e poi sia avviluppa¹³ta intrāsparēte forte, e come l'è ferma, ¹⁴sega la grossa 2 dita, e lascia secca¹⁵re; Ancora se fai cartone fisso di ¹⁶sardonio, e seccalo e poi ¹⁷lo metti infra 2 carte di papiro ¹⁸e lo rōpi dentro cō martel di legno, col pu¹⁹gno, poi apri cō diligenza tenēdo ferma ²⁰per piano ²¹la carta ²²di sotto a²³cciochè li pez²⁴zi rotti nō ²⁵si sconpa²⁶gnino, po²⁷i abbi

Very excellent will be a stiff white paper, made of the usual mixture and filtered milk of an herb called calves foot; and when this paper is prepared and damped and folded and wrapped up it may be mixed with the mixture and thus left to dry; but if you break it before it is moistened it becomes somewhat like the thin paste called *lasagne* and you may then damp it and wrap it up and put it in the mixture and leave it to dry; or again this paper may be covered with stiff transparent white and *sardonio* and then damped so that it may not form angles and then covered up with strong transparent size and as soon as it is firm cut it two fingers, and leave it to dry; again you may make stiff cardboard of *sardonio* and dry it and then place it between two sheets of papyrus and break it inside with a wooden mallet with a handle and

615. 2. po. 3 effa pasare. 5. agoli macati.
616. 1. quessa charda. 4. biacha. 5. nistāpa stanpire. 6. chosi . . pāra. 8. interuene . . il.
617. 1. biācha. 2. falta . . ellatte . . gichero colato. 3. eppoi. 4. avilupata achaso. 5. lasssiata sechare Massella. 6. achaso.
 8. aviluppa po . . ellascia. 9. sechare . . settal. 10. biācho . . ettras. 11. essardonio . . poi inumidi. 12. acco no facca anoli
 e poi . . aviluppa. 14. lasscia secha. 15. seffai. 16. essechalo epoi ī la picha info]. 17. [glio] lo . . palpiro. 18. ello.

616. This text, which accompanies a facsimile impression of a leaf of sage, has already been published in the *Saggio delle Opere di L. da Vinci*, Milano 1872, p. 11. G. Govi observes on this passage: "*Forse aveva egli pensato ancora a farsi un erbario, od almeno a riprodurre facilmente su carta le forme e i particolari delle foglie di diverse piante; poichè (modificando un metodo che probabilmente gli era stato insegnato da altri, e che più tardi si legge ripetuto in molti ricettarii e libri di segreti), accanto a una foglia di Salvia impressa in nero su carta bianca, lasciò scritto: Questa carta . . .*

Erano i primi tentativi di quella riproduzione immediata delle parti vegetali, che poi sotto il nome d' Impressione Naturale, fu condotta a tanta perfezione in questi ultimi tempi dal signor de Hauer e da altri."

vna ²⁸carta in²⁹collata cal³⁰da, e appicca ³¹la sopra tut³²ti essi pez³³zi, e lascia ³⁴fermare, ³⁵poi la uol³⁶ta sotto so³⁷pra e da di ³⁸transparē³⁹te più vol⁴⁰te nello spa⁴¹tio, ch'è tra ⁴²li pezzi ve⁴³rsādo og⁴⁴ni volta, ⁴⁵poi di ne¹⁶ro e poi ⁴⁷di bianco ⁴⁸fisso, e co⁴⁹sì lascia o⁵⁰gni volta se⁵¹ccare, po⁵²i la spiana ⁵³e pulisci.

then open it with care holding the lower sheet of paper flat and firm so that the broken pieces be not separated; then have a sheet of paper covered with hot glue and apply it on the top of all these pieces and let them stick fast; then turn it upside down and apply transparent size several times in the spaces between the pieces, each time pouring in first some black and then some stiff white and each time leaving it to dry; then smoothe it and polish it.

C. A. 258 a; 784 a]

618.

Per fare verde bello ‖ togli il uerde · e mescola ²colla mūmia ‖ e farai l'ōbra più scura ·, poi · per farla ³più chiaro · verde e oquria · e per più chiara · verde ⁴e giallo · e pe' lumi giallo ischietto ·, di poi togli ⁵verde e curcuma j̄sieme, e vela sopr' o⁶gni · cosa; ⁷per fare v̄ rosso bello togli cinabrese o mattita ⁸o oquria arsa pell'ōbre scure e pelle più · · · · ⁹matita e minio, e pe' lumi minio solo, poi vela ¹⁰cō lacca bella ¹¹per fare olio buono a dipigniere ‖ Vna parte d'olio ¹²vna di prima dirinentia · e una di seconda.

On the preparation and use of colours (618—627).

To make a fine green take green and mix it with bitumen and you will make the shadows darker. Then, for lighter [shades] green with yellow ochre, and for still lighter green with yellow, and for the high lights pure yellow; then mix green and turmeric together and glaze every thing with it. To make a fine red take cinnabar or red chalk or burnt ochre for the dark shadows and for the lighter ones red chalk and vermilion and for the lights pure vermilion and then glaze with fine lake. To make good oil for painting. One part of oil, one of the first refining and one of the second.

C. A. 70 a; 207 a]

619.

¶ Onbra nera: adopera ²lume, biacca, giallo, verde, minio e lacca; ³Onbre mezzane; togli l'ombra di sopra ⁴c mescola colla detta īcarnazione arre⁵cādovi vn poco di giallo e vn po' di uerde, e alle ⁶volte della lacca; ⁷per avere l'onbre togli verde e lacca nell'ōbre mezzane · · ¶

Use black in the shadow, aud in the lights white, yellow, green, vermilion and lake. Medium shadows; take the shadow as above and mix it with the flesh tints just alluded to, adding to it a little yellow and a little green and occasionally some lake; for the shadows take green and lake for the middle shades.

H.² 46 b]

620.

Farai bella oquria se terrai il modo ²che si tiene a fare la biacca.

You can make a fine ochre by the same method as you use to make white.

23. cioche li pe. 26. appi. 30. apica. 44. poi di dine. 50. chate. 53. pulisca.
618. 1—12 P. 1. emēscola. 2. cholla mūmia effarai . . isscura poi per ⧵⧵ a. 3. eoquria e per. 4. isscietto. 5. churchuma j̄ sieme cheuela. 6. chosa. 8. o oquria . . isscure e pelle piu chan. 9. emminio eppellumi. 10. chō. 11. parce. 12. dirinentia . . sechonda.
619. 1. nera e oqurie (?). 2. biaccha gialla . . ellacha. 3. mezane. 4. ēmesschola cholla . . īchazione arripi. 5. ēdovi . . pocho. 6. laccha. 7. lonbre o verde ellacche . . mezane enella.
620. 1. oquria settierai. 2. chessi . . affare . . biaccha.

618 and 619. If we may judge from the flourishes with which the writing is ornamented these passages must have been written in Leonardo's youth.

C. A. 70 *b*; 207 *b*] **621.**

GIALLO BELLO.

²Disolui risagallo a vno sorbiméto con acqua ³forte.

BIANCO.

⁵Metti la biacca in vn tegame, che ui sia g⁶rossa vna corda per tutto, e lasci⁷a la stare 2 dì al sole e al sereno, e fa ⁸che la mattina quando il sole a rasciutto ⁹la rugiada della notte \|\|\|\|\|

A FINE YELLOW.

Dissolve realgar with one part of orpiment, with aqua fortis.

WHITE.

Put the white into an earthen pot, and lay it no thicker than a string, and let it stand in the sun undisturbed for 2 days; and in the morning when the sun has dried off the night dews.

Tr. 78] **622.**

Per fare rosso ī nero per īcarnatione: ²togli rubini di Rocca Nova o granati e mischia un attimo; ancora il bolo ³armeno è bono ī parte.

To make reddish black for flesh tints take red rock crystals from Rocca Nova or garnets and mix them a little; again armenian bole is good in part.

L. 92 *a*] **623.**

La ōbra fia verde terra bruciata.

The shadow will be burnt ‚terra-verte'.

A. 8 *b*] **624.**

PROPORTIONE DI COLORI.

²Se una oncia di nero · misto · con vna ōcia di biacca · fanno uno grado di scurità ·, quāti gradi ³di scurità · farā 2 ōcie di nero sopra una oncia di biacca?

THE PROPORTIONS OF COLOURS.

If one ounce of black mixed with one ounce of white gives a certain shade of darkness, what shade of darkness will be produced by **2** ounces of black to **1** ounce of white?

W. P. 5 *a*] **625.**

¶Ricuocere nera ·, gialla uerdegiāte nel fine azzurra. ¶

Remix black, greenish yellow and at the end blue.

F. 96 *b*] **626.**

Verde rame e aloe o fiele o curcuma fa ²bel verde, ancora il zafferano o l'opiméto ³bruciato, ma dubito che in brieue nō diuēga nero; ⁴azzurro, oltramarino e giallo di

Verdigris with aloes, or gall or turmeric makes a fine green and so it does with saffron or burnt orpiment; but I doubt whether in a short time they will not turn

621. 2. risalghallo . . sorpiméto chon acq for. 4. biancho. 5. biaccha nvm teghame. 6. chorda . . ellasce. 7. effa. 8. chella . . rasciutto. 9. rugada.
622. 1. lorubini di rocha . . miscia chollattimo. 3. amenio.
623. 1. brucata.
624. 1. cholori. 2. se ī onchia . . chon . . biacha fannogrado . . schurita. 3. schurita . . sopra [2] ī . . biacha.
625. 1. richuocere. 2. azura.
626. 3. brucato . . diuēgha. 5. ssti . . coe. 6. Lacha . . fa . . azzuro.

uetro insieme mi⁵sti fanno verde bellissimo in fresco, cioè in muro.

⁶Lacca e verderame · fã bon ōbra allo azzurro a o⁷lio.

black. Ultramarine blue and glass yellow mixed together make a beautiful green for fresco, that is wall-painting. Lac and verdigris make a good shadow for blue in oil painting.

S. K, M. II.¹ 95 a]

627.

Macina il verderame colorato molte volte insie²me cō sugo di limō, e guardalo dal giallorino.

Grind verdigris many times coloured with lemon juice and keep it away from yellow (?).

A. 1 a]

628.

A PREPARARE IL LEGNIAME PER DIPĪGNIERE SU;

²Il legnio sarà d'arcipresso o pero o sorbo o noce, il quale salderai cō ma³stico e tremētina secōda destillata · e biacca o vuoi calcina, e metti ī telajo ⁴ī modo possa cresciere e discresciere secōdo l'umido o secco; dipoi ⁵li da con acquavite ·, che vi sia dentro disoluto, arsenico o solimato 2 ⁶o 3 volte, di poi da olio di lino bolito in modo peni⁷tri per tutto, e inanzi si freddi fregalo bene con v̄ panno in modo parrà ⁸ascivtto ·, e dalli di sopra verniceliquida e biacca colla stecca, poi laua ⁹con orina, quādo è ascivtta ·; e poi spoluerezza e proffila ¹⁰il tuo disegno sottilmēte e da di sopra l'imprimitura di 30 parti di uerde¹¹rame e vna di ucrderame e 2 di giallo.

TO PREPARE A PANEL FOR PAINTING ON.

The panel should be cypress or pear or service-tree or walnut. You must coat it over with mastic and turpentine twice distilled and white or, if you like, lime, and put it in a frame so that it may expand and shrink according to its moisture and dryness. Then give it [a coat] of aqua vitae in which you have dissolved arsenic or [corrosive] sublimate, 2 or 3 times. Then apply boiled linseed oil in such a way as that it may penetrate every part, and before it is cold rub it well with a cloth to dry it. Over this apply liquid varnish and white with a stick, then wash it with urine when it is dry, and dry it again. Then pounce and outline your drawing finely and over it lay a priming of 30 parts of verdigris with one of verdigris with two of yellow.

Of preparing the panel.

S. K. M. III. 52 b]

629.

OLIO.

²Fa olio di semēza di senape, · e se lo ³voi fare cō piv facilità mischia la ma⁴cinata semēza · con olio di linseme, ⁵e metti ogni cosa sotto'l torchio.

OIL.

Make some oil of mustard seed; and if you wish to make it with greater ease mix the ground seeds with linseed oil and put it all under the press.

The preparation of oils (629—634).

627. 1. chollarata. 2. guardallo.
628. 2. ilegnio . . ossorbo . . qua. 3. sticho . . destilata . ebiacha ovoi . . chalcina. 4. cressciere e discressciere sechōdo . . ossecho. 5. chon acq"a" vite . . disoluuto . . sollimato. 6. da [vernice] olio . . imodo. 7. enāzi [z] si . . chonv̄panimodo para. 8. biacha cola stecha po. 9. chōn . . assciutta . . spoluereza. 10. lanprimiera.
629. 2. senapi essello. 3. voi . . mista. 5. ōni sottol torchio f.

628. M. RAVAISSON's reading varies from mine in the following passages: 1. opero allor [?] bo [alloro?] = "ou bien de [laurier]."

6. fregalo bene con un panno. He reads pane for panno and renders it. "Frotte le bien avec un pain de façon [jusqu'à ce] qu'il etc.

7. colla stecca po laua. He reads "polacca" = "avec le couteau de bois [?] polonais [?]."

630.

A TORRE ODORE ALL' OLIO.

[2]Togli l' olio forte e mettine 10 [3]boccali in ū uaso, e fa vn segnio nel [4]vaso secondo l' altezza dell' olio, e poi v' a[5]gugni uno boccale d' aceto e fallo tā[6]to bollire che l' olio diminuisca in[7]sino alla bassezza del fatto segno, [8]e così sarai certo l' olio essere tor[9]nato nella prima quātità e l' aceto essere [10]se ne ito tutto in fumo e portato [11]ne con seco tutto il tristo odore, e'l [12]simile credo farebbe all' olio di no[13]ce e ogni altro olio che auesse tri[14]sto odore.

TO REMOVE THE SMELL OF OIL.

Take the rank oil and put ten pints into a jar and make a mark on the jar at the height of the oil; then add to it a pint of vinegar and make it boil till the oil has sunk to the level of the mark and thus you will be certain that the oil is returned to its original quantity and the vinegar will have gone off in vapour, carrying with it the evil smell; and I believe you may do the same with nut oil or any other oil that smells badly.

631.

Perchè le noci · sono fasciate da una cierta bucciolina che uiene della natura de, [2]se tu non le spogli quando ne fai l' olio, quel mallo tigne l' olio, e quando lo metti [3]in opera quel mallo si parte dall' olio e viene in sulla superficie della pittura, [4]e questo è quel che la fa cambiare.

Since walnuts are enveloped in a thin rind, which partakes of the nature of . . ., if you do not remove it when you make the oil from them, this skin tinges the oil, and when you work with it this skin separates from the oil and rises to the surface of the painting, and this is what makes it change.

632.

PER FAR RINUENIRE COLORI SECCHI A OLIO.

[2]Se vuogli far rinuenire i colori secchi a olio, [3]tiēgli ī molle nella maestra del sapone [4]una notte, e col dito · gli rimena con detta [5]maestra ·, e versa in un bicchiere e laualo cō [6]l' acqua e in questo modo riaurai i colori che si [7]seccano, Ma fa che ogni colore rīuenuto abbi [8]il suo bicchiere di per se, dandogli il suo colore di ma[9]no ī mano che tu gli rinvieni, e fa che sieno molli, [10]e quando li uolessi adoperare attēpera e tu li laua [11]cō acqua 5 o · 6 volte con aqua di pozzo, e lascia posare; [12]se la maestra · s' intorbida con alcuni colori [13]fa la passare per feltro.

TO RESTORE OIL COLOURS THAT HAVE BECOME DRY.

If you want to restore oil colours that have become dry keep them soaking in soft soap for a night and, with your finger, mix them up with the soft soap; then pour them into a cup and wash them with water, and in this way you can restore colours that have got dry. But take care that each colour has its own vessel to itself adding the colour by degrees as you restore it and mind that they are thoroughly softened, and when you wish to use them for *tempera* wash them five and six times with spring water, and leave them to settle; if the soft soap should be thick with any of the colours pass it through a filter.

630. 1. Attorre , . ne io. 3. bochali nū. 4. vaso 2° laltezza. 5. gugni ī bochale . . effallo. 6. chellolio diminuissca. 7. basseza. 9. nella p° quātita ellaceto. 13. auessi.

631. 1—4 *written from the left to the right*. 1. fassciate . . cierta "bucciolina" che e natura de \\\\\\\\. 2. settu. 3. qul . , dalloc. 4. equessto . . chella fa chanbiare.

632. 1. per rinuenire cholori. 2. far *is wanting*; cholori. 3. maesstra. 4. ecchol . . chon. 5. maesstra . . īnum . . ellaualocho. 6. ēquessto . . riarai i cholori chessi. 7. sechano . . onicholore. 8. cholore. 9. chettu . . effa chessieno molle. 10. ettu. 11. coaque o . . chon aqua di pozo ellasscia. 12. sella masstra . . chon . . cholore. 13. falla.

632 and **634.** The same remark applies to these sections as to No. 618 and 619.

S. K. M. III. 85 *a*] **633.**

OLIO. OIL.

Semēza di senepa · pesta con olio di lino. Mustard seed pounded with linseed oil.

C. A. 108 *b*; 339 *b*] **634.**

....... di fuori della catinella piv · basso
2 dita che non è il piano dell' olio ·, e falla
²entrare nel collo d'una anpolla e lasciala
stare, e tutto · l'olio così se partirà da quel
latte, ³verrà · in questa · anpolla · e · sarà ·
chiaro · come cristallo ·, e cō questo macina
· i tua colori, ⁴e ogni bruttura e viscosità ·
rimarrà insieme cō quell' acqua ‖ sappi che
tutti gli oli che sono ⁵creati ne' semi · o
frutti sono chiarissimi di lor natura, ma il
colore giallo che tu vedi in loro nō nascie
se nō ⁶dal non · saper lo trarre fuori; il
fuoco o caldezza di sua natura à forza di
farli ⁷pigliare colore; piglia la sperienza da
licori o gomme d'albori · i quali, se tengono
di ragia, in breue ⁸tenpo si rassodano,
perchè v'è dentro più caldezza che non è
nell' olio, e col lungo tenpo ⁹pigliano vn
cierto giallo che pende in nero, ma l'olio
perchè non è si caldo nō fa questo, ¹⁰ben-
chè alquanto si rassodi in sedimento tutta
via si fa più bello, ¹¹e 'l cambiare dell' olio,
che fa nel dipigniere, non nascie se non
è da vn cierto fūgo, di natura del mallo,
¹²il quale è incorporato in quella bucciol-
lina che chiude dentro a se la noce ·, la
quale · essendo · pesta ¹³insieme colle noci e
perch' egli è di natura quasi simile all'olio si
mescola con esso ed è si sottil cosa ¹⁴ch' egli
à forza di penetrare e uscire · sopra a tutti i co-
lori ·, e questo è quella cosa ch' egli fa mutare,
· ¹⁵e se tu · volessi · che l'olio sapessi di buo-
no e non īgrossassi ·, mettivi dentro vn poco
di canfora, ¹⁶fondata al lēto fuoco, e mescola-
si col'olio bene e mai non si rassodi.

....... outside the bowl 2 fingers lower
than the level of the oil, and pass it into the
neck of a bottle and let it stand and thus
all the oil will separate from this milky liquid;
it will enter the bottle and be as clear as
crystal; and grind your colours with this,
and every coarse or viscid part will remain in
the liquid. You must know that all the oils
that have been created in seads or fruits are
quite clear by nature, and the yellow colour
you see in them only comes of your not
knowing how to draw it out. Fire or heat
by its nature has the power to make them
acquire colour. See for example the exudation
or gums of trees which partake of the nature of
rosin; in a short time they harden because there
is more heat in them than in oil; and after
some time they acquire a certain yellow hue
tending to black. But oil, not having so
much heat does not do so; although it
hardens to some extent into sediment it
becomes finer. The change in oil which
occurs in painting proceeds from a certain
fungus of the nature of a husk which exists
in the skin which covers the nut, and this
being crushed along with the nuts and being
of a nature much resembling oil mixes with
it; it is of so subtle a nature that it com-
bines with all colours and then comes to the
surface, and this it is which makes them
change. And if you want the oil to be
good and not to thicken, put into it a little
camphor melted over a slow fire and mix
it well with the oil and it will never
harden.

633. 2. sēmemēza.
634. 1. ellaltr \|\|\|\| nda . . chatinella . . effalla. 2. ellentrare nell chollo . . ellascia lasstare ettutto . . chossi . . perera da quel-
latte. 3. quessta . . essara . . chome crisstallo . ecchō quessto . . e tua cholori. 4. vissciosita . . chō . . chettutti . . chessono.
5. neserai offrutti . . "di lor natura" ma . . gallo chettu vediloro no nascie sēnnō. 6. saperllo . . fuocho o chaldezza . .
afforza. 7. cholore . . lassperienza dallichori o ghomme . . equali settenghono di ragie in brieue. 8. chaldeza chennon . .
ecchol [tenp] lugho. 9. cheppende . . mallolio . . chaldo . . quessto. 10. [esseno] bench . . inse dimeno cuttavia. 11.chan-
biare . . cheffa . . nasscie sennon . . fugho. 12. el . . inchorporato . . asse . . pessta. 13. cholle epperch . . chon . .
chosa. 14. usscire . . attutti i cholori . ecquesto ecqualla chosa. 15. essettu . . chellolio . . sapessi . . enonn īgrossasi . .
pocho dichanfora. 16. alleto fuocho emmesscola . . chol . . emmai (?) . . rassoda.

S. K. M. I.² 5] **635.**

[VERNICE.

On varnishes
[or powders]
(635—637).

²Tolli cipresso ·, e quello · destilla · e abbi vna brocca ³grāde · e lì · metti · detta destillatione · cō tanta · acqua ⁴che parsii l'anbra ·, e tura · ben di sopra · in modo nō ⁵ui spiri ·, e quādo · è disoluta · arrogi in detta cosa ⁶della detta · stilatione · ī modo sia · liquida · a tuo modo, ⁷e sappi che le carabe è liquore d'arcipresso].

[VERNICE.

⁹E perchè la vernice · e gomma di ginepro ·, se stilerai · ¹⁰il ginepro, potrai disoluere in questa stilatione detta ¹¹vernice · nel modo. detto disopra].

VARNISH [OR POWDER].

Take cypress [oil] and distil it and have a large pitcher, and put in the extract with so much water as may make it appear like amber, and cover it tightly so that none may evaporate. And when it is dissolved you may add in your pitcher as much of the said solution, as shall make it liquid to your taste. And you must know that amber is the gum of the cypress-tree.

VARNISH [OR POWDER].

And since varnish [powder] is the resin of juniper, if you distil juniper you can dissolve the said varnish [powder] in the essence, as explained above.

S. K. M. I.² 8] **636.**

[VERNICE.

²Intacca vn ginepro · e dalli · l'acqua · a piedi, e quello ³liquore · mischia · con olio di noce · e avrai vernice perfetta fatta ⁴di vernice d'anbra · bella · e buona · per eciellētia ⁵fallo · di magio · over d'aprile]·

VARNISH [OR POWDER].

Notch a juniper tree and give it water at the roots, mix the liquor which exudes with nut-oil and you will have a perfect varnish [powder], made like amber varnish [powder], fine and of the best quality make it in May or April.

G. 46 b] **637.**

VERNICE.

²Mercurio cō giove e venere, fattone il pa³stello, sia colla sagoma corretto ⁴al continuo insino che mercurio ⁵si separi integralmēte da giove e venere.

VARNISH [OR POWDER].

Mercury with Jupiter and Venus,—a paste made of these must be corrected by the mould (?) continuously, until Mercury separates itself entirely from Jupiter and Venus.

B. 2 b] **638.**

On chemical
materials
(638—650).

Ricordo come · l'acqua vite racoglie ī se tutti i colori e odori ²de' fiori, e se uoi fare azzurro metti ui fiordalisi e per rosso solani.

Note how aqua vitae absorbs into itself all the colours and smells of flowers. If you want to make blue put iris flowers into it and for red solanum berries (?)

635. 2. ecquello . . bocca. 3. elli meti. 4. pareci lanbraetura . . imodo. 5. disoluuta arogi. 6. attuo. 7. essapi chele carabe darci plesso. 9. goma.

636. 2. intacha . . acquello. 3. ara.

637. 1. vernice dellaigna. 2. merchurio chō giove "evenere" . . il pas. 3. saghoma correcto. 4. al chontinuo . . merchurio.

638. 1. chome . . tu \\\ i cholori edori. 2. azuro . . fiorarisi e . . solaci.

637. Here, and in No. 641 *Mercurio* seems to mean quicksilver, *Giove* stands for iron, *Venere* for copper and *Saturno* for lead.

W. XIII.]

639.

Sale fatto di sterco vmano bruciato ²e calcinato e fattone liscia·, e que³lla · dissecca al lēto fuoco e tutti li ster⁴chi in simile modo fanno sale e quelli ⁵sali destillati · sono molto · penetrāti.

Salt may be made from human excrement burnt and calcined and made into lees, and dried by a slow fire, and all dung in like manner yields salt, and these salts when distilled are very pungent.

Tr. 49]

640.

¶L'aqua del mare, gocciolata dal fango over tera arzila, ²lassia ī quella ōgni salsedine.¶ ³¶Le lane, messe alle spōde del navilio, sorbiscono l'acqua dolce.¶ ⁴Se stilli cō cāpana, l'aqua marina fia ī principale ecielēza, ⁵e adattādo vn fornello alla sua cucina quelle medesime ⁶legnie che cuociono, stilleranno vna grā quantità d'acqua, ⁷se la cāpanà fia grāde.

Sea water filtered through mud or clay, leaves all its saltness in it. Woollen stuffs placed on board ship absorb fresh water. If sea water is distilled under a retort it becomes of the first excellence and any one who has a little stove in his kitchen can, with the same wood as he cooks with, distil a great quantity of water if the retort is a large one.

G. 53 a]

641.

SAGOMA.

²La sagoma sia di uenere overo di giove ³o saturno è spesso rigittata in grēbo ⁴alla madre sua; E sia adoperata con ⁵sottile, e'l sagomato sia ⁶venere e giove inpastato sopra vene ⁷re; Ma prima proverai uene⁸re e mercurio misto cō giove e tieni ⁹modo che mercurio se ne fugga¹⁰poi in volgili bene in modo che ¹¹venere o giove sinnectuti ui sottilissimamē¹²te quanto sia possibile.

MOULD (?).

The mould (?) may be of Venus, or of Jupiter and Saturn and placed frequently in the fire. And it should be worked with fine emery and the mould (?) should be of Venus and Jupiter impasted over (?) Venus. But first you will test Venus and Mercury mixed with Jove, and take means to cause Mercury to disperse; and then fold them well together so that Venus or Jupiter be connected as thinly as possible.

W. VIII.]

642.

Sal nitro, ²vitriolo, ³cinabro, ⁴allume, iamene ⁵sal ammoniaco, ⁶mercurio, sullimato, ⁷salgemma, ⁸sal arcali, ⁹sal comune, ¹⁰allume di roco ¹¹allume scisso, ¹²arsenico, ¹³sullimato, ¹⁴risagallo, ¹⁵tartero, ¹⁶orpimēto, ¹⁷verderame.

Nitre, vitriol, cinnabar, alum, salt ammoniac, sublimated mercury, rock salt, alcali salt, common salt, rock alum, alum schist (?), arsenic, sublimate, realgar, tartar, orpiment, verdegris.

639. stercho. 2. chalcinato effatto neliscia ecque. 3. disecha . . focho ettutti lisster. 5. desstilati.

640. 1. cholata . . tera arzila. 2. lassia ī quela . . salsendine. 3. tesse . . spōte sorbisschono lacq"a". 4. stili chō . . lacq. 5. e dattādo . . fornelo . . chusina. 6. chochano . stilerano . . dacqa. 7. chapana.

641. 1. saghoma. 2. saghoma. 3. essaturno esspesso. 4. Essia . . chon is. 5. olgirams soctile. 6. inpassato sopra erē. 7. ev Ma . . proverrai. 8. merchurio missto . . ettieni. 9. merchurio . . fugghe. 10. ppoi invulghana. 11. oggiove sinnectuti ui soctilissimamē.

642. 2. vitrolo. 4. allume iamene. 5. armoniacho. 7. salgemme. 8. arkalai. 9. rocho. 12. arsenicho. 13. risalghallo.

641. See the note to 637.
5. *olgirams* and 6, 7. *erēnev*. The apparent unmeaning of these words is solved, if we read them backwards: *olgirams* = *smariglio; erēnev* = *venere.*

H.1 18 *b*] **643.**

¶ Pece oncie 4, ²cera nova oncie 4, ³ īn-
ciēso oncie 2, ⁴olio rosato oncia una.¶

Pitch four ounces virgin wax, four ounces
incense, two ounces oil of roses one ounce.

H.3 88 *b*] **644.**

Oncie 4 cera nova, ²oncie 4 pece greca,
³oncie 2 incēso, ⁴oncia una olio rosato, ⁵fōdi
prima cera e olio, ⁶poi la pece greca, ⁷poi
l'altre cose in polvere.

Four ounces virgin wax, four ounces
Greek pitch, two ounces incense, one ounce oil
of roses, first melt the wax and oil then the
Greek pitch then the other things in powder.

Br. M. 139 *a*] **645.**

Il uetro assottigliato si taglia ²con for-
bici, il quale posto so³pra le tarsie d'osso
dorate o ⁴d'altri colori, tu le puoi legare
⁵insieme coll'osso e poi met⁶tere, e resterà
cō lustro che ⁷nō si frāge nè cōsuma col
fre⁸garsi con mano.

Very thin glass may be cut with scissars
and when placed over inlaid work of bone,
gilt, or stained of other colours you can saw
it through together with the bone and then
put it together and it will retain a lustre that
will not be scratched nor worn away by
rubbing with the hand.

S. K. M. III. 53 *a*] **646.**

Ad aquare il uino ²BIĀCO · E FARSI NERO.

³Fa polverizare · la galla e stare 8 · dì in
⁴vino bianco ·, e così · fa disoluere il ⁵vitriolo
· nell'acqua ·, e fa ben posare e rischi⁶arare
l'acqua e 'l uino ognivno per se e bē co-
⁷lare, e quādo con essa · acqua adac⁸querai
· il uino · bianco ·, esso si farà ⁹vermiglio.

To DILUTE WHITE WINE AND MAKE IT PURPLE.

Powder gall nuts and let this stand 8 days
in the white wine; and in the same way
dissolve vitriol in water, and let the water
stand and settle very clear, and the wine
likewise, each by itself, and strain them well;
and when you dilute the white wine with the
water the wine will become red.

S. K. M. III. 55 *a*] **647.**

Metti la marchesita ²in acqua forte, e se
fa ³verde ·; sappi · che à ⁴in se rame, ⁵tralo
cō sal nitro ⁶e sapone tenero.

Put marcasite into aqua fortis and if it
turns green, know that it has copper in it.
Take it out with saltpetre and soft soap.

L. 2 *a*] **648.**

Il cavallo bianco si può ismachia²re col
ferretto di spagna o acqua for³te overo col
merdocco leuare il pe⁴lo nero al bianco cō
rottorio, forzare ⁵a terra.

A white horse may have the spots re-
moved with the spanish haematite or with
aqua fortis or with Removes the
black hair on a white horse with the singe-
ing iron. Force him to the ground.

643. 1. ō 4. 2. ō 4. 3. ōciēso ō 2. 4. ō ɫ.
644. 1—7 R. 1. ō 4. 2. ō 4 grecha. 3. ō 2. 4. ō ɫ. 5. primo. 7. chose.
645. 4. tulle poi comrame.
646. 2. effarassi. 3. esstare. 4. chosi. 5. nellacq"a" . effa . . rissci. 6. lacq"a". 7. ecquādo chon.
647. 2. acq"a" . . esse tralo. 6. essavō.
648. 1. po issmachia. 2. ferretto disspagna o acq"a". 3. merdocho. 4. al nere e "bianco" cōrattorio sorzare. 5. attera.

S. K. M. I.² 5]

649.

Fuoco.

²Se volessi · fare · vn fuoco che sēza · dāno · infocherebbe · vna sala, ³farai · così: profuma · prima · la · sala · con spesso · fumo ⁴d'incēso · o d'altra · cosa · odorifera ·, di poi · buffa; overo ⁵farai bolendo · andare infumo libre 10 d'acquavite, ⁶ma fa che la sala · sia · bē serrata e gitta poluere ⁷di vernice · infra detti · fumi, che sarà · il polverio ⁸assai bē sostenvto · dai fumi, di poi entra subito ⁹con vna torcia · a presso · ī detta · sala · e subito ogni ¹⁰cosa s'infocherà.

Fire.

If you want to make a fire which will set a hall in a blaze without injury do this: first perfume the hall with a dense smoke of incense or some other odoriferous substance: It is a good trick to play. Or boil ten pounds of brandy to evaporate, but see that the hall is completely closed and throw up some powdered varnish among the fumes and this powder will be supported by the smoke; then go into the room suddenly with a lighted torch and at once it will be in a blaze.

S. K. M. I.² 8]

650.

Fuoco.

²Tolli · quella · superfitie · gialla, ch'ànno · i pomi · rāci, ³e quelli · destilla · al limbico ·, che sarà · detta · stilatiō ⁴perfetta.

Fire.

Take away that yellow surface which covers oranges and distill them in an alembic, until the distillation may be said to be perfect.

[Fuoco.

⁶Serra · bene · vna camera · e abbi · vna · piastra ⁷di rame o di ferro · īfocata ·, e spruzzavi · suso · dua bocca⁸li d'acqua · vite · a poco · per uolta ·, in modo · si converta in fumo, ⁹di poi fa · ētrare · vno con un lume, e subito vedrai ¹⁰la camera īfocarsi a vso d'ū vā-peggiare cieleste e nō ¹¹farà alcuna lesione · a persona.

Fire.

Close a room tightly and have a brasier of brass or iron with fire in it and sprinkle on it two pints of aqua vitae, a little at a time, so that it may be converted into smoke. Then make some one come in with a light and suddenly you will see the room in a blaze like a flash of lightning, and it will do no harm to any one.

649. 1. fuocho. 2. focho . . infocherebe. 3. chosi . . chonispesso. 5. dacq"a". 6. serata. 9. chon . . apreso . . essubito ōni.
650. 1. fuocho. 3. ecquelli allimbicho chessara. 5. fuocho. 6. chamera. 7. fero . . espluzavi su so dua bocha. 8. dacq"a" . a pocho . . imodo si chonverla īfum"o". 9. chonū. 10. chamera īfocharsi . vāpegiare. 11. alchuna.

VII.

PHILOSOPHY AND HISTORY OF THE ART OF PAINTING.

S. K. M. III. 19*b*]

651.

Cosa bella mortal passa e nō d'arte.

What is fair in men, passes away, but not so in art.

The relation of art and nature (651. 652).

Ash. I. 15*b*]

652.

COME CHI SPREZZA LA PITTURA · NŌ ²AMA · LA FILOSOFIA NE LA NATURA.

³Se tu · sprezzerai · la pittura ·, la quale · è sola · imitatrice · di tutte l'opere evidēti di natura, ⁴per certo · tu sprezzerai una sottile · invētione · la quale cō filosofica e sottile specula-⁵tione · cōsidera tutte le qualità delle forme: mare e siti, piāte, animali, erbe e fiori, le ⁶quali sono · cīte d'onbra · e lume; e vera-mēte questa è sciētia, e legittima · figliuo⁷la di natura ·, perchè la pittura · è partorita da · essa natura ·; ma per dire piv corretto ⁸diremo nipote di natura ·, perchè tutte le cose evidēti sono state partorite dalla natura,

HE WHO DESPISES PAINTING LOVES NEITHER PHILOSOPHY NOR NATURE.

If you contemn painting, which is the only imitator of all visible works of nature, you will certainly despise a subtle invention which brings philosophy and subtle speculation to the consideration of the nature of all forms—seas and plains, trees, animals, plants and flowers—which are surrounded by shade and light. And this is true knowledge and the legitimate issue of nature; for painting is born of nature—or, to speak more correctly, we will say it is the grandchild of nature; for all visible things are

652. 1. spreza. 2. nella. 3. settio . isprezerai. 4. ciertu . tu sprezerai ï . . filosoficha . . spechula. 5. essiti. 6. ellume . . questa [arte e] e . . figli. 7. coretto. 8. direno . . chose. 9. chose . . dimādereno.

9delle quali cose partorite · è nata la pittura, · adūque rettamēte la dimāderemo nipote di natura, parēte di dio.

produced by nature, and these her children have given birth to painting. Hence we may justly call it the grandchild of nature and related to God.

Ash. I. 16*b*] **653.**

COME LA PITTURA AVĀZA TUTTE [2]L'OPERE VMANE PER SOTTILE SPECULATIO[3]NI APPARTE-NENTI · A QUELLA.

[4]L'occhio · che si dice finestra dell'anima [5]è la prīcipale · via, dōde il comvne · sēso può piv copiosa- e magīfica[6]mēte · cōsiderare · le īfinite opere di natura ·, e l'orechio è il secōdo il qua[7]le si fa nobile · per le cose racōte, le quali à veduto l'ochio ·; se uoi istoriografi [8]o poeti · o altri mattematici nō ui aueste col'ochio viste le cose, male le potreste [9]riferire per le scritture, e se tu poe[10]ta figurerai · una storia colla pittura della penna, el pittore col pennello la fa[11]rà di piv facile sadisfatione e mē tediosa a es-sere cōpresa: se tu dimāderai [12]la pittura muta poesia, ācora il pittore potrà dire del poeta · [13]orba pittura ·; or guarda quale è più dannoso morbo [14]o cieco o mvto; se 'l poeta è libero come 'l pittore nelle īuētioni, le sua finti[15]oni · nō sono di tāta sadisfatione ali omini quāto le pitture, perchè se la poesia [16]s'astēde colle parole a figvrare forme, atti e siti, il pittore si move colle [17]propie si-militudini delle forme a cōtrafare esse forme; or guarda qual'è [18]piv propīquo all'omo · o 'l nome d'omo o la similitudine d'esso omo; il nome [19]dell'omo si uaria ī uari paesi e la forma non è mvtata se nō da morte.

THAT PAINTING SURPASSES ALL HUMAN WORKS BY THE SUBTLE CONSIDERATIONS BELONGING TO IT.

The eye, which is called the window of the soul, is the principal means by which the central sense can most completely and abundantly appreciate the infinite works of nature; and the ear is the second, which acquires dignity by hearing of the things the eye has seen. If you, historians, or poets, or mathematicians had not seen things with your eyes you could not report of them in writing. And if you, O poet, tell a story with your pen, the painter with his brush can tell it more easily, with simpler completeness and less tedious to be under-stood. And if you call painting dumb poe-try, the painter may call poetry blind pain-ting. Now which is the worse defect? to be blind or dumb? Though the poet is as free as the painter in the invention of his fictions they are not so satisfactory to men as paintings; for, though poetry is able to describe forms, actions and places in words, the painter deals with the actual similitude of the forms, in order to represent them. Now tell me which is the nearer to the actual man: the name of man or the image of the man. The name of man differs in different countries, but his form is never changed but by death.

Painting is superior to poetry (653. 654).

Ash. I. 16*a*] **654.**

E se il poeta · serue al sēso per la uia del'orechio, il pittore per ochio, piv degnio [2]senso; ma io nō uoglio da questi tali al-tro · se nō che uno bono pittore figuri [3]il furore d'una battaglia e che 'l poeta ne scriua uno altro ·, e che sieno mes[4]si ī pub-blico di cōpagnia, vedrai i veditori doue piv si fermerāno, doue [5]piv cōsedererano, doue si darà piv laude e quale sadisfarà meglio; certo [6]la pittura, di grā lunga piv utile e

And if the poet gratifies the sense by means of the ear, the painter does so by the eye—the worthier sense; but I will say no more of this but that, if a good painter represents the fury of a battle, and if a poet describes one, and they are both together put before the public, you will see where most of the spectators will stop, to which they will pay most attention, on which they will bestow most praise, and which will satisfy them best. Undoubtedly painting being by a long way the more intelligible and beau-

bella, piv piacerà; poni scritto il no⁷me di
dio in v̄ loco e ponui la sua figura a ri-
scōtro, vedrai quale fia piv ⁸reverita; se la
pittura abbraccia ī se tutte le forme della
natura, voi no⁹n avete se non i nomi i quali
non sono vniversali come le forme, se voi
¹⁰avete li effetti delle dimostrationi, noi ab-
biamo le dimostrationi delli effetti; ¹¹tolgasi
uno poeta che discriva · le bellezze d'una
doña al suo inamorato, ¹²tolsi uno pittore ·
che la figuri, vedrai dove la natura volgerà
piv ¹³il givdicatore innamorato ·; cierto il
cimēto delle cose dourebbe lascia¹⁴re dare
la sētentia alla speriētia: voi avete messa
la pittura īfra ¹⁵l'arti mecaniche, cierto · se
i pittori fussino atti al laudare collo scriue-
¹⁶re l'opere loro come voi, io dubito nō
giacerebbe ī si uile cognome; ¹⁷se uoi la
chiamate mecanica, perchè è prima manvale
che le mani figur¹⁸ano quel che truovano
nella fantasia, voi scrittori disegniate colla
penna ¹⁹manualmēte quello che nello īgie-
gnio vostro si truova ·, e · se voi ²⁰diceste
essere mecanica perchè si fa a prezzo chi
cade ī questo errore, ²¹se errore si può
chiamare piv di uoi ·? se voi legiete per li
studi, nō andate voi ²²a chi piv vi premia?
fate voi alcuna opera sāza qualche premio?
Bē²³chè questo nō dico per biasimare simili
openioni, perchè ogni fatica ²⁴aspetta pre-
mio, e potrà dire uno poeta, io farò una fin-
tione che significa ²⁵cose grādi, questo me-
desimo farà il pittore, come fecie Apelle
²⁶la calūnia; se voi diceste la poesia è piv
eterna, per questo dirò ²⁷essere piv · eterne
· le opere d'un calderaio, chè 'l tēpo piv le
cōserua ²⁸che le vostre o nostre opere;
niēte di meno è di poca fātasia; ²⁹e la pit-
tura si può, dipigniēdo sopra rame cō colori
di uetro, fare ³⁰molto piv eterna; noi per
arte possiamo essere detti nipoti a dio; ³¹se
la poesia s'astēde · ī filosofia morale., è questa
ī filosofia naturale, ³²se quella descrive l'ope-
rationi della mēte, questa cōsidera · quello
che la ³³mēte opera ne mouimēti: se quella
· spavēta i popoli colle īfernali ³⁴fitioni ·,
questa colle medesime cose in atto fa il
simile: pōga si il ³⁵poeta · a figurare una
bellezza, vna fierezza ·, una cosa nefāda
e brutta, ³⁶vna mostruosa · col pittore ·, faccia
a suo modo comè vole trasmv³⁷tationi di

tiful, will please most. Write up the name of
God [Christ] in some spot and set up His image
opposite and you will see which will be most
reverenced. Painting comprehends in itself
all the forms of nature, while you have
nothing but words, which are not universal
as form is, and if you have the effects of the
representation, we have the representation
of the effects. Take a poet who describes
the beauty of a lady to her lover and a
painter who represents her and you will see
to which nature guides the enamoured critic.
Certainly the proof should be allowed to rest
on the verdict of experience. You have
ranked painting among the mechanical arts
but, in truth, if painters were as apt at
praising their own works in writing as you are,
it would not lie under the stigma of so base
a name. If you call it mechanical because it
is, in the first place, manual, and that it is the
hand which produces what is to be found in
the imagination, you too writers, who set down
manually with the pen what is devised in
your mind. And if you say it is mechanical
because it is done for money, who falls into
this error—if error it can be called—more
than you? If you lecture in the schools do
you not go to whoever pays you most?
Do you do any work without pay? Still, I
do not say this as blaming such views,
for every form of labour looks for its reward.
And if a poet should say: "I will invent a
fiction with a great purpose," the painter
can do the same, as Apelles painted Calumny.
If you were to say that poetry is more eternal,
I say the works of a coppersmith are more
eternal still, for time preserves them longer
than your works or ours; nevertheless they
have not much imagination [29]. And a picture,
if painted on copper with enamel colours
may be yet more permanent. We, by our
arts may be called the grandsons of God.
If poetry deals with moral philosophy, paint-
ing deals with natural philosophy. Poetry
describes the action of the mind, painting
considers what the mind may effect by the
motions [of the body]. If poetry can terrify
people by hideous fictions, painting can do
as much by depicting the same things in action.
Supposing that a poet applies himself to re-
present beauty, ferocity, or a base, a foul

654. 1. esse. 2. che î. 3. î altro . . sieno me. 4. vederai. 5. lalde. 7. rischōtro vederai. 8. abraccia . . dela. 9. enomi.
10. abbiano . . deli. 11. î poeta . . belleze . . dona. 12. tolsi î . . vederai . . voltera. 13. dourebe. 15. larte mechani-
che . . laldare. 16. diacierebbe. 17. ciamate mechanicha . . chelle. 18. disegniādo cola. 19. quelo . nelo . . vstro . .
esse. 20. diciessi . . mechanicha . . prezo . . chade . . erore. 21. erore si po. 22. alchuna. 23. faticha. 24. pora dire î
. . faro î . . significha. 25. grāde. 26. calunia . . dicessi. 27. eterno lopere. 28. pocha. 29. ella . . sipo. 30. posiano . .
deti. 31. sella . . ecquesta. 32. secquela . . loperatione . . mētique considera . ucella cella. 33. secquella . . cole. 34. chole.
35. affigurare una . . fiereza î. 36. assuo. 37. sadisfacci. 38. chonformita colla cosa vua chella īganato.

forme, che il pittore nō sadisfacci piv; nō s'è egli uiste ³⁸pitture auere tāta cōformità colla cosa uiva ch'ell'ā īgānato ³⁹homini e animali?

or a monstrous thing, as against a painter, he may in his ways bring forth a variety of forms; but will the painter not satisfy more? are there not pictures to be seen, so like the actual things, that they deceive men and animals?

Come la scoltura è di minore īgegnio ²che la pittura e mācano in lei molte parti naturali.

THAT SCULPTURE IS LESS INTELLECTUAL THAN PAINTING, AND LACKS MANY CHARACTERISTICS OF NATURE.

³Adoperādomi io nō meno in iscultura che ī pittura e faciēdo l'una ⁴e l'altra · in vn medesimo grado, mi pare cō piccola īputatione potere ⁵dare sētētia ·, quale sia · di maggiore ingiegnio e difficoltà · e perfectio⁶ne · l'una · che l'altra ·; Prima · la scoltura è sottoposta · a cierti lumi, ⁷cioè di sopra ·, e la pittura porta per tutto · cō seco lume e ōbra; ⁸E lume e ōbra è la īportātia adūque della scoltura ·; lo scultore · ī questo caso è ajvtato ⁹dalla natura · del rilievo · ch'ella gienera per se, e 'l pittore per accidētale arte ¹⁰lo fa ne'lochi dove · ragionevolmēte lo farebbe la natura ·; lo scultore non si ¹¹può diversificare nelle varie nature de'colori delle cose ·, la pittura ¹²nō māca · in parte alcuna; le prospettive delli scultori nō paio¹³no niēte vere, quelle del pittore paiono a cētinaja di miglia ¹⁴di là dall'opera; La prospettiva aerea è lōtana da lor opera; ¹⁵nō possono figurare i corpi trāsparēti ·, nō possono figurare i lu¹⁶minosi, nō linie reflesse, nō corpi lucidi come spechi e simili ¹⁷cose lustrāti, nō nebbie, nō tēpi oscuri e infinite cose che nō ¹⁸si dicono per nō tediare ·; ciò che l'à è ch'ella è piv resistēte al tenpo, ben¹⁹chè à simil resistētia · la pittura, fatta sopra rame grosso coperto ²⁰di smalto biāco e sopra quello dipīto cō colori di smalto e rimesso ²¹ī foco e fatto cuocere, questa per eternità · avāza la scoltura; Potrà ²²dire che doue fanno uno errore nō esser facile il raccōciare, questo è ²³tristo argomēto a volere provare che una ismemoratagine inremediabile ³⁴faccia l'opera piv degnia, ma io dirò bene che

I myself, having exercised myself no less in sculpture than in painting and doing both one and the other in the same degree, it seems to me that I can, without invidiousness, pronounce an opinion as to which of the two is of the greatest merit and difficulty and perfection. In the first place sculpture requires a certain light, that is from above, a picture carries everywhere with it its own light and shade. Thus sculpture owes its importance to light and shade, and the sculptor is aided in this by the nature, of the relief which is inherent in it, while the painter whose art expresses the accidental aspects of nature, places his effects in the spots where nature must necessarily produce them. The sculptor cannot diversify his work by the various natural colours of objects; painting is not defective in any particular. The sculptor when he uses perspective cannot make it in any way appear true; that of the painter can appear like a hundred miles beyond the picture itself. Their works have no aerial perspective whatever, they cannot represent transparent bodies, they cannot represent luminous bodies, nor reflected lights, nor lustrous bodies—as mirrors and the like polished surfaces, nor mists, nor dark skies, nor an infinite number of things which need not be told for fear of tedium. As regards the power of resisting time, though they have this resistance[19], a picture painted on thick copper covered with white enamel on which it is painted with enamel colours and then put into the fire again and baked, far exceeds sculpture in permanence. It may be

Painting is superior to sculpture (655. 656).

655. 2. chella . . mācha illei. 3. pittura effaciēdo. 4. ellaltra nv . . pichola. 5. magiore . . dificulta. 7. chōsecho. 8. Ellume ella . . chaso e avtato. 9. chela. 11. diversifichare. 12. mācha . . alchuna . . paia. 13. pitore . . paiono a cētinara. 14. dallor. 15. possano . . i chorpi . . possāno. 16. refresse . . chorpi . . chome . . essimili. 17. soschuri . . chose. 18. dichano . . Cio chela chele piv. 19. assimil. 20. essopra . . chō. 21. chocere. 22. fano î erore . . rachōciare. 23. che î.

655. 19. From what is here said as to painting on copper it is very evident that Leonardo was not acquainted with the method of painting in oil on thin copper plates, introduced by the Flemish

lo ingiegnio del ²⁵maestro fia piv difficile a raccōciare che fa simile errori, che non è a ra³⁶cōciare l'opera da chi l'à guastata.

said that if a mistake is made it is not easy to remedy it; it is but a poor argument to try to prove that a work be the nobler because oversights are irremediable; I should rather say that it will be more difficult to improve the mind of the master who makes such mistakes than to repair the work he has spoilt.

Ash. I. 11*b*] **656.**

Noi sappiamo · bene che quello ·, che sarà pratico e bono, nō farà simili ²errori ·, anzi cō bone regole · andrà leuādo tanto poco per volta che bē cō³ducerà sua opera; · ācora lo scoltore, se fa di terra o ciera, può leuare ⁴e porre ·, e quādo è terminata · cō facilità · si gitta di brōzo ·, e questa ⁵è l'ultima operatione e la piv permanēte ch'abbi la scultura · Imperocchè ⁶quella ch'è sola di marmo è sottoposta alle rouine, e nō lo brōzo; adūque ⁷quella · pittura, fatta ī rame che si può, come dissi della pittura, levare e porre ⁸è pari al brōzo; che quādo facievi quell'opera prima di ciera, ancor si poteva ⁹leuare e porre; se questa scoltura di brōzo è eterna, questa di rame ¹⁰e di uetro è etternissima; se 'l brōzo rimane nero e brutto, questa è piena ¹¹di uari e vaghi colori e d'infinite varietà, della quale com'è di sopra ·; ¹²e se tu volessi dire solamēte della pittura fatta ī tauola, di questa son io ¹³cōtēto dare la sētētia colla scultura, diciēdo così, come la pittura ¹⁴è piv bella e di piv fantasia e piv copiosa, è la scultura piv dura¹⁵bile ·; altro nō à; la scoltura · cō poca fatica mostra quel che nel¹⁶la pittura · pare cosa miracolosa; a far parere palpabile ¹⁷cose īpalpabili, rileuate le cose piane, lontane le cose vicine; ¹⁸in effetto la pittura è ornata d'infinite speculationi che la scultura nō le adopera.

We know very well that a really experienced and good painter will not make such mistakes; on the contrary, with sound rules he will remove so little at a time that he will bring his work to a good issue. Again the sculptor if working in clay or wax, can add or reduce, and when his model is finished it can easily be cast in bronze, and this is the last operation and is the most permanent form of sculpture. Inasmuch as that which is merely of marble is liable to ruin, but not bronze. Hence a painting done on copper which as I said of painting may be added to or altered, resembles sculpture in bronze, which, having first been made in wax could then be altered or added to; and if sculpture in bronze is durable, this work in copper and enamel is absolutely imperishable. Bronze is but dark and rough after all, but this latter is covered with various and lovely colours in infinite variety, as has been said above; or if you will have me only speak of painting on panel, I am content to pronounce between it and sculpture; saying that painting is the more beautiful and the more imaginative and the more copious, while sculpture is the more durable but it has nothing else. Sculpture shows with little labour what in painting appears a miraculous thing to do; to make what is impalpable appear palpable, flat objects appear in relief, distant objects seem close. In fact painting is adorned with infinite possibilities which sculpture cannot command.

24. facia. 25. dificile . . cheffa . . erori. 36. cōtiare lopera dacquello guasta *4*.

656. 1. *4* noi sappiano . . checquello . chessara praticho. 2. erori . . pocho . . chō. 3. anchora la scholtura seffa di tera occiera po. 4. pore . . ecquesta. 5. ellultima . . ella abi. 6. chessola. 7. chessipo chome ti di della pitura . . pore. 8. quella prima lopera. 9. pore . . brōza. 10. brōso. 12. essettu. 13. cholla. 14. ella. 15. pacha faticha . . chel. 16. chosa . . affar. 17. īpalpabile. 18. effecto . . speculatione chella.

painters of the XVIIth century. J. LERMOLIEFF has already pointed out that in the various collections containing pictures by the great masters of the Italian Renaissance, those painted on copper (for instance the famous reading Magdalen in the Dresden Gallery) are the works of a much later date (see *Zeitschrift für bildende Kunst.* Vol. X pg. 333, and: *Werke italienischer Meister in den Galerien von München, Dresden und Berlin.* Leipzig 1880, pg. 158 and 159.—Compare No. 654, 29.

K. 3 30 b]

657.

PITTURA.

²Li omini e le parole ³son fatti, e tu pitto⁴re nō sapiēdo adopera⁵re le tue figure, tu ⁶se' come l'oratore che ⁷nō sa adoperare le pa⁸role sue.

OF PAINTING.

Men and words are ready made, and you, O Painter, if you do not know how to make your figures move, are like an orator who knows not how to use his words.

Aphorisms (657—659).

W. A. IV. 152 a]

658.

Quando il poeta cessa del figurare colle parole ²quel che in natura è in fatto, allora il poeta nō ³si fa equale al pittore, perchè se il poeta, la⁴sciando tal figuratione, e' descrive le parole or⁵nate e persuasiue di colui a chi esso vole fare par⁶lare, allora egli si fa oratore e non è più poeta nè è pittore, e se lui ⁷parla de' celi, egli si fa astrologo e filosofo, e te⁸ologo parlando delle cose di natura o di dio, ma ⁹se esso ritorna alla figuratione di qualunche co¹⁰sa e' si farebbe emulo al pittore, se potesse soddi¹¹sfare all' ochio in parole come fa il pittore.

As soon as the poet ceases to represent in words what exists in nature, he in fact ceases to resemble the painter; for if the poet, leaving such representation, proceeds to describe the flowery and flattering speech of the figure, which he wishes to make the speaker, he then is an orator and no longer a poet nor a painter. And if he speaks of the heavens he becomes an astrologer, and philosopher; and a theologian, if he discourses of nature or God. But, if he restricts himself to the description of objects, he would enter the lists against the painter, if with words he could satisfy the eye as the painter does.

Ash. I. 15 b]

659.

Se tu saprai ragionare e scrivere la dimostratione delle forme, ²il pittore le farà che parrāno · animate con ōbre e lumi, cōponitori dell'aria de' volti, ³della quale · tu nō puoi agivgniere colla pēna dove s'agivgnie col penello.

Though you may be able to tell or write the exact description of forms, the painter can so depict them that they will appear alive, with the shadow and light which show the expression of a face; which you cannot accomplish with the pen though it can be achieved by the brush.

C. A. 139 a; 419 a]

660.

COME LA PITTURA VA D'ETÀ IN ETÀ DECLINANDO E PĒDĒDOSI, ²QUĀDO I PITTORI NON ÀNNO PER AUTORE · ALTRO CHE LA FATTA PITTURA.

⁴Siccome il pittore avrà la sua pittura di poca eccielenza ·, se quello · piglia per autore ⁵l'altrui · pitture ·, ma s'egli · jnparerà · dalle cose naturali · farà bono frutto, ⁶come vedemo in ne' pittori dopo · i romani, i quali senpre imitarono l'uno dall'altro ⁷e di età ·

THAT PAINTING DECLINES AND DETERIORATES FROM AGE TO AGE, WHEN PAINTERS HAVE NO OTHER STANDARD THAN PAINTING ALREADY DONE.

Hence the painter will produce pictures of small merit if he takes for his standard the pictures of others. But if he will study from natural objects he will bear good fruit; as was seen in the painters after the Romans who always imitated each other and so their art constantly declined from age to age. After

On the history of painting (660. 661).

657. 1—8 R. 2. elle. 3. ettu. 4. opera.

658. 2. facto. 4. desscrive. 6. oratore "e non e piu poeta ne" e no pictore .. essellui. 7. asstrolagho e filosofo ette. 8. olagho. 9. potessi cos. 10. sodidi. 11. ochio \\\\\j parole.

659. 1. settu .. esscrivere. 2. ellumi. 3. poi chol.

660. 1. chome .. va "deta in eta" declinando. 2. ano per altore . altore chella. 3. chome la pittura. 4. si chome .. ara .. pocha .. secquello .. altore. 5. massegli .. chose. 6. chome .. ine .. imitorono. 7. andaro .. dechinatione .. vene. 5. [ēstado chōtēto alo .. suo maestro non avēdo] nato i mōti. 9. abitato .. chapre essimil .. assimile. 10. super .. capre de

in età · senpre andava · detta arte ī decli-
natione·; dopo questi · venne Giotto Fiorētino,
[8]il quale [nō è stato cōtēto allo imitare
l'opere di Cimabue suo maestro] nato ī
mōti [9]soletari, abitati solo da capre e simil
bestie, — questo, sēdo volto · dalla natura ·
a simile arte, [10]comīciò a disegniare sopra
i sassi li atti delle capre delle quali lui
era guardatore; [11]e così comīciò a fare
tutti li animali che nel paese si trovavā in
tal modo, che questo dopo molto [12]studio
avāzò nō che i maestri della sua età, [13]ma
tutti quelli · di molti secoli passati·; dopo ·
questo · l'arte [14]ricadde, perchè tutti imi-
tavano [15]le fatte pitture ·, e così di secolo
ī secolo ādò declinādo īsino [16]a tāto, che
Tomaso fiorētino, cognominato Masacio,
mostrò con opera perfetta co[17]me quelli
che pigliavano per autore altro che la natura,
· maestra dei maestri, [18]s'afaticavano īuano ·;
[19]così voglio dire di queste cose matematiche,
· che quegli che solamēte studiano [20]li autori
· e nō le opere di natura ·, sō per arte ñi-
poti e nō figlioli d'essa natura, mae[21]stra di
boni autori; O della sōma stoltitia di quelli i
quali biasimano · coloro che [22]īparano dalla
natvra ·, lasciādo stare li autori discepoli
d'essa natura!

these came Giotto the Florentine who—not
content with imitating the works of Cimabue
his master—being born in the mountains and
in a solitude inhabited only by goats and
such beasts, and being guided by nature to
his art, began by drawing on the rocks the
movements of the goats of which he was
keeper. And thus he began to draw all the
animals which were to be found in the
country, and in such wise that after much
study he excelled not only all the masters
of his time but all those of many bygone
ages. Afterwards this art declined again, because
everyone imitated the pictures that were
already done; thus it went on from century
to century until Tomaso, of Florence, nick-
named Masaccio, showed by his perfect works
how those who take for their standard any
one but nature—the mistress of all masters—
weary themselves in vain. And, I would say
about these mathematical studies that those
who only study the authorities and not the
works of nature are descendants but not
sons of nature the mistress of all good
authors. Oh! how great is the folly of those
who blame those who learn from nature[22],
setting aside those authorities who themselves
were the disciples of nature.

Ash. I. 18a] **661.**

Come la prima pittura fu sol d'una linia,
la quale circūdaua [2]l'ōbra dell'omo, fatta
dal sole ne'mvri.

That the first drawing was a simple line
drawn round the shadow of a man cast by
the sun on a wall.

S. K. M. III. 48a] **662.**

The pain-
ter's scope. Il dipintore disputa e gareggia [2]colla
natura.

The painter strives and competes with
nature.

[quali] le. 11. affare tuti. 12—22 *are written in a parallel column*. 12. 4 studio avazo [tutti i ma] . . dela. 13. queli . .
secholi. 14. richade [insinom] perche tutti [pigliavano per altore] imitavano. 15. chosi di secholo ī seculo ādo diclinādo.
16. attāto che "to" maso "fiorētino" cogniominato masacio . . chon . . cho. 17. quelgli . . altore . . chella. 18. iuano.
19. chosi . . chose matematice. 20. altori . . le opre . soprarteui potienō figlioli. 21. altori . . di soma . . queli . . choloro.
22. altori.
661. 1. circhūtaua.
662. 1. garegia. 2. cola.

660. 22. *lasciando stare li autori*. In this obser-
vation we may detect an indirect evidence that
Leonardo regarded his knowledge of natural history
as derived from his own investigations, as well as
his theories of perspective and optics. Compare what
he says in praise of experience (Vol II; *XIX*).

X.

Studies and Sketches for Pictures and Decorations.

An artist's manuscript notes can hardly be expected to contain any thing more than incidental references to those masterpieces of his work of which the fame, sounded in the writings of his contemporaries, has left a glorious echo to posterity. We need not therefore be surprised to find that the texts here reproduced do not afford us such comprehensive information as we could wish. On the other hand, the sketches and studies prepared by Leonardo for the two grandest compositions he ever executed: The Fresco of the Last Supper in the Refectory of Santa Maria delle Grazie at Milan, and the Cartoon of the Battle of Anghiari, for the Palazzo della Signoria at Florence—have been preserved; and, though far from complete, are so much more numerous than the manuscript notes, that we are justified in asserting that in value and interest they amply compensate for the meagerness of the written suggestions.

The notes for the composition of the Last Supper, which are given under nos. 665 and 666 occur in a MS. at South Kensington, II², written in the years 1494—1495. This MS. sketch was noted down not more than three or four years before the painting was executed, which justifies the inference that at the time when it was written the painter had not made up his mind definitely even as to the general scheme of the work; and from this we may also conclude that the drawings of apostles' heads at Windsor, in red chalk, must be ascribed to a later date. They are studies for the head of St. Matthew, the fourth figure on Christ's left hand—see Pl. XLVII—, the sketch (in black chalk) for the head of St. Philip, the third figure on the left hand—see Pl. XLVIII—, for St. Peter's right arm–see Pl. XLIX, and for the expressive head of Judas which has unfortunately somewhat suffered by subsequent restoration of outlines,—see Pl. L. According to a tradition, as unfounded as it is improbable, Leonardo made use of the head of Padre Bandelli, the prior of the convent, as the prototype of his Judas; this however has already been contradicted by Amoretti "Memorie storiche" cap. XIV. The study of the head of a criminal on Pl. LI has, it seems to me, a better claim to be regarded as one of the preparatory sketches for the head of Judas. The

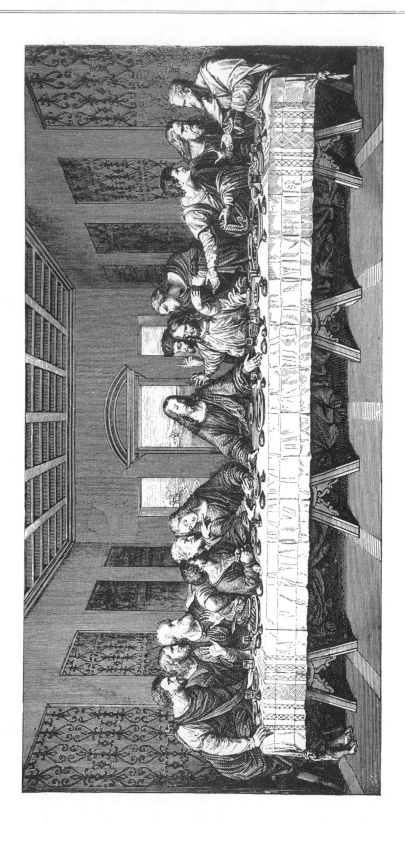

Windsor collection contains two old copies of the head of St. Simon, the figure to the extreme left of Christ, both of about equal merit (they are marked as Nos. 21 and 36) —the second was reproduced on Pl. VIII of the Grosvenor Gallery Publication in 1878. There is also at Windsor a drawing in black chalk of folded hands (marked with the old No. 212; No. LXI of the Grosvenor Gallery Publication) which I believe to be a copy of the hands of St. John, by some unknown pupil. A reproduction of the excellent drawings of heads of Apostles in the possession of H. R. H. the Grand Duchess of Weimar would have been out of my province in this work, and, with regard to them, I must confine myself to pointing out that the difference in style does not allow of our placing the Weimar drawings in the same category as those here reproduced. The mode of grouping in the Weimar drawings is of itself sufficient to indicate that they were not executed before the picture was painted, but, on the contrary, afterwards; and it is, on the face of it, incredible that so great a master should thus have copied from his own work.

The drawing of Christ's head, in the Brera palace at Milan was perhaps originally the work of Leonardo's hand; it has unfortunately been entirely retouched and re-drawn, so that no decisive opinion can be formed as to its genuineness.

The red chalk drawing reproduced on Pl. XLVI is in the Accademia at Venice; it was probably made before the text, Nos. 664 and 665, was written.

The two pen and ink sketches on Pl. XLV seem to belong to an even earlier date; the more finished drawing of the two, on the right hand, represents Christ with only St. John and Judas and a third disciple whose action is precisely that described in No. 666, l. 4. It is hardly necessary to observe that the other sketches on this page and the lines of text below the circle (containing the solution of a geometrical problem) have no reference to the picture of the Last Supper. With this figure of Christ may be compared a similar pen and ink drawing reproduced on page 297 below on the left hand; the original is in the Louvre. On this page again the rest of the sketches have no direct bearing on the composition of the Last Supper, not even, as it seems to me, the group of four men at the bottom to the right hand—who are listening to a fifth, in their midst addressing them. Moreover the writing on this page (an explanation of a disk shaped instrument) is certainly not in the same style as we find constantly used by Leonardo after the year 1489.

It may be incidentally remarked that no sketches are known for the portrait of "Mona Lisa", nor do the MS. notes ever allude to it, though according to Vasari the master had it in hand for fully four years.

Leonardo's cartoon for the picture of the battle of Anghiari has shared the fate of the rival work, Michael Angelo's "Bathers summoned to Battle": Both have been lost in some wholly inexplicable manner. I cannot here enter into the remarkable history of this work; I can only give an account of what has been preserved to us of Leonardo's scheme and preparations for executing it. The extent of the material in studies and drawings was till now quite unknown. Their publication here may give some adequate idea of the grandeur of this famous work. The text given as No. 669 contains a description of the particulars of the battle, but for the reasons given in the note to this text, I must abandon the idea of taking this passage as the basis of my attempt to reconstruct the picture as the artist conceived and executed it.

I may here remind the reader that Leonardo prepared the cartoon in the Sala del Papa of Santa Maria Novella at Florence and worked there from the end of October 1503 till February 1504, and then was busied with the painting in the Sala del Consiglio in the Palazzo della Signoria, till the work was interrupted at the end of May 1506. (See Milanesi's note to Vasari pp. 43—45 Vol. IV ed. 1880.) Vasari, as is well known, describes only one scene or episode of the cartoon—the Battle for the Standard in the foreground of the composition, as it would seem; and this only was ever finished as a mural decoration in the Sala del Consiglio. This portion of the composition is familiar to all from the disfigured copy engraved by Edelinck. Mariette had already very acutely observed that Edelinck must surely have worked from a Flemish copy of the picture. There is in the Louvre a drawing by Rubens (No. 565) which also represents four horsemen fighting round a standard and which agrees with Edelinck's engraving, but the engraving reverses the drawing. An earlier Flemish drawing, such as may have served as the model for both Rubens and Edelinck, is in the Uffizi collection (see Philpots's Photograph, No. 732). It seems to be a work of the second half of the XVIth century, a time when both the picture and the cartoon had already been destroyed. It is apparently the production of a not very skilled hand. Raphael Trichet du Fresne, 1651, mentions that a small picture by Leonardo himself of the Battle of the Standard was then extant in the Tuileries; by this he probably means the painting on panel which is now in the possession of Madame Timbal in Paris, and which has lately been engraved by Haussoullier as a work by Leonardo. The picture, which is very carefully painted, seems to me however to be the work of some unknown Florentine painter, and probably executed within the first ten years of the XVIth century. At the same time, it would seem to be a copy not from Leonardo's cartoon, but from his picture in the Palazzo della Signoria; at any rate this little picture, and the small Flemish drawing in Florence are the oldest finished copies of this episode in the great composition of the Battle of Anghiari.

In his Life of Raphael, Vasari tells us that Raphael copied certain works of Leonardo's during his stay in Florence. Raphael's first visit to Florence lasted from the middle of October 1504 till July 1505, and he revisited it in the summer of 1506. The hasty sketch, now in the possession of the University of Oxford and reproduced on page 337 also represents the Battle of the Standard and seems to have been made during his first stay, and therefore not from the fresco but from the cartoon; for, on the same sheet we also find, besides an old man's head drawn in Leonardo's style, some studies for the figure of St. John the Martyr which Raphael used in 1505 in his great fresco in the Church of San Severo at Perugia.

Of Leonardo's studies for the Battle of Anghiari I must in the first place point to five, on three of which—Pl. LII 2, Pl. LIII, Pl. LVI—we find studies for the episode of the Standard. The standard bearer, who, in the above named copies is seen stooping, holding on to the staff across his shoulder, is immediately recognisable as the left-hand figure in Raphael's sketch, and we find it in a similar attitude in Leonardo's pen and ink drawing in the British Museum—Pl. LII, 2—the lower figure to the right. It is not difficult to identify the same figure in two more complicated groups in the pen and ink drawings, now in the Accademia at Venice—Pl. LIII, and Pl. LIV—where we also find some studies of foot soldiers fighting. On the sheet in the British Museum —Pl. LII, 2—we find, among others, one group of three horses galloping forwards: one

horseman is thrown and protects himself with his buckler against the lance thrusts of two others on horseback, who try to pierce him as they ride past. The same action is repeated, with some variation, in two sketches in pen and ink on a third sheet, in the Accademia at Venice, Pl. LV; a coincidence which suggests the probability of such an incident having actually been represented on the cartoon. We are not, it is true, in a position to declare with any certainty which of these three dissimilar sketches may have been the nearest to the group finally adopted in executing the cartoon.

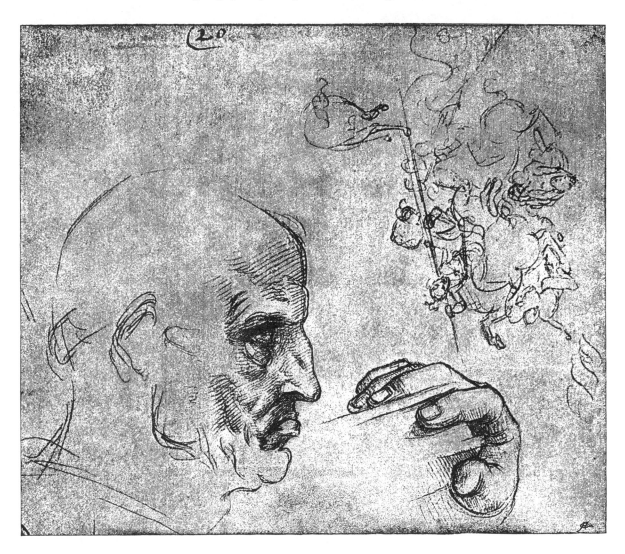

With regard, however, to one of the groups of horsemen it is possible to determine with perfect certainty not only which arrangement was preferred, but the position it occupied in the composition. The group of horsemen on Pl. LVII is a drawing in black chalk at Windsor, which is there attributed to Leonardo, but which appears to me to be the work of Cesare da Sesto, and the Commendatore Giov. Morelli supports me in this view. It can hardly be doubted that da Sesto, as a pupil of Leonardo's, made this drawing from his master's cartoon, if we compare it with the copy made by Raphael—here reproduced,

for just above the fighting horseman in Raphael's copy it is possible to detect a horse which is seen from behind, going at a slower pace, with his tail flying out to the right and the same horse may be seen in the very same attitude carrying a dimly sketched rider, in the foreground of Cesare da Sesto's drawing.

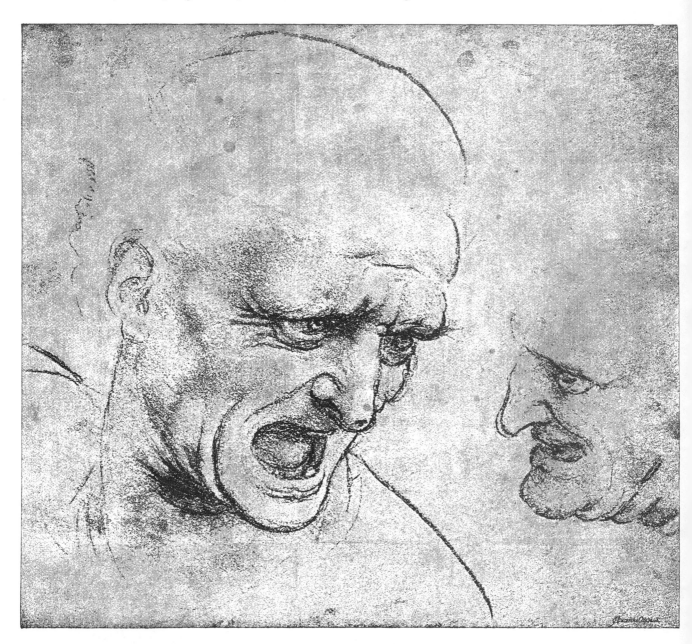

If a very much rubbed drawing in black chalk at Windsor—Pl. LVI—is, as it appears to be, the reversed impression of an original drawing, it is not difficult to supplement from it the portions drawn by Cesare da Sesto. Nay, it may prove possible to reconstruct the whole of the lost cartoon from the mass of materials we now have at hand which we may regard as the nucleus of the composition. A large pen and ink

drawing by Raphael in the Dresden collection, representing three horsemen fighting, and another, by Cesare da Sesto, in the Uffizi, of light horsemen fighting are a further contribution which will help us to reconstruct it.

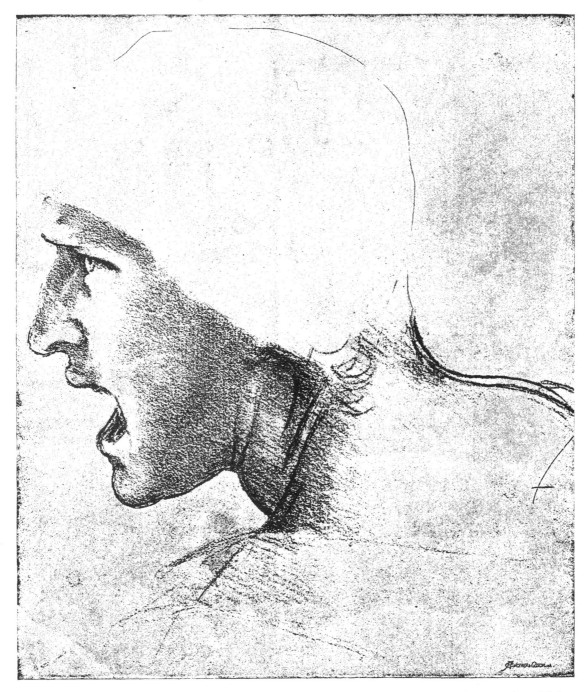

The sketch reproduced on Pl. LV gives a suggestive example of the way in which foot-soldiers may have been introduced into the cartoon as fighting among the groups of horsemen; and I may here take the opportunity of mentioning that, for reasons which

it would be out of place to enlarge upon here, I believe the two genuine drawings by Raphael's hand in his "Venetian sketch-book" as it is called—one of a standard bearer marching towards the left, and one of two foot-soldiers armed with spears and fighting with a horseman—to be undoubtedly copies from the cartoon of the Battle of Anghiari.

Leonardo's two drawings, preserved in the museum at Buda-Pesth and reproduced on pages 338 and 339 are preliminary studies for the heads of fighting warriors. The two heads drawn in black chalk (pg. 338), and the one seen in profile, turned to the left, drawn in red chalk (pg. 339), correspond exactly with those of two horsemen in the scene of the fight round the standard as we see them in Madame Timbal's picture and in the other finished copies. An old copy of the last named drawing by a pupil of Leonardo is in MS. C. A. 187b; 561b (See Saggio, Tav. XXII). Leonardo used to make such finished studies of heads as those, drawn on detached sheets, before beginning his pictures from his drawings—compare the preparatory studies for the fresco of the Last Supper, given on Pl. XLVII and Pl. L. Other drawings of heads, all characterised by the expression of vehement excitement that is appropriate to men fighting, are to be seen at Windsor (No. 44) and at the Accademia at Venice (IV, 13); at the back of one of the drawings at Buda-Pesth there is the bust of a warrior carrying a spear on his left shoulder, holding up the left arm (See Csataképek a XVI—lk Századból összeállitotta Pvlszky Károly). These drawings may have been made for other portions of the cartoon, of which no copies exist, and thus we are unable to identify these preparatory drawings. Finally I may add that a sketch of fighting horse and foot soldiers, formerly in the possession of M. Thiers and published by Charles Blanc in his "Vies des Peintres" can hardly be accepted as genuine. It is not to be found, as I am informed, among the late President's property, and no one appears to know where it now is.

An attempted reconstruction of the Cartoon, which is not only unsuccessful but perfectly unfounded, is to be seen in the lithograph by Bergeret, published in Charles Blanc's "Vies des peintres" and reprinted in "The great Artists. L. da Vinci", p. 80. This misleading pasticcio may now be rejected without hesitation.

There are yet a few original drawings by Leonardo which might be mentioned here as possibly belonging to the cartoon of the Battle; such as the pen and ink sketches on Pl. XXI and on Pl. XXXVIII, No. 3, but we should risk too wide a departure from the domain of ascertained fact.

With regard to the colours and other materials used by Leonardo the reader may be referred to the quotations from the accounts for the picture in question given by Milanesi in his edition of Vasari (Vol. IV, p. 44, note) where we find entries of a similar character to those in Leonardo's note books for the year 1505; S. K. M. I² (see No. 636).

That Leonardo was employed in designing decorations and other preparations for high festivals, particularly for the court of Milan, we learn not only from the writings of his contemporaries but from his own incidental allusions; for instance in MS. C. 15b (1), l. 9. In the arrangement of the texts referring to this I have placed those first, in which historical personages are named—Nos. 670—674. Among the descriptions of Allegorical subjects two texts lately found at Oxford have been included, Nos. 676 and 677. They are particularly interesting because they are accompanied by large sketches which render the meaning of the texts perfectly clear. It is very intelligible that in other cases, where

there are no illustrative sketches, the notes must necessarily remain obscure or admit of various interpretations. The litterature of the time affords ample evidence of the use of such allegorical representations, particularly during the Carnival and in Leonardo's notes we find the Carnival expressly mentioned—Nos. 685 and 704. Vasari in his Life of Pontormo, particularly describes that artist's various undertakings for Carnival festivities. These very graphic descriptions appear to me to throw great light in more ways than one on the meaning of Leonardo's various notes as to allegorical representations and also on mottoes and emblems—Nos. 681—702. In passing judgment on the allegorical sketches and emblems it must not be overlooked that even as pictures they were always accompanied by explanations in words. Several finished drawings of allegorical compositions or figures have been preserved, but as they have no corresponding explanation in the MSS. they had no claim to be reproduced here. The female figure on Pl. XXVI may perhaps be regarded as a study for such an allegorical painting, of which the purport would have been explained by an inscription.

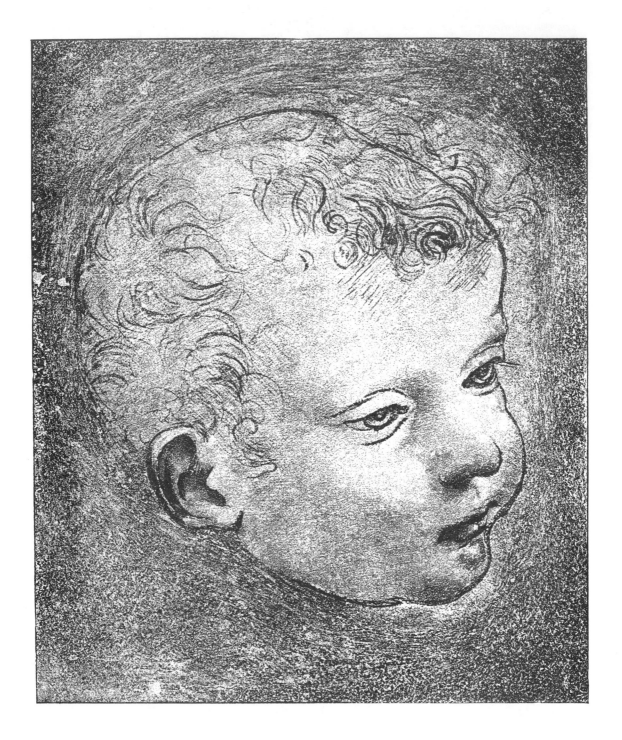

663.

\\\\\\bre 1478 | jcomīciai le 2 vergini Marie.

[In the autumn of] 1478 I began the two Madonna [pictures].

663. 1. ʃchomīciai . . Vergine.

663. Photographs of this page have been published by BRAUN, No. 439, and PHILPOT, No. 718.

1. *Incominciai.* We have no other information as to the two pictures of the Madonna here spoken of. As Leonardo here tells us that he had begun two Madonnas at the same time, the word *'incominciai'* may be understood to mean that he had begun at the same time preparatory studies for two pictures to be painted later. If this is so, the non-existence of the pictures may be explained by supposing that they were only planned and never executed. I may here mention a few studies for pictures of the Madonna which probably belong to this early time; particularly a drawing in silver-point on bluish tinted paper at Windsor—see Pl. XL, No. 3—, a drawing of which the details have almost disappeared in the original but have been rendered quite distinct in the reproduction; secondly a slight pen and ink sketch in the Codex VALLARDI, in the Louvre, fol. 64, No. 2316; again a silver point drawing of a Virgin and child drawn over again with the pen in the His de la Salle collection also in the Louvre, No. 101. (See Vicomte BOTH DE TAUZIA, *Notice des dessins de la collection His de la Salle, exposés au Louvre.* Paris 1881, pp. 80, 81.) This drawing is, it is true, traditionally ascribed to Raphael, but the author of the catalogue very justly points out its great resemblance with the sketches for Madonnas in the British Museum which are indisputably Leonardo's. Some of these have been published by Mr. HENRY WALLIS in the Art Journal, New Ser. No. 14, Feb. 1882. If the non-existence of the two pictures here alluded to justifies my hypothesis that only studies for such pictures are

meant by the text, it may also be supposed that the drawings were made for some comrade in VERROCCHIO's atelier. (See VASARI, Sansoni's ed. Florence 1880. Vol. IV, p. 564): *"E perchè a Lorenzo piaceva fuor di modo la maniera di Lionardo, la seppe così bene imitare, che niuno fu che nella pulitezza e nel finir l'opere con diligenza l'imitasse più di lui."* Leonardo's notes give me no opportunity of discussing the pictures executed by him in Florence, before he moved to Milan. So the studies for the unfinished picture of the Adoration of the Magi— in the Uffizi, Florence—cannot be described here, nor would any discussion about the picture in the Louvre *"La Vierge aux Rochers"* be appropriate in the absence of all allusion to it in the MSS. Therefore, when I presently add a few remarks on this painting in explanation of the Master's drawings for it, it will be not merely with a view to facilitate critical researches about the picture now in the National Gallery, London, which by some critics has been pronounced to be a replica of the Louvre picture, but also because I take this opportunity of publishing several finished studies of the Master's which, even if they were not made in Florence but later in Milan, must have been prior to the painting of the Last Supper. The original picture in Paris is at present so disfigured by dust and varnish that the current reproductions in photography actually give evidence more of the injuries, to which the picture has been exposed than of the original work itself. The wood-cut given on p. 344, is only intended to give a general notion of the composition. It must be understood that the outline

and expression of the heads, which in the picture
is obscured but not destroyed, is here altogether
missed. The facsimiles which follow are from

drawings which appear to me to be studies for *"La
Vierge aux Rochers."*

1. A drawing in silver point on brown toned

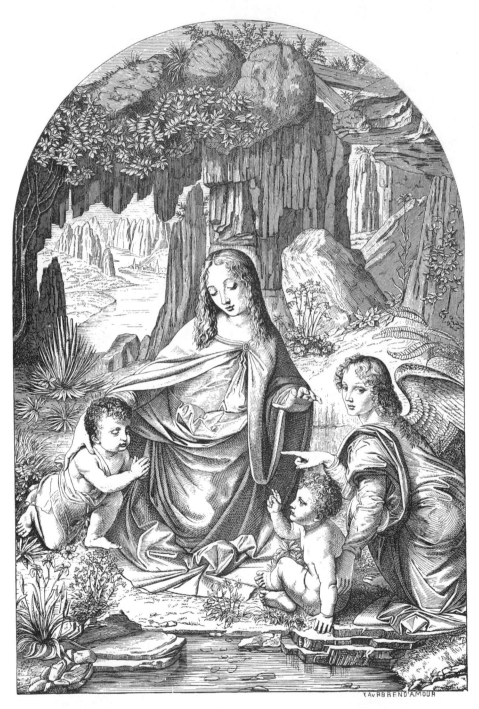

paper of a woman's head looking to the left. In
the Royal Library at Turin, apparently a study
from nature for the Angel's head (Pl. XLII).

2. A study of drapery for the left leg of the
same figure, done with the brush, Indian ink on
greenish paper, the lights heightened with white.

Th.] 664.

Bernardo
di Bandino's
Portrait.

Berrettina di tanè,	A tan-coloured small cap,
²farsetto di raso nero,	A doublet of black serge,
³cioppa nera foderata,	A black jerkin lined
⁴giubba turchina foderata	A blue coat lined,
⁵di gole di volpe,	with fur of foxes' breasts,
⁶e'l collare della givbba	and the collar of the jerkin
⁷soppannato di velluto appicchiet-	covered with black
⁸tato nero e rosso;	and white stippled velvet.
⁹Bernardo di Bandino	Bernardo di Bandino
¹⁰Baroncigli;	Baroncelli;
¹¹calze nere.	black hose.

664. 1. berettino. 4. giupba. 5. di ghole di gholpe. 6. chollare. 7. appicci. 8. lato . . errosso. 10. baroncigli. 11. chalze.

The original is at Windsor, No. 223. The reproduction Pl. XLIII is defective in the shadow on the upper part of the thigh, which is not so deep as in the original; it should also be observed that the folds of the drapery near the hips are somewhat altered in the finished work in the Louvre, while the London copy shows a greater resemblance to this study in that particular.

3. A study in red chalk for the bust of the Infant Christ—No. 3 in the Windsor collection (Pl. XLIV). The well-known silver-point drawing on pale green paper, in the Louvre, of a boy's head (No. 363 in REISET, *Notice des dessins, Ecoles d'Italie*) seems to me to be a slightly altered copy, either from the original picture or from this red chalk study.

4. A silver-point study on greenish paper, for the head of John the Baptist, reproduced on p. 342. This was formerly in the Codex Vallardi and is now exhibited among the drawings in the Louvre. The lights are, in the original, heightened with white; the outlines, particularly round the head and ear, are visibly restored.

There is a study of an outstretched hand—No. 288 in the Windsor collection—which was published in the Grosvenor Gallery Publication, 1878, simply under the title of: "No. 72 Study of a hand, pointing" which, on the other hand, I regard as a copy by a pupil. The action occurs in the kneeling angel of the Paris picture and not in the London copy.

These four genuine studies form, I believe, a valuable substitute in the absence of any MS. notes referring to the celebrated Paris picture.

664. These eleven lines of text are by the side of the pen and ink drawing of a man hanged—Pl. LXII, No. 1. This drawing was exhibited in 1879 at the *Ecole des Beaux-Arts* in Paris and the compilers of the catalogue amused themselves by giving the victim's name as follows: "*Un pendu, vêtu d'une longue robe, les mains liées sur le dos . . . Bernardo di Bendino Barontigni, marchand de pantalons*"

(see *Catalogue descriptif des Dessins de Maîtres anciens exposés à l'Ecole des Beaux Arts*, Paris 1879; No. 83, pp. 9—10). Now, the criminal represented here, is none other than Bernardino di Bandino Baroncelli the murderer of Giuliano de' Medici, whose name as a coadjutor in the conspiracy of the Pazzi has gained a melancholy notoriety by the tragedy of the 26th April 1478. Bernardo was descended from an ancient family and the son of the man who, under King Ferrante, was President of the High Court of Justice in Naples. His ruined fortunes, it would seem, induced him to join the Pazzi; he and Francesco Pazzi were entrusted with the task of murdering Giuliano de' Medici on the fixed day. Their victim not appearing in the cathedral at the hour when they expected him, the two conspirators ran to the palace of the Medici and induced him to accompany them. Giuliano then took his place in the chancel of the Cathedral, and as the officiating priest raised the Host—the sign agreed upon—Bernardo stabbed the unsuspecting Giuliano in the breast with a short sword; Giuliano stepped backwards and fell dead. The attempt on Lorenzo's life however, by the other conspirators at the same moment, failed of success. Bernardo no sooner saw that Lorenzo tried to make his escape towards the sacristy, than he rushed upon him, and struck down Francesco Nori who endeavoured to protect Lorenzo. How Lorenzo then took refuge behind the brazen doors of the sacristy, and how, as soon as Giuliano's death was made known, the further plans of the conspirators were defeated, while a terrible vengeance overtook all the perpetrators and accomplices, this is no place to tell. Bernardo Bandini alone seemed to be favoured by fortune; he hid first in the tower of the Cathedral, and then escaped undiscovered from Florence. Poliziano, who was with Lorenzo in the Cathedral, says in his 'Conjurationis Pactianae Commentarium': "*Bandinus fugitans in Tiphernatem incidit, a quo in aciem receptus Senas pervenit.*" And Gino Capponi in summing up the reports of the

Notes on the Last Supper 665—668).

Vno che beveua e lasciò ²la zaina nel suo sito · e volse la testa inver³so il proponitore;

⁴Vn altro tesse le dita · delle · sue mani insieme ⁵e cō rigide ciglia · si uolta · al cōpagnio, ⁶l'altro colle mani aperte mostra le palme di quelle ⁷e alza le spalle · inverso li orechi e fa la bocca della ⁸maraviglia;

One who was drinking and has left the glass in its position and turned his head towards the speaker.

Another, twisting the fingers of his hands together turns with stern brows to his companion [6]. Another with his hands spread open shows the palms, and shrugs his shoulders up his ears making a mouth of astonishment [8].

665. 1. vno che [voleua bere e per] beveua ellasscio. 5. cho. 6. cholle. 7. lesspalli inver . . effa la bocha. 9. ecquello.

numerous contemporary narrators of the event, says: "*Bernardo Bandini ricoverato in Costantinopoli, fu per ordine del Sultano preso e consegnato a un Antonio di Bernardetto dei Medici, che Lorenzo aveva mandato apposta in Turchia: così era grande la potenza di quest' uomo e grande la voglia di farne mostra e che non restasse in vita chi aveagli ucciso il fratello, fu egli applicato appena giunto*" (*Storia della Republica di Firenze II*, 377, 378). Details about the dates may be found in the *Chronichetta di Belfredello Strinati Alfieri:* "*Bernardo di Bandino Bandini sopradetto ne venne preso da Gostantinopoli a dì* 14. *Dicembre* 1479 *e disaminato, che fu al Bargello, fu impiccato alle finestre di detto Bargello allato alla Doana a dì* 29. *Dicembre MCCCCLXXIX che pochi dì stette.*" It may however be mentioned with reference to the mode of writing the name of the assassin that, though most of his contemporaries wrote Bernardo Bandini, in the *Breve Chronicon Caroli Petri de Joanninis* he is called Bernardo di Bandini Baroncelli; and, in the *Sententiae Domini Matthaei de Toscanis*, Bernardus Joannis Bandini de Baroncellis, as is written on Leonardo's drawing of him when hanged. Now VASARI, in the life of *Andrea del Castagno* (Vol. II, 680; ed. Milanesi 1878), tells us that in 1478 this painter was commissioned by order of the Signoria to represent the members of the Pazzi conspiracy as traitors, on the façade of the Palazzo del Podésta—the Bargello. This statement is obviously founded on a mistake, for Andrea del Castagno was already dead in 1457. He had however been commissioned to paint Rinaldo degli Albizzi, when declared a rebel and exiled in 1434, and his adherents, as hanging head downwards; and in consequence he had acquired the nickname of Andrea degl' Impiccati. On the 21th July 1478 the Council of Eight came to the following resolution: "*item servatis etc. deliberaverunt et santiaverunt Sandro Botticelli pro ejus labore in pingendo proditores flor. quadraginta largos*" (see G. MILANESI, *Arch. stor. VI* (1862) p. 5 note.

As has been told, Giuliano de' Medici was murdered on the 26th April 1478, and we see by this that only three months later Botticelli was paid for his painting of the "*proditores*". We can however hardly

suppose that all the members of the conspiracy were depicted by him in fresco on the façade of the palace, since no fewer than eighty had been condemned to death. We have no means of knowing whether, besides Botticelli, any other painters, perhaps Leonardo, was commissioned, when the criminals had been hanged in person out of the windows of the Palazzo del Podestà to represent them there afterwards in effigy in memory of their disgrace. Nor do we know whether the assassin who had escaped may at first not have been provisionally represented as hanged in effigy. Now, when we try to connect the historical facts with this drawing by Leonardo reproduced on Pl. LXII, No. 1, and the full description of the conspirator's dress and its colour on the same sheet, there seems to be no reasonable doubt that Bernardo Bandini is here represented as he was actually hanged on December 29th, 1479, after his capture at Constantinople. The dress is certainly not that in which he committed the murder. A long furred coat might very well be worn at Constantinople or at Florence in December, but hardly in April. The doubt remains whether Leonardo described Bernardo's dress so fully because it struck him as remarkable, or whether we may not rather suppose that this sketch was actually made from nature with the intention of using it as a study for a wall painting to be executed. It cannot be denied that the drawing has all the appearance of having been made for this purpose. Be this as it may, the sketch under discussion proves, at any rate, that Leonardo was in Florence in December 1479, and the note that accompanies it is valuable as adding one more characteristic specimen to the very small number of his MSS. that can be proved to have been written between 1470 and 1480.

665. 666. In the original MS. there is no sketch to accompany these passages, and if we compare them with those drawings made by Leonardo in preparation for the composition of the picture—Pl. XLV, XLVI—, (compare also Pl. LII, 1 and the drawings on p. 297) it is impossible to recognise in them a faithful interpretation of the whole of this text; but, if we compare these passages with the finished picture (see p. 334) we shall see that in many places they

9 Vn altro parla nell' orechio all' altro,
e quello che ¹⁰l' ascolta si torcie inverso lui
e gli porgie li orechi, ¹¹tenendo · vn col-
tello nel' una mano e nell' altra il pa¹²ne
mezzo diuiso da tal coltello; ¹³l' altro nel
uoltarsi tenendo vn coltello in mano versa
¹⁴con tal mano vna zaina sopra della tavola.

[9] Another speaks into his neighbour's ear
and he, as he listens to him, turns towards
him to lend an ear [10], while he holds a knife
in one hand, and in the other the loaf half
cut through by the knife. [13] Another who has
turned, holding a knife in his hand, upsets
with his hand a glass on the table [14].

S. K. M. II.² 1 b]

666.

L'altro posa le mani sopra della tavola
e guarda, ²l'altro soffia nel boccone, ³l'altro
si china per uedere il proponitore e fassi
⁴ōbra colla mano alli ochi, ⁵l'altro si tira
inderieto a quel che si china · e ⁶vede il
proponitore infra 'l muro e 'l chinato.

Another lays his hand on the table and
is looking. Another blows his mouthful.
[3] Another leans forward to see the speaker
shading his eyes with his hand. [5] Another
draws back behind the one who leans
forward, and sees the speaker between the
wall and the man who is leaning [6].

S. K. M. II.² 786]

667.

CRISTO.

²Giovā cōte ·, quello del ca³rdinale del
Mortaro.

CHRIST.

Count Giovanni, the one with the Cardinal
of Mortaro.

V. A. X. 8]

668.

Filippo, Simone, Matteo, Tome, Jacopo
maggiore, Pietro, ²Filippo, Andrea, Barto-
lomeo.

Philip, Simon, Matthew, Thomas, James
the Greater, Peter, Philip, Andrew, Bartho-
lomew.

10. porcie . . orechicō. 11. choltello. 12. mezo. 13. imman.
666. 2. bochone. 3. effassi. 5. acquel chessi . . he. 6. cinato.

667. 1—3 R. 1. crissto. 2. del cha.
668. 1—2 R. 1. Matteo [tōme], tōme . . magore. 2. filipo.

coincide. For instance, compare No. 665, l. 6—8,
with the fourth figure on the right hand of Christ.
The various actions described in lines 9—10, 13—14
are to be seen in the group of Peter, John and Judas;
in the finished picture however it is not a glass but
a salt cellar that Judas is upsetting.

In No. 666. Line 1 must refer to the furthest
figure on the left; 3, 5 and 6 describe actions which
are given to the group of disciples on the left hand
of Christ.

6. *chinato*. I have to express my regret for having
misread this word, written *cinato* in the original, and
having altered it to *"cielo"* when I first published this
text, in 'The Academy' for Nov. 8, 1879 immediately
after I had discovered it, and subsequently in the
small biography of Leonardo da Vinci (Great Artists)
p. 29.

667. As this note is in the same small Manu-

script as the passage here immediately preceding
it, I may be justified in assuming that Leonardo
meant to use the features of the person here named
as a suitable model for the figure of Christ. The
celebrated drawing of the head of Christ, now
hanging in the Brera Gallery at Milan, has obviously
been so much restored that it is now impossible to
say, whether it was ever genuine. We have only
to compare it with the undoubtedly genuine drawings
of heads of the disciples in Pl. XLVII, XLVIII and
L, to admit that not a single line of the Milan
drawing in its present state can be by the same hand.

668. See Pl. XLVI. The names of the disciples
are given in the order in which they are written
in the original, from right to left, above each head.
The original drawing is here slightly reduced in
scale; it measures 39 centimètres in length by 26
in breadth.

C. A. 73 a; 214 a] **669.**

Fiorentini	Niccolò da Pisa
On the battle ²Neri di Gino Capponi	Conte Francesco,
of Anghiari. ³Bernardetto de' Me-	Micheletto,
dici.	⁴Pietro Giāpaolo
	⁵Guelfo Orsino,
	⁶Ms. Rinaldo delli Al-
	bizzi

⁷Cominciasi dal' oration di Niccolò Piccinino a sol⁸dati e fuori usciti Fiorentini tra quali est ms. Rinaldo delli Albizzi e altri Fiorentini; ⁹Di poi si faccia come lui prima mō- tò a cavallo ¹⁰armato; e tutto lo esercito li andò direto, ¹¹40 squadre di cavalli, ¹²2000 pedoni andavano con lui; ¹³E'l Patriarca la mattina di buon'ora montò ¹⁴in su un monte per scoprir il paese, cioè colli, ¹⁵campi, e valle irrigata da uno fiume, ¹⁶e uide dal Borgo a San Sepolco venire ¹⁷Niccolò Picinino con le genti con gran polvere, ¹⁸e scopertolo tornò al campo delle genti e parlò loro; ¹⁹Parlato ch'ebbe pregò Dio ad mani giunte, comparì ²⁰una nugola, dalla quale usciva san Piero che parlò ²¹al Patriarca; ²²500 cavalli furono mandati dal Patriarca per impe²³dire o raffrenare lo impeto nimico; ²⁴Nella prima schiera Francesco, figliuolo di Niccolò Picci²⁵nino, venne il primo ad investire il ponte, ²⁶ch'era guardato dal Patriarca e Fiorentini; ²⁷Dopo il ponte da mano sinistra mandò fanti ²⁸per impedire li nostri, i quali ripugnavano, ²⁹de' quali era capo Micheletto, il quale quel dì ³⁰per sorte aveva in guardia lo esercito; ³¹Qui, ad questo ponte si fa una

Florentines	Niccolò da Pisa
Neri di Gino Capponi	Conte Francesco
Bernardetto de' Medici	Micheletto,
	Pietro Gian Paolo
	Guelfo Orsino,
	Messer Rinaldo degli
	Albizzi

Begin with the address of Niccolò Piccinino to the soldiers and the banished Florentines among whom are Messer Rinaldo degli Albizzi and other Florentines. Then let it be shown how he first mounted on horseback in armour; and the whole army came after him—40 squadrons of cavalry, and 2000 foot soldiers went with him. Very early in the morning the Patriarch went up a hill to reconnoitre the country, that is the hills, fields and the valley watered by a river; and from thence he beheld Niccolò Picinino coming from Borgo San Sepolcro with his people, and with a great dust; and perceiving them he returned to the camp of his own people and addressed them. Having spoken he prayed to God with clasped hands, when there appeared a cloud in which Saint Peter appeared and spoke to the Patriarch.—500 cavalry were sent forward by the Patriarch to hinder or check the rush of the enemy. In the foremost troop Francesco the son of Niccolò Piccinino [24] was the first to attack the bridge which was held by the Patriarch and the Florentines. Beyond the bridge to his left he sent forward some infantry to engage ours, who drove them back, among

669. 1—63 *written from left to right.* 1. fioren"no" Nie "o". 2. gino Caponi . . franc"o". 3. Bernardecto d'. 4. giāpaulo. 5. Ghuelfo orsino. 6. albizi. 7. Comintisi . . nico. 8. Fior"ni" . albizi. 13. Patriarcha . . bonahora. 14. In susù monte. 19. Parlato hebbe . . giunte chon. 21. Patriarcha. 22. Patriarcha. 26. Patriarcha. 32. Vinsono. 33. hastorre. 37. vinnono.

669. This passage does not seem to me to be in Leonardo's hand, though it has hitherto been generally accepted as genuine. Not only is the writing unlike his, but the spelling also is quite different. I would suggest that this passage is a description of the events of the battle drawn up for the Painter by order of the Signoria, perhaps by some historian commissioned by them, to serve as a scheme or programme of the work. The whole tenor of the style seems to me to argue in favour of this theory; and besides, it would be in no way surprising that such a document should have been preserved among Leonardo's autographs.

2—7. *Neri di Gino Capponi* and *Bernardetto de' Medici* were the *Commissari* of the Florentine Republic.

Nicolò da Pisa, compare line 44.

Conte Francesco, see line 24.

Micheletto Sforza Attendolo, see line 29. He and *Pier Giampaolo Orsino* were Captains together of the Lombard troops.

13. *Il Patriarcha,* Cardinal Scarampi, Patriarch of Aquileia, Legate of the Papal see.

16. *Borgo San Sepolcro.* On a map drawn by Leonardo and reproduced on Pl. CXIII *borgo a sã sepolcro* is to be read near the upper margin to the left between a view of a town and a sketch of the windings of the Tiber. Below somewhat more to the left is the word '*Anghiari,*' the name of the village where the battle was fought.

20. *Usciva San Piero.* The battle took place on St. Peter and St. Paul's day, June 29th, 1440.

gran pugna; [32]Vinsero li nostri e lo inimi-
co è scacciato; [33]Qui Guidoe Astorre suo
fratello, signore di [34]Faenza, con molte
genti si rifeciono e resta[35]urarono la guer-
ra, e urtarono tanto forte [36]le genti Fioren-
tine, che ricuperarono il ponte e [37]vennero
sino ad li padiglioni, contro a quali [38]venne
Symonetto con 600 cavalli ad urtare [39]li
inimici, e li cacciò un altra volta dal
[40]luogo, e riacquistarono il ponte, e drieto
[41]a lui venne altra gente con 2000 cavalli,
[42]e così lungo tempo si combattè variamente;
et [43]dipoi il Patriarca per disordinare lo ni-
mico, mandò [44]Niccolò da Pisa innanzi e
Napoleone Orsino, [45]giovane senza barba, e
drieto a costoro [46]gran moltitudine di gente,
e qui fu fatto [47]un altro gran fatto d'arme;
In questo tempo [48]Niccolò Piccinino spinse
innanzi il restante delle [49]sue genti, le
quali feciono un'altra volta incli[50]nare i
nostri; e se non fusse stato che il Patriarca
[51]si mise innanzi e con parole e fatti non
avesse rite[52]nuto que' capitani, sarebbono
iti li nostri in fuga; [52]Fece il Patriarca pi-
antare certe artiglierie [54]al colle, colle quali
sbaragliava le fanterie delli [55]nimici; e fu
questo disordine tanto che Niccolò [56]comin-
ciò a rivocare il figliuolo e tutte le sue
[57]genti, e si misero in fuga verso il borgo;
[58]e qui si fece una grande strage d'uo-
mini, [59]nè si salvarono se non li primi che
fuggirono [60]o si nascosero · Durò il fatto
d'arme fino al [61]tramontar del sole · e 'l Pa-
triarca attese[62]a ritirare le genti, e seppel-
lire li morti [63]e da poi ne fece uno trofeo.

whom was their captain Micheletto [29]whose
lot it was to be that day at the head of
the army. Here, at this bridge there is a
severe struggle; our men conquer and the
enemy is repulsed. Here Guido and Astor-
re, his brother, the Lord of Faenza with a
great number of men, re-formed and renewed
the fight, and rushed upon the Florentines with
such force that they·recovered the bridge and
pushed forward as far as the tents. But Simo-
netto advanced with 600 horse, and fell upon
the enemy and drove them back once more
from the place, and recaptured the bridge;
and behind him came more men with 2000
horse soldiers. And thus for a long time
they fought with varying fortune. But then
the Patriarch, in order to divert the enemy,
sent forward Niccolò da Pisa[44] and Napo-
leone Orsino, a beardless lad, followed by a
great multitude of men, and then was done
another great feat of arms. At the same
time Niccolò Piccinino urged forward the
remnant of his men, who once more made
ours give way; and if it had not been that
the Patriarch set himself at their head and,
by his words and deeds controlled the
captains, our soldiers would have taken to
flight. The Patriarch had some artillery
placed on the hill and with these he dis-
persed the enemy's infantry; and the disorder
was so complete that Niccolò began to
call back his son and all his men, and
they took to flight towards Borgo. And
then began a great slaughter of men; none
escaped but the foremost of those who had
fled or who hid themselves. The battle
continued until sunset, when the Patriarch
gave his mind to recalling his men and
burying the dead, and afterwards a trophy
was erected.

H.3 50a] 670.

L'ermellino col sangue, [2]Galeazzo tra
tēpo trāquillo [3]e effigie di fortuna.

Ermine with blood Galeazzo, between calm
weather and a representation of a tempest.

Allegorical representa- tions refer- ring to the duke of Milan (670—673).

43. Patriarcha. 46. facto. 50. fussi . . Patriarcha. 51. fatti havesse. 53. Patriarcha. 57. missero. 60. nascosono.
61. Patriarcha. 63. ne fe.
670. 1—3 R. 1. sange. 3. effigita di.

670. Only the beginning of this text is legible;
the writing is much effaced and the sense is con-
sequently obscure. It seems to refer like the fol-
lowing passage to an allegorical picture.

2. *Galeazzo* probably here means Gian Galeazzo
Maria Sforza, whose tragical death took place in
the year when this MS. was written. His father

Galeazzo Maria—who succeeded Francesco, the
founder of the Sforza family—had been murdered in
1476 and his mother, Bona of Savoy, held the regency
during the youth's minority; he was imprisoned
in 1494 by his uncle Lodovico il Moro and pro-
bably poisoned by his orders.

H.² 40 b]

671.

Il Moro cogl' ochiali ²e la invidia colla falsa ī³famia dipīta, e la ⁴givstitia nera pel ⁵Moro.

⁶La fatica colla vite ⁷ī mano.

Il Moro with spectacles, and Envy depicted with False Report and Justice black for il Moro.

Labour as having a branch of vine [or a screw] in her hand.

I.² 90 b]

672.

Il Moro in figura di uētura ²colli capelli e panni e mani ināzi, e messer ³Gualtieri cō riverēte atto lo pi⁴glia per li panni d'abasso, venēdo⁵li dalla parte dināzi.

⁶ācora la povertà in figura spa⁷ventevole corra dirieto a vn giovanetto ⁸e'l Moro lo copra col lembo della ⁹vesta, e colla verga dorata ¹⁰minacia tale mostro.

¹¹Erba colle ra¹²dici in sù per u¹³no che fusse ¹⁴in sul finire; ¹⁵la roba e la ¹⁶gratia.

¹⁷Delle taccole e storne¹⁸lli.

¹⁹Quelli che si fideranno ²⁰abitare appresso di lui, che ²¹sarāno grā turbe, questi tut²²ti morirāno di crudele mor²³te, e si vedrā i padri e le ²⁴madri d'insieme colle sue ²⁵famiglie esser da crudeli anima²⁶li divorati e morti.

Il Moro as representing Good Fortune, with hair, and robes, and his hands in front, and Messer Gualtieri taking him by the robes with a respectful air from below, having come in from the front [5].

Again, Poverty in a hideous form running behind a youth. Il Moro covers him with the skirt of his robe, and with his gilt sceptre he threatens the monster.

A plant with its roots in the air to represent one who is at his last;—a robe and Favour.

Of tricks [or of magpies] and of burlesque poems [or of starlings].

Those who trust themselves to live near him, and who will be a large crowd, these shall all die cruel deaths; and fathers and mothers together with their families will be devoured and killed by cruel creatures.

I.² 91 a]

673.

Era più · nero · ch'un calabrone, ²gli ochi auea · rossi · com' ū foco ardēte ³e cavalcaua sopra vn grā rōzone, ⁴largo sei spanne e lungo · piv di 20 ⁵cō sei giganti · attaccati · all'arcione, ⁶e vno ī mano: che rodea col dēte, ⁷e dirieto · li uenivano porci cō zāne ⁸fori della bocca forse dieci spanne.

He was blacker than a hornet, his eyes were as red as a burning fire and he rode on a tall horse six spans across and more than 20 long with six giants tied up to his saddle-bow and one in his hand which he gnawed with his teeth. And behind him came boars with tusks sticking out of their mouths, perhaps ten spans.

671. 1—7 R. 1. choglochiali. 2. ellaūidia cholla. 3. ella.

672. 17—26 R. panni "e mani" . . meser. 3. gualtieri conriverēte. 7. cora . . avgiovanetto. 8. lenbo delle. 9. vesa echolla. 10. minacci dale. 12. dice. 13. cheffussi. 15. ella. 17. tachole. 19. Quelle lichessi. 21. gra turbe quesitu. 22. crudeli mo. 23. le essi vedra . . elle. 24. chelle. 25. eser da crudele "anima".

673. 1. hera . . chuchalabrone. 2. chomūfocho. 3. chaualchaua . . gā. 4. se . . ellungo. 5. cōse . . attachati allarcone. 6. īmano . chello rodea chol. 7. uenia . . zane. 8. bocha.

672. 1—10 have already been published by *Amoretti* in *Memorie Storiche* cap. XII. He adds this note with regard to Gualtieri: "*A questo M. Gualtieri come ad uomo generoso e benefico scrive il Bellincioni un Sonetto (pag. 174) per chiedergli un piacere; e 'l Tantio rendendo ragione a Lodovico il Moro, perchè pubblicasse le Rime del Bellincioni; ciò hammi imposto, gli dice: l'humano fidele, prudente e sollicito executore delli tuoi comandamenti Gualtero, che fa in tutte le cose ove tu possi far utile, ogni studio vi metti.*" A somewhat mysterious and evidently allegorical composition— a pen and ink drawing—at Windsor, see Pl. LVIII, contains a group of figures in which perhaps the idea is worked out which is spoken of in the text, lines 1—5.

11. Above this line in the MS. is a small indistinct sketch of a plant, evidently intended to illustrate this remark.

Br. M. 250 a]

674.

Sopra dell' elmo fia una · mezza · palla la quale · à significatione · dello nostro emisperio, in forma di mōdo, [2]sopra il quale fia uno paone colla coda distesa che passi la groppa, riccamēte ornato, e ogni ornamēto [3]che al cavallo s'apartiene sia di peñe di paone · in cāpo d' oro, a significatione dalla bellezza che risulta della gra[4]tia che viene da quello che ben serue.

Above the helmet place a half globe, *which is to signify our hemisphere, in the form of a world; on which let there be a peacock, richly decorated, and with his tail spread over the group; and every ornament belonging to the horse should be of peacock's feathers on a gold ground, to signify the beauty which comes of the grace bestowed on him who is a good servant.*

Allegorical representations (674—678).

[5]Nello scudo uno spechio [6]grāde a significare che, chi [7]bē uol fauore, si spechi nelle sue [8]virtù.

[9]Dall' opposita parte fia similmēte collocata la fortezza [10]colla sua colonna ī mano, vestita di biāco che significa...
[11]E tutte coronate, e la prudētia con 3 occhi; [12]la sopraveste · del cavallo fia di senplice oro tessuto, [13]seminata di spessi ochi di pagoni, e questo s'intēde per tutta [14]la sopraveste dell cavallo · e dell'omo; e 'l cimiero dell' omo [15]e'l suo torchione di peñe di paō · in campo d' oro;

[16]Dal lato · sinistro fia vna rota, il ciētro della quale [17]fia collocato al ciētro della coscia dirieto del cauallo [18]e al detto ciētro apparirà la prudētia vestita di rosso per la carità sedēte [19]in focosa qua-

On the shield a large mirror to signify that he who truly desires favour must be mirrored in his virtues.

On the opposite side will be represented Fortitude, in like manner in her place with her pillar in her hand, robed in white, to signify... And all crowned; and Prudence with 3 eyes. The housing of the horse should be of plain cloth of gold closely sprinkled with peacock's eyes, and this holds good for all the housings of the horse, and the man's dress. And the man's crest and his neck-chain are of peacock's feathers on golden ground.

On the left side will be a wheel, the centre of which should be attached to the centre of the horse's hinder thigh piece, and in the centre Prudence is seen robed in red, Charity sitting in a

674. 1. meza . . assignifichatione . . nosstro emissperio. 2. cholla choda disstesa chi . . richamēte. 3. pene . . chāpo . . assignifichatione . . belleza. della. 4. dacquello chi . . della. 15. schudo. 6. assignificare. 9. oposita . . chollochata la forteza. 10. cholla . . chollona . . biācho . . significha. 11. tutti . . chon. 12. chavallo. 13. disspessi . . ecquesto. 14. sopravesste . . chavallo. 15. pene doro di paō . in chanpo. 17. cholochata . . chauallo. 18. [per la carita] e al rosso "per la carita". 16. fochosa

driga e vn ramicello di lauro ī man a si-
[20]gnificatione della sperāza, che nascie dal
ben seruire.
 [21]Messer Antonio Grimani [22]venetiano,
cōpagno [23]d'Antonio Maria.

fiery chariot and with a branch of laurel in
her hand, to signify the hope which comes
of good service.
 [21]Messer Antonio Grimani of Venice
companion of Antonio Maria[23].

B. 3*b*]
 675.

 A la fama si de' dipigniere · tutta la
persona piena di līgue [2]in scanbio · di penne,
e ī forma di uccello.

 Fame should be depicted as covered all
over with tongues instead of feathers, and
in the figure of a bird.

Ox. 2 *a*]
 676.

 Piacere e dispiacere [2]fannosi binati,
perchè mai [3]l'uno è sanza · l'altro co[4]me
se fussin appicati, voltāsi [5]le schiene per-
chè sō cōtrari.
 [6]Fango, oro.
 [7]Se piglierai il piacere sappi che lui à
dirieto · a se chi, ti porgierà [8]tribolatione e
pētimēto.

 [9]Questo si è · il piacere · īsieme col dis-
piacere · e figuransi binati, perchè mai
l'uno è spiccato dal altro; [10]fañosi colle
schiene voltate ·, perchè son contrari l'uno
al'altro; fañosi fondati sopra vn me[11]desimo

 Pleasure and Pain represent as twins,
since there never is one without the other;
and as if they were united back to back,
since they are contrary to each other.
 [6]Clay, gold.
 If you take Pleasure know that he has
behind him one who will deal you Tribula-
tion and Repentance.

 [9]This represents Pleasure together with
Pain, and show them as twins because one
is never apart from the other. They are
back to back because they are opposed to
each other; and they exist as contraries in

 chadriga ‖ "carta" e un . . laro īmanalsi. 20. nasscie. 21. Meser antonio gri. 22. chōpagno.
675. 2. penne . ē forma di ucciella.
676. 2. fano. 3. cho. 4. apichati. 5. sciene. 7. piacie sa piche lui [ch] adirieto . asse chitti. 9. chol disspiacere . . ma luno
 esspichato dalal \\\\\\. 10. fano si chole . . chontrari . . fanosi. 11. v medesimo. 12. faticha chol. 13. chola chana . . esēza

 674. *Messer Antonio Gri.* His name thus abbre-
viated is, there can be no doubt, Grimani. Antonio
Grimani was the famous Doge who in 1499 com-
manded the Venetian fleet in battle against the Turks.
But after the abortive conclusion of the expedition
—Ludovico being the ally of the Turks who took
possession of Friuli—,Grimani was driven into
exile; he went to live at Rome with his son Cardi-
nal Domenico Grimani. On being recalled to Ve-
nice he filled the office of Doge from 1521 to 1523.
Antonio Maria probably means Antonio Maria Gri-
mani, the Patriarch of Aquileia.

 676. The pen and ink drawing on Pl. LIX be-
longs to this passage.

 7. *oro. fango:* gold, clay. These words stand
below the allegorical figure.

 8. *tribolatione.* In the drawing caltrops may be seen
lying in the old man's right hand, others are falling
and others again are shewn on the ground. Similar
caltrops are drawn in MS. Tri. p. 98 and underneath
them, as well as on page 96 the words *triboli di ferro*
are written. From the accompanying text it appears

that they were intended to be scattered on the
ground at the bottom of ditches to hinder the advance
of the enemy. Count Giulio Porro who published a
short account of the Trivulzio MS. in the *"Archivio
Storico Lombardo"*, Anno VIII part IV (Dec. 31, 1881)
has this note on the passages treating of *"triboli"*:
*"E qui aggiungerò che anni sono quando venne fabbricata
la nuova cavallerizza presso il castello di Milano, ne
furono trovati due che io ho veduto ed erano precisa-
mente quali si trovano descritti e disegnati da Leonardo
in questo codice"*.

 There can therefore be no doubt that this means
of defence was in general use, whether it were origi-
nally Leonardo's invention or not. The play on the
word *"tribolatione"*, as it occurs in the drawing at
Oxford, must then have been quite intelligible.

 9—22. These lines, in the original, are written on
the left side of the page and refer to the figure
shown on Pl. LXI. Next to it is placed the group
of three figures given in Pl. LX No. 1. Lines 21
and 22, which are written under it, are the only ex-
planation given.

corpo, perchè àno vn medesimo fondamē-
to, jperochè 'l fondamēto del piaciere [12] si
è la fatica col dispiacere, il fondamēto del
dispiacere si sono i vari e lascivi [13] piacieri;
E però qui si figura colla canna nella mā
destra ch'è vana e sēza forza, [14] e le pvnture
fatte con quella sō uenenose; mettōsi j Tos-
cana al sostegnio [15] de' letti, a significare
che quivi si faño j vani sogni e quivi si
consuma [16] grā parte della vita, quiui si
gitta di molto vtile tempo, cioè quel della
mattina, [17] chè la mēte è sobria e riposata
e così il corpo atto a ripigliare nove fatiche;
[18] ancora lì si pigliano molti vani piaceri
e colla mēte jmaginādo co[19]se jmpossibili
a se, e col corpo pigliādo que' piacieri che
spesso son ca[20]gione di mācamēto di uita,
sichè per questo si tiene la cāna per tali
fōdamenti.

[21] Il mal pēsiero è jvidia [22] over jgra-
titudine.

the same body, because they have the same
basis, inasmuch as the origin of pleasure
is labour and pain, and the various forms of
evil pleasure are the origin of pain. There-
fore it is here represented with a reed in
his right hand which is useless and without
strength, and the wounds it inflicts are
poisoned. In Tuscany they are put to sup-
port beds, to signify that it is here that vain
dreams come, and here a great part of life
is consumed. It is here that much precious
time is wasted, that is, in the morning, when
the mind is composed and rested, and
the body is made fit to begin new labours;
there again many vain pleasures are
enjoyed; both by the mind in imagining
impossible things, and by the body in taking
those pleasures that are often the cause of
the failing of life. And for these reasons
the reed is held as their support.

Evil-thinking is either Envy or Ingratitude.

Ox. 2 *b*] 677.

Questa jvidia si figura colle fiche verso
jl cielo, [2] perchè, se potesse, vserebbe le sue
forze cōtro a dio; [3] fassi colla maschera j
volto di bella dimostratio[4]ne; fassi ch'ella
è ferita nella vista da palma [5] e olivo; fassi
ferito l'orechio di lavro e [6] mirto a signi-
ficare che vittoria e verità [7] l'offendono;
fassi le vscire molti fvlgori, [8] a significare
il suo mal dire; fassi magra [9] e secca, per-
ch'è sempre j continuo strvgimēto, [10] fassi
le jl core roso da vn serpēte ēfian[11]te;
fassi le vn turcasso, e le freccie [12] lingue,
perchè spesso cō quelle offēde; [13] fassi le
vna pelle di liopardo, perchè quello [14] per
invidia āmazza il lione, con īgāno; [15] fassi
le vn uaso ī mano piē di fiori e si[16]a quello
piē di scorpioni e rospi e altri [17] veneni;
fassi le cavalcare la morte, [18] perchè la invi-
dia, nō morēdo, mai languisce [19] a signo-

Envy must be represented with a contemp-
tuous motion of the hand towards heaven,
because if she could she would use her
strength against God; make her with her face
covered by a mask of fair seeming; show her
as wounded in the eye by a palm branch
and by an olive-branch, and wounded in the
ear by laurel and myrtle, to signify that
victory and truth are odious to her. Many
thunderbolts should proceed from her to
signify her evil speaking. Let her be lean
and haggard because she is in perpetual
torment. Make her heart gnawed by a
swelling serpent, and make her with a quiver
with tongues serving as arrows, because she
often offends with it. Give her a leopard's
skin, because this creature kills the lion out
of envy and by deceit. Give her too a vase
in her hand full of flowers and scorpions
and toads and other venomous creatures;
make her ride upon death, because Envy,
never dying, never tires of ruling. Make
her bridle, and load her with divers kinds

fo \\\\\\. 14. choquele . . mettāsi j toscana. 15. significhare . . fano . . chonsuma. 16. dela . . tēnpo . . dela mati \\\\\\.
17. soblia . . chosi il chorpo. 18. anchora . . piglia . . chola . . cho. 19. jposibili . . chol chorpo . . cha. 20. māchamēto
. . chāna . . fōdam""ē". 21. pēsieri.
677. 1. chole . . jl cie \\\\\. 2. potessi vserebe . . chōtro a \\\\\\\. 3. fasi cola . . bela dimostr \\\\\\. 4. chele ferita . . vissta da pal \\\\\\\.
5. lavro \\\\\\. 6. assignificare . . vettoria eve \\\\\\\. 7. fassele vsscire molte folgore. 8. assignificare . . fassimage \\\\\\\.
9. essecha . . strugimē \\\\\\\. 10. fasse. 11. turchasso che le frecie. 12. speso chōquela. 13. fasse . . pele . . chuel \\\\\.
14. amazā . . chon ī gano. 15. fasse . . fioriess \\\\\. 16. acqueli . . rosspical \\\\\\\. 17. fassele chavalchare la mo \\\\\\. 18. lan-
vidia . . mai lan \\\\\\\\\\\\. 19. asignioregiare fasse . . briglia c \\\\\. 20. cha e charicha . . diversi . . 21. tuti . . dela. 24. que.

reggiare; fassi le la briglia²⁰carica di diverse armi perchè ²¹tuti strumēti della morte.

²²Tolerare.

²³Ĵtolerabile.

²⁴Subito che nascie la uirtù, quel²⁵la partoriscie contra se la invidia, ²⁶e prima · fia · il corpo · sēza · l'ō²⁷bra che la virtù · sanza · la invidia.

of arms because all her weapons are deadly.

Toleration.

Intolerable.

No sooner is Virtue born than Envy comes into the world to attack it; and sooner will there be a body without a shadow than Virtue without Envy.

Br. M. 231 *b*]　　　　　　**678.**

Quādo si apre il paradiso di ²Plutone alor siā diavo³li che son in dodici olle, ⁴a uso di bocche īfernali ·, ⁵quiui sia la morte, ⁶le furie, ⁷cenere, ⁸molti putti nudi che piāgino; ⁹e uiui fochi fatti di vari colori....

When Pluto's Paradise is opened, then there may be devils placed in twelve pots like openings into hell. Here will be Death, the Furies, ashes, many naked children weeping; living fires made of various colours....

I.² 59 *a*]　　　　　　**679.**

<table>
<tr><td>Arrange-
ment of a
picture.</td><td>Joanes Battista
²San Piero
³Elisabetta　Nostra Doña
⁴Bernardino
⁵Bonaventura
⁶Sto Francesco
　⁶Francesco,
⁷Antonio, giglio e libro,
⁸Bernardino col Gesù,
⁹Lodovico co 3 gigli nel petto, cō corona
　　　　　　　　　a piedi,
¹⁰Bonavētura cō serafini,
¹¹Sta Chiara col tabernaculo,
¹²Elisabetta cō corona di regina.</td><td>S. Agostino
Paolo
Sta Chiara
Lodovico
Antonio da
　　Padua</td><td>John the Baptist
Saint Peter
Elisabeth
Bernardino　Our Lady
Bonaventura
Saint Francis.
Francis,
Anthony, a lily and book;
Bernardino with the [monogram of] Jesus,
Louis with 3 fleur de lys on his breast and
　　　　　　　the crown at his feet,
Bonaventura with Seraphim,
Saint Clara with the tabernacle,
Elisabeth with a Queen's crown.</td><td>Saint Augustin
Paul
Saint Clara.
Louis
Anthony of Padua.</td></tr>
</table>

25. partorisscie chontra. 26. chorpo. 27. chella . . lanvidia.

678. 1. sapre. 3. liche sonco dodici olle . . 4. boce. 7. cennere. 8. piāghino. 10. *the leaf is here distroyed, only the words* vino bolē *in the middle of the line have remained legible.*

679. *The five names on the right side:* Jo bsita &c. *and lines* 7 *to* 12 *are written from left to right. None of the names have capital initial letters.* 1—6. iobs"i"ta . . saostino . . nostra dona . . sca ciara . . lodovco . . franc"o" . . Padu"a". 7. franc"o". 9. peto cō coronna piedi 1. co. 11. ciara.

677. The larger of the two drawings on Pl. LXI is explained by the first 21 lines of this passage. L. 22 and 23, which are written above the space between the two drawings, do not seem to have any reference to either. L. 24—27 are below the allegorical twin figure which they serve to explain.

679. The text of the first six lines is written within a square space of the same size as the copy here given. The names are written in the margin

following the order in which they are here printed. In lines 7—12 the names of those saints are repeated of whom it seemed necessary to point out the emblems.

680. This has already been published by AMORETTI *Memorie storiche* cap. XVI. His reading varies somewhat from that here given, *e. g.* l. 5 and 6. *Certi Sangirolami in su d'una figura;* and instead of l. 13. *Un San Bastiano.*

680.

Una testa in faccia di giouane
²cō una bella capellatura,
³Molti fiori ritratti di naturale,
⁴vna testa ī faccia riccivta,
⁵cierti sā Girolami,
⁶misure d'una figura,
⁷disegni di fornegli,
⁸vna testa del Duca,
⁹Molti disegni di gruppi,
¹⁰4 disegni della tavola di sāto angielo,
¹¹vna storietta di Girolamo da Fegline,
¹²vna testa di Cristo fatta di penna,
¹³8 sā Bastiani,
¹⁴Molti cōponimēti d'āgioli,
¹⁵vn calcidonio,
¹⁶vna testa ī proffilo cō bella capellatura,
¹⁷cierti coppi di prospettiva,
¹⁸cierti strumēti per navili,
¹⁹cierti strumēti d'acqua,
²⁰vna testa ritratta d'Atalāta che alzava il uolto,
²¹la testa di Geronimo da Fegline,
²²la testa di Giā Francesco Borso,
²³molte gole di vechie,
²⁴molte teste di vechi,
²⁵molti nvdi īteri,
²⁶molte bracia ganbe piedi e attitudini,
²⁷vna nostra donna finita,
²⁸vn' altra quasi ch'è in proffilo,

A head, full face, of a young man
with fine flowing hair,
Many flowers drawn from nature,
A head, full face, with curly hair,
Certain figures of Saint Jerome,
[6] The measurements of a figure,
Drawings of furnaces.
A head of the Duke,
[9]many designs for knots,
4 studies for the panel of Saint Angelo
A small composition of Girolamo da Fegline,
A head of Christ done with the pen,
[13]8 Saint Sebastians,
Several compositions of Angels,
A chalcedony,
A head in profile with fine hair,
Some pitchers seen in(?) perspective,
Some machines for ships,
Some machines for waterworks,
A head, a portrait of Atalanta raising her face;
The head of Geronimo da Fegline,
The head of Gian Francisco Borso,
Several throats of old women,
Several heads of old men,
Several nude figures, complete,
Several arms, eyes, feet, and positions,
A Madonna, finished,
Another, nearly in profile,

680. *Lines 1 and 2 are written from left to right and upside down.* 1. nvna tessa . . gouane. 4. tessta. 5. sāgirolami. 6. msure . . fighura. 8. ducha. 11. girolamo da feghine. 12. di x̄p̄ō fatta. 13. basstiani. 14. chōponimēti. 15. chalcidonio. 16. tessta . . chō . . chapellatura. 17. choppi di prosspettiva. 19. dacq"a". 20. tessta . . dattalāta. 21. tessta de ieronimo da feglino. 22. tessta di giāfranciessco. 23. ghole. 24. moltesste. 25. ītegri. 26. attitudine. 27. nosstra. 28. qusi chē proffilo. 29. tessta di nosstra . . vācielo. 30. tessta . . chol meto lūgho. 31. tessta di zīghana. 32. tessta

9. *Molti disegni di gruppi.* VASARI in his life of Leonardo (IV, 21, ed. MILANESI 1880) says: "*Oltrechè perse tempo fino a disegnare* gruppi *di corde fatti con ordine, e che da un capo seguissi tutto il resto fino all' altro, tanto che s'empiessi un tondo; che se ne vede in istampa uno difficilissimo e molto bello, e nel mezzo vi sono queste parole:'Leonardus Vinci Accademia"*. Gruppi *must here be understood as a technical expression for those twisted ornaments which are well known through wood cuts. AMORETTI mentions six different ones in the Ambrosian Library. I am indebted to M. DELABORDE for kindly informing me that the original blocks of these are preserved in his department in the Bibliothèque Nationale in Paris. On the cover of these volumes is a copy from one of them. The size of the original is 23½ centimètres by 26¼. The centre portion of another is given on p. 361. G. GOVI remarks on these ornaments (*Saggio* p. 22): "*Codesti gruppi eran probabilmente destinati a servir di modello a ferri da rilegatori per adornar le cartelle degli scolari (?). Fregi somigliantissimi a questi troviamo infatti impressi in oro sui cartoni di vari volumi contemporanei, e li vediam pur figurare nelle lettere iniziali di alcune edizioni del tempo.*"

Dürer who copied them, omitting the inscription, added to the second impressions his own monogram. In his diary he designates them simply as "*Die sechs Knoten*" (see THAUSING, Life of A. Dürer I, 362, 363). In Leonardo's MSS. we find here and there little sketches or suggestions for similar ornaments. Compare too G. MONGERI, *L'Arte in Milano*, p. 315 where an ornament of the same character is given from the old decorations of the vaulted ceiling of the Sacristy of S. Maria delle Grazie.

680. 17. The meaning in which the word *coppi,* literally pitchers, is here used I am unable to determine; but a change to *copie* seems to me too doubtful to be risked.

²⁹la testa di nostra donna che va in cielo,	Head of Our Lady ascending into Heaven,
³⁰vna testa d'ū uechio col mēto lūgo,	A head of an old man with long chin,
³¹una testa di zīgana	A head of a gypsy girl,
³²vna testa col capello ī capo,	A head with a hat on,
³³vna storia di passione fatta in forma,	A representation of the Passion, a cast,
³⁴vna testa di putta cō treccie rānodate,	A head of a girl with her hair gathered in a knot,
³⁵vna testa con bruna cōciatura.	A head, with the brown hair dressed.

W. 243]

681.

Mottoes and Emblems (681—702).

Ostinato rigore.
²Destinato rigore.

Stubborn rigour.
Doomed rigour.

W. L. 198 a]

682.

¶Inpedimento nō mi piega;
² ogni īpedimeto è distrutto dal rigore;
³nō si·uolta chi a stella è fisso.

Obstacles cannot crush me
Every obstacle yields to stern resolve
He who is fixed to a star does not change
his mind.

W. L. 198 b]

683.

L'edera è di lunga vita.

Ivy is [a type] of longevity.

W. P. 11 a]

684.

Vertià il sole
²bugia maschera
³innocētia
⁴malignità
⁵¶Il foco distrugie la
⁶bugia, cioè il sofistico, e
⁷rende la uerità, scacciādo
⁸le tenebre·¶
 ⁹Il foco è da essere messo per cōsuma-
¹⁰tore d'ogni sofistico e scopri-
¹¹tore e dimostratore di uerità,
¹²perchè lui è luce, scaccia-
¹³tore delle tenebre occultatri-
¹⁴ci d'ogni essentia.

Truth the sun.
falsehood a mask.
innocence,
malignity.
Fire destroys falsehood,
that is sophistry, and
restores truth, driving out
darkness.
 Fire may be represented as the destroy of
all sophistry, and as the
image and demonstration of truth;
because it is light and drives
out darkness which conceals
all essences [or subtle things].

chol chapello ī chapo. 33. vnasstoria. 34. tessta . . chō tregte ranodate. 35. tessta bruna chōciatura.
681. 1. hostinato.
682. 1. nomi piegha. 2. ōnipedimēto. 3. asstella effisso.
683. 1. lungha.
684. 2. mascera. 5. distrugie [la] la. 6. coe. 7. scacādo. 10. soffisticho e escōpri. 12. lui [sca] e luce scacca. 13. ochultatri.

681. See Pl. LXII, No. 2, the two upper pen and ink drawings. The originals, in the Windsor collection are slightly washed with colour. The background is blue sky; the plough and the instrument with the compass are reddish brown, the sun is tinted yellow.

682. This text is written to elucidate two sketches which were obviously the first sketches for the drawings reproduced on Pl. LXII, No. 2.

683. In the original there is, near this text, a sketch of a coat wreathed above the waist with ivy.

684. See Pl. LXIII. L. 1—8 are in the middle of the page; l. 9—14 to the right below; l. 15—22 below in the middle column. The rest of the text is below the sketches on the left. There are some other passages on this page relating to geometry.

VERITÀ.

[16]Il foco destrugie ogni soffistico cioè
　　　　　lo īgāno,
[17]e sol mātiene la verità cioè l' oro.
　[19]La uerità al fine nō si cela;
[20]nō ual simulatione; ¶ Simulatiō è fru-
　　　[21]strata avanti a tāto
　　　[22]giudice. ¶
[23]la bugia mette maschera;
[24]¶ nulla occulta sotto il sole.
　[25]Il foco è messo per la verità, perchè
　　　　　　destrug-
[26]ge ogni soffistico e bugia, e la ma-
[27]schera per la falsità e bugia,—
　[28]ocultatri ce del uero. —

TRUTH.

　Fire destroys all sophistry, that is de-
　　　　　ceit;
and maintains truth alone, that is gold.
　　Truth at last cannot be hidden.
Dissimulation is of no avail. Dissimulation is
　　　　　to no purpose before
　　　　　so great a judge.
Falsehood puts on a mask.
Nothing is hidden under the sun.
　Fire is to represent truth because it
destroys all sophistry and lies; and the
mask is for lying and falsehood
which conceal truth.

W. P. 11 δ]

685.

Prima privato di moto che stanco
[2]di giouare.
　　　　7　　　2　　　6　　　　13
[3]¶ mancherà primae il moto ch' l giouamēto;
[4]prima morte che | nō mi stāco nel giouare
[5]stanchezza; | è motto da carnovale;
[6]nō m̄i satio di ser- | sine lassitudine.
　　　uire;
[7]tutte le opere
[8]nō sō per istancarmi;
[9]mani nelle quali fio-
[10]ccā ducati e pietre pre-
[11]tiose, queste mai si stā-
[12]cano di seruire, ma
[13]tal seruitio è sol per sua
[14]vtilità e non è al no- | non mi stanco
[15]stro proposito; | nel giovare.
　[16]naturalmēte
　[17]natura così m̄i dispone;

Movement　will　cease　before　we　are
　　　　　　　　　　　　　　　weary
of being useful.
Movement will fail sooner than usefulness.
Death sooner than | I am never weary of
weariness. | 　being useful,
In　serving　others I | is a motto for carnval.
　cannot do enough. | Without fatigue.
No labour is
sufficient to tire me.
Hands into which
ducats and precious
stones fall like snow; they
never become tired by serving,
but this service is only for its
utility and not for our | I am never weary
own benefit. | of being useful.
　Naturally
nature has so disposed me.

Ash. I. 1a]

686.

Sia fatto ī mano alla ī gra-
　　　　　titudine;
[2]il legnio · nutrica il foco che
　　　lo cōsuma

This shall be placed in the
　　hand of Ingratitude.
Wood nourishes the fire that
　　consumes it.

16. focho . . coe lōgāno. 17. essol. 18. soffi. 19. nō ual simula. 21. sta. 22. gudice. 23. mette massce. 24. ochulta.
25. [og]. 26. messa. 27. oni . . ella. 28. scera. 29. ochultatrice.
685. 1. stancho. 2. di digouare. 3. gouameto. 4. govare. 10. chaducati. 12. gano. 13. essol. 14. nonee al nos . . stancho.
15. gorare.
686. 1. fa"to" imano. 2. ilegnio notricha il focho.

Br. M. 173 *a*] **687.**

PER LA INGRATITUDINE. TO REPRESENT INGRATITUDE.

²Quando apparisce il
sole che scaccia ³le te- When the sun appears
nebre in comvne, tu speg- which dispels darkness in
ni il lume che te le sca- general, you put out the
ciava in particulare ⁴a tua light which dispelled it
necessità e commodità. for you in particular
 for your need and conve-
 nience.

W. IX] **688.**

Di qua Adā e di là Eva; On this side Adam and Eve on the other;
²o miseria vmana, di quāte cose per da- O misery of mankind, of how many things do
nari ti fai seruo! you make yourself the slave for money!

H.3 51*b* **689.**

Così si se²para la trista vni³tione. Thus are base unions sundered.

H.3 53*a*] **690.**

Cōstantia nō comīcia, ma è quel Constancy does not begin, but is that
²che persevera. which perseveres.

H.3 70*a*] **691**

Amor Timor e Reverentia, questo Love, Fear, and Esteem,—
²scrivi in tre sassi; de' serui. Write these on three stones. Of servants.

H.2 1*b*] **692.**

Prudentia fortezza. Prudence Strength.

687. 2. apariscie . . chesscancia. 3. ilume chettellescaciava in particul. 4. attua neciessita.
688. 1. adā . . eva. 2. chose **689.** 1—3 R. 2. pera. **690.** 1—2 R. 2. ce. **691.** 1—2 R. **692.** R. forteza.

688. See Pl. LXIV. The figures of Adam and
Eve in the clouds here alluded to would seem
to symbolise their superiority to all earthly needs.

689. A much blurred sketch is on the page
by this text. It seems to represent an unravelled
plait or tissue.

690. A drawing in red chalk, also rubbed,
which stands in the original in the middle of this
text, seems to me to be intended for a sword hilt,
held in a fist.

H.² 13 a]

693.

La fama sola si leva al cielo, ²perchè le cose virtuose sono amiche ³a dio; ⁴La infamia sottosopra figurare si ⁵debbe, perchè tutte le sue operationi ⁶sō contrarie a dio e inverso l'inferi ⁷si dirizzano.

Fame alone raises herself to Heaven, because virtuous things are in favour with God.

Disgrace should be represented upside down, because all her deeds are contrary to God and tend to hell.

H.² 15 b]

694.

Corta libertà.

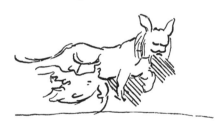

Short liberty.

H.1 40 a]

695.

Nessuna cosa è da temere più che sozza fama; ²Questa sozza fama è nata da uita.

Nothing is so much to be feared as Evil Report.

This Evil Report is born of life.

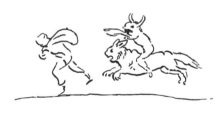

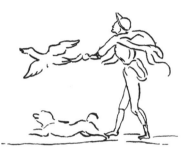

H.1 40 b]

696.

Per nō disobbidire.

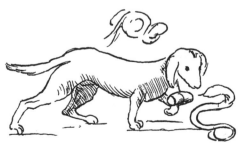

Not to disobey.

693. 1. la famasola essi leva. 2. chose vertudiose sono miche. 5. tutte sue. 7. dirizano.
695. 1. chosa edatteme "piu chella" quāto soza. 2. soza.
696. R. disubidire.

S. K. M. II²; 1 δ] **697.**

Abbero tagliato che ri- A felled tree which is shooting
 mette again.
 30 30
 40 40
 ─── ───
 1200 1200
 ²ancora spero; I am still hopeful.
 ³falcon A falcon,
 ⁴tenpo. Time.

F. 0″] **698.**

 La verità fa qui che la ²bugia affligge Truth here makes Falsehood torment
le līgue ³bugiarde. lying tongues.

M. 4 a] **699.**

 Tale è 'l mal che nō mi noce qual è il Such as harm is when it hurts me not,
bene ²che non mi giova. is good which avails me not.

M. 4 δ] **700.**

 Chi altri offende, se nō sicura. He who offends others, does not secure
 himself.

M. 5 a] **701.**

 Ingrati² tudo. Ingratitude.

C. A. 67 δ; 203 δ] **702.**

 I pēsieri si voltano alla sperāza. One's thoughts turn towards Hope.

697. 2. anchora. **698.** 1. chella. 2. afrigue. 3. bugarde **699.** 2. nommi [gi] giova. **700.** sichura.
702. (R).

697. I. *Albero tagliato*. This emblem was dis- *che ritēgō le paglucole (pagliucole) chelli (che li) anniegano.*
played during the Carnival at Florence in 1513. **700.** See Pl. LX, No. 3.
See Vasari VI, 251, ed. Milanesi 1881. But the **701.** See Pl. LX, No. 4. Below the bottom
coincidence is probably accidental. sketches are the unintelligible words "*sta stilli.*" For
 699. See Pl. LX, No. 2. Compare this sketch "*Ingratitudo*" compare also Nos. 686 and 687.
with that on Pl. LXII, No. 2. Below the two lines **702.** By the side of this passage is a sketch of
of the text there are two more lines: *li gūchi (giunchi)* a cage with a bird sitting in it.

C. A. 228 *b*; 687 *b*] **703.**

Uccello della comedia. A bird, for a comedy.

I.2 1 *b*] **704.**

VESTA DA CARNOVALE.

[2] Per fare vna bella veste tagli tela sot- tile e dale [3] vernice odorifera, fatta da olio di tremētina e [4] vernice in grana ī colla stampa traforata [5] e bagnata, acciò nō si ap- picchi, e questa stāpa [6] sia fatta a gruppi, i quali poi siē riēpivti [7] di miglio nero e 'l cāpo di miglio biāco.

A DRESS FOR THE CARNIVAL.

To make a beautiful dress cut it in thin cloth and give it an odoriferous varnish, made of oil of turpentine and of varnish in grain, with a pierced stencil, which must be wetted, that it may not stick to the cloth; and this stencil may be made in a pattern of knots which afterwards may be filled up with black and the ground with white millet[7].

Mz. 10 *a* (14)] **705.**

Porterassi neve [2] distante ne lochi [3] caldi, tolta dall' al[4]te cime de' monti, [5] e si las- cierà ca[6]dere nelle feste [7] alle piazze nel [8] tenpo dell' estate.

Snow taken from the high peaks of mountains might be carried to hot places and let to fall at festivals in open places at summer time.

703. ocel. **704.** 2. dalle. 3. in grane e o | colla. 5. acio non sia pi \\\\ chi. 6. posiēriēpivti.
705. 3. chaldi . . dellal. 5. essi. 7. delle piaze. 8. dellastate.

703. The biographies say so much, and the author's notes say so little of the invention attributed to Leonardo of making artificial birds fly through the air, that the text here given is of exceptional interest from being accompanied by a sketch. It is a very slight drawing of a bird with outspread wings, which appears to be sliding down a stretched string. Leonardo's flying machines and his studies of the flight of birds will be referred to later.

704. Ser Giuliano, da Vinci the painter's brother,

had been commissioned, with some others, to or- der and to execute the garments of the Allegorical figures for the Carnival at Florence in 1515—16; VASARI however is incorrect in saying of the Flo- rentine Carnival of 1513: "*e quelli che feciono ed ordi- narono gli abiti delle figure furono Ser Piero da Vinci, padre di Lionardo, e Bernardino di Giordano, bellissimi ingegni.*" (See MILANESI's ed. Vol. VI, pg. 251.)

7. The grains of black and white millet would stick to the varnish and look like embroidery.

REFERENCE TABLE TO THE NUMERICAL ORDER OF THE CHAPTERS.

108.	E. 16 *a*.	152.	H.² 18 *a*.		
109.	Br. M. 62 *a*.	153.	E. 17 *a*.		

250.	C. 24 *a*.
251.	C. 23 *a*.
252.	C. 5 *a*.
253.	C. 1 *b*.
254.	C. 1 *a*.
255.	C. 14 *b*.
256.	C. 14 *a*.
257.	C. 21 *b*.
258.	C. 12 *a*.
259.	C. 8 *b*.
260.	C. 8 *b*.
261.	C. 13 *b*.
262.	C. 10 *a*.

V.

THEORY OF COLOURS.

263.	G. 37 *a*.
264.	E. 32 *b*.
265.	W. 232 *b*.
266.	Br. M. 211 *b*.
267.	Ash. I. 2 *a*.
268.	E. 17 *a*.
269.	W. 240 *b*.
270.	W. L. 145. B *a*.
271.	C. A. 178 *a*; 536 *a*.
272.	C. A. 44 *b*; 137 *b*.
273.	C. A. 187. II.² 562 *a*.
274.	W. L. 145. D *b*.
275.	Ash. I. 22 *a*.
276.	W. L. 145. C *a*.
277.	F. 23 *a*.
278.	F. 75 *a*.
279.	C. A. 192 *b*; 571 *b*.
280.	C. A. 181 *b*; 546 *b*.
281.	A. 19 *b*.
282.	A. 20 *a*.
283.	Ash. I. 3 *a*.
284.	Ash. I. 2 *b*.
285.	Ash. I. 9 *b*.
286.	E. 18 *a*.
287.	W. An. IV. 232 *b*.
288.	W. L. 145. A *b*.

VI.

PERSPECTIVE OF COLOUR AND AERIAL PERSPECTIVE.

289.	C. 12 *b*.
290.	C. 13 *a*.
291.	Ash. I. 17 *b*.
292.	W. 232 *b*.
293.	Ash. I. 25 *b*.
294.	Ash. I. 13 *a*.
295.	Ash. I. 10 *a*.
296.	Tr. 75.
297.	W. 3.

298.	Ash. I. 17 *a*.
299.	Ash. I. 17 *b*.
300.	Leic. 4 *a*.
301.	Leic. 36 *a*.
302.	F. 18 *a*.
303.	C. 18 *a*.
304.	H.² 29 *b*.
305.	Br. M. 169 *a*.
306.	G. 53 *b*.
307.	L. 75 *b*.

VII.

ON THE PROPORTIONS AND ON THE MOVEMENTS OF THE HUMAN FIGURE.

308.	H.¹ 31 *b*.
309.	C. A. 157 *a*; 463 *a*.
310.	W. P. 2 *a*.
311.	A. 62 *b*.
312.	A. 63 *a*.
313.	W. P. 119 *a*.
314.	W. P. 7 *a*.
315.	Ven. Ac. IV. 16.
316.	W. P. 12.
317.	W. P. 5 *a*.
318.	W. P. 3. I *a*.
319.	Tur. 7.
320.	Tur. 11.
321.	W. P. 3. II.
322.	W. P. 1 *b*.
323.	W. P. 8 *a*.
324.	W. P. 1 *a*.
325.	W. P. 4 *b*.
326.	W. P. 7 *a*.
327.	W. P. 3. II *a*.
328.	W. P. 7 *a*.
329.	B. 3 *b*.
330.	W. P. 7 *a*.
331.	W. P. 8 *a*.
332.	W. P. 6. I *b*.
333.	W. P. 6. I *b*.
334.	W. P. 6. II *a*.
335.	W. P. 6. II *b*.
336.	W. P. 5 *a*.
337.	W. P. 2 *a*.
338.	W. P. 7 *a*.
339.	W. P. 7 *b*.
340.	C. A. 350 *a*; 1089 *a*.
341.	W. P. 5 *a*.
342.	W. P. 7 *b*.
343.	Ven. (121) nᵒ .A.
344.	Ash. I. 12 *a*.
345.	W. P. 8 *a*.
346.	B. 3 *b*.
347.	W. P. 4 *a*.
348.	W. P. 5 *a*.

349.	W. P. 7 *b*.
350.	Br. M. 44 *a*.
351.	W. 197.
352.	Ash. I. 25. II *a*.
353.	C. A. 44 *b*; 137 *b*.
354.	C. A. 98 *b*; 308 *a*.
355.	E. 17 *a*.
356.	W. III.
357.	W. A. II. 203 *b* (24).
358.	W. 215.
359.	A. 29 *a*.
360.	E. 3 *a*.
361.	Ash. I. 15 *a*.
362.	E. 20 *a*.
363.	E. 19 *b*.
364.	Ash. I. 7 *a*.
365	W. 240 *b*.
366.	E. 6 *b*.
367.	Ash. I. 7 *a*.
368.	Ash. I. 6 *b*.
369.	A. 28 *b*.
370.	W. A. III. 167 *b*.
371.	F. 83 *a*.
372.	S. K. M. II.² 14 *a*.
373.	M. 55 *a*.
374.	C. A. 178 *a*; 536 *a*.
375.	W. A. II. 203 *a*.
376.	S. K. M. II.² 20 *a*.
377.	H.² 27 *a*.
378.	L. 27 *b*.
379.	W. 3 *a*.
380.	E. 15 *a*.
381.	Mz. 13 *a*.
382.	C. A. 341 *a*; 1052 *a*.
383.	A. 30 *b*.
384.	S. K. M. III. 58 *b*.
385.	S. K. M. I.² 7.
386.	Leic. 8 *a*.
387.	W. 1 *a*.
388.	C. A. 344 *b*; 1066 *a*.
389.	W. IV.
390.	Ash. I. 29 *b*.
391.	Ash. I. 17 *b*.
392.	Ash. I.¹ 8 *a*.

VIII.

BOTANY FOR PAINTERS AND ELEMENTS OF LANDSCAPE PAINTING.

393.	L. 87 *a*.
394.	I.¹ 12 *b*.
395.	M. 78 *b*.
396.	M. 79 *a*.
397.	G. 34 *b*.
398.	G. 35 *a*.
399.	G. 13 *a*.
400.	G. 14 *a*.

401.	G. 37 a.
402.	G. 33 a.
403.	E. 6 b.
404.	G. 32 b.
405.	G. 5 a.
406.	G. 4 b.
407.	G. 35 b.
408.	G. 36 a.
409.	G. 36 b.
410.	G. 51 a.
411.	G. 88 b.
412.	G. 33 a.
413.	G. 27 a.
414.	G. 28 a.
415.	G. 16 b.
416.	G. 30 b.
417.	G. 29 a.
418.	G. 27 a.
419.	G. 33 b.
420.	M. 77 b.
421.	G. 8 a.
422.	G. 24 a.
423.	G. 10 a.
424.	G. 10 b.
425.	G. 3 a.
426.	G. 2 b.
427.	G. 3 b.
428.	G. 4 a.
429.	G. 4 b.
430.	G. 8 a.
431.	G. 8 b.
432.	G. 9 a.
433.	G. 10 b.
434.	G. 28 b.
435.	Br. M. 114 b.
436.	G. 12 a.
437.	G. 15 a.
438.	G. 28 b.
439.	Ash. I. 4 a.
440.	E. 18 b.
441.	E. 19 a.
442.	G. 9 b.
443.	G. 19 b.
444.	G. 20 b.
445.	G. 21 a.
446.	G. 21 b.
447.	G. 22 a.
448.	G. 22 b.
449.	L. 87 a.
450.	G. 25 b.
451.	G. 26 b.
452.	I.¹ 37 b.
453.	B. M. 114 a.
454.	B. M. 172 b.
455.	G. 6 a.
456.	W. VI.
457.	G. 27 b.
458.	B. M. 113 b.
459.	B. M. 114 b.

460.	G. 11 b.
461.	E. 19 a.
462.	C. A. 181 b; 546 b.
463.	I.¹ 48 a.
464.	H.² 20 a.
465.	G. 19 b.
466.	C. A. 157 a; 463 a.
467.	E. 3 b.
468.	G. 22 b.
469.	G. 23 a.
470.	E. 6 b.
471.	B. M. 172 b.
472.	C. A. 78 a; 228 a.
473.	B. M. 277 b.
474.	F. 35 a.
475.	W. VI.
476.	B. M. 172 b.
477.	W. 231.
478.	C. A. 346 a; 1072 a.
479.	E. o'.
480.	E. o''.
481.	G. 37 b.

IX.

THE PRACTICE OF PAINTING.

I. MORAL PRECEPTS FOR THE STUDENT OF PAINTING.

482.	G. 25 a.
483.	Ash. I. 18 a.
484.	Ash. I. 2 b.
485.	Ash. I. 25 b.
486.	Ash. I. 10 a.
487.	C. A. 145 a; 431 a.
488.	L. 79 a.
489.	Ash. I. 8 b.
490.	C. A. 196 b; 586 b.
491.	Ash. I. 7 b.
492.	Ash. I. 8 a.
493.	C. A. 181 b; 546 b.
494.	Ash. I. 8 a.
495.	Ash. I. 9 a.
496.	Ash. I. 9 b.
497.	Ash. I. 8 b.
498.	S. K. M. III. 24 b.
499.	G. 25 a.
500.	Ash. I. 10 a.
501.	Ash. I. 10 b.
502.	Ash. I. 9 b.
503.	G. 5 b.
504.	Ash. I. 4 a.
505.	G. 5 b.
506.	Ash. I. 31 b.
507.	Ash. I. 9 a.
508.	Ash. I. 13 a.

II. THE ARTIST'S STUDIO.— INSTRUMENTS AND HELPS FOR THE APPLICATION OF PERSPECTIVE.—ON JUDGING OF A PICTURE.

509.	Ash. I. 19 b.
510.	B. M. 171 b.
511.	B. 20 b.
512.	Ash. I. 29 a.
513.	Ash. I. 15 b.
514.	A. 23 a.
515.	Ash. I. 2 b.
516.	Ash. I. 2 a.
517.	Ash. I. 28 b.
518.	A. 2 a.
519.	Ash. I. 18 a.
520.	Ash. I. 15 a.
521.	A. 1 a.
522.	Ash. I. 6 b.
523.	Ash. I. 11 b.
524.	A. 1 b.
525.	A. 42 b.
526.	A. 38 b.
527.	A. 42 a.
528.	Ash. I. 4 a.
529.	Ash. I. 11 a.
530.	Ash. I. 7 b.
531.	Ash. I. 11 b.
532.	Ash. I. 9 b.
533.	Ash. I. 21 a.
534.	Ash. I. 25 b.
535.	Ash. I. 16 b.
536.	Ash. I. 4 b.
537.	Ash. I. 25 b.
538.	Ash. I. 12 b.
539.	Tr. 71.
540.	Ash. I. 4 a.
541.	Ash. I. 25 b.
542.	Ash. I. 19 b.
543.	A. 40 b.
544.	A. 41 a.
545.	A. 41 b.
546.	Ash. I. 22 b.
547.	Ash. I. 3 a.

III. THE PRACTICAL METHODS OF LIGHT AND SHADE AND AËRIAL PERSPECTIVE.

548.	C. A. 196 b; 586 b.
549.	A. 23 a.
550.	Ash. I. 14 a.
551.	Ash. I. 2 b.
552.	Ash. I. 14 a.
553.	G. 33 b.
554.	G. 19 a.

555.	Ash. I. 7 *a*.	606.	Ash. I. 14 *b*.	655.	Ash. I. 10 *b*.
556.	G. 11 *b*.	607.	G. 6 *b*.	656.	Ash. I. 11 *a*.
557.	Ash. I. 19 *a*.	608.	W. 158 *a*.	657.	K.3 30 *b*.
558.	Ash. I. 12 *b*.	609.	W. 158 *b*.	658.	W. A. IV. 152 *a*.
559.	Ash. I. 14 *a*.	610.	C. A. 78 *a*; 228 *a*.	659.	Ash. I. 18 *a*.
560.	Ash. I. 29 *b*.	611.	C. A. 152 *a*; 451 *a*.	660.	C. A. 139 *a*; 419 *a*.
561.	Ash. I. 4 *a*.			661.	Ash. I. 18 *a*.
562.	E. 4 *a*.		**VI. THE ARTIST'S MATE-**	662.	S. K. M. III. 48 *a*.
563.	Ash. I. 4 *a*.		**RIALS.**		
564.	G. 23 *b*.	612.	S. K. M. II.' o'.		**X.**
565.	Ash. I. 19 *a*.	613.	F. 96 *a*.		**STUDIES AND SKETCHES**
566.	Ash. I. 15 *b*.	614.	S. K. M. III. 53 *a*.		**FOR PICTURES AND**
567.	Ash. I. 15 *a*.	615.	Br. M. 174*a*.		**DECORATIONS.**
568.	Ash. I. 4 *a*.	616.	C. A. 71 *b*; 209 *b*.		
569.	G. 53 *b*.	617.	F. 56 *a*.	663.	F. U. 115, 446.
570.	W. A. IV. 218 *b*.	618.	258 *a*; 784 *a*.	664.	Th.
		619.	70 *a*; 207 *a*.	665.	S. K. M.²; 2 *a*.
	IV. OF PORTRAIT AND	620.	H.² 46 *b*.	666.	S. K. M. II.²; 1 *b*.
	FIGURE PAINTING.	621.	C. A. 70 *b*; 207 *b*.	667.	S. K. M. II.²; 78 *b*.
571.	Ash. I. 8 *a*.	622.	Tr. 78.	668.	V. A. X. 8.
572.	Ash. I. 9 *a*.	623.	L. 92 *a*.	669.	C. A. 75 *a*; 214 *a*.
573.	Ash. I. 6 *b*.	624.	A. 8 *b*.	670.	H.3 50 *a*.
574.	Ash. I. 3 *b*.	625.	W. P. 5 *a*.	671.	H.² 40 *b*.
575.	W. I.	626.	F. 96 *b*.	672.	J.² 90 *b*.
576.	Ash. I. 19 *a*.	627.	S. K. M. II.¹ 95 *a*.	673.	J.² 91 *a*.
577.	W. I.	628.	A. 1 *a*.	674.	Br. M. 250 *a*.
578.	Ash. I. 18 *a*.	629.	S. K. M. III. 52 *b*.	675.	B. 3 *b*.
579.	Ash. I. 26 *a*.	630.	K.3 32 *b*.	676.	Ox. 2 *a*.
580.	Ash. I. 2 *a*.	631.	C. A. 46. 11 *b*.	677.	Ox. 2 *b*.
581.	C. A. 157 *a*; 463 *a*.	632.	C. A. 70 *b*; 207 *b*.	678.	Br. M. 231 *b*.
582.	Ash. I. 17 *b*.	633.	S. K. M. III. 85 *a*.	679.	J.² 59 *a*.
583.	Ash. I. 18 *a*.	634.	C. A. 108 *b*; 339 *b*.	680.	C. A. 317 *a*; 959 *a*.
584.	Ash. I. 6 *a*.	635.	S. K. M. I.² 5.	681.	W. 243.
585.	Ash. I. 6 *b*.	636.	S. K. M. I.² 8.	682.	W. L. 198 *a*.
586.	A. 23 *a*.	637.	G. 46 *b*.	683.	W. L. 198 *b*.
587.	Ash. I. 8 *b*.	638.	B. 2 *b*.	684.	W. P. 11 *a*.
588.	Ash. I. 19 *a*.	639.	W. XIII.	685.	W. P. 11 *b*.
589.	Ash. I. 2 *a*.	640.	Tr. 49.	686.	Ash. I. 1 *a*.
590.	G. 26 *a*.	641.	G. 53 *a*.	687.	Br. M. 173 *a*.
591.	Ash. I. 13 *a*.	642.	W. VIII.	688.	W. IX.
592.	Ash. I. 6 *a*.	643.	H.¹ 18 *b*.	689.	H.3 51 *b*.
593.	C. A. 137 *a*; 415 *a*.	644.	H.3 88 *b*.	690.	H.3 53 *a*.
594.	Ash. I. 14 *b*.	645.	Br. M. 139 *a*.	691.	H.3 70 *a*.
595.	Ash. I. 5 *b*.	646.	S. K. M. III. 53 *a*.	692.	H.² 1 *b*.
596.	A. 28 *b*.	647.	S. K. M. III. 55 *a*.	693.	H.² 13 *a*.
597.	W. L. 145 *a*.	648.	L. 2 *a*.	694.	H.² 15 *b*.
598.	C. A. 337 *b*; 1026 *b*.	649.	S. K. M. I.² 5.	695.	H.¹ 40 *a*.
599.	C. A. 341 *a*; 1051 *a*.	650.	S. K. M. I.² 8.	696.	H.¹ 40 *b*.
600.	Ash. I. 15 *b*.			697.	S. K. M. II.² 1 *b*.
			VII. PHILOSOPHY AND HI-	698.	F. o".
	V. SUGGESTIONS FOR COM-		**STORY OF THE ART OF**	699.	M. 4 *a*.
	POSITION.		**PAINTING.**	700.	M. 4 *b*.
601.	Ash. I. 4 *b*.			701.	M. 5 *a*.
602.	Ash. I. 5 *a*.	651.	S. K. M. III. 19 *b*.	702.	C. A. 67 *b*; 203 *b*.
603.	G. 15 *a*.	652.	Ash. I. 15 *b*.	703.	C. A. 228 *b*; 687 *b*.
604.	Ash. I. 17 *a*.	653.	Ash. I. 16 *b*.	704.	J.² 1 *b*.
605.	Br. M. 169 *a*.	654.	Ash. I. 16 *a*.	705.	Mz. 10 *a*.